The Age of Modernism
Art in the 20th Century

Martin-Gropius-Bau, Berlin

7 May – 27 July 1997

This exhibition has been made possible by a generous grant from the
Stiftung Deutsche Klassenlotterie

The Age of Modernism
Art in the 20th Century

Edited by
Christos M. Joachimides and Norman Rosenthal

Essays by
Brooks Adams, Stephen Bann, Dieter Daniels, Arthur C. Danto,
Boris Groys, Christos M. Joachimides, Wolf Lepenies,
Odo Marquard, Robert C. Morgan, Anna Moszynska, Norman Rosenthal,
Peter Schjeldahl, Wieland Schmied, Shearer West, Beat Wyss

Co-ordinating Editors
Gerti Fietzek and Henry Meyric Hughes

ZEITGEIST-Gesellschaft e.V.

Verlag Gerd Hatje

This catalogue is published on the occasion of the exhibition *The Age of Modernism – Art in the 20th Century*, held at the Martin-Gropius-Bau, Berlin, 7 May – 27 July, 1997

Editing assistance
Christine Traber

Copy editing
Henry Meyric Hughes

Assistance
Hetty Meyric Hughes

Colour illustrations
Karin Osbahr

Picture research (portraits of the artists)
Regina Dorneich

Translations from the German
David Britt, London (essays by Dieter Daniels, Boris Groys, Christos M. Joachimides, Wolfgang Lepenies, Odo Marquard, Wieland Schmied, Beat Wyss); Julia Barnes, Yorkshire; Lorna Dale, London; Francisca Garvie, London; Henry Meyric Hughes, London; Rachel McCall, Suffolk; Michael Robinson, London; Barbara Wilson, London; David Wilson, Cardigan (biographies of the artists)

Cover design
Nicolaus Ott + Bernard Stein

Layout
Gabriele Sabolewski

Reproductions
Fotosatz Weyhing, Stuttgart
Repromayer, Reutlingen

Binding
Kunst- und Verlagsbuchbinderei, Leipzig

Production
Dr. Cantz'sche Druckerei, Stuttgart

Cover illustration
Wassily Kandinsky, *Composition VI*, 1913 (detail)

Published by
Verlag Gerd Hatje,
Senefelderstraße 9,
73760 Ostfildern-Ruit
T. (0) 711/44 99 30
F. (0) 711/441 45 79

ISBN 3-7757-0682-8 (English trade edition)
ISBN 3-7757-0672-0 (German trade edition)
Printed in Germany

Distribution in the US
DAP, Distributed Art Publishers
155 Avenue of the Americas, Second Floor
New York, N.Y. 10013
T. (001) 212 – 627 19 99
F. (001) 212 – 627 94 84

Distribution in Great Britain
and British Commonwealth
Thames & Hudson Ltd.
30–34 Bloomsbury Street
London WC1B 3QP
T. (171) 636 16 95
F. (171) 636 54 88

Contents

The Exhibition

Exhibition Organisers
Christos M. Joachimides, Berlin
Norman Rosenthal, London

in association with
Henry Meyric Hughes, London
Carmen Giménez, Madrid und New York

Curatorial Assistants
Karin Osbahr, Wendy Wallis,
Anke Daemgen, Isabel Schulz,
Christoph Lademann,
Jeanne Greenberg (New York)

Organisation
Tina Aujesky

Exhibition Assistants
Regina Gelbert, Ulmann-Matthias
Hakert, Mark Giannori, Simone Lücke,
Viviane Kafitz, Bettina Held, Kassandra
Nakas, Roland Enke, Ursula Nußbaum,
Werner Braunschädel, Berit Schuck.
Moscow: Selfira Tregulova, Svetlana
Dzhafarova, Faina Balakhovskaia

Administration
Silke Taupe, Jutta Ritte

Secretariat
Marita Frei, Christiane Friedrich

Press
Katja Maurer, Ute Kiehn, Richard Szklorz

Exhibition Architect
Jürg Steiner

Exhibition Design
Hasso von Elm (lighting), Thomas Büsch
(graphics), building supervision: Ralf
Keuthan, Jörg Zander, Sebastian Wagner

Exhibition Contractors
Museumstechnik GmbH, Berlin
(Uwe Kolb, Mathias Broda, Thomas
Kupferstein), Ema GmbH, Berlin,
Beltec GmbH, Berlin

Conservation
Keith Taylor, Abigail Bowen, Matthew
Nation (Taylor Pierce Restoration
Services Ltd., London); Christiane
Altmann, Petra Breidenstein,
Hana Streicher

Transport
Hasenkamp Internationale Transporte
GmbH & Co. KG

Insurance
Kuhn & Bülow Versicherungsmakler
GmbH, Berlin

Acknowledgements

We have received help and information in many forms and from many quarters. Without this support, freely and unselfishly given, there would have been no exhibition. Accordingly, the number of those whom we have to thank is a large one.

This exhibition would have been impossible without the generous support of the Stiftung Deutsche Klassenlotterie Berlin. Our particular thanks are therefore due to the Board of the Foundation.

We are extremely grateful to Professor Jörn Merkert, Director of the Berlinische Galerie, for cooperating so magnificently in the work of accommodating this exhibition in the space of the Martin-Gropius-Bau.

Without the committed and active collaboration and support of the Solomon R. Guggenheim Museum, New York, and in particular of its Director, Mr Thomas Krens, and its Curator, Ms Lisa Dennison, the exhibition could not have taken place in this form. Our heartfelt thanks go out to them.

We also owe a special debt of gratitude to Senatsrat Jörg-Ingo Weber, who has given us the benefit of his advice and assistance in what has been a far from easy organisational process. Where would any such exhibition be without the generosity of the lenders? We are deeply indebted to all those many major museums, private collections and artists in Europe and overseas who have been prepared to part with their masterpieces for the duration of this show.

Particular thanks are due to Mr Rudi H. Fuchs, Director of the Stedelijk Museum, Amsterdam, and Mr Nicholas Serota, Director of the Tate Gallery, London, for their generous willingness to lend works from their collections and for their support and cooperation. Without the personal commitment of Mr Mikhail Shvydkoi, Deputy Minister of Culture of the Russian Federation, the unique contribution of the Russian museums would not have been present in such richness and depth. Special thanks, too, to Mr Philippe Daverio, Assessore alla Cultura of the City of Milan, who, inspired by the idea of the exhibition, smoothed the way for us to show important works loaned from the civic museums in Milan. Mr Jean-Jacques Aillagon, President of the Centre Georges Pompidou, Paris, opened to us the doors of the most important European museum of modern art: hence the presence in Berlin of outstanding works from the collection of the Musée National d'Art Moderne. Our heartfelt thanks are also due to all those private collectors who have chosen to remain anonymous.

We are most grateful to the members of the Advisory Committee, and above all to Professor Dr Wieland Schmied, who has followed this project with great energy and enthusiasm from its inception.

Our warm appreciation is due to the authors of the essays in this catalogue, whose contributions have enriched the exhibition in important ways. In this acknowledgement we must include Gerti Fietzek and Henry Meyric Hughes, who have brought their ideas, their knowledge and their powerful commitment to the editing of the catalogue. We

8

would also like to thank the staff of our publishers, Verlag Gerd Hatje, and of our printers, Dr. Cantz'sche Druckerei, who have devoted all their energies to the production of this massive and complex catalogue.

Without the tireless commitment of all our own staff, during the often difficult preparatory stages, this project could never have been brought to fruition. We owe them all our deepest gratitude.

We should also like to thank all those who, in their many different ways, have given us help, inspiration and encouragement. Among them, special mention is due to the following:

David Anfam	Jean Frémon	Tom Phillips
Paolo Baldacci	Elena Geuna	Marla Prather
Heiner Bastian	Barbara Gladstone	Ursula Prinz
Douglas Baxter	Krystina Gmurzynska	Mathias Rastorfer
Neal Benezra	David Gordon	Samuel Sachs II
Maria Grazia Medici Benini	Peter Goulds	Chiara Sarteanesi
Marc Blondeau	Karsten Greve	Jan Sassen
Irving Blum	Volker Hassemer	Peter-Klaus Schuster
Achim Borchardt-Hume	Max Hollein	Christoph Schwarz
Annette Bradshaw	Antonio Homem	Mario Serio
Emily Braun	Christian Klemm	Klaus Siebenhaar
Diana Brocklebank	Chrysanthi Kotrouzinis	Amanda Simmons
Beverly Calté	Marlies Krebs	Ileana Sonnabend
Richard Calvocoressi	Yvon Lambert	Morgan Spangle
Massimo Di Carlo	Catherine Lampert	Werner Spies
Desmond Corcoran	Loïc Malle	Christoph Stölzl
Chantal Crousel	Georges Marci	Martin Summers
Jeffrey Deitch	Massimo Martino	Sami Tarica
Diane Dewey	Karin Frank von Maur	Alain Tarica
Volker Diehl	Pia und Franz Meyer	Catherine Thieck
Sir Philip Dowson	David Mitchinson	Susan Thompson
Andrew Fabricant	Akim Monet	Daniela Tilkin
Richard L. Feigen	David Nahmad	Leslie Waddington
Maria Teresa Fiorio	Hans-Peter Nerger	Sarah Wilson
Marcel Fleiss	Anthony d'Offay	Heribert Wuttke
Simonetta Fraquelli	Vibeke Petersen	

Christos M. Joachimides Norman Rosenthal

CHRISTOS M. JOACHIMIDES

The Age of Modernism

Twentieth-century art is not identical with Modernism; and, conversely, Modernism is not identical with twentieth century art. This exhibition is not about the whole evolution of twentieth-century art; it is about Modernism in art. Nor does it show 'world art', but the art produced within the Western tradition and in the countries of the Western hemisphere – Europe and North America – in the wake of Romanticism and in reaction against Post-Impressionism. The birth of this art coincided with the advent of an age dominated by euphoric, utopian visions of the future of humanity and of society. There were revolutions on every side: in science and technology, where progress seemed to have no limit; but also in philosophy, in music and in literature. It was the dawn of a century of contradictions.

What is Modernism? Is it a period of art history, like, say, the Baroque? Is it an historical phenomenon, an international style? Or is it an artistic attitude that retains its validity to this day, a dialectical quest that still remains very far from a conclusion? In recent years, the apostles of conservatism and defeatism have proclaimed the impending death of art, and have spoken of a mood of eschatological depression in which the wells of imagination have run dry. These are Cassandra voices, like those that proclaim the End of History or *la posthistoire*. Such observers fail to realise that – to put it in Joseph Beuys' terms – just so long as human beings inhabit this planet, a huge creative potential will constantly be generated; that particles of that creativity will coalesce into artistic production; and that this will perennially confront us with new, unsuspected or unperceived questions, and with experiences that we find alien or distressing. It will confront us, in fact, with the innovative and onward-leading power of art. The Age of Modernism is not over and done with: it is still in progress and still surprising us with new impulses, unexpected suggestions and daring surmises.

What of so-called Postmodernism? This is a term that emerged from the architectural debate and was then foisted upon art in the late 1970s. It gave rise to some modish speculation as to whether a sudden scene-shift might reveal contemporary art as the enervated, repetitious, terminal phase of Modernism.

Modernism, with its inbuilt theory of innovation, certainly has had its crisis. But this took place back in the 1930s, after two decades dominated by a whirlwind succession of revolutions and of blueprints for new worlds. In that crisis, creative impulses were paralysed, and the avant-garde relapsed into manifest impotence. But then the very forces that sought to destroy Modernism – Hitler and Fascism – involuntarily became its saviours. Early on the Second World War, after the fall of France, many of the most cele-

brated artists of the day took flight from Paris, the last European refuge of the avant-garde, to the safe haven of New York. It was Fascist persecution that ennobled Modernism and gave it martyr status – as a representative embodiment of those spiritual values that had been left to perish in Europe. Its postwar return to Europe turned into the triumphal progress of a Church Militant. Modernism had acquired moral authority. It took on a new dimension: no longer a purely aesthetic phenomenon, it became the standard-bearer of freedom and the art of democracy. In the culture of the postwar world, Modernism stood for an ideological concept of purity. Political persecution had finally turned Modernism into the thing it had always meant to be.

On reaching New York, European artists found not only a refuge but an extraordinarily gifted and forward-looking artistic generation. The two sides sized each other up and kept their distance; and this tension was a fruitful one. Against this background the American artists went on to reformulate and develop a language of their own. Their impressive vitality and expressive power was to dominate the history of art throughout the late 1940s and the 1950s. The vital artistic impulses – which had formerly come from Paris and the other major European artistic centres, Milan, Moscow, Berlin – now originated in New York. This was the new centre of art after the Second World War, and the place where Modernism took off again – sadder and wiser, and with its faith in progress much impaired by a wartime experience of unimagined bestiality and unprecedented destruction. That was the starting-point of a new meta-Modernism, which was manifested partly in such verbal labels as 'Abstract Expressionism', 'Neo-Dadaism' and 'Geometric Abstraction' – and which ushered in a new phase of twentieth-century art history.

The title of this exhibition, *The Age of Modernism,* thus asserts a thesis. This is an age that extends from Picasso to Kounellis, and from Malevich to Gary Hill; it is a continuum that leads from the first decade of this century as far as our own 1990s – a paradoxial, dialectical process full of question-marks and hiatuses, detours and U-turns.

In this exhibition, wo do not so much put the twentieth century under a microscope as observe it through a telescope: we see the age as a whole, from a distance – but in the full awareness that we are its contemporaries.

The exhibition begins with the year 1907, the year in which Modernism was born, when Picasso established the crucial principle of the autonomy of the work of art and inaugurated his own radical exploration of reality by painting *Les Demoiselles d'Avignon.* It concludes with the work of a number of younger artists, whose activity extends into the 1990s and offers sufficient points of reference for critical judgment, while also exerting a demonstrable influence within their own generation.

This exhibition, *The Age of Modernism,* should not be seen as an encyclopaedia but as an essay. It does not set out to offer an exhaustive overview but to ask questions, to reveal discontinuities, to provide snapshots of moments in time, and to illuminate situations – like a screenplay. To focus on masterpieces, to worship the gods, is not enough: only surprising juxtapositions, combined with the promptings of intellectual history, can shock visitors into finding their own angle on the century.

An exhibition, as we understand it, is an expressive medium in its own right, subject to laws utterly distinct from those that apply to a book, a film or a video. The presentation must be both laconic and epic; it must be taut, because elliptical; it must have its own rhythm, its own musicality; it must build a crescendo and insinuate a diminuendo. An exhibition embodies a different reality, which the visitor traverses on a voyage of adventure through space and time – in the way that a film plunges us, for two hours, into an alternative world of vicarious experience and emotional upheaval.

Twentieth-century art has a hermetic quality that needs to be purveyed, as Bertolt Brecht put it, 'with cunning'. In order to cast a spell, 'truth must be beautiful'. An initial appeal to the senses offers the visitor a key; with this, he or she can crack the codes and enter a universe of experience that jealously guards its secrets: the universe of art. Only then is there room for the intellectual curiosity that leads to a deeper and more complex understanding. Through enjoyment to gnosis.

This exhibition invites the visitor to visualise the twentieth century as traversed by four main paths – paths full of inbuilt paradoxes and porous transitions. Their titles are as follows: 'Reality – Distortion'; 'Abstraction – Spirituality'; 'Language – Material'; 'Dream – Myth'. Within each of them, in place of a slavish adherence to chronology, a loose historical thread runs through the century. Some artists are to be found on more than one path, because at different times they have made different major contributions. Each of the four paths is presented as a self-contained whole; and a synoptic view of all four paths constitutes the exhibition.

The decision has also been taken to concentrate on the essential media of painting and sculpture. Painting is interpreted in a wider sense to embrace three-dimensional collage, combine painting and assemblage; sculptural forms include environments, installations and video sculptures.

The central issue on the first path, 'Reality – Distortion', is that of the representation of reality after the Post-Impressionist experience (which was an experience of poetry with Gauguin, tragedy with van Gogh). The first to tackle this was Picasso, with the radical language of distortion and reduction that he employed in *Les Demoiselles d'Avignon*; here we also detect the inspiration of African sculpture, which inspired such enthusiasm among the artists of the early twentieth-century avant-garde. This path took a radical turn with Picasso and with Georges Braque, when both artists cracked open the coherent image to reveal the multifaceted reality beneath the surface of objects. The breathtaking pace of an age of technological enthusiasm inspired parallel developments in Italy, as well as in France and Germany, and these are represented by Umberto Boccioni, Giacomo Balla, Robert Delaunay and Franz Marc. The expressive vision, basic to the art of Northern Europe, surfaces in the work of E. L. Kirchner, Emil Nolde, Oskar Kokoschka and Max Beckmann; and three French artists, Henri Matisse, Claude Monet and Pierre Bonnard, stand for the Cartesian balance between world and image.

In the period after the Second World War, the human image appears in a distorted, lonely, alienated form. The elongated, melancholy figures of Alberto Giacometti; the

figures of Jean Dubuffet, which seem to spring from the world of children's drawings; the women of Willem de Kooning; the heads of Asger Jorn; the blurred creatures of Francis Bacon; Georg Baselitz's attempt to liberate painting at a stroke through a 'world turned upside down': all these are attempts to address the human condition by walking the knife-edge between abstraction and figuration.

In their rejection of the object, Kandinsky in Munich and Malevich with his black square (the icon of revolutionary abstraction) constitute the twin poles of a single force-field to which we give the name of 'Abstraction – Spirituality'. Spirituality, because this translation of the absolute into an image takes place against a background of theosophical and other mystical influences. We can trace this through the *Pier and Ocean* paintings of Piet Mondrian, by way of Barnett Newman's *Stations of the Cross* and Mark Rothko's transcendental landscapes, to the ascetic, reductionist panels of Ad Reinhardt, the monochrome artifacts of Yves Klein, and the dematerialised image in the projections of James Turrell.

The third path, 'Language – Material', is based on a method first defined by Marcel Duchamp. When Picasso integrates words or fragments of text into his collages, he is using found material either as colour or as drawing. By contrast, Duchamp – followed in this by such artists as Beuys and Bruce Nauman – uses either material or language with an ambivalence that distances and deepens perception. Like no one else this century, Duchamp calls in question the role of art and of the artist. His Readymades are mass-produced objects that are turned into works of art by the artist's signature, by being shown in a museum, and by the viewer's acceptance of them. This is a frontal assault, calculated to dismantle the mythical 'aura' of the work of art. A continuation of these same strategies is visible in the work and philosophy of Andy Warhol. He went one decisive step further, by dwelling so obsessively on the banalities of the world around him that he further devalued second-hand imagery by a process of reduplication – whereupon he had only to add his signature, for the commonplace image to be transformed into a work of art.

To capture the dream within a pictorial reality, and to give visual expression to myth, are the aims that dominate the fourth path within this exhibition, entitled 'Dream – Myth'. In his disturbing visions, Giorgio de Chirico pursues the sinister ramifications of meaning that lie within objects. Max Ernst creates a poetic, alternative universe through an intricate tissue of memories, allusions, dream sequences. And René Magritte performs a breathtaking balancing-act at the outermost limits of the unconscious: the point where deep-seated associations impinge on an apparently bland reality.

Of the four paths that run through this exhibition, the ones that seem to us most relevant to the younger generation of artists are those that either point to a renewed interest in Surrealism – not in a derivative but rather in a Structuralist sense – or reflect on the work of Duchamp and its implications for the present.

For visual art, Modernism represents the most profound break with the past since the Renaissance. What has changed is not only the outward appearance of art but – above all – our notion and our understanding of what art is meant to be, and of the role it plays in society.

ARTHUR C. DANTO

A Century of Self-Analysis: Philosophy in Search of an Identity

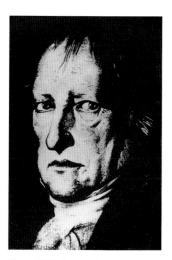

Immanuel Kant, painting by the
School of Anton Graff, c. 1790

Georg Wilhelm Friedrich Hegel,
painting by Jakob Schlesinger, 1831

The great German philosophers of the late Enlightenment and high Romanticism, pre-eminently Immanuel Kant and Georg Wilhelm Friedrich Hegel, were remarkable, in part, for the exalted place they allotted to aesthetics in their vast systems. Kant, for example, situated aesthetic judgment between pure and practical reason – between intellectual and moral judgment. And Hegel considered art, together with religion and philosophy, as a phase of what he termed Absolute Spirit – *Der absolute Geist*. This exaltation of art marks a distinction between these thinkers and their predecessors of the seventeenth century, who found scant occasion to write about art or, for that matter, about philosophy itself in any special, self-conscious way. Descartes, Spinoza and Leibniz did not perhaps regard their own practices as different in any remarkable way from what today we would call science: Descartes' *Discourse on Method* (1637) – a philosophical masterpiece – was conceived of as an introductory essay to his books on optics, geometry and cosmology. But by the time Kant published his *Critique of Pure Reason* (1781, 1787), philosophy had in itself become something of a puzzle: 'Human reason has this peculiar fate', he wrote, 'it is burdened by questions which … it is not able to ignore, but which, as transcending all its powers, it is also unable to answer.' One must, Kant felt, begin to apply reason to 'the faculty of reason' itself, in an effort to determine from within what the scope and limits of reason finally are, independently of any special subject-matter. It was this felt need to bring reason to self-consciousness which moved Clement Greenberg, in his famous essay, 'Modernist Painting', of 1960, to declare that Kant was 'the first real Modernist', because 'the first to criticize the means itself of criticism.' In a sense, Greenberg was to see his own endeavour as a kind of Critique of Pure Art, articulating what he sensed as the historical disclosure, to each of the various arts, of the need to submit itself to the kind of self-examination of which Kant felt philosophy to be so in need. But precisely this parallel between philosophy and art helps vindicate Hegel's claim of a deep kinship between them. Indeed, it was their potential for self-examination that was the defining trait of Absolute Spirit. Spirit (or mind) is absolute, when it becomes its own subject, as happened increasingly both to philosophy and art in the twentieth century.

But that meant, Hegel believed, that art in a sense had come to an end. He made this declaration in a famous passage in his *Lectures on Fine Art*, last given in Berlin in 1828/29. 'Art no longer affords that satisfaction of spiritual needs which earlier ages sought in it, and found in it alone, a satisfaction that, at least on the part of religion, was most intimately linked with art.' Hence, art 'has lost for us genuine truth and life'. This meant that art had become a problem for itself, just as philosophy had, which meant that 'the philo-

sophy of art is therefore a greater need in our day than it was in days when art by itself as art yielded full satisfaction.' The proclamation of the end of art must seem simply crazy, in view of the immense amount of art produced in the West alone since 1828, but when one reflects on that history, Hegel makes a certain deep sense. Not long after he declared the end of art, for example, the Nazarenes and the Pre-Raphaelites, feeling that painting had taken a wrong turn, attempted to reverse what would have been regarded as an irresistible progress in representing the appearances of the world, and seek new beginnings. And from about 1863 on, with Manet and with the collapse of the authority of the *Académie des Beaux-Arts*, the history of art was the history of movements, each of which carried its own definition, that is to say, its own philosophy of what art was and what it should do. Here is a singular list compiled by Mark Polizotti in his biography of André Breton:

> The decades that had witnessed the rise (and generally rapid fall) of Populism, Symbolism, Naturalism, Parnassianism, Scientism, Free-Versism (*vers-librisme*), Decadentism, Magnificism ... Magicism, the Roman School, Synthetism, Regionalism, Impressionism, Humanism (one of many), and Fauvism, not to mention literary varieties of Socialism and anarchism, gave way to an age that would bring Primitivism, Sincereism, Subjectivism, Synchronism, Impulsionism, Integralism, Intenseism, Unanimism, Neo-Mallarméism, Paroxysm, Druidism, Pluralism, Dynamism, Dramatism, Totalism, Patriartism, Vivantism, and Machinism ... before finally arriving at Futurism, Cubism, Dadism, Surrealism, and beyond.

'The schools multiply, leading to one schism after another', the sociologist of art, Pierre Bourdieu notes, composing his own inventory of movements. Modern art tended to express itself in manifestos. The art historian, Phyllis Freeman, has so far identified something over 500 formal manifestos, but even the letters artists wrote to one another were 'manifesto-like', as John Richardson describes a letter from Derain to Vlaminck in July, 1905 (there was no formal Fauve manifesto). And Greenberg's essay on Modernism is, after all, a kind of formalist manifesto, masked as a conceptual analysis of the nature of art.

The philosophy of art, so far as it was practised by artists, was subject to constant fission, activated by political and psychological aspirations and aesthetic ideologies in which artists collaterally believed, but in my view the true philosophical form of the question concerning the nature of art did not emerge until the mid-1960s, with the work of Andy Warhol, the Minimalists and the Conceptual artists, and it is certainly striking that, not long after that, very little by way of new movements emerged, other than, of course, the political and moral ones which captured artistic allegiance and spelt the great reforms of the institutions of the artworld, which continue to this day under pressure from feminism, multiculturalism, and the like. So it was very much as if the restless searching for definition had ended, as a satisfactory philosophy of art began to become visible. But this essay is not, after all, intended as a conceptual history of art in the twentieth century. My aim, rather, is to have used the history of art to throw into relief the parallel history of philosophy in the century now approaching its end. For it, too, has been marked by the fact that the question of what philosophy is has become an internal question of philosophy, and differences in how one conceives the solution to the problem of philosophy

have tended, by and large, to determine the practice of philosophers in other domains. It is fair to say, I think, that at the century's end there is no consensus among philosophers on the nature of their defining endeavours, but perhaps because philosophy, whatever its identity, is a vastly more disciplined exercise than art, it has not seen the latter's unremitting fissions into ideologies and manifestos. It is more disciplined, in large part, because philosophers in this century have been professors and, since the nature of philosophy has been seen as an internal problem and hence a topic for research, investigation into it has been conducted with the intellectual restraint of academic investigation. By contrast with the institutional structures in which art is practised, there really has only been, in the case of philosophy, the institution of the university. Of course, as with art, the past few decades have seen immense pressures on the university, from the same sources as those felt by the art world, to undertake reforms in terms of admissions and curricula, including the curriculum of philosophy. But the main story of philosophy in this century has been the struggle to achieve a sense of its own identity, of why it exists and what it can do; and I shall address some of the century's main movements from the perspective of that investigation.

<p style="text-align:center">*</p>

Most twentieth century philosophical movements tend to follow Kant, in regarding the metaphysical questions pondered from the very beginnings of philosophical speculation as somehow different from questions to which there can, in principle at least, be straightforward scientific answers. Before the invention of space satellites, no one knew whether there were mountains on the other side of the moon, since the moon presents only one face to earthly observation. But this never became a question of philosophical debate, since there was consensus on how, in principle, it might be answered. By contrast, no one knows how the universe began, and it is far less simple than imagining going around the moon to imagine what it would have been like at the beginning. But even if one cannot observe the universe coming into being, one can imagine that there would be observations, one way or another, which would count for or against suggested hypotheses. By further contrast, there is and can be no consensus on the relationship of minds to bodies, not merely because there is no consensus as to how mind itself is to be understood, but no sense at all as to what kinds of observations might settle the matter one way or another. Philosophers might regard it as a scientific question, but have continued to write and think about it, just because the science is not, and may never be, in place for putting an end to such speculations. At mid-century the computer seemed to offer a powerful analogy – the mind is to the body as software is to hardware – but the question remained as to whether machines were capable of consciousness, capable, in Hegel's terms, of participating in Absolute Spirit which was defined through self-consciousness, and no one is certain how this might be answered. On the other hand, there are all sorts of questions about whether human beings have free will, whether values have objective reality and whether the universe is one or many, that do not seem obviously to be scientific nor, if at all answerable, to find their answers through observation or inference. It would be just

such questions that Kant had in mind when he undertook his great critique of reason, and which he thought might lie beyond reason's competence to answer at all. But then, how are we to deal with them, if they also seem to present themselves as having to be dealt with? And what is philosophy to do, if its questions – including, perhaps, the question of its own nature – lie outside the limits within which it is possible to function?

The philosophies of the twentieth century have been philosophies of such limits: of reason, of language, of meaning. Since we cannot answer them from within our limits, what are we to do? This suggests that the movements of the twentieth century respect a line between what can be answered by science and what cannot, philosophy finding itself stuck with what cannot be. This gives rise to the great radical positions of twentieth century philosophy, which for the most part has sought strategies intended to stop the questions from arising or to see them as disguises for matters which can be dealt with in non-philosophical terms.

*

The division of history into decades or into centuries, or even into ages, is a product of our conception of living in time, which, because it appears in very ancient texts, must be a very natural and spontaneous mode of temporal consciousness, connected with our fundamental sense of beginning and ending, of expectation and memory, of hope and relief. There would have been little actual difference between the way people lived their lives on the last day of the nineteenth and the first day of the twentieth century, except that crossing such a boundary must have been so auspicious to those who marked the change as to represent not merely the turning of a leaf, but the turning up of an entirely new sort of leaf. Sigmund Freud, of all thinkers the one most sensitive to subjective meanings, published what he rightfully regarded as his most important contribution – *The Interpretation of Dreams* – in 1899, but he dated it 1900 because he felt it marked a sharp and, indeed, a revolutionary turn in the way human beings were to regard themselves. Kant thought his critical philosophy to be a 'Copernican revolution' in philosophy. Copernicus proposed that not the earth but the sun is the centre of things, and that what appears to be the sun's rotation, in fact, is to be understood in terms of our own rotation around it, so that even though human beings are not any longer to be regarded as at the stable centre of things, the way they see things really has to be referred to the position they occupy in the swing of the planets. And Kant similarly argued that our basic conceptions of the world are not derived from, but imposed upon, the world and that the structure of our minds is what gives a sense of order to things. Indeed, Kant went so far as to say that how the world actually is – is *in itself* – is not something we are capable of knowing. We are not, of course, conscious of this projection outward of an internal structure, or Kant could not have claimed a revolutionary discovery. Kant felt he had in fact performed a great labour, in inferring from experience inward to the determining structures of the rational mind. But on the basis of it he opposed his philosophy to what he stigmatised as *dogmatism* – to philosophies which pretend to find the basic structures outside the mind, underlying experiences, as deep but hidden truths of

nature. They *are* hidden, Kant allowed, because they are closer to us than we could have imagined. They are ourselves, and hence not objects for ourselves. We can only have access to them through a kind of critical analysis.

Freud does not especially cite Kant as among his predecessors, but he did think he had achieved a revolution parallel to that of Copernicus, who transferred us from the centre of the world to an outer orbit; and parallel as well to that of Darwin, from whose theories it follows that we are not created in the image of a perfect being, but instead are the evolutionary product of foraging and copulating forms of animal life, whose impulses and urgencies we share. *His* revolution was to dethrone our conception of ourselves as rational beings and to identify much of our behaviour as the product of irrational impulses, originating in an ineradicable sexual nature, which determines the infantile beliefs and desires which we carry with us into adult life, albeit it in disguised forms. This adversion to animal and sexual nature as our very identity is what makes Freud a modernist thinker and distinguishes him, whatever the outward similarities, from Kant. Kant was, after all, analysing Pure Reason and his system applied to human beings only insofar as humans are rational. Kant simply disregarded as part of the equation our 'lower' nature and our less than rational impulses. Earlier philosophers, like Descartes and Spinoza, wrote essays on the passions of the soul, but they regarded the passions as so many inadequate ideas, fallings off from an ideal of reason, which is our true nature, when we are not defective. Hume had written strongly that reason 'is, and ought only to be, the slave of the passions', meaning by this to claim that reason simply enables human beings to find ways of realising their desires. But Freud had an entirely compelling theory of desires themselves, which he thought of in terms of repressed but insistent wishes, formed in the infantile mind, and left there in a repressed state as we grow older and older, but which express themselves in conduct which is baffling to those who perform it and comes through with special vividness in dreams. Hence, the importance in his mind of having his great book thought of as beginning a new century, with a radically new vision of being human. Like Kant, Freud proposed that our true self is hidden from conscious introspection. And like Kant, as well, he sought to argue that the way to this hidden being is through analysis, through what he specifically designated *psychoanalysis*, which enables us to arrive at insights as to our true nature and to understand why we act as we do, dream as we dream, suffer as we suffer.

Because Freud's theories were placed by him in confrontation with philosophical theories, it is possible to view them as philosophical in their own regard, in view particularly of the light they cast on knowledge, perception, the structure of the mind, and the claims of reason. Moreover, when a medical student, Freud studied for three and a half years with Franz Brentano – a thinker whose views on the structure of consciousness were to have an impact on philosophers in mid-century, but who is otherwise now largely forgotten. And Freud respected philosophical thought sufficiently to avoid, or pretend to have avoided, reading it. In his autobiography, for example, he cites Nietzsche with great admiration, for 'his guesses and intuitions', which 'agree in the most astonishing way

Sigmund Freud, etching by Max Pollack, 1886

with the laborious findings of psychoanalysis.' Nietzsche – whose death in 1900 after a decade of catatonic silence brought on by syphilis – did not, of course, have a worked out view of the unconscious. But he did believe that philosophy was, by and large, 'confession' – a projection outward of what he termed the 'will-to-power' of philosophers, who took for objective truth their own unacknowledged desires as to how the world should be. His masterpiece, *Beyond Good and Evil* (1886), is an unrelenting 'deconstruction' – to use a term invented by the artist Robert Delaunay, but given currency late in the 1960s by Jacques Derrida – of philosophical ideas and concepts, all of which answer to deep, what we might just as well call 'unconscious', wishes of the philosophers themselves. There would, therefore, be no need to take them seriously as conveying truth about the world, but only to trace them back, by a method of analysis to which Nietzsche never gave a name: 'Having kept a sharp eye on philosophers, and having read between their lines long enough', he wrote, 'I now say that the greater part of conscious thinking must be counted amongst the instinctive functions, and it is so even in the case of philosophical thinking … The greater part of the conscious thinking of a philosopher is secretly influenced by his instincts, and forced into definite channels.'

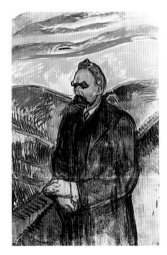

Friedrich Nietzsche, painting by Edvard Munch, 1906

Nietzsche's theory of the 'will-to-power' had a certain Kantian edge to it, for, like Kant, Nietzsche believed that the structures we find in the world are essentially imposed upon it and not resident there at all. But whereas Kant saw these structures as at one with reason, and the same for all rational beings, Nietzsche saw them as instinctive and physiological, and reflective only of the biologically average – the 'herd', as he termed it. If we all think more or less alike, this is due to the will-to-power of the herd, acting upon its members. But there is otherwise nothing sacrosanct about the structures, and they are thinkably plastic enough to yield to something different, imposed by different human beings with a different physiology, e.g. 'the strong'. Until a superman emerges to create a better world, we are mired in the world we believe we know, which (as he came vehemently to insist) is due to the will-to-power of the weak and of the slaves. He believed, indeed, that Christianity was a form of the will-to-power of 'slaves' and the enemy of anything better. In fact, what we are conscious of, when we look within, is merely the imprint upon us of the herd's vision of the world. 'Truth' is merely another name for what happens to work out for the herd's form of life.

These dramatic ideas were extremely exciting to Nietzsche's readers at the turn of the century, and it is not difficult to see how they should have recommended Nietzsche to the Nazis – his sister, a lifelong anti-Semite, assured Hitler that he was exactly what her brother would have recognised as the Superman. But there were other parts of Nietzsche's philosophy which only became visible later in the century, when language became the focus of philosophical thought, nearly to the exclusion of everything else. Nietzsche had revolutionary views on language, and he thought that our basic beliefs about the world were encoded in our grammar, to the point that 'We shall not got rid of God until we have gotten rid of [our] grammar.' He believed that the view of the world as consisting of things and relationships between things was itself a shadow cast by the

subject-predicate structure of our basic propositions, and he imagined a grammar under which there would be no way even of conceiving of things as things. One of his examples was a sentence like 'Lightning flashes.' It implies that the lightning is a thing, with flashing something that thing does, when in truth, he argued, the lightning *is* the flashing, not something distinct from it. He went even further in suggesting that this view, if applied to human activity, would make it impossible to distinguish agents from action – we are what we do – rather than something apart from the action, which has a choice of whether to do it or not. We are in this respect like the lightning.

It is the upshot of Nietzsche's system that there is no basis for examining and testing philosophical ideas, for they are none of them what philosophers believe them to be, but expressions of our instinctual make-ups, and so we do not ask whether they are true or false, but how to see through them to the will-to-power they disguise. A different will-to-power would impose a different system. From this point of view, there is a structural parallel between Nietzsche's dissolutive philosophy and that of a third set of meta-philosophical beliefs which was to exercise a major influence on twentieth century thinking – that, namely, of Marxism. Marx, too, thought he had been able to see through philosophy to something which underlay it, namely the economic situation of a ruling class, which used its philosophy to secure the status quo which was so greatly to its advantage. Karl Marx and his collaborator, Friedrich Engels, had a two-tier view of cultural reality, quite as Freud and Nietzsche had two-tiered views of mental reality. There was a basic level, consisting in the economic structures of a given culture, and then a superstructure, consisting of the moral, religious, legal, political and philosophical ideas that seemed to define that culture, but which were simply disguised ways of representing the base and securing the status quo. As the economic base changed, the superstructure changed, as a matter of course. So philosophy, under Marxist theory as under psychoanalytical theory and under the will-to-power theories of Nietzsche, was not something to be taken at face-value, but served at best as a distorting mirror of subjacent causes and forces, which it variously reflected.

Marxism had a powerful effect on the twentieth century, not so much because of historical materialism, as the base-superstructure theory was called, but because of the vision of cataclysmic revolution Marx and Engels projected, in which the divisions, and particularly the class divisions of society, would ultimately be overcome, and the expropriated working classes come into control of the system of production which had thus far exploited them. Marxism then tended to work for social change, for transformations in the systems of production, and there was very little development of the powerful critical ideas generated by historical materialism, as such. Marxist philosophy of philosophy remained for the most part undeveloped after its striking enunciation in a book called *The German Ideology* (1845/46). It gave Marxists a sense of not having to take any philosophy seriously other than their own. Everything else was merely to be interpreted in terms of what it expressed, and seen for what it was.

The twentieth century thus began with three powerful systems of interpretation, each of

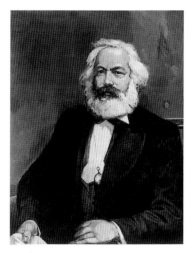

Karl Marx, painting by Willi Sitte, 1952

which held the traditional activity of philosophy in disesteem, mainly because each believed philosophy to have nothing of its own to say, since it was merely a secondary phenomenon, a set of intellectual symptoms, of something immeasurably more important, which could be more directly addressed by some form of science – economics, psychology, or physiology. Until late in the century, philosophy was, therefore, a very embattled discipline, which had, against such dissolutive systems of analysis, to establish its own credentials. Until the collapse of Communism in Eastern Europe, historical materialism was so complacent in its vision of culture that it felt no great need to do more than denounce any philosophy alternative to it as so much bourgeois ideology. Psychoanalytical theory, because it was not clearly identified with any special political order, survived until it was perceived, especially by feminists, as enjoining its own forms of oppression and indeed its own form of politics. The great slogan of the seventies and the eighties was that 'The Personal is the Political', from the perspective of which psychoanalytical theory was regarded as a system which reinforced the patriarchal structures of the family and the domination of women by males, a system of interpretation which itself owed a great deal to the structures of 'deep reading' which psychoanalysis, Marxism and Nietzscheanism exemplified. Nietzsche's views survived these attacks, chiefly because they were not finally associated with any real or perceived political structure, since Nietzsche's views were only loosely tied to Nazism, which drew its primary inspiration from the beliefs of Adolf Hitler, by whom Nietzsche was merely regarded as a sympathetic intellectual ally. Beyond that, Nietzsche's views turned out to have been appealing to professional philosophers themselves, about whom very little has so far been said. It is worth noting, before we turn to them, that their views of philosophy, as something to be analysed away, were often two-tiered in their own right. Because of the structural similarities between professional philosophy and its great rivals, one might consider the twentieth century as the *Age of Analysis*. Philosophy in this century became its own subject and its own method. It consisted in strategies for analysing itself away.

<p style="text-align:center">*</p>

Deep as the theories of Marx, Freud, and Nietzsche may have been, neither they nor the texts through which they were expressed presented great difficulties for ordinary individuals. That history is class struggle, or behaviour the outcome of repressed wishes, or that human beings are driven by a will-to-power, did not seem unduly abstract or difficult to apply. Far from that, they seemed easy to grasp and readily applied, and to make a great deal of sense. Moreover, they gave a certain air of authority to those who believed them, for they seemed to bring with them an immediate and satisfactory clarification to an otherwise difficult and disordered reality. With the writing of professional philosophers this was rarely the case, not so much because those texts were particularly obscure, though obscurity became a fashion in later twentieth century philosophy, and particularly in texts emanating from France. The issues, of course, were abstruse and uncertain enough to have caused philosophers themselves to worry about the status and viability of philosophy, but the major reason for there arising a gap between philosophy

and the ordinary person was the increasing centrality in the most advanced philosophical writing of symbolic logic, about which something must be said at this point.

Logic had been considered well into the nineteenth century as a finished science, about which very little was left to be said after Aristotle. Its central topic was the theory of syllogisms, in which certain features of propositions, such as their quality (affirmative or negative) and their quantity (universal or particular), determined the validity or invalidity of simple arguments. The idea that validity depended upon properties of form, rather than content, encouraged the German mathematician, Gottlob Frege (1848-1925), to undertake a systematisation of the concept of proof by constructing a formal language in which, as in classical logic, only the certain features of language were relevant. This suggested the possibility of an ideal language, suitable for reasoning, which left outside itself all the vaguenesses and irregularities that affect ordinary language. Frege's so-called *Begriffsschrift* rendered explicit all and only those features upon which proof depends. Certain propositions of the ideal language are intuitively true and treated as axioms, from which everything else can be derived by truth-preserving formal transformations. Frege's system moved the study of logic onto a new basis, and 'symbolic logic', as it is called, became one of the ornaments of twentieth century thought.

Gottlob Frege

In part, this development was stimulated by Frege's view that logic was an autonomous discipline, having, in particular, nothing to do with psychology. It had always been assumed without question that logic was concerned with 'the laws of thought', with the way the common mind actually worked in performing inferences. It was this idea, for example, which recommended to Nietzsche the hope that different orders of mind would evolve different logics. Frege's view, by contrast, was that logic was universal. In this (but, perhaps, only in this) his anti-psychologistic views coincided with those of Edmund Husserl, the founder of Phenomenology, whose masterpiece, *Logical Investigations,* was published in two volumes in 1900 and 1901. Husserl did not himself make a contribution to logic as a science. But he did offer a powerful critique of psychologism, or the view that logic was in some way a branch of psychology. It was, if anything, a branch of mathematics.

Edmund Husserl

Frege and Husserl are the main pillars of twentieth century philosophy, considered as a professional activity. The work of Bertrand Russell, Ludwig Wittgenstein and what is known as Analytical Philosophy, in its various versions, derives from Frege, who bequeathed to his followers the ideal of a logical, exact language, in which proof can be exhaustively explained. This led to a critique of ordinary language as unsuitable for philosophy and, collaterally, a critique of common sense. The work of Martin Heidegger, Jean-Paul Sartre, and Maurice Merleau-Ponty derives from the thought of Husserl, which concerned itself precisely with the way the world presents itself to us, independently of any theories. Indeed, Husserl proposed that we should 'bracket' phenomena off from any explanatory theories whatever, and simply address things as they manifest themselves to our awareness. This does not amount to a kind of stream of consciousness narration of the flowing past of experience, as we find it in the writing of James Joyce.

Rather, Husserl practised a form of what he termed *eidetic intuition*, which was a method of identifying the essential features – the *eidos* – of the presented world. In a way, Husserl sought the universal features which make experience intelligible, in much the same way that Frege sought the universal features of language that make inference possible. It was as though Husserl's ambition were to uncover a logic of experience which, in its own way, formed a system. His student and disciple, Martin Heidegger, attempted in his great work *Sein und Zeit* (Being and Time), of 1927, to identify what one might term the logic of human existence – the categories, or what he termed the *existentialia,* which define the structure of existence for *Dasein* – Heidegger's term for human beings.

The distinction between the logical form of language and the ordinary grammatical form of language was made vivid in an article published in 1905 in the British journal *Mind* by Bertrand Russell: 'On Denoting'. Russell addressed a problem raised by terms which refer to specific individuals, like the King of France. Usually we would imagine that 'The present King of France is bald' was made true or false by the condition of the present King of France's scalp – but suppose there was no such person? Would the sentence be true or false? Philosophers had gone so far as to say that in order for the proposition to be either true or false, there had somehow, somewhere, to be a King of France, to whom it could refer. Russell undertook to show how the sentence could have a fixed truth value, whether or not there was a King of France. He did this by showing that the original sentence, in fact, was a compound of conjoined sentences, and hence that the truth-conditions for such sentences – which seemed simple in grammar, but were complex in logic – were themselves complex. Russell's 'Theory of Description', in addition to its other merits, demonstrated how a dubious entity – non-existent kings of France and the like – could be analysed away through a logical rectification of language. With the overhaul of language came an overhaul of the universe, as we had to conceive of it. The significance of Russell's brief essay was that it showed that, in addition to its other virtues, an ideal language would eliminate terms which seemed to commit its users to dubious entities, invented to give language something to hook onto, whether it existed or not.

Bertrand Russell

Russell went further, however. He conceived the idea that the entirety of mathematics could be demonstrated to rest on the kind of logic that Frege had systematised. With his collaborator, Alfred North Whitehead, Russell composed *Principia Mathematica* (1910 – 13), a work unintelligible to readers illiterate in symbolic logic, in whose notation it is written, but a monument of abstract thought in which, at a certain point, an arithmetic proposition, like '2 + 2 = 4', is derived as a theorem from a few axioms of pure logic. What the axioms themselves rest upon, since psychology is excluded, is far from clear, but *Principia Mathematica*, as an edifice of language purged of paradox and unclarities, whose elements are held together by purely logical relations, embodies an ideal of rigour and clarity. And indeed the construction of such edifices – what the Logical Positivist Rudolf Carnap wrote of as *Der logische Aufbau der Welt* ('the logical construction of the world') – as *Principia Mathematica* seemed to point a goal for philosophers to follow, using logic as their principle of conceptual architecture. For that matter, Frege's visionary

language was taken to exemplify a general ideal for all knowledge. The axiomatic structure seemed the perfect form for housing the whole of scientific knowledge.

This vision ran aground when the limits of axiomatisation and hence the vision of a logically hygienic language were discovered by Kurt Gödel and set forth in what is known as Gödel's 'Incompleteness Theorem', of 1931, one of the great intellectual achievements of modern times. It put an end to a logical endeavour which went back to Euclid and Newton and was attempted in such philosophical masterpieces as Spinoza's *Ethics*, which undertook to present the whole of philosophy in a system consisting of axioms and definitions, and rigid proofs. It is impossible to present Gödel's Theorem in any detail here. But the gist of the proof is that certain, seemingly true, sentences can be formulated in any formalised language which the system cannot prove, which means, obviously, that any system powerful enough to generate the elements of mathematics must be formally incomplete. If one were to seek to add the sentence as an independent axiom, an inconsistency would arise, from which it would follow that formal systems were either complete or consistent, but not both. There is, in brief, an unstoppable leak in every formal system, and with this the virtue of axiomatisation and indeed of formalisation is irremediably tarnished. In its own way, Gödel's Theorem seems to echo the Uncertainty Principle of Heisenberg, which entails a deep indeterminacy in matter and hence in physics itself. Gödel discovered a limit that would have been unknown, had there not first been the immense labour that went into *Principia Mathematica*. It was as though science and logic, the ornaments of reason, together showed that neither the world nor reason itself was a rational whole.

Kurt Gödel

The victories and defeats of systematisation notwithstanding, philosophers remained obsessed with an ideal language, in part because such a language might disclose those flaws which got transformed into the sorts of philosophical propositions, summarily described as metaphysics, which just might be nonsense masquerading as deep truths, if only one could get on top of where the tradition went off the track of intellectual probity. Russell's Theory of Description encouraged the view that all the wild entities postulated by philosophers might be eliminated through grammatical rectification. 'Most propositions and questions that have been written about philosophical matters', Wittgenstein said in his *Tractatus Logico Philosophicus* (1921), 'are not false, but senseless. We cannot therefore answer questions of this kind at all, but only show their senselessness. [They] result from the fact that we do not understand the logic of our language.' But 'Language disguises the thought', Wittgenstein further wrote, 'so that from the external form of the clothes one cannot infer the form of the thought.' It is remarkable to what degree this parallels the theories of Freud (both were Viennese): one must penetrate the disguises to get to the sense – or the nonsense – of the underlying thought. But, for Wittgenstein, this meant not psychoanalysis but linguistic analysis along the lines of Russell's disclosure of the logical, as against the grammatical, form of propositions using definite descriptions. The antonym of 'nonsensical' is 'meaningful' – but what does this amount to? The members of the so-called Vienna Circle, who called themselves Logical Positivists (or Empiri-

Ludwig Wittgenstein

cists), and who were powerfully impressed with Wittgenstein's arguments, offered a stri-
dent answer: a sentence is meaningful only if it is verifiable through observation, in fact
or in principle. 'There are mountains on the other side of the moon' was meaningful
because, in principle, verifiable, though at the time (this was the 1930s) no one was cer-
tain how to carry out the observations. The Positivists based their theory on what they
took scientific meaning to be, and they felt that even this relaxed view of meaningfulness
was still strict enough to eliminate, as nonsense, 'most propositions and questions, that
have been written about philosophical matters.' Rudolf Carnap, as a leading Positivist,
spoke of a 'final solution' to – an *Überwindung* of – metaphysics. And the much feared
Verifiability Criterion of Meaningfulness seemed to the Positivists a sort of magic sword
with which the dragons of traditional philosophy could be slain, without struggle or
heroism. In 1927 Heidegger published an essay titled 'What is Metaphysics?', which
described an encounter with Nothingness, and made a celebrated claim about Nothing-
ness as a kind of active force, namely that 'Nothing nothings' – *Das Nichts nichtet*. Car-
nap felt this was exemplary nonsense – 'nonsense on stilts', to borrow an expression of
Jeremy Bentham's – chiefly because he could see no way in which it could be verified or
(to bring in an alternative view of the matter by another philosopher of science, Karl
Popper) how it could be *falsified*. It seemed transcendently clear to the Positivists that sci-
entific language rested upon verification, both for its meaningfulness and its truth.

Rudolf Carnap

The connection between (scientific) meaning and observation rested on some influential
views of the American Pragmatist, Charles Sanders Peirce (1839-1914), himself a scientist
and an innovative logician. Pragmatism must be put alongside Phenomenology and Pos-
itivism as a major movement of twentieth century philosophical thought, which, like the
latter, addressed the problem of philosophy in an eliminativist spirit. The central idea of
Pragmatism was that the meaning of a proposition lies in its practical consequences – a
view presented by William James in such a way as to imply that the 'consequences' were
personal: what a proposition meant to the person who believed it – but Peirce's view was
more exacting, and more keyed to scientific practice than to personal enthusiasm. To
ascertain the meaning of a proposition, Peirce argued, was to deduce the differences its
being true made in scientific practice: then the sum of these consequences would consti-
tute the proposition's entire meaning. By 'practical consequences', Peirce meant the out-
come of testing procedures, hence the observations that would result from putting into
practice what the proposition affirmed. Hence, Peirce connected meaning and truth with
scientific, even laboratory, practice, and its analogues in common life. Defining scientific
terms through verificatory procedures became Behaviourism in psychology and Opera-
tionalism in physical theory, both of which, Behaviourism especially, defined an entire
agenda of scientific research. It was when Behaviourism sought to understand the
acquisition of language that it ran foul of a very powerful alternative view, that the struc-
ture of language was innate and universal, advanced by Noam Chomsky.

Charles Sanders Peirce

The Positivists were obliged to flee Europe, when Nazism came, and found not merely
refuge in America, but a philosophical atmosphere in Pragmatism, which was hospitable

to their faith in scientific practice as the touchstone of meaningful discourse. But the Verifiability Principle fell upon hard times, due in large measure to defects discoverable through certain logical operations made visible in Symbolic Logic, which the Positivists, of course, accepted. And it turned out that much of what was creative and important in science was not quite of the same order as questions about the other side of the moon. There was a collaborative effort to make the Principle loose enough to retain the most creative parts of science, but tight enough to exclude the detested propositions of philosophy, and though this history cannot be written here, the Verifiability Principle slowly died of its own virtues, namely clarity of formulation and consistency with logic. Its fatal defect, however, was that it did not finally represent the actual practices of science.

Martin Heidegger

In the decades after the war, even in the austere precincts of professional philosophy, the vision of an ideal language began to lose its glamour. After all, there were the powerful results of Gödel which presented limits to formalisation, but the hard times the Verifiability Principle endured equally suggested that meaning might not be so rigidly connected with observable consequences, narrowly considered. It all at once seemed as if the ordinary language spoken by ordinary men and women was more flexible than any artificial alternative could possibly be. Wittgenstein's posthumously published *Philosophical Investigations* (1953) offered a very different picture, that of language as a set of instruments for the facilitation of ordinary life: 'To imagine a language is to imagine a form of life.' There is in Wittgenstein's later philosophy a different way of dealing with the traditional questions, by pointing out that philosophical propositions have no use in life – that 'Philosophical problems arise when language *goes on holiday*.' To ask the meaning of a proposition is then to learn how to use it – and philosophical language seems not to have any use. There was an important school of philosophical analysis at Oxford, under the leadership of J. L. Austin, who claimed that 'our common stock of words embodies all the distinctions men have found worth drawing, and the connections they have found worth marking, in the lifetimes of many generations.' This attitude toward language paralleled the 'natural attitude' toward the world which Husserl adopted in the practice of Phenomenology: to take the world as it presents itself, without imposing any theories at all. It is, after all, the basis upon which, finally, everything we know about rests, and from which all philosophy or, for that matter science, takes its departure. Husserl's pupil, Martin Heidegger, undertook, in *Sein und Zeit*, to lay out the basic structures of everyday life, of life lived by ordinary humans just as humans. His curious word 'existentials' referred to the categories of 'being in the world', and gave a name to a philosophy which flourished in the war years, namely Existentialism, whose most widely known exponent was Jean-Paul Sartre.

Jean-Paul Sartre

Sartre sloganised his differences from Heidegger in a famous lecture he gave after the war, by saying that man has an existence before he has an essence. That is, there are no defining properties of being human, and in this respect human beings are 'nothing'. But they do exist, and their non-definability means that they are free to attempt to be what they choose, with the proviso that they cannot be whatever they choose, in the way

things are what they are. Things do have essences, but human beings are condemned, by contrast, to be nothing except freedoms. Sartre exposed the outlines of his philosophy in a vast book, *Being and Nothingness* (1943), but he was also a creative writer of the highest order, and his plays and novels, as well as serving as vehicles for his philosophy, expressed the feeling of a world at war – a war in which Heidegger was on the other side, sufficiently identified with Nazi ideology that the question could not be suppressed as to whether his politics did not invalidate his philosophy in its entirety.

It is possible that the philosophical rehabilitation of ordinary language and of common sense experience was itself as much the after-effect of the war years as it was of internal philosophical criticisms, and it is difficult not to see in post-war philosophy an analogue to the celebration of ordinary and even banal objects in Pop Art, which opposed itself to Abstract Expressionism, construed as a kind of aesthetic metaphysics. 'We don't need another hero', Barbara Kruger wrote in one of her biting works of the 1980s, and this per-haps expressed as much as anything a kind of feminism which blames wars, logical architectures and denunciations of competing views as nonsense of the will to power of males. But that kind of feminism came about as one of the tremendous transformations in general consciousness, brought about by the reaction to a different kind of war, the Vietnam war, which entailed a radical distrust of the established institutions which Pop Art and Ordinary Language philosophy may tacitly have endorsed. It is possible that the revival of one form or another of Dada in art is the artistic expression of the overall cri-tique of institutions which has characterised contemporary culture, from the late 1960s to the present. Dada played a comparable, but immeasurably more circumscribed, role after World War I, whereas the aftermath of World War II meant an appreciation of the institu-tions which had been defended, with the moral comfort and cognitive predictability they afforded, a world striving to put the pieces back together. Existentialism, with its themat-isation of extreme situations, could scarcely survive into the atmosphere of common life the world sought to re-establish, whatever its philosophical credentials. But the Vietnam war ate away at the consensus, with the consequence that the beliefs and values which were so cherished after World War II were suddenly felt to be repressive – repressive of women, of other races and cultures, of youth. The great youth upheavals of 1968, all around the world, were a massive critique of social norms, which has not altogether sub-sided at the end of the century.

The philosophical expression of this mood was certainly Deconstructionism, advanced in a number of delirious, brilliant and wilfully obscure texts by Jacques Derrida, which proponents of various constituencies felt voiced their cynicism with regard to the estab-lished order. Wittgenstein, like Husserl, felt that it was not the task of philosophy to pro-pound theories. 'Philosophy is not a theory but an activity', he wrote in his *Tractatus*. He believed philosophy should consist in 'elucidations', or the logical clarification of thoughts, initially on the model of Russell's early work, and later in terms of asking what use in a form of life this or that thought would have. Derrida, too, thought philosophy an activity which consisted in the deconstruction of theories, which meant, essentially, find-

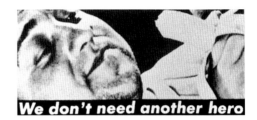

Barbara Kruger, *Untitled*, 1988

Jacques Derrida

ing out what the interests were of those who advanced those theories. This has a faint after-ring of Marxism, but mainly it reflects the overall scepticism and even cynicism of countless groups who felt themselves in one way or another victims of received ideas. The precise methods of Deconstruction were no better worked out than those of Marxism, but the mood fitted the moment. Derrida's American follower, Richard Rorty, undertook a kind of deconstruction of philosophy, in which he pretended no longer to see any point at all. The world of the intellect was well off without it, much as the Positivists and others had suspected from the beginning.

Philosophy at the end of the century is rather bruised and battered. 'Time was when metaphysics was entitled Queen of all the sciences', Kant, who began it all, writes. 'Now, however, the changed fashion of the time brings her only scorn; a matron outcast and forsaken.' The remarkable thing is that, still with no clear sense of its identity, philosophy continues as a kind of activity, content with minor clarifications and limited breakthroughs. There are parallels with art, no doubt, and though in certain ways it has been a great philosophical century, the lessons have been mainly negative, and a matter of learning, as we all must, to live within our limits. The century has shown us these limits, in real life as in thought, and mankind enters the twenty-first century chastened, but possibly less crazy. It is just thinkable that the twentieth century was the high adolescence of the human spirit, as it crosses into a more hopeful maturity.

Fang mask, Gabon. Musée National d'Art
Moderne, Centre National d'Art et de Culture
Georges Pompidou, Paris; formerly Maurice de
Vlaminck and André Derain collections, Paris

R. Rudier, bronze replica of the Fang mask.
Musée des Arts Africains et Océaniens, Paris;
formerly Ambroise Vollard collection

WOLF LEPENIES

A Self-Critical Modernity or Europe's Century nears its End

After the First World War was over, one European writer made the discovery that the civilisations of the Old Continent, like others before them, were mortal:

> We had heard tell of whole worlds vanished, of empires gone to the bottom with all their engines; sunk to the inexplorable bottom of the centuries with their gods and their laws, their academies, their sciences, pure and applied; their grammars, their dictionaries, their classics, their romantics and their symbolists, their critics and their critics' critics. We knew well that all the apparent earth is made of ashes, and that ashes have a meaning. We perceived, through the mists of history, phantoms and huge ships laden with riches and spiritual things. We could not count them. But these wrecks, after all, were no concern of ours.[1]

Thus wrote Paul Valéry, with melancholy clairvoyance, as he invited his readers to let the words 'France', 'England' and 'Russia' slip off their tongues like 'Elam', 'Nineveh' and 'Babylon'.

Valéry's maritime metaphors are not the only things in his essay that recall to mind his native harbour town of Sète. He could never have written it, had he not held in his memory the living presence of the Mediterranean Sea – the sea that terminates Europe but also, simultaneously, links it with Africa and the Orient. The piece had its first publication in English, in John Middleton Murry's Athenaeum, in London in April 1919: this is a European text. The experience of the First World War had shocked the members of Valéry's generation into a new awareness of transience. To their horror, they had learnt that great crimes are not possible without great virtues: 'Without doubt, it needed much science to kill so many men, waste so many possessions, and annihilate so many towns in so little time; but also it needed *moral qualities,* no less.'[2]

It is not that the First World War destroyed Western civilisation; on the contrary, it was precisely the achievements of the European mind and spirit that rendered that unprecedented work of destruction possible. Arts and sciences bloomed amid the moral ruin: in November 1919, Valéry translated an article on Albert Einstein's theory of gravitation, first published in the *Athenaeum*, for the *Nouvelle Revue Française*.

At the beginning of the twentieth century, Valéry was concerned for 'the future of our past'. With the last century of the second millennium hardly begun, he regarded the Europeanisation of the world as past history. Valéry raised no lament for the 'Decline of the West'; he merely foresaw that Europeans would not for long succeed in imposing their own values and priorities on the rest of the world.

Valéry described his vision too early for it to be seen as anything more than a paradox. The Treaty of Versailles, which was intended to pacify Europe – and which ultimately tore it apart – had yet to be signed. The horrors of the Russian GULag and the German death camps were still unimaginable. The atom had yet to be split, and the mechanism

1 Paul Valéry, 'The Crisis of the Spirit', *The Athenaeum*, no. 4641, 11 April 1919, p. 182; French text as 'La Crise de l'esprit', in Valéry, *Œuvres*, Paris, 1988, 1, p. 988.
2 Valéry (as note 1), *Œuvres*, 1, p. 989.

of heredity had yet to be deciphered. Africa was still a continent of European colonies; the United States of America was still, as in Leopold von Ranke's day, a Europe across the seas; and only eight years earlier, the British King George V had been crowned Emperor of India. In 1919, Europe was everywhere. The century was still young, and it would once more be Europe's century.

Valéry cited the part played by Germany in the First World War to prove his point that crime requires virtue and cruelty requires discipline. But the warlike enthusiasm of that war, the obsession with battle and combat, were symptoms of a European malady. All concerned showed the same suicidal eagerness to infect themselves with the *mal du siècle*. It took the Second World War to change this; it then became painfully evident in Germany that the civilised sceptics of the Weimar Republic had all along been a minority confronted by a grimly determined, militaristic political machine. Of course, much of the blame for this lay with Versailles, which was the blunder of the century. But German writing on the First War never showed any great evidence of acquired insight: much of it seemed to be implicitly subtitled *Just You Wait!* How much would Europe have been spared, in this bloodstained century, if those who returned from the First World War had based their future policy on the title of Robert Graves's memoirs: *Goodbye to All That*.

Where the First World War gave us duels, the Second gave us murder. The murder of the European Jews, proclaimed by National Socialism, condoned and executed by Germans, brought the history of civilisation on this continent to its most painful crux. For all its subsequent haste to make up lost economic ground, Europe has never recovered from this collapse of civilisation at the heart of the continent. Think of all the ideas with a claim to universal validity that Europe had produced since the Renaissance, and most persuasively in the Enlightenment period: in the twentieth century, those pretensions were finally demolished. By the time the twentieth century was fifty years old, the last European Age was over and done with. Europeans themselves contrived to suppress this awareness, because they could still look upon the Europeanisation of the world as their success story. The year 1989 marks the zenith and simultaneously the end of that illusion.

A Politics of Mentalities

The bicentennial year of the French Revolution, 1989, will go down in European history as an *annus mirabilis*. It was a year that faced both ways. The free-market societies of the West were triumphant – but in the moment of their triumph they failed to realise that a new age of uncertainty had long since begun. After its victory over Communism, the West had need of a politician like the French foreign minister, a member of Odilon Barrot's cabinet, who wrote 150 years ago:

> We were victorious, but it was clear to me that our real difficulties would now emerge … So long as the danger lasts, one has only one's enemies against one, and one triumphs; but after the victory one has oneself to deal with, one's own weakness, one's own pride, and the false sense of security that victory brings in its train; and the fall comes in the end.[3]

That foreign minister was Alexis de Tocqueville.

3 Alexis de Tocqueville, *Souvenirs*, Paris, 1978, p. 316.

The collapse of Communism and its possible consequences were misinterpreted in the West, not least for want of insight into the connection between event and structure. The power of events to destroy structures lured people into wishful thinking; there seems to have been little understanding of the power that events also have to *preserve* structures. Because everything had changed in the East, we were convinced that in the West everything would stay as it was. Led astray by the certainty of our own rightness, we viewed changes in the East under the short-term perspective of the history of events, while dignifying our own intellectual inertia with long-term significance. Dust to dust there, eternity here: and so – right on cue, and with the blessing of the US Department of State – the End of History was proclaimed once more. Western modernity spanned the world.

This triumphalism went along with a philosophy that attributed universal validity not just to the political self-image of Western democracy but to the accepted constants of Western culture. This philosophy was marked by the wishful supposition, inherited from the Enlightenment, that in the course of history human beings increasingly tend to give up traditional behaviour patterns and local identities, and to unite in a single civilisation in which all will coexist under the rule of a rational morality. Now, only eight years after the triumph of 1989, some question marks are in order.

However, the basic problems that confront industrialised societies are not those of the medium term. These are long-term issues, unlikely to be resolved without considerable mental reorientation. Europeans are not going to handle the challenges of the post-Communist period by simply prolonging their customary routines, or by stabilising ingrained habits of thought. Behind the spectacle of events, we begin to perceive the inertia of our own mental structures: what Francis Bacon called the 'wheeles of custome'. In the global society, we shall have to learn to deal more flexibly with the assumed truths of our culture, without thereby giving up our identity. Beyond the time-frames of legislative and electoral cycles, we need a politics of the long term, a politics of mentalities.

I shall give some examples. Global migratory movements – even here in Germany, where we still refuse to acknowledge that we have long since become a country of immigration – will one day force us to adopt a pluralistic approach to other cultures, and to integrate them into our own daily life. Under the pressure of massive demographic shifts, we shall need innovative social legislation. Above all, we must install new forms of justice between generations, by drawing the long overdue conclusions from the rapid ageing of our society.[4] In face of a hard core of unemployment that is constantly increasing, not only during recessions but even during recoveries, we shall have to ask whether traditional paid labour is going to remain the core value of industrial society, or whether we can imagine 'cancelling' the value of work, and thereby removing the stigma from unemployment.[5] Confronted with the steady advance of the poverty line, we have to find ways of resisting a process of refeudalisation,[6] in which our society's two sectors, one crisis-proof and one crisis-prone, would move further and further apart. Finally, there can be no ecological restructuring of our society without massive changes in the attitudes and behaviour of wide sections of the population: changes that entail a new pattern of mobility and a renewed ethos of coexistence.

4 See Peter Laslett and James S. Fishkin, *Justice Between Age Groups and Generations*, New Haven and London, 1992.
5 See Wolf Lepenies, '"Wäre ich König, so wäre ich gerecht". Gerechtigkeit· Ein Schlüsselbegriff in den gesellschaftspolitischen Auseinandersetzungen der Gegenwart', in *Arbeitslosigkeit und soziale Gerechtigkeit*, ed. Leo Montada, Frankfurt a. M., 1994, pp. 9–33.
6 For a French view, which holds good for other countries, too, see Laurent Joffrin, *La Régression française*, Paris, 1992.

Modernity, Self-Criticism and Self-Isolation

Modernity is principally characterised by four processes: *secularisation, scientisation, industrialisation* and *democratisation*. These take place at different speeds, and in various locally specific forms; but all over the world they are both inseparable and mutually influential. If we define modernity itself as the outcome of all these processes, it is clear that we now stand at a turning-point. When the gain in knowledge produced by science is no longer seen as a straightforward enrichment but as a possible threat; when the core value of a society based on work is undermined by the erosion of traditional paid employment; when shared concern and commitment can no longer be taken for granted in our political life, and participatory democracy turns into absentee democracy; and when, finally, the horrific deeds of our century's great secular religions, Stalinism and Fascism, suggest to us the idea of divine retribution – then we are in a crisis of disorientation that extends to every principle of our social and economic life.

Not that the exact nature of this crisis is clear. It is a moot point, for instance, whether religious belief is really on the wane, or whether an invisible Church is growing as the official ecclesiastical institutions lose their attractiveness. Again, science may be losing its power to help us orient ourselves, but alternative sources of knowledge and insight are increasingly available; and the growing disaffection from party politics coincides with an anarchic delight in freelance political mobilisation. It may well be, too, that the crumbling of traditional employment is balanced by increasing flexibility, above all in the service sector, where work is increasingly organised on a project basis. In short, for every disaster scenario there is a compensatory alternative.

One thing that is unarguable, however, is that these upheavals within modernity have struck particularly hard at the cultural self-confidence of Europeans. For, however we choose to assess the current outcome of the four processes listed above (secularisation, scientisation, industrialisation, democratisation), every one of them originated in Europe. Modernity is a European project. When Europeans – as distinct, say, from Asians – speak of the crisis of modernity, they mean that their own value system is losing its legitimacy. Industrial societies in Asia currently face structural problems that are analogous, in principle, to those of the West; but in Europe the need to rethink is more pressing.

It would of course be wrong to charge Western societies – of all societies in the world – with an inability to rethink: on the contrary, the Enlightenment has left them with a shared tendency to introspection and self-criticism. This is the *repli sur soi* whose continued existence Jacques Delors regarded as the decisive impediment to European union.[7] The European norm is neither arrogance nor self-criticism: it is a constant alternation between the two. 'Self-criticism' is a misleading term. Its conceptual pitfalls are familiar from its use in the language of Communism. It sounds modest enough in itself, but it all too easily tips over into arrogance, as soon as the critique excludes the outside world and presents itself as a prerogative of the Self. European self-criticism always includes an element of self-complacency, because Europe has always assumed the right to define the limits of its own activity. Europeans have decided for themselves how far to

7 Jacques Delors, 'L'Avenir invisible', *Le Monde* (Paris), 9 November 1993. This is a review of the book by Alain Minc, *Le Nouveau Moyen Age*, Paris, 1993.

carry the Europeanisation of the world. For all their self-castigating rhetoric, European cultures have immunised themselves against criticism from outside Europe; and hence they have remained *teaching cultures*. Their future will depend, not least, on their ability and preparedness to become *learning cultures*.

The Fundamentalism of the West

Part of the political and economic strategy for fitting the world to European ends has always been the effort to impose cultural dominance. That dominance is now fading, and there is more to this than an intellectual setback. Karl Marx was surely right, when he said that in world history every idea that has tried to do without vested interests has been a failure. All over the world, the European lead in production technology is dwindling, and as a result European ideas too are declining in relation to intellectual systems from elsewhere. It is no consolation that the international economy is becoming increasingly integrated; syncretism in automobile production remains far easier to achieve than the peaceful blending of different world-views.

Both in economic and in cultural terms, an expanding Europe expected to find overseas markets and has found overseas production sites instead. In business, as in culture, competition from non-Europeans is becoming ever keener. A shrewd remark by a democrat of preindustrial times, René Descartes, that human understanding is the most widely distributed thing in the world, is likely to ring a bell with the modern software producer who finds himself unable to compete with Indian programmers. Europe set the pace of modernisation; now the pace is being forced from elsewhere. Political or ideological recriminations are futile, because in Europe the arrogance of modernity has deep roots within every school of thought. Even Marx was insistent that the old order in Europe would destroy *itself*; he saw non-European societies as steeped in impotent stagnation.

Value judgments of this kind have evolved in the course of a lengthy historical process, and they lie deep. When they are attacked, their defence becomes a matter of ideology. This is clearly reflected in the two future scenarios current in the West since 1989. These are 'The End of History' and 'The Clash of Civilisations'. One offensive and quietistic, the other defensive and nervous, both scenarios yield little on analysis. Both are false in their central assertions;[8] at the same time, both are antiquated in character, like woodcuts in a world of computers. But they have the power to recruit adherents, and it is not only in the United States that they dominate the world of 'foreign affairs'. In intellectual disguise, both are largely emotional reactions to experiences of loss within Western modernity. Both are formulated by elites which pose as representative, with one eye on the masses. The name for all this is *Fundamentalism*.

Under the classic theory of modernisation, the West devised a scenario for the future to which no one any longer publicly subscribes, though many still privately hanker after it. Theories of modernisation defined the conditions under which, and the rate at which, others would be permitted to become like us. It is possible to see such theories in a positive light, as components of a programme of international education that has offered

8 Cogent articles to this effect in *Commentaire*, no. 66, 1994.

whole societies the chance to better themselves. On closer scrutiny, however, it becomes apparent that these are theories of *quasi*-modernisation. Under certain definable conditions, non-European societies were welcome to make up for lost time; meanwhile, however, the West was not certainly not going to wait around for them but would be developing still further, so that they would never draw level. It is Achilles who is the ancient European hero; but in this case the West became the tortoise, which Achilles in Zeno's paradox could never overtake, however close he came.

Western industries and cultures now find themselves in danger of being overtaken, by Asian competitors above all. We have great difficulty in finding an appropriate economic response to this – that is to say, a response other than the exportation of jobs. Above all, we lack the concepts to deal with the mental challenges that accompany the economic confrontations. On the one hand, we operate with breathtaking intellectual casualness: Confucianism, for instance, was long regarded as an insuperable obstacle to the industrialisation of Asia, and now we wonder whether Confucianism might be the cement that holds together the postmodern industrial cultures that owe their genesis to a Protestant ethic. On the other hand – in relation to Japan, above all – we still cherish the hope that the structures of industrialisation have settled only lightly and as it were tentatively on the surface of Asian societies, and that they would disintegrate if ever those societies were seriously shaken from within. The metaphor is deliberately chosen: after the Kobe earthquake, many Western commentators openly – not to say shamelessly – looked forward to a breakdown of Japanese national self-confidence and to the consequent collapse of the Japanese economy.

Both in economic and in cultural life, the question for the West is the same: is it possible to win markets without simultaneously creating rival sources of production? The answer to this is No! Europeans have to realise that they can never again enforce assent to a kind of cultural non-proliferation pact by defining which elements of modernity the modern West reserves for itself. Here the West still tends to hope against hope, as may be seen from its tendency to overcompensate when dealing with those cultures that baffle us by modernising without Europeanising. Earlier, when alien cultures were defined in terms of their otherness, this was done as a power ploy based on a sense of intellectual superiority; now, the same is done in a spirit of calculated modesty. The rhetoric of respect has the same consequences as the earlier rhetoric of discrimination: the alien is defined as alien in *principle* and thus excluded from full participation in modernity. This leads those so defined to overreact and to assert their eligibility for modernity by overplaying the role of aggressive agents of the Enlightenment – and thus presenting themselves as the 'last playboys of the Western world'.

The Periphery Gains Confidence

Western attempts to re-exoticise other cultures thus generally miss fire. Our Japanologists are now more Japanese than the Japanese themselves. And anyone who, out of a well-intentioned respect for native values, advises an educated African to drop the idea

of converting to Christianity and to stay faithful to his/her endangered tribal beliefs, will find that the African – with Max Weber's *Protestant Ethic* in hand and the spirit of capitalism in mind – will coolly reply that this is not about the loss of folk tradition, or indeed about religion, but about economic survival and the consolidation of social status.

The West can no longer rely on self-criticism as a source of immunity. For some time now, it has been at the receiving end of polemic, derision and general *Schadenfreude* from the non-Western world; and, with growing economic power, derision has begun to outweigh polemic. However, the polemic continues in the work of African writers, and we still need to take it to heart if we are to understand the deep wounds and insecurities left behind – even in post-colonial times – by European presumptions of superiority. Even in countries that have been politically independent for decades, the decolonisation of culture in Africa is far from complete. The shock of Lambaréné still lingers: the damage done to self-respect by an ostentatious and patronising bestowal of caritas. Even for Albert Schweizer, with all his selfless sense of brotherhood, the African always remained a younger brother; and hygiene in Schweizer's hospital at Lambaréné accordingly remained at a level lower than that in the West – as if, in Africa of all places, infectious diseases could be ignored.[9]

Schadenfreude is something that the West hears most often from Malaysia and Singapore, where the decline of European values is derided, and native values are vigorously extolled.[10] Seen from a Western standpoint, there is a degree of levity in such arguments as those of the President of Taiwan, who lays claim to a historic, native democratic tradition entirely divorced from any European prototype.

There is a derisive irony for the West, in the fact that the European language that has remained a world language is now being renewed and refreshed from the periphery. In 1981 the foremost British literary prize, the Booker Prize for Fiction, was awarded to Salman Rushdie. Over the following twelve years it went to two Australians, a half-Maori, a South African, a woman of Polish origin, a Nigerian and a Japanese brought up in England. This is regarded as entirely normal, and no one remarks on it. The British public pricks up its ears only when a 'real' British writer wins the prize. The rest of the time, 'The Empire writes back.' Well may the 'natives' take satisfaction in outdoing their former masters on the ground that is central to their culture, as it is to all culture: that of language. A literature has now arisen that can no longer be traced back to imported Western traditions of reading and writing. Like a literary migrant, a new kind of multicultural 'creative writing' is making its way from the periphery to the centre of the Western world, into the big cities of Britain and America and the transnational metropolitan centres, with their aggressive blend of cultures: New York, Toronto, London. One key word defines the new writing: and here the term 'world literature' – coined by Goethe in a gesture of Western condescension at its most benign – has given way to the more aggressive 'world fiction'.

Attempts to underpin the edifice of Western values by cementing its existing foundations, or to make it more attractive by adding suitable annexes, are viewed from Asia with growing derision. While the West is still pondering which segments of its value

9 On this see Chinua Achebe, 'An Image of Africa: Racism in Conrad's Heart of Darkness' (1977), in Achebe, *Hopes and Impediments: Selected Essays 1965–1987*, London, 1988, pp. 7–8.

10 In this connection, as Ian Buruma drily remarks, 'It is in new, insecure, racially mixed states, such as Malaysia and Singapore, that you most often hear officials talk about Asia or Asian values, or the Asian Way. Indeed, the phrase "Asian values" only really makes sense in English. In Chinese, Malay, or Hindi, it would sound odd.' Ian Buruma, 'The Singapore Way', *The New York Review of Books*, 19 October 1995, p. 67.

system to replace and which to abandon or repair, in the East those same segments are unceremoniously lumped together in a vast stockpile of values. This eclecticism goes hand in hand with a high degree of interpretative agility.

Such agility is most fully developed in Japan, where it has the support of an old tradition of religious syncretism. The Japanese find no difficulty in emphasising their own culture's sense of community, based on the family *(ie)*, while simultaneously maintaining with a degree of pride that individualism – albeit in a 'soft' variety – has autonomous roots in Japan and thus a legitimate place within its culture.[11] It is possible to emphasise the all-pervading nature of Japanese culture – as the Nihonjinron school does – and simultan-eously point to its artificial and 'constructed' aspects.[12] It is possible, too, to regard the Protestant ethic as a feature of the European mind while simultaneously offering as an equivalent the secular, mercantile asceticism of ninth-century China. Head spinning, the modern Western observer is left like the hare in the folk tale, who found the hedgehog always ahead of him: or rather the *hedgehogs*, because of course there were two of them.

What Is the Plural of 'Islam'?

The key notion in all this is that of cultural pluralism. Here the modern West has a con-siderable amount of ground to make up. If so many people feel threatened by the notion of a 'Clash of Civilisations', this is partly because the notion reflects a monolithic ideo-logy. It lumps all non-European cultures and religions together in a compact Otherness that leaves them alien by definition, and thereby incapable of joining modernity. This applies to Islam in particular. Attempts in the West to de-exoticise and to historicise – in short to pluralise – Islam still meet with bitter opposition, and not only in politics.[13]

It is high time to change the conceptual framework – the cultural colonialism 'that has dominated European self-perception and European policy since the nineteenth century. Resistance to any such change runs deep. Even in France, the historical study of Islam is increasingly tied to a philological context, which neutralises its influence. One specialist in medieval Egypt, for instance, is not permitted to teach his own subject within his university's faculty of history (where he gives only Latin language courses), but only in the faculty of Arabic languages; the chair of the history of the Muslim Orient has been converted into a chair of European medieval history.[14] We need such concrete examples to appreciate the sheer ethnocentricity of a Western world that prides itself on its open-mindedness. This defensive attitude, which has its pathological side, has been given the name of 'Occidentosis'. To speak of Eurocentricity in this context would be misleading. Only one part of Europe, one segment of its history and geography, has this narrowing effect: we have only to think of the Islamic influences on medieval Europe, and on the Mediterranean world in general.

In the history of Europe as such, a plurality of cultures and value systems is now taken for granted; but in the wider, non-European context we still shrink from it. Language conspires to feed our misgivings: for instance, what is the German plural of 'Islam'? It is time to recognise that, in contacts between cultures, any insistence on the singular is not

11 On this see Masakazu Tamazaki, *Individualism and the Japanese: An Alternative Approach to Cultural Comparison*, Tokyo, 1994.
12 Florian Coulmas and Kenichi Mishima, in partic-ular, have drawn attention to this. See their papers, read to a session of the Ost-West-Kolleg of the German Bundeszentrale für Politische Bildung and published in Christoph Müller-Hofstede, '"Zusam-menprall der Kulturen?" – Ostasien und der Westen in den neunziger Jahren', Cologne 12–17 March 1995, in *Nord-Süd aktuell. Konferenzberichte*, 2nd quarter, 1995, pp. 298–300.
13 Aziz al-Azmeh, *Islams and Modernities*, London, 1993.
14 I take these examples from a paper drawn up for the European Union by Mohammed Arkoun, a spe-cialist in Islamic studies who formerly taught at the Sorbonne: 'Contribution de la civilisation islamique à la culture européenne', unpublished, Paris 1991. For a similarly dramatic collection of instances from Britain, see Robert Irwin, 'Burying the Past. The Decline of Arab History and the Perils of Occidentosis', *The Times Literary Supplement*, 3 February 1995, pp. 9–10. This is a review of *Approaches to the History of the Middle East*, ed. Nancy Elizabeth Gallagher, Reading, 1994.

only a historical distortion but an expression of political prejudice. In countries culturally marked by Islam, there is a noticeable tendency to make political capital out of divergencies in European intellectual history – by playing off, say, the anti-religious Enlightenment in France against the pro-religious Enlightenment in Germany.[15]

Western modernity proclaims pluralism, both of convictions and of value systems, as its own central idea; and this is precisely why we tend to deny the pluralistic character of other cultures. The motive here is to cast doubt on their credentials for joining modernity – or at least to keep for ourselves some de facto control over the terms governing membership. If we have to praise Islam, then we prefer to do so in the anodyne context of philology, rather than in the vexed context of politics. Given a choice between the Western adherents of a remote and alien Islam and the Muslim champions of a modernising Islam, we would have no difficulty in settling for the alien and the remote. But it is a delusion to suppose that peace between cultures can be bought as cheaply as this.

'Modernisation' long remained a European monopoly; and it was one of Europe's prerogatives to control whatever modernising potential existed in the non-Western world, and to channel it to serve Europe's purposes. Art history offers a striking example of this. Early this century, African art began to exert a great influence on European modernism. One symbol of this was the Fang mask which so impressed Maurice Vlaminck, André Derain, Henri Matisse and Pablo Picasso, c. 1905; Ambroise Vollard, the modernists' dealer, had it cast in bronze (see Figs. p. 28). The rest is art history – Western art history.[16] For this Fang mask now has no place in the corpus of modernist art. Western modernism simply made use of it to further its own renewal. This episode has echoes in the present-day politics of art. In the Dahlem district of Berlin, the museum of ethnography and the art gallery are about to be separated. Their present accidental but forward-looking juxtaposition is to be given up in favour of the old, traditional routine. The symbiosis of European and non-European art is to be terminated.[17] European art celebrates itself; the non-European works of art return to the status of mere finds in an ethnographical ghetto.

This change may be dismissed as trivial, but it conceals a propensity for ethnic cleansing that is more deeply rooted in our Western society than we are prepared to admit. In the US, those authors who seek to play down the current collapse of the social consensus, the disintegration of the established value system, have some illuminating number games to offer us. Thus, if we separate the criminal and social statistics for whites and those for blacks, the result is a twofold image of one healthy and one incurably sick America.[18] There is no room for European complacency on this count, for similar statistical purges take place all over Europe, Germany included.

Teaching Cultures and Learning Cultures

The buzz word, 'globalisation', evokes the image of a world that is becoming ever more uniform. True, this one world is becoming superficially more and more homogeneous; but beneath the surface the diverse worlds of separate cultures collide more violently than ever. Those worlds themselves are not all of a piece; they are invariably composites.

15 On this see Friedrich Niewöhner, 'Gefährliche Begegnung. Eine tunesische Debatte über Spinoza und Averroes', *Frankfurter Allgemeine Zeitung*, 5 April 1995, N5.

16 On this see, again, Achebe (as note 9), p. 11.

17 In the academic year 1994–95, Mamadou Diawara and Hans Belting devoted a fascinating seminar to this issue at the Wissenschaftskolleg in Berlin. See also Hans Belting, 'Zeit der Hölle. In welcher Epoche befinden wir uns gerade? Neues von der Archäologie der Moderne', *Frankfurter Allgemeine Zeitung*, 14 October 1995.

18 Daniel Bell has cast a stark light on this phenomenon: 'The disunited states of America. Middle-class fears turn class war into culture wars', *The Times Literary Supplement*, 9 June 1995, pp. 16–17.

The only cultures left are hybrid cultures. This in itself discredits the prophecies of a 'Clash of Civilisations', which are based on a confusion between politics and culture. The conflict in former Yugoslavia, for instance, is not a collision between cultures or between religions: it is a situation in which cultures and religions are instrumentalised by political groups for their own ends.

If only to reduce the likelihood of more such instrumentalisations, we must put more effort than before into translation between cultures. In principle, translation is always possible. As Claude Lévi-Strauss has established, what cultures have in common is not their similarities but their differences. In the global society, much will depend on the ability of cultures to meet and learn from each other, thus expanding the potential for innovation. The experience of the years immediately after the Second World War has shown us the decisive role played by an 'agreement to learn' between the United States and Europe – and, within Europe, between Germany and France. Conversely, since 1989, major opportunities have been thrown away because – not least within Germany – the West has engaged in an orgy of didacticism, instead of dealing with new and unprecedented economic and political challenges by entering into an 'agreement to learn' with the East.

Above all, it remains an open question whether such agreements will ever be concluded between East Asian and Western countries. It has to be tried. At the same time, the great international institutions must be pressed to make more serious use than before of local, native systems of knowledge and expertise. The worldwide strengthening of local culture and local knowledge is an essential task for the future. Along with this will go a reexamination and sharpening of the instruments we use: when an institution like the World Bank relies exclusively on the advice of neoclassical economists, its failures in the area of so-called 'development policy' come as no surprise.[19]

We need to *reverse the direction of our intellectual drive* and to *redirect our external cultural policy*. Mercantilism has even less of a place in culture than it has in economics. The industrial societies of the West, which have traditionally seen themselves as teachers, must become learners. In our relations with other cultures, exportation no longer takes absolute precedence; we need to strengthen an import-based cultural policy. The question here is partly whether our fledgling diplomats should acquire, alongside their juridical, regulatory skills, rather more of an anthropologically based, interpretative competence. Where alien peoples and societies are concerned, there needs to be more research *with* rather than research *on*. There needs to be more awareness of the intellectual scandal represented by the fact that at each of our universities a dozen students are studying India, and at most fifty studying China and Japan, while thousands devote themselves to the sociology and psychology of overfed populations.[20]

The cultural policy of the West must free itself from the tradition of being a 'teaching culture' and begin to listen and learn more from others than in the past. When Johann Georg Hamann felt misunderstood – as he often did, not without reason – he wrote to Immanuel Kant: 'If you want to understand me, you must ask me, not yourself.' In its relations with non-European societies, the modern West should hasten to follow this advice.

19 On this see Guy Gran, 'Beyond African Famines: Whose Knowledge Matters?' in *Alternatives. Social Transformation and Humane Governance*, vol. 11, no. 2, April 1986, pp. 275–96.
20 See Lucien Febvre, 'Geschichte und Psychologie' (1938), in Febvre, *Das Gewissen des Historikers*, ed. and trans. Ulrich Raulff, Frankfurt a. M., 1990, p. 88.

This essay is based on a lecture given in Frankfurt in October 1995 as part of a symposium organised by DG Bank. It has appeared in print on several occasions, and is reprinted here with further additions and corrections.

ODO MARQUARD

Presentation off Duty and Depoliticised Revolution: Philosophical Remarks on Art and Politics

Philosophy is when you insist on thinking. In what follows, I shall apply this insistence to the topic of aesthetics – the philosophy of art – and specifically to that of the relationship between art and politics.

What is politics? What is art, so-called fine art? Otto von Bismarck, born in 1815, defined politics (though his actual words were slightly different) as the art of the possible. The comic playwright Johann Nestroy, only a few years his senior, said of so-called fine art – with a shrewd dig at the idea that art is based on know-how – that art was based on not knowing how: if you knew how to do it, it was not art. It is true of both these forms of art politics and 'fine' art, the art of the possible and the art of the maybe impossible that, as Gottfried Benn put it, 'Good intentions are the opposite of art.' These two arts, politics and fine art, thus have things in common. They also of course have differences. The relationship between them is very incompletely expounded in what follows, though I often avail myself of the philosopher's prerogative of making sweeping statements. I shall certainly also succeed in demonstrating all over again – concrete though both topics are – that a philosopher can be counted on to turn abstract, even when discussing highly concrete topics. You can give no more than you have.

I shall seek to argue the following thesis. The modern world[1] transforms tied art into aesthetic art; the tendency for art to turn into political presentation[2] is – on many levels – an escape route from this process; aesthetic art tends to dispense with this escape route, and thus to free itself from politics and release itself from (political as well as other) presentational duty.

In the process, I attempt to formulate qualifications that require to be attached to this thesis, and to articulate questions that require to be asked in relation to it. I expound my thesis – the remarks of a partly politicised observer – in the following five ultra-brief sections:

1. Tied Art and Aesthetic Art

2. Art as Political Presentation

3. Aestheticised Revolution: the Total Work of Art

4. Aestheticised Revolution: the Avant-Garde

5. Aestheticisation and Democracy

Translator's notes
1 The word *modern* refers here (as in the author's German) to the cultural consequences of the Renaissance, of eighteenth-century rationalism and of the Industrial Revolution.
2 Presentation is used here as the nearest convenient English equivalent to the German word *Repräsentation*, with its connotations of prestige, status and public relations.

1. Tied Art and Aesthetic Art

Art in the modern world is marked by the process whereby it has become aestheticised. Among the signs of this aestheticisation is the existence – unique to the modern world –

of aesthetics itself, a philosophy that deals primarily with fine art. Its first emergence can be precisely dated to the year 1750, at the watershed or 'saddle' of the eighteenth century (the *Sattelzeit*, as Reinhart Koselleck has called it). Before that, aesthetics did not exist, for very good reasons. In premodern times, the philosophy of beauty was not a philosophy of art, and the philosophy of art was not a philosophy of beauty. Beauty was pre-existent, and therefore could not be made: it was non-artistic. Accordingly, what could be made – by art – was not beautiful, precisely because it was artificial rather than pre-existent. Fine art had no place except as a servant of the pre-existent, the Divine. Fine art, the art of beauty, thus makes its first appearance as an art tied to religion. It forms part of religious worship. Architecture provides sacred space; sculptures of the divine are placed in temples; the Madonna is set up in church; drama has a religious significance; poetry and music find a place in divine worship. The museum, the concert-hall, the secular library, do not yet exist. The criterion of art is not the artistic but the divine; the purpose of art is salvation, and not art itself.

In the modern world, all this changes. As the world rapidly turns rational, traditions are neutralised, and with them the religious ties that bind art. Art is freed from its presentational role on behalf of religion. Gradually, the divine ceases to be the criterion of art; the new criterion of art is the artistic. Increasingly, the purpose of art is not salvation but art itself. And so art – fine art, soon joined by not-so-fine art in all its forms, from the art of uplift to anti-art – gradually sheds its religious ties and in that sense becomes autonomous. Architecture increasingly concerns itself with secular space; the book becomes literature; drama becomes an autonomous, secular institution; music moves over to the concert-hall; sculpture and painting transfer themselves to exhibitions and into the museum – a modern innovation, devised specifically for this purpose. This vastly simplified outline can be summed up in the following formula: in the modern world, (religiously) tied art becomes aesthetic art.

This process has its causes, of which I shall cite just a few. As the monotheistic God of the Bible is converted into the transcendental God, the world itself turns secular. Now that the spell of religion is broken, the world has room for secular including aesthetic – fascinations. Beauty, which religion takes out of this world, must now be aesthetically grasped and defined in this world. As the modern world – under the influence of experimental science and technology – becomes more and more artificial, beauty needs to be artificially sustained; and this is done by aesthetic art. This process is reinforced by the historical effects of a theological assault on the notion of justification by good works. Good works escape from the theological realm by assuming the guise of good works of fine art: in other words, aesthetic artworks. In a sense, aesthetics – in the specific, modern sense of the term – represents a continuation of the principle of justification by good works, in reaction against the Protestant Reformers' condemnation of that principle. In the modern world, for this and many other reasons, tied religious art changes into aesthetic art.

There is more than one way of looking at this aestheticisation of art in the modern age: negatively, as the 'loss of the centre', the undermining of a core of religious commitment;

or positively, as the shedding of tradition and the freeing of art to be itself. I make no secret of my own position. I regard the aestheticisation of art as an advance. To this day, there tends to be an assumption that affirmation is uncritical and therefore illegitimate; the truth is, however, that affirmation, saying Yes, is sometimes the most difficult and the most necessary form of criticism.

2. Art as Political Presentation

Wherever politics clearly distinguishes itself from religion – and this, too, is a characteristically modern event – art is given the option of replacing its dwindling religious ties with political ones. Art then overtly becomes political presentation. This may be seen as an attempt by art to circumvent the aestheticisation process. Here, I would point to two major options open to art as political presentation: the State and the Revolution.

First the option offered by the State. With this option, instead of cutting all its ties and aestheticising itself, art assumes a political, presentational role on behalf of the State. The State – the modern State, in its initial, absolutist form – first emerged as a necessity and a reality in the role of a peacemaker after a period of religious civil wars. It settled those conflicts, not by deciding where the disputed religious truth lay, but by *not* deciding where the disputed religious truth lay. It settled them by using its authority and its power to keep the source of the bloody conflict, the disputed religious element, well out of politics. The religious question – the right-or-wrong issue of salvation – is politically neutralised by the secular power of the State, this side of religion. This leaves art – this side of its former religious ties – available to present the increasingly secularised political power of the State. We have before us, above all, the early Baroque forms of presentational art: the palaces, the gardens, the political sculptures, the courtly poetry and music. The State goes on needing art for political presentation even when – in its modern, liberal form, equipped with the rule of law and the separation of powers – it keeps the peace by neutralising rival ideologies, and even when art begins to lose both the capacity and the inclination for a political role in the presentation of the State.

Then there is the option offered by the Revolution. With this option, instead of cutting all its ties and aestheticising itself, art assumes a presentational, political role as an aid to the Revolution in its utopian task. The more the State succeeds in keeping the peace – in staving off the menace of ideological civil wars – the more the people take the peace for granted. The more the people take the peace for granted, the less they take for granted the political neutralisation of the big issue: the religious or post-religious issue of the one true way to human happiness, the one true goal of humankind. They no longer want the life they have but the perfect life, and they attack the State because it does not provide it, and because its blind spots are interpreted as repression. In a utopian spirit, people strive for heaven on earth; they perceive what they have – which is not heaven – as hell on earth, and forget what reality really is: earth on earth. It is here, in a kind of parasitical relationship to State power, that we find the utopias of the philosophers of history, and the revolutions that are governed by them. Those revolutions, from the French Revolution to

the Communist October Revolution and its aftermath, renew (and, where necessary, attempt to implement by force) the promise of universal salvation, this time on a post-religious basis. Art, by turning against the State, can now enlist in the service of revolutionary aims, and give presentational support to the revolutionary doctrine of universal salvation. Art becomes a means to the end of revolutionary utopianism.

I have tried to outline the two extreme cases in which art, shaking off its religious ties while not yet daring to grasp its aesthetic freedom, can assume a political, presentational function – on behalf of the State on the one hand, and of the Revolution on the other. What interests me is what happens next. For, ultimately, art's retreat into political presentation which I regard as an attempt to circumvent the modern process of the aestheticisation of art – does not halt that process but actively furthers it. As a way of evading aestheticisation, it is counterproductive. I shall try to explain this in the light of an arbitrarily selected instance: that of art politically tied to the Revolution. Such art is never more than a kind of understudy for the Revolution itself; for it never constitutes true revolutionary practice but always – whatever its revolutionary zeal – remains just art. This understudy is in the same position as understudies in the theatre, who have no importance except when the leading player drops out. Just so long as the leading player does *not* drop out, the understudy is at best a rival. The same happens with committed, revolutionary art in a Revolution. When the leading player, the Revolution, drops out, then the understudy, art, becomes tremendously important. But when the leading player, the Revolution, seems to be a big hit, the understudy, art, becomes tremendously suspect. This, in fact, is how the avant-garde gets itself outlawed. I shall discuss both these eventualities in more detail in the two sections that follow.

3. Aestheticised Revolution: the Total Work of Art

Come the Revolution, dreams turn into reality. Expectation is succeeded by experience; and a bad experience it is, because in the French Revolution and in the Communist Revolution the Revolution did not keep its promises. Instead of absolute freedom, it led to terror; instead of sweeping away repressions, it swept away freedoms; and – *fiat utopia, pereat mundus,* let there be utopia, though the world perish – what was meant to be universal salvation became universal destruction. For this reason, the great modern revolutions inspired by a philosophy of history invariably disappoint their own revolutionary hopes and expectations. Or, to put it more simply: those revolutions fail.

How do revolutionaries mentally survive the failure of the Revolution? With regard to the Communist Revolution, the answer is not yet clearly apparent – to me, at least. With regard to the French Revolution, however, the question can be answered, and the answer is relevant to the theme of art and politics. It is this. Revolutionary sympathisers survive the political failure of the Revolution aesthetically. They attempt (at all events) to compensate for failed politics with successful art. They salvage the revolutionary principle by carrying it over from its politically failed form to its depoliticised form. They aestheticise the revolutionary principle by inventing the *Gesamtkunstwerk*: the artistic synthesis,

the total work of art. To put it crudely, the *Gesamtkunstwerk* is the aircraft in which crippled revolutionary hopes make a belly-landing. The revolutionary aim is no longer a totally perfect reality but a totally perfect work of art: the *Gesamtkunstwerk*, which is therefore required to stand in for the longed-for reality – its own essential aim being to erase the boundary between art and reality.

It must be realised that the idea of the *Gesamtkunstwerk* did not stem from Richard Wagner but from German Idealist philosophy. Friedrich Wilhelm Joseph Schelling – the man who in Wagner's youth, according to Nietzsche, addled the heads of the young – aestheticised the philosophy of the Revolution. Those who, at a twentieth-century Milan Triennale, declared policemen to be artworks, were modest by comparison with Schelling. He erected an 'Identity System' according to which the whole of reality was an artwork; and he concluded his account of this system with a 'Philosophy of Art' in which he invented the very concept of the *Gesamtkunstwerk* that Wagner was to revive in his *Oper und Drama*. Wagner, who was himself a failed revolutionary – hence his long march from the barricades of Dresden to the green hill of Bayreuth – took up Schelling's idea as follows: reality, the goal of the Revolution, is a status that the *Gesamtkunstwerk* can attain only through the 'communism' of the arts. By 'communism', Wagner meant here the combination of all the individual arts into a single work of art which, being the *Gesamtkunstwerk*, abolishes the boundary between art and reality. Wagner's successors in the *Gesamtkunstwerk* business – or those of them who came within the ambit of Surrealism, Dadaism and Futurism – took a rather different view. For them, it was not the combination but the destruction of all the individual arts in a total anti-artwork that conferred on that work the dignity of reality. This process can be taken a very long way – even as far as the aestheticisation of war, against which Walter Benjamin warned us in his 'Work of Art' essay, and the aestheticisation of civil war, against which he forgot to warn us. But all devotees of the *Gesamtkunstwerk* have been in favour of the 'communism of genius', whereby all human beings together are the artists of the total work of art. And today, any individual who seeks to achieve it alone, by being able to do and experience everything, needs to suggest – through rituals of costume, if nothing else – that he is not on his own at all. This is why, for instance, Joseph Beuys – the Total Art Potterer, the avant-garde Salvationist, the pacifist, anti-uniform, one-man army – was the most disciplined, not to say fanatical, uniform-wearer of the present day: meaning's steadfast Tin Soldier.

The Revolution – this is my thesis here – survives its own failure by becoming aestheticised, in the *Gesamtkunstwerk*. But this is an artwork whose aim is the most perfect reality. For that reason, it compels human beings to live exclusively within it: within this work of art. But that is something that no one can seriously do. And so what is questionable about the aesthetic is not, as some of its fiercest critics (Sören Kierkegaard among them) have alleged, that it remains too unreal. On the contrary, the aesthetic becomes intolerable where it becomes too real: where the boundary between art and reality is erased by the insistence on seeing reality only as art and art only as reality. Indirectly, this forces us into a quest for the exclusively aesthetic.

4. Aestheticised Revolution: the Avant-Garde

The French Revolution having failed, either the Revolution must be aestheticised in the *Gesamtkunstwerk* or there has to be a real-life – indeed larger-than-life – replay of the Revolution itself. That was the goal of the Communist revolutionaries. The Revolution survives its own failure through the total work of art; the Revolution survives the total work of art as a renewed Revolution. Once again, *fiat utopia, pereat mundus*: the aim is to replace real life with perfect life; utopian dreams prevail; the political salvation of the world is hoped for. And, once again, art – whether sympathetic or wholly committed – relates positively to all this. Once again, art serves a political, presentational function for the Revolution; and it is the avant-garde – as painting, sculpture, architecture, literature, theatre, film – that enlists in the revolutionary cause of universal salvation. The most progressive art champions the supposedly most progressive new world. But this is a risky undertaking.

I have already hinted at the dilemma of a committed, revolutionary art: for the political Revolution, revolutionary art is always only the understudy. It never constitutes true revolutionary practice, but always – whatever its revolutionary zeal – remains just art. The understudy becomes important only when the Revolution fails. As I have said, this is where the total work of art comes in. But when the star of the show – the Revolution – seems to be winning, then things become dangerous for revolutionary art. For then the political Revolution expects art to toe the line. 'Literature,' said Lenin as early as 1905, 'must not be a matter for the individual. It cannot be independent of the activities of the proletariat as a whole. Down with nonpartisan writers! Down with the literary supermen! Literature must be a component part of organised, planned and consistent Party work.' This demand became a reality after the October Revolution. As soon as the Revolution wins through and sets about consolidating and stabilising its victory, revolutionary art (as, eventually, in the extreme case of Stalinism) starts to look politically unreliable and probably deviant. The creative is potentially subversive. And so, in Russia in the 1920s, revolutionary – avant-garde – art became suspect and was cut adrift, to be replaced by monumental eulogies. The artists themselves were eliminated. In the name of the Communist Revolution, they were hounded out of the country – think of Kandinsky's second emigration – or, like Blok, Mayakovsky, Mandelstam, Meyerhold and Babel, out of life itself. The avant-garde was spurned and outlawed.

What this entailed outside the homeland of Revolution, the Soviet Union, was what Arnold Gehlen, in his book *Zeit-Bilder*, has called 'depoliticised Revolution'. He writes with painting specifically in mind, but his words have a general application:

> Without any doubt, when the modern movements of Expressionism, Cubism and so on first appeared, they were regarded as 'revolutionary' in more than a purely artistic sense: people could detect the ideological overtones. When the Soviets outlawed abstract art, something very decisive happened: they thereby depoliticised modern Western painting. It had now become impossible to link any new movement credibly with left-wing political ideas. As a result, the artistic revolution was freed of its political background noise, or in other words art was forced into mere self-referentiality … And so, insofar as the artist … chooses to enact instincts of aggression and disquiet, this aggression is depoliticised and can turn only against the other art in its own genre … This is surely one of the essential causes of the perpetual artistic revolution.

In this way, the political Revolution outlaws the artistic avant-garde and cuts it adrift. Politically, the avant-garde becomes a despised outcast. Thus spurned – and against its will it is 'forced into mere self-referentiality'. The whole process is an indirect aestheticisation of art.

Where this art and its artists – dumped by the Revolution – still seek to maintain a left-wing, revolutionary ideological posture, this has turned into rather a pathetic affair, wholly lacking in political credibility. Its seriousness a sham, this posture remains relevant only to those who have lived for the Revolution while relying on it not to arrive. As the support system of an ideological clique that has overlooked, or refused to acknowledge, the demise of revolutionary political ideology in art, it is objectively passé. By dropping and thereby 'depoliticising' avant-garde art, the Revolution ultimately aided the very process that the avant-garde had hoped to avoid by becoming politicised in the first place: the comprehensive aestheticisation of art.

5. Aestheticisation and Democracy

It is time to restate my thesis, which I have attempted to illustrate by a number of specific references. In the modern world, tied art turns into aesthetic art. Art's attempt to assume a role in political presentation – whether on behalf of a State or on behalf of the Revolution – has mostly turned out to be a way of opting out of this process. But, by opting out in this way, it ends up doing the exact opposite: opting into the systematic aestheticisation of art. As I have emphasised, I do not look upon this aestheticisation as a bad thing: on the contrary, I look upon it as a good thing, even though it is not without its painful side-effects.

By being aestheticised, art is released from its ties, freed from politics; and this emancipation of art from politics is part and parcel of modern liberal democracy. It is no use bringing in the dogma that everything is political, and therefore there is no escaping from politics; because that – everything is politics – is a totalitarian dogma. Liberalism means that not everything has to be political, not even art. As I see it, it is implicit in the liberal, democratic Bill of Rights that absolutely no single aspect of reality can ever be 'everything'. It would be just as bad if everything were religion or if everything were education or if everything were economics or if everything were art. The individual has to be able to stand back from any or all of these – which means that one of the many freedoms of modern liberal democracy is the freedom of art from politics. This does not preclude – indeed it presupposes – the need to defend art's freedom politically. Nor does it preclude art from taking an interest in politics. Art – and this is part of the logic of its aestheticisation – must be free to do many and various things, indeed almost anything at all; but it need not *have* to do anything, and especially anything political. Above all, it is under no obligation to take any specific political line – such as that of rejecting bourgeois values and longing for states of emergency. A person of sense will steer clear of states of emergency wherever possible. It all comes down to this: art that is consistently aesthetic may be, but need not be, political.

How are we to reconcile this with the fact that under democracy the need for presentational art – for political presentation through art – continues to exist? How is this need to be satisfied – in a modern, liberal, bourgeois democracy – if art's emancipation from politics is part and parcel of the aestheticisation of art, which in its turn is part and parcel of democracy? In answer, I point to two facts. Firstly, modern, representative democracy presents itself not primarily through art but through the representative institutions of the sovereign people. The foremost of these is parliament; then come the other – separated – powers of the liberal constitution; only then can one begin to look for political presentation on an indirect level. Secondly, liberal democracy presents itself through art indirectly: by supporting art – by writing its freedom into the constitution, by according it prestige and money – *without* making any demands of a political nature; and thus, not least, by releasing art from the duty of political presentation.

Within a liberal democracy, aestheticised art is thus released from presentational duty. Having retired – having been released from duty – as a professor of philosophy three years ago, I hope to be forgiven for assigning such a central role to a phrase that has extraordinarily positive personal connotations for me, and for describing contemporary art (partly and indeed especially in relation to politics) as presentation released from duty. Not that this exhausts the topic of the relationship between art and politics. Far from it. But this emphasis on the way in which aestheticised art is released from duty may cast light on a not unimportant aspect of that relationship. It is an aspect which – like the relationship as a whole – is and remains complicated and conceptually unwieldy. But it still demands to be thought through. For philosophy is when you insist on thinking.

This essay stems from a lecture given in 1993 as part of a series organised by the Hessische Landeszentrale für politische Bildung. It was published in German in the book *Kunst und Politik*, edited by Bernd Heidenreich (Wiesbaden, 1994), and appears here in a slightly modified form.

Bracketed letters are used to indicate the section of the exhibition in which an artist's work appears.

R: Reality – Distortion, p. 73
P: The Portrait in the 20th Century, p. 153
A: Abstraction – Spirituality, p. 221
S: Language – Material, p. 323
T: Dream – Myth, p. 441

The catalogue numbers of the works in the exhibition are listed on the pages indicated above.

The Artists in the Exhibition

CARL ANDRE (A)
FRANCIS BACON (R/P)
GIACOMO BALLA (R)
BALTHUS (D)
GEORG BASELITZ (R/P)
MAX BECKMANN (R/P)
JOSEPH BEUYS (P/L)
UMBERTO BOCCIONI (R)
CHRISTIAN BOLTANSKI (D)
PIERRE BONNARD (R)
CONSTANTIN BRANCUSI (R/A)
GEORGES BRAQUE (R)
MARCEL BROODTHAERS (L)
ALBERTO BURRI (L)
ALEXANDER CALDER (D)
MARC CHAGALL (D)
EDUARDO CHILLIDA (A)
GIORGIO DE CHIRICO (R/P/D)
CHUCK CLOSE (P)
LOVIS CORINTH (R/P)
SALVADOR DALÍ (D)
HANNE DARBOVEN (L)
ALEXANDER DEINEKA (R)
ROBERT DELAUNAY (R/A)
JAN DIBBETS (L)
OTTO DIX (P)
JEAN DUBUFFET (R/P)
MARCEL DUCHAMP (L)
MAX ERNST (L/D)
JEAN FAUTRIER (R)
DAN FLAVIN (A)
GÜNTHER FÖRG (A)
LUCIO FONTANA (A)
LUCIAN FREUD (R/P)
KATHARINA FRITSCH (D)
NAUM GABO (A)
ALBERTO GIACOMETTI (R/P/D)
GILBERT & GEORGE (L)
ROBERT GOBER (D)
JULIO GONZÁLEZ (A)
ARSHILE GORKY (D)
GEORGE GROSZ (L)
RAOUL HAUSMANN (L)
EVA HESSE (A)

GARY HILL (L)
DAVID HOCKNEY (P)
JENNY HOLZER (L)
EDWARD HOPPER (D)
JASPER JOHNS (L)
ASGER JORN (R)
DONALD JUDD (A)
ILYA KABAKOV (L)
FRIDA KAHLO (P)
WASSILY KANDINSKY (A)
MIKE KELLEY (L)
ELLSWORTH KELLY (A)
ANSELM KIEFER (D)
EDWARD KIENHOLZ (L)
ERNST LUDWIG KIRCHNER (R/P)
R. B. KITAJ (P)
PAUL KLEE (D)
YVES KLEIN (A)
OSKAR KOKOSCHKA (R/P)
WILLEM DE KOONING (R/A)
JEFF KOONS (P/L)
JANNIS KOUNELLIS (L/D)
BERTRAND LAVIER (L)
FERNAND LÉGER (R)
WILHELM LEHMBRUCK (R)
ROY LICHTENSTEIN (L)
RICHARD LONG (A)
RENÉ MAGRITTE (L/D)
ARISTIDE MAILLOL (R)
KAZIMIR MALEVICH (R/A)
PIERO MANZONI (L/A)
FRANZ MARC (R)
HENRI MATISSE (R/P)
MIKHAIL MATIUSHIN (A)
MATTA (D)
MARIO MERZ (L)
JOAN MIRÓ (D)
AMEDEO MODIGLIANI (P)
PIET MONDRIAN (A)
CLAUDE MONET (R)
HENRY MOORE (D)
GIORGIO MORANDI (D)
REINHARD MUCHA (L)
BRUCE NAUMAN (L)

BARNETT NEWMAN (A)
HERMANN NITSCH (L)
EMIL NOLDE (R)
CLAES OLDENBURG (L)
JOSÉ CLEMENTE OROZCO (R)
NAM JUNE PAIK (L)
PINO PASCALI (L)
FRANCIS PICABIA (L/D)
PABLO PICASSO (R/P)
SIGMAR POLKE (L)
JACKSON POLLOCK (R/A)
LIUBOV POPOVA (A)
ROBERT RAUSCHENBERG (L)
AD REINHARDT (A)
GERHARD RICHTER (L/P)
ALEXANDER RODCHENKO (A/P)
MARK ROTHKO (A)
OLGA ROZANOVA (A)
THOMAS RUFF (P)
ROBERT RYMAN (A)
CHRISTIAN SCHAD (P)
EGON SCHIELE (P)
OSKAR SCHLEMMER (R)
KURT SCHWITTERS (L)
RICHARD SERRA (A)
CINDY SHERMAN (D)
MARIO SIRONI (R)
DAVID SMITH (A)
STANLEY SPENCER (P)
FRANK STELLA (A)
CLYFFORD STILL (A)
YVES TANGUY (D)
ANTONI TÀPIES (L)
VLADIMIR TATLIN (A/L)
JEAN TINGUELY (L)
ROSEMARIE TROCKEL (L)
JAMES TURRELL (A)
CY TWOMBLY (A/D)
BILL VIOLA (D)
JEFF WALL (D)
ANDY WARHOL (P/L)
LAWRENCE WEINER (L)
WOLS (D)

Reality – Distortion

NORMAN ROSENTHAL

Questions to a Broken Mirror

The twentieth century draws to a close. It is a century that has seemed to its participants and observers to have existed in a state of self-conscious and permanent revolution, as far as invention within the visual arts is concerned. For the visual arts, as much as any sphere of human culture, have acted as a complex metaphor for the immense changes and convulsions that have characterised every aspect of this century. We have been witnesses of a story of art – or rather, inter-connected stories of art – and this exhibition proposes the existence of four that speak of change and innovation, of flux and uncertainty, possibilities of expression seemingly without end, only waiting for the individual artist working in whichever medium to give them form.

Official academies, bodies dedicated to laying down rules and standards for art, were already perceived to be dying well before the end of the nineteenth century, only to be replaced by a cacophony of artistic options, secessionists from the norm and small groups of artists fighting subversive battles on behalf of new ideas. The individual artist, through his (and very occasionally her) imagery and, above all, style, proclaimed his uniqueness to the public as though he had hailed from nowhere. Art was an address that was meant to destabilise held assumptions about both art and living, making the viewer contemplate the fragility of his or her own existence. It was the all too complacent viewer who, as Marcel Duchamp famously stated, alone completed the work of art by virtue of the process of looking, thus, perhaps, becoming a little more aware of love and friendship and, equally, of the possibilities of chaos, horror and the abyss.

The consensus has rightly proclaimed Pablo Picasso the archetypal artist of the century. Gertrude Stein, in her classic book on Picasso, perceived the twentieth century to be an outstandingly *splendid* one, in spite of the fact that she was writing on the verge of a second, catastrophic World War. For all the horror and cruelty of the times in which she lived, Stein found it possible to write, in her inimitable faux-naïf style, that

> the twentieth century is more splendid than the nineteenth century, certainly it is much more splendid. The twentieth century certainly has much less reasonableness in its existence than the nineteenth century, but reasonableness does not make for splendor. So the twentieth century is that, it is a time when everything is destroyed, everything isolates itself, it is a more splendid thing than a period where everything follows itself.[1]

With the simplicity that is a virtue when describing art, Gertrude Stein makes sense of the apparent disjunctions that have added to the richness of our visual culture. She penetrates the apparent confusion and the contrary options that Picasso exemplifies in his own art, Apollo versus Dionysus, where emblems of calm and classical poise are in constant battle with disruptive intrusions of violent emotion. We need to live in a world of

1 Gertrude Stein, *Picasso* (1938), New York and London, 1946, pp. 48–9.

visual options where Picasso's and Braque's analytical Cubism may co-exist with the ecstatic spirituality of Kandinsky, the ironic semantic games of Duchamp or the Nietzschean/Freudian world of de Chirico. For all the seductive talk of Post Modernism, that prefers to place the quasi-parthenogenic revolution in the art of our century around 1960, when for example Andy Warhol presented his *Brillo Boxes* to the world,[2] rather than in 1906–08 at the time of the invention of Cubism, this may have been no more than an extension of Modernism itself. Perhaps the world that has christened itself 'post-modern' is merely expanding the range of artistic possibilities which we should be confident will survive into the next decades and, coincidentally, a new century. Here the question, ultimately unanswerable, is whether this new millenium, in the sense of a real New Age, did not in fact begin precisely one century ago. Certainly artists and commentators around 1900 were much more conscious of fundamental changes, as far as the world and the production of art were concerned, than the present time, in which we seem surprisingly nonchalant about the much vaunted revolution in information technology, as well as the potential demise of a Eurocentric view of culture.

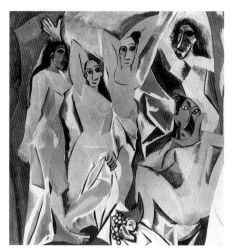

Fig. 1 Pablo Picasso, *Les Demoiselles d'Avignon*, 1906–07. The Museum of Modern Art, New York

In many ways, this seems an appropriate time to review our assumptions about art and to look again at those 'masterpieces' – an unfashionable concept – which of themselves create new authority. What precisely is the difference wrought by 'masterpieces' and the seemingly endless production that emanates from them and serves to disseminate their message? Reflecting on the production of art in the first decade of this century, we are entitled to ask to what extent, ninety or so years later, the seemingly radical world that then emerged was firmly located in a tradition that has its roots in the nineteenth century or even in the Renaissance? There is perhaps a sense in which the thing we recognise as Modernism, that was arguably inaugurated by Picasso's painting *Les Demoiselles d'Avignon* in 1906–07 (Fig. 1), belongs to an irrecoverable past, as much the last outburst of a dying tradition as the beginning of a new age. Did the *Demoiselles* break more radically with the Western canon than the pioneering works by Manet, Gauguin, and Cézanne? Manet in his *Olympia* (1865), in the mid-nineteenth century, had appeared to question, even to mock, the value of the classical tradition, whilst paradoxically securing its continuity. Gauguin in Tahiti, in 1897, was asking the quintessential modern question, 'Where do we come from? What are we? Where are we going?' *(D' où venons-nous? Que sommes-nous? Où allons-nous?)*, and had gone a long way in that work, as in many others, to establish the artistic validity of the so-called 'primitive'. Cézanne in his late work – in his figure paintings, in particular, as well as in his landscape paintings – raised complex poetic and perceptual questions about time and space, the essence of reality and, in his own way, the issue of primitivism; expressively explosive issues, that have little to do with exact visual appearance.

For a long time after he had completed the *Demoiselles*, Picasso preferred to hide the painting – for several years after it was 'completed'. The painting in fact remained incomplete. It was turned to the wall in his studio and even those of his close friends, patrons and admirers who were allowed to glimpse it were perplexed by the brutality of

2 See Arthur C Danto, *After the End of Art. Contemporary Art and the Pale of History*, Princeton, 1997, especially p. 123 ff.

Fig. 2 Pierre Matisse, *Le Bonheur de vivre* (The Joy of Life), 1905–06. The Barnes Foundation, Philadelphia

its imagery. He set aside the work in 1907, only a short time after Henri Matisse, the official leader of the Paris avant-garde, had finished painting his own manifesto masterpiece, *Le Bonheur de vivre* (1905–06) – a psychedelic fantasy of the good life – that now resides almost out of public reach, in the Barnes Collection in Philadelphia (Fig. 2). But no one who saw Matisse's painting on its recent, exceptional world tour can have failed to be overwhelmed by its hallucinogenic poetry and melting colour, that seem to anticipate the fantasy kitsch world of Walt Disney, with its constantly changing forms which dance and dissolve in a vision of endless erotic pleasure. *Le Bonheur de vivre* is a painting without angles and straight lines. Picasso, around the time of *Le Bonheur de vivre*, was a young, ambitious painter, whose blue and pink El Greco-inspired visions of *Saltimbanques* had made him little more than an impressive, but nonetheless derivative, second generation post-Impressionist and Symbolist. He was surely less 'modern', in the sense of being profoundly involved with the existential issues of modern life, than an older generation of artists, still active or only recently dead – Cézanne, Gauguin and Degas. Matisse's answer to the questioning of his forebears was to evoke a world of almost mindless sensuality that attempts to escape from all history and all sense of social reality. *Le Bonheur de vivre* seems the ultimate painterly colour fantasy, and even the barbarism of almost contemporaneous works such as *Le Luxe II* (1907–08) (Cat. 5), *La Danse* (1909–10) and *La Musique* (1910), with their hints of ritualistic primitivism, is also an escapist dream world, nowhere located in any reality or sense of place. Matisse's arcadian visions are surely not abstract landscapes either, and have little emotionally in common with Kandinsky's explosive *Compositions* (Cat. 123 and 124) or the more cerebral notations of Mondrian's *Pier and Ocean* paintings, for which Matisse only found abstract equivalents at the end of his life, with his *Cut-outs*.

In the *Demoiselles*, and in paintings such as *Femme nue assise* (1908) (Cat. 3), Picasso provided an ambitious, yet covert, riposte to the rivalry of Matisse. Here he must surely have wanted to seize the high-ground of the avant-garde from the Fauves and offer a challenging alternative to their colourful landscapes. Picasso chose somehow to eliminate colour, to eliminate the sexuality of the curve, to break the mirror of luxury. The new manifesto was an aggressive primitivism without illusion, the primivitism of the bordello, whose image mirrors, much as the painting itself in many ways resembles, a cracked mirror, a reality in which the painter challenges the viewer to become an active and, maybe, compromised participant. He gives us a consciously angular delineation of primitive form, whose source – whether Egyptian, Iberian, African or even Oceanic – is ultimately immaterial, and whose value had hitherto been held to be of anthropological interest only. The contrast and comparison between the older Matisse and the somewhat younger Picasso at this moment in Paris – which clearly was the central forum where the issue of Modernity was being debated – could not have been more striking. In the long term, the answer for the new century clearly could not be an escapist avoidance of reality. Rather, it would inevitably lie with an ever heightening confrontation with it (itself, often the expression of existential agony), which would serve to heighten the sense of

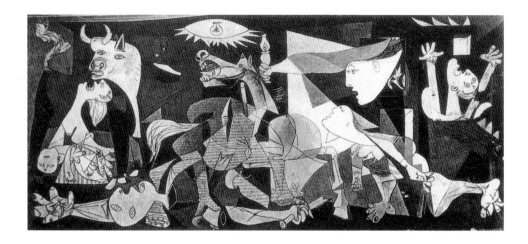

Fig. 3 Pablo Picasso, *Guernica*, 1937. Museo Nacional del Prado, Madrid

realism where mere illusionism, particularly in an age of photography, could only leave the viewer indifferent.

Not only the *Demoiselles*, but the subsequent analytical Cubist works of Picasso and Braque, are notable for their colouristic restraint. Picasso was never a great colourist. Not for nothing was his most ambitious political painting, *Guernica* (1937) – his response to the Spanish Civil War – painted in black, grey and white only (Fig. 3). There is too little pleasure to be found in the bordello of Avignon. Its masked, angular faces stare out with all the sadness and nightmares of a living hell – even the much commented-upon still life, with its implied sexual symbolism, seems quite meagre. Matisse's idea of the future-present was a Paradise. Picasso describes almost straightforwardly a place of great sadness and apprehension; he stares into the abyss of the twentieth century and the social consequences of both its inventiveness and its self-destructive urges.

Both *Le Bonheur de vivre* and *Les Demoiselles* are self-conscious masterpieces. They are paintings which proclaim by virtue of their size and problematic meaning their intention to change the agenda of art. These works, which broke new boundaries, inspired, on the one hand, fear and awe and, on the other, the production of works by other artists, which were frequently misunderstandings of the real thing. They act very much as points of culmination and points of reference within the culture of the visual arts. If the master-piece is such an unfashionable concept at the end of this century, it is because of a general wish on the part of the academic establishment in particular to reject ideas of authority and hierarchy, in favour of concepts that relate to continual process, as well as elimination and other reductive phenomena. Yet even Marcel Duchamp, the hero and chief prophet of so much of today's modernity, clearly concentrated most of his effort on three key works. Indeed, apart from the readymades, it is these 'spectacular' works that give form to his idea of art. *Nude Descending a Staircase no. 2* (1912) was a comparatively minor synthesis of Cubist and Futurist ideas, which was rejected by the Cubist members of the *Salon des Indépendants* in Paris as not being authentically Cubist; yet it did as much as any other individual painting to carry the message of modernity from Paris to New York, where it created a sensation at the *Armory Show*, in 1913. There followed

3 Pierre Cabanne, *Dialogues with Marcel Duchamp*, trans. Ron Padgett, London, 1979, pp. 69–70.

Fig. 4 Oskar Kokoschka, *Die Windsbraut* (The Tempest), 1913–14. Kunstmuseum Basel

Duchamp's two principal and most self-conscious masterpieces, the hermetic *Large Glass* or *The Bride stripped bare by her Bachelors, even* (1915–23) (see. Fig. 10, p. 310) and, much later, the more bluntly erotic *Etant donnés* (1946–66), his extraordinary peep show environment, which has also served as a spectacular point of departure for so much art made since its existence was revealed (see Figs. 12 and 13, p. 311). In an interview, published in 1967, Duchamp said:

> In the production of any genius, great painter or great artist there are really only four or five things that really count in his life. The rest is just everyday filler. Generally, these four or five things shocked when they first appeared. Whether it's *Les Demoiselles d'Avignon*, or *La Grande Jatte*, they're always shocking works ... I dream of rarity, what otherwise could be known as a superior aesthetic.

He went on to assert that 'A work of art is made of the admiration we bring to it.'[3] Duchamp was nothing if not elitist, in his attitude to both life and art.

But similar thoughts were expressed by Oskar Kokoschka, whose attitude to the production of art could not be further away from Duchamp's. Kokoschka's great masterpiece, *Die Windsbraut* (The Tempest, 1914) (Fig. 4), as well as *Irrender Ritter* (Knight Errant, 1915) (Cat. 29) represent culmination points of ecstatic Expressionism – attempts to make a 'Liebestod' of Expressionism. Kokoschka was to say that 'Expressionism gives form to experience as such, as a direct message from the "I" to the "Thou". As in love, it takes two to establish communication. Expressionism does not inhabit an ivory tower – it addresses the next person, arouses their attention.'[4]

It is thus that painting, as a form of communication in this century, has had to resort to ever more extreme strategies of dislocation and distortion in order to awake in the informed viewer, who himself participates in the discourse, feelings of empathy and encourage him to join in the search for equivalents for reality. Optical realism, as it was understood by academic artists and late Impressionists alike, became an untenable basis for communicating either feeling or a sense of reality. Expressionism, as a means of communicating from the 'I' to the 'Thou', became one of the principal adventures and explorations of modern art that took in, amongst others, the greatest works of Picasso, Léger and Boccioni, of Nolde, Kirchner, Kokoschka and Beckmann, and later artists such as Fautrier, Giacometti, Bacon, de Kooning and Baselitz. All these artists have lived through a century that many have defined as consisting principally of a drive towards abstraction and looked with increasing desperation for ways of strategically safeguarding the idea that it is possible to create visual equivalents of reality. It is this struggle against abstraction that makes Expressionism as defined by Kokoschka, in spite of so much aesthetic scepticism and irony, such a powerful motor, and such a force of cultural continuity. Centred to a considerable extent within the German cultural landscape, it managed to survive the political and social abyss of the thirties and forties of this century, when dictatorship and brutality all but snuffed it out.

Expressionism was, at one level at least, an enthusiastic response given, in Germany, first to van Gogh and secondly to the Fauvism of Matisse, Derain and Vlaminck. Based primarily on colour as a vehicle for conveying the notion of pleasure, Fauvism had

4 Quoted by Werner Hofmann, *Experiment Weltuntergang. Wien um 1900*, exh. cat., Hamburg, Kunsthalle, (Prestel) Munich, 1981, p. 71.
5 John Richardson, *A Life of Picasso*, vol. II, 1907–1917, London, 1996, p. 106.

quickly worn out its validity and its essential 'wildness'. It was Nolde and the artists of the Dresden group, 'Die Brücke', who understood that Fauvist colour was only valid as a means for overcoming the pretensions of bourgeois normality. The paintings of Ernst Ludwig Kirchner and his friends were hymns to personal freedoms that could only be achieved within the studio, naked on the shores of a lake or in the anonymity of the big city. Thus, Kirchner gives heroic intensity to the grand prostitute of the *Potsdamer Platz* (1914) (Cat. 23), as she proudly walks the busy streets. In her way, this whore is made to look as impressive as the *Demoiselles d'Avignon*. There is within Expressionism an almost god-like exaltation of low (or perhaps, real) life, that serves to reinforce deliberately fierce deformations of colour and form. It was no accident that the broad reception of Picasso was more advanced in Germany than anywhere else, in the years before the First World War. Largely thanks to the efforts of promoters, dealers, collectors and critics there, Picasso was perceived to be the Expressionist painter par excellence.[5] It was as though his arguably greatest achievements as a cerebral Cubist – the extraordinary series of portraits, landscapes and still lifes that he made at the time of his close partnership with Braque – were atypical of his life's work. In reality, the culminating points in Picasso's career were expressionist paintings such as the *Demoiselles* (1906–07), *Les Trois Danseurs* (1925) (Fig. 5) and *Guernica* (1937); indeed, his entire post-Second World War output was motivated by a Dionysian force of self-destructive, intensely autobiographical, Expressionism that characterises by far and away the largest part of the œuvre of this most fecund of artists.

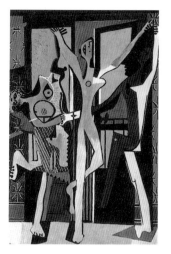

Fig. 5 Pablo Picasso, *Les Trois Danseurs* (The Three Dancers), 1925. The Tate Gallery, London

Let us once more reflect on the singular work of art – the masterpiece that somehow needs to be contemplated in isolation and yet exists within a context which it is essential for the viewer to be aware of, if he or she is to comprehend it fully. This is the dilemma of all cultural manifestations – but is quite especially the dilemma of the visual arts, which during this century have been exposed to an intense mass of critical, often manipulative, writing that is so overwhelming that it threatens the integrity of the works themselves. It is all too easy to evoke distorting confrontations, without regard for the emotional as well as the technical and historical fields of discourse. If we accept the premiss of Duchamp, that we complete the work of art by our contemplation, how are we, as individuals, to decide which works deserve wide validity, in the context of the discourse about art? Exhibitions such as this afford opportunities for recording in our minds the vast amount of material that lays claim to belong to the accepted canon of art in this century. Works of art have a particular and proven propensity for speaking to each other in a significant way, and this suggests that the most legitimate form of art criticism is the exhibition, which might be defined as a meaningful and considered confrontation between individual works of art. Like the changing constellation of the stars or the chance or structured meeting of individuals, works of art, when they confront each other in public exhibition, debate, enliven, promote and even demote themselves as 'useful' images in our minds. How 'splendid' it would be – to return to Gertrude Stein – to confront Picasso's *Demoiselles d'Avignon* with Kirchner's *Potsdamer Platz*, Picasso's *Three Dancers*

Fig. 6 Georg Baselitz, *Nachtessen in Dresden* (Night-time Meal in Dresden), 1983. Kunsthaus Zürich

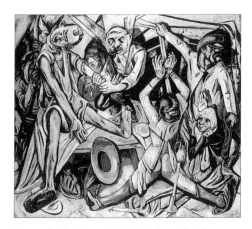

Fig. 7 Max Beckmann, *Die Nacht* (The Night),
1918–19. Kunstsammlung Nordrhein-Westfalen,
Düsseldorf

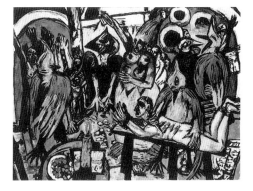

Fig. 8 Max Beckmann, *Hölle der Vogel* (Birds' Hell),
1938. The St. Louis Art Museum

with Beckmann's *Apachentanz* (Dance of the Cut-throats, 1938) and de Kooning's *Woman I* (1950–52) (see Fig. 12) with Bacon's *Three Studies for Figures at the Base of a Crucifixion* (1944), or to speculate in this context on Georg Baselitz's *Nachtessen in Dresden* (Night-time Meal in Dresden, 1983), which evokes the artists of 'Die Brücke' at a Last Supper, perhaps discussing the honorary election to their group not only of Edvard Munch, but of Henri Matisse (Fig. 6).

History itself becomes real through such confrontations. In 1912, Max Beckmann, even before his catastrophic, but ultimately cathartic, experience as a medical orderly in the First World War, wrote of his purpose 'as being to make the invisible visible through reality.'[6] Beckmann was an archetypal exponent of the fractured reality of the twentieth century, relentless in his search to find visual equivalents for the spiritual condition of man. Early on, his painting *Die Nacht* (The Night, 1918–19) demonstrated the extreme potential of man's inhumanity to man (Fig. 7). This depicts a scene of almost indescribable sadistic torture and is a powerful witness to an increasing brutalisation of society that was such a terrifying consequence of the First World War. Going yet further in this direction, Beckmann's masterpiece allegory *Hölle der Vögel* (Birds' Hell, 1938) was arguably the most powerful and direct protest against totalitarian persecution in the history of modern painting (Fig. 8). It depicts puffed up and fetishistically dressed birds doing their unspeakable worst to the scarred and scared victim, whilst in the background the crowd of history eggs on the torturers. Picasso's *Guernica* is a unique confrontation with contemporary history and, specifically, the European trauma caused by the Spanish Civil War. Beckmann's masterpiece of one year later turns out to be a still more cathartic confrontation with the horrors of torture. The question must be, to what extent has it been possible for artists and, more especially, painters to confront the issues of history in this century, the threats of catastrophe on so many different fronts, and even the possibility of total extinction, with the consequent elimination of the Western civilisation? Are works of Picasso, of the sculptor Lehmbruck, of Beckmann, Dix, Sironi, Dalí, Chagall or, indeed, Fautrier adequate, as metaphors of catastrophe, or are they ultimately 'kitsch'? Is it a singular imperative of art to 'face history', as a recent exhibition in Paris suggested?[7] To what extent can art cross the issues of history with those of the individual human condition? In both the nineteenth and the twentieth centuries the answer appears only at rare moments. Memorable works such as Goya's *The Shootings of the Third of May*, or Géricault's *Raft of the Medusa*, or even Manet's *Execution of the Emperor Maximilian* are complex contemporary history paintings, but each is exceptional in its confrontation with the realities of war and cruelty, rather than with those positivistic celebrations of victory, for which there is any number of precedents. Does the modesty of Fautrier's *Otages* (Hostages, 1943–45) allow us to make deductions about politics as profound as the complex allegories of Beckmann's triptychs? Art that pays adequate homage to the victims and the defeated, without pathos and sentimentality, is astonishingly rare. This is especially true, in an age overrun by intense and usually instantaneous communication, that brings the horrors of the battlefields and other forms of cruelty into the living room. In our Musée

6 Max Beckmann, 'Gedanken über zeitgemäße oder unzeitgemäße Kunst', *Pan*, II, March 1912, pp. 499–502.

7 *Face à l'histoire 1933–1996. L'artiste moderne devant l'événement historique*, exh. cat., Paris, Centre Georges Pompidou, 1996.

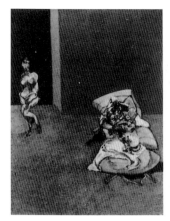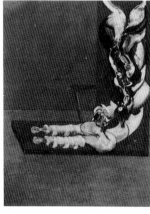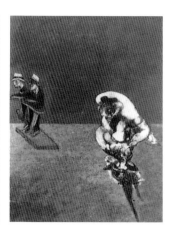

Fig. 9 Francis Bacon, *Crucifixion*, 1965. Staatsgalerie Moderner Kunst, Munich

Imaginaire, *The Third of May* might confront *Guernica*, the horrors of *The Raft of the Medusa* the *Birds' Hell*. But can the history of our century be inferred from less ambitious works, from a still life or a portrait? To what extent can we connect the perceptual developments of Cubism to analogous 'advances' in science? What connection was there between Einstein's complex theory of relativity (first propounded in 1905) and contemporaneous discussion in artistic circles of the fourth dimension? Does our culture derive its principal energy from the social, economic and political realities that have culminated so many times in this century in war and mass destruction? Or does it draw strength from scientific and artistic invention, both of which have a way of imposing themselves through defining works, at certain key moments in history?

All these are rhetorical questions, and yet it is worth asking, what is the significance of those metaphoric distortions of perceived reality, represented by Picasso's *Demoiselles* or *Femme nue assise*, who appear to press against history? – In what lies the genuine value of these paintings, in terms of their poetics? How did they make a powerful imprint on the century that is about to end? As we walk through this exhibition or at least consider the images as they are laid out in a particular order in this book, what are the recollections of times past, lost or made real, that they evoke? What absolute values and temporal memories are contained within these distorted images that speak for their time and are themselves supreme achievements of the culture to which they belong? Bacon's so-called 'Crucifixions' might simultaneously evoke ancient cultural memories of Greek drama, Christian imagery or its own culture of existentialism, which in the meantime has come to represent an episode of a past culture. If we reflect on Bacon's outstanding *Crucifixion* triptych of 1965, now in Munich, we can recognise in it an alienation from violent death (Fig. 9). We are like the figures, right and left, that regard the dead, possibly murdered, body as a spectator sport or as something from which we can walk nonchalantly away. It is a drama as transformative as Beckmann's triptych *Versuchung* (Temptation, 1936–37), also in Munich, in which the tightly pressed figures pass each other by, each imprisoned in their own world, without exchanging so much as a glance (Fig. 10). These ambitious works represent metaphors and memories that lodge in the mind and serve as moral reminders of ugly truth, every bit as much as a Christian crucifix might have done, in a less

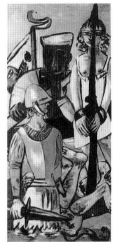

Fig. 10 Max Beckmann, *Versuchung* (Temptation), 1936–37. Bayerische Staatsgemäldesammlungen, Staatsgalerie Moderner Kunst, Munich

secular age than ours. The artist forces us to look at, and not away from, the ladies imprisoned in their brothel. The spirit of capturing memory was described to perfect effect by the great art historian-philosopher Aby Warburg who, whilst discussing Renaissance imagery, might equally have been representing the hidden or hermetic agenda of much contemporary expressive imagery:

> It is in the zone of orgiastic mass-seizures that we must look for the mint which stamps upon the memory the expressive movements of the extreme transports of emotion, as far as they can be translated into gesture language, with such intensity that these engrams of the experience of suffering passion survive as a heritage stored in the memory. They become the exemplars, determining the outline traced by the artist's hand as soon as maximal values of expressive movement desire to come to light in the artist's creative handiwork.[8]

The idea of social memory represented by Warburg's 'Mnemosyne', as resembling an ideal exhibition, is surely one creative way in which we, the viewers of art, need to come to terms with those cracked and alienated images that speak so powerfully of our century. Such images show all the extremes of feeling and reality that encompass us as individuals, as well as our history. One haunting example is Boccioni's *Dynamism of a Human Body* (1913) (Cat. 18), painted on the eve of the First World War, when so many artists in Europe looked to war as a liberating experience for the human condition. Equally evocative is the world exemplified by Baselitz's *Die großen Freunde*, (The Great Friends, 1965) (Cat. 74), which allows personal liberation and grim heroism only in defeat. In this image, painted twenty years after the end of the Second World War, we find ourselves still in a world of stupid, small-headed heroes astride a burnt landscape which seems to offer humanity only within the context of defeat and ruin. Such images represent valuable memories of attitudes that make each painting a useful document of history from which we might try to extrapolate as much information as possible about our recent past, as if it were the only surviving document or witness. It is useful to reflect on such 'masterpieces' as though they were pieces within an archaeological puzzle, out of which we should be able to reconstruct a fictional reality. It is in this sense that paintings by Picasso – not only *Guernica*, but also *Le Baiser* (The Kiss, 1969) (Cat. 70) – allow us to mirror history in an

expressive sense, and to reconstruct the erotic melancholy and the frustrations, as well as the pleasures, of age and decadence. It is above all the ambiguity of history, a world turned upside down, that is mirrored by art of all kinds and, especially, the fractured and splintered painterly tradition of this century. Each masterpiece represents a frozen moment in time and, therefore, in history – it has a place within an ideal geographical map that serves as a way of remembering history.

For Georg Baselitz, who in this exhibition represents a point of culmination in an expressive painterly tradition, the art of painting is ambiguous: 'The painting has a double meaning, for behind the canvas, there exists more than one can imagine.'[9] There is something in a painting, its colour, its structure and its compositional aspect, which allows it, unlike the photograph, both to celebrate and to stand as a witness to melancholy. Of course, this is not something unique to the art of this century, neither as regards complexity nor allusiveness. But it is the crucial strategy by which artists, from the time of *Les Demoiselles d'Avignon* onwards, have sought to heighten that sense of temporal ambiguity which alone gives a sense of life to their art. This has been done through ever more inventive ways of distortion, both of subject-matter and technique, that have given the individual masterpiece its sense of expressive purpose, necessity and uniqueness. Each work engenders that vital sensation of looking into an abyss where, like the inventive scientist searching for new techniques with which to command the world, no man has looked before.

Gertrude Stein reports, or perhaps imagines, Picasso once saying

> that he who created a thing is forced to make it ugly. In the effort to create the intensity and the struggle to create this intensity, the result always produces a certain ugliness, those who follow can make of this thing a beautiful thing because they know what they are doing, the thing having already been invented, but the inventor because he does not know that he is going to invent inevitably the thing he makes must have its ugliness.[10]

Ugliness is clearly upsetting, even for the most sophisticated viewer. Stein reports the Russian collector, Sergei Shchukin's reaction on seeing the *Demoiselles*: 'What a loss for French art.'[11] At that moment, it was as though the whole game of art was over for Picasso. There are few involved in art who have not had that experience.

The beauty or, at least, the necessity of ugliness is a leitmotif of modern painting and sculpture that even now gives art a peculiar charge and potential for resistance. At least two or three times in this century, artists have tended to take fright and retreat from radical, explosive positions into an apparently conservative, classical stance. When Picasso painted *The Pipes of Pan* in 1923 (Fig. 11) , he was part of a generalised classicising trend that had already been initiated before the end of the First World War, when much European painting appeared to yearn for a 'Return to Order'.[12] It was a new realism that quite consciously rejected formal painterly and sculptural innovation, in which ugliness was at best reflected in a harsh metaphysical realism of subject-matter. By the end of the 1930s, when Fascism and other forms of dictatorship were overwhelming Europe, Arcadia was again inappropriate: creative talent went into real or internalised exile, and the potential for innovative culture, expressed through imagery, was exhausted. Europeans who went

Fig. 11 Pablo Picasso, *La Flûte de Pan* (The Pipes of Pan), 1923. Musée Picasso, Paris

9 Georg Baselitz, 'Warum das Bild, "Die großen Freunde", ein gutes Bild ist', Manifesto, Berlin, 1966.
10 Stein (as note 1), p. 9.
11 Stein, ibid., p. 18.
12 The term, 'Le Retour à l'ordre', was first coined by Jean Cocteau in 1917, in an essay with that title.

Fig. 12 Willem de Kooning, *Woman I*, 1950–52. The Museum of Modern Art, New York

Fig. 13 Jean Fautrier, *Tête d'Otage no. 10*, 1943. Private collection, Geneva

to America mainly succeeded in firing younger Americans with an urge to continue within the surreal and abstract tradition. But the figurative tradition did find expression in the early works of Jackson Pollock and, above all, in the misogynistic excrements that are de Kooning's paintings of Women (Fig. 12), every bit as imprisoned within their expressions of sexuality as the tortured male figures of Bacon.

For all the vagaries of political history, painting has managed to find ways of moving on through the pandemonium. In writing that is worthy of Bataille or Artaud, Warburg pokes fun at and pours scorn on the 'hedonistic aesthetes' who

> can easily gain the cheap favours of an art-loving public when they explain this change of form by the greater sensuous appeal of the far-sweeping decorative lines. May he who wants to be satisfied with a flora of the most odorous and most beautiful plants; that will never lead to a botanical physiology explaining the rising of the sap, for this will only yield its secrets to those who examine life in its subterranean roots.[13]

The subterranean roots of art that we have come to understand as representing Modernism are many and often apparently contradictory – some are deep, some closer to the surface of time. One might take the metaphor further, to perceive the gathering of masterpieces under one roof, in one volume, as being a garden with different species, full of amazing shapes and colours and all the scope for cross fertilisation. The garden is a walled garden, and outside it there are other worlds of creativity. But whilst we are in the garden, it is enough to look and reflect on that alone. No individual work of art is able to solve the problems of the world. Art can only flourish and be understood within the confines of the walled garden. Its hermetic nature alone permits the individual masterpiece to function as a thing that it might be useful to contemplate. In the realm of painted or sculpted reality, this century has produced, not so much distortions, as the evidence of fragmentation; a world stood on its head, yet recognisable for what it is; a sense of the motif; and a sense of ornament and style – all devices to enable the description and marking of facts. It is this that links and give a certain unity to the Cubist and late works of Picasso; this, that suggests a unity of purpose to the works of Fautrier, Giacometti, Bacon, de Kooning, and Lucian Freud. The work of all these artists reflects, at the highest level, the violence of history, and of war, with its social and psychological consequences. André Malraux, writing of Fautrier's *Otages*, speaks of them as representing a hieroglyph of pain (Fig. 13). For him,

> ... modern art was doubtlessly born on the day when the idea of art and that of beauty were separated. Perhaps with Goya ... A less important, but unique, revolution occurred in our Twentieth Century: just as we are no longer able to see a work of art independent of its historical ramifications – no matter whether we want to admit it or not – we likewise have begun to view some paintings in terms of their maker's artistic history. It was not by accident that Picasso substituted dates for titles in his paintings ... Thus if each single *Hostage* is a valid painting, the meaning of *Hostages* at their fullest strength is inseparable from the space in which you see them gathered, where they are at the same time the damned of a coherent hell and moment of trapped evolution.[14]

Perhaps we can claim that the gathering of 'masterpieces', each of which carries with it a host of further associative memories and echoes, gives the garden that is the exhibition its meaning, as a metaphor for existence in its own right.

13 Warburg, ibid., p. 245.
14 André Malraux, from preface to *Fautrier*, exh. cat., Paris, Galerie René Drouin, 1945, reprinted in *Theories and Documents of Contemporary Art*, ed. Kristine Stiles and Peter Selz, Berkeley, 1996, p. 191.

I've always hoped to put things over as directly and rawly as I possibly can, and perhaps, if a thing comes across directly, people feel that that is horrific. Because, if you say something very directly to somebody, they're sometimes offended, although it is a fact. Because people tend to be offended by facts, or what used to be called truth.

Thus, Francis Bacon.[15] Likewise, de Kooning was

not interested in making a good painting ... I didn't work on it with the idea of perfection, but to see how far one could go – but not with the idea of really doing it. With anxiousness and dedication to fright, maybe, or ecstasy, like the Divine Comedy, to be like a performer: to see how long you can stay on the stage with that imaginary audience ...[16]

It is the sense of continuous performance which finds the singular work of art existing in the space between the absolute and the ephemeral. Lucian Freud wrote as early as 1954 (though he will scarcely have changed his attitude, since) that

A moment of complete happiness never occurs in the creation of a work of art. The promise of it is felt in the act of creation but disappears towards the completion of the work. For it is then that the painter realises that it is only a picture he is painting. Until then he had almost dared to hope that the picture might spring to life.[17]

It is the struggle with the fundamental impossibility of realism that artists face, when they attempt to depict the reflection they imagine in the cracked and distorting mirror. De Kooning even manages to laugh at himself and at others. 'The Cubists – when you think about it now, it is so silly to look at an object from many angles.'[18]

It is the 'stupidity' of art, or rather the impossibility of making a representation, that makes comparisons of the various options devised in our century so endlessly fascinating. When we look at a painting by Georg Baselitz, we know that the world is not upside down, just as we know that the violin of Braque in his still life is not refracted through a many-angled perspective. We know that the prostitutes of Picasso and Kirchner neither have the shaped head of the African mask nor are made up of those stabbing, elongated brushstrokes. Within the realm of depicting reality in the twentieth century, we are constantly confronted with what might be described as the pathetic fallacy. The distortions in the mirror, interpretations of reality from Cubism to the present, are all more or less heroic attempts to overcome the fallacy which is the spur to creation. At best, the artist may hope to discover a pictorial equivalent of emotion – the laugh, the scream, the abyss itself. For Baselitz, the stab at realism starts with the idea of pandemonium and is transmuted into the issues of ornament and motif. Antonin Artaud, inspiration of the young Baselitz, suggested with perhaps more than a hint of poetic licence that

An exhibit of Van Gogh's paintings is always an historical event, not in the history of painted things but in plain historical history.
For there is no famine, no epidemic, no volcanic eruption, no earthquake, no war that heads off the monads of the air that wring the neck of the grim face of fama fatum and the neurotic destiny of things,
like a Van Gogh painting – brought out into the sunlight, and put directly back into view,
hearing, touch,
smell,
onto the walls of an exhibition hall –
finally launched anew into present actuality, reintroduced into circulation.[19]

Our times have changed since 1947, half a century ago, when Artaud was able to find such ecstasy in the mirror of Van Gogh's reality. We are difficult to shock. The great shocks of depicting reality in the twentieth century, the shock of Cubism, the shock of painterly Expressionism, the shock of *Les Demoiselles*, and of *Guernica*, the shock of the

15 Francis Bacon, 'Interviews with David Sylvester', Interview I, 1966, reprinted in Stiles and Selz, ibid., p. 201.
16 Willem de Kooning, 'Content Is a Glimpse; Interview with David Sylvester', 1963, reprinted in Stiles and Selz, ibid., pp. 198–9.
17 Lucian Freud, 'Some Thoughts on Painting', 1954, reprinted in Stiles and Selz, ibid., p. 221.
18 Willem de Kooning (as note 16), p. 197.
19 Antontin Artaud, 'Van Gogh: The Man Suicided by Society', in *Antonin Artaud Anthology*, ed. Jack Hirschman, San Francisco, 1965, Part II: 1943–1948, p. 140.

emaciated realism of Giacometti's *Diego* and *Annette*, the shock of Bacon's morbid *Crucifixions*, the shock of Baselitz's *World Stood on its Head*, have all but been eliminated, so familiar are we with these images. We prefer to expose ourselves to the byways and eccentricities of twentieth century art, we are suspicious as to whether there is a great tradition, whether the singular masterpiece can be the carrier of the idea of art. In this so-called 'post-modern' age, we are exposed to a surfeit of images – often reproductions – and need to find ways of refreshing our vision at source. This demands confronting the singular work of art with its elected peers, so that we may absorb the energy created in the tension between subject matter and surface, nuances of colour and form, vision and facture, the cerebral and the erotic and, finally, between the idea of contemporaneity and tradition. None of this represents a moral imperative. Rather, it represents a luxury that is no mere indulgence but one option amongst many, one method of finding ourselves and a better self-awareness through the broken mirror. So, *pace* Tatlin (Cat. 243), let us give the last word to Gertrude Stein, by recalling her description of how,

> When I was in America I for the first time travelled pretty much all the time in an airplane and when I looked at the earth I saw all the lines of cubism made at a time when not any painter had ever gone up in an airplane. I saw there on the earth the mingling lines of Picasso, coming and going, developing and destroying themselves, I saw the simple solutions of Braque, I saw the wandering lines of Masson, yes I saw and once more I knew that a creator is contemporary, he understands what is contemporary when the contemporaries do not yet know it, but he is contemporary and as the twentieth century is a century which sees the earth as no one has ever seen it, the earth has a splendor that it never has had, and as everything destroys itself in the twentieth century and nothing continues, so that the twentieth century has a splendor which is its own and Picasso is of this century, he has that strange quality of an earth that one has never seen and of things destroyed as they have never been destroyed. So then Picasso has his splendor.

Yes. Thank you.[20]

20 Stein (as note 1), p. 50.

Portraiture in the 20th Century

SHEARER WEST

Masks or Identities?

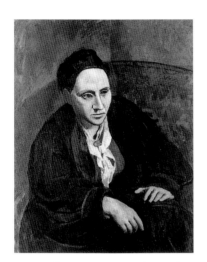

Fig. 1 Pablo Picasso, *Portrait of Gertrude Stein*, 1906. The Metropolitan Museum of Art, New York

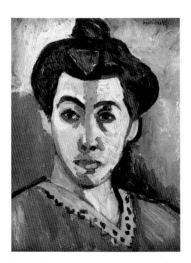

Fig. 2 Henri Matisse, *Portrait of Madame Matisse with the Green Stripe*, 1905. Statens Museum for Kunst, Copenhagen

Among the few early twentieth-century portraits discussed in standard histories of modernism are Picasso's representation of Gertrude Stein and Matisse's portrayal of his wife with a green line painted down her nose (Figs. 1 and 2). These works are usually classified in terms of their contribution to the development of iconoclastic art movements and for their disruption of traditional ideas of form and colour, while their status as portraits is rendered secondary. There are good reasons for this emphasis. Any attempt to identify a clear role for portraiture within the history of modernist art inevitably leads to frustration and confusion. Theoretically, portraiture appears to have little place in the evolution of modernism, bound as it is by conventions of representation, while seemingly resisting the creative freedom assigned to the avant-garde. The modernist ethos of universality and abstraction is alien to the occasionality and specificity of the portrait in a way that it is not to landscape, still life or other types of figure painting. But, paradoxically, in a period of mass culture, with a rhetoric of universality and generality, portraiture has played a fundamental part in rethinking the phenomenology of representation and the artist's interpretative role. Although few modernist artists were exclusively portraitists in the conventional sense, many of them turned to portraiture sporadically, or frequently, during the course of their careers. The place of portraiture in the twentieth century is also complicated by its multivalence: while Picasso could paint Gertrude Stein's face overlaid with the features of Iberian sculpture, other artists have continued to produce flattering boardroom portraits of company presidents or kitsch depictions of athletes and film stars. This plurality of functions makes discussion of the modernist dimension to portraiture even more crucial. The extent to which modern portraits draw upon stylistic and iconographic traditions, challenge notions of what constitutes public and private, penetrate or falsify identity and utilise the fragility of the corporeal self, all frames portraiture's contribution to the art of the twentieth century.

The notion of portraiture rests on its representational qualities – on its ability to catalogue or suggest something specific or essential about a distinct individual. In this respect, portraiture would seem to resist the pull of modernist abstraction towards a non-mimetic and even non-objective mode of representation. However, there are a number of twentieth-century 'portraits' which are partially, or fully, abstracted or at least non-representational: the 'poster portraits' of Charles Demuth; Picasso's synthetic Cubist homages to Eva Gouel as 'Ma Jolie'; Louise Bourgeois' sculpted self-portrait torso, with its echoes of genitalia. There are also portraits which are representationa but eschew the idea of likeness: for example, the 'object portraits' of Francis Picabia (Fig. 3); Giorgio de

Chirico's *Self-Portrait* of 1913, in which he defines himself through an egg, an inexplicable plaster foot and factory chimneys (Fig. 4); or Jean Arp's painted relief 'portrait' of Tristan Tzara (1916). Likewise, the stylistic quirks of Fauvism, Cubism and Expressionism all found their way into portraiture, deepening and complicating portraiture's accepted ability to reveal a likeness. On one level, the portraits of a canonic artist like Picasso could be said to catalogue his stylistic experiments, as the somewhat ironic references to his 'Marie-Thérèse' or 'Dora Maar' periods indicate. Picasso's portraits often snare the observer with their humour and stylistic deliberation. His *Self-Portrait* of 1972, for example, is painted in a Cubist style, both as a tribute to his own history and as an effective way of evincing the impact of age on his face (Cat. 85). However, the tensions between stylistic experiment and revelation of the individual cannot be denied, and the descriptive and referential qualities of twentieth-century portraiture have shackled even the most radical stylistic departures to portraiture's established revelatory, celebratory and mimetic traditions.

Referentiality often takes the form of realism in modern portraiture and is frequently (and often inaccurately) tied with an anti-modernist conventionalism. Certainly, skilled portrait painters such as de Chirico and Beckmann were at various times vehemently opposed to modernist tendencies in art, and even such individualists as Modigliani, Matisse and Stanley Spencer produced portraits which deliberately echoed southern or northern Renaissance old masters. Equally, one of the most stylistically conservative eras in twentieth-century art – the interwar period – was dominated by portraiture. It was during this time, for example, that Otto Dix consciously reintroduced background and environment into his portraits, showing the urologist Hans Koch with a syringe and lurid operating implements; the journalist Sylvia von Harden with her monocle and spritzer (Fig. 5); and the photographer Hugo Erfurth sharing a canvas with his Alsatian dog (Cat. 99). Such environmental clues to the character or status of the individual sitter were an established part of portraiture's history throughout previous centuries, when profession and status were the primary motivating factors in portrait commissions. What Dix was doing in his portraits was, in this sense, commensurate with the methods of Hans Holbein, Frans Hals or John Singer Sargent.

However, despite the continued relationship between portraiture and an academic, realist or classicising style, realism and the traditions of portraiture were continually subverted. In keeping with portraiture's conventional presentation of 'likeness', many modern artists produced portraits 'from the life', often on the basis of dozens of sittings. Giacometti was such an artist, who subjected his handful of sitters to endless sessions while he worked and reworked his representations. Instead of intensifying the realism of his representation, Giacometti's close studies give his works a disturbing, alien quality that makes the sitter's character and likeness elusive, rather than apprehensible (Cat. 106). This alienating mood is also present in the figurative work of Georg Baselitz, who paints his subjects upside down in order to force the viewer to a more objective positioning, even while his studies refer distinctly to individual sitters (Cat. 112). The ruptures in

Fig. 3 Francis Picabia, *Portrait de Marie Laurencin. Four in Hand,* 1916–17. Musée National d'Art Moderne, Centre Georges Pompidou, Paris

Fig. 4 Giorgio de Chirico, *Metaphysical Composition (Metaphysical Self-Portrait),* 1913. The Alex Heilman Family Foundation, New York

Fig. 5 Otto Dix, *Portrait of the Journalist Sylvia von Harden,* 1926. Musée National d'Art Moderne, Centre Georges Pompidou, Paris

Fig. 6 Salvador Dalí, *Impressions of Africa*, 1938. Museum Boijmans Van Beuningen, Rotterdam

Fig. 7 Pablo Picasso, *Portrait of Ambroise Vollard*, 1910. Pushkin Museum, Moscow

realist portraiture are nowhere more apparent than in the work of Dalí, who represented his wife Gala with painstaking realism, but placed her in settings constructed to mirror his own paranoid view of the universe.[1] Gala was thus both the woman Dalí knew and an emanation of himself and his disturbed imagination (Fig. 6).

This intrusion of the artist's personal life and private obsessions into the production of portraiture is perhaps more important than stylistic radicalism, in explaining how the modernist portrait breaks with tradition. Although artists before the twentieth century often painted themselves and their circle, it is the self-conscious elaborations of the self and the subjection of private, often sexual, fantasies to public scrutiny that distinguish many twentieth-century portraits from the work of the past. On a superficial level, some of the most startling twentieth-century portraits were painted by artists in homage to friends, patrons or art dealers – Kokoschka's portraits of Adolf Loos and Herwarth Walden (Cat. 77 and 79); Picasso's portraits of Wilhelm Uhde, Ambroise Vollard and Daniel-Henry Kahnweiler (Fig. 7); Matisse's portrait of Sarah Stein (Cat. 87); Dix's portraits of Alfred Flechtheim and Mutter Ey. Artists who were part of a collective endeavour were also constantly turning to each other in their portraiture to signal their group solidarity. In England, this form of commemorative portraiture was practised by the Vorticists and the Bloomsbury group, while in France, the Surrealists adopted this method, and the artists of Kandinsky's circle (although not Kandinsky himself) painted portraits of each other during their frequent forays to Murnau.

However, more frequently, artists realised their own obsessions through their portrayal of sexual partners. Before the twentieth century, male artists would frequently have liaisons with their models, and they often produced private portrait drawings or watercolours of them, as Dante Gabriel Rossetti did with Elizabeth Siddal. However, in their public output, the identities of these women would be submerged in whatever narrative situation they were placed. Siddal, for example, became Beatrice or Guinevere in Rossetti's imaginative works, and the public outside the artist's immediate circle were not aware of, or not conditioned to recognise, the transformative process. During the modern period, with a greater media attention to artists and the availability of candid, as well as posed, photographs, models have been identified and representations of them – however intimate – have been construed as public portraits rather than private studies. The valorisation of the twentieth-century artist has thus extended the meaning of portraiture, which no longer only involves producing a likeness of a named sitter.

The critical classification of many works as portraits is sometimes at odds with the intentions of the artist. For example, Picasso's sporadic and inconsistent use of the term 'portrait' has been belied by a massive exhibition of his portraiture held in 1996, which comprised every remotely identifiable image he painted of all his various lovers throughout his career.[2] Artists themselves have been keen to avoid the label of 'portraitist', which they undoubtedly see as pejorative, given portraiture's history of subjecting the artist to the whims of a sitter/patron and denying him or her freedom of interpretation. More often than not, twentieth-century portraits rely solely on the name of the

1 For a full explanation of the semiotic workings of Dalí's representations of Gala, see Fiona Bradley, 'Doubling and Dédoublement: Gala in Dalí', *Art History*, vol. 17, no. 4, December 1994, pp. 612–30.
2 *Picasso and Portraiture: Representation and Transformation*, ed. William Rubin, exh. cat., New York, The Museum of Modern Art, (Thames and Hudson) London, 1996.

sitter, or a generic title, and the label of 'portrait' is imposed by the critic or art historian. This critical perspective is part of the canonisation of modern artists, as it validates the vagaries of their private life by playing upon the implications of their public output.

The artist's exploration of his or her own world, combined with the voyeurism of the public, has thus enabled the intrusion of private relationships into art designed for public consumption. Artists have exploited this potential through both realistic and fanciful visions of themselves with their partners: Chagall's playful portrayal of his passion for his wife Bella, Corinth's self-important visions of himself as both artist and family man, Stanley Spencer's brooding and aloof nude double-portraits with Patricia Preece (Cat. 104), and Egon Schiele's allegorical representation of himself, his wife and his non-existent children as *The Family* (Fig. 8). To a point, this revelation of private and personal identities helped twentieth-century artists construct their own role in a modern industrial age. The metamorphosis of their female partners from models to portraits is part of this self-fashioning.[3]

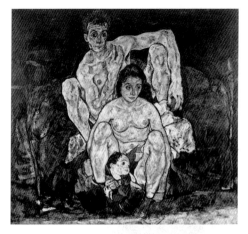

Fig. 8 Egon Schiele, *Die Familie* (The Family), 1918. Österreichische Galerie im Belvedere, Vienna

It is the nature of these private visions and of the artist's role, in parading them in public that transforms portraits in the twentieth century from putatively 'objective' views of a sitter to explorations of identity. In the early part of the century, particularly in Vienna, where portraiture flourished, identity was less important than the psychology of the individual. In the wake of Freud, artists saw their mission as unmasking the inner life of the sitter. Kokoschka described this practice most succinctly:

> When I paint a portrait, I am not concerned with the externals of a person – the signs of his clerical or secular eminence, or his social origins. It is the business of history to transmit documents on such matters to posterity. What used to shock people in my portraits was that I tried to intuit from the face, from its play of expressions, and from gestures, the truth about a particular person, and to recreate in my own pictorial language the distillation of a living being that would survive in memory.[4]

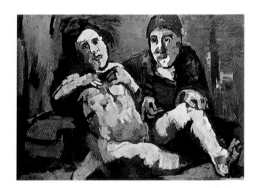

Fig. 9 Oskar Kokoschka, *Self-Portrait with Doll*, 1920–22. Nationalgalerie, Staatliche Museen zu Berlin – Preußischer Kulturbesitz

Ironically, while Kokoschka's penetrating portraits of his lover, Alma Mahler, gained their power from Expressionist painterliness, he chose to commemorate his ill-fated passion with a super-realistic doll, devised as a fetish to replace the fickle Alma (Fig. 9). Despite the contradictions within his own thinking, Kokoschka's view of portraiture was commensurate with a climate in which the human subconscious and its disturbing revelations were being explored within the scientific community. The portraitist's job was to 'distil' the complex individual into a monolithic, but meaningful, visualisation of their character and soul.

As the century progressed, the psychology of the individual was superseded by representations of pluralist identities. Through portraiture, artists explored different manifestations of themselves and their sitters – not to unmask the soul, but to emphasise the complexity of human character and circumstance. Artists frequently produced self-portraits which cast themselves in different roles or guises: Beckmann, Picasso and Rouault all chose the persona of a clown to evoke the fragile and tragi-comic aspects of human experience (Fig. 10). Picasso disguised himself as the voracious minotaur; de Chirico associated himself with the Olympian deities; Beckmann questioned the stability of human existence through representations of himself with attributes such as cigarettes,

3 A full analysis of how gender relations have affected twentieth-century art is given in Irit Rogoff, 'The Anxious Artist – Ideological Mobilisations of the Self in German Modernism' in *The Divided Heritage: Themes and Problems in German Modernism*, ed. Irit Rogoff, Cambridge, 1990 and Marsha Meskimmon, *The Art of Reflection: Women Artists' Self-Portraiture in the Twentieth Century*, New York, 1996.

4 Oskar Kokoschka, *My Life*, London, 1974, p. 33.

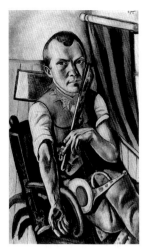

Fig. 10 Max Beckmann,
Selbstbildnis als Clown
(Self-Portrait as a Clown), 1921.
Von der Heydt-Museum, Wuppertal

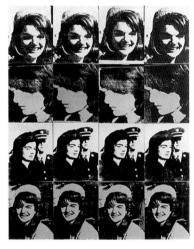

Fig. 11 Andy Warhol, *Sixteen Jackies*, 1964.
Walker Art Center, Minneapolis

5 *Joshua Reynolds, Discourses on Art,* ed. Robert
Wark, New Haven and London, 1981.

champagne glasses and saxophones, scowling or smiling at the observer (Cat. 89 and 91). Frida Kahlo made conscious allusions to her half-Mexican heritage by painting herself wearing a Tehuanan wedding dress, although such manifestations of ethnic identity have been rare in modernist portraits (Cat. 103). Stanley Spencer's explorations of identity became massive personal allegories in his various Cookham paintings, which were inhabited by fictional characters, most of whom were recognisable portraits of himself and his immediate circle. Each of these artists attempted to suggest a plurality of experience and identity by costuming themselves, and their choice of roles and conscious self-mythologising enhanced the ambiguity and power of their work.

While psychology and shifting identities of the individual form a leitmotif in twentieth-century portraiture, individuality is frequently subverted by typology. Although portraits represent distinct sitters, who can be recognised and named, the artists themselves do not always stress the unique qualities of their subjects. In numerous instances, twentieth-century portraits are icons, with their sitters becoming so many 'motifs'. This is particularly evident with artists who painted a series representing the same sitter. Matisse's busts of Jeannette, Giacometti's portraits of Annette or Yanaihara, Modigliani's models are repetitions of faces, rather than explorations of individuality (Cat. 86, 58 and 88). These works become like stylistic icons, making their real sitters into something aesthetic, even while their individuality of character and appearance can be discerned. Such iconic portrayals are thrown into sharp relief by Andy Warhol's silkscreen impressions of Marilyn Monroe or Jackie Kennedy (Fig. 11). Here, mechanical reproduction takes over the task of representation, but the repetition of imagery and the consequent dulling of individuality become an explicit theme. The complexity of modern portraiture lies in the process of converting the individual into a stylistic morphology, despite a conflicting tendency to probe the inner life of the individual.

While modern artists play games with notions of identity, and the individualism of the portrait subject is both enhanced and resisted, twentieth-century portraiture also communicates much about the body. Here again the modernist portrait tests the traditions from which it also borrows. Although there are notable exceptions in the history of art, portraiture before the twentieth century tended towards the idealisation of the sitter. The artist was, therefore, constrained not only by the conventions of portraiture itself, but by the expectations of the sitter, to 'raise and improve', as Joshua Reynolds put it.[5] Caricature was the only consistent arena where this notion of portraiture could be contested, whereas in the twentieth century, the exaggerations, distortions and 'ugliness' of the caricatural form have become accepted tools of the portraitist's trade. In some instances, such as the portraits by Jean Dubuffet, caricature becomes the only means by which a portrait can be conceived. Dubuffet's schematic images strip the body to its essentials and render it in a cartoon reductivism that takes the outer frame, rather than the inner individual, as its point of reference (Cat. 105).

Lack of pretence underlies many twentieth-century views of the body, to the point at which ugliness, rather than beauty, becomes the desired goal of the portrait artist. Egon

Schiele was one of the first to exploit this idea. In his numerous watercolour studies of his emaciated and attenuated body he represented himself as ugly (Fig. 12). He extended this to his face, which he depicted scowling, grinning and screaming, working against the expressionless mask that was so frequently characteristic of portraits before the twentieth century. His representations of the nude body explore ideas of sexuality, but they also show the body as an imperfect and hideous thing, surprisingly inadequate for its role in the physicality of human relationships. When Stanley Spencer and Lucian Freud borrowed Schiele's x-ray view of the body, with its purple veins and swollen genitals, they added to this the wrinkles of age and the pendulous swells of fat that are all too human but do not represent the side of humanity that the sitters of the past wished to see (Cat. 104 and 113).

Fig. 12 Egon Schiele, *Self-Portrait*, 1910. Albertina, Vienna

Other artists, such as Christian Schad and Otto Dix, made use of the *Neue Sachlichkeit* aesthetic to depict sitters whose faces and bodies offended traditional notions of beauty. Schad's portrait of *Agosta the Pigeon-chested Man and Rasha the Black Dove* presented fairground 'freaks' in a bland and detached way, their blank faces and traditional poses contrasting sharply with the distortions of Agosta's body (Fig. 13). Dix's portraits of his unprepossessing parents again veer into the realm of caricature and come very close to being a visual joke about working-class domesticity (Fig. 14). These representations of ugliness were more than simply attempts to *épater le bourgeois*. In each case, these works were exploring the limits of portraiture and its potential to expand the possibilities of art, rather than confine them. When Francis Bacon repeatedly represented George Dyer and Isabel Rawsthorne with bulbous noses, hooded eyes, crooked heads and monster mouths, he was not only revealing the evanescence of the corporeal self, but was using the body as a way to penetrate the soul of his sitters (Cat. 108 and 109). The fact that such works elude simple explanation attests to their visual power and their efficacy as portraits which are more than simple likenesses.

Fig. 13 Christian Schad, *Agosta, der Flügelmensch und Rasha, die schwarze Taube* (Agosta the Pigeon-chested Man and Rasha the Black Dove), 1929. Private collection

It is clear that portraiture in the twentieth century both draws from tradition and contests it; it both contributes to the modernist canon and has properties which cannot be confined to the development of modernism alone. Indeed, the tendency of portraiture to resist abstraction means that it rests uneasily within a modernist ethos, despite the fact that it has allured artists who practised many different styles, in different periods. It could be said that portraiture does not really find its place until postmodernism restored the importance of representation to avant-garde art. Instability of identity and plurality of roles are endemic in postmodernist consciousness, and portraiture allows the artist to experiment with these ideas. Perhaps this is one reason why the photograph has been of only marginal importance to modernist art, while postmodernism has adopted it as its most valued tool. Postmodernist artists like Cindy Sherman play with ideas of gender identity through her self-portrait photographs in the roles of film stars and women in famous paintings (Fig. 15), while Robert Mapplethorpe took famous, recognisable individuals and presented them in a cosmetic way, endowing them with whatever guise he chose to convey upon them.[6] The recognition that photography can be an alienating and

Fig. 14 Otto Dix, *Die Eltern des Künstlers II* (The Parents of the Artist II), 1924. Niedersächsisches Landesmuseum, Hanover

Fig. 15 Cindy Sherman, *Untitled, # 183*, 1988.
Raymond Learsy, Sharon, Connecticut

disruptive medium, as well as a revelatory and probing one, has relegated painting and sculpture to second place in the production of portraiture. Consequently, much post-war portrait painting and sculpture has been reduced to a tired academicism.

The public nature of portraiture has been renewed, as the media are now in full possession of the private lives of famous people – whether they be artists, entertainers or politicians. The privacy of famous people is no longer emerging into the public domain; it has been fully claimed as public property. Because of this, the mystery has disappeared from much portrait painting at the end of the century, while photography, paradoxically, brings a new enigma to a human face and body. By presenting everything, photography reinforces how little we know about the individual represented. However, it was modernism, in all its manifestations, that freed the portrait from the conventions of idealisation, problematised notions of realism, and allowed artists to refashion themselves and their subjects in their own vision.

6 For many other examples, see *Das Selbstportrait im Zeitalter der Photographie: Maler und Photographen im Dialog mit sich selbst,* ed. Erika Billeter, exh. cat., Lausanne, Musée Cantonal des Beaux-Arts, (Benteli) Bern, 1985.

Reality – Distortion

PABLO PICASSO (Cat. 1–3, 8, 11, 13, 37, 46–47, 70–72)

HENRI MATISSE (Cat. 4–6, 32–33)

CONSTANTIN BRANCUSI (Cat. 7)

GEORGES BRAQUE (Cat. 9–10, 12)

ROBERT DELAUNAY (Cat. 14)

FERDINAND LÉGER (Cat. 15, 36)

UMBERTO BOCCIONI (Cat. 16–18)

GIACOMO BALLA (Cat. 19–20)

FRANZ MARC (Cat. 21)

ERNST LUDWIG KIRCHNER (Cat. 22–23, 25)

WILHELM LEHMBRUCK (Cat. 24, 28)

EMIL NOLDE (Cat. 26–27)

OSKAR KOKOSCHKA (Cat. 29–30)

LOVIS CORINTH (Cat. 31)

PIERRE BONNARD (Cat. 34)

CLAUDE MONET (Cat. 35)

ARISTIDE MAILLOL (Cat. 38)

GIORGIO DE CHIRICO (Cat. 39)

OSKAR SCHLEMMER (Cat. 40, 42)

MARIO SIRONI (Cat. 41)

KASIMIR MALEVICH (Cat. 43)

ALEXANDER DEINEKA (Cat. 44)

MAX BECKMANN (Cat. 45, 48, 50)

JOSÉ CLEMENTE OROZCO (Cat. 49)

JACKSON POLLOCK (Cat. 51)

JEAN FAUTRIER (Cat. 52–55)

ALBERTO GIACOMETTI (Cat. 56–59)

JEAN DUBUFFET (Cat. 60–63)

WILLEM DE KOONING (Cat. 64–65)

FRANCIS BACON (Cat. 66–68)

ASGER JORN (Cat. 69)

LUCIAN FREUD (Cat. 73)

GEORG BASELITZ (Cat. 74–76)

Dimensions are given in centimetres, height before width, before depth.

The works illustrated on plates 10, 23, 24, 36, 48, 76, 89, 157, 161, 190, 249, 309, 321, 384 are not included in the exhibition or have been substituted with other works.

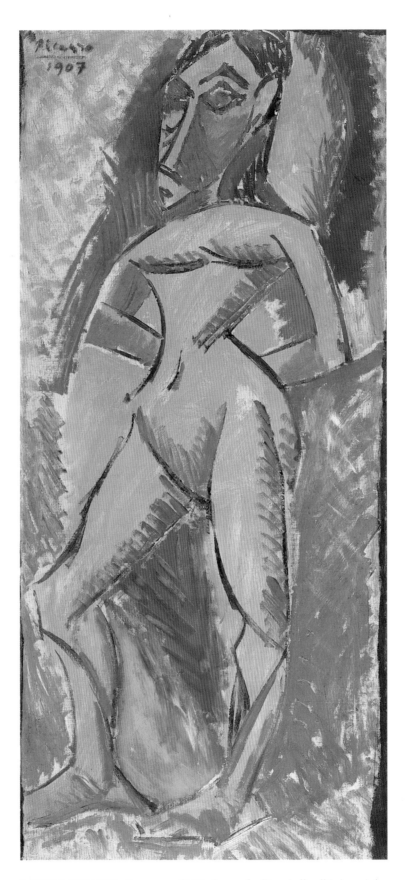

1 PABLO PICASSO, *Femme nue (L´Etude pour les Demoiselles d´Avignon)* /
Female Nude (Study for Les Demoiselles d'Avignon), 1907
Oil on canvas, 93 x 43 cm
Civico Museo d'Arte Contemporanea, Milan

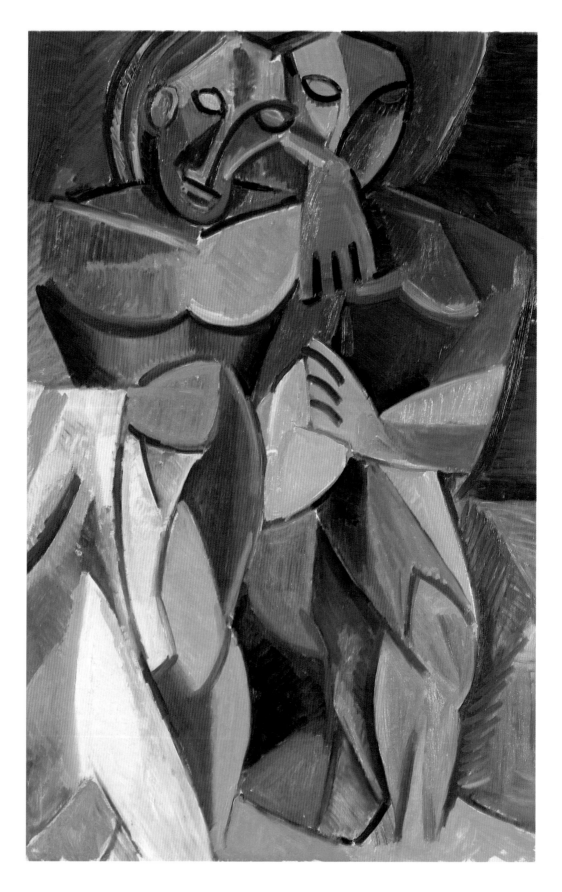

2 PABLO PICASSO, *L'Amitié* / Friendship, 1908
Oil on canvas, 152 x 101 cm
State Hermitage, St. Petersburg

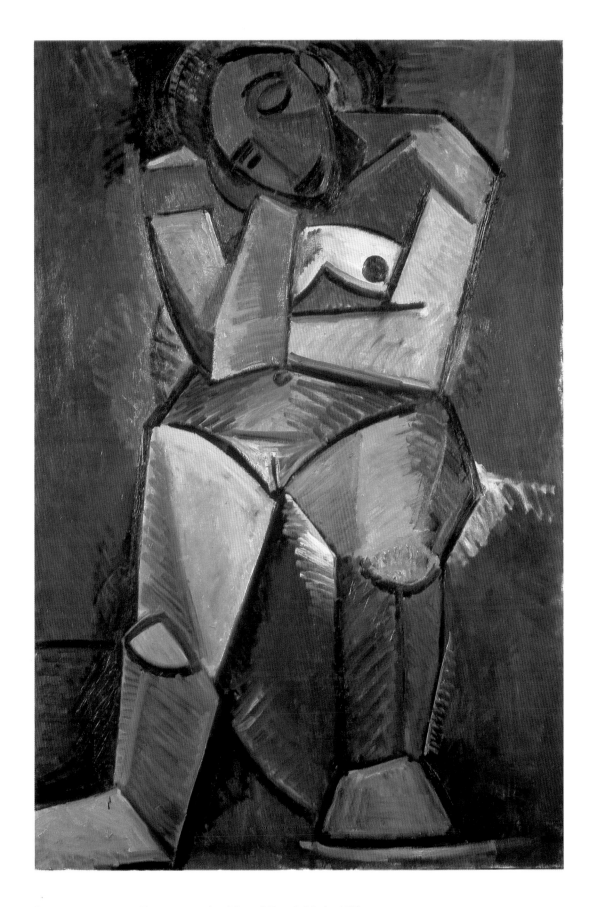

3 PABLO PICASSO, *Femme nue assise* / Seated Female Nude, 1908
 Oil on canvas, 150 x 99 cm
 State Hermitage, St. Petersburg

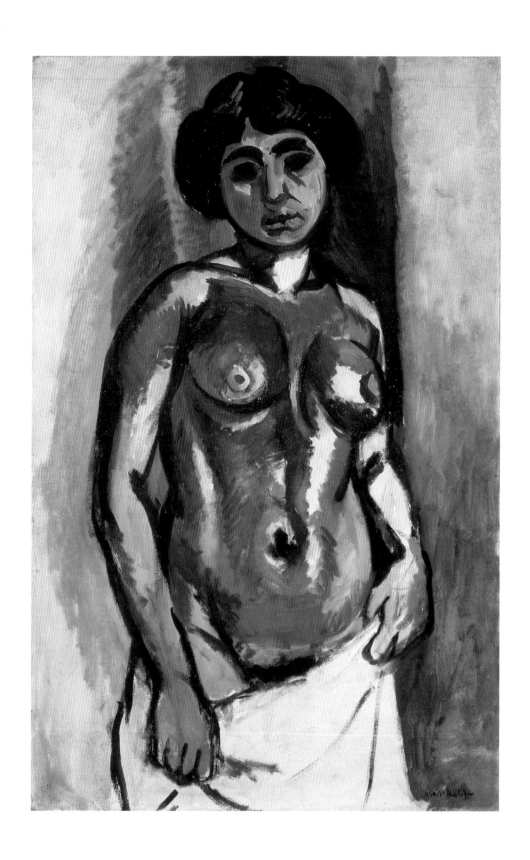

4 HENRI MATISSE, *Nu, noir et or* / Nude, Black and Gold, 1908
 Oil on canvas, 100 x 65 cm
 State Hermitage, St. Petersburg

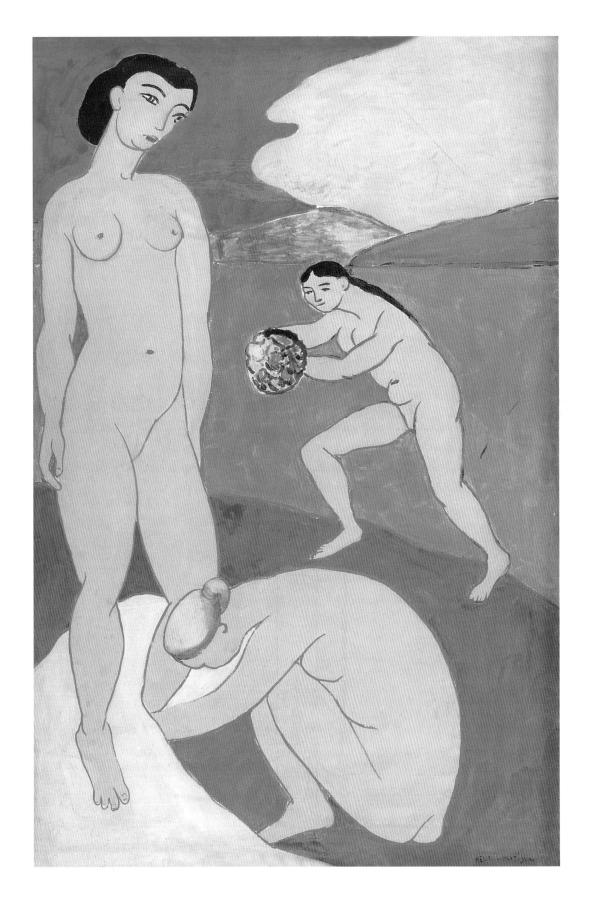

5 HENRI MATISSE, *Le Luxe II* / The Luxury II, ca. 1907–1908
 Tempera on canvas, 209.5 x 139 cm
 Statensmuseum for Kunst, Copenhagen

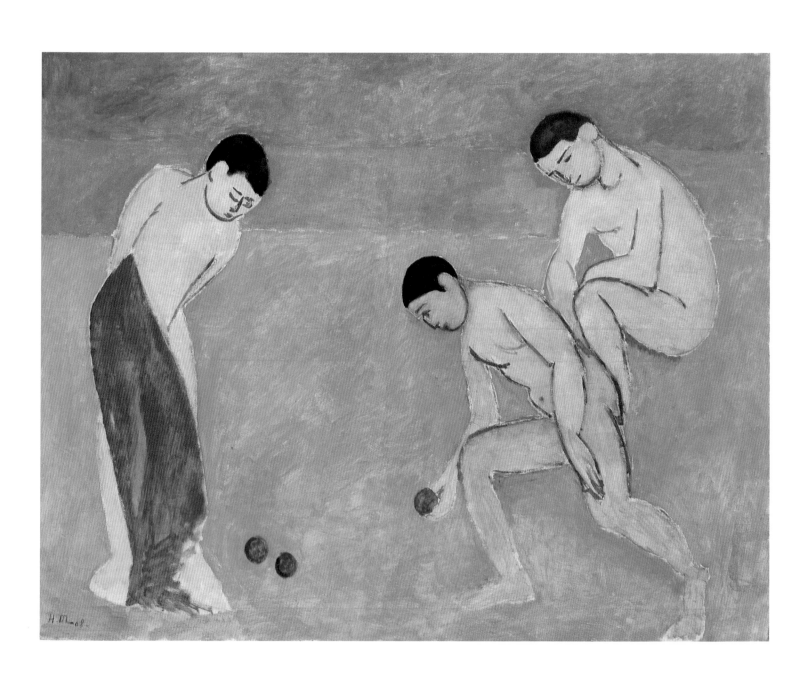

6 HENRI MATISSE, *Joueurs de boules (Jeu de balles)* /
 Boules players (Ball game), 1908
 Oil on canvas, 113.5 x 145 cm
 State Hermitage, St. Petersburg

7 CONSTANTIN BRANCUSI, *Adam et Eve*, 1916–1921
Wood, height 227 cm
Solomon R. Guggenheim Museum, New York

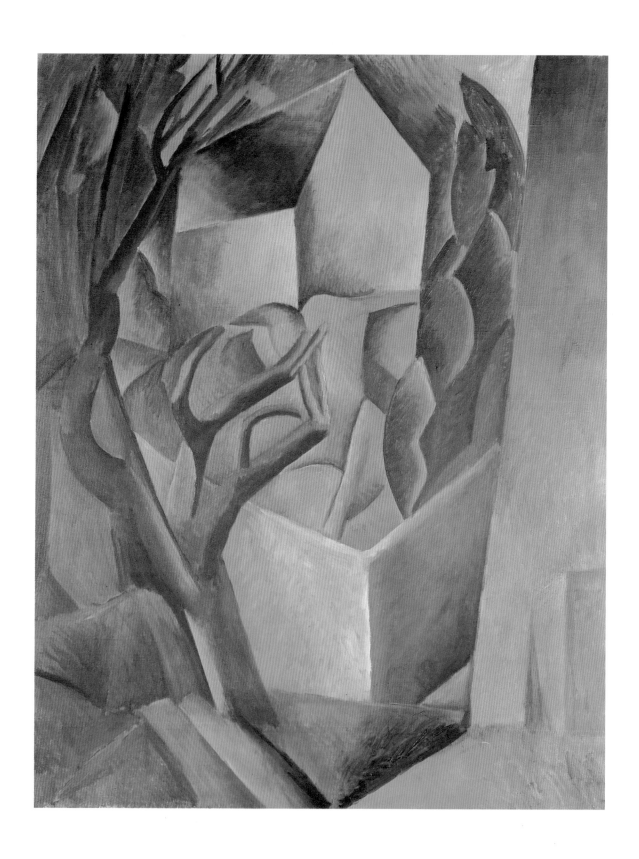

8 PABLO PICASSO, *Maisonette dans un jardin (Maisonette et arbres)* /
House in a Garden (Cottage and Trees), 1909
Oil on canvas, 92 x 73 cm
State Pushkin Museum, Moscow

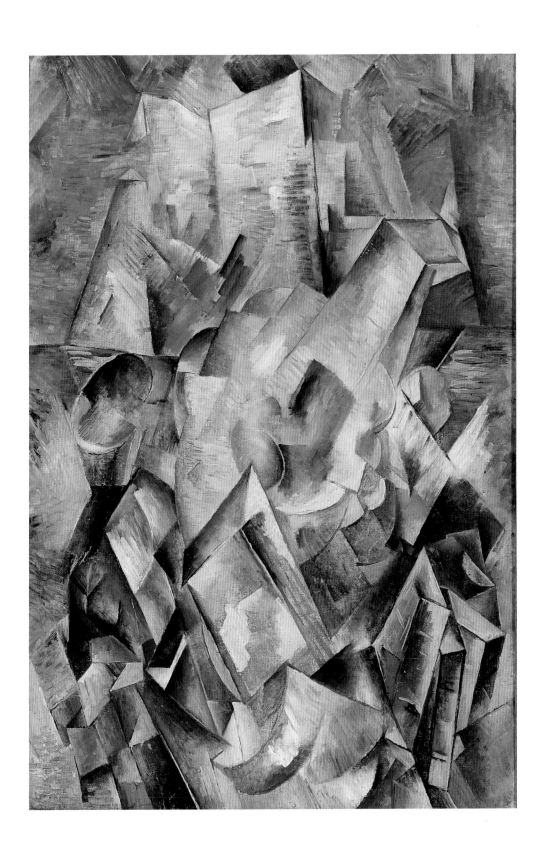

9 GEORGES BRAQUE, *Nature Morte à la mandola et au métronome* /
Still life with Mandoline and Metronome, 1909
Oil on canvas, 81 x 54 cm
Private collection

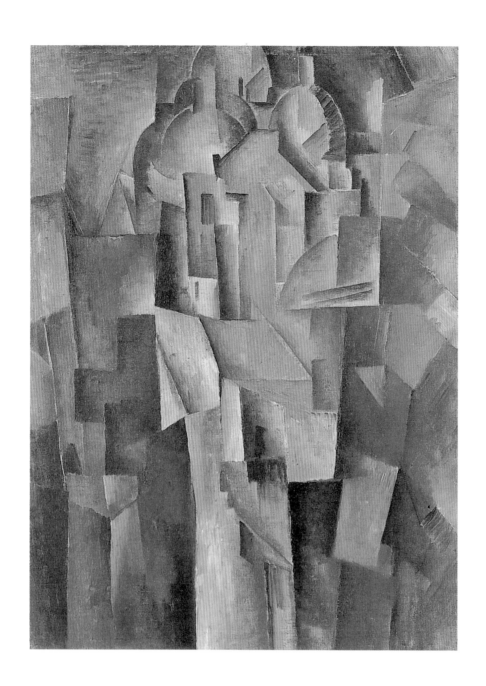

10 GEORGES BRAQUE, *Le Sacré-Cœur*, 1909–1910
 Oil on canvas, 55 x 40.5 cm
 Musée d'Art Moderne, Villeneuve-d'Ascq, Gift of Geneviève and Jean Masurel

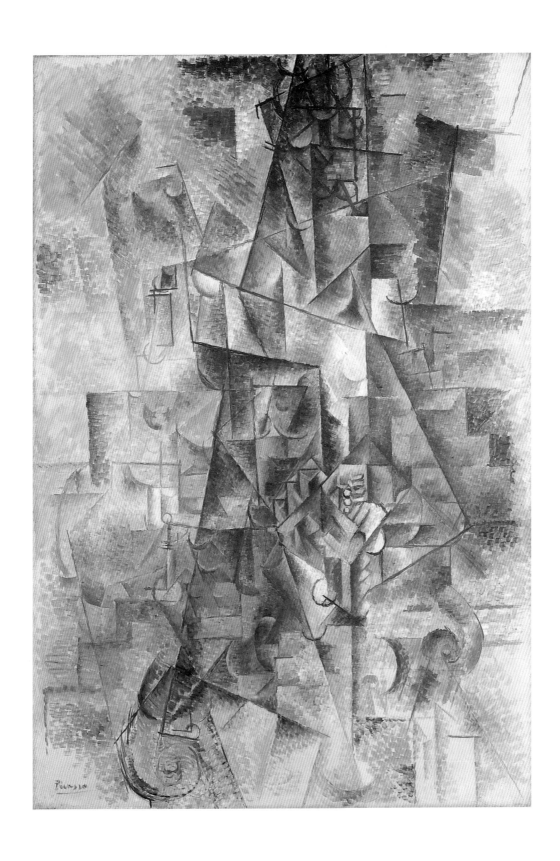

11 PABLO PICASSO, *L'Accordéoniste* / The Accordionist, 1911
Oil on canvas, 130 x 89.5 cm
Solomon R. Guggenheim Museum, New York;
Gift of Solomon R. Guggenheim 1937

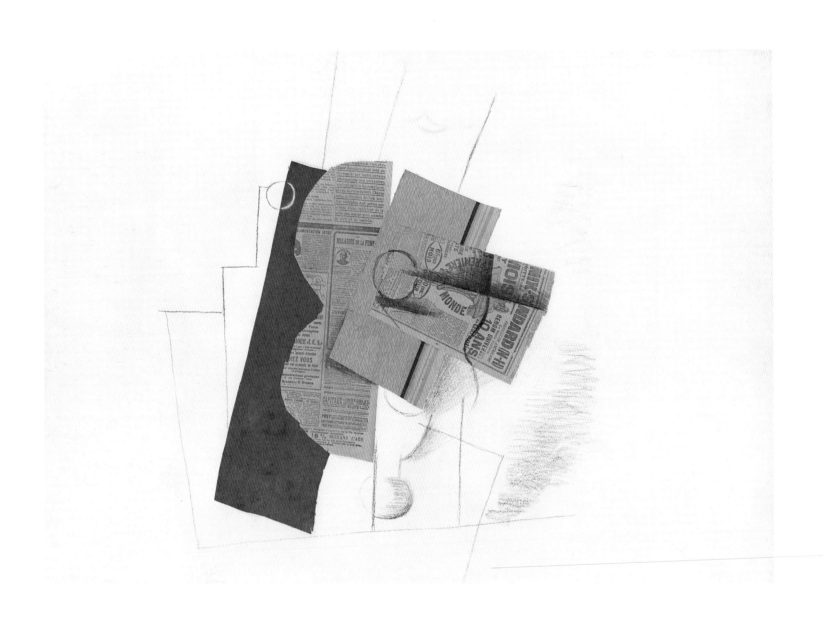

12 GEORGES BRAQUE, *Bouteille et Verre, Standard* / Bottle and Glass, Standard, 1913
Papier collé, wood imitation, charcoal on cardboard, 72 x 101 cm
Private collection

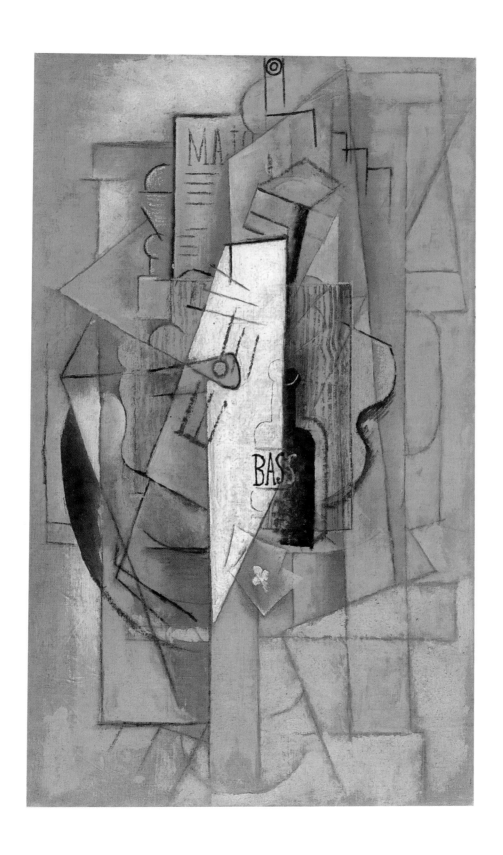

13 PABLO PICASSO, *La bouteille de Bass* / The Bottle of Bass, 1913
 Oil on canvas, 108 x 65.5 cm
 Civico Museo d'Arte Contemporanea, Milan

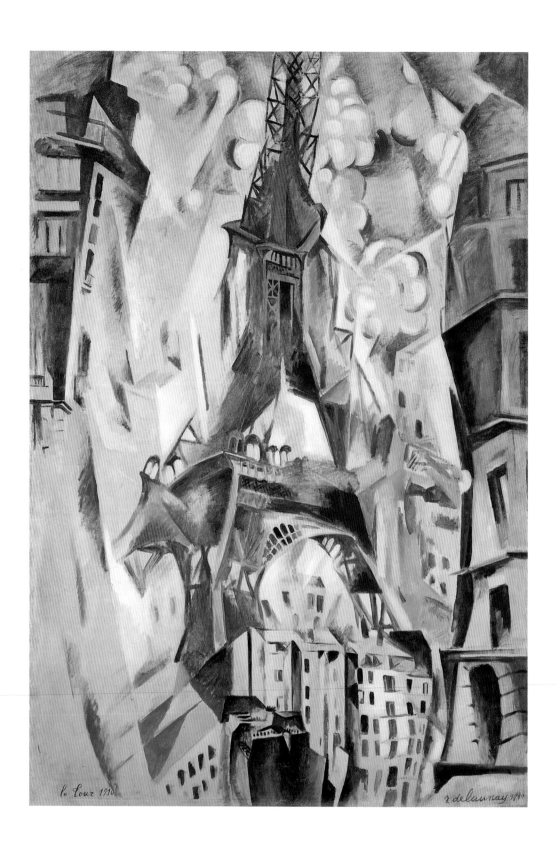

14 ROBERT DELAUNAY, *Tour Eiffel* / Eiffel Tower, 1910
Oil on canvas, 198 x 136 cm
Solomon R. Guggenheim Museum, New York;
Gift of Solomon R. Guggenheim, 1937

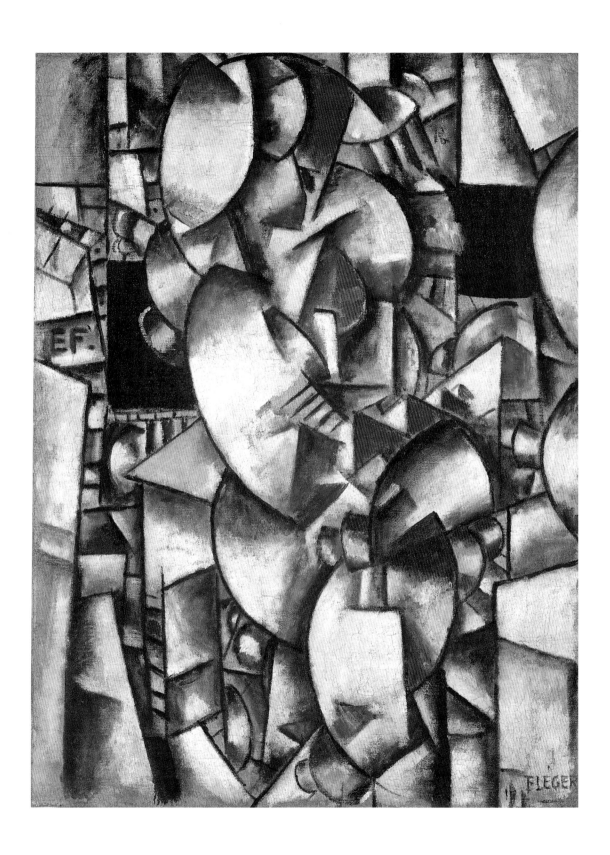

15 FERNAND LÉGER, *Modèle nu dans l´atelier* / Nude Model in the Studio, 1912–1913
 Oil on burlap, 128 x 96 cm
 Solomon R. Guggenheim Museum, New York

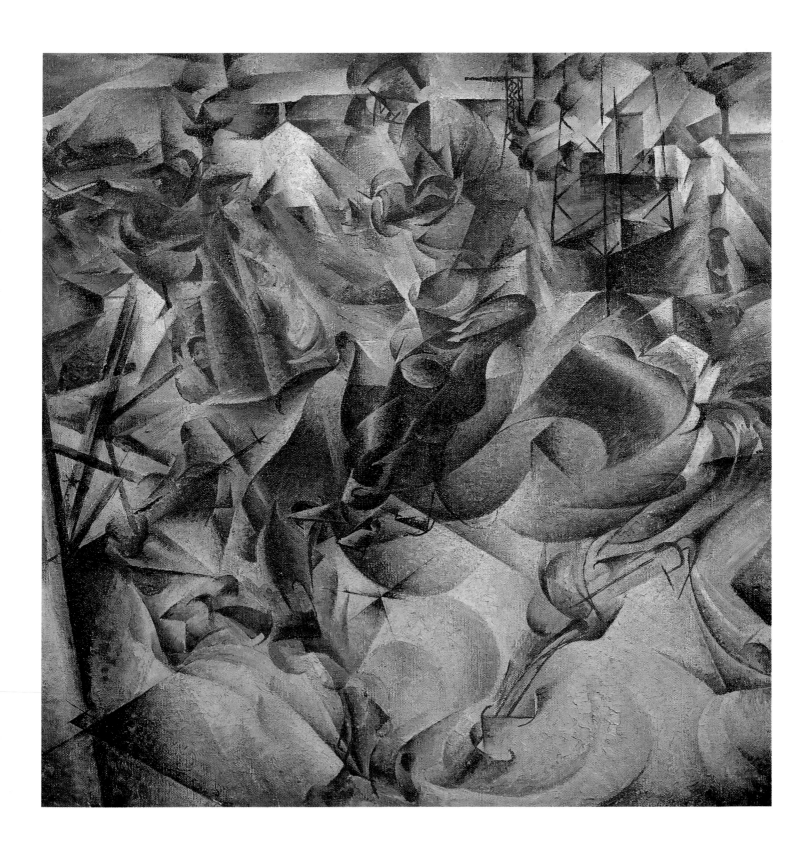

16 UMBERTO BOCCIONI, *Elasticità* / Elasticity, 1912
Oil on canvas, 100 x 100 cm
Civico Museo d'Arte Contemporanea, Milan

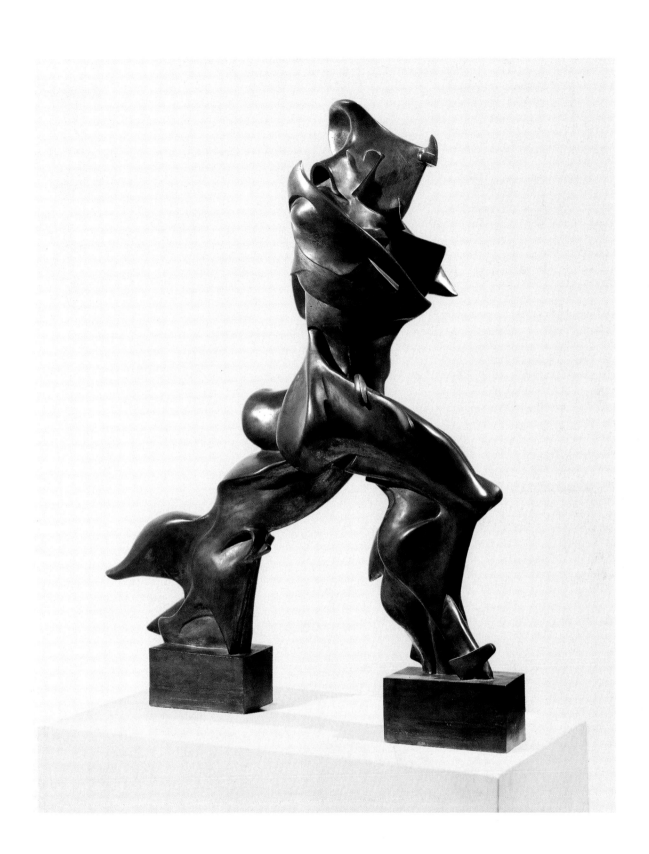

17 UMBERTO BOCCIONI, *Forme uniche della continuità nello spazio* /
Unique Forms of Continuity in Space, 1913
Bronze, 114 x 84 x 37 cm
Civico Museo d'Arte Contemporanea, Milan

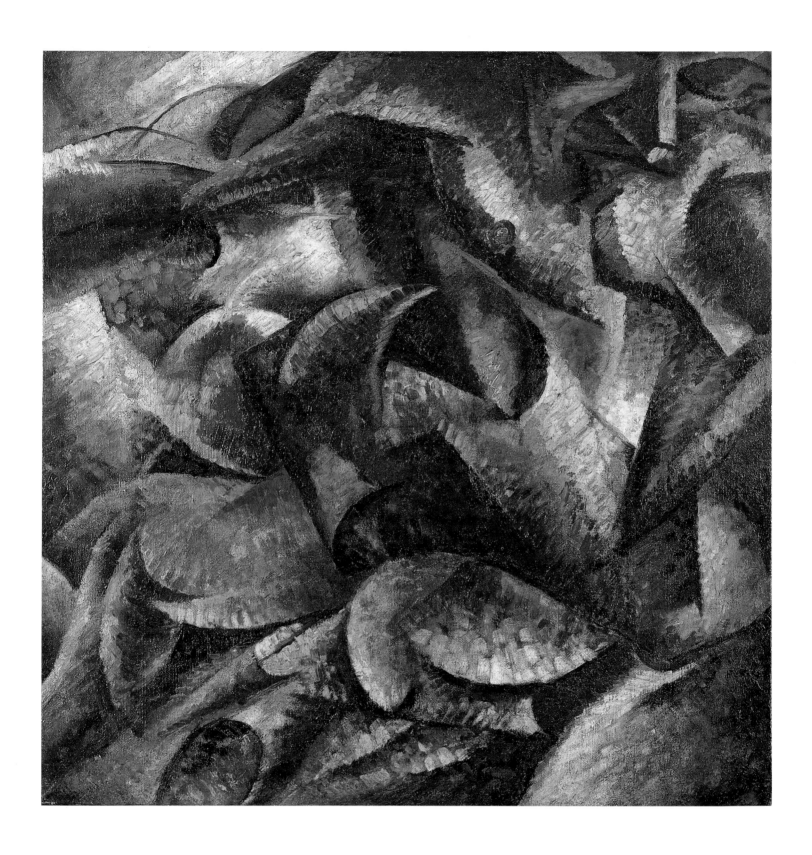

18 UMBERTO BOCCIONI, *Dinamismo di un Corpo Umano /*
 Dynamism of a Human Body, 1913
 Oil on canvas, 100 x 100 cm
 Civico Museo d'Arte Contemporanea, Milan

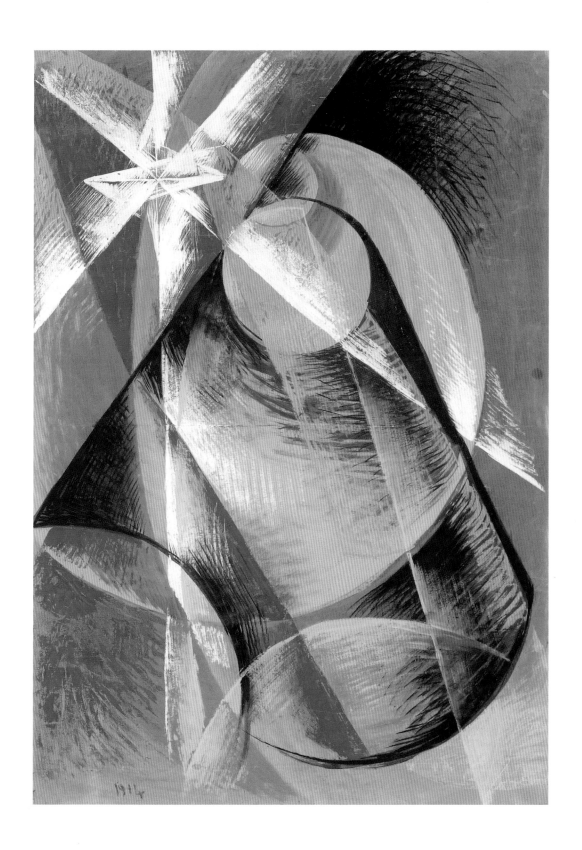

19 GIACOMO BALLA, *Mercurio passa davanti al sole visto dal cannocchiale* /
Mercury Passing in Front of the Sun, Seen Through the Binoculars, 1914
Tempera on cardboard on canvas, 143 x 100 cm
Museum Moderner Kunst, Stiftung Ludwig Wien

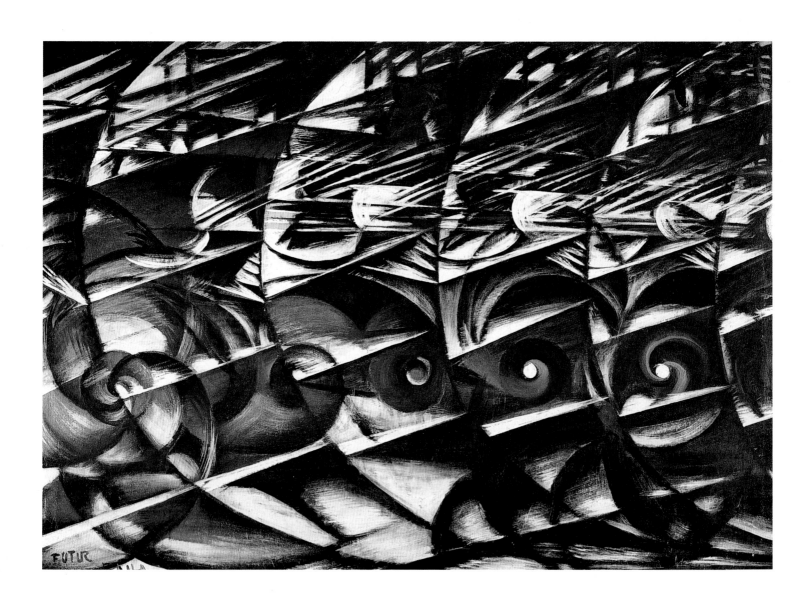

20 GIACOMO BALLA, *Velocità astratta (è passata l'automobile)* /
Abstract Speed (the Car has Passed), 1913
Oil on canvas, 78 x 108 cm
Private collection

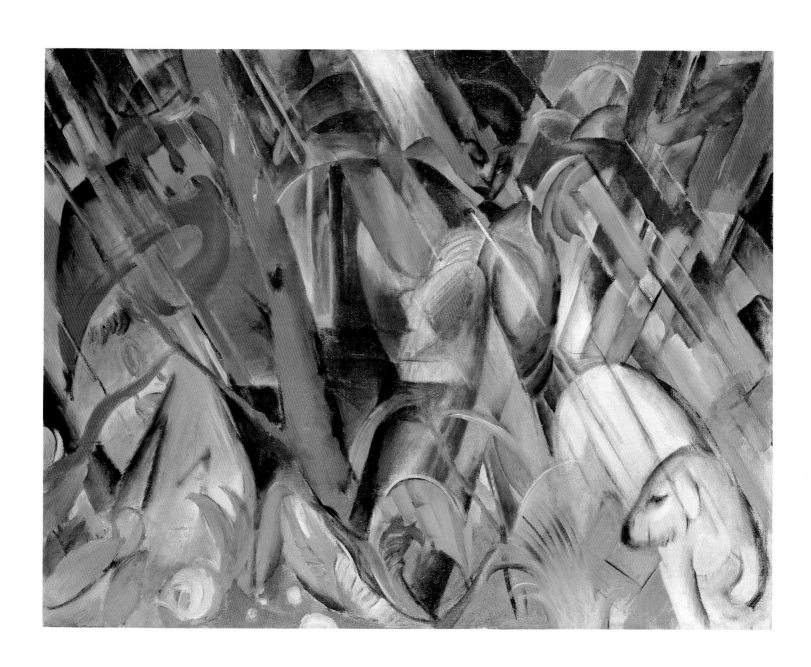

21 FRANZ MARC, *Im Regen* / In the Rain, 1912
 Oil on canvas, 81 x 105.5 cm
 Städtische Galerie im Lenbachhaus, Munich

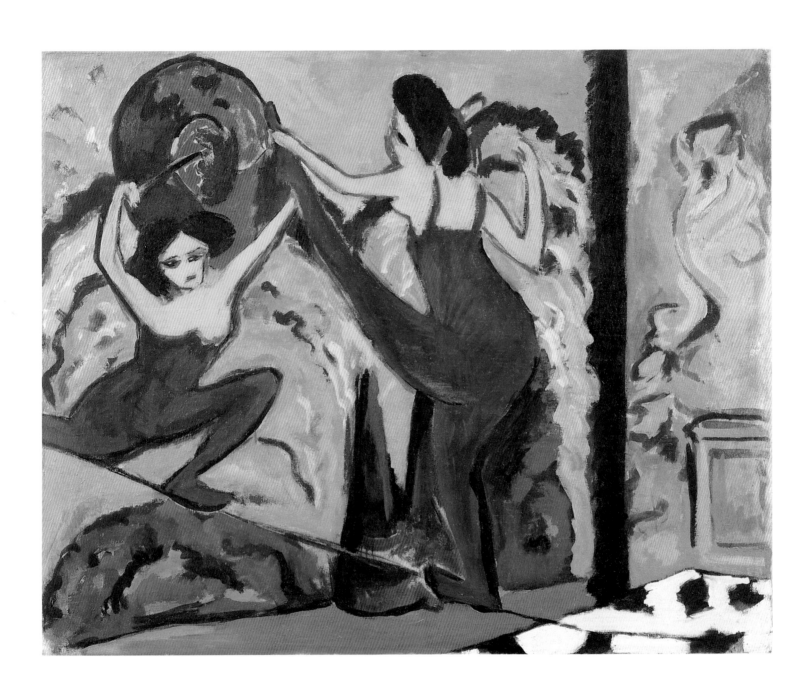

22 ERNST LUDWIG KIRCHNER, *Drahtseiltanz* / Tightrope-Dance, 1909
 Oil on canvas, 120 x 149 cm
 Private collection

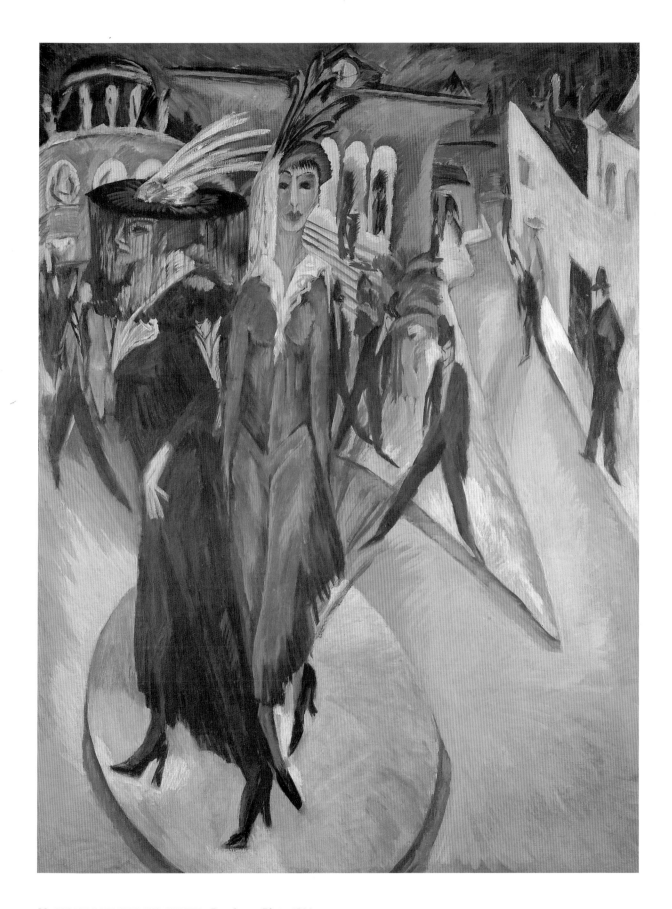

23 ERNST LUDWIG KIRCHNER, *Potsdamer Platz*, 1914
Oil on canvas, 200 x 150 cm
Nationalgalerie, Staatliche Museen zu Berlin, Preußischer Kulturbesitz

24 WILHELM LEHMBRUCK, *Mädchenkopf, sich umwendend* /
Girl's Head Turning
Artificial stone, heigt 41 cm
Nationalgalerie, Staatliche Museen zu Berlin – Preußischer Kulturbesitz

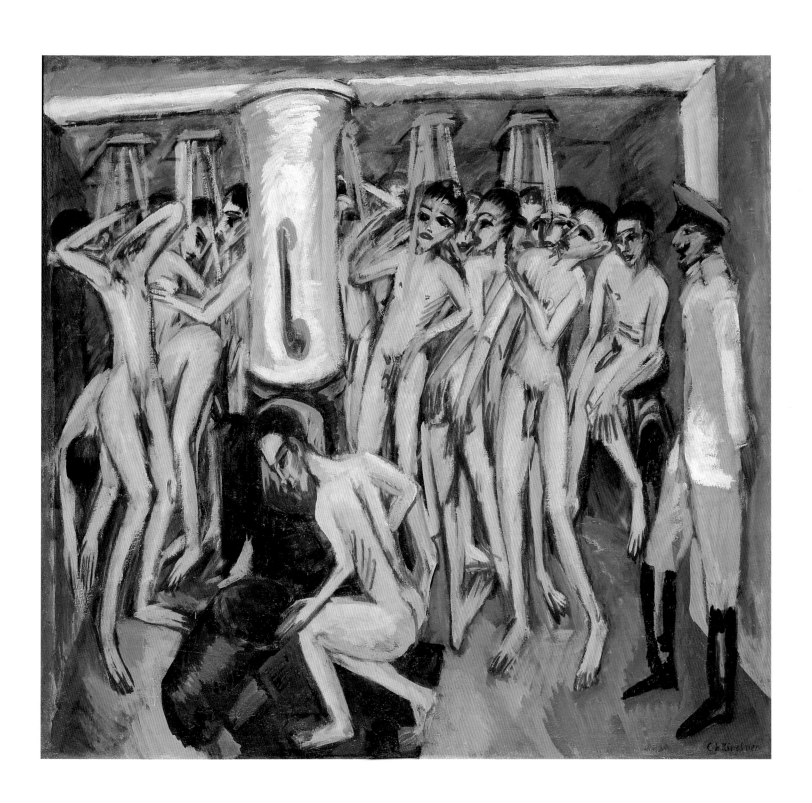

25 ERNST LUDWIG KIRCHNER, *Das Soldatenbad* / Artillerymen, 1915
Oil on canvas, 140 x 153 cm
Solomon R. Guggenheim Museum, New York

26 EMIL NOLDE, *Publikum im Cabaret* / Cabaret Audience, 1911
Oil on canvas, 86 x 99 cm
Stiftung Seebüll Ada und Emil Nolde

27 EMIL NOLDE, *Kerzentänzerinnen* / Candle Dancers, 1912
 Oil on canvas, 100.5 x 86.5 cm
 Stiftung Seebüll Ada und Emil Nolde

28 WILHELM LEHMBRUCK, *Kopf eines Denkers (mit Hand)* /
 Head of a Thinker (with Hand), 1918
 Stone cast, 64.5 x 57 x 30 cm
 Museum am Ostwall, Dortmund

29 OSKAR KOKOSCHKA, *Irrender Ritter* / Knight Errant, 1915
Oil on canvas, 89.5 x 180 cm
Solomon R. Guggenheim Museum, New York

30 OSKAR KOKOSCHKA, *Die Macht der Musik* / The Power of Music, 1918
 Oil on canvas, 100 x 151.5 cm
 Stedelijk Van Abbemuseum, Eindhoven, Netherlands

31 LOVIS CORINTH, *Das Trojanische Pferd* / The Trojan Horse, 1924
 Oil on canvas, 105 x 135 cm
 Nationalgalerie, Staatliche Museen zu Berlin, Preußischer Kulturbesitz

32 HENRI MATISSE, *Les Tulipes* / Tulips, 1914
 Oil on canvas, 100 x 73 cm
 Joseph Hackmey Collection

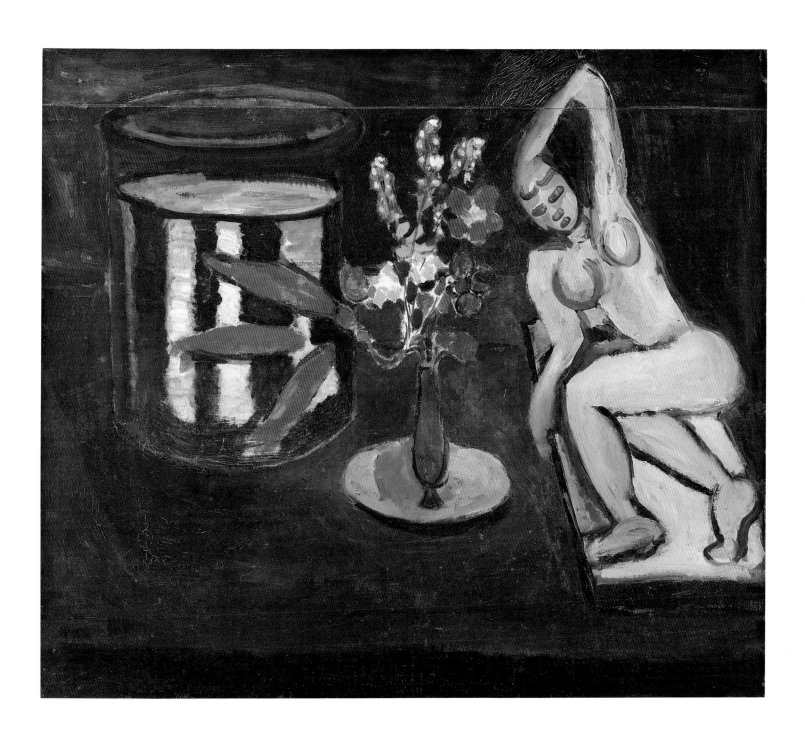

33 HENRI MATISSE, *Les Poissons rouges* / The Goldfishes, 1912
Oil on canvas, 82 x 93.5 cm
Statensmuseum for Kunst, Copenhagen

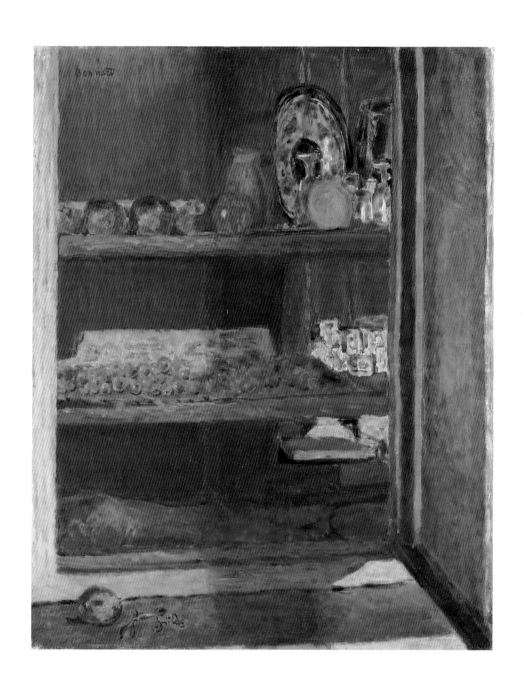

34 PIERRE BONNARD, *Le buffet rouge* / The Red Cupboard, ca. 1930
 Oil on canvas, 81.5 x 65 cm
 Private collection, New York

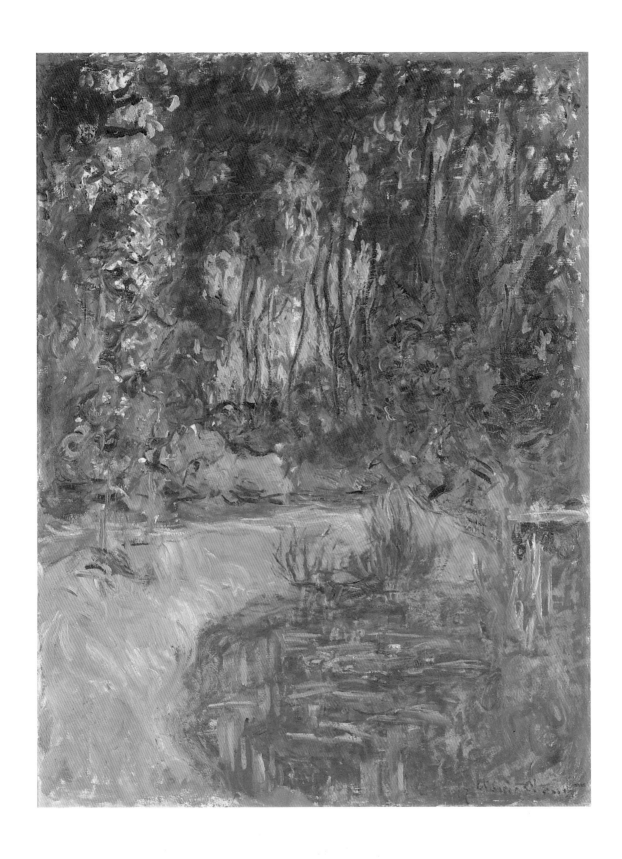

35 CLAUDE MONET, *Un coin de l´étang de Giverny* /
 A Corner of the Pond at Giverny, 1918–1919
 Oil on canvas, 117 x 83 cm
 Musée de Grenoble

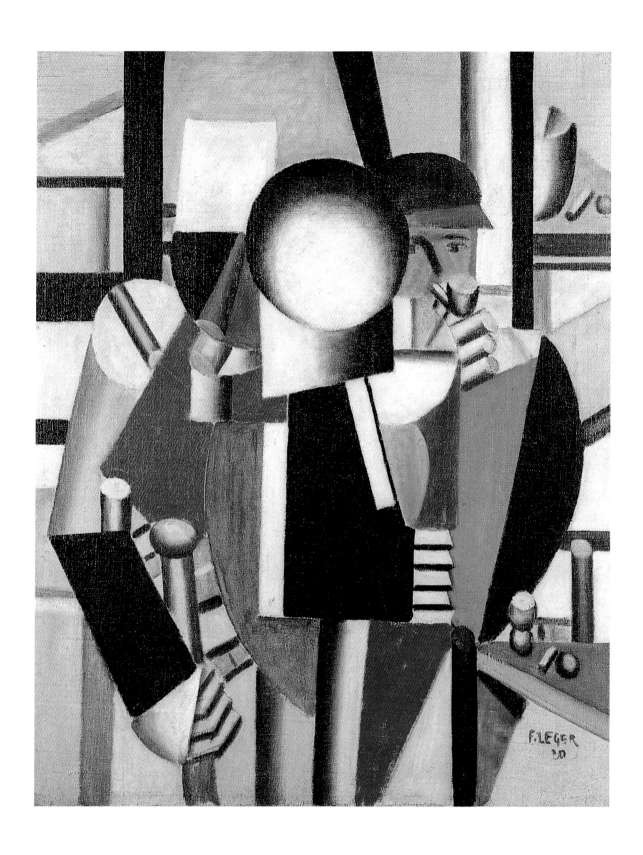

36 FERNAND LÉGER, *Les Trois Comrades* / Three Comrades, 1920
 Oil on canvas, 92 x 73 cm
 Stedelijk Museum, Amsterdam

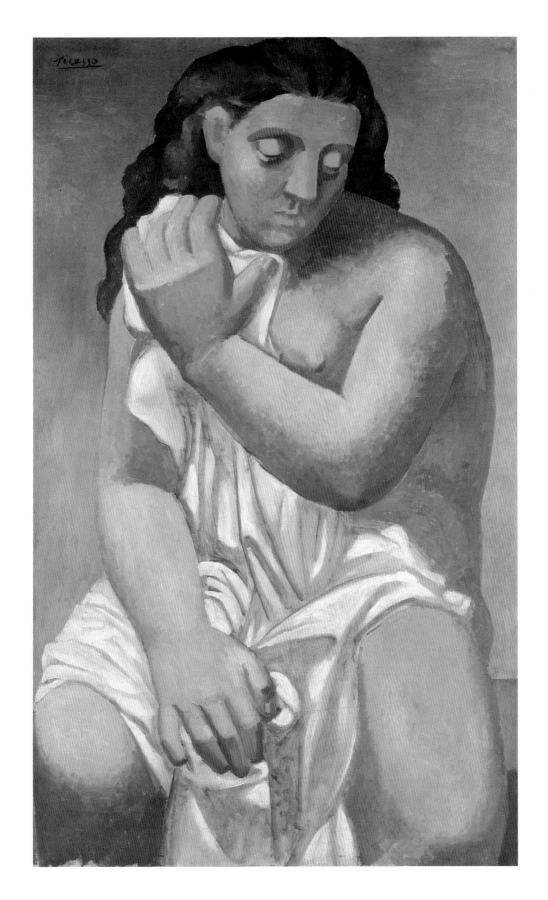

37 PABLO PICASSO, *Grand nu à la draperie* / Big Nude with Drapery, 1923
 Oil on canvas, 155 x 95 cm
 Musée de l'Orangerie, Paris; Collection of Jean Walter and Paul Guillaume

38 ARISTIDE MAILLOL, *Torse de l'Ile-de-France*, 1921
Bronze, height: 120 cm
Musée Maillol, Paris

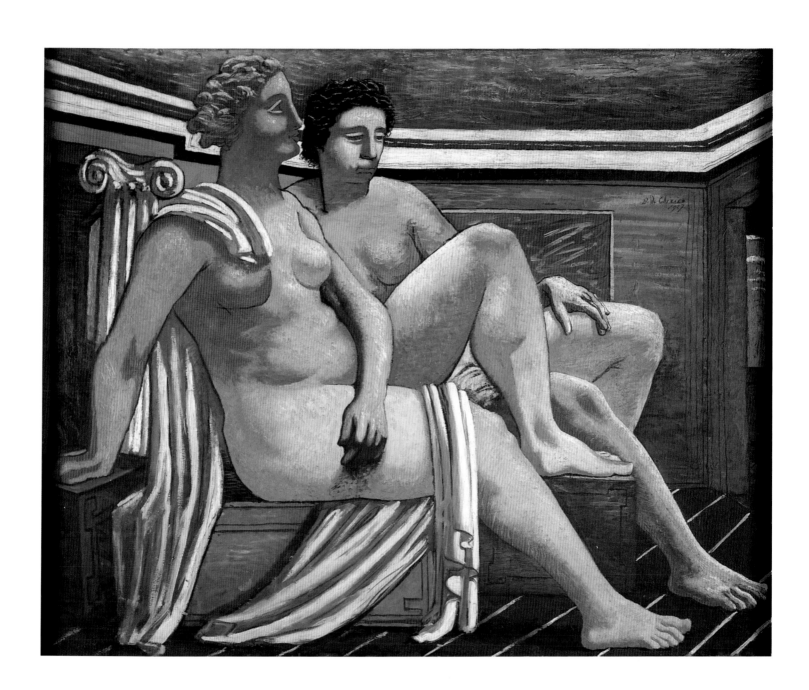

39 GIORGIO DE CHIRICO, *Figure mitologiche / Nus antiques /*
Mythological Figures /Antique Nudes, 1927
Oil on canvas, 130 x 162 cm
Private collection, Courtesy Galleria dello Scudo, Verona

40 OSKAR SCHLEMMER, *Gegeneinander im Raum* /
 Against One Another in Space, 1928
 Oil on canvas, 99.5 x 74.5 cm
 Sprengel Museum, Hanover

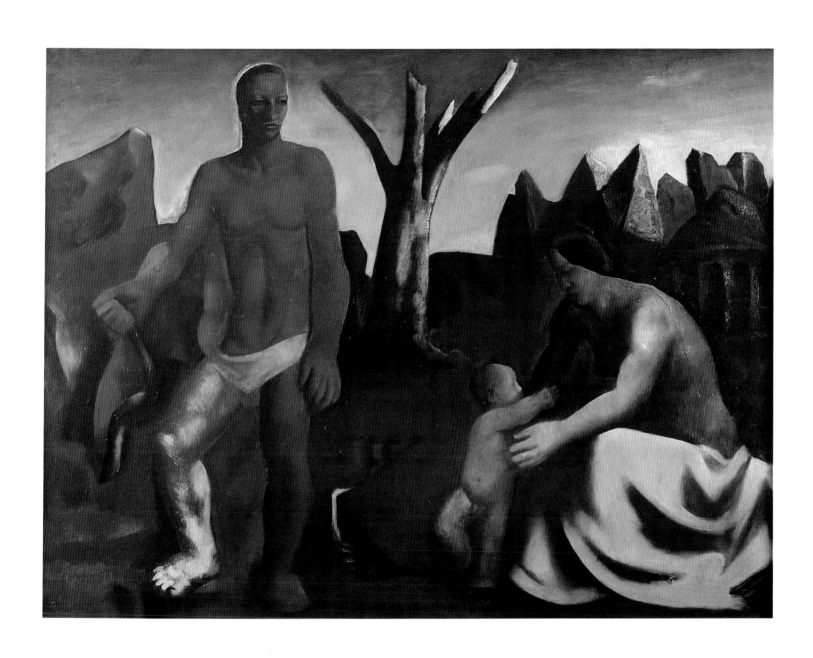

41 MARIO SIRONI, *La Famiglia*, 1929
 Oil on canvas, 167 x 210 cm
 Courtesy Claudia Gian Ferrari, Milan

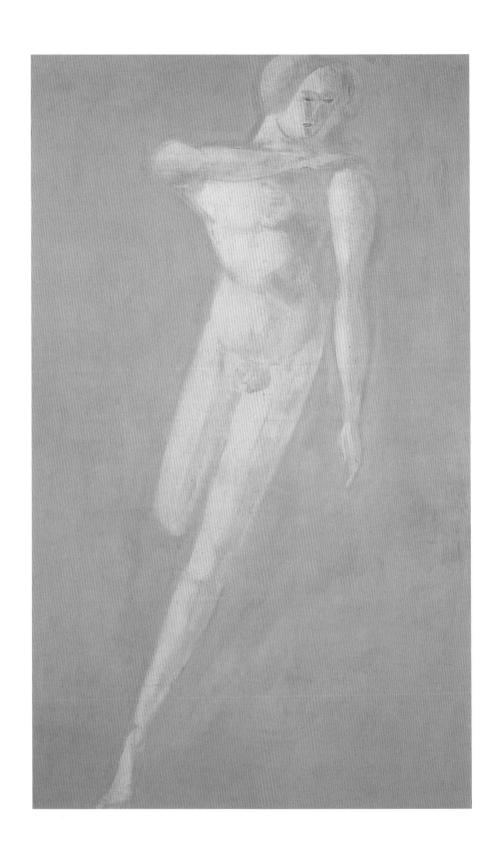

42 OSKAR SCHLEMMER, *Einzelfigur, schräg* / Single Figure, Sloping, 1928
 Oil and tempera on canvas, 146.5 x 90 cm
 Staatsgalerie Stuttgart

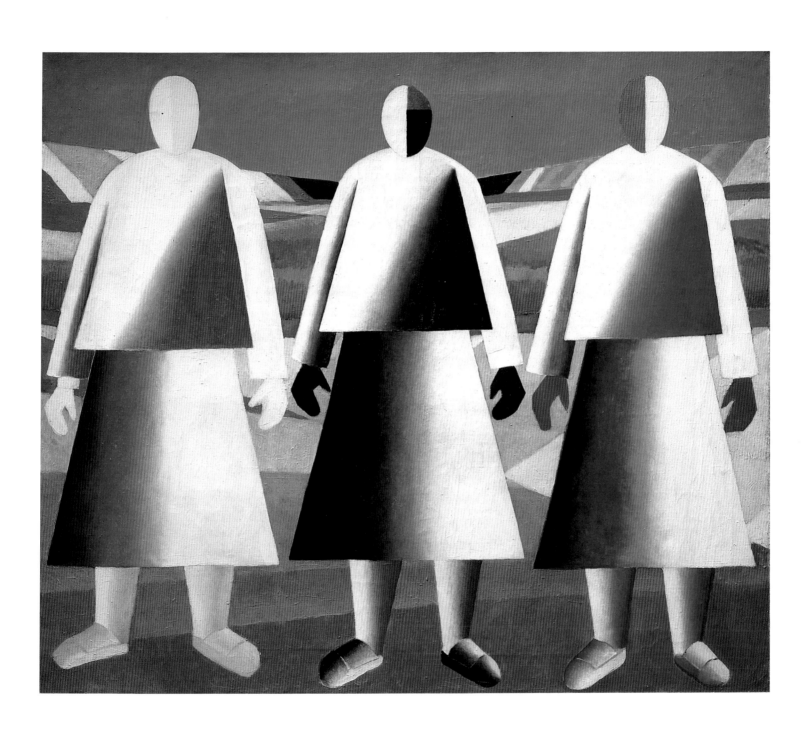

43 KAZIMIR MALEVICH, *Girls in the Field*, 1928–1932
 Oil on canvas, 106 x 125 cm
 State Russian Museum, St. Petersburg

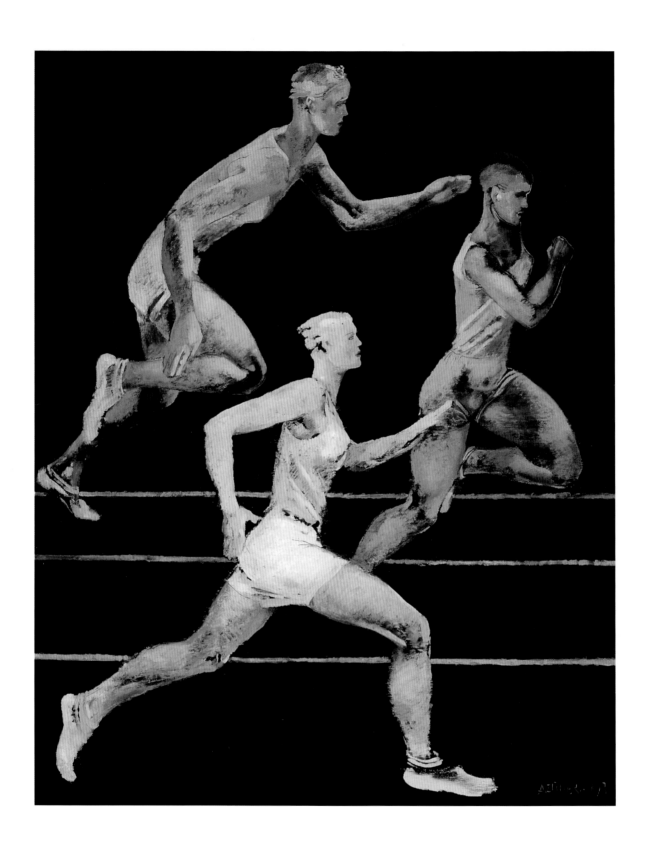

44 ALEXANDER DEINEKA, *The Race*, 1930
 Oil on plywood, 150 x 120 cm
 Galleria Internazionale d'Arte Moderna, Ca'Pesaro, Venice

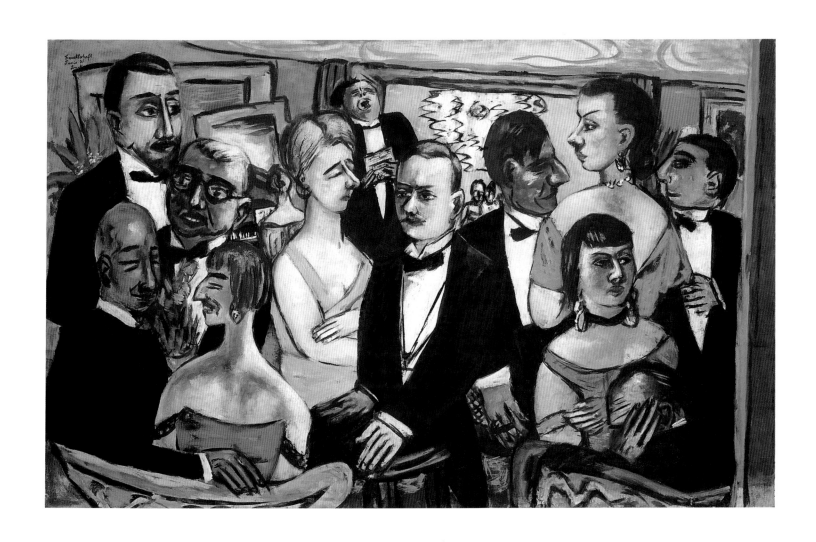

45 MAX BECKMANN, *Gesellschaft Paris* / Paris Society, 1931
 Oil on canvas, 110 x 176 cm
 Solomon R. Guggenheim Museum, New York

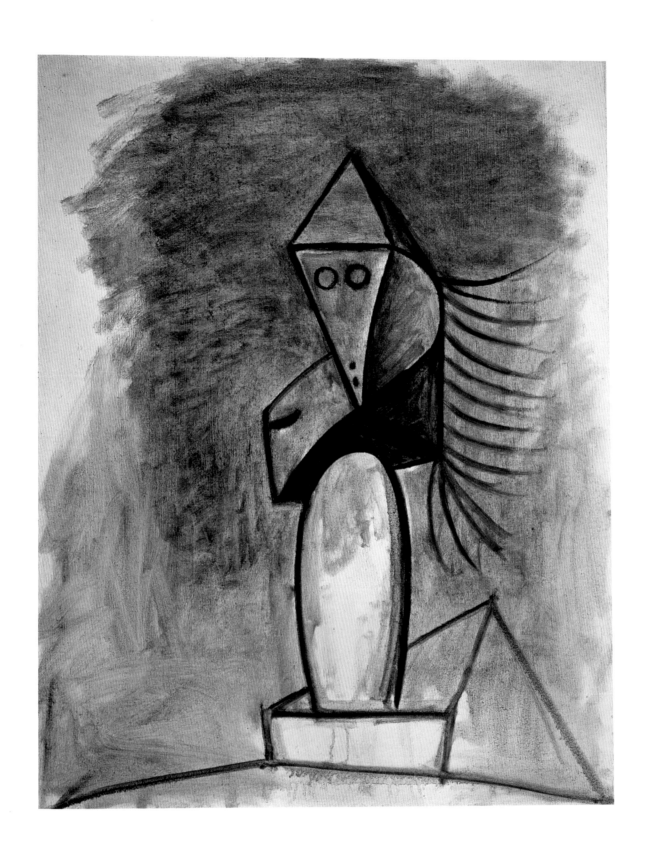

46 PABLO PICASSO, *Tête de femme* /
Head of a Woman, 1944
Oil on canvas, 92 x 73 cm
Private collection

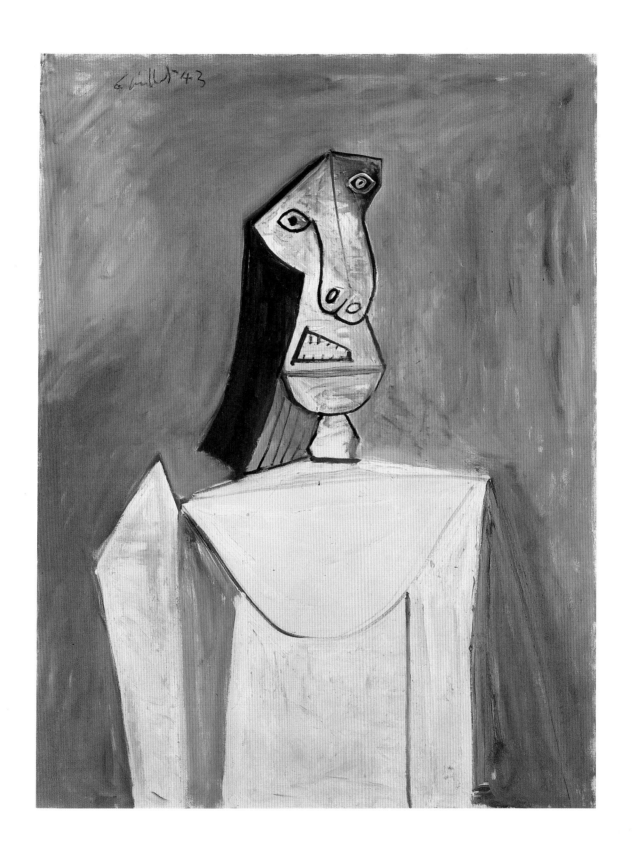

47 PABLO PICASSO, *Buste de femme sur fond gris* /
 Bust of a Woman on Grey Background, 1943
 Oil on canvas, 116 x 89 cm
 Private collection

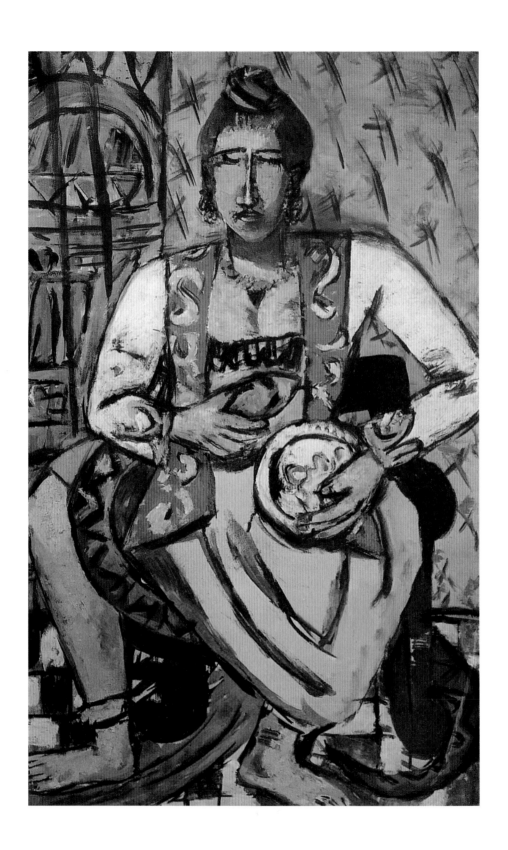

48 MAX BECKMANN, *Frau mit Schlange /*
Woman with Serpent, 1940
Oil on canvas, 145.5 x 91 cm
Private collection

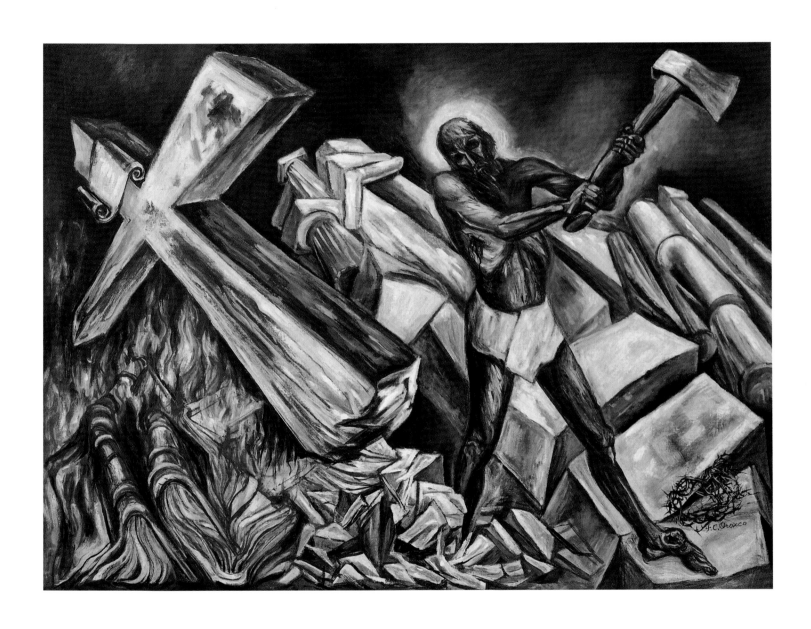

49 JOSÉ CLEMENTE OROZCO, *Christ destruye su cruz* / Christ destroying his Cross, 1943
Oil on canvas, 93 x 130 cm
INBA/Museo de Arte Alvar Y Carmen T. de Carillo Gil

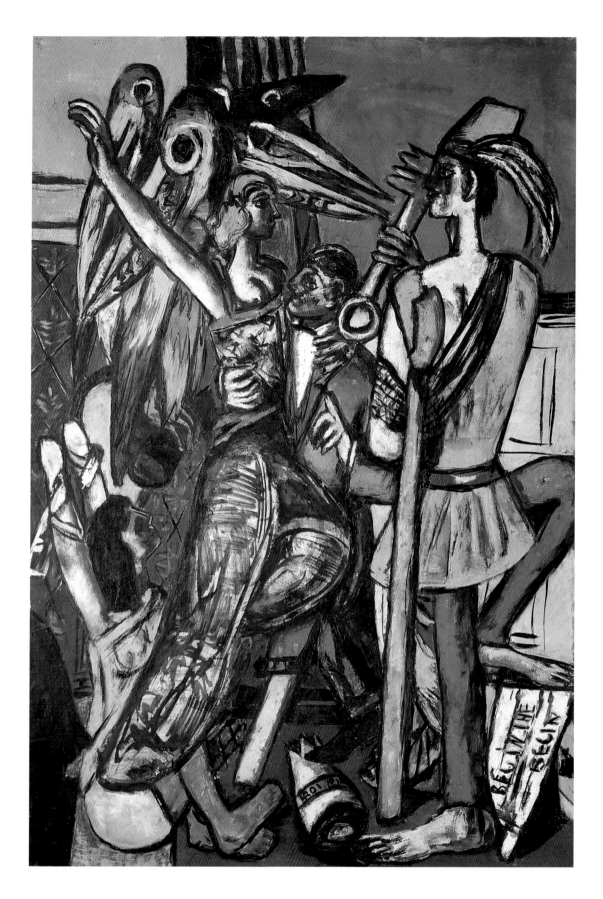

50 MAX BECKMANN, *Begin the Beguine*, 1946
 Oil on canvas, 178 x 121 cm
 University of Michigan, Museum of Art, Ann Arbor

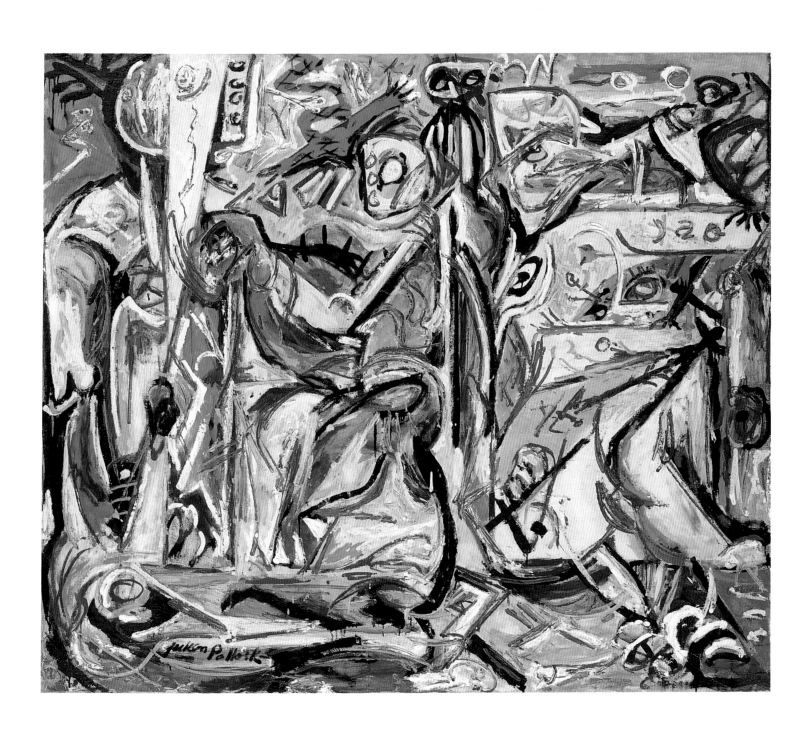

51 JACKSON POLLOCK, *Circumcision*, 1946
 Oil on canvas, 142 x 168 cm
 Peggy Guggenheim Collection, Venice

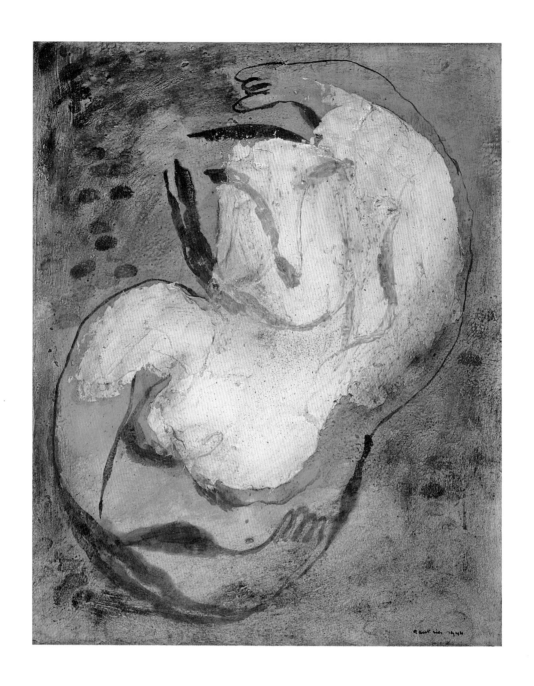

52 JEAN FAUTRIER, *La Jolie Fille* / The Pretty Girl, 1944
 Oil on paper on canvas, 62 x 50 cm
 Private collection

53 JEAN FAUTRIER, *La Juive* / The Jewess, 1943
 Oil on paper on canvas, 73 x 115.5 cm
 Musée d'Art Moderne de la Ville de Paris

54 JEAN FAUTRIER, *Mademoiselle*, 1956
 Oil on paper on canvas, 89 x 116 cm
 Private collection, Berlin

55 JEAN FAUTRIER, *Croisillons* / Lattice, 1958
 Oil on paper on canvas, 81 x 100 cm
 Private collection, Berlin

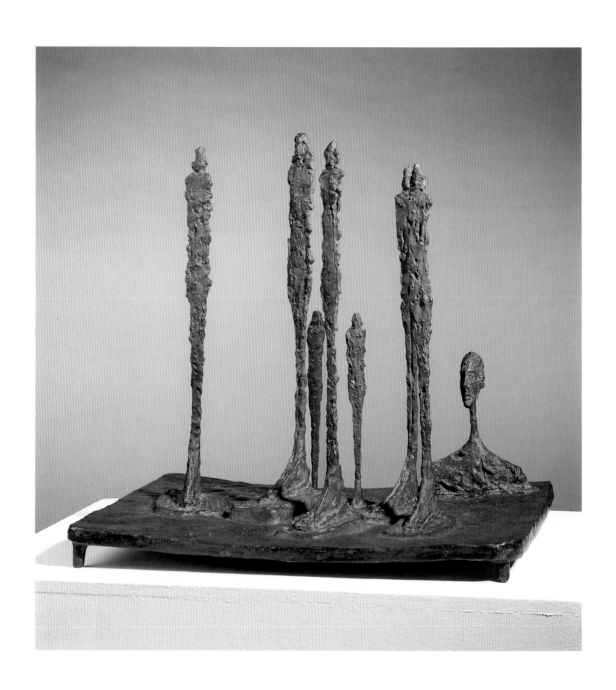

56 ALBERTO GIACOMETTI, *La Forêt* / The Forest, 1950
Bronze, 57 x 61 x 49.5 cm
Kunsthaus Zürich, Zurich

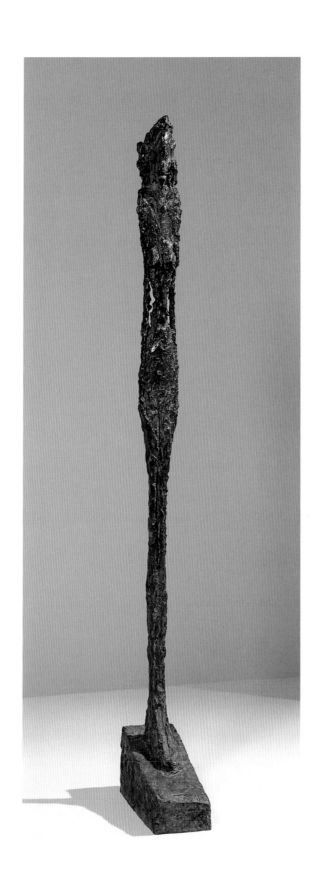

57 ALBERTO GIACOMETTI, *Femme debout (Leoni)* /
Standing Woman (Leoni), 1947
Bronze, 135 x 14.5 x 35.5 cm
Private collection

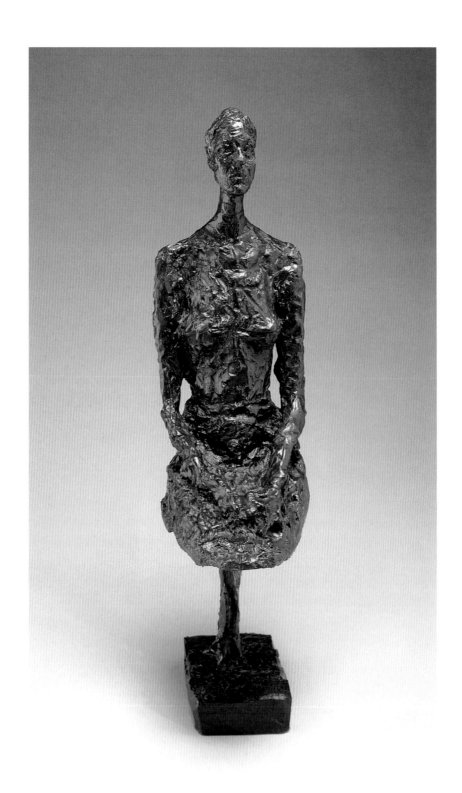

58 ALBERTO GIACOMETTI, *Grande Femme Assise (Annette Assise)* /
Large Woman Seated (Annette seated), 1958
Bronze, height: 82.5 cm
Courtesy Sotheby's

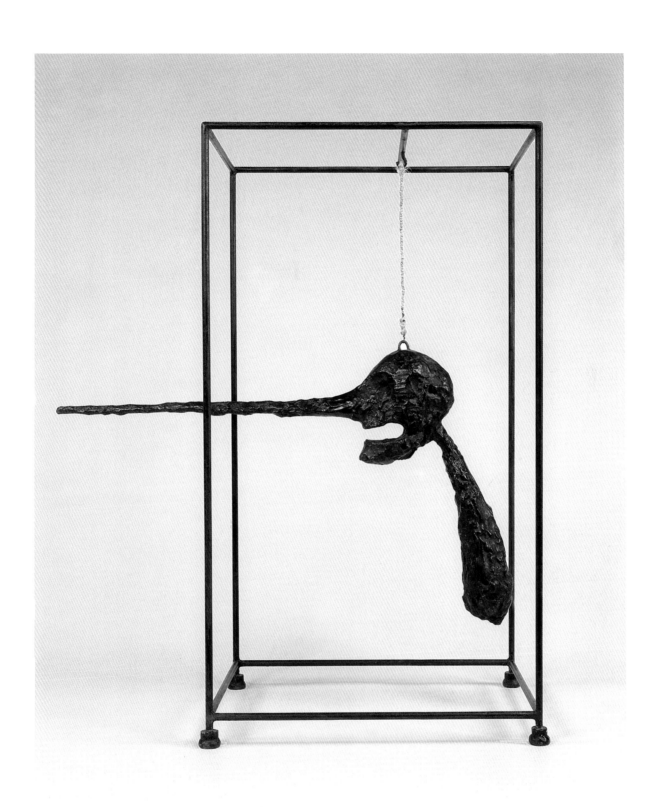

59 ALBERTO GIACOMETTI, *Le nez* / The Nose, 1947
Bronze, 82 x 73 x 37 cm
Solomon R. Guggenheim Museum, New York

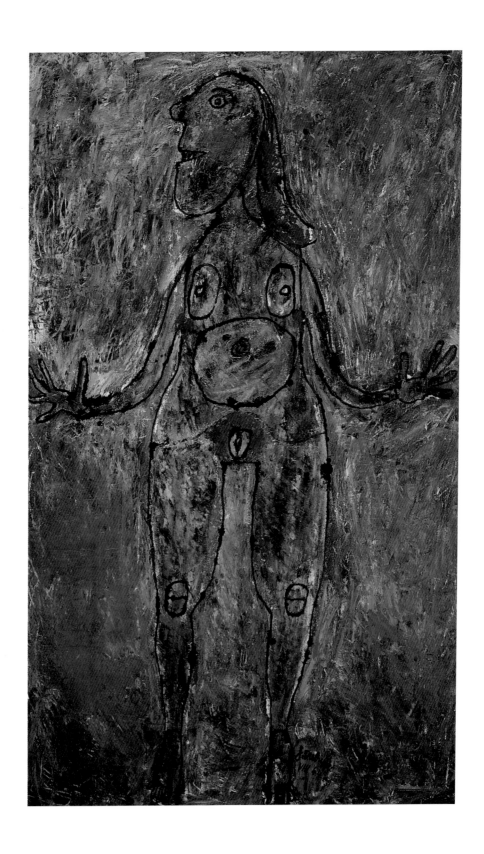

60 JEAN DUBUFFET, *Grand nu charbonneux* / Big Blackened Nude, 1944
 Oil on canvas, 162 x 97 cm
 Linda and Harry Macklowe Collection, New York

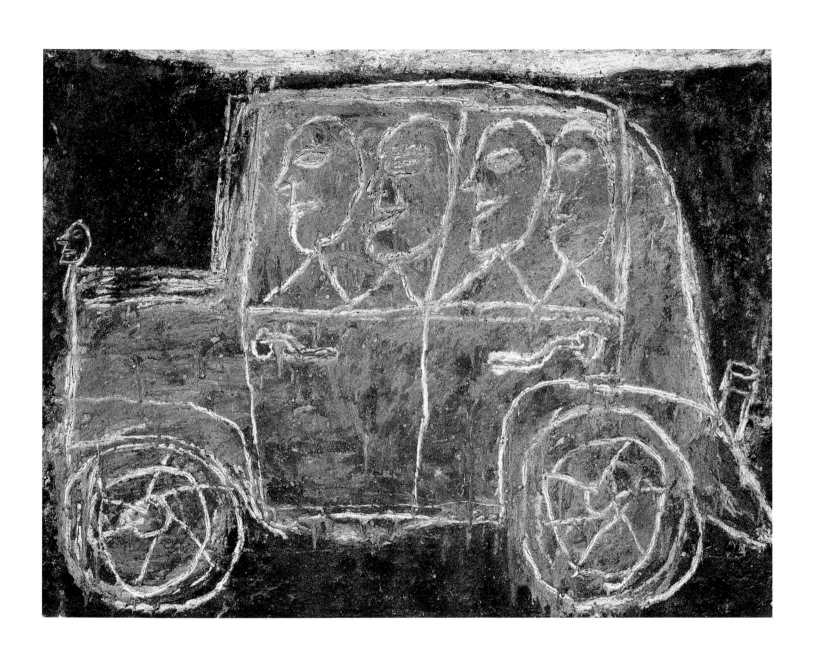

61 JEAN DUBUFFET, *Touring Club*, 1946
High paste on canvas, 97 x 130 cm
Richard S. Zeisler Collection, New York

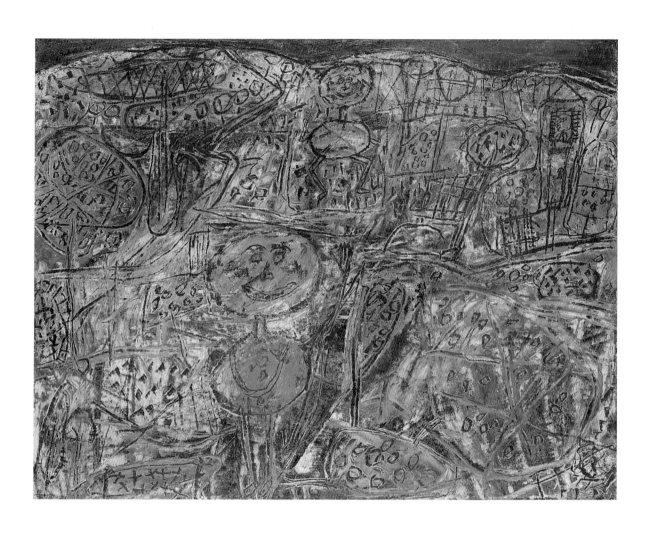

62 JEAN DUBUFFET, *Crépuscule de l'esprit /*
Twilight of the Spirit, 1949
Oil on canvas, 89 x 116 cm
Private collection, Berlin

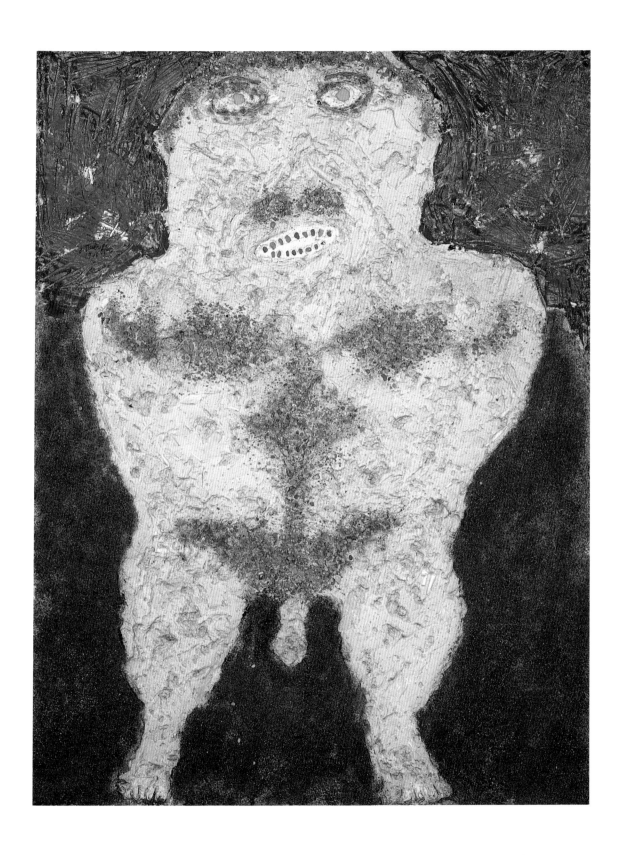

63 JEAN DUBUFFET, *Volonté de puissance* / Will to Power, 1946
 Oil on canvas, 116 x 89 cm
 Solomon R. Guggenheim Museum, New York

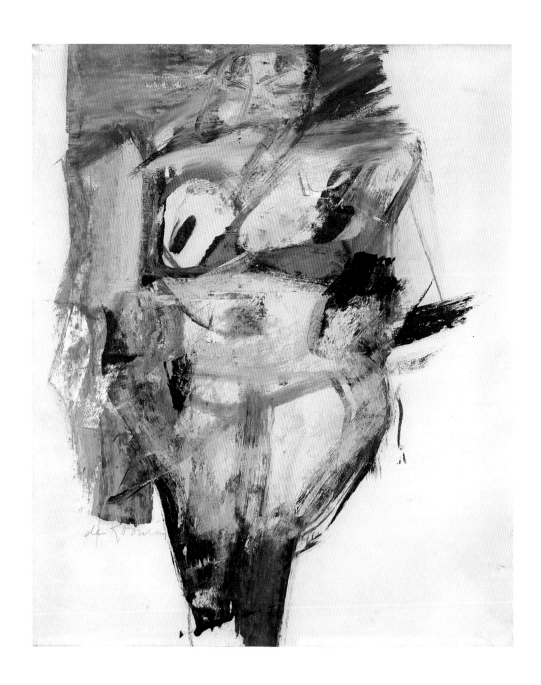

64 WILLEM DE KOONING, *Woman*, 1952–1953
 Oil on paper on canvas, 57 x 48.5 cm
 Aaron I. Fleischman

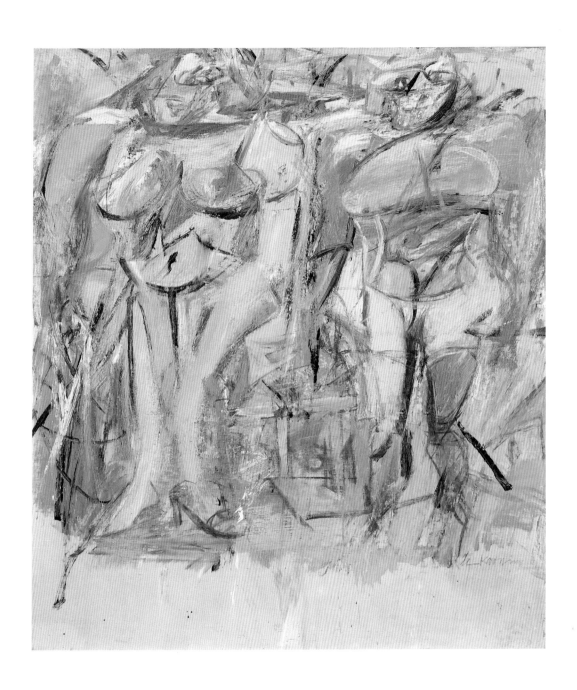

65 WILLEM DE KOONING, *Two Women in the Country*, 1954
 Oil and enamel and charcoal on canvas, 117 x 103.5 cm
 Hirshhorn Museum and Sculpture Garden, Smithsonian Institution;
 Gift of Joseph H. Hirshhorn, 1966, Washington D.C.

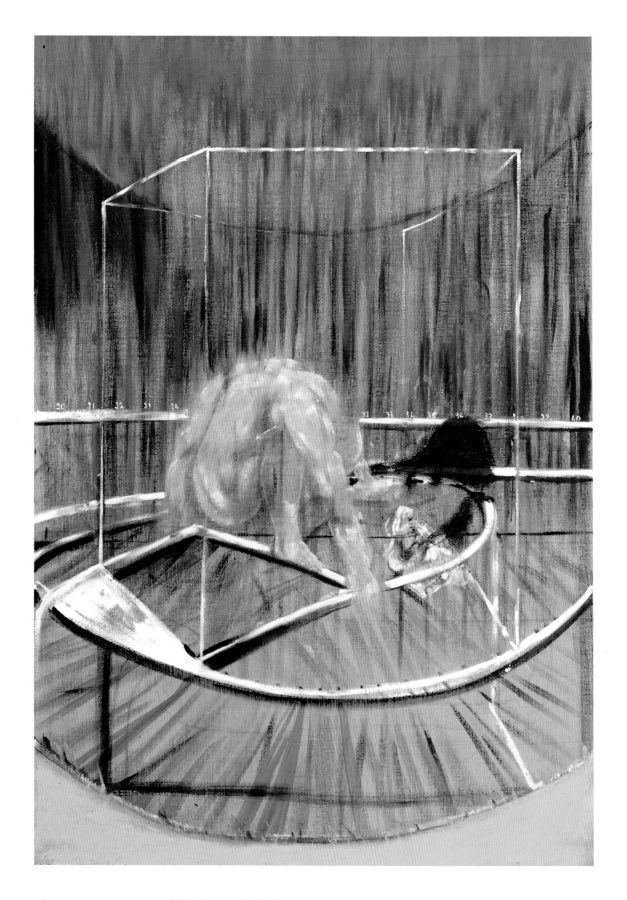

66 FRANCIS BACON, *Study for Crouching Nude*, 1952
 Oil on canvas, 198 x 137 cm
 The Detroit Institute of Arts; Gift of Dr. Wilhelm R. Valentiner

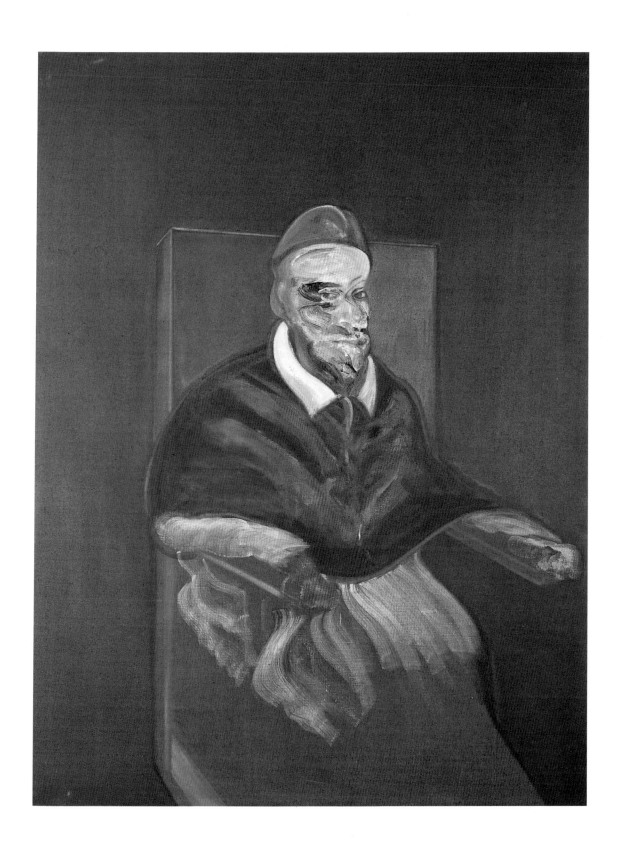

67 FRANCIS BACON, *Study for Portrait of Pope Innocent X by Velázquez*, 1959
 Oil on canvas, 151 x 119 cm
 Dingwall Investments S.A.

68 FRANCIS BACON, *Study for Portrait of van Gogh VI*, 1957
Oil on canvas, 198 x 142 cm
Arts Council Collection, Hayward Gallery, London

69 ASGER JORN, *Verlust der Mitte* / Loss of Centre, 1958
Oil on canvas, 114 x 145 cm
Museum van Hedendaagse Kunst, Ghent

70 PABLO PICASSO, *Le Baiser* / The Kiss, 1969
 Oil on canvas, 97 x 130 cm
 Gilbert de Botton Family Trust

71 PABLO PICASSO, *La Famille*, 1970
Oil on canvas, 162 x 130 cm
Musée Picasso, Paris

72 PABLO PICASSO, *Nu allongé* / Reclining Nude, 1970
Oil on canvas, 130 x 195 cm
Gilbert de Botton Family Trust

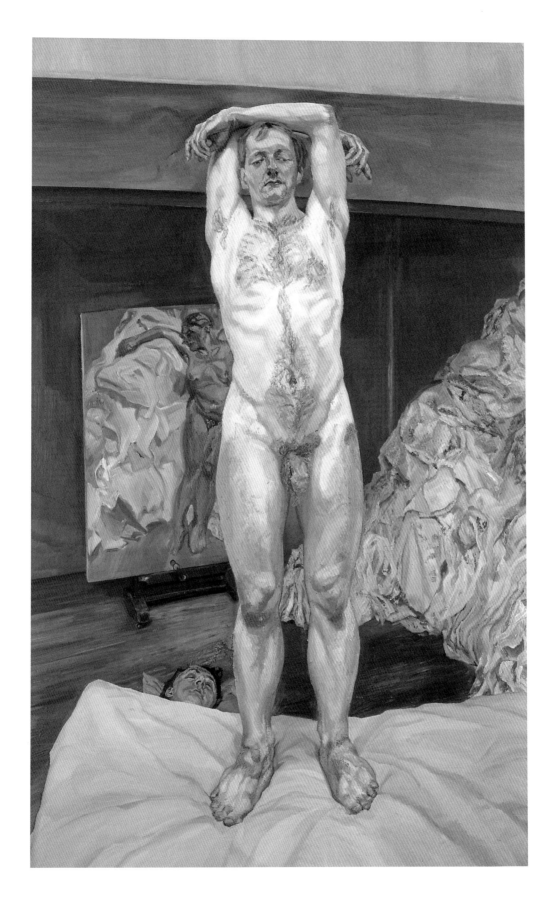

73 LUCIAN FREUD, *Two Men in the Studio*, 1987–1989
Oil on canvas, 185.5 x 121 cm
Private collection

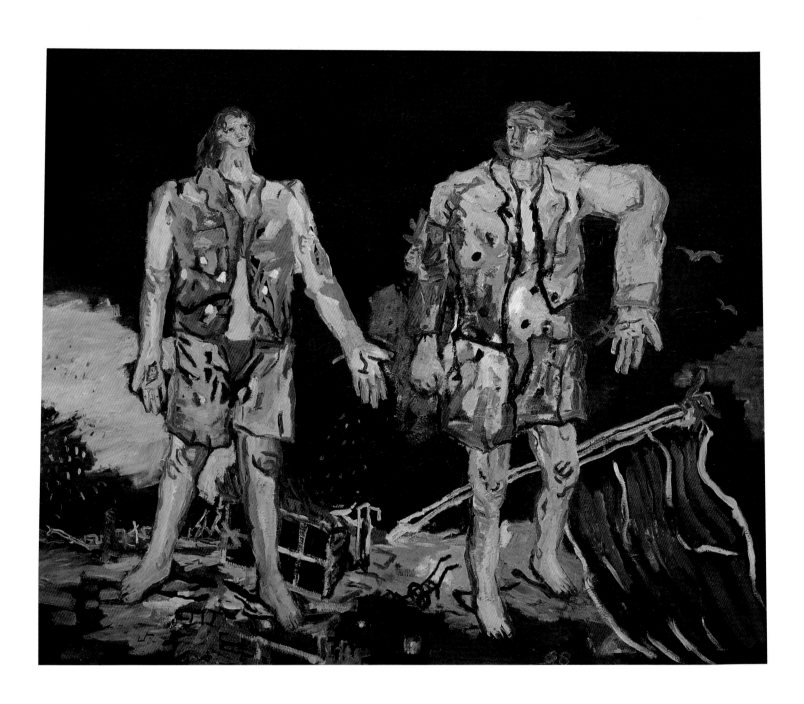

74 GEORG BASELITZ, *Die großen Freunde* / The Great Friends, 1965
 Oil on canvas, 250 x 300 cm
 Museum Ludwig; Collection Ludwig, Cologne

75 GEORG BASELITZ, *Strandbild 2* / Beach Picture 2, 1980
Tempera on canvas, 250 x 200 cm
Private collection

76 GEORG BASELITZ, *Bildzwei* / Picturetwo, 1991
Oil on canvas, 280 x 450 cm
Private collection

Portraiture in the 20th Century

OSKAR KOKOSCHKA (Cat. 77–79)

EGON SCHIELE (Cat. 80)

PABLO PICASSO (Cat. 81–85)

HENRI MATISSE (Cat. 86–87)

AMEDEO MODIGLIANI (Cat. 88)

MAX BECKMANN (Cat. 89–91)

LOVIS CORINTH (Cat. 92)

ERNST LUDWIG KIRCHNER (Cat. 93)

ALEXANDER RODCHENKO (Cat. 94)

GIORGIO DE CHIRICO (Cat. 95–97)

OTTO DIX (Cat. 98–99)

CHRISTIAN SCHAD (Cat. 100–101)

FRIDA KAHLO (Cat. 102–103)

STANLEY SPENCER (Cat. 104)

JEAN DUBUFFET (Cat. 105)

ALBERTO GIACOMETTI (Cat. 106–107)

FRANCIS BACON (Cat. 108–109)

DAVID HOCKNEY (Cat. 110)

R. B. KITAJ (Cat. 111)

GEORG BASELITZ (Cat. 112)

LUCIAN FREUD (Cat. 113)

ANDY WARHOL (Cat. 114–115)

GERHARD RICHTER (Cat. 116–117)

CHUCK CLOSE (Cat. 118)

JOSEPH BEUYS (Cat. 119)

THOMAS RUFF (Cat. 120)

JEFF KOONS (Cat. 121)

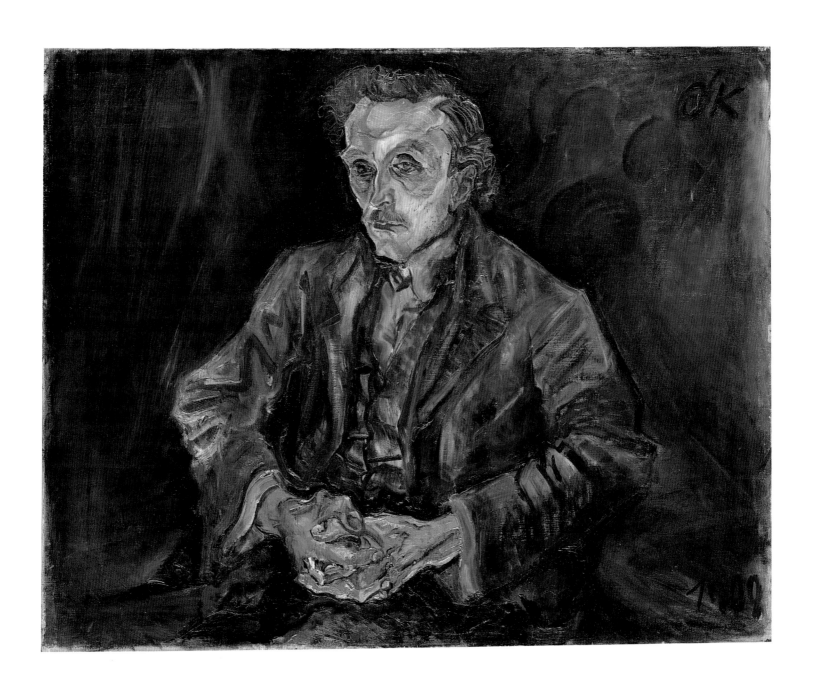

77 OSKAR KOKOSCHKA, *Portrait Adolf Loos*, 1909
Oil on canvas, 74 x 91 cm
Nationalgalerie, Staatliche Museen zu Berlin, Preußischer Kulturbesitz

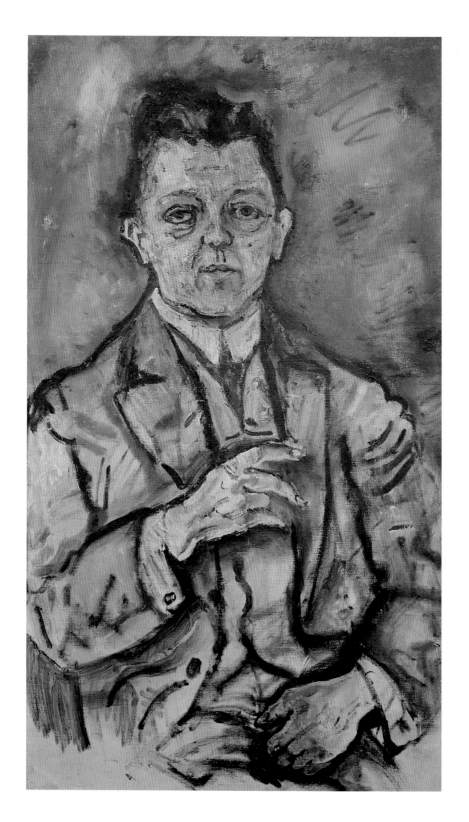

78 OSKAR KOKOSCHKA, *Portrait William Wauer*, 1910
 Oil on canvas, 94 x 53.5 cm
 Stedelijk Museum, Amsterdam

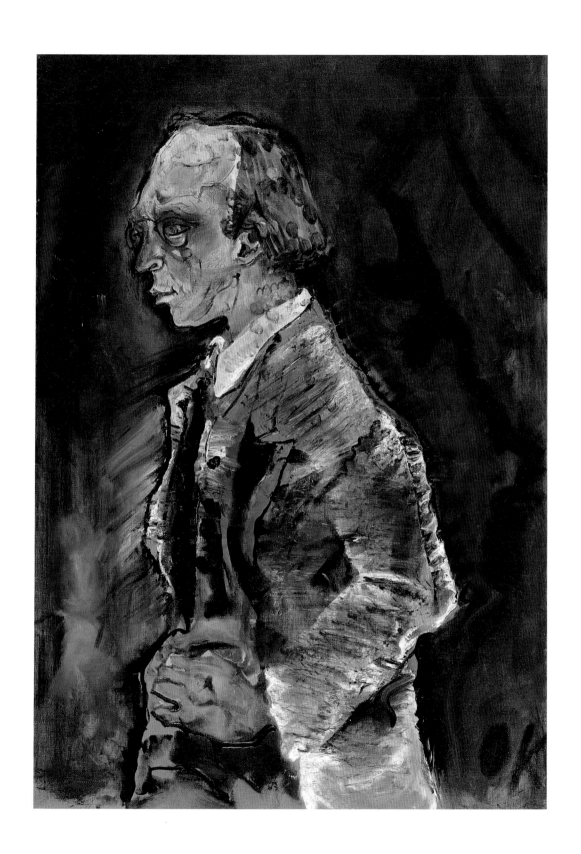

79 OSKAR KOKOSCHKA, *Portrait Herwarth Walden*, 1910
 Oil on canvas, 100 x 69.5 cm
 Staatsgalerie Stuttgart

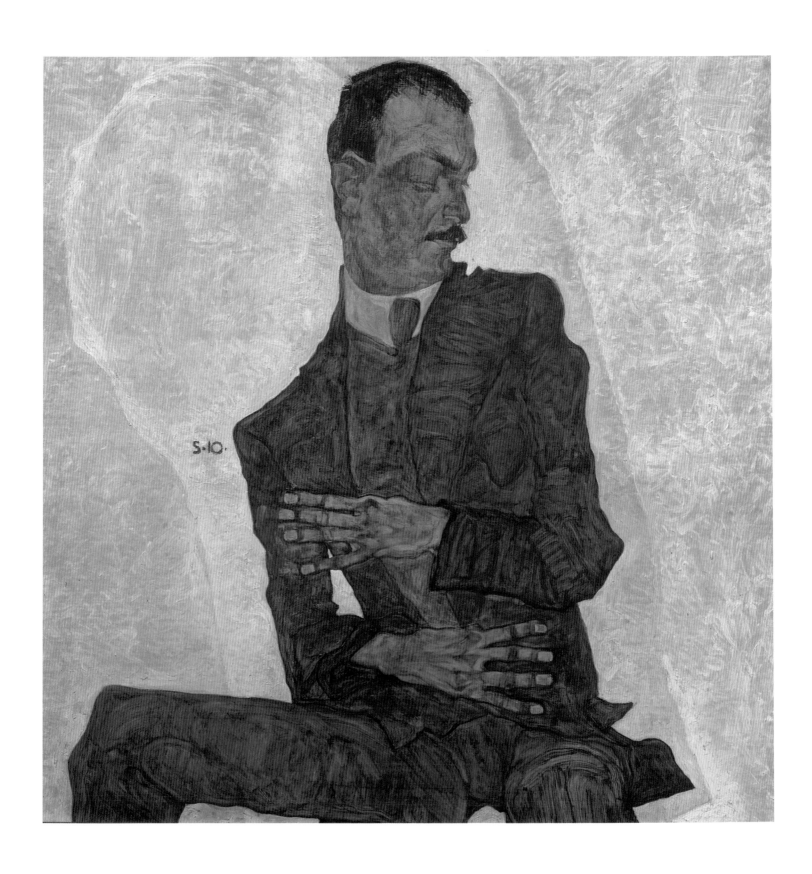

80 EGON SCHIELE, *Portrait Arthur Roessler*, 1910
 Oil on canvas, 99.5 x 100 cm
 Historisches Museum der Stadt Wien, Vienna

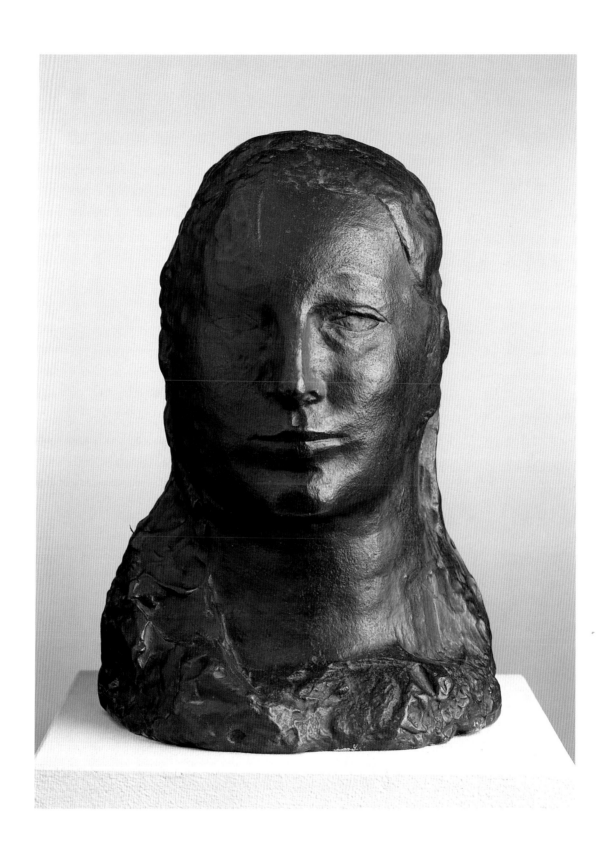

81 PABLO PICASSO, *Tête de Femme (Fernande)* / Woman's Head (Fernande), 1909
Bronze, 35.5 x 24.5 x 24.5 cm
Kunsthaus Zürich, Zurich

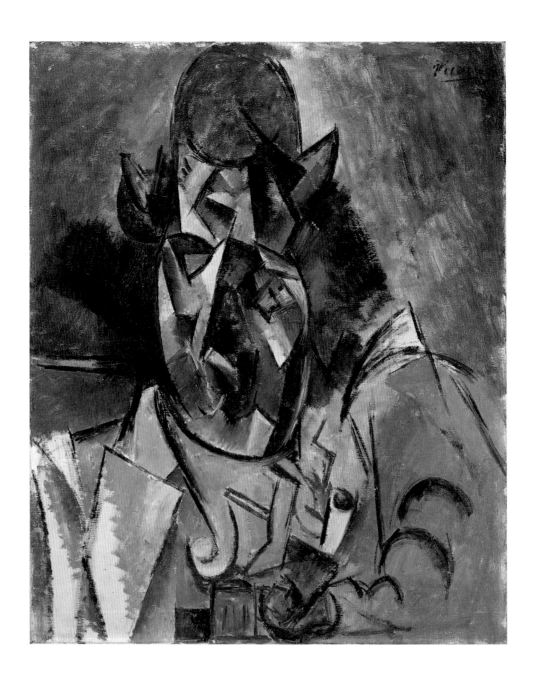

82 PABLO PICASSO, *Portrait de Georges Braque*, 1909–1910
 Oil on canvas, 61 x 50 cm
 Nationalgalerie, Staatliche Museen zu Berlin, Preußischer Kulturbesitz;
 loan of the Berggruen Collection to the Staatlichen Museen zu Berlin

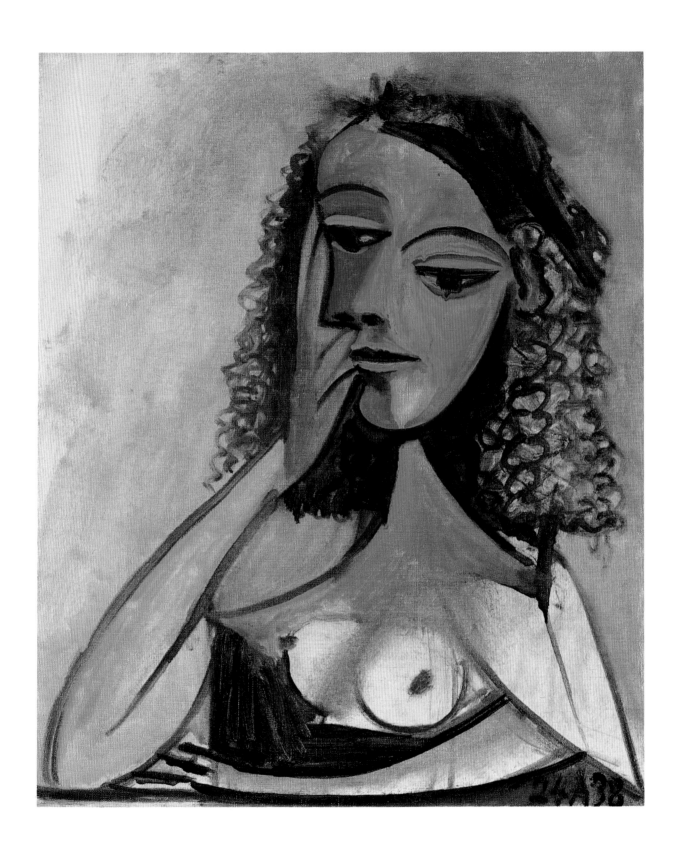

83 PABLO PICASSO, *Portrait de Nusch Eluard*, 1938
 Oil on canvas, 55 x 46 cm
 Collection A. Rosengart

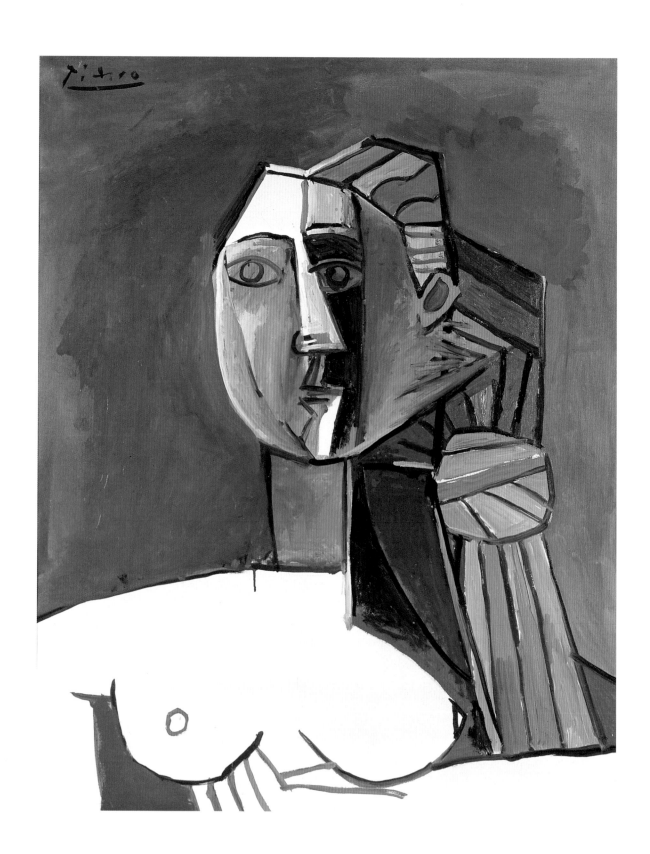

84 PABLO PICASSO, *Buste de femme (Portrait de Françoise Gilot)* /
Bust of a Woman (Portrait of Françoise Gilot), 1953
Oil on canvas, 81 x 65 cm
Collection A. Rosengart

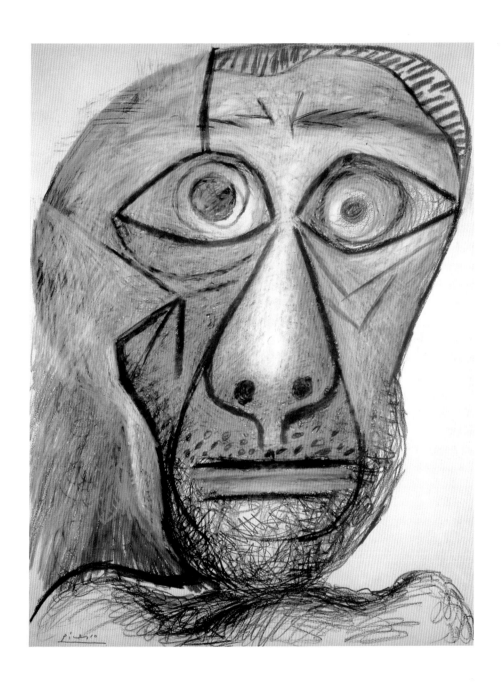

85 PABLO PICASSO, *Autoportrait* / Self-Portrait, 1972
 Crayon and coloured crayons on paper, 66 x 50. 5 cm
 Courtesy Fuji Television Gallery, Tokyo

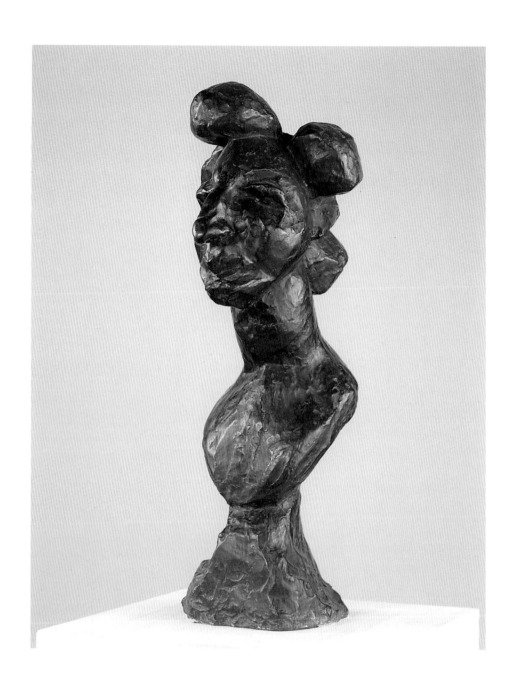

86 HENRI MATISSE, *Jeannette IV*, 1911
Bronze, 61.5 x 27.5 x 29 cm
Musée de Grenoble

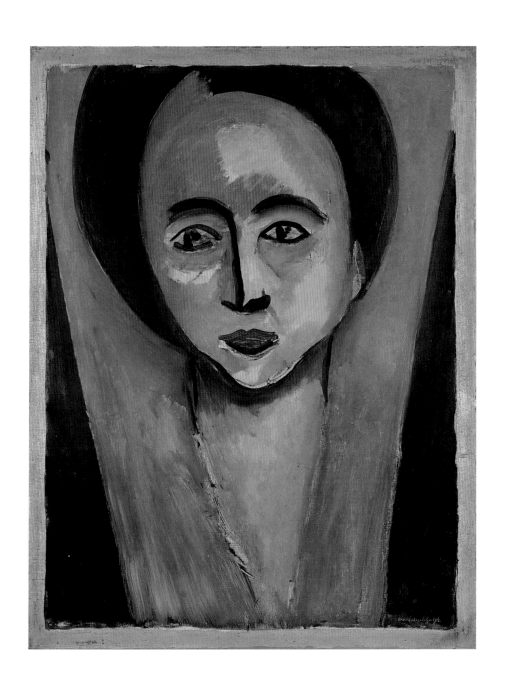

87 HENRI MATISSE, *Portrait de Sarah Stein*, 1916
 Oil on canvas, 72.5 x 56.5 cm
 San Francisco Museum of Modern Art;
 Sarah and Michael Stein Memorial Collection,
 Gift of Elise S. Haas

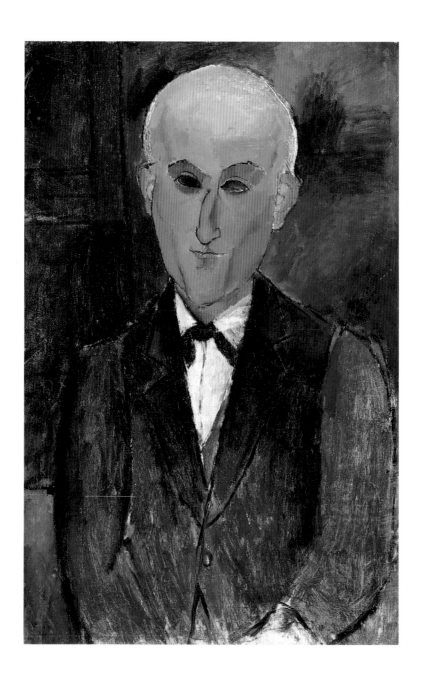

88 AMEDEO MODIGLIANI, *Portrait de Max Jacob*, ca. 1920
 Oil on canvas, 93 x 60 cm
 Cincinatti Art Museum, Gift of Mary E. Johnston

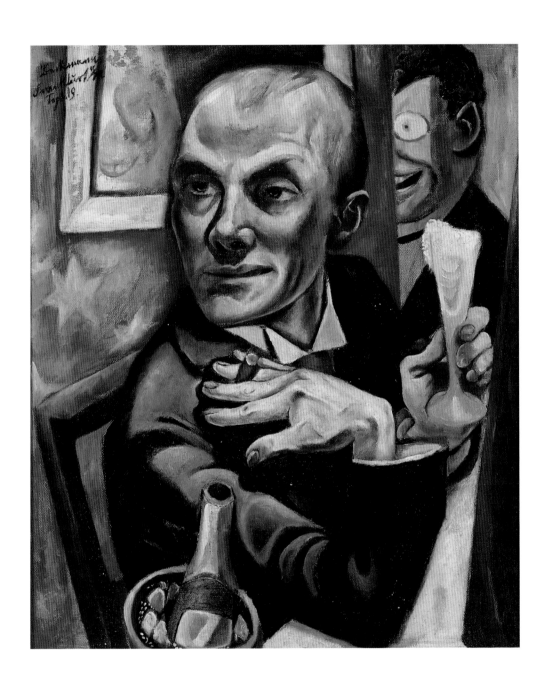

89 MAX BECKMANN, *Selbstbildnis mit Sektglas* /
Self-Portrait with Champagne Glass, 1919
Oil on canvas, 65 x 55 cm
Private collection

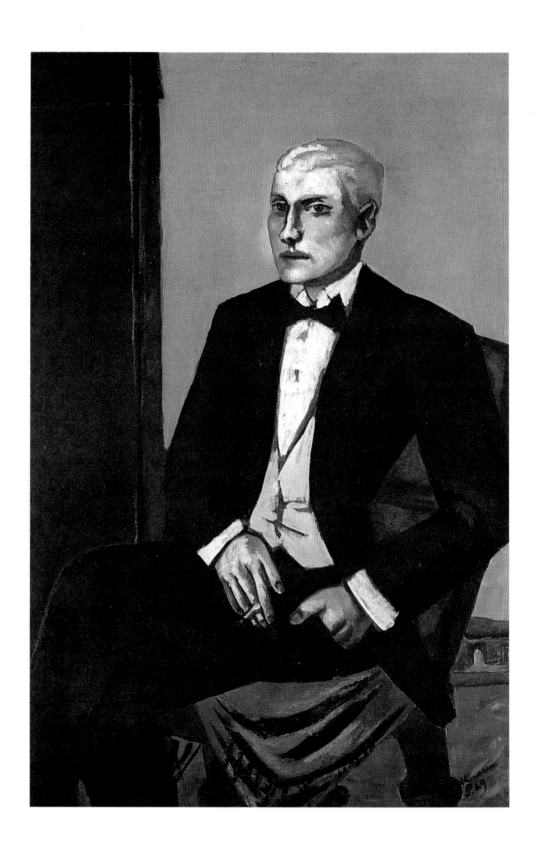

90 MAX BECKMANN, *Junger Argentinier* / Young Argentinian, 1929
Oil on canvas, 125.5 x 83.5 cm
Bayerische Staatsgemäldesammlungen, München,
Staatsgalerie moderner Kunst, Munich

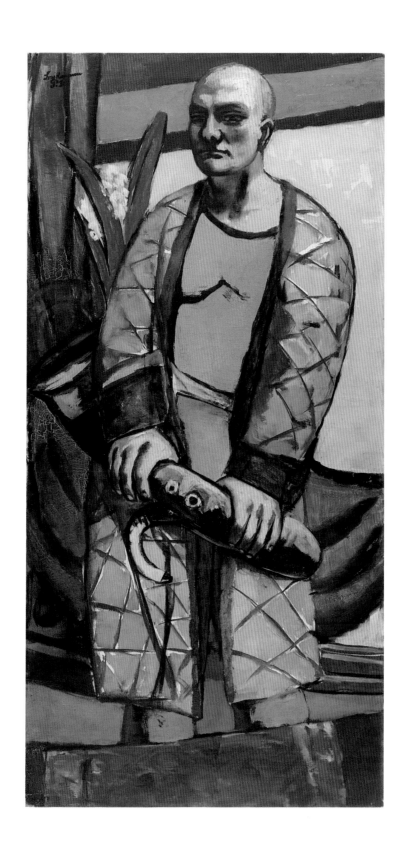

91 MAX BECKMANN, *Selbstbildnis mit Saxophon* /
 Self-Portrait with Saxophone, 1930
 Oil on canvas, 140 x 69.5 cm
 Kunsthalle Bremen

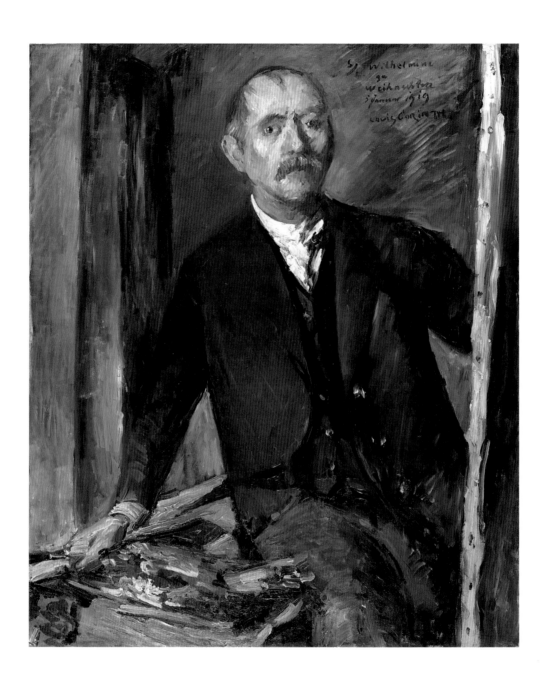

92 LOVIS CORINTH, *Selbstporträt vor der Staffelei* / Self-Portrait in front of the Easel, 1919
Oil on canvas, 126 x 106 cm
Nationalgalerie, Staatliche Museen zu Berlin, Preußischer Kulturbesitz

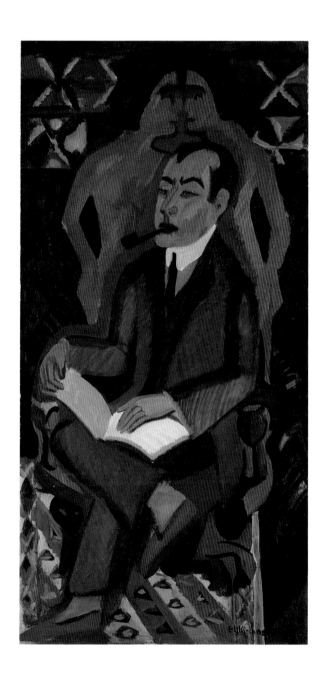

93 ERNST LUDWIG KIRCHNER, *Portrait Manfred Schames*, 1925–1932
 Oil on canvas, 151 x 75 cm
 Schleswig-Holsteinisches Landesmuseum, Schloß Gottorf,
 Donation and Collection Rolf Horn

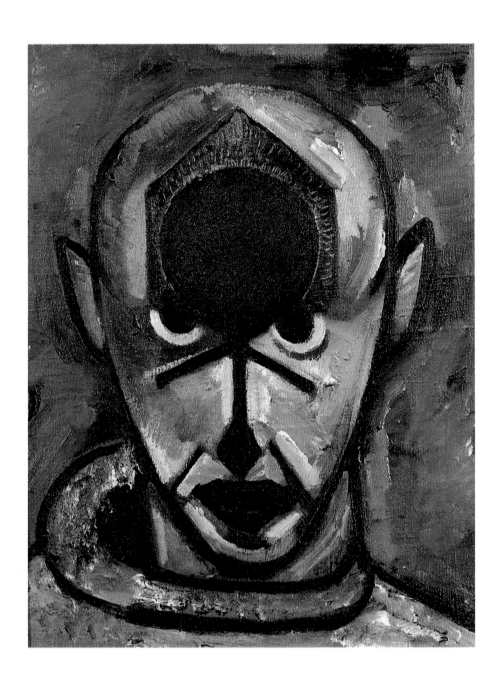

94 ALEXANDER RODCHENKO, *Selfportrait*, 1920
 Oil on canvas, 49 x 37.5 cm
 Archive of A. Rodchenko and V. Stepanova, Moscow

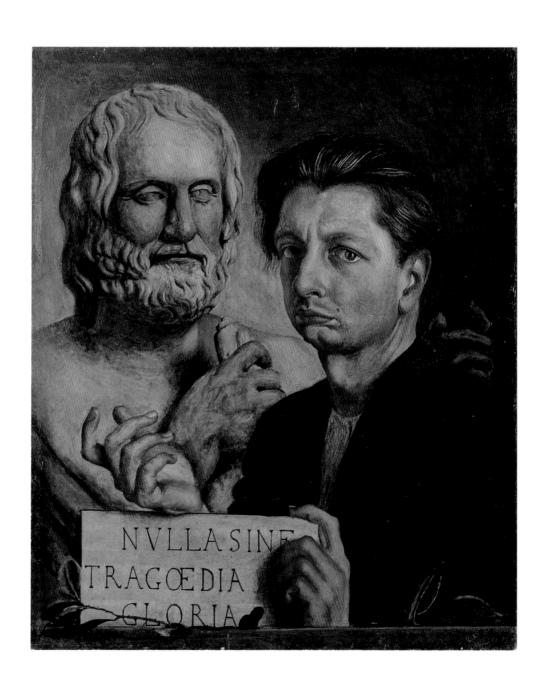

NVLLA SINE
TRAGŒDIA
GLORIA

95 GIORGIO DE CHIRICO, *Autoritratto con busto d'Euripide* /
 Self-Portrait with Bust of Euripides, 1922–1923
 Tempera on canvas, 59.5 x 49.5 cm
 Private collection, Courtesy Galleria dello Scudo, Verona

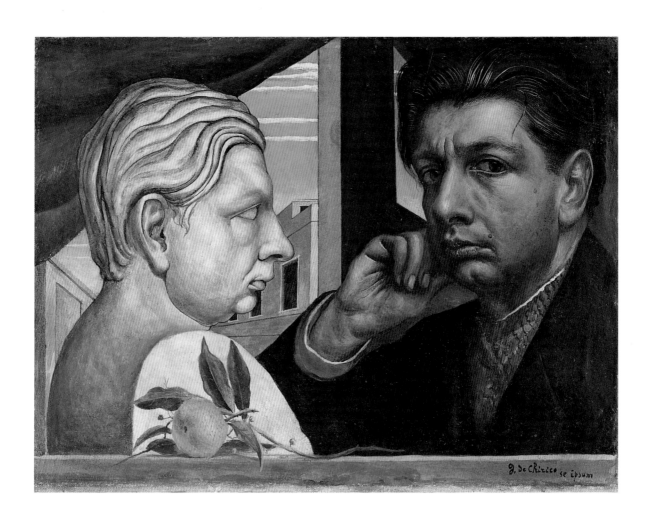

96 GIORGIO DE CHIRICO, *Autoritratto* / Self-Portrait, ca. 1922
 Oil on canvas, 38.5 x 51 cm
 The Toledo Museum of Art; Purchased with funds from the Libbey Endowment,
 Gift of Edward Drummond Libbey

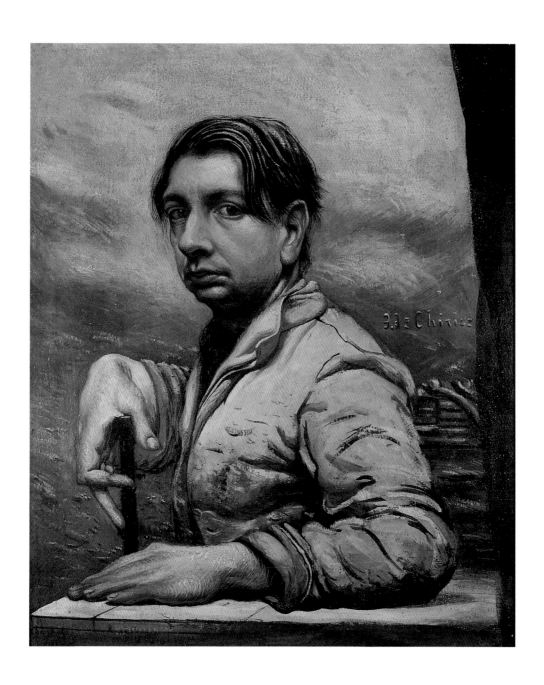

97 GIORGIO DE CHIRICO, *Autoritratto* / Self-Portrait, 1924
 Tempera on canvas, 75 x 62 cm
 Giovanni Deana Collection, Venice

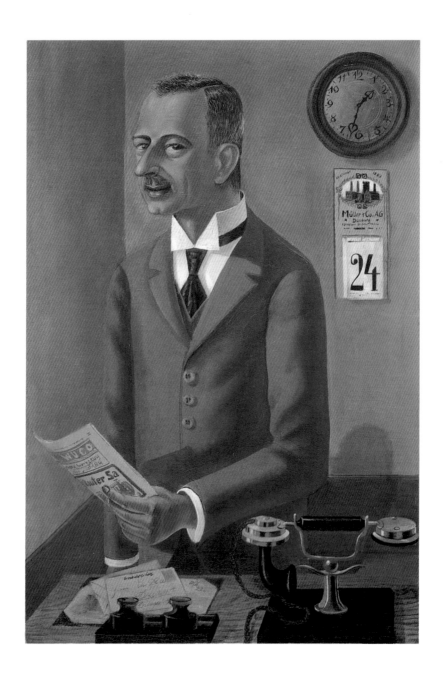

98 OTTO DIX, *Der Geschäftsmann Max Roesberg, Dresden* /
 The Businessman Max Roesberg, Dresden, 1922
 Oil on canvas, 94 x 63.5 cm
 The Metropolitan Museum of Art, New York;
 Purchase, Lila Acheson Wallace Gift, 1992

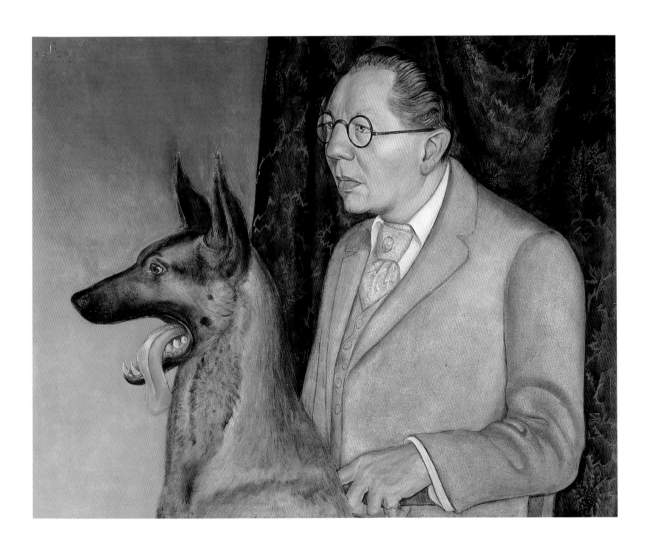

99 OTTO DIX, *Hugo Erfurth mit Hund* / Hugo Erfurth with Dog, 1926
Tempera and oil on wood, 80 x 100 cm
Fundación Colección Thyssen-Bornemisza, Madrid

100 CHRISTIAN SCHAD, *Triglion (Reichsgräfin Triangi-Taglioni)*, 1926
 Oil on canvas, 115 x 86 cm
 Private collection

101 CHRISTIAN SCHAD, *Sonja*, 1928
 Oil on canvas, 90 x 60 cm
 Nationalgalerie, Staatliche Museen zu Berlin, Preußischer Kulturbesitz

102 FRIDA KAHLO, *Autorretrato con Monos* / Self-Portrait with Monkeys, 1943
 Oil on canvas, 81.5 x 63 cm
 Collection Jacques and Natasha Gelman, Courtesy Centro Cultural/Arte
 Contemporaneo, A.C., Mexico City

103 FRIDA KAHLO, *Diego en mi pensiamento* / Diego on my Mind, 1943
 Oil on masonite, 76 x 61 cm
 Collection Jacques and Natasha Gelman,
 Courtesy Centro Cultural/Arte Contemporáneo,
 A.C., Mexico City

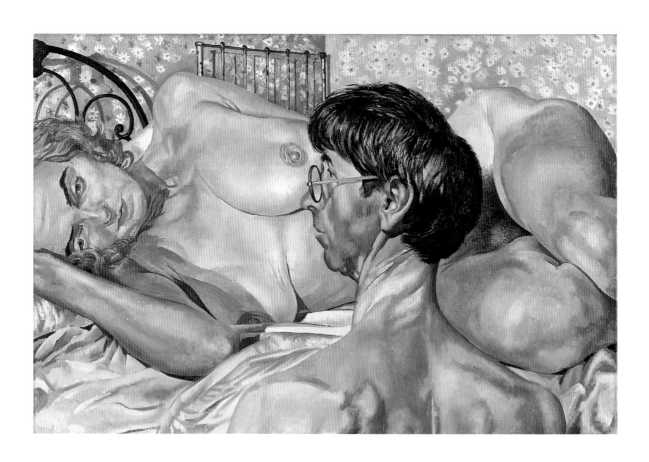

104 STANLEY SPENCER, *Self-Portrait with Patricia Preece*, 1936
 Oil on canvas, 61 x 91 cm
 Syndics of the Fitzwilliam Museum, Cambridge

105 JEAN DUBUFFET, *Bertelé bouquet fleuri, Portrait de parade* /
Bertelé as a Blossoming Bouquet, Sideshow Portrait, 1947
Oil, plaster and sand on canvas, 116 x 89 cm
National Gallery of Art, Washington D.C.;
The Stephen Hahn Family Collection (Partial and Promised Gift)

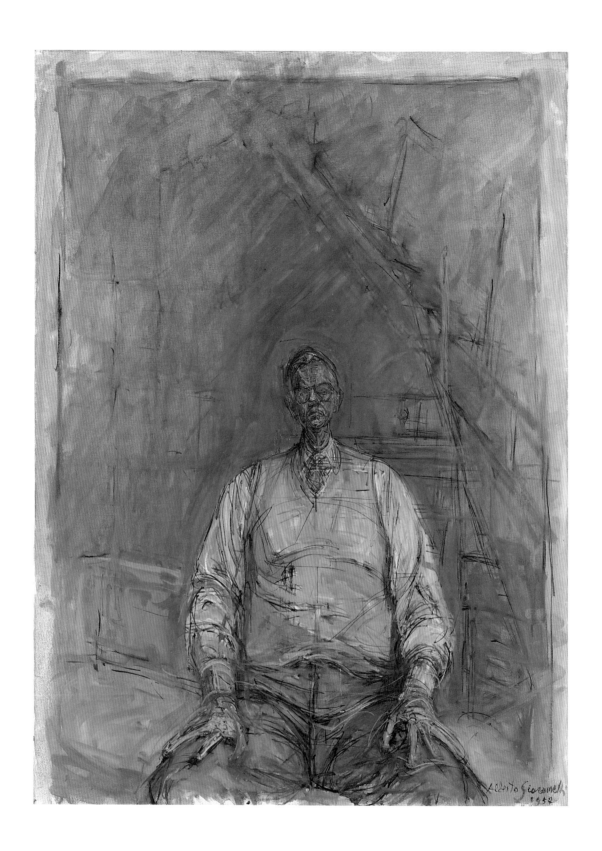

106 ALBERTO GIACOMETTI, *Portrait de G. David Thompson*, 1957
 Oil on canvas, 100 x 73 cm
 Kunsthaus Zürich, Zurich

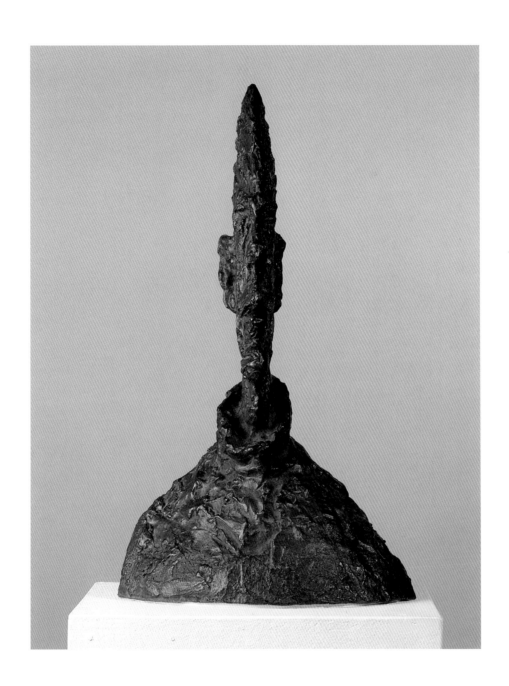

107 ALBERTO GIACOMETTI, *Grande tête de Diego /*
 Large Head of Diego, 1954
 Bronze, 65 x 39 x 22 cm
 Kunsthaus Zürich, Zurich

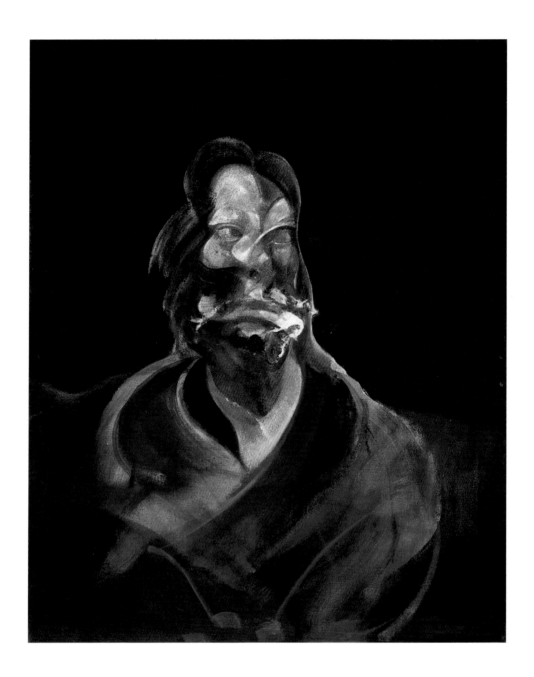

108 FRANCIS BACON, *Portrait of Isabel Rawsthorne*, 1966
 Oil on canvas, 67 x 46 cm
 Tate Gallery, London; Purchased 1966

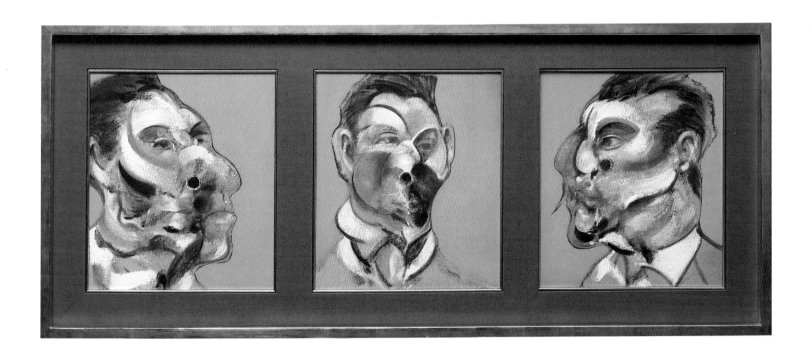

109 FRANCIS BACON, *Three Studies of George Dyer*, 1969
 Oil on canvas, 3 panels, each 36 x 30.5 cm
 Louisiana Museum of Modern Art, Humlebæk, Denmark;
 Donation New Carlsberg Foundation

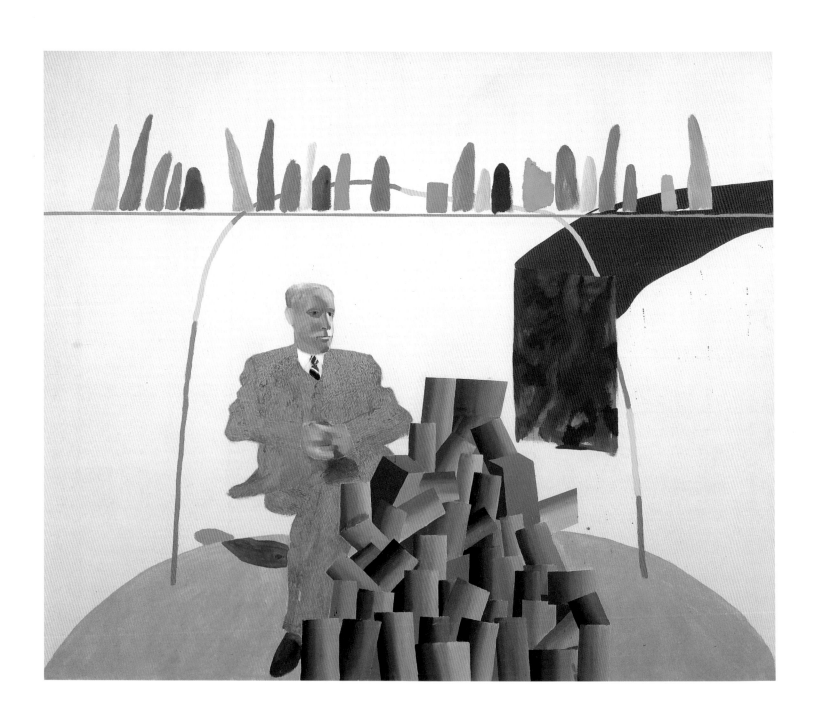

110 DAVID HOCKNEY, *Portrait Surrounded by Artistic Devices*, 1965
 Acrylic on canvas, 152.5 x 183 cm
 Arts Council Collection, Hayward Gallery, London

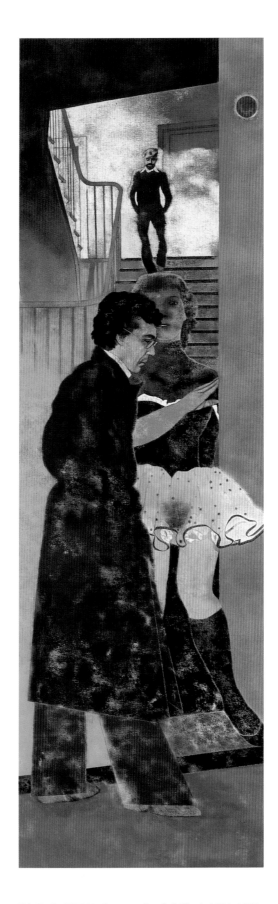

111 R. B. KITAJ, *Smyrna Greek (Nikos)*, 1976–1977
Oil on canvas, 244 x 76 cm
Fundación Colección Thyssen-Bornemisza, Madrid

112 GEORG BASELITZ, *Dreieck zwischen Arm und Rumpf* /
Triangle between Arm and Body, 1973
Oil on canvas, 250 x 180 cm
Galerie Thomas, Munich

113 LUCIAN FREUD, *The Painter's Mother*, 1982–1984
Oil on canvas, 105.5 x 127.5 cm
James Kirkman Ltd., London

114 ANDY WARHOL, *Self-Portrait*, 1967
Acrylic on canvas, 183 x 183 cm
Bayerische Staatsgemäldesammlungen, München,
Staatsgalerie moderner Kunst, Munich

115 ANDY WARHOL, *Robert Mapplethorpe*, 1983
 Acrylic and silkscreen ink on canvas, 101.5 x 101.5 cm
 Collection of the Andy Warhol Foundation for the Visual Arts, Inc.

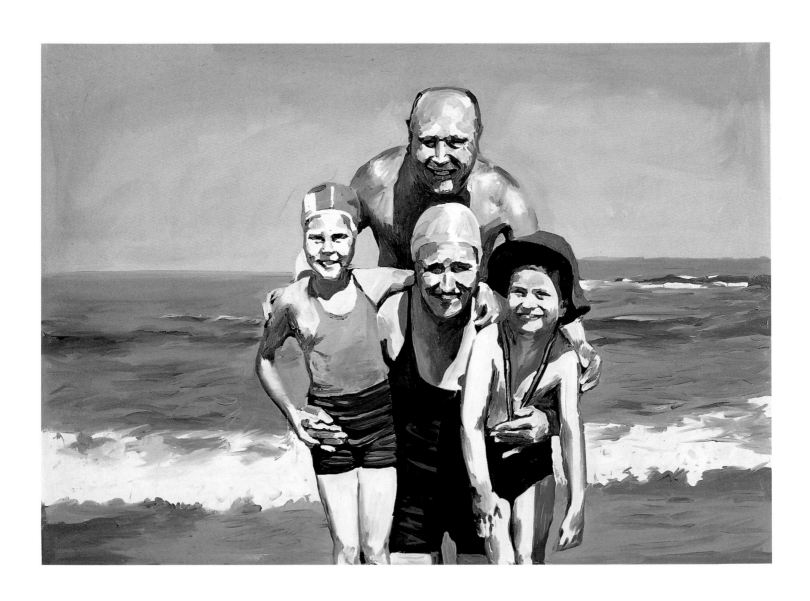

116 GERHARD RICHTER, *Familie am Meer* / Family at the Seaside, 1964
Oil on canvas, 150 x 200 cm
Kunstmuseum Bonn; on permanent loan from the Grothe Collection

117 GERHARD RICHTER, *Portrait Kühn*, 1970
 Oil on canvas, 2 panels, each 60 x 50 cm
 Private collection, Courtesy Massimo Martino S.A., Mendrisio

118 CHUCK CLOSE, *Mark*, 1979
 Acrylic on canvas, 275 x 213.5 cm
 Private collection, Courtesy PaceWildenstein

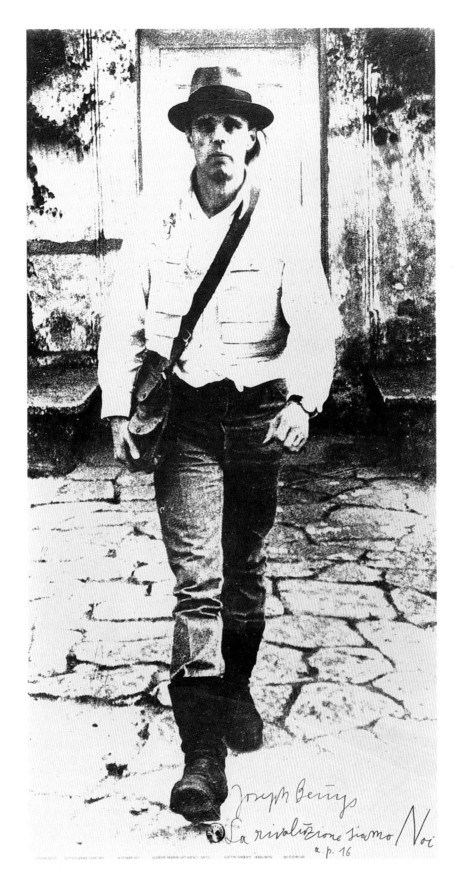

119 JOSEPH BEUYS, *La rivoluzione siamo Noi /*
We are the revolution, 1972
Blueprint on polyester foil, 191 x 100 cm
Edition Staeck

120 THOMAS RUFF, *Portrait (Sabine Weirauch)*, 1988
 Colour photograph, 205 x 166 cm
 Collection of the artist

121 JEFF KOONS, *Self-Portrait*, 1991
 Marble, 95 x 52 x 37 cm
 Caldic Collection, Rotterdam

Abstraction – Spirituality

ANNA MOSZYNSKA

Purity and Belief: The Lure of Abstraction

Over the past century, the lure of abstraction has proved hard to resist. The urge to withdraw from the world of appearances, to strip away and reach an essence, has proved so strong that even now, at the century's end, artists still find the challenge of abstraction hard to ignore. Yet the capacity to grasp purity or essence has proved as persistently elusive as the terminology which frames it. Abstract art often defies the interpretative possibilities of language. Being difficult to pin down, it is either seen as abstruse and obdurate, and discussed only in terms of its formal appearance; or alternatively, attention is focussed on the larger implications of the work, which are hinted at in a segregated body of artists' statements and texts. Either way, the history of abstraction can be read as a series of attempts to deal with its closed self-referentiality, as well as a search for formal expression which goes beyond the limits of representation.

Looking back from the end of the century, it seems possible to isolate three key periods in which abstraction played a particularly vital role in the development of western art: roughly 1910–30 in Europe; 1940–50 in America; and 1955–70 on both sides of the Atlantic. Yet despite the inevitable differences between countries, periods and media implied by such an account, there is a remarkable, underlying unity to the abstract works in this exhibition. What we are looking at here is a particular historical 'moment': the major constitutive part of the project of modernism where individual claims of both periodicity and teleology can be collapsed.[1] This essay identifies a number of interlocking themes which also suggest a sense of continuity across the modernist period: new beginnings and the sense of ending; calls for purity and spirituality; the challenge of space; and, finally, the question of presence versus transcendence.

New Beginnings and the Sense of Ending

The notion of a new beginning within artistic practice was announced far in advance of the first abstract painting. The possibility of a non-representational form had been anticipated in discussion of music and literature within early Romanticism, but the presage of the new in fine art is particularly to be found filtering through the channels of Symbolism during the final decades of the nineteenth century. In Symbolist thought, which owed much to Platonic idealism, forms and colours were intended to communicate directly with the spectator without the intermediary of literary forms; so for Albert Aurier writing on Gauguin in 1891, 'The normal and final end of painting as well as the other arts can never be the direct representation of objects. Its aim is to express Ideas by translating them into a special language'.[2] Yet it was to be a further twenty years before

1 See Arthur C. Danto, 'Post-Historical Abstract Painting', in *Tema Celeste*, no. 32–33, autumn 1991, pp. 54–5, first of a three-part enquiry 'The New Forms of Abstraction'. See also the various viewpoints in *Abstraction*, ed. Andrew Benjamin, *Journal of Philosophy and the Visual Arts*, no. 5 (special issue), London, 1995.

2 Albert Aurier, 'Symbolism in Painting: Paul Gauguin' (1891), in *Theories of Modern Art: A Source Book by Artists and Critics*, ed. Hershel B. Chipp, Berkeley and Los Angeles, 1968, p. 90.

artists began to make real headway into fully abstract painting. Even then the move towards a completely new language of forms was surprisingly slow to emerge in the pioneering work of Kandinsky, Mondrian and Malevich (and also that of Delaunay and Kupka). There was a fear of rushing it – of succumbing to the lure of abstraction, without fully understanding its ramifications. Thus Mondrian's transition from Cubism to 'purely plastic' expression was painfully slow. His *Composition* (1916) was one of only two paintings produced over a period of two and a half years, from the summer of 1914 to the end of 1916, as he struggled with the implications of leaving behind the illusions of the real world, in favour of reaching a purity of form (Fig. 1).[3] For Mondrian, Neo-Plasticism was both completely new – a break – but also a necessary outcome of art's evolution.

Fig. 1 Piet Mondrian, *Composition*, 1916. Solomon R. Guggenheim Museum, New York

A similarly Hegelian notion of progression underscores Kandinsky's claim that abstraction 'was in no way the rejection of all kinds of harmony and beauty but was their organic, immutable and natural continuation'.[4] At the same time, Kandinsky's paintings of 1913 show considerable concern with rupture. The abstract forms of *Composition VI* (Cat. 122) are based on the earlier glass painting *Sintflut (zu Komposition VI)*, whose title translates as 'Flood', in the Biblical sense (Fig. 2). Although only vestiges of the earlier deluge imagery appear (references can be made to a coracle form in the lower left), the issue at stake in the oil painting is one of catastrophe that both presages an end and announces a beginning. The apocalyptic and eschatalogical notion of the deluge as purging process endemic to the work is clarified in Kandinsky's own comment that *Composition VI* sounded 'the hymn of that new creation that follows upon the destruction of the world'.[5]

Fig. 2 Wassily Kandinsky, *Sintflut (zu Komposition VI)*, 1911. Lost

The idea of the very new linked to the very old re-emerges in other ways throughout the history of abstraction. Brancusi's egg form, which constitutes the formal basis of *Sleeping Muse* (1917–18), occurs in other works as the trope of the cry of the newborn child (Cat. 153). The return to origins suggests a return to birth with Brancusi: the formation of the new points to a cycle of regeneration epitomised in the repeating pods of the *Endless Column* (1st version, 1918) (Fig. 3). As Brancusi's use of carved bases attests, the appeal of elemental form could also find its justification in the 'primitive' – a dominant source for much modernist sculpture in the first decades of the century, as can be seen in the figurative imagery of Picasso, Henri Gaudier-Brzeska and Jacob Epstein, as well as in the more abstracted works by Henry Moore and Barbara Hepworth. The appeal of the 'primitive' is an issue which stretches far wider than the ambit of the purely abstract. Yet the call to begin again 'from scratch' – to return to origins – echoes repeatedly down the century in both the practice and theory of abstraction.

What seems clear is that abstract art flourishes under the threat of apocalypse. It is no coincidence that two of its dominant periods coincide with the eras of two world wars and the Russian revolution. In Europe, Kandinsky's apocalyptic painting and Mondrian's desire for utopia frame either side of the First World War, just as the development of Abstract Expressionism in America takes its place in the context of the Second

3 The starting point of *Composition* was the church tower in Domberg. Gradually the details were eliminated until all that was left in the final sketch were intimations of the arched windows and graduated buttresses. All Gothic detailing was then subsequently omitted from the final painting.
4 Wassily Kandinsky, 'Whither the New Art?' (Odessa, 1911), reprinted in *Wassily Kandinsky: Collected Writings on Art*, ed. Kenneth C. Lindsay and Peter Vergo, London, 1982, vol. I, p. 102.
5 Wassily Kandinsky, *Kandinsky 1901–1913* (Berlin, 1913), trans. as 'Reminiscences/Three Pictures', in *Kandinsky: Collected Writings* (as note 4), p. 388. For further discussion of the apocalyptic strain in Kandinsky's work, see Sixten Ringbom, *The Sounding Cosmos*, Åbo, 1970.
6 Barnett Newman, 'Response to Reverend Thomas F. Mathews' at the First International Congress on Religion, Architecture and the Visual Arts, New York, 1967, in *Barnett Newman: Selected Writings and Interviews*, ed. John P. O'Neill, New York, 1990, p. 287.

Fig. 3 Constantin Brancusi, *La Colonne sans fin* (Endless Column), 1920. Musée National d'Art Moderne, Centre Georges Pompidou, Paris

Fig. 4 Barnett Newman, *Pagan Void*, 1946. Collection of Annalee Newman, New York

7 Mark Rothko and Adolph Gottlieb, 'The Portrait and the Modern Artists', script of broadcast at WNYC, 13 October 1943. For recent examination of the American search for new beginnings and for discussion of other ideas in this essay, I am indebted to David Anfam. See his 'Beginning at the End: The Extremes of Abstract Expressionism', in *American Art in the Twentieth Century*, ed. Christos M. Joachimides and Norman Rosenthal, exh. cat., London, Royal Academy of Arts, (Prestel) Munich, 1993, pp. 85–91.

8 Quoted by Harold Rosenberg, *Barnett Newman*, New York, 1978, p. 41.

9 Jackson Pollock from an interview with William Wright (pub. 1958), in *Jackson Pollock: Catalogue Raisonné of Paintings, Drawings, and Other Works*, eds. Francis V. O'Connor and Eugene V. Thaw, New Haven, 1978, vol. 4, p. 238.

10 From Bruce Glaser: 'Questions to Stella and Judd', *Art News*, vol. 65, no. 5, September 1965, reprinted in *Minimal Art: A Critical Anthology*, ed. Gregory Battcock, New York, 1968, reprinted Berkeley and Los Angeles, 1995, p. 150.

World War. In periods of dramatic turmoil, artists were driven to search for meaning in what appeared to be a meaningless world dominated by human atrocity. It was Barnett Newman who expressed the need to begin again 'from scratch'. For him, response to 'the moral crisis of a world in shambles' involved a 'moral crisis in relation to what to paint',[6] and the immediate answer was a return to primal origins. Spermatazoa penetrate an egg in *Pagan Void* (1944) (Fig. 4), while various drawings from 1944–46 display a circular form in the midst of veiled darkness. An abiding reference is to the very beginning of the world itself, to the biblical Book of *Genesis*: the separation of all matter and the division of the universe into light and darkness. Here, in plasmic chaos, there is yet hope of order, and its discovery in painterly terms leads Newman on to what is surely the significance of *Onement I* (1948) and other zip paintings with their resonant titles, like *The Command* (1946) and *Day One* (1951–2). These reflect back, later in the artist's career, to the moments of creation and to the will of the creator. Abstraction, seen this way, appears to be about absolutes and fundamentals – not an esoteric art, but a transcendent one.

For many of the Abstract Expressionists in the early 1940s, a particularly Nietzschean impulse spurred a return to other beginnings: to archaic art, as this seemed to deal with the symbols of 'primitive fears and motivations' which they felt mirrored the anxiety of their own age.[7] Native American Indian art provided an indigenous model – for as Newman pointed out, these artists were able to use a geometric shape, not as a representation of a head or a torso but as 'a magically active "vehicle" which carries awesome feelings.'[8] Pollock also paid allegiance here: his 'drip' technique owes as much to the example of the Native American sand painters of the West as it does to contemporary experimenters such as David Alfaro Siqueiros and Hans Hofmann or to the small-scale swirls of Janet Sobel. His own claim to newness was nevertheless evocatively made in a radio interview in 1951: 'It seems to me that the modern painter cannot express the age, the airplane, the atom bomb, the radio in the old forms of the Renaissance, or of any other past culture. Each age finds its own technique.'[9] Yet his artistic practice was embedded in ancient tensions understood by Nietzsche: Dionysian primal energy is unleashed via the thrown paint, even though the final result suggests a compensatory Apollonian control (Cat. 163, 164 and 166). Beginning and end, chaos and order are held in tandem, as surface tension is pushed to the utmost and yet saved from confusion. Pollock's 'drip' paintings, while having none of Kandinsky's vestigial figural references, are still indexed to the body's energies and show how abstraction always works with reference to something else. As cognitive psychologists and phenomenologists such as Maurice Merleau-Ponty and Gaston Bachelard have argued, image-making is always in some way referential.

Part of the American quest for newness was also a rhetoric of dismissal of all earlier work, and this continue into the 1960s, when subsequent artists repudiated both Abstract Expressionism and European geometric composition. On this last matter, Donald Judd was particularly forthright: 'It suits me fine if all that's down the drain', as he found 'pretty objectionable' the effect of 'order and quality' that 'traditional European painting had'.[10] Instead, Minimalism offered what Frank Stella called 'nonrelational' art: where

there was to be no sense of trying to relate parts to the whole in a complex if balanced relationship, but instead a simple gestalt: 'a definite *whole* and maybe no parts, or very few'. (Judd)[11] Yet despite the rejection of past art in this uncompromising search for simple, unadulterated form, the Minimalist quest for purity and unity (whatever the ultimate phenomenological experience for the viewer) ultimately derives from Plato.[12] Moreover, for all the rhetoric, Stella's black canvases, such as *Getty Tomb* (1959), present a variation of the European monochrome, as seen in the work of Rodchenko, for example (Cat. 162). Although, in Stella's painting, we find not a totally undifferentiated surface but a regulated, biaxially symmetrical, linear and minimally patterned one, his contribution to newness is not in the conception of the canvas as almost uniform, but in its uncompromising repudiation of facture and illusionistic depth, on an enormous scale.

If the rhetoric of new beginnings is recurrent, so also is the notion of the 'end of painting' which surfaces repeatedly through the history of abstraction. This idea goes back to Russia immediately after the Revolution, in the first explorations of the monochrome by Kazimir Malevich, with his 'White on White' paintings of 1918 (Cat. 131).[13] Produced as part of his Suprematist project, these paintings were a logical extension to the spiritual concerns of his work. But Alexander Rodchenko, in turn, reacted strongly against this. Not only did he countermine them with his own 'Black on Black' paintings (1918) (Cat. 142), which like Malevich's 'White on White' series still contained a discernible abstract shape of a uniform colour, but he also went on to produce three pure monochromes for exhibition in 1921 (Cat. 143). Of these, he later proclaimed,

> I reduced painting to its logical conclusion and exhibited three canvases: red, blue and yellow. I affirmed: It's all over. Basic colors. Every plane is a plane, and there is to be no more representation.[14]

Following this gesture, Rodchenko gave up painting entirely and moved over to productivist design.

The fascination of the monochrome is that, despite the similarity of formal appearance (a canvas covered with a single colour), the artists who actively engaged with it at different points in their career (besides Malevich and Rodchenko, these include Strzeminski, Rauschenberg, Reinhardt, Kelly, Fontana, Klein, Manzoni, Mack, Uecker, Ryman, Armando and Charlton) did so with significantly different agendas. With Malevich and others, one can find a metaphysical dimension behind the endeavour (underpinned by a quest for purity, at the very least), while with Rodchenko, Rauschenberg and Ryman there is an inverse desire to repudiate all such claims, in favour of what Robert Storr has called in Ryman's work 'a total concentration on the sensory fact'.[15] Further readings of the monochrome point to wider concerns about painting itself. Yve-Alain Bois, for instance, has suggested that Rodchenko's gesture showed that painting could have a real existence only if it claimed its end, while Ryman, he asserts, is not a postmodernist but 'the guardian of the tomb of modernist painting, at once knowing of the end and also knowing the impossibility of arriving at it without working it through'.[16] If Bois' tone sounds apocalyptic, it needs to be recognised that the whole history of modernist

11 Ibid., p. 149, p. 154.
12 For Plato, absolute and natural beauty was to be found in 'something straight or round and what is constructed out of these with a compass, rule and square, such as plane figures and solids'. From Plato, *Philebus*, trans. Dorothea Frede, Indianapolis and Cambridge, Mass., 1993, p. 60.
13 In fact, the very first monochrome as such was shown in Paris in 1883 as an anarchistic gesture by the painter, Alphonse Allais (1855–1905) in the annual exhibition of 'Art Incohérent', where he installed a large white piece of paper entitled *First Communion of Anaemic Young Girls in the Snow*. He went on in a similar vein to show two further monochromes the following year. See *Post Impressionism: Cross Currents of European Painting*, exh. cat., London, Royal Academy of Arts, 1979, p. 26, entry no. 2.
14 Alexander Rodchenko, 'Working with Maiakovsky' (1939), quoted by Yve-Alain Bois, 'Painting: The Task of Mourning', in Bois, *Painting as Model*, Cambridge, Mass., and London, 1990, p. 238.
15 Robert Storr, *Robert Ryman*, exh. cat., London and New York, Tate Gallery and Museum of Modern Art, 1993, p. 238.
16 Bois (as note 14), p. 232. See also Thierry de Duve's 'The Monochrome and the Blank Canvas' in his book of essays, *Kant after Duchamp*, Cambridge, Mass., and London, 1996, pp. 199–279.

Fig. 5 Page from Stéphane Mallarmé,
Un coup de dés jamais n'abolira le hasard

17 See Stéphane Mallarmé, 'Un coup de dés jamais n'abolira le hasard', Mallarmé, *Œuvres complètes*, Paris, 1945, especially p. 457 (see above Fig. 5). For further discussion of Mallarmé on this matter, see Dee Reynolds, *Symbolist Aesthetics and Early Abstract Art*, Cambridge, Mass., 1995.

18 Mallarmé, 'Sur Poe', ibid., p. 872. Quoted by Frederick A. Karl, *Modern and Modernism. The Sovereignty of the Artist. 1825–1925*, New York, 1985, p. 16.

19 Jean-François Lyotard, 'The Sublime and the Avantgarde', in *The Lyotard Reader*, ed. Andrew Benjamin, Oxford and Cambridge, Mass., 1989, pp. 206–7.

20 Jean-François Lyotard, 'Newman: The Instant', ibid., p. 241.

21 Wassily Kandinsky, 'On the Question of Form' (1912), in *Kandinsky: Complete Writings* (as note 4), p. 256, and Kazimir Malevich, 'From Cubism and Futurism to Suprematism: The New Painterly Realism' (3rd ed., 1916) in *Russian Art of the Avant-Garde. Theory and Criticism 1902–1934*, ed. John E. Bowlt, rev. ed., London, 1988, p. 118.

22 Quoted in Mark A. Cheetham, *The Rhetoric of Purity: Essentialist Theory and the Advent of Abstract Painting*, Cambridge, Mass., 1991, p. 110.

23 See Roger Lipsey, *An Art of Our Own: The Spiritual in Twentieth Century Art*, Boston, 1988; Maurice Tuchman et al, *The Spiritual in Art. Abstract Painting 1890–1985*, exh. cat., Los Angeles County Museum of Art, (Abbeville Press) New York, 1986.

24 Wilhelm Worringer, *Abstraction and Empathy: A Contribution to the Psychology of Style* (1908), trans. Michael Bullock, New York, 1953, repr. 1980, p. 133.

abstraction has this dimension inherent within it. Ironically, despite the calls for an end to painting, this end is constantly deferred.

The implied blankness of the monochrome also leads to a fascination with the void – a concern already anticipated by the Symbolist poet, Stéphane Mallarmé, whose 'page blanche', or empty page, represents absolute emptiness upon which the poet and the mathematician can only speculate (Fig. 5).[17] The analogy to art is that the emptiness which embraces us on the blank page is the spectre in abstraction: something which is both there and not there, something irreducible to a material substance – an interest in 'significant silence'[18], which is traceable from Mallarmé to Brice Marden. It is precisely the difficulty of pinning down the spectre which haunts the discourse of abstract art. Jean-François Lyotard indicates this when he suggests that 'the art object no longer bends itself to models but tries to present the fact that there is an unpresentable'. He notes how the very 'task of having to bear witness to the indeterminate carries away, one after another, the barriers set up by the writings of theorists and by the manifestos of the painters themselves'.[19] Thus, he argues, the problem when confronting the works of Newman is 'What can one say that is not given?' The best gloss consists not of description but of an exclamation of surprise, 'Ah, look at that': expressions of 'a feeling of "there" (voilà)'.[20] It is this feeling which Lyotard defines as the sublime.

In Search of the Spiritual

One of the prime motivations behind the development of abstraction was the strong desire of many artists to turn away from the world of things – condemned by Kandinsky as 'the soulless material life' of the nineteenth century and, by Malevich, as the mundane, artistic inheritance of 'the *rubbishy slough of academic art*'.[21] Banishing references to wordly materialism became a central goal for abstract artists and it led both to a search for formal purity and to consideration of ways of expressing the inner spirit. Underpinning this quest lay the major crisis of religious belief. The shift towards pragmatism and positivism, which had marked much philosophical and intellectual enquiry during the nineteenth century, also stimulated the quest for spiritual meaning in the twentieth.

Yet where was a model to be found for the visual arts in a post-Nietzschean world, where God was declared dead and conventional Christianity moribund? This dilemma was not confined to painting and sculpture, for, as George Steiner put it in 1974, 'The political and philosophic history of the West during the past 150 years can be understood as a series of attempts to fill the … emptiness left by the erosion of theology and other explanatory systems'.[22] In fact, there was no shortage of options and spirituality, in its widest sense, became for many artists the backbone of their pursuit of abstraction, which offered an ideal vehicle to express the unceasing human quest for transcendence.[23] As Wilhelm Worringer put it, in 1908, 'the soul knows here *only one* possibility of happiness, that of creating a world beyond appearance, an absolute, in which it may rest from the agony of the relative'.[24] For others (including Tatlin, Rodchenko, Tinguely, Judd and Stella), such dependence on the spiritual would be viewed as anathema.

Kandinsky and Mondrian called upon a wide range of philosophical sources to underpin their venture into non-representational art. They were also deeply influenced by the quasi-religious teachings of the Theosophists[25] among others, and by their own religious upbringings (Kandinsky in the Russian Orthodox faith and Mondrian as a Calvinist). Mondrian's writings are full of references to the 'pure', to the 'universal,' and to the notion of 'objective vision'. His abiding interest in the terminology of the absolute, as expressed in Platonic thought and nineteenth-century idealist philosophy, is inevitably reflected in his art. The strong accent of the bold, black intersecting lines in his compositions of the 1920s and 1930s, the clarity and brilliance of the bounded white rectangles and squares and the isolated, yet resonant, carefully balanced areas of primary colours present us with classic examples of Mondrian's Neo-Plasticism (Cat. 150–152). Counterposed to areas of pure white on the canvas, the relation of the crossing lines suggests a reassuring stability – a sense of 'repose' within the composition, obtained by the perpendicular crossing of the verticals and horizontals. The resulting harmony can be traced to rationalist philosophy, to mysticism, or to geometry.

Mondrian's statement that: 'Art – as one of the manifestations of truth – has always expressed the truth of oppositions; but only today has realized this truth in its *creation*',[26] echoed the Hegelian notion that spirit was essentially rational and its structure dialectical. However, following the more mystical strain of Theosophy (of which Mondrian was equally aware), the vertical line, according to Madame Blavatsky, could also be equated with the 'male principle' and the horizontal with the 'female principle', while the cross formed by the intersection of the two lines expressed the single, mystical concept of life and immortality. When the cross was inscribed within the perfect square it was 'the basis of the occultist' for 'within its mystical precinct lies the master key which opens the door to every science, physical as well as spiritual'.[27] In terms of geometry, Mondrian acknowleged Aristotle's notion of the absoluteness of mathematics in his own essay, 'The New Plastic in Painting' (1917) but in practice, he only used geometry as a bridge towards the emotive or transcendental. The fact that Mondrian guided his gridded lines intuitively and adjusted them visually, in the act of painting, was overlooked by later critics who stressed the rigidity of geometric abstraction at the expense of its spiritual potential.[28]

What is essential to an understanding of the spiritual in early twentieth-century art is the contribution of colour. In his influential book, *On the Spiritual in Art* (1912), Kandinsky discussed colour's physical and psychological effect, suggesting that the 'harmony of colours can only be based upon the principle of purposefully touching the human soul'.[29] For him also Theosophy provided a key. In Rudolf Steiner's *Theosophie* (1904) Kandinsky had read that 'each colour, each perception of light represents a spiritual tone';[30] and in Annie Besant and C. W. Leadbeater's *Thought-Forms* (1901) he found the theory of vibrations – that thoughts and feelings emanating from the individual could be seen in colours and forms by the initiated (Fig. 6). A number of other painters, from Marc, Delaunay and Kupka to the American Synchromists, were also directly influenced by the theosophists'

Fig. 6 *Sudden fright*, 'Thought-Form' from Annie Besant und C. W. Leadbeater, *Thought-Forms*, 1901

25 The founding of the Theosophical Society in New York in 1875 and its later re-establishment in India by Mme Blavatsky and H. S. Olcott was a reaction by a group of people with spiritualist concerns who opposed nineteenth-century materialism. The impact of the Society throughout Europe was considerable.

26 Piet Mondrian, 'The New Plastic in Painting' (1917), reprinted in *The New Art – The New Life: The Collected Writings of Mondrian*, London, 1987, p. 44.

27 Mme Blavatsky, 'Isis Unveiled' (1877); quoted in Robert R. Welsh 'Mondrian and Theosophy', in *Piet Mondrian 1872–1944*, exh. cat., New York, Solomon R. Guggenheim Museum, 1971, p. 49.

28 It is interesting to note how in attempting to bridge the contradiction between the values of science and those of spritualism through a structuralist analysis of grids in 1978, Rosalind Krauss declared that 'we find it indescribably embarrassing to mention *art* and *spirit* in the same sentence'. See 'Grids', in Rosalind Krauss, *The Originality of the Avantgarde and Other Modernist Myths*, Cambridge, Mass., 1985, p. 12. A decade later or so, discussions of the spiritual in abstract art were to become considerably more common. See note 23.

29 Wassily Kandinsky, *Über das Geistige in der Kunst* (On the Spiritual in Art), Munich, 1912, trans. in *Complete Writings* (as note 4), p. 160. The musical reference at the heart of this quotation points also to the fundamental role which music also played in the formation and development of abstraction. See Anna Moszynska, *Abstract Art*, London, 1990, pp. 38–43.

30 Quoted in Rose-Carol Washton Long, *Kandinsky: The Development of an Abstract Style*, Oxford, 1980. Kandinsky read Annie Besant's and C. W. Leadbeater's book in a German translation, *Gedankenformen*, Leipzig, 1908.

Fig. 7 The Rothko Chapel, Houston, Texas; dedicated 1971

Fig. 8 Alfred Manessier, *Pour la fête du Christ Roi* (For the Feast of Christ the King), 1952. Collection of David Thompson, Pittsburgh

colour theories in the period immediately preceding the First World War, but it was the fact that colour could be perceived as both physical and metaphysical – something intensely empirical, yet defying ready articulation – which exerted such a powerful fascination on abstract artists of succeeding generations, including Newman, Rothko, Kelly, Klein, Agnes Martin, Flavin and Turrell, to name but a few.

In North America, after the Second World War, the neo-Platonic philosophical rhetoric of earlier European abstraction was largely replaced by an even more inward-looking, intuitive response, fuelled by Surrealism and C. G. Jung's idea of the collective unconscious. Plotinus' notion that the artist could rely 'on his inner resources'[31] was developed differently, as Kandinsky's expressionism now became extended into the 'colour-field' paintings of Rothko, Still and Newman, which absorb the spectator by virtue of their scale and colour, and by concentration on a simple, yet powerfully resonant spatial organisation. The intellectual inspiration switched to Nietzsche and to subsequent theories of the mind,[32] as well as to contemporary French Existentialism, with its themes of reliance upon the self and on the individual's responsibility to act. It is easy to detect the influence of Sartre in many artists' statements of the time, as well as in much of the contemporary critical literature. However, the emphasis on self-reliance, the turning inwards, was at a price. Rothko, Gorky and de Staël all committed suicide, while Kline, Pollock and Wols died prematurely. In this period of terrible doubt about human nature, overshadowed by Auschwitz and Hiroshima, esoteric spiritualism no longer seemed to offer the inspiration it had done earlier.

References to the spiritual still exist, but they now touch, albeit ambiguously, on more conventional forms of religion. Thus Rothko made panels for a (non-denominational) chapel in Texas (Fig. 7), while Newman, besides designing a synagogue, also created a series of 'The Stations of the Cross' (1958–66), based on the theme of the Lema Sabachthani (Why hast thou forsaken me?). It was left to the 'Art Sacré' movement in France to provide a more distinctly Catholic response to the aftermath of the war, allowing painters like Bazaine and Manessier to create abstract images of sacred intent on canvas and stained glass (Fig. 8).

A new emphasis which emerged in America at this time was a sense of the sublime, as highlighted in an essay by Barnett Newman in 1948, 'The Sublime Is Now'. Kant, to whom he referred, wrote of the sublime:

> there is such an absence of anything leading to particular objective principles and forms of nature corresponding to them that it is rather in its chaos or its wildest and most irregular desolation, provided size and might are perceived, that nature chiefly excites us in the ideas of the sublime.[33]

Newman followed Edmund Burke in extending the idea of the sublime to art, rather than nature, and insisted upon its contemporary importance. It seems reasonable to suggest that the will to immediacy was followed through into his own art as indicated by the very title of his steel sculpture *Here Now* (1965–66), but his painting seems also to allow for a sublime moment of totality, accompanied by a paradoxical sense of emptiness. In Newman's *The Promise* (1949), for example, our attention is held by the extensive colour

31 The quote derives from a longer citation of Plotinus, which was published in the first issue of *De Stijl* (1918). See H. L. C. Jaffé, *The Dutch Contribution to Modern Art* (1956), reprinted Cambridge, Mass., 1986, p. 113.

32 See Arthur C. Danto's essay in this catalogue for a consideration of theories of the mind.

33 Immanuel Kant, *The Critique of Judgment* (1790), trans. James Meredith, New York, 1973, p. 40.

field, stretching in both directions from a central viewing position (Fig. 9). But our gaze is also simultaneously attracted by the narrow field which is placed slightly off centre and cordoned off by two pale zips. The eye is pulled towards this vertical, slim 'gap', which beckons like a portal stretching to infinity, above and below the confines of the canvas edge, and draws us in, while making us totally aware of our own bodily presence and corporeal inability to 'be' there. Only the spirit or imagination is free. The theologian, Mark Taylor, has interpreted this effect as indicative of aphaeretic theology: a stripping down, and a will to purity and immediacy, which are part of that tradition.[34] The Neo-Platonist, Speusippus, developed aphaeresis as a method of negation. It occurs by subtracting or abstracting particular qualities from an entity, moving from volume to plane to line to point. Its ultimate aim is to reach the essential One which underlies the many composing the phenomenal world, and as such involves a stripping away of the world of appearances. This method allows the initiate to draw near the purity of the origin: the 'darkness' which the mystics saw as divine. In Cabbalistic thought, God is hidden. For creation to occur, God who once filled the universe must withdraw into a point. Presence and absence are thus simultaneously experienced: an effect analogous to the dual experience of Newman's painting.

Ad Reinhardt's persistent creation of black paintings, in his late career, can also be seen as belonging to this aphaeristic tradition[35], and one of his aims was to see the revival of spiritual art in a secular mass culture. *Abstract Painting* (1956) (Cat. 160) shows the importance to the artist of black as an 'absence of color', a 'negative presence', 'darkness', a 'getting rid of', 'non-being', 'dematerialization'.[36] However, absence of colour also functions as a hidden presence, while absence of form betokens the presence of divine formlessness. Reinhardt's black paintings are highly complex, being neither utterly colourless nor formless, but composed of different hues and, in some cases, containing cross-like imagery. As may be suggested by this lingering Christian reference, the artist was aware that darkness itself could be perceived as deeply spiritual. St John of the Cross spoke of 'the dark night of the soul' and Meister Eckhart of the 'divine dark', while for Lao Tzu, 'the Tao is dark and dim'.[37] The possibility that darkness might be the source of inner vision may be seen to underpin the 'black' works of Malevich, Newman, Rothko and Serra as well as those of Reinhardt.

Although Rothko produced a series of works for the Menil chapel in Houston, Texas[38], and though, like Newman, he had a Jewish upbringing, his own response to the spiritual was sceptical and ambiguous. His late paintings were left untitled, without Newman's allusive references, while his vocalised response to the issue was also non-committal: 'If people want sacred experiences, they will find them here' he said in the 1950s, 'if they want profane experiences they'll find these too. I take no sides'.[39] Immersed in Nietzsche as he was, it would be difficult for Rothko to find much hope in the spiritual realm. In a discussion of what he called 'a marvellous book [sic], Kierkegaard's *Fear and Trembling/The Sickness unto Death*' in the Pratt Lecture of 1958, he made the point that what Abraham was prepared to do (in the sacrifice of his son Isaac) was 'beyond understand-

Fig. 9 Barnett Newman, *The Promise*, 1949. Collection of Carter Burden, New York

34 Mark C. Taylor, *Disfiguring: Art, Architecture, Religion*, Chicago, 1992, pp. 86–93.
35 Like Mondrian, Reinhardt was brought up as a Protestant and influenced by Theosophy. However his friendship with the monk Thomas Merton fostered a religious perspetive which blended Eastern and Western mysticism to form a 'via negativa'.
36 Ad Reinhardt, unpubl. and undated notes on 'Black', printed as 'Black as Symbol and Concept' in *Art-as-Art: The Selected Writings of Ad Reinhardt*, New York, 1975, repr. 1991, p. 95 and pp. 97–8.
37 Ibid., p. 95 and p. 98. It is worth noting that Reinhardt's black paintings also betoken the interest, inherent to the monochrome, in the replaying of the end: for despite attempts in over fifty paintings of this type, Reinhardt could not produce *the* final painting. The challenge was left for others to take up.
38 See David Anfam, 'Dark Illumination: The Context of the Rothko Chapel', in *Mark Rothko: The Chapel Commission*, exh. cat., Houston, The Menil Collection, 1996, in which he argues that spirituality was still Rothko's goal – more than ever in these works.
39 Quoted in Taylor (as note 34), p. 94. See also James E. B. Breslin, *Mark Rothko: A Biography*, Chicago and London, 1993, p. 484, for Rothko's ambivalent response to the spiritual.

ing. There was no universal that condoned such an act', and Rothko compared such sacrifice to the role of the artist.[40]

And yet … There is a question of infinity in the veils of colour that hang across Rothko's canvases of the 1950s, that block out and yet suggest something existing beyond the softly pulsating surface textures, with their ragged edges and suggestive layers (Cat. 177). The very shifting boundaries of the large enclosed shapes seem to accentuate the need for us to lose ourselves in contemplation of that which can never be of us and cannot be read in any narrative or biblical sense, but only seen in a complete absorption of object and subject, inner and outer. Jacques Derrida's comment on scepticism, in his book *Memoirs of the Blind* (1993), seems helpful: it is 'the difference between believing one *sees* [croire voir] and seeing between, catching a glimpse [entrevoir] – or not. Before doubt ever becomes a system, skepsis has to do with the eyes'.[41] As the theologian, David Jasper, has suggested, an alternative hermeneutics can be offered by such painting, for it invites the impossible possibility of vision apart from knowing.[42]

The Challenge of Space

As in so much twentieth-century art, pictorial space in abstraction is predicated on an entirely different spatial system than that which had dominated art since the Renaissance. Cézanne was pivotal, in opening up the possibility of allowing natural, perceptual vision to take over the role of more conventional monocular and binocular vision, in order to incorporate the 'truth' revealed by the artist's own shifting perspectival viewpoint into the picture plane. But the seeds for change were also anticipated in literature and music, when late-nineteenth century dissatisfaction with the real provoked the search for a new aesthetic space. Mallarmé's empty page not only set up a model for the pictorial 'tabula rasa', leading to the monochrome – it also pointed to a dread of the void, anticipating the all-over, 'horror-vacui' treatment of space, found in pre-war paintings by Kandinsky and, later, in works by Pollock, Twombly and other artists. Yet in parallel to the fragmented, collaged spaces found in modernist literature – in the writings of James Joyce and T. S. Eliot, for example – there emerged a compensatory desire for regulating order in the works of Malevich, Mondrian and later grid painters.

Probably the most important impulse throughout the century in the development of abstract pictorial space was the drive towards flatness. As Kandinsky said in 1912, 'the turn away from the representational – and one of the first steps into the *realm of the abstract* – was the *exclusion of the third dimension*'[43] and even earlier, Wilhelm Worringer, in his book *Abstraction and Empathy* (1908), declared that 'space therefore is the major enemy of all striving after abstraction and hence is the first thing to be suppressed.'[44] Once again, there had to be a large shift in sensibility and knowledge before this position could be arrived at in practice. Besides Cézanne's contribution, this included the invention of photography, to force a rethinking of spatial representation; the repression of linear narrative; Symbolism's imaginative 'turning inwards', in place of a desire to represent the outside world; new theories of optics and colour; and, not least, growing public

40 Notes from a lecture, given at the Pratt Institute 1958, cited in Irving Sandler, *Mark Rothko: Paintings 1948–1969*, exh. cat., New York, Pace Gallery, 1983, p.11.
41 Jacques Derrida, *Memoirs of the Blind, The Self Portrait and other Ruins*, trans. Pascale-Anne Brault and Michael Naas, Chicago and London, 1993, p. 1.
42 David Jasper, unpubl. lecture about 'Theology and American Abstract Expressionism', given for Art and Christianity Enquiry at St Alban's Centre, St Alban's, April 1995.
43 Kandinsky, *On the Spiritual in Art* (as note 29), p.194.
44 Worringer (as note 24), pp. 38–9.

awareness of the revolution within physics, which encompassed theories of relativity and of the divisibility of the atom. Even then, artists' concerns were not confined to abstraction, but formed part of the whole modernist agenda. Picasso's Cubist paintings of 1911 teeter on the brink of abstraction, while Matisse's *French Window at Collioure* (1914) shows how extraordinarily close he too came to relinquishing illusory depth, at that point in his career (Fig. 10). Ultimately, for both artists, a turn towards total abstraction would have completely deflected their individual artistic trajectories.

For other artists, the formal choice lay broadly between a 'grid' or a more unquantifiable 'field'. With the latter, especially as it developed after the Second World War, we find the possibility of a sensuous, imaginative and far-reaching landscape of the mind. What fed into these choices was also a matter of how the individual artist viewed abstract pictorial space – as something spiritual, concrete, real or imaginary. Once three-dimensional space had been repudiated, however, the first question was how to energise the picture plane. Various solutions presented themselves. Mondrian created a sense of 'dynamic equilibrium', by visually adjusting the linear composition of his grids to avoid stasis; Kandinsky created visual complexity in his 1913 paintings through the use of shallow space with a centrifugal dynamic, which recalled Yeats' 'the centre cannot hold'; while Delaunay's *Discs* offered a calmer centring, activated by colour reverberations (Cat. 125). In Russia, impelled by their search for the spiritual, Malevich and Mikhail Matiushin explored the possibilities of the fourth dimension.

Malevich's Suprematist painting, *Blue Triangle and Black Rectangle* (1915) creates an extraordinary tension between two simple, overlapping geometric forms as they float, otherwise unanchored, in the white surrounding space of the painting's ground (Cat. 126). This effect may be due to Malevich's knowledge of the 'hyperspace' philosophy of Charles Howard Hinton and P. D. Ouspensky, which involved an understanding of the fourth dimension through a process of higher intuition as both time and motion, and of Claude Bragdon's book *Man the Square* (1912), which illustrated some of these ideas (Fig. 11).[45] But it can also be explained, less mystically, by his resort to a geometrical use of axonometric perspective, evidenced in his drawings and implied in many of his Suprematist paintings of 1915, where the vanishing point is cast into the infinite, with 'orthogonals' transformed into groups of parallel lines on the surface. Whatever the case, both Malevich and Matiushin certainly discussed the need to educate their 'space sense' and repudiate the tyranny of three-dimensional space, which Matiushin interestingly refers to as 'the annoying bars of a cage in which the human spirit is imprisoned'.[46] The two-dimensional, coloured bars of Matiushin's own painting, *Movement in Space* (1918) (Cat.139), are tipped on the diagonal and stretch out beyond the edges of the picture plane, as if trying to reach infinity on either side. Malevich's *White on White* seems to reflect his own concern with the 'white, free depths, eternity' and his earlier Ouspenskian interest in the 'void'. But he also cast the whiteness in terms of space travel, anticipating the path of satellites in space and calling for 'comrade aviators [to] sail on into the depths'.[47]

Fig. 10 Henri Matisse, *Porte-fenêtre à Collioure* (French Window in Collioure), 1914. Musée National d'Art Moderne, Centre Georges Pompidou, Paris

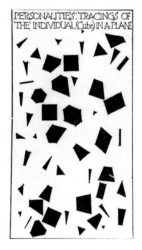

Fig. 11 Page from Claude Bragdon, *Man the Square*, 1912

45 In an exhibition of his paintings at the *Last Futurist Exhibition of Pictures O,10*, 1915, Malevich subtitled some of the works, 'Colour Masses in the Fourth Dimension'. For further discussion of this issue, see Linda Dalyrymple Henderson, 'The Merging of Time and Space: The Fourth Dimension in Russia', *The Structurist*, vol. 15, 1976, and *The Fourth Dimension and Non-Euclidean Geometry in Modern Art*, Princeton, 1983.
46 Mikhail Matiushin, Preface to *Troe*, September, 1913; quoted in Henderson (as note 45), p. 101.
47 Kazimir Malevich, 'Suprematism' (in exh. cat., *Nonobjective Creation and Suprematism*, Moscow, 1919), in *Russian Art of the Avant-Garde* (as note 21), p. 145.

Fig. 12 Yves Klein, *RP 7, Le globe terrestre bleu* (The Blue Terrestrial Globe), 1957. Private collection

Fig. 13 Morris Louis, *Gamma Gamma*, 1959–60. Kunstsammlung Nordrhein-Westfalen, Düsseldorf

48 Clement Greenberg, 'Towards a Newer Laocoon' (1940), in *Clement Greenberg: The Collected Essays and Criticism* ed. John O'Brian, Chicago and London, 1986, vol. 1, p. 38.
49 For a recent discussion of Greenberg on this topic, see Andrew Benjamin, *What is Abstraction?*, London, 1996, p. 16–7.
50 See Lucy Lippard, *Eva Hesse*, New York, 1976, p. 192, where she specifically comments upon this tendency.

The fascination with outer or cosmic space can be traced in other artists of the Revolutionary period (El Lissitzky, Klutsis and Chashnik, for example) but it also stretched into European abstraction of the late 1950s and 1960s with the different concerns of Yves Klein, Lucio Fontana, Victor Vasarely, Günther Uecker and the rest of the Zero Group, at a time when space travel itself had become a reality. Yves Klein's sponge paintings, for example, evoke the moon's craters, and when Yuri Gagarin announced in 1961 that the world looked blue from space, Klein felt vindicated in his earlier act of appropriating a classroom globe and painting it blue (Fig. 12).

Whereas it could be said that the issue of space tended to carry an Utopian and technological connotation in much European abstract art and discourse, formalist criticism in America around the middle of the century forced a rather different emphasis. Although formalist theories were already developed by that time, it is an extraordinary quirk of history that one man, Clement Greenberg, not only held sway over the realm of art criticism for twenty years or so, but through his criticism prescribed the very direction American abstract painting would take. From the time of his essay 'Towards a Newer Laocoon' (1940), Greenberg argued that the history of avant-garde painting practice was encapsulated in the development towards an emphasis on flatness and surface. What he called 'the fictive planes of depth' were to be overcome by a reduction to the object's two-dimensionality, as once the picture plane could be understood as moving towards a commensurability 'upon the real and material plane which is the actual surface [of the canvas] …', painting would be able to attain its own 'purity' as a medium – thus distinguishing it from the other arts, especially literature[48] (and later, he also argued, sculpture). However, for Greenberg, abstraction consisted not in the negation of representation, as such, but in the repudiation of the space that recognisable objects could inhabit.[49] Although Greenberg applied his critique to European abstract artists, such as Mondrian and Kandinsky, his influence was most pronounced on American art of his own time. His emphasis on painting's 'all-over' quality dictated the terms in which Pollock's painting, for example, was discussed after 1948, and later, his stress on 'opticality' was equally significant, culminating in a review of Barnett Newman's work in 1959 in which he discussed the artist's colour and light completely at the expense of his 'content'. In the face of this, very few illusionistic effects are to be found in 1960s American abstract painting. Instead, as in Morris Louis' *Gamma Gamma* of 1959/60 (Fig. 13), the breathing openness of colour, the complete flatness of form (to the point where the pigment is actually soaked into the weave of the unprimed canvas) and the exclusion of any ostensible reference to the world outside the painting itself can all be related to the dominance of formalist criticism by this time.

Greenberg's overriding emphasis on painting in his critical writings inevitably made it difficult to deal with sculpture. At times, analogies were made to the two-dimensional arts: thus, the sculptural works of Julio Gonzalez and David Smith were discussed as exploring the possibilities of 'drawing in space'.[50] However, a great deal of the rhetoric surrounding sculptural abstraction focussed on the question of 'real' space. Malevich's

rival, Vladimir Tatlin, was the first to use the slogan 'real materials in real space', extending the implications of Picasso's sheet metal guitar (1912–13) into completely abstract form, and in *Corner Counter-Relief*, making it occupy real space by suspending it across the corner of a room (Cat. 135). While this direction was extended by other Russian Constructivists, the emphasis on the 'real' re-emerged later both in European kinetic art of the 1950s and '60s (in the work of Tinguely, for instance) and in American Minimalism. Significantly, Greenberg did not think much of the sculptural direction of the minimalist object which extended the logic of his own theory into three dimensions. He preferred the more constructed and articulated forms of Anthony Caro (Fig. 14). But great claims were made by the artists themselves, on behalf of their use of space, and they emphasised the minimalist object's physical presence, as preferable to the opticality of recent painting. Hence, Donald Judd:

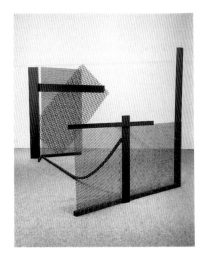

Fig. 14 Anthony Caro, *Carriage*, 1966. Collection of Mr. and Mrs. Raymond D. Nasher

> Three dimensions are real space. That gets rid of the problem of illusionism and of literal space, space in and around marks and colors – which is riddance of one of the salient and most objectionable relics of European art ... Actual space is intrinsically more powerful and specific than paint on a flat surface.[51]

The space occupied by the minimalist object is a mathematically circumscribed one: fluorescent light tubes, steel plates, iron boxes mark out a particular geometry on wall and floor, reflecting the industrial nature of their material and fabrication (Cat. 181–189). In fact, this pragmatic focus on the real, seen in the Minimalist work of Judd, Andre and Flavin (and also differently, in that of Smithson, Serra, Tinguely, Caro and Long) moves away from the earlier emphasis on metaphysics and epitomises the more general drive, from the late fifties onwards, towards an art of the real.[52]

Yet despite what might appear within abstraction as a domination by the shaped, the ordered, the structured or the mathemetically controlled, it is also possible to posit a quite different reading of abstract space which not only repudiates Greenberg's formalist stress on the eye,[53] but proposes an assault on rationalist form. This emphasises instead qualities such as formlessness and imagination and favours the Dionysian impulse over the Apollinian.[54] Thus for Georges Bataille, writing in 1930, Joan Miró's recent painting could be discussed in terms of the 'traces' of its act or 'disaster', where 'decomposition was taken to the point where nothing remained but several formless spots'[55] (Fig. 15). Bataille's definition of the 'informe' (formless), as a term which serves to 'declassify the requirement in general that everything should have a form', positing instead that the universe 'resembles nothing at all ... is only formless ... something akin to a spider or a gob of spittle',[56] offered a model for readings of other painters who create a similarly chaotic, decomposed space: Riopelle as well as Pollock, Kandinsky as well as Miró, Michaux as well as Gorky, Tobey as well as early Rothko, Twombly as well as Sam Francis. In this way, Roland Barthes could discuss Cy Twombly's 'wisdom', in introducing a sense of time or event into his 'scattered' pictorial space which was quite different from mythical narrative,[57] while Rosalind Krauss was able to find in the indexical mark of Pollock's drip pictures, 'a thematics of the sexual and rivalrous that will return against the very "oceanic" condition of modernist aesthetics the aggressivity and formlessness of its repressed.'[58]

51 Donald Judd, 'Specific Objects' (1965), reprinted in Donald Judd, *Complete Writings*, New York, 1975, pp. 184–7.
52 An exception here might be Dan Flavin, whose use of fluorescent light often dematerialises the surrounding architectural environment, provoking, despite his stated intentions, a metaphysical affect. In terms of the 'real,' it is worth noting the impact of Russian Constructivism on later American art. See Maurice Tuchman, 'The Russian Avant-garde and the Contemporary Artist', in *The Avant-garde in Russia, 1910–1930: New Perspectives*, exh. cat., Los Angeles, County Museum of Art, 1980, pp. 118–21.
53 See Greenberg 'Modernist Painting' (1965), in Greenberg (as note 48), vol. 4, p. 198.
54 In this exhibition, work by many of the artists discussed in the paragraphs which follow is to be seen under the headings of 'Reality', 'Language' and 'Dream'.
55 Georges Bataille, 'Joan Miró: Peintures récentes' (1930), in Bataille, *Œuvres Complètes*, vol. 1, Paris, 1970, p. 255.
56 Georges Bataille, *Encyclopédie acéphalica* (1947), reprinted in Bataille, *Dictionnaire: Comprising the Critical Dictionary and Related Texts*, London, 1995, pp. 51–2.
57 Roland Barthes, 'Cy Twombly: The Wisdom of Art', in *Cy Twombly*, exh. cat., New York, Whitney Museum of Art, 1979, pp. 13 and 22.
58 Rosalind Krauss, *The Optical Unconscious*, Cambridge, Mass., 1993, p. 308.

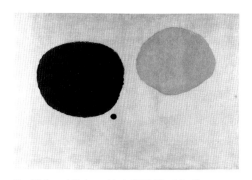

Fig. 15 Joan Miró, untitled, 1930. The Menil Collection, Houston

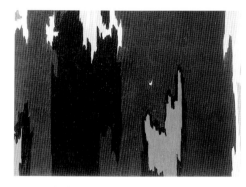

Fig. 16 Clyfford Still, *Untitled*, 1957. Whitney Museum of American Art, New York

59 'Reminiscences/Three Pictures' (Berlin 1913), in *Kandinsky: Complete Writings* (as note 4), p. 368.
60 Gaston Bachelard, *L'Eau et les rêves*, Paris, 1942. English citation from *Water and Dreams* in Jean-Clarence Lambert, *Cobra*, London, 1983, pp. 17–8.
61 Bachelard lectured on 'la pâte' as primal matter at the Collège de France, Paris during the War as well as writing on it in both *Water and Dreams* (1942) and *Earth as the Dreams of Will* (1947). See Sarah Wilson, 'Paris Post War: In Search of the Absolute', in *Post-War Paris: Existentialism 1945–55*, exh. cat., London, Tate Gallery, 1993, pp. 25–52.
62 Robert Rosenblum, *Modern Painting and the Northern Romantic Tradition: Friedrich to Rothko*, London, 1975, p. 200
63 The term derives from Julia Kristeva and evokes, in Lacanian terms, the unpresentable place of the mother – that which is prior to nomination or any form of unity and which constitutes instead the radically indeterminate. See Kristeva, *Revolution in Poetic Language*, trans. Margaret Weller, New York, 1984, and also Jacques Derrida, *Khora*, Paris, 1993.

In closing down the possibility that pictorial space itself could be a site of imaginative space, Greenberg's formalism refused the possibility of a different and fertile type of interaction between the work and the observer – one which could also challenge the limits of logic and experience through new forms of signifying. Kandinsky's experience, recounted in his *Reminiscences*, of visiting peasant houses in the Vologda and finding himself able 'to move within the picture, to live in the picture'[59] evokes a way that the viewer likewise can enter the space in his paintings, by becoming fully absorbed in them and transcending the boundaries of self.

The privileging of the imaginary, in connection with the unformed, was taken further in Europe after the Second World War, in Gaston Bachelard's writings. As he wrote in 1942, 'we always want our imagination to be the faculty of forming images. Well, it is rather the faculty of unforming images furnished by perception … the basic term corresponding to the imagination is not image, it is imaginary'.[60] While this idea of the 'imaginary' could be extended to deal with work that was on the cusp of representation and abstraction (as in the paintings of Wols, Fautrier, some of the COBRA artists, and even, at times, Dubuffet), Bachelard's concerns with 'la pâte', as primal matter, had direct ramifications for abstract pictorial space.[61] The non-optical, 'built up', substantial surfaces of European abstract 'matière' painting, found in work by Antoni Tàpies and Alberto Burri (Cat. 245, 289 and 290), as well as the artists named above, suggest the widespread influence of Bachelard's ideas and offer alternatives to the increasing flatness and opticality of American painting.

However, even in America, an antidote was offered to Greenberg's formalism in the writings of Robert Rosenblum. His book, *Modern Painting and the Northern Romantic Tradition* (1975) placed the work of Barnett Newman, Mark Rothko and Clyfford Still in the Romantic tradition of the sublime. Thus, in juxtaposing Still's work with that of the nineteenth-century American landscape painter, Augustus Vincent Tack, he was able to suggest that Still's craggy *Untitled* (1957) (Fig. 16), might equally have been inspired by the 'sublime storms and mountains of the American West'.[62] Rosenblum's placing of Abstract Expressionism as a continuation of the line of Northern Romantic painting offered an important critical alternative to Greenberg and, with his stress on the sublime, he both echoed Newman's own concerns while anticipating other, more recent, preoccupations with the indeterminate. For it is precisely a concern with matters beyond determinate perception as linked to the sublime, with indeterminate space, with the pre-rational, with the *khora*, which has become a major issue in contemporary art criticism.[63] In place of the teleological thrust of formalism, this criticism invokes the unconscious and psychoanalysis, as models with which to review abstraction, and in so doing adopts a more open, lateral system for discussing it.

Presence versus Transcendence

Throughout the history of abstraction there has been a resurgent dichotomy between those who affirm that abstract art is about transcendence and those who believe that it is

about presence or its own autonomous existence. This dichotomy relates to a difference in philosophical, historical and social positioning, but it also reflects wider, recurring problems within modernist art generally – notably the conflicting claims for art's social purpose and the idea of an 'art for art's sake'.[64] The issue is further complicated by the modern artist's relationship to the avant-garde. As Lyotard puts it, 'Avant-garde research is functionally ... or ontologically ... located outside the system and by definition, its function is to deconstruct everything that belongs to order, to show that all this "order" conceals something else, that it represses'.[65] To what extent abstraction can be viewed as oppositional to 'the system', and what it might repress, are matters which also need to be addressed.

For many artists, the central issue became the definition of what was real and concrete. From the time of Kant and Schiller, philosophers had argued the case for an art which was separated from, and disinterested in, the real world. Once artists began to relinquish mimesis, in favour of the image as a thing in itself, naturalistic references became anathema to those who believed in the purity of abstract art. By the early 1920s, a polarisation had occurred between those who wanted to construct autonomous abstract forms and those who believed in the more empirical process of 'abstracting from' nature. Thus Kurt Schwitters, writing in the first issue of *Merz*, in 1923, averred that the picture was to refer to 'nothing outside itself', stating that a consistent work of art had to be 'abstract'.[66] Eventually, the word 'concrete' came to be substituted for the more allusive 'abstract' in the vocabularies of several artists, so that, by 1930, the manifesto, 'Art Concret' could affirm that

> The picture should be constructed entirely from purely plastic elements, that is to say, planes and colours. A pictorial element has no significance other than 'itself' and therefore the picture has no other significance than 'itself'.[67]

Inevitably, this particular theoretical stance underpinned a whole tranche of abstraction on both sides of the Atlantic, which denied both metaphysical or natural references within the work. Frank Stella's insistence that 'what you see is what you see'[68] extends these earlier assertions, while also drawing upon later theories on the nature of perception and phenomenology.[69]

However, such a standpoint was clearly at odds with ideas of the artist's 'commitment' – the problematic issue which surfaced, particularly clearly, in the cases of Kandinsky and Mondrian. Both artists, heavily influenced by Platonic thought, believed fervently in the power of their art to instigate social and political reform.[70] Mondrian also claimed that 'Art is disinterested and for this reason it is free'.[71] Yet how could art be both disinterested and politically effectual?[72] Paradoxically, the emphasis on freedom in abstract art ended up as a retreat into a belief in change in the future. As Mark Cheetham has shown[73], both artists reverted to a search for absolutes which, under the banner of freedom, could not properly take account of the actual historical circumstances of the day. Kandinsky's stress on internal, spiritual development eventually undermined his external human concerns. Although he felt that art could and should lead society, he

64 One can find several examples of this dichotomy in the nineteenth century: in France, Courbet's realism on the one hand opposing Mallarmé's symbolism on the other; in Russia, the philosophy of the 'Wanderers' contrasting that of the 'World of Art' group.
65 Jean-François Lyotard, 'On Theory: An Interview', *Driftworks* ed. Roger McKeon, New York, 1984, p. 29.
66 'Holland Dada' (1923), cited in John Elderfield, *Kurt Schwitters*, London, 1985, p. 88. In fact, Schwitters' emphasis on autonomy was the primary reason for his exclusion from Dada.
67 Theo van Doesburg, 'La Base de la peinture concrète' and 'Commentaires sur la base de la peinture concrète', *Art Concret*, no. 1, April 1930, p. 1, p. 2. Carlsund, Hélion, Tutundjian and Wantz also signed the manifesto. Van Doesburg explained that 'we speak of concrete and not abstract painting because nothing is more concrete, more real than a line, a colour, a surface.' Ibid., p. 2.
68 Glaser, 'Questions to Stella and Judd' (as note 10), p. 158.
69 See for example, Maurice Merleau-Ponty, *The Primacy of Perception and Other Essays on Phenomenological Psychology, the Philosophy of Art History and Politics*, ed. James M. Edie, Evanston, Illinois, 1964.
70 Kandinsky was opposed both to what he called 'airy-fairy' art for art's sake values but also to the 'practical, utilitarian' concerns of Constructivism. However, a duty to communicate to a wide audience was a prime goal of his aethetic research. See Mark Cheetham (as note 22), pp. 98–9.
71 Mondrian, 'Liberation from Oppression in Art and Life' (1939–40), in *The New Art* (as note 26), p. 327.
72 Interestingly, this question parallels the contemporary debate within Surrealism, apropos the political context of Stalinist Russia, as to whether the psychical or materialist revolution was to take precedence.
73 Cheetham (as note 22). See especially chapter 4, 'Purity as Aesthetic Ideology', pp. 102–138.

Fig. 17 Sports Costume by Varvara Stepanova, modeled by E. Zhemchuzhnaia. Photograph: Alexander Rodchenko

Fig. 18 Funeral procession for Kazimir Malevich, Leningrad, 1935.

74 Mondrian, *The New Art* (as note 26), p. 324.
75 See Cheetham (as note 22), p. 136. See also Taylor (as note 34), p. 132, for a similar view concerning modernist art and architecture.
76 Alexander Rodchenko, 'Slogans' (1920-21); quoted in *Alexander Rodchenko*, exh. cat., Oxford, Museum of Modern Art, 1979, p. 129.

ultimately was only able to present this as a belief in an ahistorical turning inwards to the self. Mondrian, with his calls to liberate society, ventured further than Kandinsky into the realm of politics, but he not only failed dismally in his ambition to change politics through art – he ended up adopting a stance which had worrying implications. Discussing fascism he stated, even as late as 1939, that 'art is freeing itself from oppressive factors that veil the pure expression of life ...'.[74] The rhetoric of purity, which Kandinsky also engaged in, has ironically been perceived as not dissimilar to Nazi ambitions of purity[75], and certainly the absolutism of Mondrian's art did seem to eliminate the possibility of alternatives, of ways of embracing the other.

Inevitably, the question of commitment became more urgent in periods of social turmoil, most notably that of the Russian Revolution. The rivalry which developed between Malevich and Tatlin about whether art should be for the amelioration of the spirit (or soul) or for the betterment of society illustrates the dilemma, which was not confined to abstraction. Should the artist continue to paint at all or should s/he relinquish the easel and enter 'life'? Tatlin wanted to engage with the real, but the *Corner Counter-Reliefs* were ultimately insufficient testimony, still too much like art. His own attempt to do more for society, with the *Monument to the IIIrd International* (1920) (see Fig. 2, p. 544), was as doomed as his flying machine project, *Letatlin* (1929–32) (Cat. 243), but it acted as a talisman to other artists embracing the theme of artist as producer. Thus it was left to Rodchenko, Popova and others to go one stage further in producing practical items – clothing and stage design, architecture and typography – which were often successful as an adaptation of an abstract formal vocabulary to functionalist ends (Fig. 17). Yet this development also raised questions about the status of fine art. For Rodchenko, 'Art which has no part in life will be filed away in the archaeological museum of ANTIQUITY'.[76]

With Malevich, the situation is paradoxical. Although he remained committed to the belief that Suprematism knew no utilitarian aims, but instead reflected universal harmony, cosmic balance, nothingness, his work posthumously assumed a societal role. His three-dimensional 'arkitectonics', a development from his painting concerns, can be viewed as both abstract and mimetic harbingers of a future, universal order, based on Suprematism and non-objectivity, and talismanic objects of non-representation, which were manifestations of a spiritual world. At the height of the Stalinist period in 1935, the black square borne ceremoniously on the front of his funeral car and placed upon his tomb became a cult object for a small group of artists, who adored his work as prophecy and saw the educative possibility of such art as a means of changing the world (Fig. 18). Russian art of the revolutionary period thus highlights a further dialectic which runs like a common thread through the history of abstraction: that of a belief in a transcendent realm as opposed to a commitment to presence, the claims of the here and now.

In terms of straight politics, however, it is ironic that abstraction should have been tacitly enlisted in support of two mutually opposed ideologies – Leninist Communism in the immediate post-revolutionary period and American capitalism at the time of the Cold War. As historical realities changed and hard line Soviet Socialist Realism held sway,

American Abstract Expressionism – assiduously promoted by Government agencies in a number of touring exhibitions of the 1950s – came to be seen as a tool with which to suggest the advantageous 'freedom' of American culture and politics.[77] Yet whatever gloss was applied to their work, the situation for artists in America was substantially different to that of artists in post-revolutionary Russia. Following extreme disillusionment with events in the 1930s, politics was something most Abstract Expressionists specifically wanted to avoid in their work. Instead, their search for 'tragic and timeless' subject-matter took them outside temporal affairs.[78] The purpose of Abstract Expressionist art was arguably to create an analogue of the human condition: a shared sense of 'awesome feelings before the void'. But this did not prevent abstract painting from being presented as a domain of freedom, as the palpable symbol of 'an individual who realizes freedom and deep engagement of self within his work'.[79]

The desire to enlist abstraction for ideological purposes testifies to the fact that, whichever side abstract artists ended up on – autonomy or commitment, presence or transcendence – there was a tacit belief throughout the period of modernism that art had at least the possibility of making a contribution to society. Paralleling the productive workings of nature, even 'Art Concret' had to mean something, communicate to someone. In this respect, Minimalism can be seen as a transitional point in the ideals of modernism. For although, in 1970, the Minimalist Donald Judd posited an avant-gardist, oppositional role for contemporary American art in claiming that it was 'against much in the society'[80], Minimalism itself had already been noted by the artist-critic Brian O'Doherty as confronting 'what has become the illusionism of avant-gardism' and instead developing 'a sort of intellectual connoisseurship of non-commitment'.[81]

In respect of the period as a whole, perhaps the heroic element of modernist abstraction can best be summed up by the social/aesthetic reflections of Marcuse: 'Art may not be able to change the world', but 'it can contribute to changing the consciousnesses and drives of the men and women who could change the world'.[82] However, this belief in the potential for change, like other comparable lofty beliefs in the sublime, in spirituality, in purity – in short in the 'grand metanarratives' which underpinned modernist aesthetics – have, at the end of the millennium, become increasingly destabilised.

Abstraction and representation have always had to confront each other throughout the history of modernism, but the antithesis becomes more urgent and productive within the legacy of late Modernism. The deliberate, dualistic confrontation of both abstraction and representation in the space of one work may well go back to Jasper Johns, whose *Flags* have exercised many minds on the subject (Fig. 19). Gerhard Richter and Sigmar Polke have problematised the dichotomy in their own paintings, with Richter moving freely between both options (Cat. 312–314) and Polke combining the two (Fig. 20). Anselm Kiefer has indicated the enormous contribution of abstraction to spatial composition in his painting, while reconciling this with a need to suggest history through, among other things, a palimpsetic accumulation (Cat. 397–399). Now, more than ever, abstraction seems to be only one of many languages for artists to call upon.

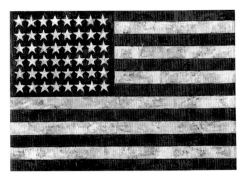

Fig. 19 Jasper Johns, *Flag*, 1954–55. The Museum of Modern Art, New York

Fig. 20 Sigmar Polke, *Schnecken* (Snails), 1982. Private collection

77 See Serge Guilbaut, *How New York Stole the Idea of Modern Art*, Chicago and London, 1983, and the materials in *Pollock and After, The Critical Debate*, ed. Francis Frascina, New York, 1985.
78 Inevitably the issue of politics was not clear cut. Barnett Newman said that, if read properly, his painting 'would mean the end of all state capitalism and totalitarianism' (Barnett Newman, interview with Dorothy Seckler, 1962, in Newman [as note 6], p. 251), while Ad Reinhardt pursued his own political agenda in a separate career as a magazine cartoonist and illustrator for the Communist publication *The New Masses*, during the early 1940s.
79 Meyer Schapiro, 'The Nature of Abstract Art' (1937), in Schapiro, *Modern Art – Nineteenth and Twentieth Centuries*, New York, 1985, p. 218.
80 Donald Judd, 'The Artist and Politics: A Symposium', *Artforum*, September 1970, quoted in Anna C. Chave, 'Minimalism and the Rhetoric of Power', *Arts Magazine*, vol. 64, no. 5, January 1990, p. 54.
81 Brian O'Doherty, 'Minus Plato', *Art and Artists*, September 1966; quoted in Chave (as note 80), p. 54.
82 Herbert Marcuse, *The Aesthetic Dimension*, London, 1979, p. 32.

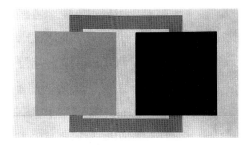

Fig. 21 Peter Halley, *Two Cells with Circulating Conduit*, 1988. Goetz Collection, Munich

Fig. 22 Jonathan Lasker, *Artistic Painting*, 1993. Buchmann Gallery, Basel

Since the second-half of the 1980s, more and more artists and writers on abstraction have pointed to something of a turning-point, and although there may be nostalgia, it no longer seems possible to read the contemporary situation as contiguous with the earlier, 'historic moment' of abstraction. American abstract painting in the 1980s, for instance, became obsessed with either irony or nostalgia, in a backwards look at abstraction's history. The emptying out of the signified, through the dominance of Jean Baudrillard's notions of simulation, micro-chip technology and televisual communication, became a consistent theme in the work and writing of Peter Halley. Geometry became an ironic paradigm of confinement in his painting and, eventually, of redundance in his writings (Fig. 21). 'Now that we are enraptured by geometry, geometric art has disappeared.'[83]

More recently, American artists including David Reed, Fabian Marcaccio, Lydia Dona, Jonathan Lasker and Stephen Ellis have looked back to earlier abstraction in ways which suggest a continuity, but one which is far from seamless. Chance and risk are taken as part of this engagement (Fig. 22). Rather than posit an uncorrupted teleological progression within the abstract project, derived from earlier Hegelian models, this recent painting often seems to relate to the 'rhizomic' possibility of lateralness or to notions of the 'desiring machine' – models borrowed from the writings of Gilles Deleuze. As Dona puts it,

> The collapse of categories of the high paradigmatic structures of Modernism, self-referentiality, homogeneity, surface and facture and the modalities of heroic/scale gesture, are replaced by what I refer to as the 'virus of excess'.[84]

Recent European painting has pursued similar revisions of abstract pictorial form and has variously dealt with combination, quotation, disjuncture and with the play between the abstract and the real in the paintings of Gary Hume, Ian Davenport and Fiona Rae, for example. For the artist Olivier Mosset, the most interesting forms of abstraction being made are 'by those who question and deconstruct abstraction: the painters whose cool abstractions reject "the humanistic and metaphysical proclamations of classical abstract art"', while in Gerwald Rockenschaub's case, painting has been left behind in favour of other ways of exploring space and its boundaries.[85]

Although differences between media have become increasingly blurred, concerns in sculpture have shifted to evoking or replacing that which was lost in the modernist abstract project: a sense both of the body and of memory. The work of Eva Hesse in the 1960s represents both an extension of minimalism and a riposte to it, and in this way anticipates some important concerns within recent sculptural practice. *Accession* (1967–68) makes use of the familiar Minimalist box but undermines its unitariness as object and its machine-made precision, through punctured surface and visceral interior (Cat. 194 and 195). Manual threading and cutting of tubes equally oppose Minimalism's factory aesthetic. This allusive evocation of the body and of a potent, memorialised space have since been tellingly explored in the work of Richard Deacon, Alison Wilding, Rebecca Horn, Rachel Whiteread and Alain Kirili, among others, where oblique references to the body and to the space it absently occupies implicitly critique the more meta-

83 Peter Halley, 'Deployment of the Geometric' (1984), in *Peter Halley: Collected Essays*, Zürich and New York, 1988, p. 130.
84 Lydia Dona, 'Reluctance, Ambivalence and the Infra-Language', in *Abstraction* (as note 1), p. 90.
85 Olivier Mosset, 'Reconstructing Abstraction', *Tema Celeste*, no. 32-33, Autumn 1991, p. 78.

physical ideals of modernist abstraction (Fig. 23). It could, perhaps, be argued that the legacy of feminism, with its privileging of the somatic, as well as its psychoanalytic challenges to Freudian readings of the mind, is one of the few late twentieth-century 'ideas' now capable of fuelling abstract art in the way that the lofty beliefs of the past fuelled it earlier in the century.

The 'new' directions in abstract art can only reflect the wider context of doubt as to the legitimacy of older systems of belief, set against the acknowledged possibilities of theoretical alternatives currently on offer. At this end of the century, we witness both nostalgia for the more utopian visions of earlier eras of abstraction and ironic detachment from them. The implications for the future of abstraction are still in question.

Fig. 23 Rachel Whiteread, *Untitled (Convex)*, 1993. Photo: Prudence Cumming Associates

Abstraction – Spirituality

WASSILY KANDINSKY (Cat. 122–124)

ROBERT DELAUNAY (Cat. 125)

KAZIMIR MALEVICH (Cat. 126–132)

VLADIMIR TATLIN (Cat. 133–135)

LIUBOV POPOVA (Cat. 136–138)

MIKHAIL MATIUSHIN (Cat. 139)

OLGA ROZANOVA (Cat. 140–141)

ALEXANDER RODCHENKO (Cat. 142–147)

NAUM GABO (Cat. 148)

PIET MONDRIAN (Cat. 149–152)

CONSTANTIN BRANCUSI (Cat. 153–154)

JULIO GONZÁLEZ (Cat. 155)

DAVID SMITH (Cat. 156)

BARNETT NEWMAN (Cat. 157–159)

AD REINHARDT (Cat. 160)

CLYFFORD STILL (Cat. 161)

FRANK STELLA (Cat. 162)

JACKSON POLLOCK (Cat. 163–164, 166)

WILLEM DE KOONING (Cat. 165)

YVES KLEIN (Cat. 167, 178–179)

LUCIO FONTANA (Cat. 168–171)

CY TWOMBLY (Cat. 172)

PIERO MANZONI (Cat. 173–175)

ELLSWORTH KELLY (Cat. 176)

MARK ROTHKO (Cat. 177, 180)

DONALD JUDD (Cat. 181–182)

CARL ANDRE (Cat. 183–185)

DAN FLAVIN (Cat. 186–189)

JAMES TURRELL (Cat. 190)

RICHARD SERRA (Cat. 191–193)

EVA HESSE (Cat. 194–195)

RICHARD LONG (Cat. 196)

EDUARDO CHILLIDA (Cat. 197)

ROBERT RYMAN (Cat. 198–199)

GÜNTHER FÖRG (Cat. 200–205)

122 WASSILY KANDINSKY, *Kleine Freuden* / Small Pleasures, 1913
 Oil on canvas, 110 x 120 cm
 Solomon R. Guggenheim Museum, New York

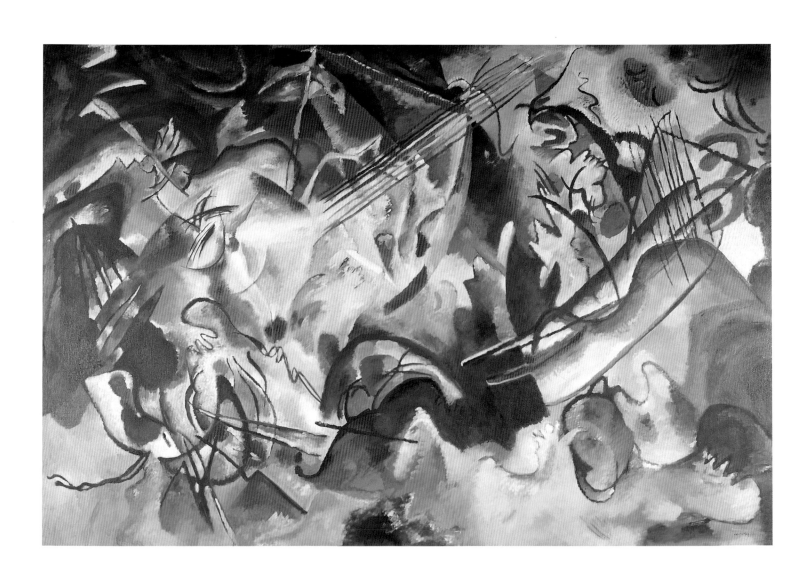

123 WASSILY KANDINSKY, *Composition VI*, 1913
Oil on canvas, 195 x 300 cm
State Hermitage, St. Petersburg

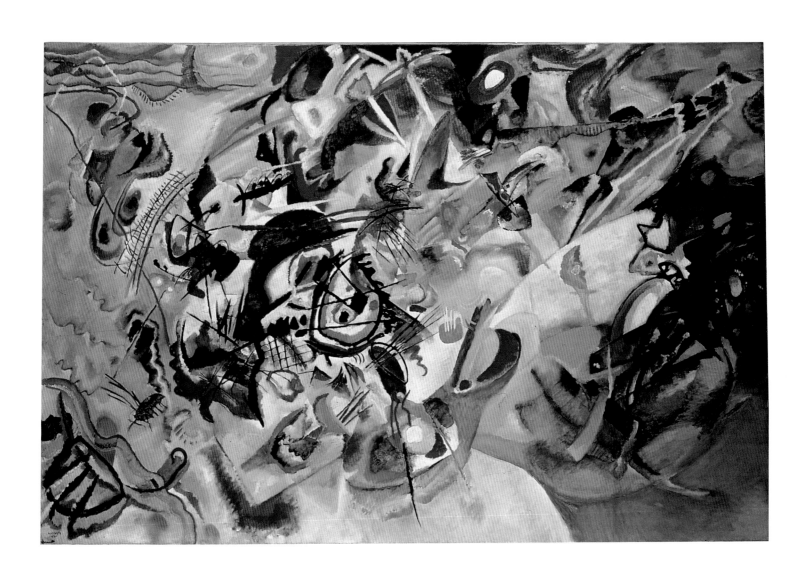

124 WASSILY KANDINSKY, *Composition VII*, 1913
 Oil on canvas, 200 x 300 cm
 State Tretyakov Gallery, Moscow

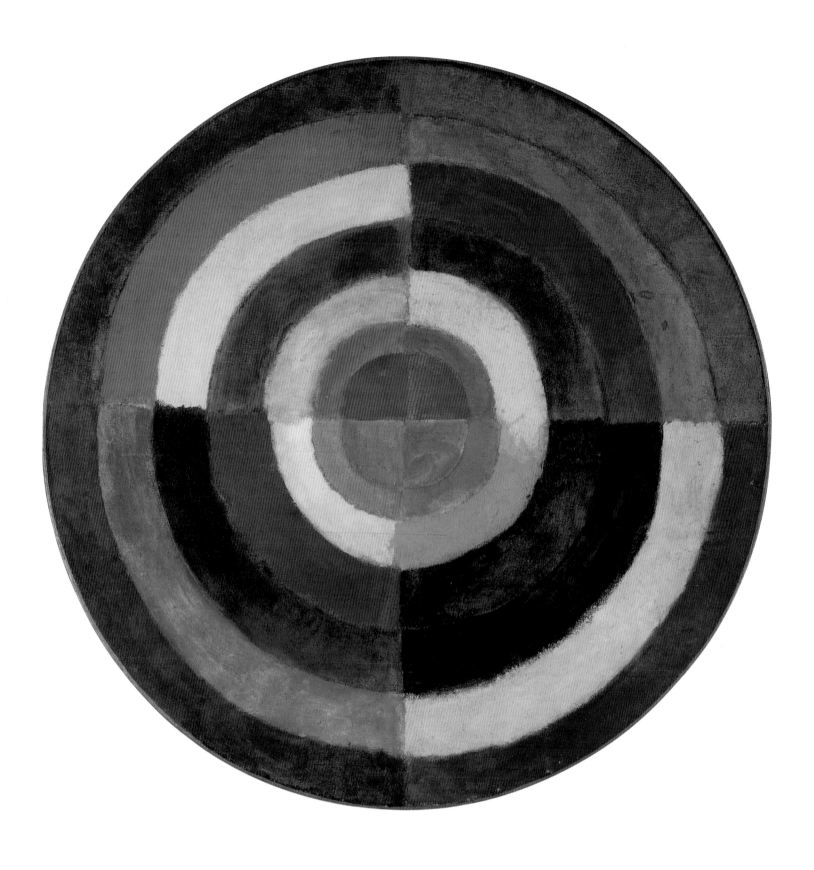

125 ROBERT DELAUNAY, *Premier disque* / First Disc, 1912
Oil on canvas, ø 135 cm
Private collection, Switzerland

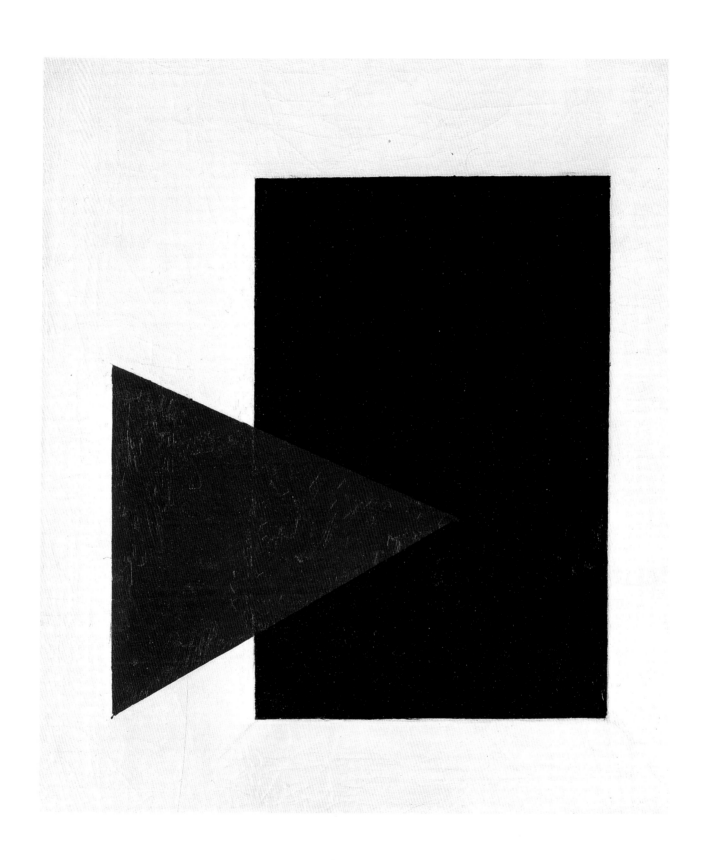

126 KAZIMIR MALEVICH, *Suprematism*, 1915
Oil on canvas, 66.5 x 57 cm
Stedelijk Museum, Amsterdam

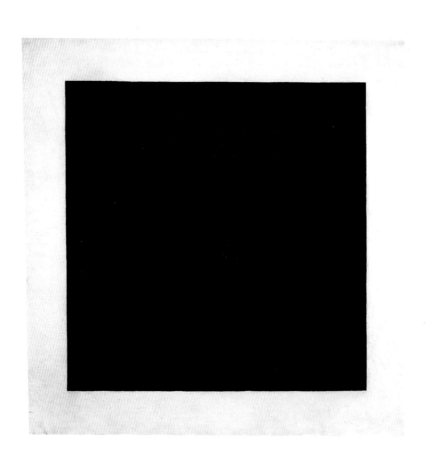

127 KAZIMIR MALEVICH, *Black Square*, 1920s
Oil on canvas, 110 x 110 cm
State Russian Museum, St. Petersburg

128 KAZIMIR MALEVICH, *Black Circle*, 1920s
Oil on canvas, 110 x 110 cm
State Russian Museum, St. Petersburg

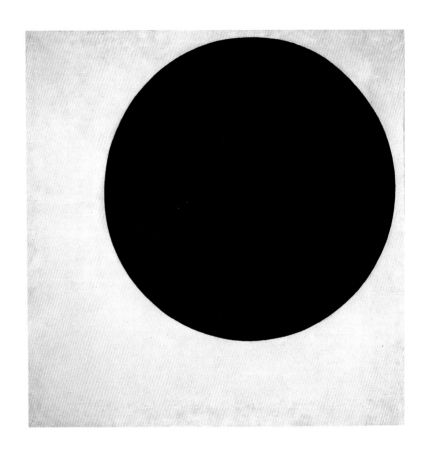

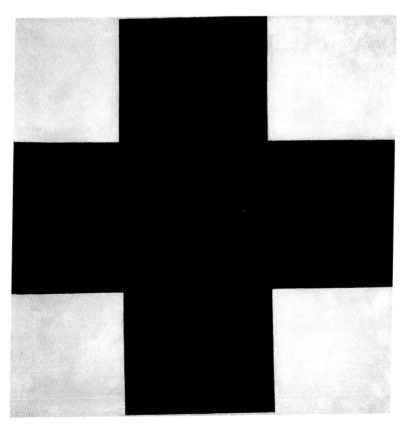

129 KAZIMIR MALEVICH, *Black Cross*, 1920s
Oil on canvas, 110 x 110 cm
State Russian Museum, St. Petersburg

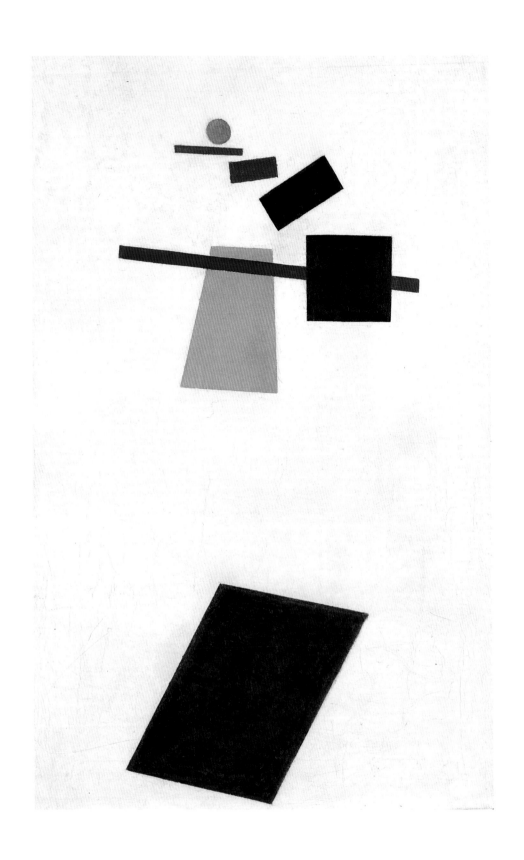

130 KAZIMIR MALEVICH, *Suprematism: Painterly Realism of a Football-Player*, 1915
Oil on canvas, 70 x 44 cm
Stedelijk Museum, Amsterdam

131 KAZIMIR MALEVICH, *Suprematist Painting (Sound Waves)*, 1917–1918
 Oil on canvas, 97 x 70 cm
 Stedelijk Museum, Amsterdam

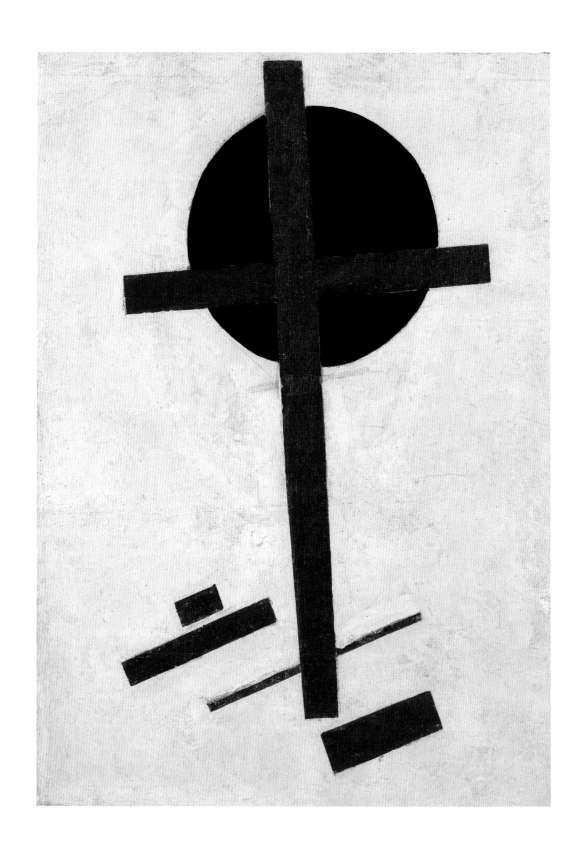

132 KAZIMIR MALEVICH, *Suprematism*, 1921–1927
 Oil on canvas, 72.5 x 51 cm
 Stedelijk Museum, Amsterdam

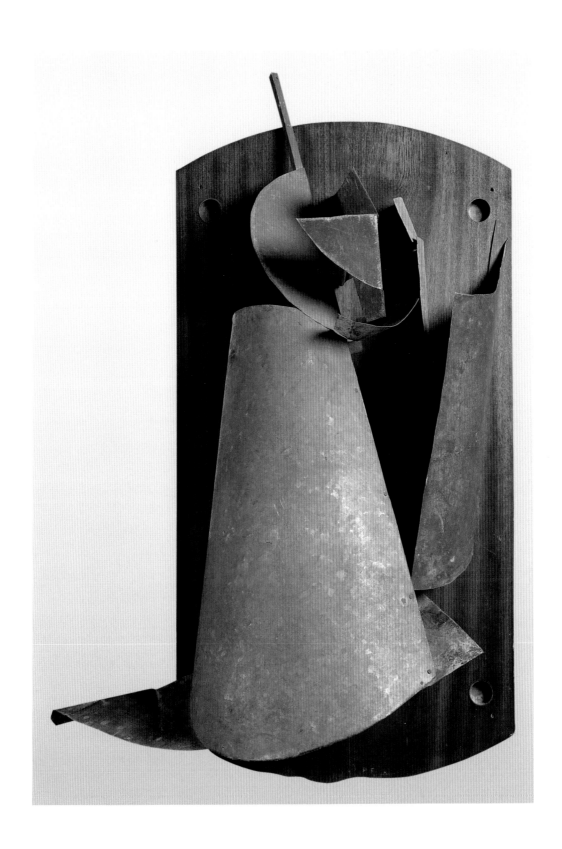

133 VLADIMIR TATLIN, *Counter-Relief*, 1916
 Zinc, jacaranda, spruce, 100 x 64 x 27 cm
 State Tretyakov Gallery, Moscow

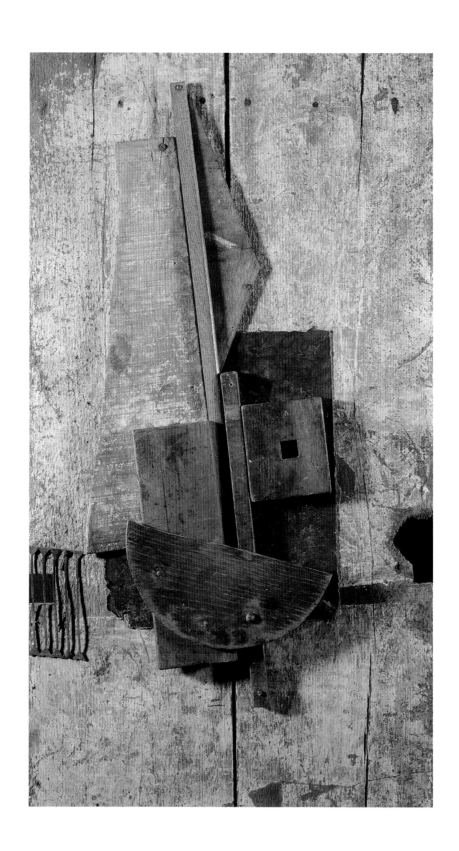

134 VLADIMIR, TATLIN, *Blue Counterrelief*, 1914
 Mixed media, 79.5 x 44 x 7.5 cm
 Private collection

135 VLADIMIR TATLIN, *Corner Counter Relief*, 1915–1925
 Mixed media, 71 x 118 cm
 State Russian Museum, St. Petersburg

136 LIUBOV POPOVA, *Painterly Architectonic*, 1917
 Oil on canvas, 106 x 88 cm
 A.F. Kowalenko-Art Museum, Krasnodar

137 LIUBOV POPOVA, *Painterly Architectonics: Black, Red, Grey*, 1916
 Oil on canvas, 89 x 71 cm
 State Tretyakov Gallery, Moscow

138 LIUBOV POPOVA, *Spatial Force Construction*, 1921
 Oil on plywood, 83.5 x 64.5 cm
 State Tretyakov Gallery, Moscow

139 MIKHAIL MATIUSHIN, *Movement in Space*, 1918
 Oil on canvas, 124 x 168 cm
 State Russian Museum, St. Petersburg

140 OLGA ROZANOVA, *Non-objective Composition*, 1918
 Oil on canvas, 62.5 x 40.5 cm
 State Russian Museum, St. Petersburg

141 OLGA ROZANOVA, *Green Stripe*, 1917–1918
 Oil on canvas, 71.5 x 49 cm
 Architectural-Artistic Museum Resort, Rostov-Yaroslavski

142 ALEXANDER RODCHENKO, *Black on Black*, 1918
Oil on canvas, 82 x 65 cm
State Russian Museum, St. Petersburg

143 ALEXANDER RODCHENKO, *Pure Red, Pure Yellow, Pure Blue*
 (Triptych with Plain Colours), 1921
 Oil on canvas, 3 panels, each 62.5 x 52 cm
 Archive of A. Rodchenko and V. Stepanova, Moscow

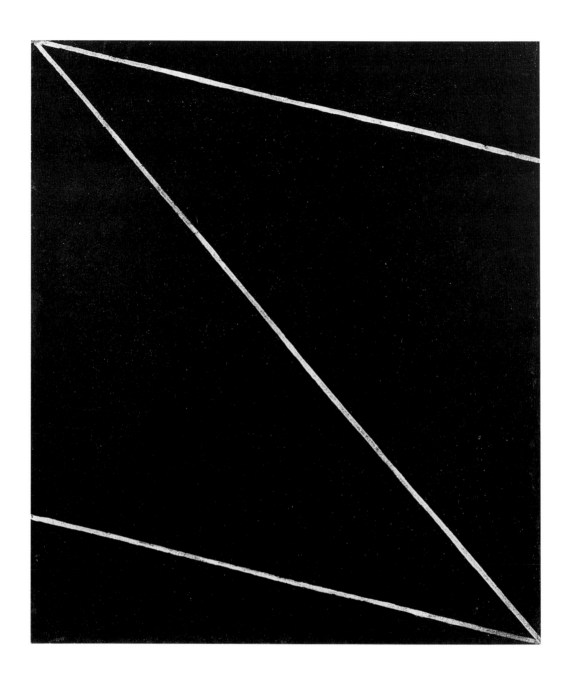

144 ALEXANDER RODCHENKO, *Line*, 1920
Oil on canvas, 58.5 x 51 cm
Private Collection, Courtesy Annely Juda Fine Art, London

145 ALEXANDER RODCHENKO, *Hanging Construction No. 11*, 1920/1921,
reconstructed 1995
Aluminium, 130 x 85 x 85 cm
Berlinische Galerie, Landesmuseum für Moderne Kunst,
Photographie und Architektur

146 ALEXANDER RODCHENKO,
Hanging Construction No. 12, 1920
reconstructed 1973
Aluminum, 85 x 55 x 47 cm
Galerie Gmurzynska, Cologne

147 ALEXANDER RODCHENKO,
Hanging Construction No. 10, 1920
reconstructed 1982
Aluminum, 59 x 68 x 59 cm
Galerie Gmurzynska, Cologne

148 NAUM GABO, *Kinetic Construction*, 1919–1920, reconstructed 1985
Metal stick, electrical motor, height 61.5 cm
Berlinische Galerie, Landesmuseum für Moderne Kunst,
Photographie und Architektur

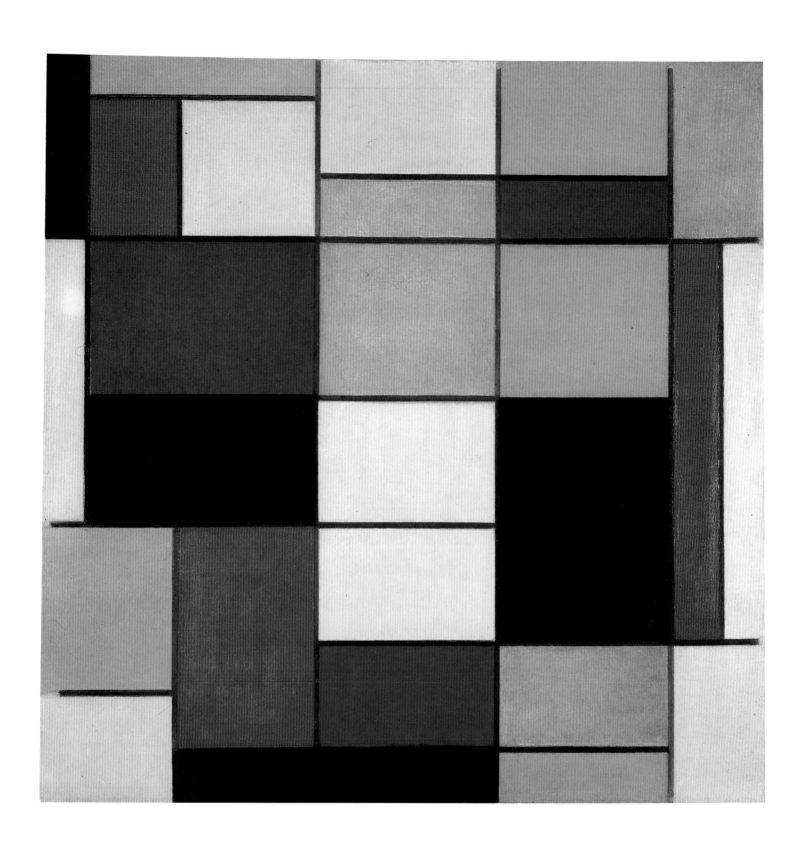

149 PIET MONDRIAN, *Composition A*, 1920
 Oil on canvas, 91 x 91 cm
 Galleria Nazionale d'Arte Moderna, Rome

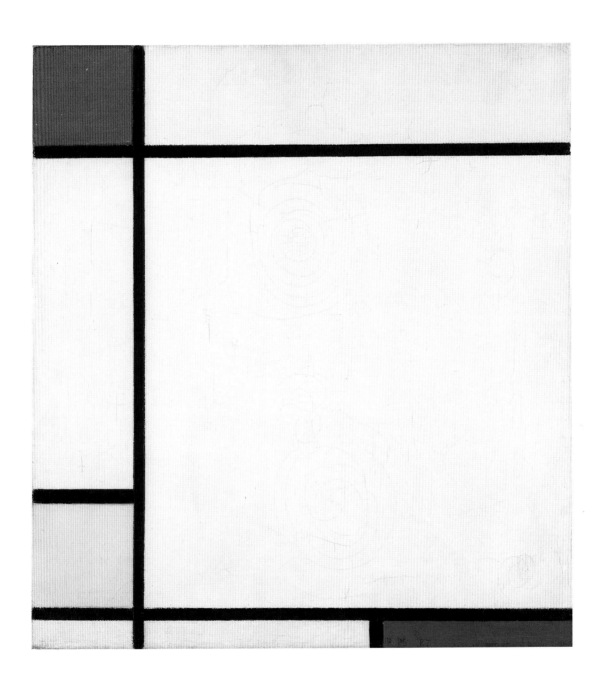

150 PIET MONDRIAN, *Composition avec rouge, jaune et bleu* /
Composition with Red, Yellow, Blue, 1927
Oil on canvas, 38 x 35 cm
Courtesy Annely Juda Fine Art, London

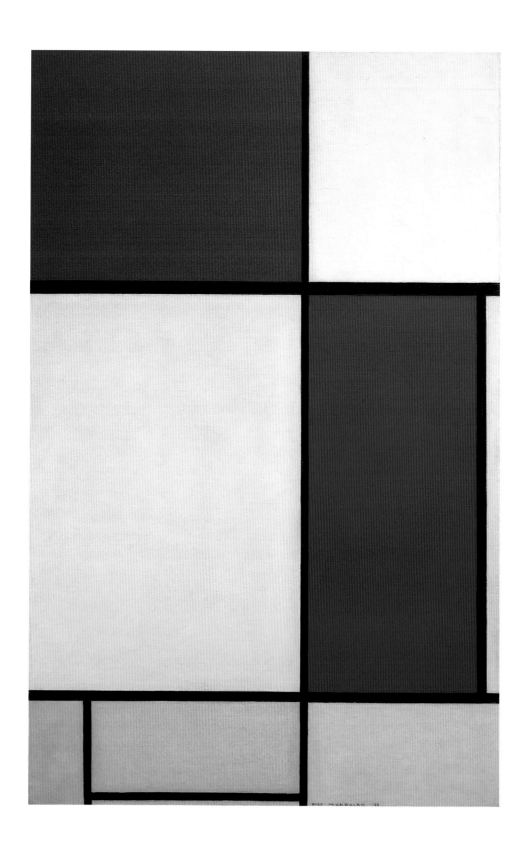

151 PIET MONDRIAN, *Composition avec rouge, jaune et bleu /*
 Composition with Red, Yellow and Blue, 1928
 Oil on canvas, 124 x 80 cm
 Stefan T. Edlis Collection

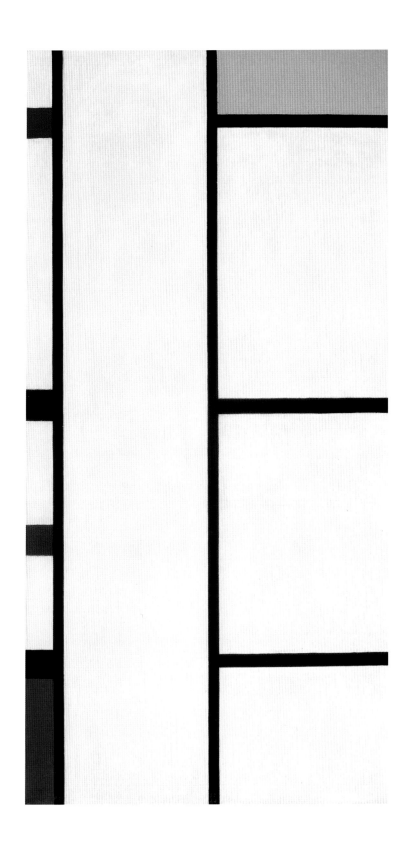

152 PIET MONDRIAN, *Composition avec rouge, jaune et bleu /*
 Composition with Red, Yellow and Blue, 1935–1942
 Oil on canvas, 101 x 51 cm
 Private collection, Courtesy Christie's, New York

153 CONSTANTIN BRANCUSI, *Muse endormie (III), Étude /*
Sleeping Muse (III), Study, 1917–1918
Marble, 18.5 x 29.5 cm
Private collection

154 CONSTANTIN BRANCUSI, *Oiseau dans l'espace* / Bird in Space, 1927
Bronze, bird: 184 x 45 cm base: 18 cm
National Gallery of Art, Washington D.C.; Given in loving memory of her husband,
Taft Schreiber, by Rita Schreiber

155 JULIO GONZÁLEZ, *La femme au miroir* / The Woman with a mirror, 1936
Bronze, 204 x 67 x 36 cm
Estate Julio González, Paris, Courtesy Galerie de France, Paris

156 DAVID SMITH, *Cubi XVIII*, 1964
 Stainless steel, 294 x 152 x 55 cm
 Museum of Fine Arts, Boston; Gift of Susan W. and Stephen D. Paine

157 BARNETT NEWMAN, *By-Two's*, 1949
Oil on canvas, 168 x 40.5 cm
Private collection

158 BARNETT, NEWMAN, *White Fire I*, 1954
 Oil on canvas, 122 x 152 cm
 Joseph Hackmey Collection

159 BARNETT NEWMAN, *Here III*, 1965–1966
 Stainless and Cor-Ten steel, 318 x 60 x 47 cm
 Whitney Museum of American Art, New York

160 AD REINHARDT, *Abstract Painting*, 1956
Oil on canvas, 152 x 152 cm
Collection Onnasch

161 CLYFFORD STILL, *1955-D*, 1955
Oil on canvas, 296 x 282 cm
Courtesy Gagosian Gallery

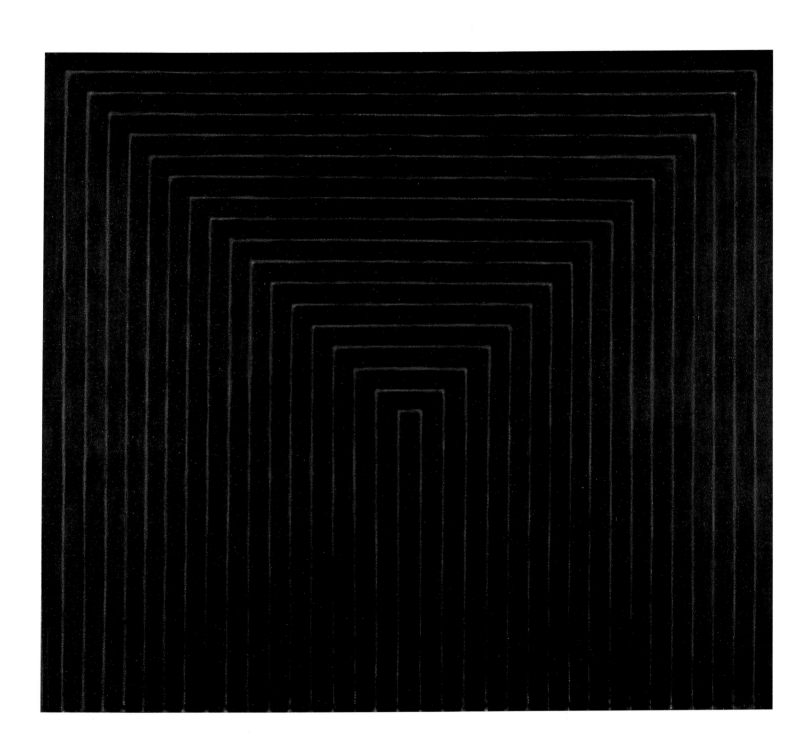

162 FRANK STELLA, *Getty Tomb, 2nd version*, 1959
 Oil on canvas, 213 x 244 cm
 Los Angeles County Museum of Art;
 Purchased with Contemporary Art Council Fund

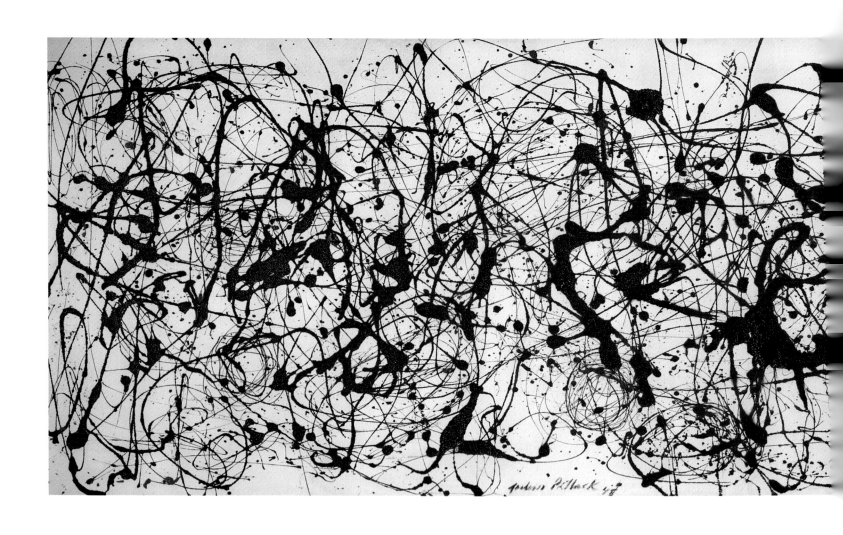

163 JACKSON POLLOCK, *Number 7 A*, 1948
Oil and enamel on canvas, 91.5 x 343 cm
A. Alfred Taubman

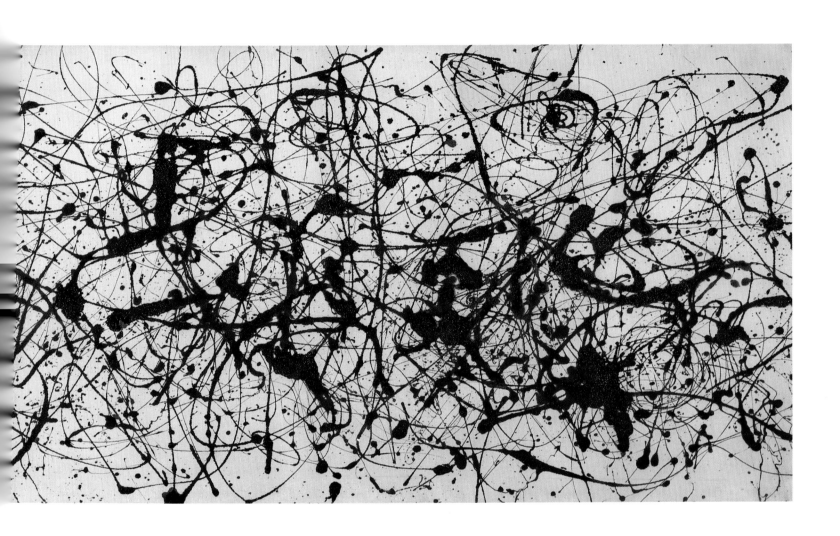

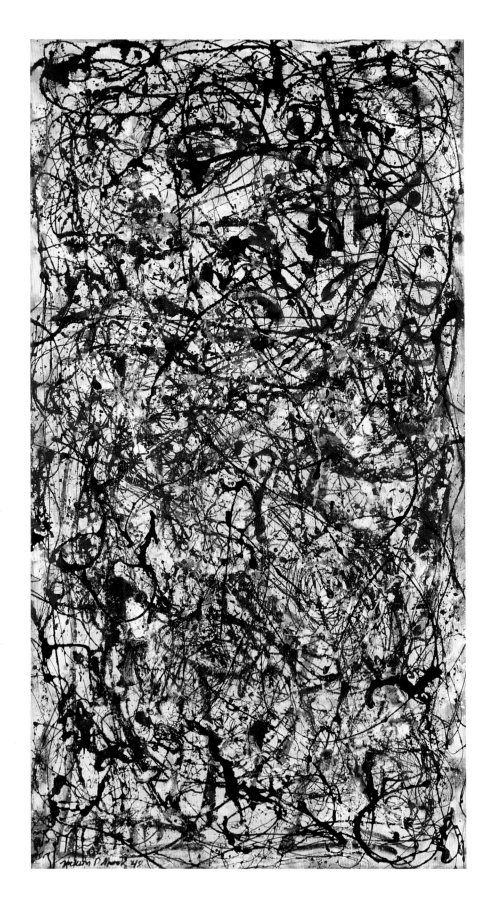

164 JACKSON POLLOCK, *Number 26 A "Black and White"*, 1948
 Enamel on canvas, 205 x 122 cm
 Musée National d' Art Moderne, Centre Georges Pompidou; Donation 1984

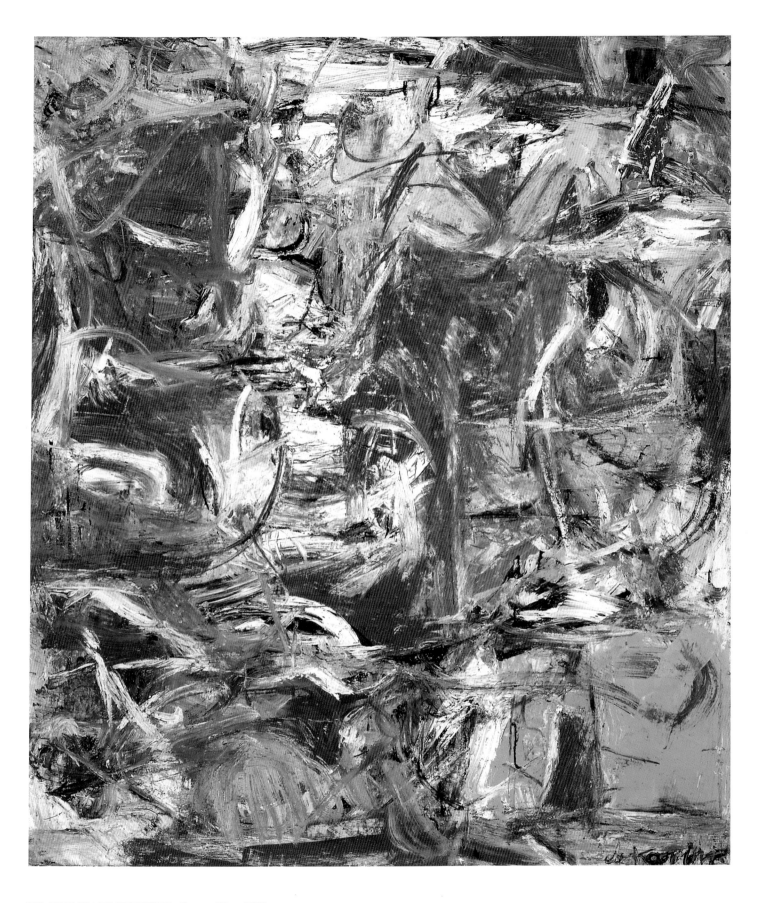

165 WILLEM DE KOONING, *Composition*, 1955
 Oil, email, charcoal on canvas, 201 x 176 cm
 Solomon R. Guggenheim Museum, New York

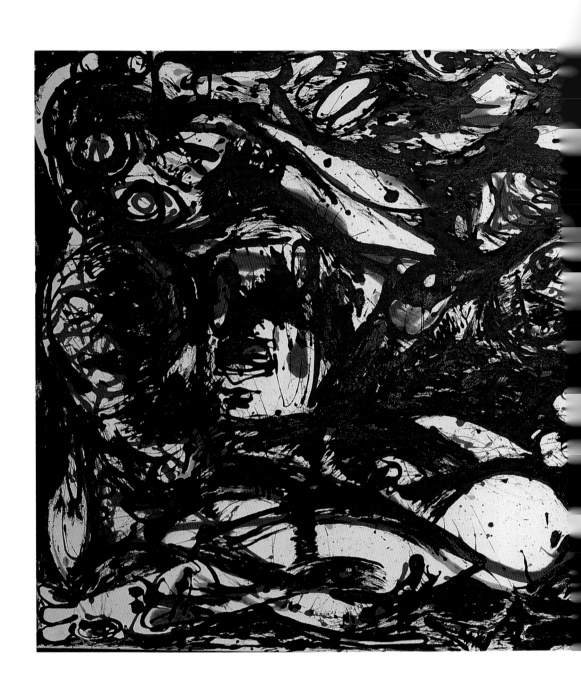

166 JACKSON POLLOCK, *No. 11*, 1951
Oil on canvas, 146 x 352 cm
Private collection

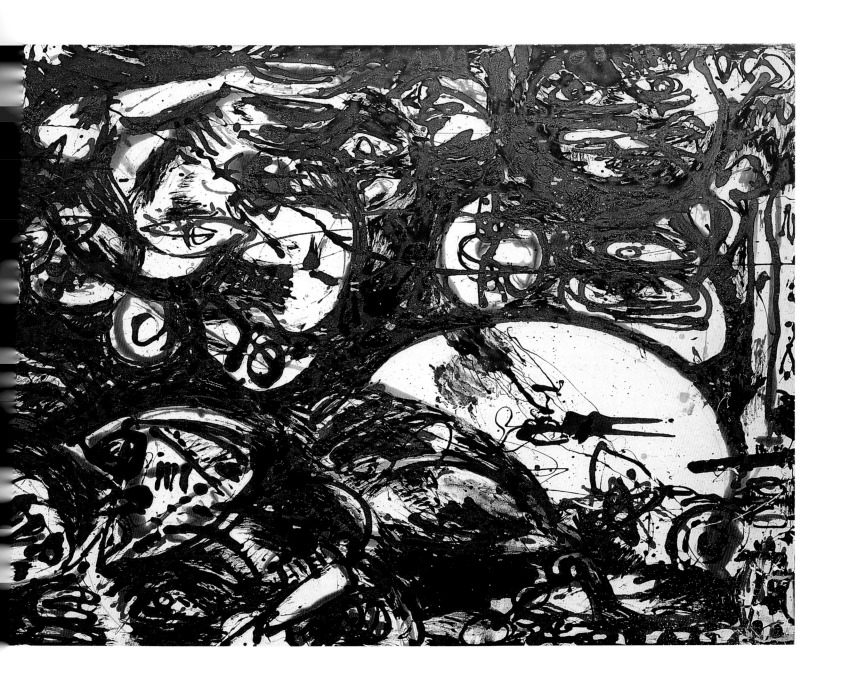

167 YVES KLEIN, *La grande Anthropométrie bleue, ANT 105 /*
Big Blue Anthropometry, ANT 105, ca. 1960
Blue pigments and synthetic resin on paper on canvas, 280 x 428 cm
Courtesy Galerie Gmurzynska, Cologne

168 LUCIO FONTANA, *Concetto spaziale* / Concept of Space, 1949
 Oil and paper on canvas, 100 x 100 cm
 Fondazione Fontana, Milan

169 LUCIO FONTANA, *Concetto spaziale (La bara del marinaio)* /
Concept of Space (The Sailor's Stretcher), 1957
Mixed media on canvas, 114 x 164 cm
Civico Museo d'Arte Contemporanea, Milan

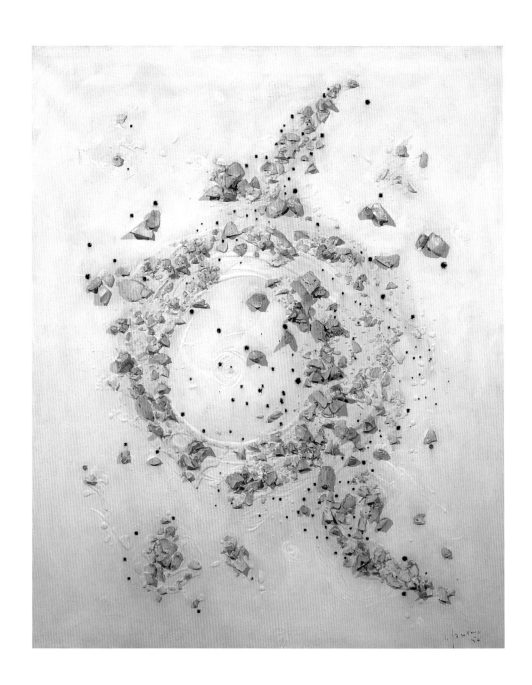

170 LUCIO FONTANA, *Concetto spaciale* / Concept of Space, 1956
 Oil on canvas, 80 x 65 cm
 Civico Museo d'Arte Contemporanea, Milan

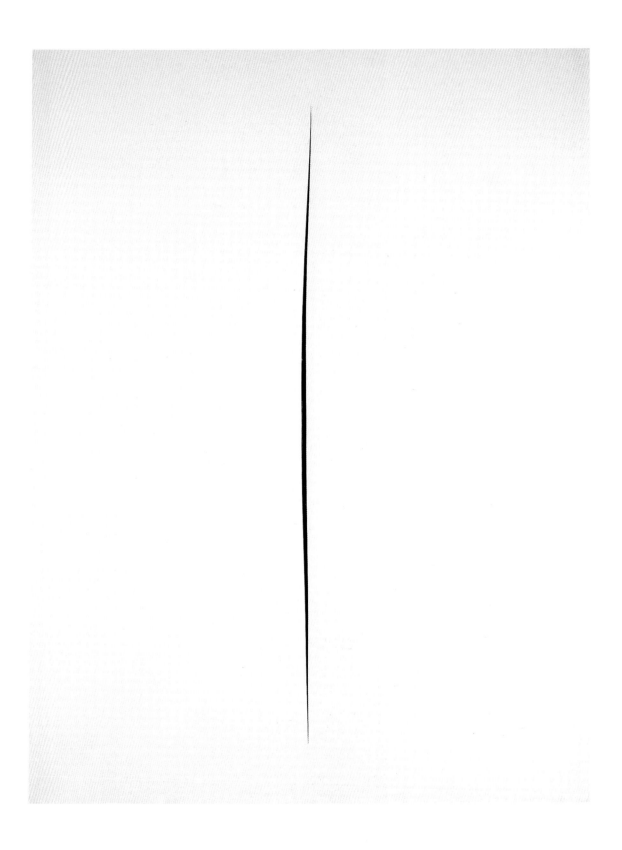

171 LUCIO FONTANA, *Concetto spaziale. Attesa /*
Spatial Concept. Expectation, 1960
Acrylic on canvas, 116 x 89 cm
Museo Nacional Centro de Arte Reina Sofía, Madrid

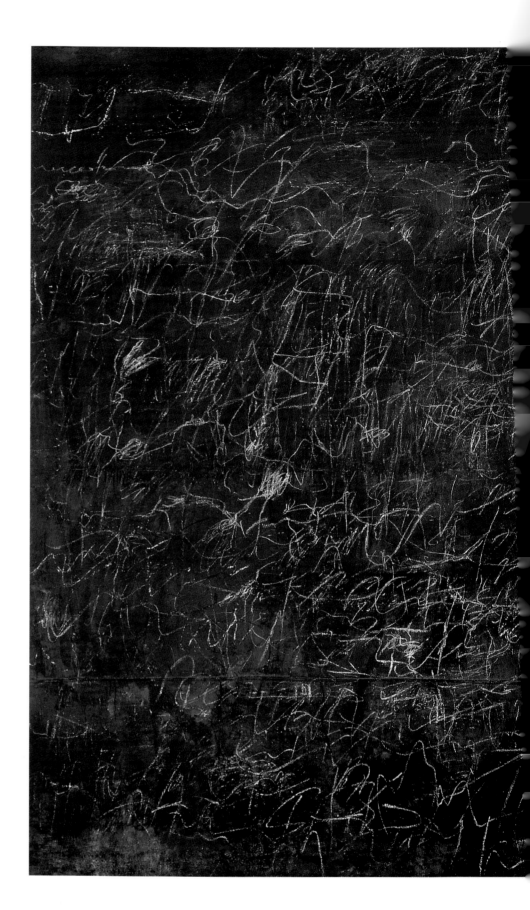

172 CY TWOMBLY, *Panorama*, 1955
House paint, crayon and chalk on canvas, 254 x 340.5 cm
Private collection

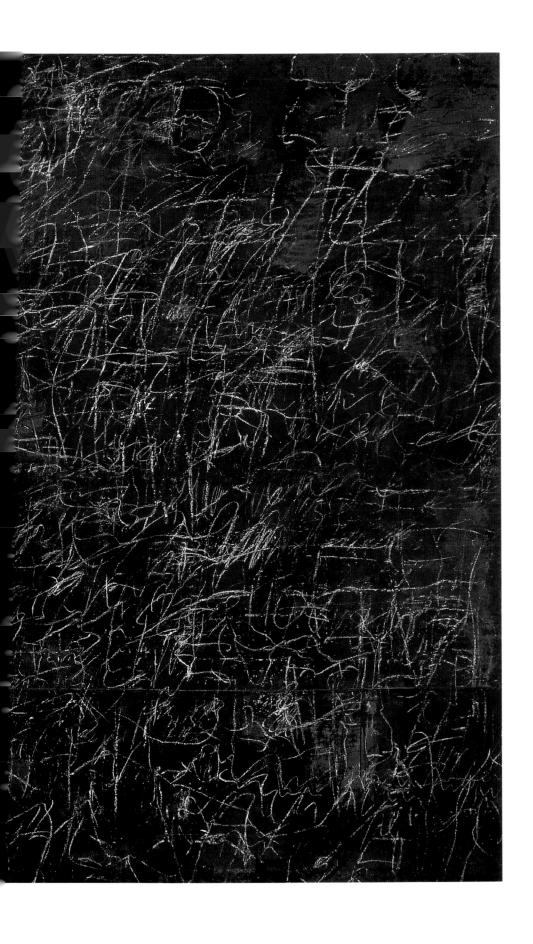

173 PIERO MANZONI, *Achrome*, 1958
Kaolin on canvas, 60 x 80 cm
Civico Museo d'Arte Contemporanea, Milan

174 PIERO MANZONI, *Achrome*, 1958
Chalk on canvas, 130 x 97 cm
Civico Museo d'Arte Contemporanea, Milan

175 PIERO MANZONI, *Achrome*, 1959
Kaolin on canvas, 100 x 70 cm
Civico Museo d'Arte Contemporanea, Milan

176 ELLSWORTH KELLY, *Black over White*, 1966
 Oil on canvas, two panels: 218.5 x 203 cm overall
 Private collection

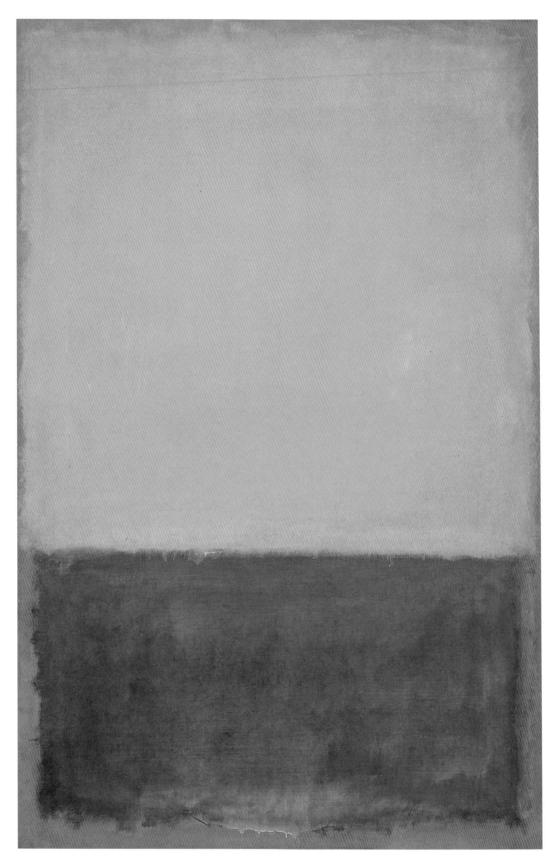

177 MARK ROTHKO, *Untitled (Yellow, Blue on Orange)*, 1955
Oil on canvas, 260 x 169.5 cm
The Carnegie Museum of Art, Pittsburgh; Fellows Fund,
Women's Committee Acquisition Fund, and Patrons Art Fund, 1974

178 YVES KLEIN, *RE 23, 1957*, 1957
 White pigment, casein and sponges on board, 100 x 200 cm
 Courtesy Blondeau Fine Art Services S.A., Geneva

179 YVES KLEIN, *L'Accord bleu, RE 10* / Blue Harmony, RE 10, 1960
Sponges, pebbles, dry pigment in synthetic resin on board, 196 x 163 x 13.5 cm
Stedelijk Museum, Amsterdam

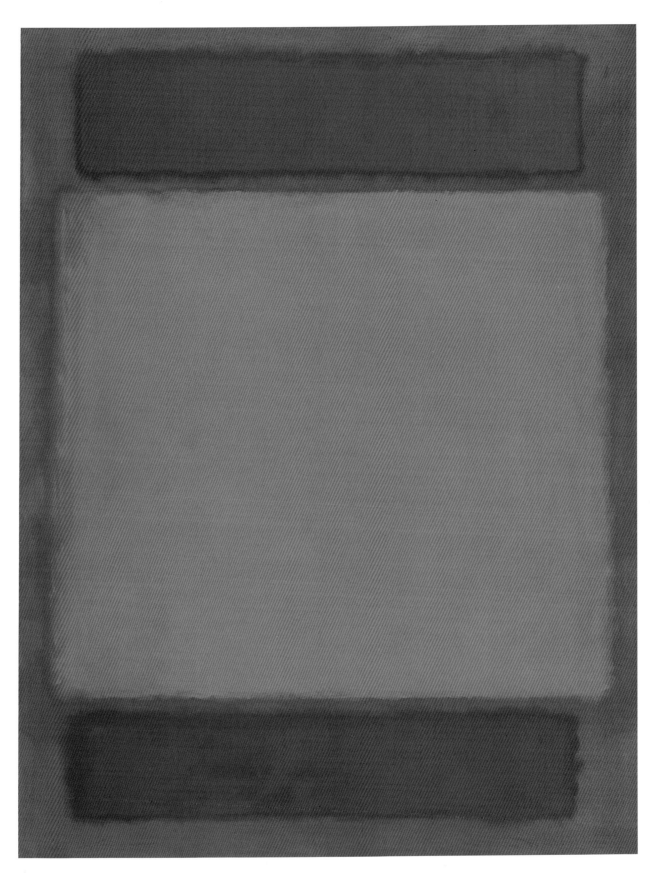

180 MARK ROTHKO, *Orange, Brown*, 1963
Oil on canvas, 226 x 178 cm
Detroit Institute of Arts;
Founders Society Purchase, W. Hawkins Ferry Fund

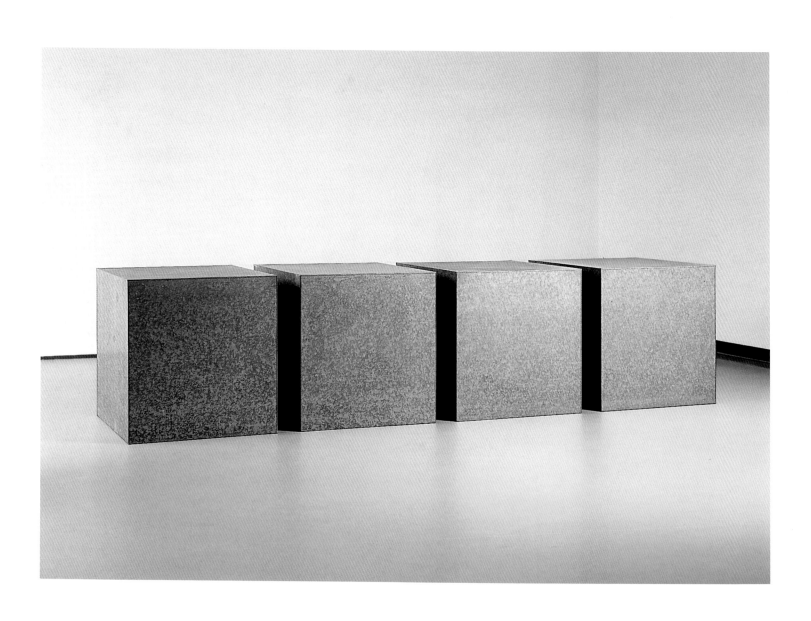

181 DONALD JUDD, *Untitled (Galvanized Iron 17 January 1973)*, 1973
Galvanized iron, 4 parts, each 102 x 102 x 102 cm
Museum Boijmans Van Beuningen, Rotterdam

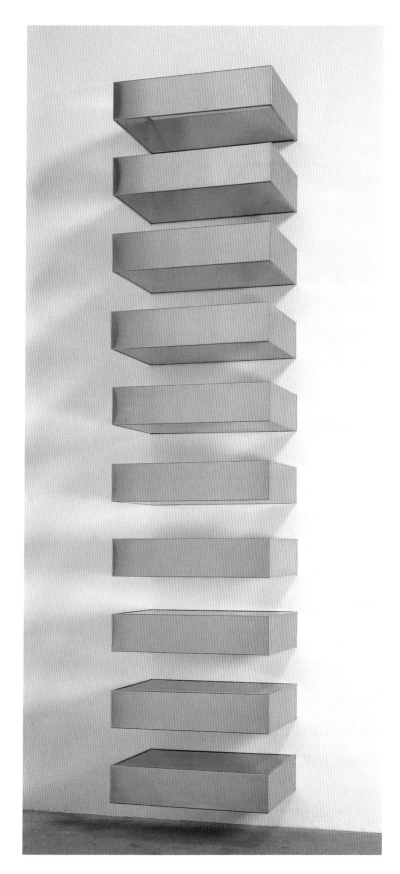

182 DONALD JUDD, *Untitled*, 1968
 Plexiglass and high grade steel, 10 units,
 each 23 x 101.5 x 79 cm, total height 437 cm
 Froehlich Collection, Stuttgart

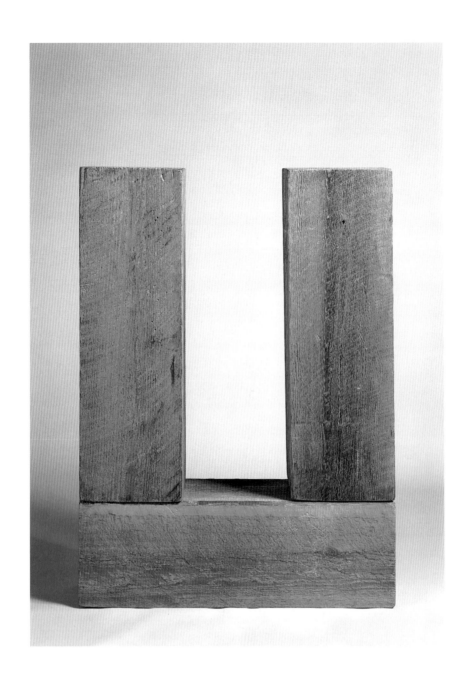

183 CARL ANDRE, *Posts on Threshold (Element Series)*, 1960/1971
Western red cedar, 3 units,
each 30.5 x 91.5 x 30.5 cm, overall 122 x 91.5 x 30.5 cm
Froehlich Collection, Stuttgart

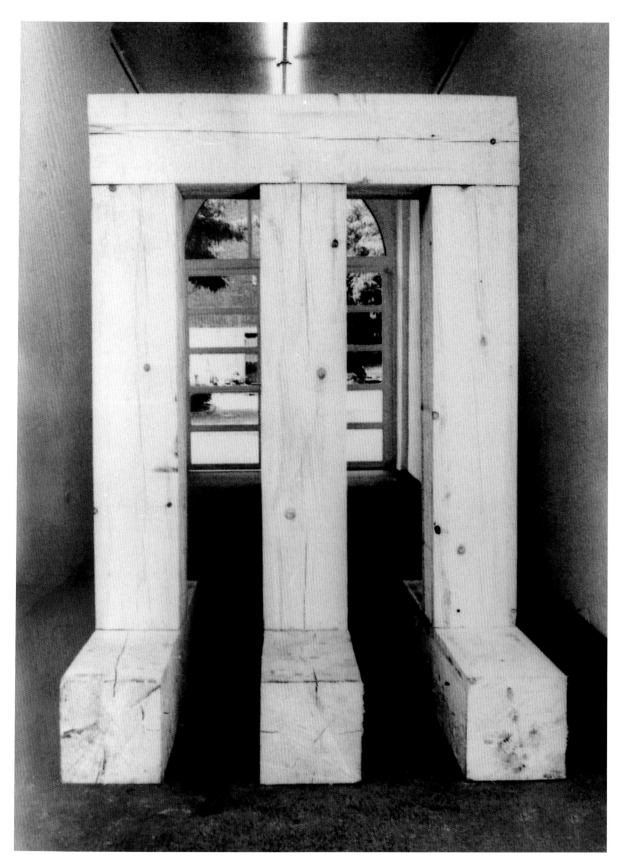

184 CARL ANDRE, *Henge on 3 Right Thresholds*
 (Meditation on the year 1960), 1971
 Wood, 210 x 150 x 150 cm
 Collection Herbert, Ghent

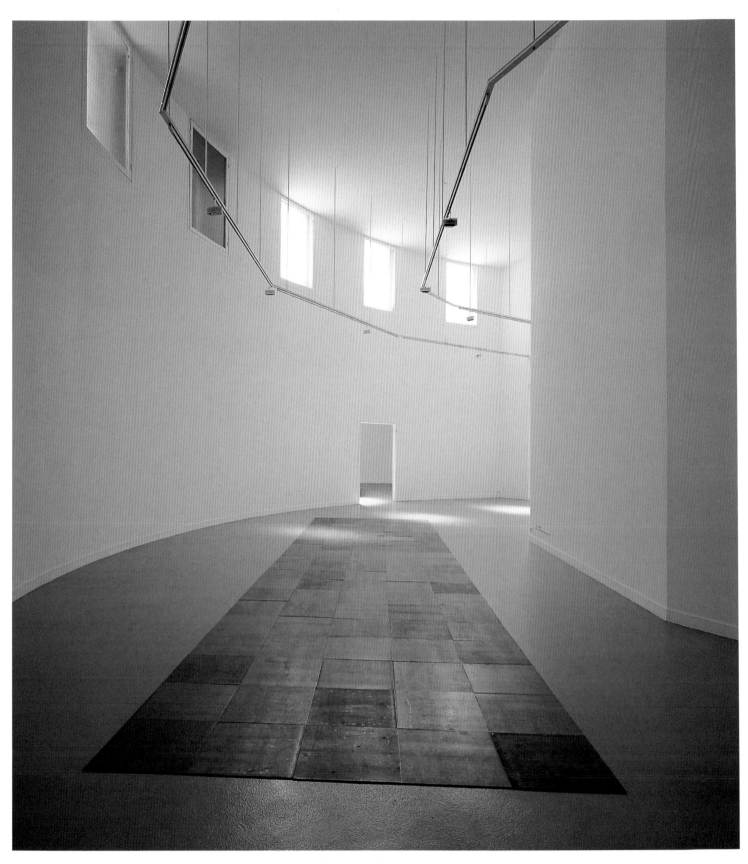

185 CARL ANDRE, *5 x 20 Altstadt Rectangle*, 1967
 Hot rolled steel plates, 100 plates, each 0.5 x 50 x 50 cm, overall 2.50 x 10 m
 Solomon R. Guggenheim Museum, New York; Panza Collection,
 Gift of Count Panza, 1991

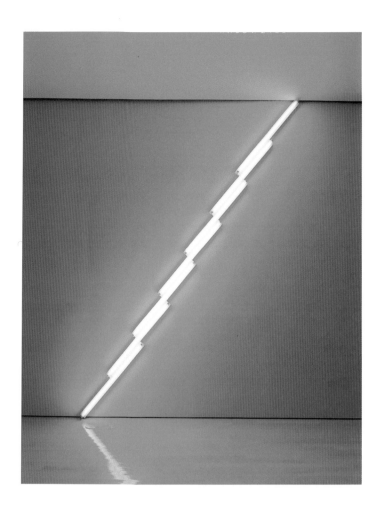

186 DAN FLAVIN, *Untitled*, 1975
Fluorescent light tubes, 427 cm
Solomon R. Guggenheim Museum, New York;
Panza Collection, extended loan

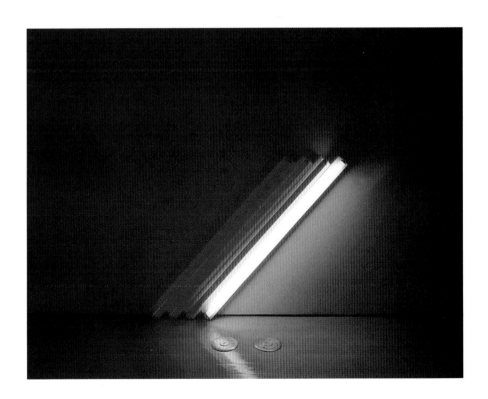

187 DAN FLAVIN, *Untitled*
(to the citizens of the Swiss cantons), 1987
Fluorescent light tubes, 244 cm
Solomon R. Guggenheim Museum, New York;
Panza Collection, extended loan

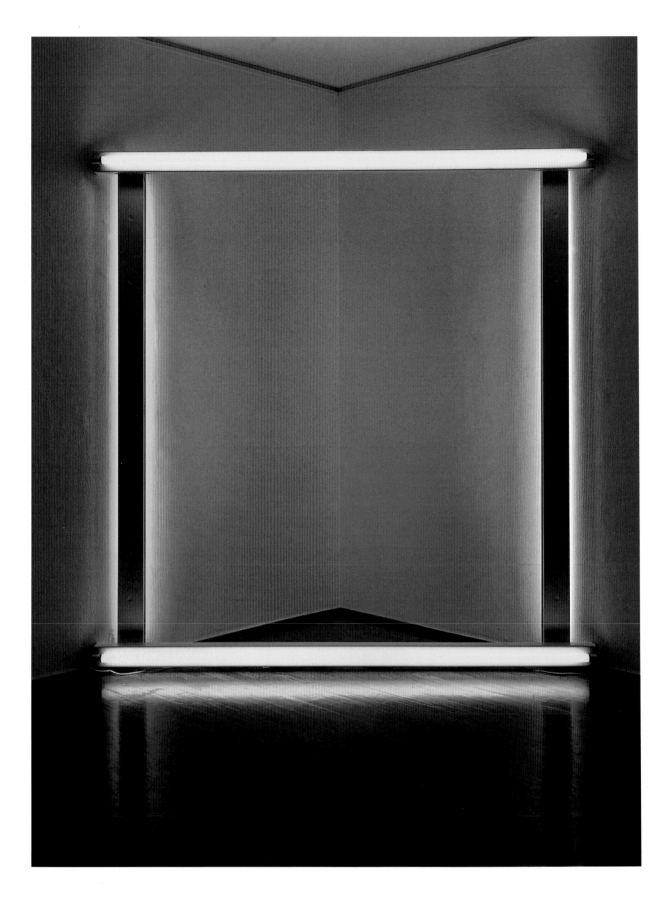

188 DAN FLAVIN, *Untitled (for Donna)*, 1971
Fluorescent light tubes, 244 x 244 cm
Froehlich Collection, Stuttgart

189 DAN FLAVIN, *Untitled*, 1987
Fluorescent light tubes, 244 x 244 x 25.5 cm
Onnasch Collection

190 JAMES TURRELL, *Porter Powell*, 1967
 Light projection, dimensions variable
 The artist, Courtesy of Michael Hue-Williams Fine Art, London

191 RICHARD SERRA, *Template*, 1967
Vulcanized rubber, height 244 cm
Solomon R. Guggenheim Museum, New York;
Panza Collection, Gift of Count Panza, 1991

192 RICHARD SERRA, *Right Angle Prop*, 1969
 Lead antimony, 183 x 183 x 86.5 cm
 Solomon R. Guggenheim Museum, New York;
 Purchased with Funds from the Theodoron Foundation, 1969

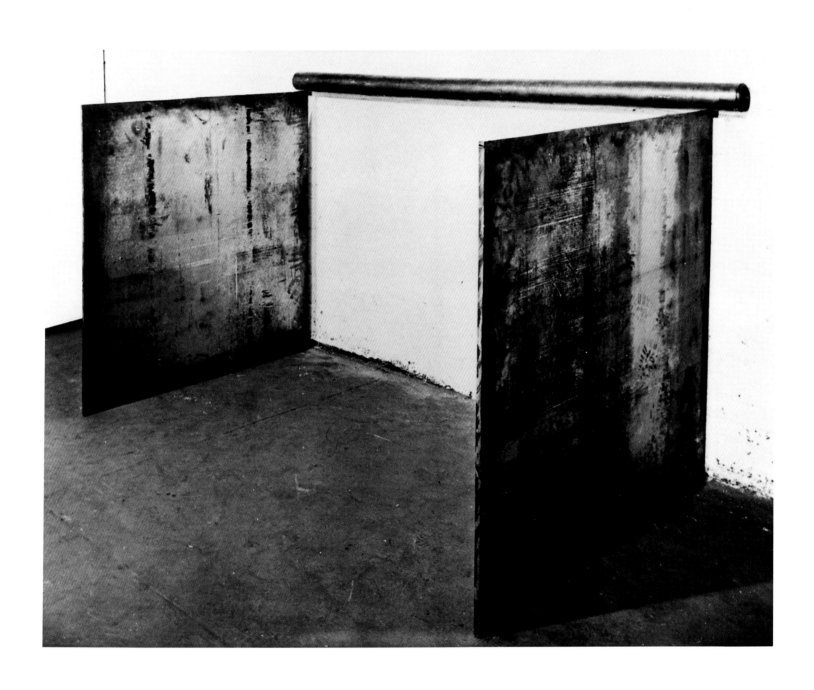

193 RICHARD SERRA, *No. 5*, 1969
 Lead antimony, 132 x 213 x 122 cm
 Onnasch Collection

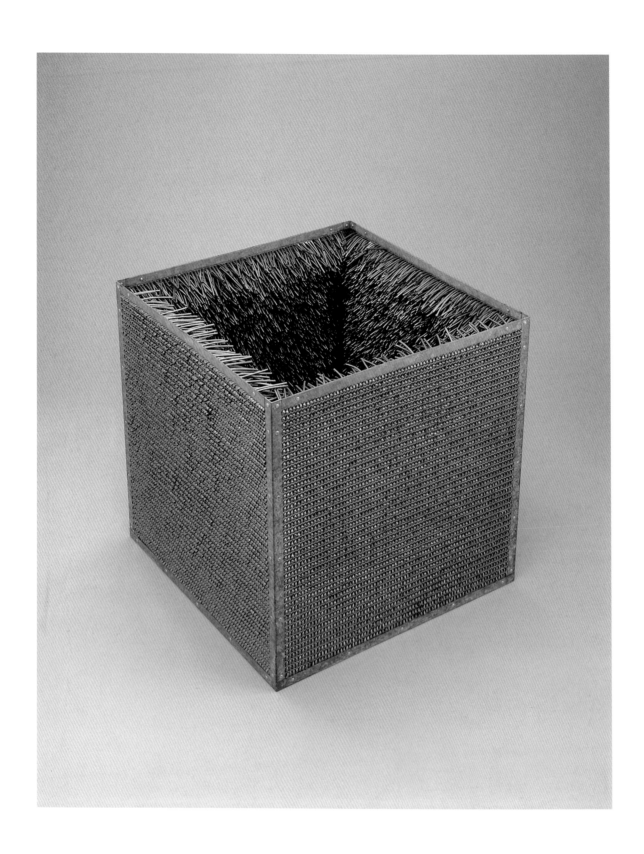

194 EVA HESSE, *Accession II*, 1967
 Galvanized steel and plastic tubing, 78 x 78 x 78 cm
 The Detroit Institute of Arts; Founders Society Purchase,
 Friends of Modern Art Fund and Miscellaneous Gifts Fund

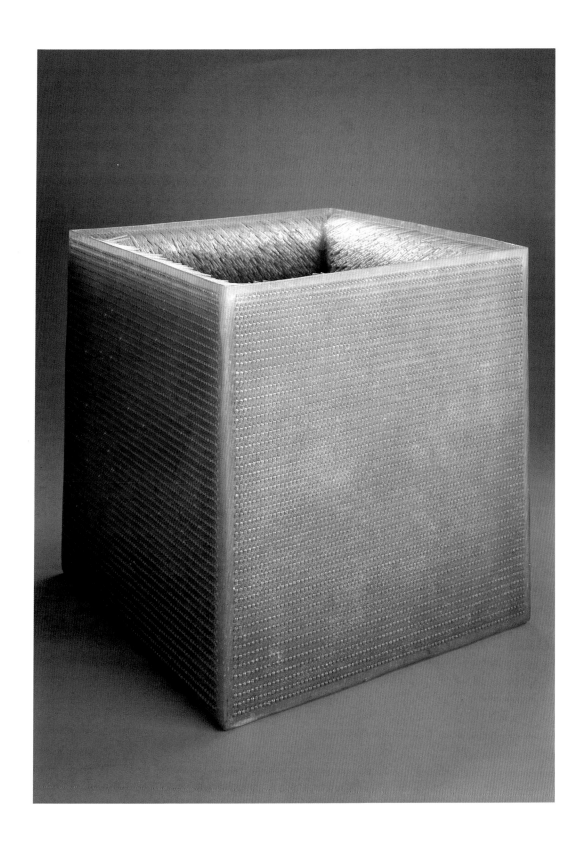

195 EVA HESSE, *Accession III*, 1967–1968
Fibreglass and plastic tubing, 80 x 80 x 80 cm
Museum Ludwig, Cologne

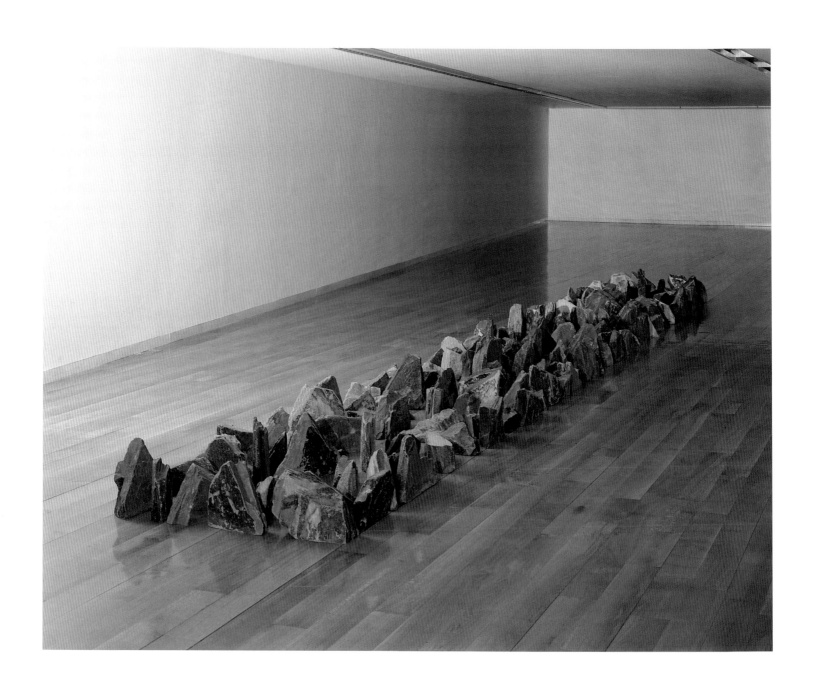

196 RICHARD LONG, *Standing Stone Line*, 1987
 Cornwall slate, 116 x 940 cm
 Collection of the Centro Galego de Arte Contemporánea;
 Deposit of the ARCO Foundation

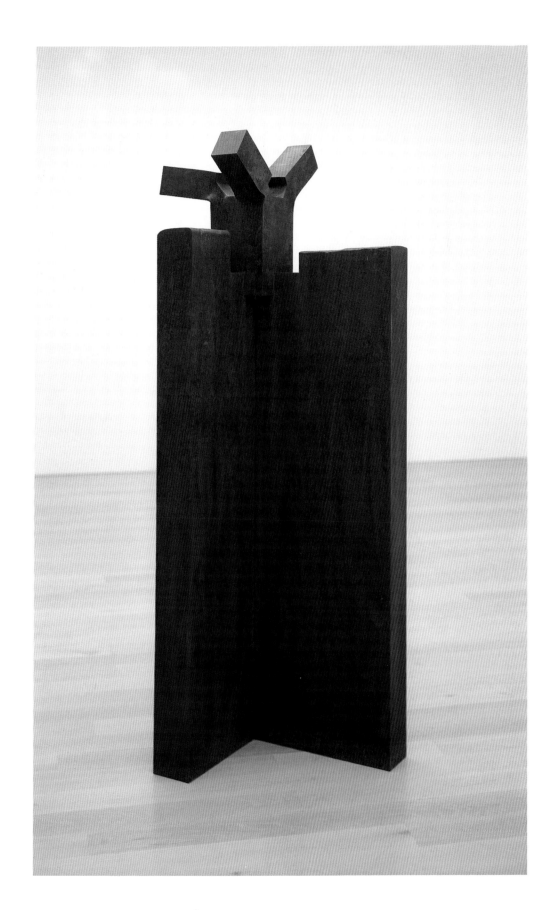

197 EDUARDO CHILLIDA, *Txoko*, 1989
 Steel, 180 x 78 x 66 cm
 Collection of the Artist, Courtesy Annely Juda Fine Art, London

198 ROBERT RYMAN, *Mayco*, 1965
 Oil on linen on canvas, 192 x 192 cm
 Private collection

199 ROBERT RYMAN, *Exeter*, 1968
Oil on linen with tape frame, 250 x 250 cm
Private collection

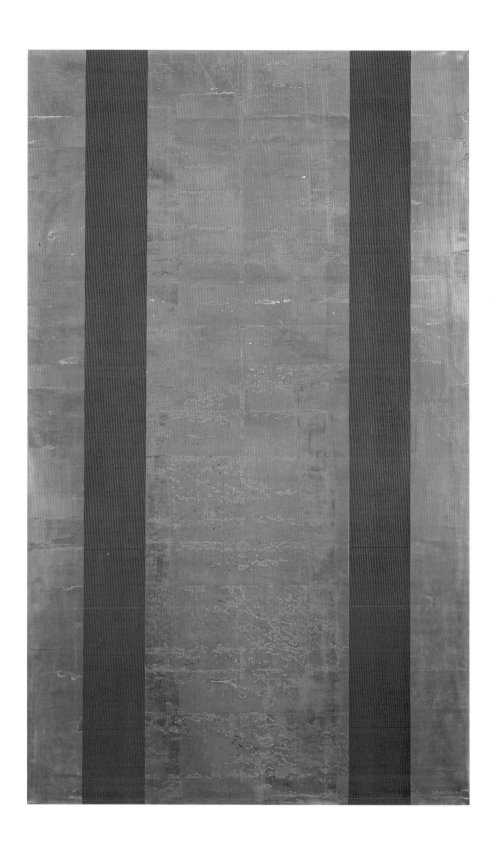

203 GÜNTHER FÖRG, *Untitled* (fg 00035), 1990
 Acrylic on lead, 180 x 110 cm
 Gräßlin Collection, St. Georgen

200–205 GÜNTHER FÖRG, *Untitled*
(fg 00034, fg 00036, fg 00032, fg 00035 fg 00030, fg 00026), 1990
Acrylic on lead, 180 x 110 cm
Gräßlin Collection, St. Georgen

Language – Material

BROOKS ADAMS

Like Smoke: A Duchampian Legacy

Fig. 1 Paul Cézanne, *Portrait of the painter Achille Empéraire,* c. 1868–70. Musée d'Orsay, Paris

Fig. 2 Jasper Johns, *False Start,* 1959. Private collection

1 For George Grosz's Cruel Cubism, see Brooks Adams, 'The Master of Identified Debris', in *George Grosz: Berlin – New York*, exh.cat., New York, Associated American Artists, 1995, p. 8.

Prologue

In the beginning, there was early Cézanne: the stencilled letters identifying the sitter in a full-length portrait of the dwarf painter, Achille Empéraire (Fig. 1), beam forward as a precedent for Jasper Johns' use of stencils for the naming of colours nearly a century later (Fig. 2). Stencilled letters in paint were in and of themselves nothing new in either the 1870s or 1950s: rather, it was a matter of their inarticulate, standardised, industrialised and readymade qualities being used deliberately to underscore, and undermine, the context of *La belle peinture*. At once childlike, ham-fisted, intellectually sophisticated and pictorially deft, they simultaneously refer to the painterly tradition of sixteenth-century portraiture and to the strictly artisanal: they give off a whiff of the signmaker's craft. The stencilled word is symptomatic of a verbal-conceptual strain that reverberates through twentieth-century art.

I. Duchamp and the Concept of the Twentieth Century

Duchamp is at the origin of both modernism and postmodernism. His work was as important in the teens, twenties, and thirties for the gestation of Dada, Machine Age art and Surrealism as it was in the sixties, seventies and eighties for the emergence of Pop Art, Conceptual Art and 1980s High Concept painting and sculpture by artists such as David Salle and Jeff Koons.

The Duchampian oeuvre offers a paradigm for a century that has kept echoing and turning back on itself. Duchamp, in fact, began life as a child of the late nineteenth century and is in the process of being reborn a child of the late twentieth century as well. His art can be used to justify both the thesis and the antithesis of the twentieth-century progressive modernist argument. To this extent he resembles Francis Picabia, Max Ernst, Giorgio de Chirico, René Magritte and George Grosz. It can be argued that each of these stellar modernists actually turned postmodernist considerably earlier than the 1950s, by which time all their varied and quizzical late styles had become manifest – also the decade during which that hybrid, historicist movement later called Postmodernism was supposedly first incubating in the work of Jasper Johns, Robert Rauschenberg and Andy Warhol. In Duchamp's case, Postmodernism strikes as early as 1912, with his Cubistic charades that, like Grosz's gothic-prismatic cityscapes, suggest a novel twist that might be called Cruel Cubism.[1]

Duchamp's oeuvre, furthermore, does not progress. It flares to a radical early climax, then hibernates, then reappears, only to revert to a kind of Symbolism with the belated

evil-flowering that is *Etant donnés* (1946–66) (see Figs. 12 and 13). It has long been recognised that Duchamp's work, especially the early paintings, is a manifestation of late Symbolism. The ideas for his brides and nudes gestated in Munich during his sojourn there in the summer of 1912, and paintings such as *Virgin* (July, 1912), for instance, and *Bride* (August, 1912) (Fig. 3) belong in the company of Franz von Stuck's sirens, Loïe Fuller's dances, and all manner of other fin-de-siècle *femmes fatales* and *hommes blessés* – including, not least, Kandinsky's knights and damsels, which were often painted on glass. Today, Duchamp's Munich moment might also seem to suggest a precedent for Jeff Koons' Bavarian honeymoon in the late eighties and early nineties, a period during which some of his most elaborately rococo, sometimes quasi-pornographic sculptures were fabricated.

Fig. 3 Marcel Duchamp, *Mariée* (Bride), 1912. Philadelphia Museum of Art

With the great exception, arguably, of *Etant donnés*, Duchamp's career is not capped by anything one can identify as a late style. In this respect he is certainly unlike Picabia, whose quizzically unorthodox later works (the palimpsests and polka-dots, for instance), although long dismissed, were of greater influence on young artists during the eighties than the early, classically modernist paintings. With Duchamp, it is more a matter of the early work being reinterpreted by successive schools of thought. The modernist argument would in fact have it that Duchamp was an early bloomer whose post-1920s efforts trail off into assorted random actions, vaguely fetishistic pursuits and arcana.

The postmodernist sensibility, however, delights in Duchamp's later trajectory of ineffable poetic gestures and inactions, his peculiar muteness and even his 'failure'. (So-called 'abject art' of the early 1990s is an obvious manifestation of this: Mike Kelley's 'pathetic', found or bought, stuffed-animal sculptures, for instance, inject a comic pathos into the idea of the readymade.) Similarly, such previously 'inferior' constructs and practices as fashion, decoration, handiwork, campiness in 'serious' art, and sheer silliness have become lodestars in the late-century aesthetic firmament.

Duchamp redefined the word artist for the twentieth century. His roles were endless, ever-proliferating and, whether performed inside or outside the studio, must be considered part of his oeuvre: Duchamp-as-artist means Duchamp as painter, sculptor, glassworker, tinkerer, installation artist, collaborator with other artists, traumatised younger brother to artists, exhibition designer, dealer, advisor to collectors, curator, go-between, chess player, gambler, androgyne, monastic flirt, late bloomer, early bloomer, genius, failure, muse, father-figure, ladies' man, Gallic *coq*, feminist, supporter of women artists, role-model for gay artists and cross dressers, draft-dodger, ambassador for (and betrayer of) French culture, procrastinator (delayer), professional *fainéant*, and more besides.

Duchamp was one of the great *allumeurs*: From his first appearance at the informal court of the Arensberg salon where, in around 1916, New York Dada was born, to his later apotheosis, on both coasts of the United States during the fifties and sixties, as guru to the avant-garde, he catalysed and was in turn sparked off by his various patrons (most notably Katherine Dreier), acolytes (for instance the lesser known New York Dadaist

John Covert, an Arensberg cousin, who made art only for about ten years before joining the family's Vesuvius Crucible Company near Pittsburgh), friends and lovers (among them, the former actress and celebrated ceramicist Beatrice Wood, who at the time of this writing is alive and well in Ojai, California, at the age of 104).[2]

Duchamp's early intercourse with New York anticipates by almost twenty years that seismic shift in energies from Paris to New York that is usually associated with the emigration of the Surrealists during World War II. Duchamp's participation in New York Dada undermines this chronology, even as it galvinises the notion of a near-continuous aesthetic back-and-forth between Europe and the United States, not to mention with most of the rest of the world as well.

II. The Painting Paradox

Duchamp, who famously gave up painting, is both integral to the history of twentieth-century painting and a continuing source for it. Is this a conservative argument? It does seem to undermine the compartmentalising tendencies of this show that would see Duchamp's importance mainly in relation to Object Art and, in general, conceptualism, with Kandinsky standing alone and apart on the opposite pole of the modernist force field, as the signal generator for Abstraction. To be sure, Duchamp's example has been instrumental to the development this century of photography, video, performance, and even writing ('Oulipian' strategies of chance or arbitrariness, for instance, in the works of Raymond Queneau, Georges Perec or Harry Matthews), along with that of any number of anarchistic or sexually subversive aesthetic genres (highminded cross-dressers, for instance, claim Duchamp as one of their patron saints). Indeed, his unorthodox use of materials lent to all art forms, not least painting, an unprecedented freedom of process in which chance procedures, as well as all manner of substances, were at once aestheticised and recognised as vital. As is well known, Duchamp was integral to a phenomenological trend that by the late sixties had developed to such an extent that critics such as Lucy Lippard were engaged in widespread discussion of 'the dematerialisation of art'. But it can also be argued that in the same years his example was equally essential for what might be termed a simultaneous rematerialisation of art, for example in the work of Joseph Beuys and the entire Arte Povera movement. One could argue even further that the Duchampian revolution, contrary to much of what has been said about him (and even by him), is important *primarily* within the context of what he called 'retinal' art. Here I am thinking not only of the Pop Art reinterpretation of the consumerist ready-made, but of the last four decades of abstraction, more specifically to what Robert Rosenblum has referred to as 'found abstraction'[3], in works by such various artists as Ellsworth Kelly, Peter Halley and, indeed, Andy Warhol, whose eighties 'Rorschach' paintings are perhaps the quintessential case in point.

2 For John Covert, see Francis M. Naumann with Beth Venn, *Making Mischief: Dada Invades New York*, exh. cat., New York, Whitney Museum of American Art, 1996, p. 198. For Beatrice Wood, see *Beatrice Wood: A Centennial Tribute*, ed. Francis Naumann, exh. cat., New York, American Craft Museum, 1997.
3 Robert Rosenblum used the term 'found abstraction' in a lecture 'Warhol as an Abstract Artist', given at the New York Studio School of Drawing, Painting and Sculpture on 21 May 1996.

III. The Word

Duchamp, who came out of a turn-of-the-century apprenticeship in magazine illustration, is, along with the Cubist collageists, Kurt Schwitters and the Berlin Dadaists, a necessary link between the nineteenth-century tradition of printed satire and the whole mid-twentieth century Pop phenomenon. From Duchamp, it's just a hop, a skip and a jump to Johns, Rauschenberg and Warhol, who used the printed or stencilled word, as well as all kinds of 'current events' in the form of painted or silkscreened newspaper photographs and headlines – *A Boy for Meg* (1961) or *129 Die in Jet (Plane Crash)* (1962), for instance, Warhol's paintings of a *New York Post* and *New York Mirror* cover respectively (Fig. 4) – in their variously fey and biting parodies of that epochal American 'action' genre, Abstract Expressionism.

Duchamp's first museum retrospective took place at the Pasadena Art Museum in 1963 and was the catalyst for a new regional manifestation of Duchamp*ophilia* which in turn had an enormous impact on the development of the word as it was sometimes cruelly deployed in California – in a word, Bruce Nauman. Nauman's word-inspired sculpture puns of the late sixties (for example *From Hand to Mouth*, 1967) (Fig. 5), along with the later neon word-reliefs and videos, are a direct offspring of the 'West Coast Duchamp', crossed with Johns.[4]

Halfway around the world in Belgium, we find Marcel Broodthaers following Duchamp up a Brussels alley with his quirky and disjunctive embossed signs (Cat. 271–282). (Indeed the definitive precedent, also Belgian, for disjunctions of word-and-image, René Magritte's *La trahison des images* with its representation of a pipe and its famous contradictory caption, 'Ceci n'est pas une pipe', is nothing if not Duchampian.) Both Duchamp's and Broodthaers' crypto-archaeological signs convey something that is at once idiosyncratically personal and redolent of an odd, humorously nostalgic feeling for old Europe and such cities as Brussels and Rouen. In Rouen, for instance, Duchamp created a plaque for his parents' house that begins with the words, 'Ici a vécu, entre 1905 et 1925, une famille d'artistes normande …'. (His words are in fact mildly hyperbolic: the various Duchamp family members never did live there all at once as artists.) Broodthaers' open-ended and multifarious installation project concerning the iconography of eagles, grouped under the rubric *Musée d'Art Moderne, Département des Aigles* (Cat. 274), is both a spoof on museological methodology and a fondly satirical evocation of a musty and self-serious institution such as the *Musée de la Dynastie* in Brussels, with its inadvertently comic genealogies and displays of national pomp.

In work by the American conceptualist Joseph Kosuth, who for the last few years has been living in Ghent, we find a great many examples of this sort of post-Duchampian involvement with signage, meanings, epistemologies and methodologies – from his mid- and late sixties paintings of word-definitions as they appear in dictionaries, to his didactic and 'curatorial' installations from the late eighties and early nineties, including *The Play of the Unsayable: Ludwig Wittgenstein and the Art of the 20th Century* at the Vienna Secession in 1989, involving texts, archival images and works of art borrowed from museums.

Fig. 4 Andy Warhol, *129 Die in Jet (Plane Crash)*, 1962. Museum Ludwig, Cologne

Fig. 5 Bruce Nauman, *From Hand to Mouth* 1967. Hirshhorn Museum and Sculpture Garden, Smithsonian Institution, Washington, DC

4 See *West Coast Duchamp*, ed. Bonnie Clearwater, Miami Beach, 1991.

Fig. 6 Lawrence Weiner, *HERE THERE & EVERY-WHERE*, 1989. Installation at the Whitney Biennial, Whitney Museum of American Art, 1996

Fig. 7 Marcel Duchamp, string installation at the exhibition *First Papers of Surrealism*, New York 1942

Fig. 8 Marcel Duchamp, *3 stoppages-étalon*, (3 Standard Stoppages), 1913–14. The Museum of Modern Art, New York

5 Katherine Dreier's elevator painted by Duchamp is illustrated in *Marcel Duchamp*, ed. Anne d'Harnoncourt and Kynaston McShine, exh. cat., New York, The Museum of Modern Art, 1973, p. 24.
6 See Calvin Tomkins, *Duchamp, A Biography*, New York 1996, p. 202.
7 See Romy Galan, 'Matta, Duchamp et le Mythe: Un nouveau Paradigme pour la dernière phase du surréalisme,' in *Matta*, exh. cat., Paris, Musée National d'Art Moderne, Centre Georges Pompidou, 1985, pp. 37–51.

Lawrence Weiner, however, hits the Duchampian jackpot by occasionally printing his ambiguous word-messages on glass. *HERE THERE & EVERYWHERE* (1989), for example, installed in the fall of 1996 on the Whitney Museum's ground floor window (Fig. 6), coincided most fortuitously with *Making Mischief: Dada Invades New York*, at the museum this winter – a show that included the Swedish reconstruction of Duchamp's *The Large Glass*.

Among artists of a younger generation we have Christopher Wool and his big stencilled-word paintings, in which black letters proceed inexorably across white canvases, whose edges create inevitable yet arbitrary 'page breaks' that disrupt word-meaning, or at least delay comprehension, forcing the eye as well as the mind to switch into a sort of remedial high-gear. There are also Wool's roller-printed pattern-paintings, which find precedents not only in Warhol's wallpaper pieces, but also in a decorative painting of leaves by Duchamp, commissioned in 1946 by his friend and patron Katherine Dreier, for the elevator of her Milford, Connecticut house – a pattern designed to match the existing wallpaper in the surrounding space.[5]

Duchamp and the politically correct word: Among many young identity-fixated artists in New York during the early 1990s, we find Glenn Ligon, whose stencilled, black-ink drawings resembling gravestone rubbings comprise hard-to-read texts (all of them appropriated) that allude to his blackness and, slightly later, to his gayness as well. Ligon's texts function as veils, disguises or semantical alter egos that permit Duchamp, the *sine qua non* of meaningful indirection, to infiltrate the discourse even of late-century race and gender politics.

IV. Abstraction, Lost and Found

Duchamp's relationship to abstraction, although intermittent, is as powerful as his relationships to the word and the object in twentieth-century art. The Duchamp biographer Calvin Tomkins has pointed out that the right section of *Tu m'* (1918) (see Fig. 11) resembles a Kandinsky abstraction.[6] One might add that the painting's left-central motif of cascading planes of colour prefigures Kandinsky's hard-edge, Bauhaus and Paris styles of the twenties and thierties. As for Duchamp's impact on Abstract Expressionism – well, the skein-like tangle of roughly a mile of string that he devised for the installation of the *First Papers of Surrealism*, a 1942 show in a New York City mansion (Fig. 7), presents itself as a three-dimensional precedent for the 'allover' compositional style that Jackson Pollock would introduce only a few years later in abstract 'drip' paintings. (The historian Romy Galan has already posited the influence of Duchamp's 1942 string installation on Matta's forties work.[7] Why not fast-forward to the eighties to posit Warhol's silkscreened 'Yarn' paintings as double puns on Pollock and Duchamp.)

Cut to the 1960s and Postminimalism: Richard Serra's early lead sculptures can be cross-referenced to Johnsian grisaille, to the aleatory processes of John Cage and therefore, of course, to Duchamp's *3 Standard Stoppages* (1913–14), whose arbitrary contours were generated by dropping a metre of string from a metre's height (Fig. 8). Serra's eddying

layers of poured lead are essentially high-materialist incarnations of the *Stoppages* (Fig. 9). Brice Marden, on the other hand, derives more of a quicksilver element from Duchamp's alchemy of glamour and negation. The exquisitely nuanced shades of grey in Marden's monochromatic paintings from that period suggest, at least obliquely, the Duchampian prerogative of dandified understatement – something he would certainly have absorbed as Robert Rauschenberg's studio assistant in the mid sixties.

More recently, even Philip Taaffe has emerged as something of a Duchampian: in the enormous *Megalopolis*, a thirty-foot-long painting the artist made for his fall '96 show at the Vienna Secession, we find – amid fantastically complex layers of images and abstractions and appropriations, including allusions that range from Warhol to Klimt – what is no doubt the most monumental reference yet to Duchamp's *Stoppages*, in the form of several irregularly shaped columns used to signify new urban-tribal rhythms in paint.

With hindsight, even the late, Tiepolo-esque paintings of Willem de Kooning might be said to convey a hint of Duchampian transparency. De Kooning probably first saw *The Large Glass* sometime between 1943 and 1946, when it was in New York on extended loan to the Museum of Modern Art (Fig. 10). In any case, in a 1965 article by Thomas Hess in *ArtNews*, de Kooning, when questioned about the future, responded that he didn't know where he was going, but that he would be getting there 'on the same train as Marcel Duchamp'.[8] A distant memory of *The Large Glass* seems to have insinuated itself in de Kooning's eighties paintings: in those senescent masterpieces, with their white, translucent grounds and their euphorically dizzying suggestions of flux and apotheosis, the artist manages to conjure up illusions of three- and even four-dimensionality – the very goal that Duchamp aspired to. (Duchamp eventually summed these qualities up as being 'infra-thin', the inexpressibly subtle relationship between spaces and sensations, such as the feeling of the width of a piece of paper.) Finally, like *The Large Glass*, de Kooning's late paintings are transparent, and yet imponderable, allegories of desire.

Today, however, it is *Tu m'* (1918), Duchamp's last painting, that tends to strike one as *the* seminal work, one that may supercede even *The Large Glass* in contemporary relevance (Fig. 11). *Tu m'* is a paradigm for virtually all late-century abstract orchestrations of representational imagery and/or actual objects (and vice versa), including work by Johns, Kelly, Warhol, Lichtenstein, Richter, Salle, Halley, Koons and Taaffe, among others. (It is, for instance, the textbook precedent for Johns' *According to What* (1964), the multi-panelled painting with a flip-down section illustrating Duchamp's profile.) Indeed, Duchamp's deployment of trompe-l'œil imagery combined with real objects and appro-

Fig. 9 Richard Serra, *Splashing*, 1968. Castelli Warehouse, New York (destroyed). Photo: Peter Moore

Fig. 10 Marcel Duchamp, *La Mariée mise à nu par ses célibataires, même* (The Bride stripped bare by her Bachelors, even) (The Large Glass), 1915–23. Philadelphia Museum of Art

8 Quoted in Tomkins (as note 6), p. 438.

Fig. 11 Marcel Duchamp, *Tu m'*, 1918. Yale University Art Gallery, New Haven, Connecticut

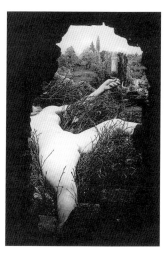

Fig. 12 and 13 Marcel Duchamp,
*Etant donnés: 1° la chute d'eau, 2° le gaz
d'éclairage* (Given: 1. The Waterfall,
2. The Illuminating Gas), 1946–66.
Philadelphia Museum of Art

9 Quoted in William Camfield, 'Duchamp's Foun-
tain: Aesthetic Object, Icon, or Anti-Art?' in *The
Definitively Unfinished Marcel Duchamp*, ed. Thierry
de Duve, Cambridge, Massachusetts, 1993, p. 169.

priated signage make it a prototype of postmodernist painting in all its tropes and guises, at once figurative and abstract, mundane and arcane, advanced and retardataire.

V. The Poetics of Place

The site-specific quirkiness of *Tu m'*, along with its essential compactness and completeness, also make it a declaration of actuality – a kind of combination résumé and prospectus. Commissioned for a space above a bookshelf in Katherine Dreier's first house in Reading, Connecticut, its genesis further suggests a precedent for modern site-specificity in general. Robert Smithson's entropic earthworks take root in the Duchampianism that was so prevalent in the sixties: As Smithson himself wrote in the seventies, 'Duchamp's objects are just like relics, relics of the saints or something like that. It seems that he was into some kind of spiritual pursuit that involved the commonplace. He was a spiritualist of Woolworth, you might say … at bottom I see Duchamp as a kind of priest of a certain sort. He was turning a urinal into a baptismal font.'[9]

Indeed, the ever-notorious readymade known as *Fountain*, submitted pseudonymously by 'R. Mutt' to the 1917 Independents exhibition in New York – Duchamp-as-himself was head of the Hanging Committee for that show – presents itself historically as a veritable allegory of transformation and displacement (see Fig. 5, p. 520). The piece, which was not only rejected for the exhibition but eventually lost (all versions seen subsequently have been reconstructions), infiltrated and subverted the very meaning of art, and the practice of making art for the rest of the century. It is the *éminence blanche*, of course, behind such disparate painterly achievements as Ellsworth Kelly's *Toilette* (1949), a quasi-abstract, Paris-made painting based on the view from above of a public *pissoir*, and Warhol's late seventies *Oxidation* or 'Piss' paintings; and behind such recent sculptures as Robert Gober's early eighties 'sinks' and, most literally, his *Three Urinals* of 1988.

Duchamp's revolutionary latrine is but one manifestation of the powerful, almost archaeological sense of situation and place that informs his work, lending many specific and mundane objects a kind of esoteric, peripatetic, promiscuous poetry. To me, for example, the cachet of a piece like *In advance of the broken arm* (Cat. 207) comes not so much from the fact that it is a snow shovel hanging in a museum (I recently saw a 1964 edition of it at the Whitney, as part of the *Dada Invades New York* show), but from the fact that the original tool was bought by the artist in 1915, in a hardware store on Columbus Avenue near where he lived, on Manhattan's West Side (see Fig. 10, p. 549) – where I live. From that point of cathexis, I found myself free-associating about other, later 'neighbourhood' artists, and miscellaneous Duchampianisms both deliberate and inadvertent, including Lucas Samaras – he of the ambiguously Duchampian guises – and Richard Estes, the hyper-realist who in the 1970s painted a Columbus Avenue hardware store.

Duchampian site-specificity reaches its apogee with the disturbing and clandestine *Etant donnés* (Fig. 12 and 13). The piece is installed in its own chamber in the Philadelphia Museum of Art, from where it cannot be moved. In order to see it, furthermore, *you* cannot move: A precise vantage position, aligned to a battered and old-looking double peep-

hole, is required. Once properly affixed to that spot, you are privy to what is essentially a lurid carnival view, strongly reminiscent of that popular ninetieth-century phenomenon, the mechanised panoramic installation. Thus one enters this private 'chapel' as a kind of pilgrim, but one exits a voyeur.[10]

Something of Duchamp's subliminal poetics of place was imparted to certain contemporary artists more generally under the master's influence. The floorplans, for instance, in some of Jasper Johns' most recent paintings – mnemonic improvisations on the theme of his grandparents' long-demolished house in South Carolina – are a prominent case in point. Likewise several metal floor pieces by the Polish sculptor Miroslaw Balka, wherein the layout of the cramped Warsaw apartments of the artist's childhood are indelibly limned. Many paintings of the young Argentine artist Guillermo Kuitca also feature floorplans that refer to the artist's mytho-poetic memories of an actual place – an apartment, in this instance, in Buenos Aires. Kuitca's persistent and varied use of maps – on vaguely Rauschenbergian painted sculptures, for instance, of small beds – draws further attention to the primacy of site-specific dreams in a city that is Vienna's successor as the capital of psychoanalysis. Indeed Duchamp, who spent some formative months in Buenos Aires towards the end of 1918 and early in 1919, sowed seeds of modern art and loss in Argentina. He tried to organise an exhibition there of Cubist painting, but it never took off. It was also while in Buenos Aires that he learned of the death of his brother, Raymond Duchamp-Villon. Unable to return to France in time for the funeral, he seems at that point to have suffered the kind of blank angst that would later inform so many modern and contemporary works of art about the idea of home, absence and desire, including those recent paintings by Kuitca and Johns.

VI. Matériel

Duchamp's readymades redefined the course of modern art. After the urinal, anything and everything was admissible *materiél* for painting and sculpture. The ensuing history of the century can be seen as an exploration, and an explosion, of the idea of what constitutes art.

'Real material in real space' was the rallying cry of the Russian Constructivist Vladimir Tatlin. His 'Corner Reliefs' (1915) seem to hover miraculously in mid-air, but are in fact elaborately rigged with taut wires and ropes that are vaguely maritime in feeling; Tatlin had for many years made his living as a sailor (Cat. 135). His *Monument to the IIIrd International* (1919–20) was envisioned as an enormous kinetic skyscraper, whose various revolving parts would in effect convey a paradigm of spiralling growth and human progress (see Fig. 2, p. 544). His wooden model for a glider *Letatlin* (1929–32), its name a combination of 'Tatlin' and the Russian word 'to fly', was based on the artist's scrupulous observation of insects' movements (Cat. 243). The glider, which Tatlin worked on for the last thirty years of his life, now seems a belated symbol of a Soviet euphoria that would eventually lead to pioneering the exploration of outer space. What a strange irony, then, that Tatlin's insectile high-flier has come down to earth in Ilya Kabakov's hilari-

10 Amidst the current spate of gay-specifc neo-Conceptual art, a visually spare, yet theory-laden installation *Call to Glory ... or Afternoon Tea with Marcel Duchamp* (1992–96), by Simon Leung, associates *Etant donnés* with what is known in gay slang as 'tearoom' sex. Leung sees the two peepholes in the door of *Etant donnés* as punning on the 'glory holes' in the walls between public bathroom stalls in which anonymous sex between men can occur. As a part of an installation in July 1996 at Pat Hearn's gallery in New York, Leung built a scaffolded evocation of *Etant donnés* called *Antechamber* which includes a swag of black velvet, evocative of the shrouded space behind the door in *Etant donnés*, and the figment of a face, emblematic of the many faces that have pressed up against the peepholes of Duchamp's last piece.

ously glum 1992 installation *The Life of Flies*, a provincial and fictive Soviet museum dedicated to the common household fly.

With the original Hanover *Merzbau* (now lost) of Kurt Schwitters, the collage principle turns into a similar tectonic urge (see Fig. 15, p. 551). 'Merz' was a found word fragment that came to denote a collageist worldview as well as a verbal poetics. Schwitters' use of bits of string and wood in his collage paintings should be seen as an attempt to shore up the débris of material culture after World War I. 'Merz' was to this extent a reclamatory effort.

After Schwitters' death in 1948, his work once again became essential to a new, postwar generation of artists that included Robert Rauschenberg, Cy Twombly and Jasper Johns. (Twombly is often credited today with having introduced Rauschenberg to Schwitters' work sometime around 1950. Johns, on the other hand, self-consciously expunged any obvious reference to Schwitters from his work after 1954, when a general resemblance was pointed out to him.)

Among Berlin Dadaists, it was Raoul Hausmann who 'claimed' the innovation of photo-collage. (The technique was in fact appropriated from German World War I army photographers who made oleolithographically mounted pictures of happy-looking soldiers in pleasant surroundings, but cut the original faces out to allow for portrait inserts that could be sent back home from the front to anxious loved ones.) In Hausmann's hands, the technique became a means of illustrating the mechanistic character of postwar humanity's hearts and minds (Cat. 224–226). Both Grosz and Hausmann used photo-collage to envision the new reality of shellshocked, semi-robotic veterans – distressed readymades, as it were – wandering the streets of Berlin in the company of human-animals, sometimes resembling pigs.

Max Ernst's early photocollages were more whimsical and literary: using printed imagery from fashion catalogues, illustrated magazines and scientific manuals, he made syncopated totem-like figures, often set in primordial landscapes. (These tableaux would later be expanded into full-scale collage-novels.) Ernst's first Dada manifestation, undertaken with the artist Johannes Theodor Baargeld (a pseudonym, meaning 'Ready Money'), took place in Cologne in April of 1920, in the courtyard of a brewery in the middle of the city. One entered through a public urinal, where one encountered a young girl in a white communion dress singing obscene verses.

During the thirties, the halcyon years of full-blown Surrealism, the Dada techniques of disjunction and dislocation became ever more attenuated. Art, fashion and theatre were thoroughly intertwined at the 1938 International Exhibition of Surrealism in Paris, which Duchamp helped to design and install· there the female mannequin, once the subject of Metaphysical painting and Dada collage, became a sculptural module upon which the Surrealists could impose fantasies of cross-dressing and rape (Fig. 14). At about the same time in Berlin, Hans Bellmer's *Poupée* – an assembled sculpture depicted in various stages of dismemberment – further reflected the growing fascination during this period of increasing tension with the concept of *Lustmord* (Sex Murder).

Fig. 14
The central 'grotto' staged by Marcel Duchamp, with coal sacks on the ceiling and revolving doors as display panels, *Exposition Internationale du Surréalisme*, Galerie des Beaux-Arts, Paris, 1938

When the war was over, in 1946, Duchamp began work on a secret piece that would occupy him periodically for the next twenty years: By the time *Etant donnés* was finished, in 1966, another war was raging, this time in Vietnam. But the broken bricks that frame our peephole view of *Etant donnés*, together with the prone figure of a naked woman (rendered in pigskin) holding a gas lamp in the foreground of a derelict landscape, suggest a post-apocalyptic vision of Europe in ruins, a Europa (the Bride?) definitively raped.

In postwar Europe, in fact, a new generation of artists transformed homely materials such as burlap into a metaphor for general spiritual impoverishment and national penitence. Alberto Burri's 'sack' paintings of the early fifties set the tone of this ruinous vocabulary (Cat. 289 and 290). Gouged with rips and holes, and often sewn summarily together, the sacks evoked the poorest and most downtrodden sorts of clothes and baggage. Rauschenberg's early exposure to Burri's work in Italy in the early fifties contributed to the scrappy collage aesthetic that would define his own mid-fifties 'Combine Paintings' (Cat. 246–248). Rauschenberg in turn passed his findings on to Johns, whose newspaper-and-encaustic works from the fifties suggest related metaphors involving 'poor' materials and mortified flesh. (Burri's sack-cloth aesthetic has also been cited as a source for Julian Schnabel's late eighties paintings on tarps.[11])

In retrospect, however, Duchamp seems to have had a first word on this 'wounded' collage aesthetic. Ten years earlier, in 1943, he had been asked to design a George Washington cover for American *Vogue*. The resulting collage, *Allégorie de Genre*, shows an American flag made of red-stained gauze and applied metallic stars that can be read both as a profile of our country's first President and, turned 90 degrees, as an outline of the map of the United States (Fig. 15). The editors, perhaps unsurprisingly, rejected this proposed cover: Not only was it found politically disturbing, but too closely reminiscent of a used sanitary napkin – not the sort of thing ladies' fashion magazines prefer to dwell on. Today *Allégorie de Genre* seems a likely precedent for Johns' fifties 'Flag' and 'Map' paintings, as well as for his extensive use in recent work of double profiles and other perceptual puns.

In Spain, Antoni Tàpies embraced assemblage with an almost spiritual fervour. He used found materials such as a corrugated metal door, or a poured cement trough, that not only reeked of the gutter but hinted (in the context of Franco's Spain) at carefully coded graffiti on urban walls (Cat. 245). On these streetwise supports Tàpies made primitive marks – a cross, a hand- or footprint – that all served to proclaim the ineffable and indomitable presence of 'the artist'. By the mid-sixties this materialist prerogative had become part of a larger international style, now principally associated with the survivalist and shamanistic props of Joseph Beuys. (Tàpies' emergence coincided with Duchamp's first Spanish interlude, during the summer of 1958, in the Catalonian fishing town of Cadaquès: The great wooden door of *Etant donnés* was in fact shipped over from Spain, thereby providing an Old World element to Duchamp's post-apocalyptic fusion of European and American wastelands.)

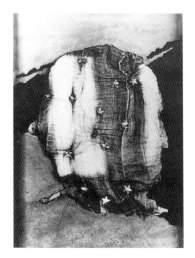

Fig. 15 Marcel Duchamp, *Allégorie de Genre (George Washington)*, 1943. Private collection, Paris

Fig. 16 Marcel Duchamp, *Feuille de vigne femelle* (Female Fig Leaf), 1950. 'Private collection

11 For the Burri-Schnabel connection, see Brooks Adams, "'I Hate to Think'. The New Paintings of Julian Schnabel', *Parkett*, no. 18, December 1988, pp. 110–22.

Fig. 17 Jasper Johns, *Painted Bronze*, 1960.
Museum Ludwig, Cologne

Fig. 18 Joseph Beuys, *Das Rudel*
(The Pack), 1969

12 See Roberta Bernstein, 'Seeing a Thing Can
Sometimes Trigger the Mind to Make Another
Thing', in Kirk Varnedoe, *Jasper Johns*, exh. cat., New
York, The Museum of Modern Art, 1996, p. 44.
13 Saul's painting was shown at the George Adams
Gallery in New York in October 1996.

In France at about this time, Yves Klein was using naked female models smeared with blue paint to make body-printed versions of Duchamp's *Nude Descending a Staircase*, while Johns, in New York, was using Duchamp's small sculpture, *Female Fig Leaf* (1950) (Fig. 16), directly to make a print.[12] (Almost indecipherable in its imprint, it is but a surface incident in a 1961 painting by Johns entitled *No*.) More generally, Johns' small, late fifties still-life sculptures of body parts, beer and paint cans, and other mundane objects – all to some extent inspired by Duchamp's early fifties multiples, of which *Female Fig Leaf* is merely the best known – are venerated today in Beuysian museological vitrines, as if they were fragments of the True Cross (Fig. 17). Indeed, the importance of Johns' impact on the sixties resurgence of the body-as-object in Happenings, Fluxus events and ephemera, performance art and video sculpture should not be underestimated. (In recent years, we have perhaps seen the mundane object most effectively enshrined in work by Jeff Koons – his early and mid eighties vacuum cleaners in display cases, for example (Cat. 333); as for early nineties body-part imagery, we find a most sublime, micro-into-macro materialisation in Kiki Smith's glass sculptures of sperm.)

In Düsseldorf in the late fifties and sixties, Joseph Beuys – teacher, shaman, war veteran, fashion plate – was making comparably diverse alchemical fusions of materials, objects and words. Beuys' signature ingredients, most notably felt, fat, honey, a dead hare and a live coyote, combined their essences to create an ideational stew equally rich in olefactory and tactile sensations. A vintage Beuys performance, *The Silence of Marcel Duchamp is Overrated* – broadcast live on West German television on 11 November 1964 – is perhaps most remarkable for its pointed critique of Duchampian inaction: at one point Beuys scrawls his eponymous condemnation in chocolate on a piece of paper, then places it in a corner, next to one of his own wood sculptures smeared with fat. (The tradition of 'smearing' Duchamp continues to thrive: in 1996, to cite just one example, the American figurationist painter Peter Saul painted the scatological *Pooping on Duchamp*, which includes a cartoon self-portrait in the process of shitting on R. Mutt's sacred/profane *Fountain*.[13]) Beuys nevertheless made ample use of the Duchampian precedent of readymades in pieces such as *The Pack*, a 1969 sculpture comprising an actual Volkswagen bus disgorging a fleet of actual sleds, each in turn outfitted with a flashlight, a rolled felt blanket, and a small stash of lard (Fig. 18). (When first revealed in Edinburgh in August of 1970, *The Pack* was accompanied by a four-hour Nordic action, Beuys' *Celtic (Kinloch Rannoch) Scottish Symphony*.)

In Italy, the Beuysian *révolution matérielle* found clearcut parallels in efforts by a group of artists loosely gathered under the rubric of Arte Povera. These artists – including among others Pino Pascali, Mario Merz and the Greek-born Jannis Kounellis – had a powerful predecessor in the form of the brilliant and shortlived Piero Manzoni (1933–63). Manzoni's small still-life sculptures aimed for the stars and the sewer with equal aplomb and had in common with John's cast beercans and lightbulbs the nifty trick of behaving like little bombs dropped on people's sense of decorum: Manzoni's cardboard tubes enclosing invisible lines (Cat. 291 and 294) – and best of all, his little sealed tins of artist's shit

(Cat. 295) – were outrageous provocations to a viewer's senses and imagination. The most elegant, however, of Manzoni's daredevil commodifications must surely be his 'packaging' of artist's breath (Cat. 296). In any case, we must take Manzoni's printed labels on faith alone: who knows for sure whether measured segments or biological turds are actually there in the containers? We are instead encouraged to believe in the artist's godlike ability to endow base materials with creational significance, by means of his Word.

With hindsight, it seems that Manzoni's materials were transmogrified through the charisma of the label itself – a typographical phenomenon that Marcel Broodthaers would exploit to great effect a few years later in his unique, deadpan-absurdist signage. (However, Broodthaers' aggregates of mussel shells must be seen within the context of Belgian identity and florid mock-patriotism (Cat. 266 and 269): *Moules* are of course the Belgian national dish, of the order of fish and chips in England, and, therefore, a national cliché.) In contrast, the artists of the Arte Povera movement *per se* were generally more preoccupied with the redemptive properties inherent in the materials themselves. Pino Pascali's lifesize sculptures of cannons and guns, for instance, from 1965, are anti-Vietnam antimonuments, wherein hostile implications of the theme are undercut by 'friendly' substances such as wood, rubber, scrap metal and junk (Cat. 299). (Pascali's sculptures have in common with Claes Oldenburg's sculptures their 'confusions' of hard and soft.) It was no doubt Mario Merz, however, who cleared the way for organic materials – installations of plants, fruits and vegetables that would enact the whole process of decay and decomposition, during the lifespan of a gallery exhibition. In the 1968 sculpture *Giap Igloo – If the Enemy Masses His Forces, He Loses Ground; If He Scatters, He Loses Strength*, Merz's neon message rests on a mound of packed earth (Fig. 19). The artist's insistence on a primal form, and on juxtaposing it with high-tech lettering, also suggests parallels among American artists of the period, including Keith Sonnier and, especially, Bruce Nauman, whose spiralling neon sculpture, *The True Artist Helps the World by Revealing Mystic Truths* (1967), is also the combination of a primordial shape with technologically suffused words (Cat. 305). Neon, indeed, became a kind of Zeitgeist material during this period, directly following Dan Flavin's pioneering fluorescent tubes of 1963.

Fire, usually generated by a propane gas torch, was Jannis Kounellis' signal contribution to the rematerialisation of sixties art. Kounellis came out of both the Material and Verbal traditions in twentieth-century European art. Whereas his late fifties lettriste abstractions recall Schwitters (as well as Manzoni and Johns), his seventies wall reliefs with burlap bags and iron plates constitute a deliberate hommage to Burri. One of Kounellis' most stirring and unexpected uses of animate material, however, was in installing a number of live horses in a Roman art gallery in 1969 (Fig. 20). By the early seventies his paintings were frequently accompanied by a live performer, generally a musician or ballerina. Kounellis' device of using metal shelves to house shards of wood, marble and even haunches of red meat further reveals his desire to make of sculpture an alchemical gathering spot of unlikely materials. He was also instrumental in giving wider currency to the practice of removing art from the context of the museum or gallery and relocating it

Fig. 19 Mario Merz, *Igloo di Giap – Se il nemico si concentra perde terreno se si disperde perde forza* (Giap Igloo – If the Enemy Masses His Forces, He Loses Ground; If He Scatters, He Loses Strength), 1968. Collection of the artist

Fig. 20 Jannis Kounellis, *Senza Titolo (Cavalli) /* Untitled (Horses), Galleria L'Attico, Rome, 1969

to, say, a hotel room (in Rome), or to abandoned industrial buildings (e.g. in downtown Chicago, at the time of his 1986 retrospective at that city's Museum of Contemporary Art).

From the mixed worlds of avant-garde German music, late Surrealist installations and Fluxus Happenings came Nam June Paik. His ability to transform old, discarded TVs into sculpturally and archaeologically compelling objects immediately established his reputation as an ironic materialist, and he has since ascended to the status of pop guru. His late fifties sculptures are still essentially Surrealist in nature: broken mannequins, reclining in bathtubs. But Paik's sixties experimentation with video installations took the idea of sculpture and blasted it into another stratosphere, all the way to outer space via satellite, before landing back on earth again as a considerably enlarged world-concept. (The more intimate video sculptures of Shigeko Kubota, who is married to Paik, inflected the new technology with a warmer, pastoral resonance (Fig. 21). Typically upfront, even plainspokenly literal in their appropriations of Duchamp's themes and objects, Kubota's video-landscape constructions and telegenic nudes descending staircases that are at once videotaped and carpentered, absorb and refract the technological 'heat' of television by means of plywood siding and mylar mirrors.)

Fig. 21 Shigeko Kubota, *Duchampiana: Bicycle Wheel One, Two and Three*, 1990. Courtesy of the artist

Postwar German painters were as important to the rematerialisation of art during the sixties as the pioneers of new technology. With his painted smoke signals, volatile substances and wizardly alchemical gestures, Sigmar Polke would eventually emerge as the magus of this generation ten or fifteen years younger than Beuys. But his early drawings were more like Pop Art – wry, graphic send-ups of both consumer culture and ivory-tower pretentiousness. His late sixties and seventies paintings on cheesy printed fabrics profaned the sacred precinct of Painting by revising the notion of what constituted 'serious' material. (In this, he was inspired by the example of later Picabia, exploring the format of the palimpsest.) Polke's oxidising abstractions on artificial resin from the late eighties seem, and in fact literally *are* shape-shifting before your eyes. Any notion of there being any fixity of colour and shape in painting was permanently banished from Polke's magic act. His material metamorphoses have furthermore been set against a miscellany of literary and historical themes or subjects, ranging from *Alice in Wonderland* to the French Revolution.

Gerhard Richter emerged as a rematerialist of a different, more tightly focussed stripe. His background was East German, and his training in Dresden was of the retardataire, academic kind. Once into the West, however, he let loose. His youthfully impudent, three-man art movement dubbed Capitalist Realism, with Polke and Konrad Fischer (alias Konrad Lueg), was known to express itself occasionally through neo-Dadaist actions or events, including a legendary 1963 Happening in that most mundane of capitalist venues, a Düsseldorf furniture store. But Richter also twisted up the shopworn conventions of Romantic and Realist painting, giving them a subversive, yet highly disciplined edge. His sixties Pop-style paintings, with their slightly blurred grisaille figures and scenes (Cat. 312); the so-called 'Baader-Meinhof Paintings' (1988), in which the murky,

pious ghost of Eugène Carrière appears to seep through a contemporary tabloid newspaper headline; and more recently his subtly coloured, neutral yet atmospheric, landscapes – all blatantly reveal their photographic sources. In contrast, Richter's 'other' current painting style has manifested itself in richly impastoed, pseudo-gestural abstractions that somehow seem to have been photochemically rendered, even though the process involves nothing more high-tech than applying paint to canvas on plastic sheets, then lifting the sheets off. All the while, the artist's immense *Atlas* of snapshots, clippings and cards has continued to build up into a material archive that is positively Schwittersesque in its thrust (Fig. 22). Richter's disparate, but oddly complementary modalities, which lately seem to be merging somewhat, set up a whole new contradictory vocabulary for turn-of-the-century painting, one that is simultaneously abstract and representational, literal and metaphoric – an aesthetic chess move, that Duchamp's *Tu m'* seems in retrospect to have largely predicted.

Fig. 22 Gerhard Richter, *Atlas*, cuttings from various newspapers from 1965–66

Ilya Kabokov worked as an official children's book illustrator in the former Soviet Union, at the same time as making his unofficial art. Thus he brought to the West a feverish, fanatically detailed, grandly tragicomic imagination of the kind that perhaps develops best in a culture largely defined by a scarcity of basic goods, a general lack of privacy, allegiances forged by understandable duplicity, a bombastically romantic feeling about its uncouth history, and last but not least, a bureaucracy whose rival excesses of power and incompetence seem to press towards the limits of the absurd.

Many of Kabakov's almost miraculously detailed, lifelike installations have afforded us reconsitued views of daily domestic activities and cultural doings in the good old Soviet Union. They are in a sense modern-day genre paintings, transformed into hyper-real dioramas. They are also like monuments to life in the Twilight Zone. For the artist's 1992 *Incident at the Museum or Water Music*, the Ronald Feldman Gallery in New York was reconditioned precisely to evoke a leak-ridden, provincial Russian museum. To say that it had seen better days was to understate the case, but the museum was nevertheless presenting a retrospective exhibition of *echt* impressionistic genre paintings by an unheard-of regional artist who turned out, of course, to be Kabakov. At *documenta IX* in Kassel that same year, Kabakov built up a freestanding structure, *The Toilet* (Fig. 23), whose interior was a slightly cramped but perfectly *gemütlich* little family apartment set up with great aplomb within the available shelter of a public urinal. (Take that, R.Mutt!) The Kabakovian imagination assumed epic proportions with a mammoth 1995 installation at the Centre Pompidou in Paris, in which it seemed to vault past all memories and mundanities towards some new kind of abstract poetic of broken dreams. *C'est ici que nous vivons* was essentially an ideological ruin, laid out as a labyrinth along the cavernous lower floors of the museum. Allotted space had been transformed into an apparently stadium-sized maze of abandoned spaces. Among them were dishevelled classrooms and construction sites, littered with workers' clothes and tools – some evidently 'reclaimed' by stray individuals – along with a few gigantic unfinished (or half-demolished) Socialist Realist monuments. Many of Kabakov's installations posit the fictive presence

Fig. 23 Ilya Kabakov, *The Toilet*, installation at *documenta IX*, Kassel, 1992

Fig. 24 Rosemarie Trockel, *Die Rose von Kasanlak*, (Rose of Kasanlak), 1986. Courtesy of the artist

Fig. 25 Marcel Duchamp, *Belle Haleine, Eau de Voilette* (Beautiful Breath, Veil Water), 1921. Private collection

of clearly imaginable inhabitants. Whether we presuppose the absence of whichever caretaker placed all those buckets around the leaky museum or of squatters setting up shop in the derelict dream city of Beaubourg, we feel a dreamlike reality peopled with invisible others. Perhaps they have just gone out for a moment for a stroll or a smoke. No matter: they have left us with all the space in the world, and no answers with which to fill it.

More and more often, it seems, the tables are turned on viewers. Some of the most powerfully affecting video installations of the nineties have been interactive environments, whose all-encompassing atmospheres conjure up illusions of moody weather, collective dreams and memories, cryptic messages and human strangers. If Bill Viola's increasingly awe-filled videos are the poetic agents for a new Romantic Sublime of virtual fire, water and wind, Gary Hill's *Tall Ships* (1992) creates for us a virtual séance by inviting us through a dark corridor in which anonymous, yet disturbingly familiar-seeming people suddenly materialise as if to approach us with a question, only to recede inexplicably and abruptly to allow other human shades to take their eternally perplexed places.

VII. Disguise

Duchamp's two famous alter egos, R. Mutt and Rrose Sélavy, established polarities for self-transformation in later twentieth-century art. R. Mutt – the name is a triple-pun on the American slang word 'mutt' for a mixed-breed dog, an American plumbing manufacturer, J. L. Mott, and the popular American comic strip, 'Mutt and Jeff' – presented a utilitarian fiction of New World macho competence, while Rrose Sélavy, as photographed in 1921 by Man Ray (Cat. 217), proposed a polymorphous Gallic pleasure principle – 'Eros c'est la vie'. Countless constructed self-images and sexually ambiguous surrogates have populated the art of this century in their wake. A list of fairly recent examples would have to include the seahorse – an animal known to be hermaphroditic – in its role as ultra-cryptic body-double for the artist in Jasper Johns' 1985 painting *Summer*.[14] A more ornate, but also more directly Duchampian example would be a 1986 perfume bottle by Rosemarie Trockel labelled *Rose of Kasanlak* (Figs. 24 and 25), which not only invokes part of her own name but one of the master's, while simultaneously spoofing one of his more innocuously comic objects (Rrose Sélavy's *Belle Haleine* perfume) and a popular brand of Bulgarian eau-de-cologne (and, it turns out, the nickname of a female Bulgarian dissident of the 1970s).

Back in the world of Berlin Dada, the photocollagist John Heartfield and the painter and graphic artist George Grosz were quick to anglicise their names – from Helmut Herzfeld and Georg Gross, respectively – in sincere, yet faintly humorous homage to the classic English businessman and the classic American gangster. Hannah Höch, on the other hand, made photocollages in which images of the independent New Woman were intercut with ones representing archaic and 'primitive' fetish sculptures. As Maud Lavin has argued, Höch seemed to be positing a vision of the newly liberated selfs, still shackled to a newly commodified Other.[15]

14 For the seahorse reference, see Jill Johnston, *Jasper Johns: Privileged Information*, New York, 1996, p. 29.
15 See Maud Lavin, 'Hannah Höch', in *Grand Street 58: Disguises*, fall 1996, p. 128.

Max Ernst adopted his avian alter ego, Loplop, in the twenties and the bird himself in turn inspired René Magritte's memorable thirties surrogates – images of grey, rather phlegmatic urban pigeons that were themselves stand-ins for bourgeois Belgian businessmen, *en général*. Ernst eventually began to act and dress like a bird, occasionally. In a well-known 1942 photograph of the artist in New York with his collection of Katchina dolls, he is wearing his long white hair combed forward, as if in a crest, and a ceremonial feather jacket, of the kind worn by Native American shamans (Fig. 26).

Fig. 26 Max Ernst with his collection of Katchina dolls of the Hopi, New York 1942

Back in Berlin in the late fifties after his sojourn in New York, George Grosz liked to tell the story of how he was mugged on the Kurfürstendamm while impersonating a swaggering, drawling Texan. In keeping with that questionable charade, his last photocollages involve images of a clown crossed with a showgirl and a sappy puppy dog, that in their peculiar combination of sincerity and parody seem to foreshadow William Wegman's continuing polaroid saga of his Weimaraners in drag. Even the highminded Kurt Schwitters slipped into the chameleon act with a 1942, Pop-Kitsch collage involving a picture of W. C. Fields, the comic Hollywood actor, in the form of a proto-Koonsian wooden figurine.[16] These late, supposedly 'lesser' Dada works, once dismissed as incidental, now seem to be as pointedly relevant to contemporary concerns as their more classic predecessors. The symbolically freighted clown, for example, was reincarnated from the Stone Age of Picasso's Blue Period, to become a postmodern leitmotiv. It reached an early crescendo with Jonathan Borofsky's colossal 1982 sculpture *The Dancing Clown at 2,845,325* – nearly a stop along the road, in that artist's count to infinity – and possibly a definitive climax with Bruce Nauman's great, anxiety-provoking *Clown Torture* (1987), a video installation that includes a surveillance-camera view of a clown sitting (shitting?) on a public toilet. (Take *that* R. Mutt!)

Painters, too, in their self-imposed stylistic schizophrenias, took part in this postwar game of identity charades – Polke and Richter, probably first among them, as we have seen. But Roy Lichtenstein also buried his 'real' or imagined self in an impervious comic-book neutrality, of the kind which has acted as a filter for all 'important' modern styles. (The *trompe-l'œil* appropriationist Mike Bidlo has in the last couple of years accomplished something like the inverse, by drawing R. Mutt's *Fountain* in an wild variety of 'abstract' as well as representational styles, on any kind of available surface, whether a scrap of paper, hotel stationery, or a gallery invitation.)

The tendency has been either to cling to one strictly maintained elective persona or to espouse a multitude of alternative disguises, so vast as to obliterate the self quite completely. Gilbert & George have taken the former course: they have been holding their Dada-businessmen poses for almost thirty years now, in epoch-making live 'sculptural' performances, as well as in photo-montages in which they manage to maintain their strange robotic dignity, even as middle-aged men in the nude. Cindy Sherman, in contrast, has become a virtuoso among chameleons. The issue of 'gender slippage', so attractive to feminists and academics dealing with her late seventies and early eighties work, has long since been superceded by a far more ambitious, cannibalistic enterprise within

16 Schwitters' *W. C. Fields* is illustrated in Stephanie Barron with Sabine Eckmann, *Exiles and Emigrés: The Flight of European Artists from Hitler*, exh. cat., Los Angeles, Los Angeles County Museum of Art, 1997, p. 82.

Fig. 27 Matthew Barney, *CR 4: Loughton Manual*, 1994. Private collection, New York

which practically every possible role, costume, mutation or prop – from Old Master portrait subjects (see Fig. 15, p. 71), to porno-flick object – has been exploited, often to spectacular effect. With her début, this spring, as director of the feature film *Office Killer* – an homage, among other things, to classic American Grade B horror films – Sherman decamps to the other side of the camera, where she will no doubt remain as elusive as she was in front of her own lens.

Here are just a few intellectually fashionable current rediscoveries: Pierre Molinier's kinky, fundamentally old-fashioned transvestite self-portrait photos as a French maid or other garter-and-fishnet-wearing personages in high heels and bondage; Claude Cahun's photographic self-portraits as a liberated, yet ultimately narcissistic *garçonne*; sculptural work by the eccentric Baroness Elsa von Freytag-Loringhoven (seen in the *Dada Invades New York* show), who not only made maniacally rendered assemblage portraits of Duchamp, but was known as a kind of performance artist *avant la lettre*, who wandered the streets of New York wearing costumes made of garbage, earrings made out of thermometers, and who let Man Ray and Duchamp make a film of her (now lost) while she was shaving her pubic hair.

An antic, role-playing spirit has generated some of the best very recent art. Matthew Barney's *Cremaster* is a case in point. Conceived as a series of five videos – two, so far, have been completed – with a supporting constellation of prop-like sculptures and fantasia-like documentary photographs, it reintroduces the Symbolist androgyne, now reborn as a bizarre, prosthetically enhanced, orange-haired faun in a white summer suit (Fig. 27). The word 'cremaster', which is the medical term for the muscle that controls testicles, has become a kind of micro-macro shorthand for the idea of the new, post-feminist man. In *Cremaster 4*, already realised, footage of extremely customised racing cars speeding around the Isle of Man is intercut with footage of a fantastic, other voyage through the male reproductive anatomy (Fig. 24). In her catalogue essay for the 1997 Guggenheim exhibition *Rrose is a Rrose is a Rrose: Gender Performance in Photography*, the curator Jennifer Blessing was talking about *Cremaster* when she wrote that 'It's as if Duchamp's *The Large Glass* metamorphosed into a fantastical Disneyesque walk-in storybook.'[17] It would seem that the image, towards the end of the nineties, of a tap-dancing faun in a vaudevillian's costume would just about have us believing that this whole bloody, revolutionary, contradictory century has basically been a big Duchampian-Beckettian burlesque.

17 See Jennifer Blessing, 'Introduction', in *Rrose is a Rrose is a Rrose: Gender Performance in Photography*, exh. cat., New York, Solomon R. Guggenheim Museum, 1997, p. 86.

Language – Material

MARCEL DUCHAMP (Cat. 206–218)
FRANCIS PICABIA (Cat. 219–220)
GEORGE GROSZ (Cat. 221–222)
RAOUL HAUSMANN (Cat. 223–226)
KURT SCHWITTERS (Cat. 227–235)
MAX ERNST (Cat. 236–241)
RENÉ MAGRITTE (Cat. 242)
VLADIMIR TATLIN (Cat. 243)
ANTONI TÀPIES (Cat. 244–245)
ROBERT RAUSCHENBERG (Cat. 246–248)
JEAN TINGUELY (Cat. 249)
EDWARD KIENHOLZ (Cat. 250–252)
JASPER JOHNS (Cat. 253–255)
ANDY WARHOL (Cat. 256–260)
ROY LICHTENSTEIN (Cat. 261–263)
CLAES OLDENBURG (Cat. 264–265)
MARCEL BROODTHAERS (Cat. 266–282)
JOSEPH BEUYS (Cat. 283–285)
NAM JUNE PAIK (Cat. 286–288)
ALBERTO BURRI (Cat. 289–290)
PIERO MANZONI (Cat. 291–296)
JANNIS KOUNELLIS (Cat. 297, 300–302)
PINO PASCALI (Cat. 298–299)
MARIO MERZ (Cat. 303–304)
BRUCE NAUMAN (Cat. 305–307)
SIGMAR POLKE (Cat. 308–311)
GERHARD RICHTER (Cat. 312–314)
HERMANN NITSCH (Cat. 315)
GILBERT & GEORGE (Cat. 316)
LAWRENCE WEINER (Cat. 317–319)
HANNE DARBOVEN (Cat. 320)
JAN DIBBETS (Cat. 321)
ILYA KABAKOV (Cat. 322)
BERTRAND LAVIER (Cat. 323–325)
JENNY HOLZER (Cat. 326)
GARY HILL (Cat. 327)
REINHARD MUCHA (Cat. 328)
MIKE KELLEY (Cat. 329)
ROSEMARIE TROCKEL (Cat. 330–332)
JEFF KOONS (Cat. 333–335)

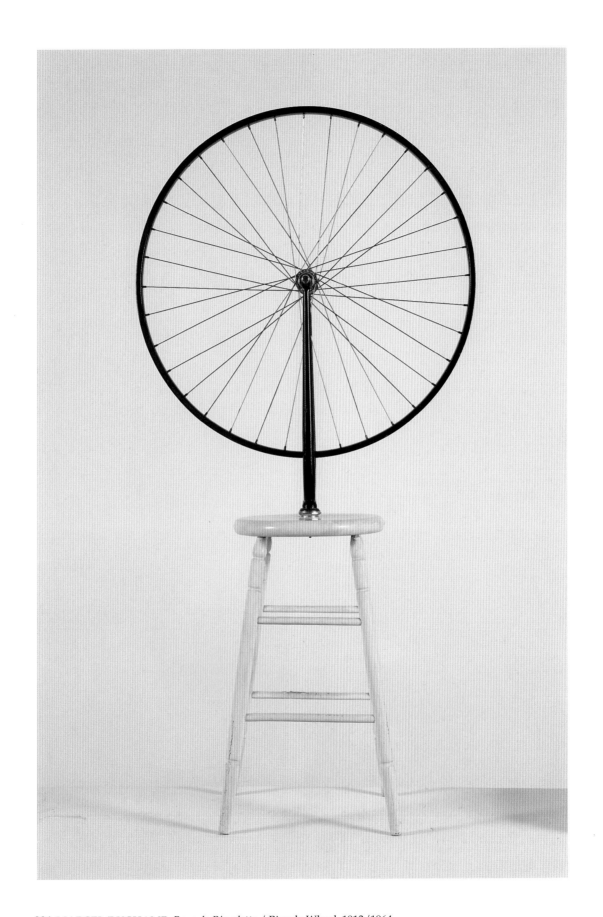

206 MARCEL DUCHAMP, *Roue de Bicyclette* / Bicycle Wheel, 1913/1964
Ready-made, height 126 cm
Hessisches Landesmuseum, Darmstadt

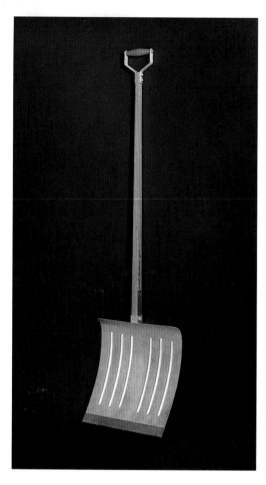

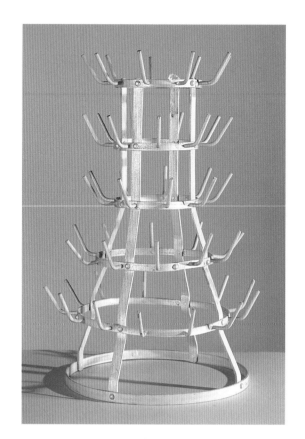

208 MARCEL DUCHAMP, *Egouttoir /
Porte bouteilles* / Bottlerack, 1914/1964
Ready-made, height 63 cm, ø 37 cm
Staatsgalerie Stuttgart

207 MARCEL DUCHAMP,
In Advance of the Broken Arm, 1915/1964
Ready-made, 121 x 35.5 cm
Private collection

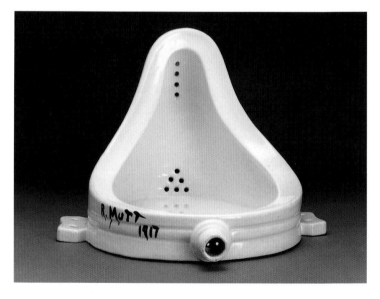

210 MARCEL DUCHAMP, *Traveller's Folding Item*, 1916/1964
Ready-made, 24 x 42.5 x 38 cm
Staatliches Museum, Schwerin

209 MARCEL DUCHAMP, *Fountain*, 1917/1964
Ready-made, 35.5 x 48 x 61 cm
Private collection

213 MARCEL DUCHAMP, *Air de Paris (50cc)*, 1919/1964
Ready-made: 13.5 cm
Collection Ronny van de Velde, Antwerp,
on loan to the Staatliches Museum, Schwerin

211 MARCEL DUCHAMP, *Trébuchet* / Trap, 1917/1964
Ready-made, 12 x 100 cm
Collection Ronny van de Velde, Antwerp,
on loan to the Staatliches Museum, Schwerin

212 MARCEL DUCHAMP, *Peigne* / Comb, 1916/1964
Ready-made, 0.3 x 16.5 x 3 cm
Collection Ronny van de Velde, Antwerp,
on loan to the Staatliches Museum, Schwerin

214 MARCEL DUCHAMP, *Boîte-en-valise* /
Box in a Valise, Serie E, 1963
Box with 68 objects, 10 x 40 x 40 cm
Collection Loïc Malle, Paris

216 MARCEL DUCHAMP, *Tondue par Georges de Zayas /*
Haircut by Georges de Zayas, 1921
(Photograph by Man Ray)
Vintage silver print, 12 x 9 cm
Private collection

215 MARCEL DUCHAMP,
Obligation pour la Roulette de Monte Carlo, 1924
Rectified Ready-made: Photo-collage
on coloured lithograph, 31 x 19.5 cm
Collection Ronny van de Velde, Antwerp,
on loan to the Staatliches Museum, Schwerin

217 MARCEL DUCHAMP, *Rrose Sélavy*, ca. 1920–1921
(Photograph by Man Ray)
Silver gelatin photograph with ink , 14 x 10 cm
Jedermann Collection, N.A.

218 MARCEL DUCHAMP, *Rotative plaques verre (optique de précision)* /
Rotary Glass Plates (Precision Optics), 1920 /1961
Iron, plexiglass, electric motor, 171 x 122 x 140 cm
Moderna Museet, Stockholm;
Gift from P.O. Ultvedt, Magnus Wibom and Pontus Hultén, 1961

219 FRANCIS PICABIA, *Composition*, 1915–1916
 Indian ink on board, 60 x 45 cm
 Collection Didier Imbert Art Production, Paris

220 FRANCIS PICABIA, *Le lierre unique eunuque* /
The Ivy, Unique, Eunuch, ca. 1920
Ripolin paint on cardboard, 75 x 105 cm
Kunsthaus Zürich, Zurich

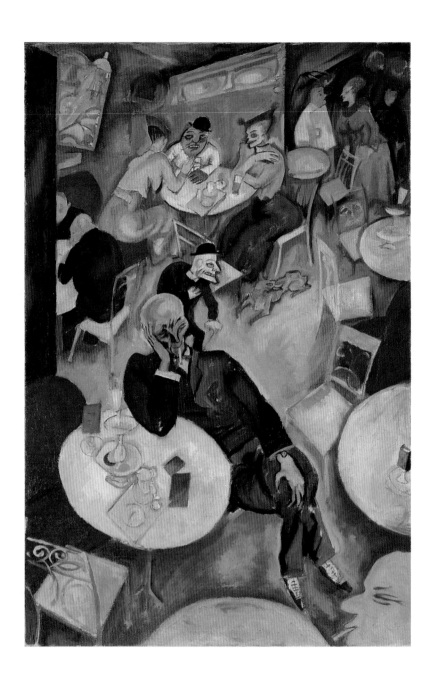

221 GEORGE GROSZ, *Das Kaffeehaus* / The Café, 1915
 Oil on canvas with charcoal underdrawing, 61 x 40.5 cm
 Hirshhorn Museum and Sculpture Garden, Smithsonian Institution, Washington D.C.;
 Gift of Joseph H. Hirshhorn Foundation, 1966

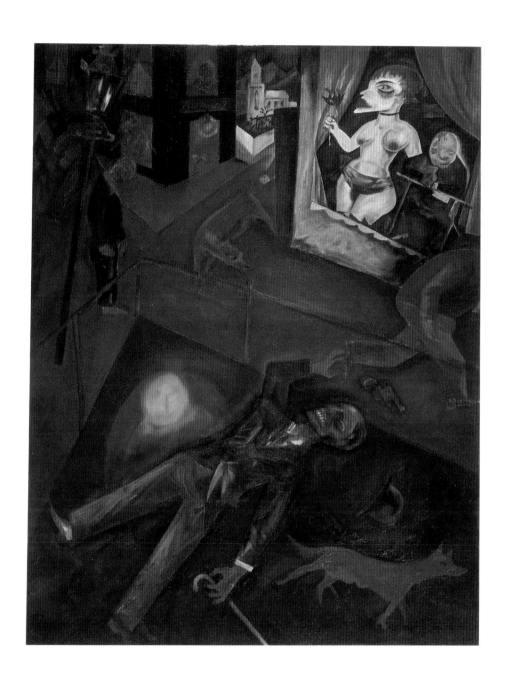

222 GEORGE GROSZ, *Selbstmord* / Suicide, 1916
Oil on canvas, 100 x 77,5 cm
Tate Gallery, London; Purchased with assistance from
the National Art Collections Fund 1976

223 RAOUL HAUSMANN, *OFFEAH-Plakatgedicht* /
OFFEAH Poem Poster, 1918
Typography on paper, 33 x 48 cm
Berlinische Galerie,
Landesmuseum für Moderne Kunst,
Photographie und Architektur

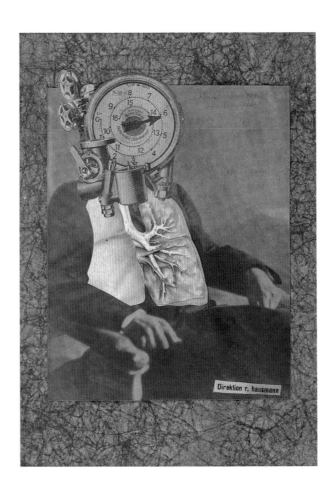

224 RAOUL HAUSMANN,
Selbstporträt des Dadasophen, Festival Dada /
Self-Portrait of the Dadasopher,
Festival Dada, 1920
Collage and photo montage on
Japan paper, 36 x 28 cm
Private Collection,
Courtesy Annely Juda Fine Art, London

225 RAOUL HAUSMANN, *Elasticum*, 1920
 Collage and gouache on cardboard, 31 x 37 cm
 Galerie Berinson, Berlin

226 Raoul Hausmann,
 Dada im gewöhnlichen Leben (Dada Cino) /
 Dada in Daily Life (Dada Cino), 1920
 Collage and photo montage on paper, 32 x 22.5 cm
 Private collection

227–230 KURT SCHWITTERS, *Mz 280 Rotfeder (für Lisker)* / Mz 280 Red Quill (for Lisker), 1921; Collage, 18 x 14.5 cm
Museum of Fine Arts, St. Petersburg, Florida; Gift from the Hanna Bekker vom Rath Collection *Tirana*, 1920;
Collage, 15 x 12 cm; *Merz 221: Dramatik* / Merz 221: Drama, 1921, Collage, 15 x 12 cm
Komposition, 1921–1923; Collage, 17.5 x 13.5 cm; Private collection

231 KURT SCHWITTERS, *Merzbild 9B. Das große Ichbild /
Merzpicture 9B. The Great I-Picture*, 1919
Collage and gouache, 97 x 70 cm
Museum Ludwig; Collection Ludwig, Cologne

232 KURT SCHWITTERS, *Mz 107, Zeichnung 1 Tag* / Mz 107, Drawing 1 Day, 1921; Collage with gouache on paper, 13 x 10.5 cm
ohne Titel (mz 478) / untitled (mz 478), 1922; Collage, 16.5 x 20.5 cm, *Spitzen* / Peaks, 1921; Collage on paper with pen, 18 x 15.5 cm;
Merzzeichnung 219 / Merz Drawing 219, 1921; Collage with paper, fabric and quill, 17.5 x 14 cm; Private collection

236 MAX ERNST, Untitled, 1921
Gouache, painting over a print, 45.5 x 66 cm
Courtesy Marc Blondeau S.A., Paris

237 MAX ERNST, *un peu malade le cheval patte pelu ... /*
a bit sick the horse with the fur paw ..., 1920
Collage, graphite, watercolour on paper on cardboard, 28 x 31.5 cm
Galleria Civica d'Arte Moderna e Contemporanea, Torino

238 MAX ERNST, Untitled, 1920
Gouache, pen, ink and pencil, painting over
of a print on cardboard, 30 x 25 cm
Courtesy Marc Blondeau S.A., Paris

239 MAX ERNST, *figure ambiguë* /
Ambiguous Figure, ca. 1919/1920
Mixed media on paper, 46 x 35 cm
Private collection

240 MAX ERNST, *Katharina ondulata*, 1920
 Gouache and pencil, ink on printed paper, 31.5 x 27.5 cm
 Scottish National Gallery of Modern Art, Edinburgh

241 MAX ERNST, *von minimax dadamax
 selbst konstruiertes maschinchen /*
 Little Machine Constructed by Minimax Dadamax
 Himself, ca. 1919/1920
 Mixed media on paper, 49.5 x 31.5 cm
 Peggy Guggenheim Collection, Venice

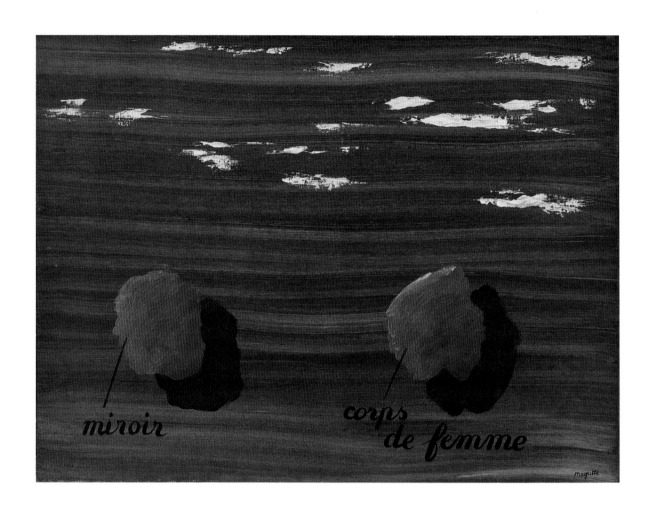

242 RENÉ MAGRITTE, *L'usage de la parole* /
The Use of Speech, 1928
Oil on canvas, 54 x 73 cm
Mis Collection, Brussels

243 VLADIMIR, TATLIN, *Letatlin*, 1929–1932
Mixed media, 110 x 1070 x 190 cm
Central State Museum for Air and Space Craft, Monino (Moscow area)

244 ANTONI TÀPIES, *Pintura amb creu vermella* / Painting with Red Cross, 1954
 Oil on canvas, 195 x 130.5 cm
 Kunstmuseum St. Gallen, loan of Collection T

245 ANTONI TÀPIES, *Porta metàl.lica i violí* / Metal Shutter and Violin, 1956
Paint and violin on metal door, 200 x 150 x 13 cm
Fundació Antoni Tàpies, Barcelona

246 ROBERT RAUSCHENBERG, *Memorandum of Bids*, 1956
 Combine painting: collage and mixed media on paper, 150 x 113 cm
 Sonnabend Collection, New York

247 ROBERT RAUSCHENBERG, *Magician II*, 1959
Combine Painting: collage and mixed media, 166 x 97 x 41 cm
Sonnabend Collection, New York

248 ROBERT RAUSCHENBERG, *Door*, 1961
Combine Painting: mixed media on wood, 219 x 94 cm
Private collection, Paris

249 JEAN TINGUELY, *Baluba Bleu*, 1962
 Mixed media, height 200 cm, ø 76 cm
 Stedelijk Museum, Amsterdam

250 EDWARD KIENHOLZ, *John Doe*, 1959
 Freestanding assemblage: various materials, 100 x 50 x 80 cm
 The Menil Collection, Houston

251 EDWARD KIENHOLZ, *The Future As An Afterthought*, 1962
Various materials and objects, 137 x 53.5 x 46 cm
Collection Onnasch

252 EDWARD KIENHOLZ, *The Illegal Operation*, 1962
 Various materials and objects, 140 x 122 x137 cm
 Betty and Monte Factor, Family Collection

253 JASPER JOHNS, *Target*, 1958
 Oil and collage on canvas, 91.5 x 91.5 cm
 Collection of the artist, on loan to National Gallery of Art, Washington D.C.

254 JASPER JOHNS, *Grey Target*, 1958
 Encaustic and collage on canvas, 106.5 x 106.5 cm
 Sonnabend Collection, New York

255 JASPER JOHNS, *0 through 9*, 1961
 Oil on canvas, 137 x 114.5 cm
 Joseph Hackmey Collection

256 ANDY WARHOL, *Silver Certificate*, 1962
 Acrylic and pencil on canvas, 132 x 183 cm
 Private Collection, Courtesy Galerie Bruno Bischofberger, Zürich

257 ANDY WARHOL, *Close Cover Before Striking (Coca-Cola)*, 1962
 Acrylic on canvas, 183 x 137 cm
 Louisiana Museum of Modern Art, Humlebæk, Denmark

258 ANDY WARHOL, *Ambulance Disaster*, 1963
 Synthetic polymer paint and silkscreen ink on canvas, 302 x 203 cm
 The Andy Warhol Museum, Pittsburgh;
 Founding Collection, Contribution Dia Center for the Arts

259 ANDY WARHOL, *Brillo Boxes*, 1964 and 1968
 Serigraphy on wood, each 43 x 43 x 35 cm
 Sonnabend Collection, New York (1);
 Max Lang, New York (2); Frits de Kneght (1)

260 ANDY WARHOL, *Double Elvis*, 1964
 Silkscreen on silverpaint on canvas, 207 x 208 cm
 Froehlich Collection, Stuttgart

261 ROY LICHTENSTEIN, *Baseball Manager*, 1963
Oil and magna on canvas, 173 x 142 cm
Courtesy The Helman Collection, New York

262 ROY LICHTENSTEIN, *Compositions II*, 1964
Oil and magna on canvas, 137 x 120.5 cm
Sonnabend Collection, New York

263 ROY LICHTENSTEIN, *Eddie Diptych*, 1963
Magna on canvas, 112 x 132 cm
Sonnabend Collection, New York

264 CLAES OLDENBURG, *Soft Engine for Airflow with Fan and Transmission, Scale 5*, 1966
 Canvas filled with kapok, enamel, rope, and wooden toggles, 134 x 183 x 46 cm
 Hirshhorn Museum and Sculpture Garden, Smithsonian Institution, Washington D.C.;
 The Regents' Collection Acquisition Program, 1985

265 CLAES OLDENBURG, *Giant Loaf of Raisin Bread, Sliced*, 1966 - 1967
canvas and canvas stiffened with glue, filled with polyurethane foam,
acrylic, wood base, 101.5 x 244 x 101.5 cm
Courtesy The Helman Collection, New York

266 MARCEL BROODTHAERS,
Pupitre à musique / Music Stand, 1964
Wood, mussel shells, plaster, paint, 136 x 96 cm
Private collection, Courtesy Galerie Christine
et Isy Brachot, Brussels

267 MARCEL BROODTHAERS, *Papa*, 1966
Various objects,
chair: 89.5 x 42 x 34.5 cm; mirror: ø 49 cm
Galerie Hauser & Wirth, Zürich

268 MARCEL BROODTHAERS,
Pyramide de toiles / Pyramid of Canvases, 1973
Canvases, paint, card, 40 x 65 x 60 cm
Courtesy Hirschl & Adler Modern, New York

270 MARCEL BROODTHAERS, *Une pelle* / A Shovel, 1965
Spade, adhesive paper, paint, marker, 115 x 19.5 x 5 cm
Caldic Collection, Rotterdam

269 MARCEL BROODTHAERS, *Moules sauce blanche* /
Mussels in White Sauce, 1967
Mixed media, 48.5 x 37 cm
Private collection, Courtesy Galerie Christine
et Isy Brachot, Brussels

271–276 MARCEL BROODTHAERS, *Service Publicité* / Publicity Department, 1971; 84.5 x 121 cm
Département des aigles / Department of Eagles, 1968; 84 x 121 cm.
Modèle: La Pipe / Model: The Pipe, 1969;
84.5 x 121.5 cm and 81.5 x 119.5 cm; plastic
Private collection, Courtesy Jule Kewenig

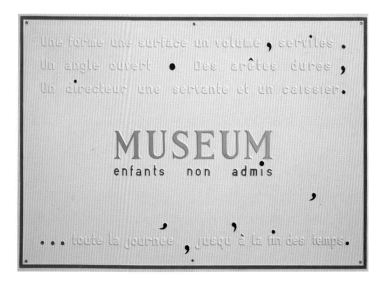

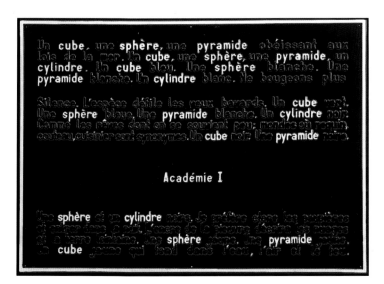
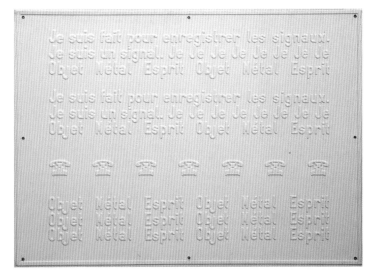

277–282 MARCEL BROODTHAERS, *Museum (Enfants non admis)* /
Museum (Children not admitted), 1968; 82 x 119 cm
Académie I, 1968; 87.5 x 120.5 cm; *Téléphone*, 1968; 85.5 x 119.5 cm
Cinéma Modèle / Cinema Model, 1970; 85 x 120 cm; plastic
Private collection, Courtesy Jule Kewenig

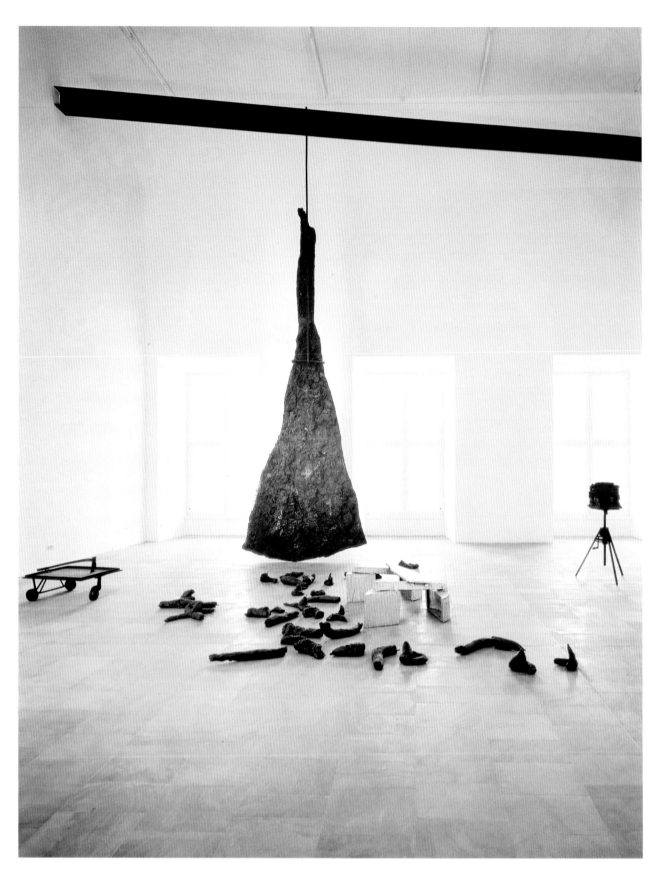

283 JOSEPH BEUYS, *Blitzschlag mit Lichtschein auf Hirsch* /
Lightning with Gleam of Light on Stag, 1958–1985
Bronze, aluminium, iron, dimensions variable (lightning 624 x 248 x 50 cm;
Boothia Felix 143 x 75 x 75 cm; goat 49 x 72 x 93 cm; stag 48 x 104 x 172 cm)
Private collection

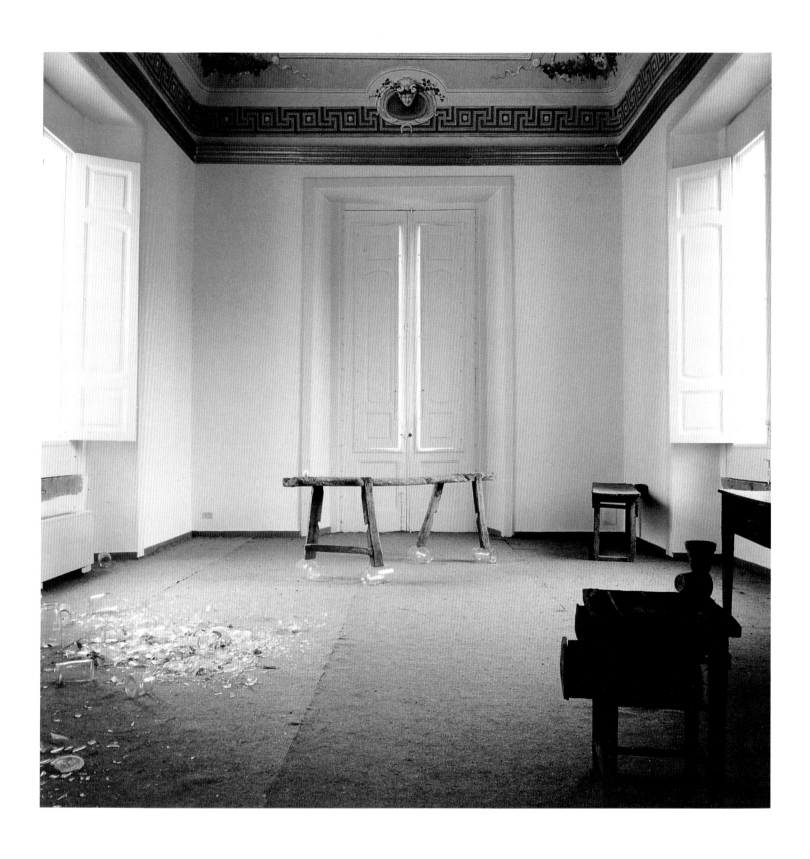

284 JOSEPH BEUYS, *Terremoto in Palazzo* / Earthquake in Palace, 1981
 Installation: mixed media and various objects, ca. 500 x 700 cm
 Fondazione Amelio; Istituto per l'arte contemporanea, Napels

285 JOSEPH BEUYS, *Tafelzeichnungen "Aktion Dritter Weg" I - III /*
Blackboard Drawings "Action Third Path" I - III, 1978
Slates, chalk, walking stick, 3 panels, each 133 x 133 cm
Private collection

286 NAM JUNE PAIK, *Zen for TV*, 1963–1975
Television set modified, 67 x 49 x 40 cm
Museum Moderner Kunst Stiftung Ludwig Wien,
former Collection Hahn Cologne

287 NAM JUNE PAIK, *Candle TV*, 1975
Television casing, candle, 45 x 60 x 50 cm
Staatsgalerie Stuttgart

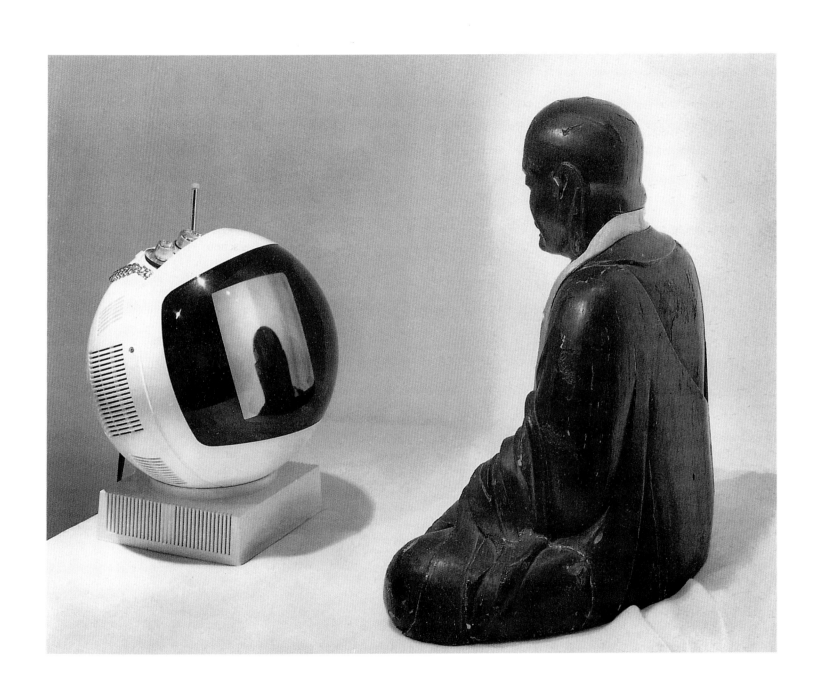

288 NAM JUNE PAIK, *TV-Buddha*, 1974,
Video installation: wooden statue of Buddha,
camera, monitor, 160 x 215 x 80 cm
Stedelijk Museum, Amsterdam

289 ALBERTO BURRI, *Sacco* / Sack, 1952
Sack, vinavil on canvas, 120 x 108 cm
Fondazione Prada Collection, Milan

290 ALBERTO BURRI, *Sacco* / Sack, 1958
 Sack, vinavil on canvas, 130 x 150 cm
 Claude Berri, Paris

291 PIERO MANZONI, *Linea, m. 7200*, 1960
Ink on paper in lead cylinder, height 66 cm, ø 96 cm
Herning Kunstmuseum, Denmark

292 PIERO MANZONI, *Base magica*, 1961
Wood, 80 x 80 x 60 cm
Attilio Codognato Collection, Venice

293 PIERO MANZONI, *Socle du monde* / Base of the World, 1961
Iron, 82 x 100 x 100 cm
Herning Kunstmuseum, Denmark

295 PIERO MANZONI, *Merda d'artista, no. 4* / Artist's Shit no. 47, 1961
Excrement in metal box, height 5 cm, ø 6.5 cm
Attilio Codognato Collection, Venice

296 PIERO MANZONI, *Fiato d'artista* / Artist's Breath, 1960
Balloon, wax, wood, metal, 2 x 18 x 18 cm
Attilio Codognato Collection, Venice

294 PIERO MANZONI, *Linea, m. 4.5*, 1959
Ink on paper in cardboard cylinder, height 22 cm, ø 6 cm
Attilio Codognato Collection, Venice

297 JANNIS KOUNELLIS, *Senza Titolo* / Untitled, 1960
 Collage and china ink on paper, 147 x 306 cm
 Claude Berri, Paris

298 PINO PASCALI, *Pelo* / Fur, 1968
Acrylic hair on wooden structure, 120 x 165 x 165 cm
Galleria Nazionale d'Arte Moderna, Rome

299 PINO PASCALI, *Lanciamissili Uncle Sam and Uncle Tom* /
Rocket Launcher Uncle Sam and Uncle Tom, 1965
Wood, scrap metal, wheels, 215 x 300 x 260 cm
"La Gaia" Collection, Cuneo

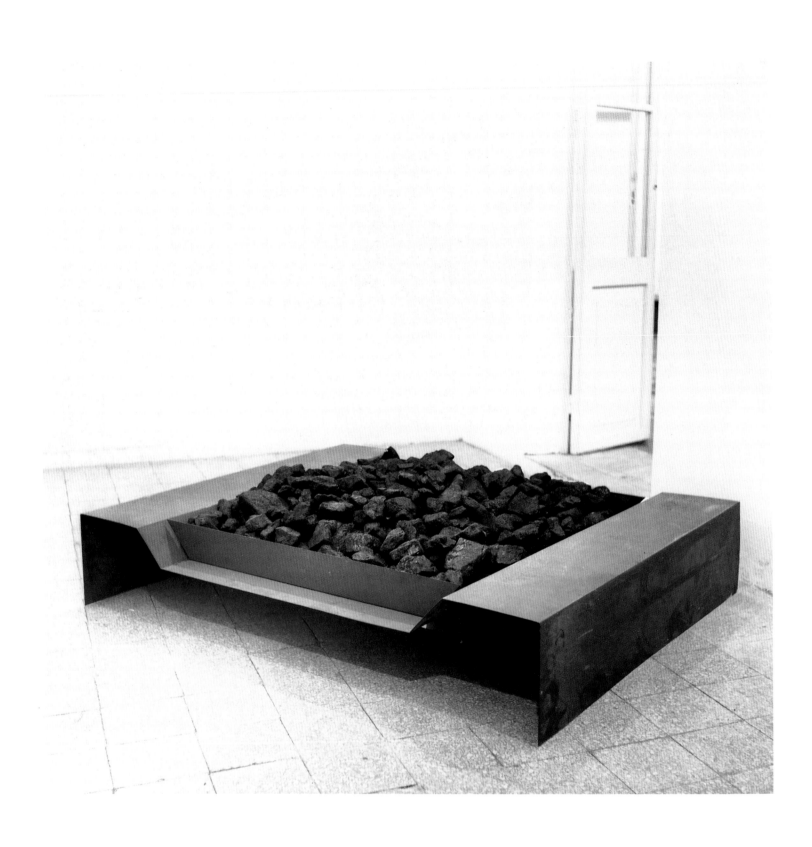

300 JANNIS KOUNELLIS, *Senza Titolo* / Untitled, 1967
Iron structure with coal, 28 x 155 x 125 cm
Collection of the artist

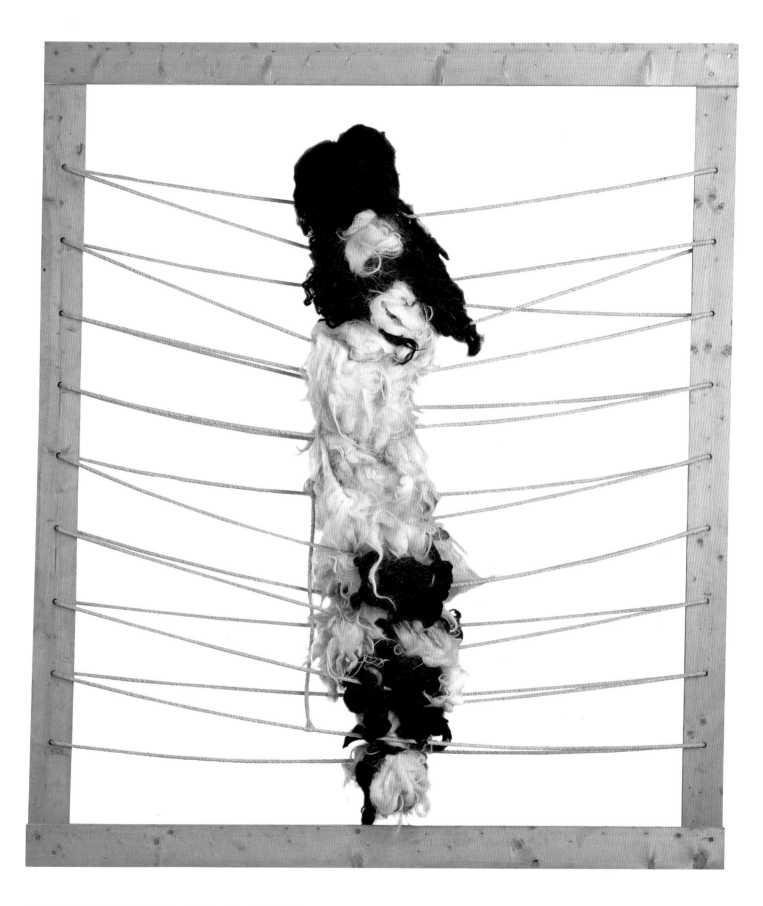

301 JANNIS KOUNELLIS, *Senza Titolo* / Untitled, 1968
Black and white wool, wooden frame, 250 x 200 cm
Karsten Greve, Cologne, Paris, Milan

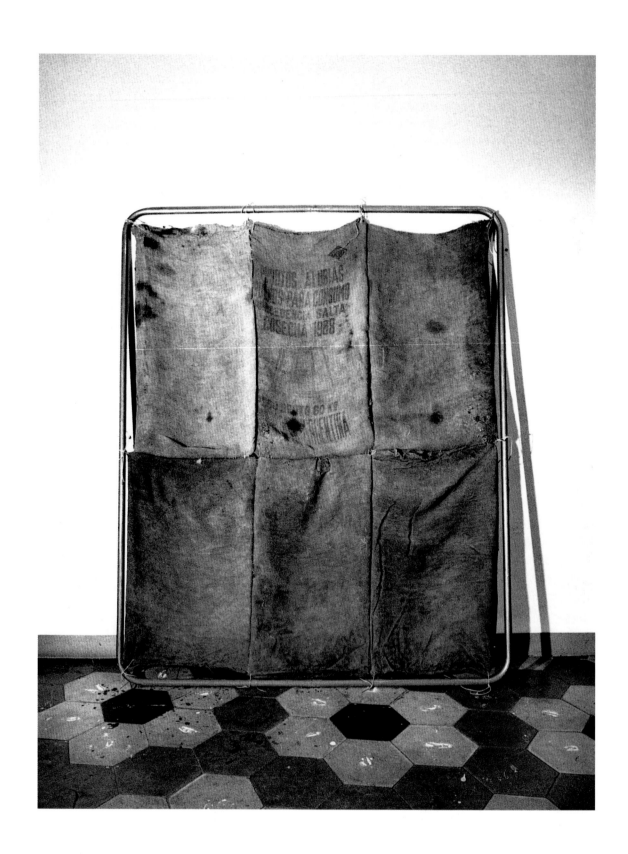

302 JANNIS KOUNELLIS, *Senza Titolo* / Untitled, 1969
 Iron structure and sack, 190 x 170 cm
 Collection of the artist

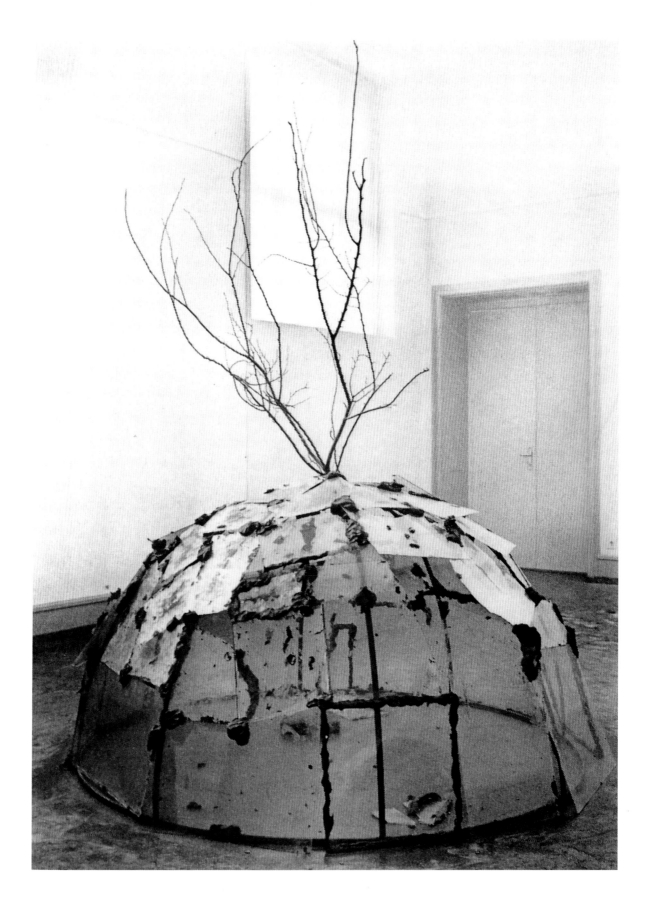

303 MARIO MERZ, *Igloo con albero* / Igloo with Tree, 1969
 Metal tubes, glass, plaster and branch, 150 x 250 cm, incl. branch 320 cm
 Courtesy Galleria Christian Stein

304 MARIO MERZ, *Iguana*, 1971
 Stuffed iguana and neon tubes, transformer,
 220 x 16 x 10 cm
 Private collection

305 BRUCE NAUMAN, *The True Artist Helps the World by*
 Revealing Mystic Truths (Window or Wall Sign), 1967
 Neon tubing, 150 x 140 x 5 cm
 Private collection, Courtesy Leo Castelli Gallery

306 BRUCE NAUMAN, *Raw Material with Continuous Shift - MMMM*, 1991
Video installation, dimensions variable
Froehlich Collection, Stuttgart

307 BRUCE NAUMAN, *Smoke Rings: 2 Concentric Tunnels Skewed,
Non-Communicating*, 1980
Cast Aluminum, height: 53 cm; ø 462 cm
The Berardo Collection - Sintra Museum of Modern Art

308 SIGMAR POLKE, *Puppe* / Doll, 1965
Wall paint on canvas, 125 x 160 cm
Private collection

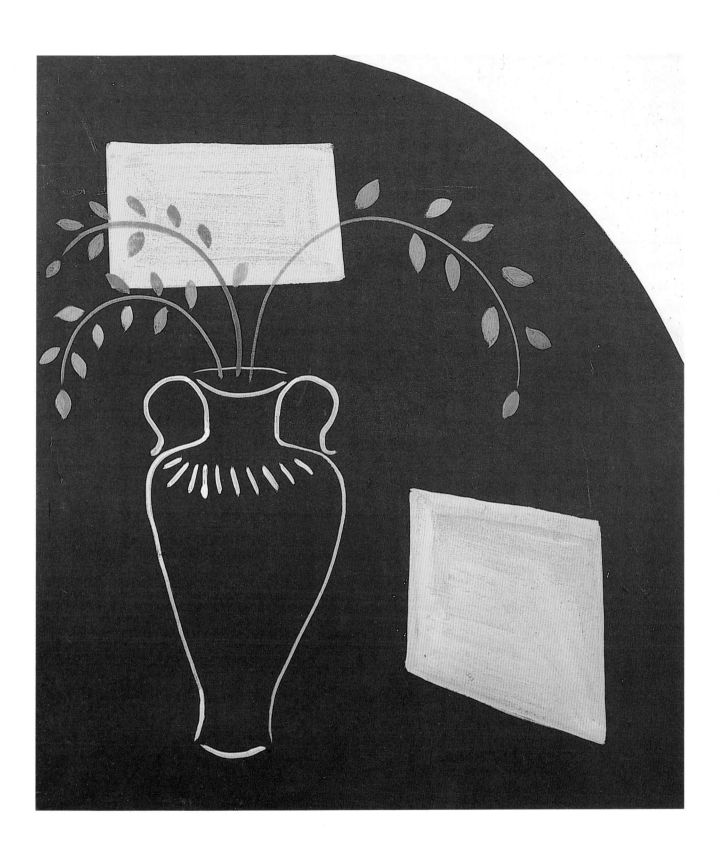

309 SIGMAR POLKE, *Vase I*, 1965
 Acrylic on canvas, 100 x 90 cm
 Collection Garnatz

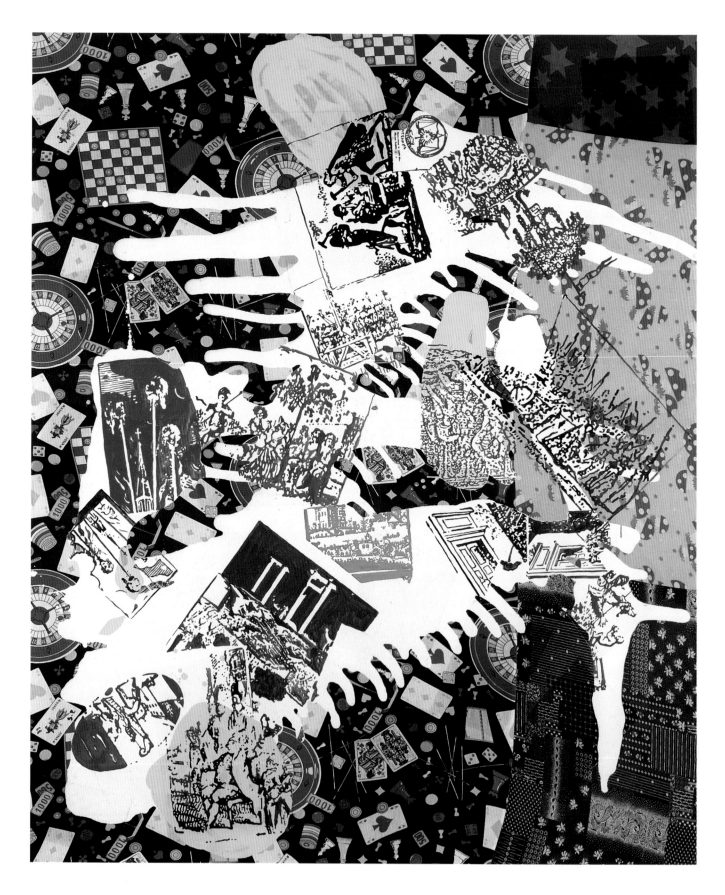

310 SIGMAR POLKE, *Monopoly*, 1989
Mixed media on fabric, 180 x 150 cm
Didier Guichard, Courtesy Galerie Chantal Crousel

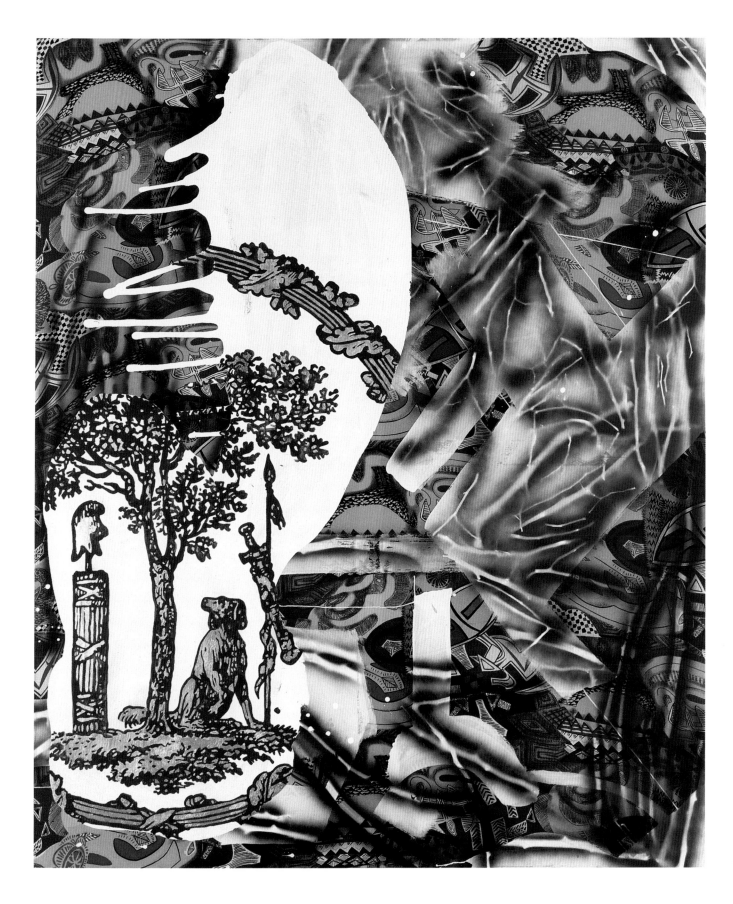

311 SIGMAR POLKE, *Forêt Nationale*, 1989
 Mixed media on fabric, 180 x 150 cm
 Collection Labeyrie

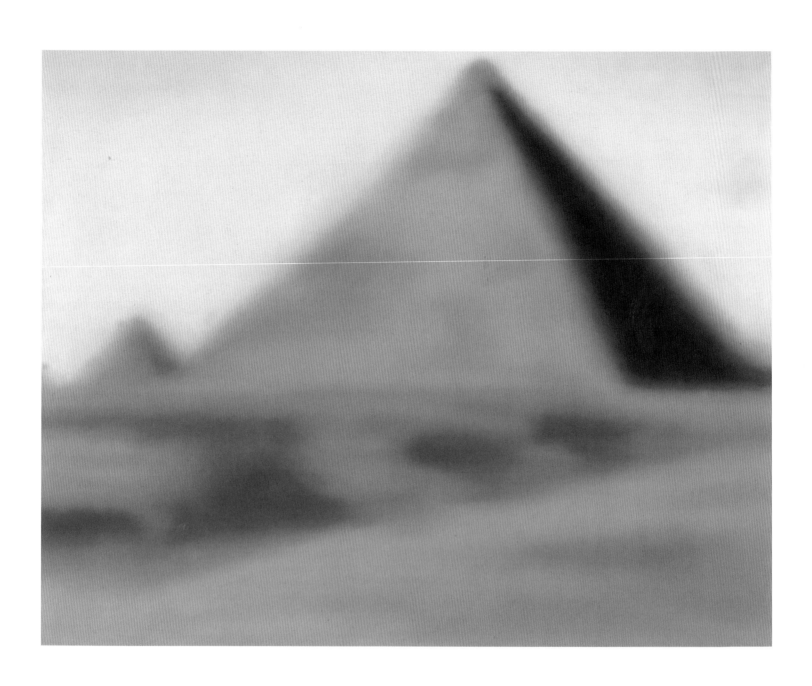

312 GERHARD RICHTER, *Große Pyramide* / Great Pyramide, 1966
 Oil on canvas, 190 x 240 cm
 Museum van Hedendaagse Kunst, Gent

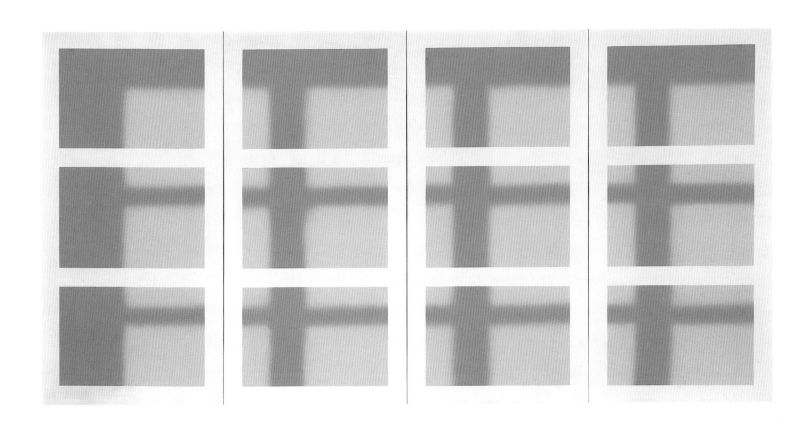

313 GERHARD RICHTER, *Schattenbild 4 >Fenster<, vierteilig /*
Shadow Picture 4 >Window<, four parts, 1968
Oil on canvas, 200 x 400 cm
Private collection

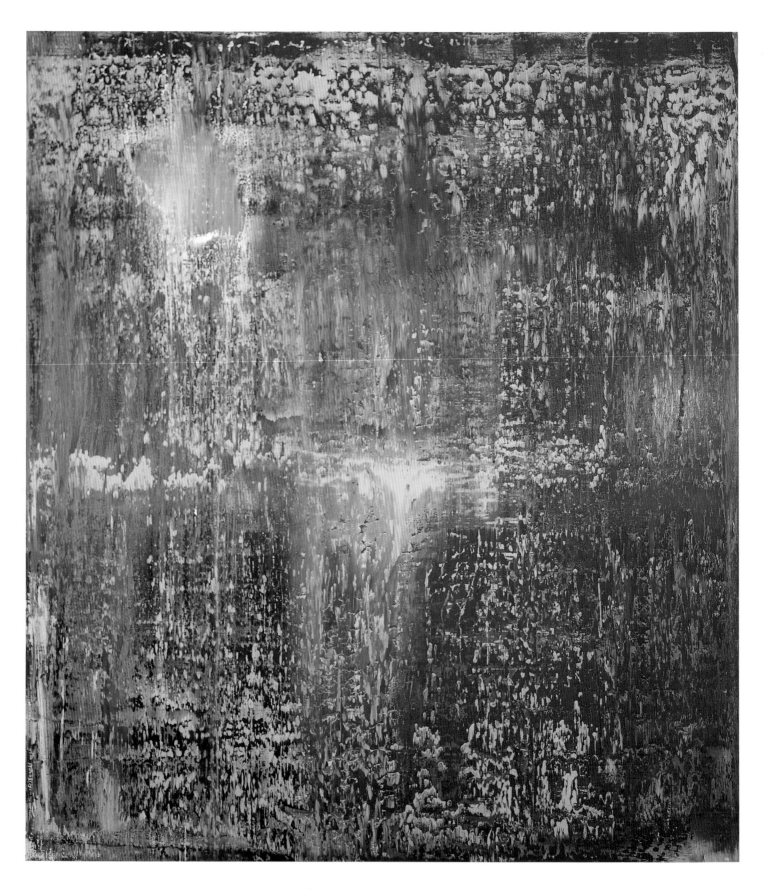

314 GERHARD RICHTER, *Abstraktes Bild* / Abstract Painting, 1987
Oil on canvas, 225 x 200 cm
Private collection, Belgium

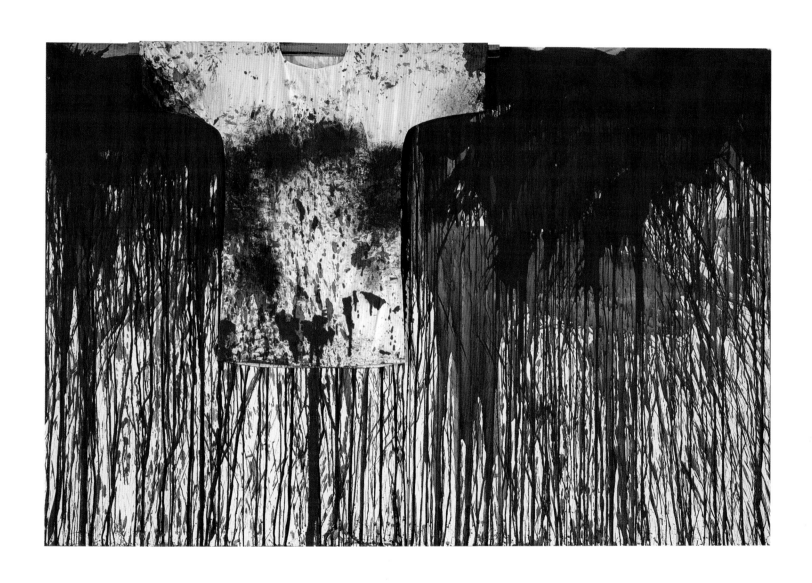

315 HERMANN NITSCH, *Großes Bild mit Malhemd /*
Large Picture with Painting Shirt, 1988
Acrylic, blood on canvas, 200 x 300 cm
Collection Essl, Klosterneuburg

316 GILBERT & GEORGE, *The Secret Drinker*, 1973
Photographs on cardboard, under glass, 287 x 648 cm
Private collection, Courtesy Massimo Martino S.A., Mendrisio

TO THE SEA
ON THE SEA
FROM THE SEA

317–319 LAWRENCE WEINER, *# 157; # 158; # 159*, 1970
Language and materials referred to, dimensions variable
Solomon R. Guggenheim Museum , New York; The Panza Collection

320 HANNE DARBOVEN, *Homer, Odyssee, 1.-5. Gesang /*
Homer, Odyssey, 1st - 5th Chant, 1971
Ink on paper, 70 sheets, each 42 x 29.5 cm
Courtesy Busche Galerie

321 JAN DIBBETS, *Comet sea 3° - 60°*, 1973
 Photographic paper on fibreboard behind perspex, 440 x 600 cm
 Stedelijk Museum, Amsterdam

322 ILYA KABAKOV, *Three Nights*, 1990
 Installation: 3 paintings, canvas, oil, mixed media, dimensions variable;
 Night 1: 368 x 226 cm, Night 2: 224 x 590 cm, Night 3: 320 x 868 cm
 Collection of Ilya and Emilia Kabakov

323 BERTRAND LAVIER, *Peinture /*
Painting, 1984
Acrylic on mirror and frame,
163.5 x 128.5 cm
Martine and Didier
Guichard Collection

324 BERTRAND LAVIER,
French Painting, 1984
Acrylic on base and book,
height 131 cm;
base 25 x 30 cm
F. and JPH.
Billarant Collection

325 BERTRAND LAVIER, *Gaveau*, 1991
 Acrylic on piano, 100 x 144 x 150 cm
 Private collection, Turin; Courtesy Galleria Christian Stein

326 JENNY HOLZER, *Survival*, 1983-85
LED-signs, dimensions variable
Courtesy of the artist and Barbara Gladstone Gallery, New York

327 GARY HILL, *Learning Curve*, 1993
Video Installation, 135 x 320 x 535 cm
Donald Young Gallery, Seattle

328 REINHARD MUCHA, *Der Bau* / The Construction, 1980–1984
 Mixed media, part A: 194 x 180 x 59 cm, part B: 202 x 470 x 77 cm,
 part C: 195 x 190 x 700 cm
 Gräßlin Collection, St. Georgen

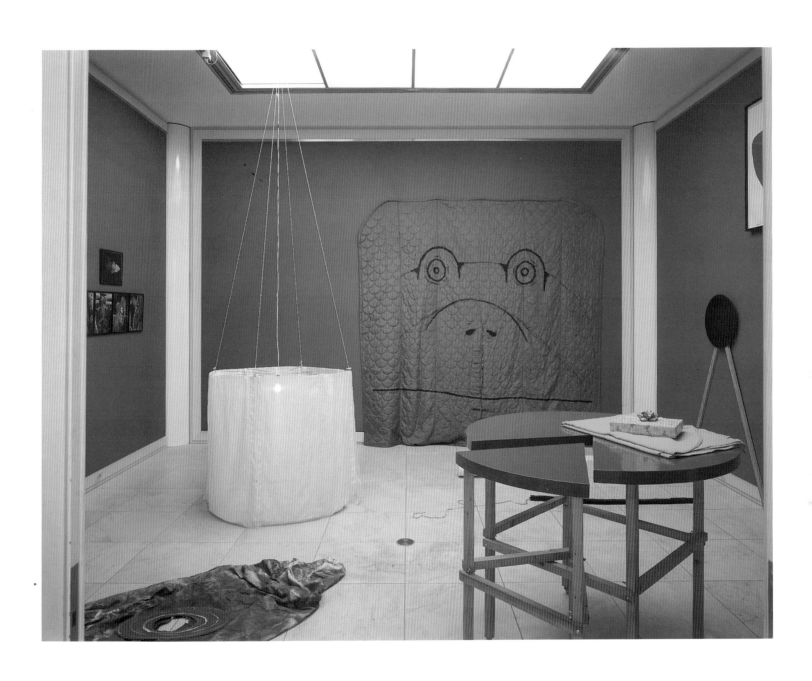

329 MIKE KELLEY, *Confusion*, 1982–1983
Various materials and objects, ca. 500 x 700 cm
Städtisches Museum Abteiberg, Mönchengladbach

330 ROSEMARIE TROCKEL, *Freude* / Joy, 1988
 Wool, 210 x 175 cm
 Froehlich Collection, Stuttgart

331 ROSEMARIE TROCKEL, *Who will be in in '99?*, 1988
Wool, 210 x 160 cm
Froehlich Collection, Stuttgart

332 ROSEMARIE TROCKEL, Untitled, 1988
Wax, irons, wood, glass, 148 x 54 x 54 cm
Froehlich Collection, Stuttgart

333 JEFF KOONS, *New Hoover Quadraflex*, *New Hoover Convertible*,
New Hoover Dimension 900, *New Hoover Dimension Doubledecker*, 1981–1986
Vacuum cleaners, Plexiglass, fluorescent lights, 249 x 133.5 x 70.5 cm
Susan and Lewis Manilow

334 JEFF KOONS, *Bear and Policeman*, 1988
Wood, 216 x 109 x 91.5 cm
Kunstmuseum Wolfsburg

335 JEFF KOONS, *Rabbit*, 1986
 Stainless Steel, 104 x 48.5 x 30.5 cm
 The Eli and Edythe L. Broad Collection, Los Angeles

Dream – Myth

WIELAND SCHMIED

Magic Realities, Dream, Myth, Fiction: From Giorgio de Chirico and Max Ernst to Jannis Kounellis and Katharina Fritsch

I

This exhibition offers four paths through twentieth-century art. As an initial attempt to establish some bearings in the complex terrain of modernism, this has the support of an early, knowledgeable and committed testimony: that of the American collector and critic, James Thrall Soby. This is what Soby wrote in 1941, as a preamble to his first book on the painting of Giorgio de Chirico:

> I believe that at least three great painters have passed in our century: Picasso, whose giant strides have left imperishable gashes in the land; Marcel Duchamp, who has walked across the scene on a tight-rope strung exquisitely taut, balancing in his hands what Hamlet called 'the abstracts and brief chronicles of the time'; and Giorgio de Chirico, who has walked by night, leaving phosphorescent footprints on the long plain. I believe that the way of de Chirico has been sure, and that certain painters will forever follow it.[1]

The trail blazed by de Chirico, which we here try to characterise by using such words as 'magic realities', 'dream', 'myth' and 'fiction', cannot be described as a straightforward one; nor was it ever pursued with any logical consistency – logic in such a case being a contradiction in terms. Of all the paths that this exhibition seeks to document, this is the least susceptible of unambiguous definition. The paths that lead, respectively, from Picasso to Bacon and from Mondrian to Newman and even, to some extent, the one that leads from Duchamp to Beuys, seem unproblematic by comparison. More than all the others, this is a lonely path. Every artist who has ever pursued it – either for a short while or for a whole lifetime – has had to make his own way, as if travelling on 'overgrown trails'.

This lack of coherence is apparent in the very fact that, from the outset, de Chirico, Carlo Carrà and Giorgio Morandi, the three chief exponents of a 'Metaphysical Painting', a *Pittura metafisica*, each meant something entirely different by that phrase; what is more, those artists whom André Breton gathered around himself in Paris, and whom he first presented to the public in the mid-1920s as the painters of the Surrealist movement, never had a style in common. It has been said of the Metaphysical painters that they aimed to express their specific experience of reality as an enigma; even if true, this certainly does not apply equally to all of them. As for the painters who belonged to Surrealism, no such thing as a common view of reality existed. Their lowest common denominator is a shared, or at least recognisable, mental attitude. In style, intentions and subject-matter their one undeniable link is that they differed even more from other contemporary artists than from each other.

1 James Thrall Soby, *The Early Chirico*, New York, 1941. What is surprising about Soby's highly perceptive account is that he mentions only three paths – and three artists who have led the way along them – rather than four. And yet Mondrian, who had almost reached the end of his own path, was right under Soby's nose. Not only had he come to New York from German-occupied Paris in October 1940, but his work had long been well known in America, and its durable influence on a younger generation of American artists was already visible.

'Magic realities', 'dream', 'myth', 'fiction': the concepts we have chosen to denote facets of this single tradition might well be supplemented by others. Foremost among these is the concept of the unconscious, together with the techniques developed in Surrealist circles to generate the image by an automatic or semi- or quasi-automatic process. All those techniques sprang from the desire to express the unconscious as directly as possible. Another notion that we might introduce is that of 'Metaphysical Art', coined by de Chirico after reading Friedrich Nietzsche and Otto Weininger. Then there is the word first employed by Guillaume Apollinaire and subsequently charged with detailed meaning by Breton: 'Surrealism', together with the kindred concept of the 'surreal' or superreal. A further key concept is that of 'mystery', which de Chirico invoked in so many of the titles of his works, and which was later to become a favourite with René Magritte, who used it to explain the meaning of his work. Finally, we might also name the delight in endless metamorphosis, both of beings and of objects, as an important characteristic of an art that professes allegiance (as in the very word 'surreal' itself) to the latent connectedness and rooted unity of all phenomena. The Surrealists saw reality and the dream, consciousness and the unconscious, banality and magic, inward and outward, as indissolubly linked; and the constant interpenetration of different spheres, their incessant transformation and metamorphosis, is among their recurrent themes.

The concepts of 'dream' and 'myth', chosen here for discussion, not only differ greatly in substance but correspond to quite different phases of artistic evolution within our century. In the work of Henri (Douanier) Rousseau, of de Chirico and of a number of Surrealists, the dream played a dominant role; after the Second World War, the same evolutionary strand produced a new form of art devoted to the evocation of myth. This began in New York in the early 1940s, when artists responded to the global menace of the war by seeking answers in the world of myth, both classical and Native American. Willi Baumeister's engagement with Greek and Near Eastern myths provides a European analogy.

With some risk of oversimplification, dream and myth may be related thus: what the dream meant to a number of artists in the first one-third of the century, myth and fiction became (after a phase overshadowed by the nightmare of war) for another group of artists in its final one-third. The renewed – though changed – interest in the mythic dimension is exemplified by Jannis Kounellis, Anselm Kiefer, Enzo Cucchi, Francesco Clemente, Giulio Paolini, Michelangelo Pistoletto and Cy Twombly. Again, the work of Robert Gober, Katharina Fritsch, Cindy Sherman and Jeff Wall has to do with what we may describe as 'fiction' – a fiction rooted not in myth so much as in the dream: the Hollywood dream factory in Sherman's case, the world of folk tales in that of Fritsch. Now that the dream has entered the age of its technical producibility, perhaps the word should be replaced by 'fiction' throughout, especially when we speak of the virtual realities generated by art.

The actualisation of the mythical by these artists has nothing to do with the illustration or paraphrase of classical myths, as attempted in this century by numerous artists, not-

Fig. 1 Giorgio de Chirico, *Voyage sans fin* (The Endless Journey), 1914. Wadsworth Atheneum, Hartford, Connecticut

Fig. 2 Max Beckmann, *Der Traum*
(The Dream), 1921.
The Saint Louis Art Museum

Fig. 3 André Masson, *Mythologie
de l'être*, 1939

2 Jean Cocteau, *Le Rappel à l'ordre* (collection of essays), Paris, 1926.
3 De Chirico's second spell in Paris (from 1925 onwards) has accordingly often been described, after the title of the essay on his work by Cocteau, as the *Mystère laïc* period: Jean Cocteau, *Le Mystère laïc*, Paris, 1928.

ably in Picasso's assertion of the vitality of classicism. Rather, it is the conscious acceptance of archaic modes of thinking and experience as genuinely artistic, because essentially imagic, and their redefinition for a 'technological age'.

II

Naturally, any attempt to draw a clear line between the realms of dream and myth leads to gross oversimplification. There are all manner of transitional and hybrid forms, as well as extensive borderline areas. Such areas seem to me to exist in the work of de Chirico and of his brother, Alberto Savinio. In the second half of the 1920s, both artists set out to elaborate a new mythology in public defiance of the Surrealists and of their belief in the dream. De Chirico's evocations of the Thessaly of the antique travellers and of classical legend – which was also the Thessaly of his own childhood – are very much more this-worldly than those fragments of columns, temples and sculptures in his early, Metaphysical work, which become the stage decor of a reality steeped in dream. Is the world of the Metaphysical paintings no more than the dream dreamed by the severed head of a toppled marble statue? De Chirico's painting of 1914, *Journey Without End* (Fig. 1), would seem to suggest as much. Accordingly, for the purposes of this exhibition, the work later created by de Chirico in the spirit of a neoclassical 'recall to order' *(Rappel à l'ordre)*[2] belongs not to the Metaphysical/Surrealist strand but to the Realism of the 1920s (cat. 39).[3]

Again, and for similar reasons, the organisers of this exhibition have assigned the work of Max Beckmann to the tradition of engagement with visible reality. Here there are strong arguments either way. Not for nothing did Beckmann stress the ambivalence of his own position by using the phrase *transzendente Sachlichkeit*, 'transcendental matter-of-factness'. His painting draws on Greek myth in many different ways – as it does on Gnostic, Cabbalistic and Hindu sources – and combines all this with motifs from our present-day world. It is Beckmann's grand design to elevate contemporary reality to the level of myth, or to transmute it into the symbolic density of a dream (Fig. 2).

Very much the same might be said of the realism of Mario Sironi, who constantly touches on the realm of magic. In his work of the early 1920s, Sironi attempts to translate the hermetic, dreamlike world of de Chirico's Italian piazzas into contemporary reality – and, specifically, into the atmosphere of the industrial outskirts of expanding modern cities. For all his stress on the concrete reality of his factories, and for all his allusions to contemporary technology – cranes, motor lorries –Sironi never loses touch with the mysterious enchantment of de Chirico's world.

A borderline case between the realms of dream and myth is to be found in the drawings that make up André Masson's two cycles of the late 1930s, *Mythologie de la nature* and *Mythologie de l'être* (Fig. 3). These show us nature enmeshed in motion and metamorphosis: all is flow. These drawings pay tribute to Heraclitus, whom Masson revered – alongside Nietzsche – as a tragic philosopher. In a Heraclitean world, phenomena are prone to metamorphosis and coalescence: this is myth as dream.

Within the evolutionary strand represented by art that conveys a magical image of reality, the distinction between the realms of dream and myth needs to be complemented by another. Of all those artists who have worked over the last few decades to actualise myth, all (with the single exception of Kiefer) have their roots in a Mediterranean world, centred on Rome. By contrast, the artists of Surrealism, those whom Breton gathered round him in Paris, are at home in the rationalistic tradition of French thought associated with the name of René Descartes. However much their work gives vent to the irrational, the unconscious, the dream, these artists never entirely cut themselves adrift from the rational world. None of them belongs to what Robert Rosenblum has called the 'Northern Tradition';[4] none reveals any inclination toward expressive mysticism; none is a bard of chaos. As they see it, the mystery of the world is not rooted in chaos. It does not spring from 'savage thought', but manifests itself as the suspension of thought. A logic that stands on its head presupposes the existence of a logical system; unreason can manifest itself only when counterpoised by reason. It is the achievement of the Surrealists (and notably of Max Ernst, Salvador Dalí, René Magritte) that they elaborate individual, rationally motivated artistic techniques and devote them to the exploration of the irrational.

III

There have been countless attempts to map the highways and byways of twentieth-century art. One attempt that demands to be mentioned here was made by Wassily Kandinsky. In an article in *The Blaue Reiter Almanac,* which he edited jointly with Franz Marc in 1912, Kandinsky sets out to consider which mental and spiritual forces, operative in the present age, might be capable of determining the future of art. There seem to be two guiding principles here, which he calls the Great Abstraction *(die große Abstraktion)* and the Great Reality or Realism *(die große Realistik):* 'These twin poles open two paths, which ultimately lead to a single goal.'[5] Kandinsky points to the ideals of abstraction as they operate within the (broadly defined) real: let abstraction be prosecuted with logic and consistency, and reality will remain present within it.

Fig. 4 Henri Rousseau, *The Dream of Yadviga*, 1910. The Museum of Modern Art, New York.

In our present context, Kandinsky's definition of the Great Reality seems particularly important. He based it on the work of one man – a life's work that was already over, although the art world in France and elsewhere was still in the process of discovering it and learning to take it seriously as art. This was the pictorial world of Henri Rousseau (Fig. 4):

> Here lies the root of the new, Great Reality. To present the outer husk of the object in perfect and total simplicity is to divorce the object from practical and functional concerns, and thus to free its inner resonance. Henri Rousseau, who ranks as the father of this form of realism, has shown the way with one simple and convincing gesture ... [he] has opened the way to the new potential of simplicity.[6]

The Great Reality, which Kandinsky envisaged as the polar opposite of the Great Abstraction that he himself practised, was thus to be found not in the early work of a Matisse, a Picasso or a Kokoschka (all represented by reproductions in *The Blaue Reiter Almanac* but in a concept of reality that was inseparable from the dimension of the magical. To Kandinsky, the Great Reality was 'the fantastic in the hardest matter'.

4 Robert Rosenblum, *Modern Painting and the Northern Romantic Tradition*, London, 1975.
5 Wassily Kandinsky, 'Über die Formfrage', *Der Blaue Reiter*, Munich, 1912; Engl., *The Blaue Reiter Almanac*, London, 1974.
6 Kandinsky (as note 5).

Fig. 5 Giorgio de Chirico, *Picasso Dining with Serge (Férat) and Hélène (d'Oettingen) and Léopold Survage*, 1915. Private collection

When André Breton opined (as late as 1959) that 'with Rousseau we can speak for the first time of "Magic Realism"',[7] he may well have had in mind the account of the Douanier given by Kandinsky almost half a century earlier. At all events, it does seem to be a curious coincidence that, at the time when Kandinsky published his essay, Giorgio de Chirico (who had moved to Paris from Florence in 1911) was discovering Rousseau's paintings for himself at the prompting of Apollinaire. A drawing of 1915 reveals that, to de Chirico, even Picasso appeared under the Douanier's spell (Fig. 5).

Apollinaire himself tells us that, when he first set eyes on paintings by de Chirico, it was Rousseau who came to mind. Carrà, when in Ferrara in 1917 he embarked for a few years on a course influenced by de Chirico, described Rousseau as one of the precursors of Metaphysical Painting. The inner affinity between the Douanier and de Chirico has since been evoked time and again,[8] but the actual nature of Rousseau's influence long remained unexamined. It was William Rubin who first discussed the affinity in some detail. It consists, for Rubin, in the handling of light: 'Rousseau's peculiar light, like that of de Chirico, is decidedly nonatmospheric.' It is a 'flat' light, which falls on objects frontally without modelling them sculpturally in any way. Often there is no telling whether it is daylight or moonlight. And yet, like de Chirico's enigmatic 'white light', it possesses what Rubin calls a 'supernatural, dreamlike clarity'.[9] This phrase, 'dreamlike clarity', applies even more strongly to de Chirico's Metaphysical Painting than it does to the work of Rousseau. De Chirico himself, in his early statements (down to the early 1920s), refers to both clarity and the dream as aspects of his work. One of his earliest and most-cited utterances reads as follows:

> To be really immortal, a work of art must go completely beyond the limits of the human: good sense and logic will be missing from it. In this way, it will come close to the dream state and also to the mentality of children ... The truly profound work will be drawn up by the artist from the innermost depths of his being. There is no murmur of brooks, no song of birds, no rustle of leaves.[10]

Ten years later, in 1922, de Chirico wrote from Rome in a forlorn attempt to explain to Breton his own turn towards classical tradition and his commitment to technical concerns. The works of his Metaphysical period were now a thing of the past, said de Chirico, and yet something of them still lingered. Once more, he linked this with the idea of the dream: the romance that he and his 'friend', Breton, had created, the visions that had so moved them.[11]

In his essay 'We Metaphysicals', published at the end of his Metaphysical period, in February 1919, de Chirico juxtaposed repeated references to dreams and visions with a commitment to clarity:

7 André Breton, *L'Art magique,* Paris, 1959.
8 Among others, by James Thrall Soby, in his monograph, *Giorgio de Chirico,* New York, 1955.
9 William Rubin, 'De Chirico and Modernism', in *De Chirico,* exh. cat., New York, The Museum of Modern Art, 1982.
10 Giorgio de Chirico (1911–15), cited from Soby (as note 8), p.110.
11 De Chirico (as note 10).
12 De Chirico (as note 10).

> The word 'Metaphysical' creates a host of misunderstandings. This happens above all with stuffy minds ... In their heads ... the word 'Metaphysical' evokes ideas of clouds and fog, of chaotic confusion and sombre masses ... Today I find in the word 'Metaphysical' no trace of imprecision. The serenity and the soulless beauty of matter seem to me to be metaphysical. I find even more Metaphysical those objects which, through the clarity of their colours and the exactitude of their measure, are the antithesis of all confusion and all obfuscation.[12]

A few months later, harking back to his early writings, de Chirico referred once more to 'madness' as an 'element immanent to every profound expression of art … The great madness that does not open itself to everyone will always exist and continue to gesticulate and give signs behind the implacable screen of reality.'[13] But this inspiration from 'madness' must be balanced by the reflective calculation of the wakeful artist: 'clear-sightedly, we construct in painting a new, metaphysical psychology of objects.'[14]

Giorgio de Chirico worked clear-sightedly even in his early, Metaphysical work. In this, he suggested the presence of visions and dreams through the mystification and encipherment of his iconography, and also of the formal elements that he used to present it; through a rigorous geometricisation of the forms; and through the balanced proportions of his architectural settings. Of course, intuition – for which we are entitled to read 'the unconscious' – played a part in this; but its promptings remained subject to the control of a wakeful consciousness. Contrary to his own poetic assertion, in the early text quoted above, there is reason (or good sense) and logic in de Chirico's works; but he applies it by contraries. The result is that both reason and logic are negated and disabled. De Chirico's naïvety, unlike Rousseau's, is deliberately assumed. It is a highly sophisticated construct – a fact that the early de Chirico concealed with somnambulistic adroitness.

IV

It was Apollinaire who first gave currency to the notion of Henri Rousseau as the 'Uccello of our century'.[15] The Douanier's art was subsequently associated with that of Paolo Uccello on a number of occasions, mostly – and notably by Werner Haftmann – in reference to the 'things "of hardest matter"' that both artists had in common.[16] De Chirico's relationship with Uccello, which was first noticed by Ardengo Soffici,[17] is very different: it refers to Uccello's fundamental achievement, which was the revolutionary transformation of perspective.

If we say that in his early, Metaphysical paintings, painted in Paris from 1911 onwards, de Chirico deliberately broke the rules of classical perspective, it may reasonably be objected that those rules had long since been swept away by the practitioners of Fauvism, Cubism and Expressionism: Matisse, Picasso, Braque, Kirchner and Kokoschka. Had not Kandinsky totally ignored them in his first abstracts? So how could de Chirico still be violating them? The answer to this is complex. De Chirico had first to postulate the continuing validity of classical linear perspective before he could undermine it and thus achieve his object of subverting perception. This subversion misled many viewers into registering only his reinstatement of Renaissance perspective and overlooking the hidden modernity of his paintings. So subtly had de Chirico shattered perspective into incompatible fragments that his violation of the outworn canon suggests that in principle it had subsisted intact.

This is where Uccello comes in. Where the disruption of perspective is concerned, we should speak of de Chirico not so much as the modern Uccello but as an Uccello in reverse. Uccello's *Battle of San Romano* (c. 1435–36), painted in three large panels, is actu-

13 De Chirico (as note 10). De Chirico's reference to Nietzsche's definition of the Dionysian principle in *Die Geburt der Tragödie (The Birth of Tragedy)* is obvious – as is his subsequent reference to Apollo.
14 De Chirico (as note 10).
15 In his article, 'The Douanier' (*Soirées de Paris*, 15 January 1914), Apollinaire quotes Arsène Alexandre's: 'If he had possessed what he totally lacked – technical knowledge – and, at the same time, had been able to preserve this freshness of conception, Rousseau would be the Paolo Uccello of our century.' (*Comoedia*, 3 April 1909).
16 Werner Haftmann, *Malerei im 20. Jahrhundert*, Munich, 1954; Engl., *Painting in the Twentieth Century*, trans. Ralph Manheim, London, 1960, 1967, p.170. (Haftmann here and on p. 170 refers simultaneously to Kandinsky's 'Great Realism' and to Rousseau as revealing a new aspect of reality – 'the fantastic in the hardest matter'.)
17 Ardengo Soffici, 'De Chirico e Savinio', *Lacerba*, 1 July 1914.

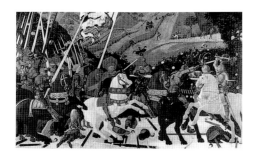

Fig. 6 Paolo Uccello, *The Battle of San Romano*,
c. 1435/36. National Gallery, London

ally a battle for perspective (Fig. 6). In order to win it, Uccello had to simplify his forms –
often virtually reducing them to cuboids – and to geometricise his backgrounds. His
three paintings of the *Battle of San Romano* allow us to grasp what an enormous step for-
ward in European intellectual history was taken with the adoption of centralised per-
spective.

De Chirico attempts to put Uccello's achievement into reverse. Not that he wants to
abandon perspective on principle; he simply intends to question its absolute, binding va-
lidity. De Chirico has found a way to combine, juxtapose and contrast multiple perspect-
ives that are really no more than fragments of perspectives. With Uccello, the imposition
of perspective gives the objects a concentrated, even ponderous, corporeal bulk; with de
Chirico, they lose their volume and shrink into two dimensions, like stage flats. His ob-
jects seem to cling to conventional perspective as if they would be lost without it.

By incorporating his objects into a system of perspective, Uccello lends them bodily pres-
ence, but he also deprives them of some of their reality as signs. They have turned into
the recessive, fugitive phenomena of an empirical world. Perspective not only ties them
into the anthropocentric dimension of space; it also immerses them in the flow of time.
De Chirico subverts their volume and thereby restores their identity as signs. He liber-
ates objects from the context of transience and releases them into timelessness.

V

When we speak of the importance of the dream to the artists of Surrealism, we must also
discuss the influence of Sigmund Freud, of his methods of dream interpretation, and of
psychoanalysis itself. It is curious that in Paris in March 1919, the group of French poets
and intellectuals associated with the newly founded magazine *Littérature* – among them
Breton, Aragon and Philippe Soupault, but also Paul Eluard, Raymond Radiguet and
Raymond Roussel – found themselves almost simultaneously within the ambit of two
'magnetic fields':[18] that of de Chirico and that of Freud.

It was Breton, above all, who was looking for a new orientation. Until 1921 or so he re-
mained committed to the spirit of Dada; but his increasing disaffection found an outlet in
a number of disagreements with Tristan Tzara and Francis Picabia. This phase, in which
the ideas of Surrealism gradually crystallised from the 'dialectical transformation' of
their Dadaist origins, has been dubbed the *Epoque floue*, the 'Period of Fluidity'. It included
a phase known as the 'Season of Slumbers' *(Saison des sommeils)*, in 1922–23; based on
the theme of sleep and dreaming, this was dominated by Freud's theories. For some of
the artists who were soon to regard themselves as Surrealists, those theories were of the
utmost significance. Breton, who had once studied medicine for a few semesters, visited
Freud in Vienna in 1921; Dalí, who wanted to make artistic use of paranoia, visited him
in London in 1938. On both occasions, Freud felt that he had been totally misunderstood;
and he himself understood very little about Surrealism. A clear case of mutual misunder-
standing, then; but for the Surrealists the misunderstanding turned out to be a highly
fruitful one.

18 See André Breton and Philippe Soupault, *Les
Champs magnétiques*, Paris, 1920, 1968.

Breton's reading of Freud confirmed him in his conviction that the 'rational approach to the irrational'[19] would inevitably lead to deeper insights and to fuller knowledge than any anarchic divagations in the Dada style. For Breton and his friends, the practice of psychoanalysis, which for Freud was a therapeutic measure, became an end in itself. Freud's method of free association, which he employed to allow his patients to bring repressions into consciousness and thus resolve their complexes, was used by the future Surrealists as a means of bringing out surprising images from the unconscious, and of associating them in shocking ways. However, their supreme source of such images was the dream. They set out to exploit this systematically, while avoiding the intervention of rational control.

Many dream records, hallucinatory word-chains and pieces of automatic writing, actually or allegedly composed in this way, found their way into the pages of *Littérature*. Among their authors were Breton, Soupault, Louis Aragon, René Crevel, Robert Desnos, Benjamin Péret, Jacques Rigaut, Raoul Vitrac and Jean Paulhan. Aragon was later to epitomise the atmosphere of their creation and their results in his poetic book *Une vague de rêves* (1924). When Breton (who had been calling himself and his friends Surrealists since 1922) first came to define Surrealism, these experiences led him to insist on two points above all: psychic automatism and the corresponding consciousness of the dream state. Both are reflected in his 'encyclopaedic' definition of Surrealism for the first Surrealist Manifesto of 1924.[20]

VI

Legends cling to the moment of the Surrealists' first encounter with paintings by de Chirico. Independently, Breton and Yves Tanguy have told of riding on the rear platform of a bus along Rue La Boëtie, seeing a painting by de Chirico in a gallery window and jumping straight off the bus to take a closer look. The painting in question was *Le Cerveau de l'enfant (The Child's Brain)*, of 1914 (Fig. 7). Ernst, who had first discovered de Chirico's paintings as reproductions in the periodical *Valori Plastici*, transferred de Chirico's dreaming father figure from *Le Cerveau de l'enfant* into a dream of his own. In his painting *Pietà or Revolution by Night*, of 1923, the dreaming father is carrying a statuette or doll-like figurine of a youth, who gazes out into the world with eyes wide open (Fig. 8). This has the effect of a manifesto in pictorial form. The Surrealists dream with their eyes open, in full consciousness. Dreaming and waking, for them, are a perfectly natural combination.[21]

The 'dialectical transformation' of Dada into Surrealism, which was largely Breton's doing, was paralleled in the artistic transformation that took place in the work of Ernst, notably in the oil paintings of the years 1921–24, which are often described as proto-Surrealist. *Pietà or Revolution by Night* (1923) is an outstanding instance of this. In it, Ernst took over elements of de Chirico's painting – the spatial stage and such iconographical details as the tailor's dummy – and used them in the collage spirit of Dada, capturing the 'spark of poetry' that cast a flash of illumination on the coming art of Surrealism.

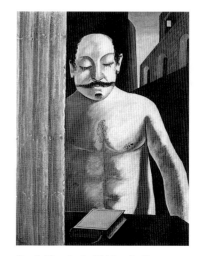

Fig. 7 Giorgio de Chirico, *Le Cerveau de l'enfant* (The Child's Brain), 1914. Moderna Museet, Stockholm

19 William S. Rubin, *Dada and Surrealist Art*, New York, 1968.

20 'SURREALISM, noun. Pure psychic automatism by which it is intended to express, either verbally or in writing, the true function of thought. Thought dictated in the absence of all control exerted by reason, and outside all aesthetic or moral preoccupations. *Encyl. phil.* Surrealism is based on the belief in the superior reality of certain forms of association heretofore neglected, in the omnipotence of the dream, and in the disinterested play of thought. It leads to the permanent destruction of all other psychic mechanisms and to its substitution for them in the solution of the principal problems of life.'
André Breton, First Surrealist Manifesto, 1924.

21 All his life, Ernst was to remember his first encounter with the paintings of de Chirico, which he associated with a *déjà-vu* experience and with the world of dreams. He wrote: 'I had the feeling of rediscovering something that had long been familiar to me, as when an event that has already taken place opens up to us a whole region of our own dream world that some kind of self-censorship has prevented us from seeing or understanding.'

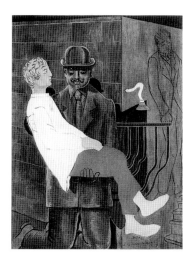

Fig. 8 Max Ernst, *Pietà ou la révolution la nuit* (Pietà or Revolution by Night), 1923. The Tate Gallery, London

Not content with incorporating elements of de Chirico's imagery, Ernst then radically transformed them. What was petrified and immobile in de Chirico awakes to new – if somnambulistic – life in the work of Ernst. Where de Chirico imposes a sense of claustrophobic enclosure, Ernst shows attempts to break out. Walls are breached, or else sloughed off like used wrapping. Ernst counters de Chirico's passivity with Surrealist rebellion. He shares with de Chirico an existential awareness of the discontinuity of the modern world. However, whereas de Chirico manifests this discontinuity primarily through content, Ernst incorporates it in the things he does to his materials: in the acts of cutting, fragmenting, masking, mutilating, overpainting, and in the techniques of process-work and paste-up, collage and photomontage, frottage and grattage. Discontinuity is present not only in his handling of material but also in his disruption of the normally unreflective interaction between rationality and craft skill. Ernst dramatises the divorce between rebellious consciousness and well-drilled hand – but also the revolt of the executant hand against the over-calculating head.

There is one more artistic preoccupation that de Chirico shares with Ernst. De Chirico's delight in covering his tracks –especially as to the origins and significance of the outlandish objects in his theatre of silence – was also basic to the work of Ernst, in whom it was perfectly developed from an early date. Werner Spies, who has traced the genesis of Ernst's collages with criminological acuity, rightly likens their making to the 'perfect crime' that leaves no clues behind.[22] Like the mediaeval painter who eliminated every sign of individuality in his brushwork to leave the painted surface homogeneous and anonymous, Ernst took care, from the early lithographs of the portfolio *Fiat modes, pereat ars* (1919) onwards, and from his earliest block prints, overpaintings and collages, to remove every trace of the working process and to conceal his own interference with the given material, his manual alterations and additions. His exploration of artistic techniques – collage and frottage, decalcomania and drip painting – gave him methods of wresting secrets from nature. His whole iconography, with all its weird, hybrid creatures and its vegetative growths, derives from his techniques. These indirect, instinctive methods, with their capacity to strike intuitive sparks, are not precisely what Breton had in mind when he spoke of 'automatic writing': rather, they are semi-automatic, semi-mechanical procedures, in which the encounter with pre-existent material sparks an imaginative impulse which is then subject to the ultimate control of an enquiring consciousness.

VII

In discussing Rousseau, de Chirico and Ernst, we have outlined one fundamental position that can serve as a vantage point for surveying the paths followed by other major artists, both inside and outside Surrealism. This line of sight will also reveal the kinship that links the artists of the so-called 'veristic' wing of Surrealism (Dalí, Magritte) with those of the 'abstract' wing (Masson, Joan Miró) – and also with the path followed, independently of Surrealism, by such artists as Marc Chagall and Paul Klee: Chagall, who

22 Werner Spies, *Max Ernst – Collagen. Inventar und Widerspruch,* Cologne, 1974.

was poles apart from Breton, and Klee, who came into occasional and peripheral contact with him.

The shared elements include not only an interest in dreams and a receptiveness to a magically attuned experience of reality, but also a number of borderline experiences connected with modern art's quest for the primal and the authentic. This Surrealist fascination with art's supposedly primordial and therefore exemplary sources – such as children's drawings, the 'artistry of the mentally ill', the art of 'primitives', sculptures from Africa – was shared by a number of other artists whose concerns were closer to visible reality, and whom we find either straining that reality in formal terms or charging it with expression. Thus, the pictorial world of mental patients and the drawings of children were a source of inspiration to Klee; children's drawings were also a stimulus to Tanguy (in his early work) and to Miró (almost throughout his life); and Alberto Giacometti was closely involved with 'primitivism' during his period as a member of the Surrealist group in the early 1930s.

Giacometti offers an interesting case in point: during his early Paris years, in his desperate efforts to attain a 'likeness' (an extremely complex concept in his case), he had come close to Cubist stylistic devices. It was at this time that he took a keen interest in African sculpture.[23] Now that he had entered the Surrealist sphere of influence, he became increasingly interested in masks and totems from Oceania, which were always of particular importance to Breton and the Surrealists. Whereas African sculpture was predominantly form-defined, Oceanic artifacts spoke of a magical experience of the world. The Surrealists increasingly directed Giacometti's interest towards the fetishistic quality of sculptural objects. Under their spell, he reflected that it ought to be possible to capture the totality of life even without direct reference to visual appearances – that is, without external 'likeness', in images that were parables and ciphers. And so he set out to encompass the dramas of the human psyche – with its components of Eros, aggression and violence – in a simple and effective language of metaphor. In these sculptural works of the years 1931–34, Giacometti found access to a new dimension of human existence: the realm of dreams, of instincts, of secret fixations and repressed desires (Cat. 350). If any 'likeness' remained in these works, it belonged in the realm of the emotions – in the way in which an encounter with a work of art could unleash processes in the psyche like those generated by an intimate encounter with another human being. It was not long, however, before Giacometti began to doubt whether this path could ever truly satisfy his aspiration to a perfect 'likeness', and he reverted to working with a live model.

VIII

Paintings by Miró were included in the first exhibition of Surrealist art, at the Galerie Pierre in Paris in 1925. Miró's 'official' declaration of allegiance to Surrealism meant a great deal to the group at that time. Alongside the collages and paintings of Ernst, it was Miró's paintings of 1924–25 that finally confirmed Breton in his view – a view that had previously fallen rather short of total conviction – that Surrealism could take objective

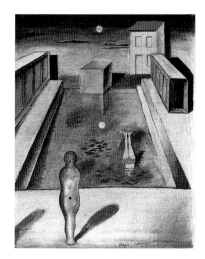

Fig. 9 Max Ernst, *Aquis submersus*, 1919.
Städelsches Kunstinstitut, Frankfurt a. M.

23 As early as 1915, Carl Einstein had remarked on their closeness to the formal universe of Cubism: Einstein, *Negerplastik*, Leipzig, 1915.
24 André Breton, *Le Surréalisme et la peinture*, 3rd expanded ed., Paris, 1965.
25 On the contrary, as Jacques Dupin remarks in his big Miró monograph, this was the painstaking reconquest of abilities lost since childhood. Jacques Dupin, *Joan Miró. Life and Work*, trans. Norbert Guterman, London, 1962.

Fig. 10 Alexander Kanoldt, *Still Life I*, 1924. Private collection

Fig. 11 Joan Miró, *Still Life with Rabbit (The Table)*, 1920. Collection of Gustav Zumsteg

form in painting just as well as in literature. 'Miró's sensational adhesion to the group in 1924', wrote Breton, 'was an important date in the evolution of Surrealist art … Miró might become the most thoroughgoing Surrealist of us all.'[24] The two men remained life-long friends, although on one occasion – surprisingly, if we reflect on what he wrote about childhood in his First Manifesto – Breton did criticise Miró for 'a certain arrested development of the personality in the stage of childhood'.[25]

It is customary, these days, to regard Miró as a Surrealist only after he became a member of the group, and to dismiss the interiors and landscapes of his native Catalonia, which he painted between 1918 and 1924, as 'poetic realism' – or else to regard them as a pendant to the 'Magic Realism' that was then emerging in many European countries, most notably Italy and Germany. However, although this early work of Miró's manifestly derives its style from Cubism, its imagery is proto-Surrealist in many ways – and thus poles apart from the aims of the 'Magic Realists'.[26]

Not for nothing was de Chirico – that creator of petrified worlds – a hero to the 'Magic Realists'. They could become his successors in a far more literal sense than the Surrealists ever could: as witness Ernst's radical reinterpretation of de Chirico's lifeless piazzas in such works as *Aquis submersus* of 1919 (Fig. 9), in which he peoples them with a fantastic fauna and with sleepwalking humans. The early, representational work of Miró is another case in point. Where a 'Magic Realist' like Alexander Kanoldt, in his Olevano paintings of the 1920s, shows us the natural setting of an ancient Italian hill town, frozen in stone, tucked into the rigid formations of a mountain range, Miró's contemporaneous paintings, such as *The Farm* (1921–22), show us nature in full bloom and richly fruitful. The difference is even more apparent if we compare one of Kanoldt's still lifes with Miró's *Still-Life with Rabbit (The Table)* of 1920 (Figs. 10 and 11). While Kanoldt's interior seems deep-frozen, as if that were its only hope of eternity, Miró's painting belies the label of still life (*nature morte*, 'dead nature') altogether. Everything here is fizzing with vitality. The rabbit and the cock clearly have no intention of ending up as roasts. They

26 Basing myself on Franz Roh's famous tabular exposition of the differences between Expressionism and Magic Realism (or 'Neo-Expressionism'), I have attempted to contrast the characteristics of *Neue Sachlichkeit* or Magic Realism with those of Surrealism. See Wieland Schmied, 'Zwischen Surrealismus und Sachlichkeit', in *Edgar Ende. Der Maler geistiger Welten*, ed. Jörg Kirchbaum, Stuttgart, 1987 (see table opposite).

Magic Realism	Surrealism
favours the inanimate	the living
inorganic	organic
petrified	vegetative, growing
static, petrified	dynamic (but not expressive)
crystalline, crystallising	blossoming – bleeding
restraint	savagery
stillness	turbulence, eruption
tightness	looseness
logic	alogic; abrogation of rational control, causality and natural laws
order	chaos
singling out	complexity
dividing, isolating	blending, self-identifying
locking, wrapping	opening
self-defence	attack
protecting self from pain	inflicting and accepting pain
tabooing	liberation, unfettering

cavort on the table top, and the table itself is not cut off from the earth but sends down roots as if it were still a tree in sap. The carpet underfoot could easily be interpreted as a ploughed field. However vast the apparent gap between Miró's early nature studies and his later abstract spaces peopled with animated signs, all derive from one and the same artistic attitude.

It was the encounter with paintings by Klee that confirmed Miró in his move towards a freer treatment of the elements of visible reality and encouraged him to embark on his animated interplay of abstracted forms. This adoption of Klee's imagery by a Surrealist proves that Klee's relationship with the Parisian group was by no means casual or super-ficial.[27] Far from it: the trains of thought that Breton and his friends were later to tie into labyrinthine knots had close counterparts in Klee's 'pictorial thinking'. Klee was among the most reflective of modernist artists. As early as 1908, he spoke of the 'primal territory [*Urgebiet*] of psychic improvisation', a concept that anticipates in many ways the notion of 'automatic writing' instrumentalised by Breton. However, though Klee analysed the elements of the artist's work and traced them back to fundamental impulses, he never lost sight of his objective, which was to combine them within a greater unity (Fig. 12). This vision of a new totality – which in later years came to resemble the *unio mystica* – first came to him on his legendary visit to Tunisia in 1914, when he stood 'before the gates of Kairouan' with his friends, August Macke and Louis Moilliet. It was then that he noted in his diary: 'Matter and dream at the same time, and as a third party, tucked well in, my own ego.' Nature, dream and ego blended and allied themselves with the artist's technical resources: 'Colour has me. That fortunate hour means this: I and colour are one.'[28] From this, in the early 1920s, Klee developed the idea of a *Zwischenreich*, a 'Realm Between', in which his art took up residence, and in which he himself was at home – a notion strangely reminiscent of a word coined at about the same time by Rainer Maria Rilke, in his *Duino Elegies:* this was *Weltinnenraum*, 'Inner Cosmos'. Klee's 'Realm Between' also corresponds to the Surrealists' sense of being at home on a borderline – on the frontier between inward and outward, unconscious and conscious, dream and wak-ing – which they could cross at will; though Klee, even more than the Surrealists, was concerned to join the two worlds in harmony.[29] The *Zwischenreich* concept made its first appearance in Klee's drawing of 1921, *Town in the Realm Between*, and was then ex-pounded to the students of the Bauhaus in lectures in the winter semester of 1921–22. In an extended studio conversation with his colleague Lothar Schreyer, Klee summarised what he associated with the word:

> I often say … that we have worlds which have opened and are still opening to us, worlds which do belong to nature, but into which not all human beings can look: perhaps only artists, lunatics, primitives can do so. By this I mean, for instance, the realm of the unborn and of the dead – the realm of what may come, would like to come, but is not necessarily going to come. A world between. Between for me, at least. I call it 'between', because I sense its presence in between those worlds that are perceptible to our outward senses, and because I can apprehend it inwardly, in such a way as to project it outward through analogies. It is a world into which children, lunatics and primitives can still (or once more) see … I shall probably never get any further than this world between. Nor is it anything like so wonderful – let alone sublime – as it seems. There is often some-thing rather puckish about it. It often feels as if I am not really taken seriously when I go there, but treated as a figure of fun.[30]

Fig. 12 Paul Klee, *Villa R*, 1919. Öffentliche Kunstsammlung, Kunstmuseum Basel

27 Klee had been included in the *Anthologie Dada* as early as 1919. In 1925 he had his first Paris one-man show in the Galerie Vavin-Raspail. In 1929 Georges Limbour, a friend of Georges Bataille and of Michel Leiris, included Klee's work in the first issue of *Documents.*

28 *Paul Klee. Tagebücher*, ed. Felix Klee, Cologne, 1957; Engl., *The Diaries of Paul Klee, 1898–1918*, Berkeley and Los Angeles, 1964.

29 Carl Einstein, *Die Kunst des 20. Jahrhunderts*, 3rd ed., Berlin, 1931, links Klee's painting both with dream and with myth: 'For Klee, the aim is to fit fig-ures and objects into reality; the meaning of myth is no longer the preservation of the past but the revolt against present fact.' Again: 'In Klee's miniatures we see the return of the dream demons that revive in ancient forces and coalesce into powerful reality.'

30 Paul Klee, quoted from Ulrich Bischoff, *Paul Klee*, Munich, 1992.

IX

Fig. 13 René Magritte, *La reproduction interdite* (Not to be reproduced), 1937. Museum Boijmans Van Beuningen, Rotterdam

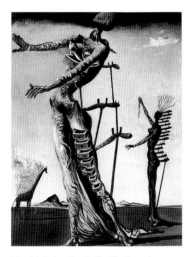

Fig. 14 Salvador Dalí, *Girafe en feu* (The Burning Giraffe), 1936–37. Kunstmuseum Basel

31 René Magritte, *Ecrits complets,* ed. André Blavier, Paris, 1979.

With his somnambulistic sureness of touch, de Chirico holds the balance between dream and clarity. René Magritte decisively tips the scales towards clarity; but with Dalí a perpetual state of agitation reduces all phenomena to chaos. With Dalí's 'paranoiac-critical' method, it is hard to say whether the triumph belongs to paranoia or to its critical application. Early in their careers, both Magritte and Dalí were avowedly impressed by de Chirico. For Magritte, his encounter with a de Chirico reproduction in 1923 (the painting was *Chant d'amour,* of 1914) was decisive. It was, he said, the first time he had ever been able to see thought. His concern thereafter was with the definition of that thought, and its appropriate visualisation in painting. 'My painting is the antithesis of the dream, since the dream is not as significant as it is made out to be,' said Magritte. 'I can work only in clarity.' And elsewhere: 'Dreams are an easily forgotten infirmity of thought.'[31]

Magritte's paintings reveal no wilful indulgence in free association, no flights of fancy. Their effects are sparingly placed and well calculated (Fig. 13). A mind is at work that seeks to reason dispassionately in the presence of the unexpected, the alarming, the absurd. For Magritte's topsy-turvy world is seen through the eyes of a man for whom the laws of logic still unquestionably hold good – the eyes, if you will, of a pedantic bourgeois who left his Brussels flat only with great reluctance to walk his dog, and who felt at ease only in a group of intimate friends.

In Magritte's paintings a fault-line runs through the visible world. There is something amiss with it: although it seems to have kept its coherence, it has been interfered with. This interference – often an apparently trivial alteration – radically changes the atmosphere, so that the familiar appears strange, the accustomed appears weird, the sane appears mad. We feel a shock of alarm, without ever knowing precisely where it comes from.

Dalí also means to shock. But for him, unlike Magritte, shock is an end in itself. Magritte aims to identify the inward affinities – or, as he liked to say, the similarity – between seemingly disparate objects, and thus to uncover a secret order within the world. Dalí's aim is the antithesis of this. The things that he shows are arbitrarily combined; they yield no meaning and will never bond with each other. Magritte (like the Romantics) poeticises reality; Dalí denounces it.

Dalí's 'paranoia' was never a pretence, though it was deliberately provoked, carefully nurtured and precisely controlled. He made systematic use of madness as a method of cracking the safe-deposits of the unconscious and laying hands on the treasures within. Those treasures were none other than his own perversions – which he spread out for our delectation as if laying tables for a banquet (Fig. 14). In his paintings, Dalí invariably set out to obscure obvious meanings and, where possible, to transform them into their opposites. At the same time, he sought to pack as much meaning as possible into his paintings – even though he himself claimed not to know what that meaning was.

Magritte set out to perfect an 'anonymous' technique, with no striving for effect. It was entirely subordinated to the visible presentation of the matter in hand. Dalí's painting, by

contrast, was precious, finicky, all for effect. In an age dominated by the avant-garde, its Old-Master pose inevitably seemed eccentric. Magritte's paintings are almost always economically staged and focussed on a single motif, from which nothing is allowed to distract us. Dalí's pictures are often overelaborate and glitter with a hundred distractions. And yet, different though Magritte and Dalí were, both have left us an array of fascinating works that draw us back under their spell, even after we think we have finally deciphered their inner workings.

The same applies to the imagery of the early Chagall. He is another special case, even among the individualists of the School of Paris. Though a dreamer, he always stood aloof from the Surrealist circle. *Astonishment* is the word for our response to Magritte, and shock for Dalí; but the paintings of Chagall generate *enchantment*.

Chagall is the great poet among twentieth-century artists. In his eyes, the world transforms itself into a land of legend, where magical things happen, dreams come true, and the marvellous is everyday. The figures he shows us – the fiddler on the roof, the animals in the ploughed field or on the meadow, the milkmaid with the cow, the Rabbi with the Torah scroll, the dancers at the wedding – have all overcome gravity. Barriers between near and far have been abolished; distinctions of great and small, inside and outside, waking and dreaming, are of no account. Houses do headstands, objects awake to a strange life of their own, human figures soar over the sky – and yet everything seems to be quite orderly and in its proper place.

Chagall moved to Paris from St Petersburg as a twenty-three-year-old art student in 1906. He rapidly absorbed the achievements of the avant-garde, and transmuted them into dream and fairytale a good ten years before the Surrealists first came on the scene (Fig. 15). He eagerly grasped the freedom that Cubism had obtained in dealing with the forms of the visible world, and used it to breathe life into all objects and to give them freedom of movement in space. The freedom achieved by the Fauves and Expressionists in dealing with colour emboldened him to let colours tell their own stories, and to infuse them with a magical intensity (Cat. 340). These colours hold his compositions together and unify his numerous pictorial anecdotes. In Chagall, everything we perceive as pure and childlike springs from an authentic, primal artistic instinct. In him, unfeigned naïvety and refined ingenuity are inseparable.

X

If we assign Giorgio Morandi to the path that begins with Rousseau and de Chirico, we can do so only with certain reservations. Of course, it is relevant that in his youth Morandi owed allegiance to Metaphysical Painting for a couple of years (1918–20); but that brief period would not suffice to qualify him if we thought he had pursued other basic goals in his later work. We do not entirely share the view held by some Italian critics, that Morandi always – at least in a sense – remained faithful to the spirit of Metaphysical Painting; but it is clear that he never became a realist plain and simple, whether in still life or in landscape.

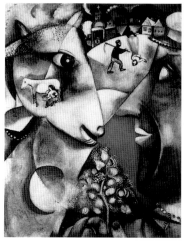

Fig. 15 Marc Chagall, *Moi et le village* (I and the Village), 1911. The Museum of Modern Art, New York

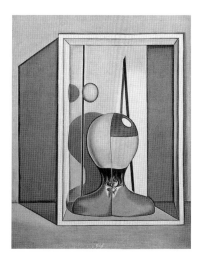

Fig. 16 Giorgio Morandi, *Natura morta*
(Still Life), 1918. The Hermitage, St. Petersburg

Fig. 17 Edward Hopper, *Lighthouse Hill*, 1927.
Dallas Museum of Fine Arts

32 For instance, Jim Dine says in an interview:
'I love the eccentric paintings of Edward Hopper.
That excites me more than Magritte's Surrealist
paintings. He is like a Pop artist.' *Jim Dine, Graphik*,
exh. cat., Hanover, Kestner-Gesellschaft, 1970.

There was always more to separate Morandi and de Chirico than to unite them. De Chirico came from Arnold Böcklin; Morandi came from Cézanne. Morandi had even less in common with Carrà. Despite repeated critical assertions to the contrary, Morandi had no interest in the 'solidity of objects', which Carrà had called for painters to reclaim as a part of Italian tradition. Without ever outwardly tampering with his objects, Morandi dissolved and abolished their solidity – though in a very different way from de Chirico, who deprived them of bodily presence by subverting perspective.

In 1918, however, when Morandi first came under the influence of Metaphysical Painting, he ceased to view objects through the eyes of Cézanne and learned a new way of seeing. The device of the 'multiple contour', as used by Cézanne, served to keep the outlines of an object open and to tie it into a unity with the surrounding space; under the influence of de Chirico and Carrà –from whom his principal iconographic borrowings were busts and tailor's dummies – Morandi learned anew to outline his objects unambiguously and precisely (Fig. 16). Later, when he set out once more to tie his objects into the space, and even to make them dissolve into it, the method he adopted was not Cézanne's colour modulation or de Chirico's 'reverse' perspective: it was light. No artist in our century has used light more subtly. Morandi paints light not on but in his objects. Light has entered the objects, has blended with them, and has been absorbed by their dusty surfaces; there is no longer any distinction between the objects and the space around them.

Like Morandi, Edward Hopper was initially influenced by Cézanne – as can be seen from the paintings he produced during his three spells in Paris (1906–07, 1909, 1910), as well as later on in New England. Many of the landscapes of those years are comparable in painterly terms to Morandi's. But, especially in the paintings of the 1920s and later, what fundamentally sets Hopper apart from Morandi is his handling of light. In Morandi we find harmony – indeed, unity – between light and the world. Light impregnates and saturates all the forms, blending with their material substance. In Hopper, by contrast, the separation between light and reality is never abolished. Light falls harshly on the objects and illuminates them, or leaves parts of them in shade. Light rebounds, is reflected, and often seems to slither down the objects as if it can find no firm hold. The light that reflects from the walls of the lighthouses in Maine, which Hopper painted between 1927 and 1929, has none of the warmth that Morandi infuses into his light. Looking at such a painting as *Lighthouse Hill*, of 1927 (Fig. 17), we seem to feel the cool, evening breeze as it comes off the ocean. This is a cold light. It reminds us of the light we remember from the 'Metaphysical' paintings of de Chirico – a light projected onto his spatial stage and its scenery from a multiplicity of invisible sources.

Hopper has translated the artificial world of Metaphysical Painting back into the real surroundings that he can see. He partakes of de Chirico's dream vision, but in the real world. The chill, the eerieness, remain. It is this sense of the slightly uncanny, the sense of not being at home in the world, that links him with the Magic Realists. The Pop artists sensed this, when they felt this element of weirdness more intensely in Hopper than in a Surrealist such as Magritte.[32]

Like Hopper, Balthus is an artist who offers plenty of scope for demarcation disputes. These began as early as 1934, when he showed paintings such as *The Street* (Fig. 18) at the Galerie Pierre in Paris, and there was fierce debate as to their closeness to or remoteness from those of the Surrealists. At all events, the Surrealists liked him – even though Balthus, with his aristocratic taste for 'splendid isolation', never belonged to their group. Not that this inhibited Marcel Jean from hailing in Balthus's paintings the same 'impulses of dream, fantasy and fairytale' as in those of many Surrealist artists, or indeed from including him in his history of Surrealist painting.[33]

Balthus had been introduced to the Galerie Pierre by Antonin Artaud, who wrote in the catalogue: 'Balthus primarily paints light and form. By way of light on a wall, on a polished floor, on a chair or on skin, he invites us to enter into the mystery of a human body.'[34] Balthus is indeed a master of subtle light effects and specular reflections. He loves to set lamplight against the sheen of a girl's skin, or the sparks from an open fire, or the flash of a cat's eyes. His paintings crackle with secret erotic obsessions. Oscillating between the chilly and the sultry, his interiors form an ideal sounding-board for the tensions of puberty. For Balthus almost always paints children and the young: growing girls and boys at the very moment when they discover, with a mixture of fascination and alarm, that a whole new world exists within them.[35]

XI

By the end of the 1930s, the initial impetus of Surrealism as a movement seemed to be exhausted, even though its major artists still held their course. Then came an infusion of new blood, in the shape of two artists from Latin America: Wifredo Lam and Matta. Lam brought with him the authentic image of the tropical rain forest, Matta a vision of technoid and biomorphic future worlds (Fig. 19).

During the Second World War – when Lam returned to Cuba for a while – Matta was in New York. There, alongside Ernst and Masson, he was one of those who transmitted the Surrealist inspiration to a new generation of American artists, among them Arshile Gorky and Jackson Pollock.[36] Gorky, one of the great tragic figures of recent American art, has been described as the 'Last Surrealist'; Pollock initiated a new Declaration of Independence on the part of American modernism. Breton's idea of 'automatic writing' now gave way to something entirely new: Action Painting. The focus changed, and the artists of the nascent New York School came to see the exiled Surrealists as heroes with 'feet of clay'. (In France, Wols, who took an analogous route to an *art autre*, retained very much more of the original Surrealist potential.)

In New York in the late 1940s, individual artists were assessed for progressiveness, and perhaps even for quality, on one criterion alone: had they or had they not set out on the royal road to abstraction? And yet such artists as Ernst and Matta – but also Masson and Tanguy, who had been so influential – defied all the trends of the moment by insisting that impulses based on form were not enough, and that the painting must be open to an objective reading while maintaining an open-ended associative field that would offer

Fig. 18 Balthus, *La Rue* (The Street), 1933–34. The Museum of Modern Art, New York

Fig. 19 Matta, *L'année 1944* (The Year 1944), 1942. Nationalgalerie, Staatliche Museen zu Berlin – Preußischer Kulturbesitz

33 Marcel Jean (with Arpad Mezei), *Histoire de la peinture surréaliste*, Paris, 1959; Engl., *The History of Surrealist Painting*, trans. Simon Watson Taylor, London and New York, 1960.
34 Antonin Artaud, in *Balthus,* exh. cat., Paris, Galerie Pierre, 1934.
35 Lindner is akin to Balthus in his fascination with eroticism à la Lolita, and with the world of adolescence. He too has a liking for toys and likes to paint young girls in such a way as to suggest that they are aware of their attractions and never want to grow up.
36 It would take a whole chapter to discuss the importance of myth to artists allied to Surrealism, such as Lam, Matta or Gorky, and to detail the role of myth in the work of such artists as Pollock, Mark Rothko or Barnett Newman, during the formative phase of the New York School in the early and mid 1940s, before the gods and heroes of classical antiquity eventually gave way to human-based myths of indigenous, i.e. Native American, origin.

Fig. 20 Richard Lindner, *The Meeting*, 1953. The Museum of Modern Art, New York

Fig. 21 Konrad Klapheck, *Der Krieg* (War), 1965. Kunstsammlung Nordrhein-Westfalen, Düsseldorf

Fig. 22 Domenico Gnoli, *Giro di collo 15 1/2* (Shirt Collar 15 1/2), 1966. Courtesy Jan Krugier Gallery, New York

37 Werner Spies, *Max Ernst 1950–1970. Die Rückkehr der schönen Gärtnerin*, Cologne, 1971.
38 Breton (as note 25).

multiple possibilities of interpretation. Ernst spoke of his 'absolute refusal to live like a tachiste, and held on to his 'compulsion to interpret',[37] to which he subordinated all forms, however spontaneously generated. Matta led the viewer ever deeper into the spaces of an absurd, deranged universe where technoid beings engaged in a science-fiction battle against biomorphic forces. In Masson landscapes were agitated in abyssal depths, and in Tanguy they were frozen into bizarre configurations (Cat. 355–357).

In the first third of this century, Metaphysical Painting, Surrealism and to some extent Magic Realism, in its diverse national variants, provided a shared orientation for all the artists discussed in this chapter. No such common points of reference existed after the Second World War. It is therefore understandable that the works of this period collected for this exhibition look even more disparate than those of the period before. The Second World War represented a profound discontinuity in the art of modernism as a whole; and particularly so in the evolutionary strand outlined here. In the postwar world there emerged a number of such phenomena as Neo-Dada, Neo-Expressionism and Neo-Constructivism (many of them in a succession of variants); but there was no such thing as Neo-Surrealism. And yet the feeling that had once sustained the art of Surrealism, as it did that of Magic Realism, was not quite dead yet.

In New York in the early 1950s, Richard Lindner seemed to be invoking the terrors and temptations of his European youth and trying to carry Magic Realism onto a new and higher plane (Fig. 20). In Germany, Konrad Klapheck found himself in a magical encounter with the world of technology. Just as Douanier Rousseau had discovered a virtual jungle in the Paris botanical gardens, Klapheck identified the machine as the mirror image of the new human being (Fig. 21). Klapheck was the youngest of the artists whose names adorned Breton's reissued anthology, *Le Surréalisme et la peinture*[38] – as if, after Gorky, the 'Last Surrealist', there had been room for just one more. In Italy, some of the ideas of Metaphysical Painting enjoyed a revival in the work of Domenico Gnoli. Here, once more, objects – as eerie as ever – seem to be trying to assert their solidity; and once more, we see how this solidity slips away as the artist inexorably identifies their surface with the surface of the painting (Fig. 22).

Magic Realism in the age of Pop art: Klapheck paints machines, utensils, apparatus; Gnoli paints furniture, garments, interiors. In both, the absent human being is an eerie presence.

XII

The ancient Greeks, Nietzsche thought, had two gods to stand for the origins of art: Apollo and Dionysus. For art springs from two elemental forces: dream and ecstasy. Apollo stands for the illusory worlds of the dream; Dionysus for the play with ecstasy. Both Apollonian dream and Dionysian ecstasy have their roots in the age of myth. But, as Nietzsche points out, the age of myth is past. Ancient myth is dead, killed by the triumph of rationality and moralism that began with Socrates. Socratic aestheticism, to which Euripides was already in thrall, not only put an end to Greek tragedy but extinguished the

power of myth. There is just one way in which this can be brought back to life: through the work of a great artist. Such was the well-nigh desperate hope which Nietzsche vested for a time in Richard Wagner – and which was to find eventual fulfilment in his own creation, Zarathustra. In an age of nihilism, myth can be resurrected only through art – on new terms, as an individual achievement. Myth has its roots in the creative potential that spans the ages to link the artist with the ancient roots of dream and ecstasy. Myth can spring to life only in our subjective interpretation of the specific work of art. And, in the age of modernism, myth can appear only in the guise of 'individual mythologies': Harald Szeemann's chosen theme for the *documenta 5* exhibition in Kassel in 1972.

Examples of such individual invocations and recreations of myth abound long before the art of the 1960s and 1970s, to which Szeemann was referring. Henry Moore's figures of the early 1950s, such as *King and Queen* (Fig. 23), invoke an alternative image of antiquity: they seem to spring from a Celtic spirit and reflect –as a retarding element on the way to some Great Abstraction – the epoch of Stonehenge. Similarly, the horrific monsters that Germaine Richier showed us in postwar Paris – those bugbears of an Existentialism carried to its extreme – are attempts to erect a modern mythology in opposition to ancient myth and its gods.

Jannis Kounellis relates to myth on a far more basic level. Like de Chirico, he grew up in Greece and later settled in Rome. It may be that this deep grounding in the Mediterranean world has given Kounellis access to the elemental forces of nature, the mastering of which is the recurrent theme of classical myth. 'Access' here means two things: reflective understanding and the ability to incorporate them directly in his work. Not only is Kounellis a deep thinker: he has the ability, shared by few artists of his generation, to make the material speak, and to make it convey utterances of elemental power.

Of the four elements, the most important to Kounellis is fire. He uses it directly, as a flame (Fig. 24) – candle, miner's lamp, propane jet – or else introduces it on a virtual level as a pile of coal, tipped from coal sacks or held in black steel frames (Cat. 300). What infinite resources of Promethean fire we possess! Often, Kounellis contrasts fire with water, the element whose ubiquitous presence he suggests by introducing fragments of boats: hulks, a keel, an oar.

Kounellis is always creating utopian – we might also say mythical – space. He begins by setting this apart from real space. Wherever we see him setting up an environment, or creating an installation, he shuts doors; he drapes, blocks, barricades windows; he builds walls; he stacks, layers, piles up materials, sacks, stones, baulks of timber, steel plates, slate fragments, to generate a different space, a kind of sacred precinct. Into this space he first put fragments of memory: plaster casts of antique heads and busts, sawn, chipped, coloured fragments; and their fragmentary quality evokes a resonance, allowing us to pick up an echo of a lost world. Later, Kounellis goes beyond fragments and resorts to elementary materials that have never yet been formed into objects; and to these he restores the dignity of the absolute beginning.[39] We can start to build the world. Utopia and myth are one.

Fig. 23 Henry Moore, *King and Queen*, 1952–53. Glenkiln Farm Estate, Dumfries, Scotland

Fig. 24 Jannis Kounellis, *Untitled*, 1967. Private collection, Rome

39 The literature on Kounellis contains several references to the way in which his materials supposedly undergo a metamorphosis. Even if they do, however, they are not transformed into another material; nor do they take on the character of objects. What can happen is that they change their aggregate state and manifest themselves as ciphers; ciphers of an elemental, mythical world.

Fig. 25 Cy Twombly, *Untitled*, 1963.
The Menil Collection, Houston

Like Kounellis, Cy Twombly is central to the revival of the mythic dimension in contemporary art. Twombly has often stressed that, as a Southerner (born in Lexington, Virginia, in 1928), he has a natural affinity for the cultures of the Mediterranean. In 1952, his very first foreign study trip, with Robert Rauschenberg, took him to Italy and North Africa. In 1959 he settled permanently in Rome. Perhaps even more important than his life in a Mediterranean setting was his contact with the world of myth: the epics of Homer and Virgil, the poems of Sappho, the ideas of Heraclitus – and also the poetry of a remote posterity, John Keats and C. P. Cavafy. He wanted to keep their spirit present in his work, and so he wrote their names – like appeals, like ideographic invocations – into his paintings (Fig. 25). Twombly's script is not 'automatic writing' in the strict sense of the term; it combines spontaneous impulses with a high level of conscious control. The scrawl inspired by children's art is an instrument created by Twombly to give letters an autonomous pictorial existence – as with the words in the abstract paintings of Miró, or the letters and hieroglyphs in Klee.

Twombly translates myth into a modern pictographic script that is resistant, like the Delphic oracle, to any literal interpretation. The word 'translate' here has both a literal and a metaphorical sense. First of all, translation was important to Twombly, in that the Greek and Latin writers were accessible to him only in English translations. As Kirk Varnedoe stresses, he has often approached classical civilisation through the imaginations of mediators,[40] among them Nicolas Poussin in painting and Alexander Pope in poetry. Twombly loved Pope's translation of the *Iliad* for its pounding energy and its driving impetus. But translation, to Twombly, was far more than an opening for interpretation and appropriation – even though he found in the imaginations of his mediators a medium whereby he could penetrate into the spirit of his texts. His reading of the great epics evoked images which he then translated into visual ciphers, gestures, strokes, blots, graffiti and scrawls –shorthand signs for a succession of psychic moods and tensions: nervous stress, unrest, drivenness, but also endurance and serenity. To Twombly, the word 'translation' also has its etymological meaning of bringing across: the crossing of the waters known to the Greeks as the Styx; the transition from the realm of the dead into that of the living and back again to the dead, which is the major theme of the mural paintings in Egyptian tombs. In many of Twombly's paintings of 1992–94 we find the motif of a boat destined for a mysterious voyage.

From the outset of his career, Anselm Kiefer, too, delved deeply into the world of myth and history. Initially it was the world of Teutonic legends, such as the Nibelung Saga, and their counterpart, in our own profane times, in an unholy and fateful Twilight of the Gods. Later, Kiefer expanded his mythical horizons to include Mesopotamian, Egyptian and Jewish traditions, Gnosticism and the Cabbala. Concurrently, he expanded beyond easel painting into large, three-dimensional installations.

Kiefer's work offers a wealth of meaning, allusion, association and reference that is rare in contemporary art. Conceptually and visually, he sets out to load his paintings to the limit with meaning. He seeks to counterpoise his own ponderings, his trains of thought,

40 Kirk Varnedoe, *Cy Twombly. A Retrospective,* exh. cat., New York, The Museum of Modern Art, 1994.

his dreams, with paint, sand, wood, lead. The techniques and materials themselves must also hold a balance: photography against painting, collage against assemblage, inserted script against added objects and other materials. Perspectival space and associative space, landscape and history, nature and myth, reality as quotation and reality as invocation: all these must match and chime (Fig. 26).

Jason quests for the Golden Fleece, Parsifal for the Holy Grail, Gilgamesh for eternal life. Kiefer quotes all these in his paintings, because he feels a kinship with all legendary and historical seekers after meaning – whether they ever attained their goal or not. Perhaps he does have something in common with the alchemists, to whom he has so often been likened. They realised that to make gold they must start at the bottom end of creation, with the basest matter, with mercury and lead; and in the same way Kiefer deliberately adopts the most banal materials, the most ordinary objects, the simplest images, in order to express the remote and the sublime. In all his endeavours, Kiefer – again like the alchemists – is trying do something more than manipulate emblems and symbols. His concern is with reality. In all that they did, the alchemists were really secret seekers after God (which is why they never attained their goal in any concrete sense). In the same way, Kiefer, in showing us fragments of myth, is concerned with what is self-evidently not there.

Fig. 26 Anselm Kiefer, *Resurrexit*, 1973. Sanders Collection, Amsterdam

XIII

Despite appearances to the contrary, Jeff Wall's works are quite as complex as Kiefer's. They have been described as 'light-box pictures' and – better still – as 'photographic paintings'. Their simplicity is deceptive. These are neither monumental enlargements of snapshots nor examples of Photo-Realism. All of Wall's pictures are carefully considered and precisely composed. They are full of art-historical references and arouse the most varied associations.

Wall's images bring the world of Hopper back to life – an everyday, authentic American reality, neither banalised nor heightened. The significance of this reality, to the attentive eye, lies precisely in its ordinariness. As with Hopper, we witness dramatically staged scenes, whose payoff is that they have no payoff. Mostly, they unfold somewhere in no-man's-land, on the outskirts of a city or in some desolate spot. The scenes, like those of Hopper, are set up, 'staged', and often they haunt the borderline between reality and dream. A concrete situation has been intensified, brought to a crux. Again as with Hopper, it is no easy matter to go beyond mere appearances and to define what it is that we are actually seeing.

Another affinity between Wall and Hopper lies in the quality of their light. Hopper's chilly, metaphysical light is echoed in the way Wall lights his 'photographic paintings' evenly from behind. The high intensity of light produced by the light-boxes has more than a physical relevance. When Wall shows us faces looking up at an event somewhere in the clouds, or on a cinema screen, with the sunlight falling on them *from in front*, or the reflection of the screen playing over them like firelight, it becomes clear that his light al-

Fig. 27 Jeff Wall, *Movie Audience*, 1979 (detail). Rüdiger Schöttle, Munich

Fig. 28 Robert Gober, *Cigar*, 1991. Courtesy Paula Cooper Gallery, New York

Fig. 29 Cindy Sherman, *Untitled Film Still, # 7*, 1978. Courtesy Cindy Sherman and Metro Pictures, New York

Fig. 30 Christian Boltanski, *Monument: Les Enfants de Dijon* (Monument: The Children of Dijon), 1985. Installation, Le Consortium, Dijon

41 *René Magritte. Die Kunst der Konversation*, exh. cat., Düsseldorf, Kunstsammlung Nordrhein-Westfalen, (Prestel) Munich, 1996.
42 *René Magritte* (as note 43).

ways comes from two sides at once and penetrates all phenomena (Fig. 27). It transcends a world that obstinately, in every detail, denies its own transcendence.

Where Wall's work recalls Hopper, the sculptures and spatial installations of Robert Gober carry a reminder of Magritte. Gober belongs to a younger generation of artists who have been seen to practise the 'Art of Conversation' with Magritte, and whose work was included in the most recent Magritte retrospective, in Toronto and Düsseldorf,[41] as an illustration of the contemporary relevance of his ideas: 'Alongside direct iconographical borrowings,' wrote Pia Müller-Tamm, 'strategies too have been appropriated, such as the technique of colossal shifts of scale, and that of paradoxical juxtapositions of objects.'[42] It is as if Gober were translating Magritte's ideas into real space: as if – overloaded as we are with stimuli, so that we react only to increasingly powerful impressions – he were setting out to remind us of the true weirdness of what the Surrealists had to say about our world (Fig. 28). And we must wonder, as we see Gober working on the 'fabrication of fictions', whether Magritte himself was not already presenting the world as pure fiction.

Like Wall, Cindy Sherman works with photography, and her shots, like his, are staged. But her subject matter, unlike Wall's, is always the artist herself. She presents her own persona, her ego, as a mirror of the age and of society. It is a mirror that reflects the ego's desires and roles – and thus remorselessly shows us that this ego exists in a state of constant metamorphosis and can never be pinned down. The dreams that Sherman dreams are those of the dream factory that used to be called Hollywood and is now called television (Fig. 29). She combines in herself the functions of a whole film crew: she is the performer – the star – and also the director, set designer, costume designer, makeup artist, camera operator, lighting director and scriptwriter: it is the perfect performance, which gives reality to a fictive world for just so long as we keep looking at it. At the end of her dreams, she has created a new myth: that of Cindy Sherman, who flies through time with the greatest of ease and turns up everywhere without ever knowing who she really is.

Christian Boltanski also works with photographs, but unlike Wall and Sherman he does not confine himself to a single medium. Boltanski assembles archives and draws up inventories in order to document something that can never really be documented: time past, *le temps perdu*. From this he assembles installations. With frail materials and tiny particles – sets of faded snapshots of vanished persons, lit by garlands of tiny electric lamps – he erects monuments to the past (Fig. 30). He is always in search of the secret ties that bind us to our own childhoods and the making of art gives him some fortunate moments when he captures them. His ideal would be to make life and art coincide: life as art, art as life. But there can be no perfect congruence, because there is always a time-lapse. So Boltanski can never lay hold of art as life, but only of art as the reconstruction of life. Hence his obsession with the past. His work has often, not unfairly, been given such labels as 'work of memory' and 'quest for clues'. He aims to make manifest the collective consciousness of the age in which he lives – and of its immediate predecessor. He also aims to make conscious what has escaped from that collective consciousness.

Boltanski can be said to work on collective memories, the shared biography of an age, and the same applies to Katharina Fritsch. Her sculptures invoke elements of memory; they also establish utopian locations in which to re-enact what is remembered. She works to reconstitute or reconstruct these concentrated moments, which survive within her, and to make them visible to the viewer, the artist's contemporary, who shares the same 'collective biography'. But since such moments cannot be invoked in visual art without a specific object – or a configuration, a series of objects – Fritsch is constantly in search of the visible analogies that set this element of memory resonating within her. Mostly, the 'objects' involved are figures: people sitting at a table in endless rows, or outsize rats – rat kings – encircling and guarding an imaginary monument (Fig. 31). Through a stereotypical repetition of individual sculptural elements (human figure, rat), Fritsch evokes in the viewer elements of folklore, folk tale and myth – and of the anxieties and phobias enshrined in them. A world submerged in the darkness of the unconscious suddenly becomes present reality.

Hans Blumenberg has spoken of 'work on myth' as one of the tasks of our age.[43] Only in works of art is myth constantly renewed, as a reminder to us that there is more to our existence than its finite nature. Artists reveal this to us in ever-new and changing imagery, as if they were drawing from an inexhaustible well.

Fig. 31 Katharina Fritsch, *Tischgesellschaft* (Table Company), 1988. Museum für Moderne Kunst, Frankfurt a. M.; long loan from the Dresdner Bank

43 Hans Blumenberg, *Arbeit am Mythos*, Frankfurt a. M., 1981.

Dream – Myth

GIORGIO DE CHIRICO (Cat. 336–339)

MARC CHAGALL (Cat. 340)

MAX ERNST (Cat. 341–344)

SALVADOR DALÍ (Cat. 345–348)

ALBERTO GIACOMETTI (Cat. 349–350)

RENÉ MAGRITTE (Cat. 351–354)

YVES TANGUY (Cat. 355–357)

FRANCIS PICABIA (Cat. 358–360)

JEAN MIRÓ (Cat. 361–364)

PAUL KLEE (Cat. 365–372)

HENRY MOORE (Cat. 373–375)

BALTHUS (Cat. 376–377)

GIORGIO MORANDI (Cat. 378–381)

EDWARD HOPPER (Cat. 382–384)

ALEXANDER CALDER (Cat. 385–387)

MATTA (Cat. 388)

ARSHILE GORKY (Cat. 389)

WOLS (Cat. 390–393)

CY TWOMBLY (Cat. 394)

JANNIS KOUNELLIS (Cat. 395)

CHRISTIAN BOLTANSKI (Cat. 396)

ANSELM KIEFER (Cat. 397–399)

BILL VIOLA (Cat. 400)

CINDY SHERMAN (Cat. 401–408)

KATHARINA FRITSCH (Cat. 409)

ROBERT GOBER (Cat. 410–411)

JEFF WALL (Cat. 412–413)

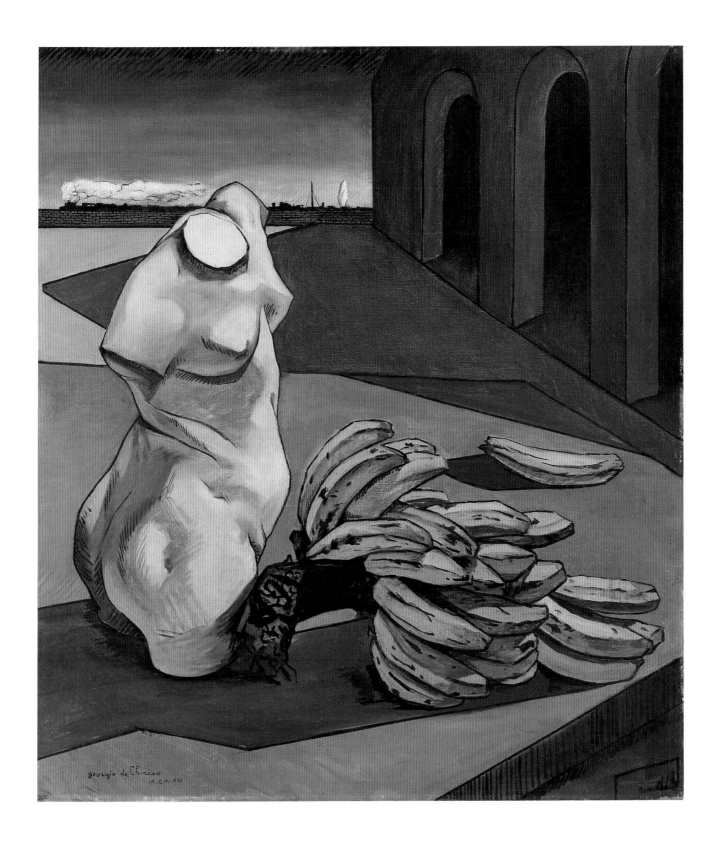

336 GIORGIO DE CHIRICO, *L'incertezza del poeta* / The Uncertainty of the Poet, 1913
Oil on canvas, 106.5 x 94.5 cm
Tate Gallery, London; Purchased with assistance from the National Art Collections
Fund (Eugene Cremetti Fund), the Carroll Donner Bequest, the Friends of the
Tate Gallery and members of the public 1985

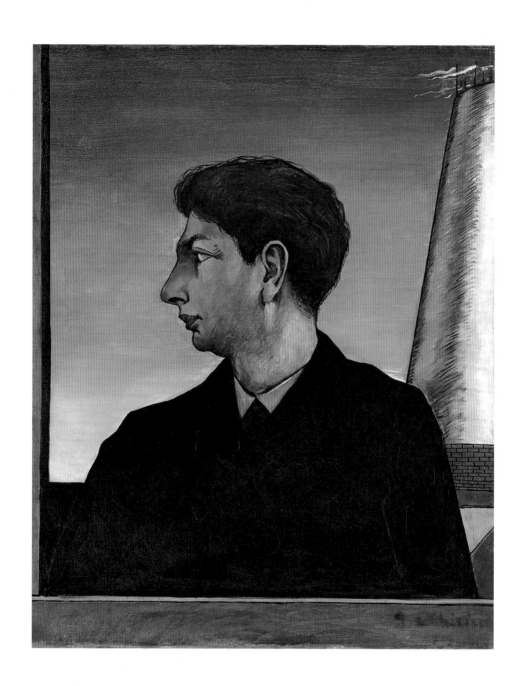

337 GIORGIO DE CHIRICO, *Autoritratto* / Self-Portrait, 1913
 Oil on canvas, 87.5 x 70 cm
 The Metropolitan Museum of Art, New York;
 Gift in memory of Carl Van Vechten and Fania Marinoff, 1970

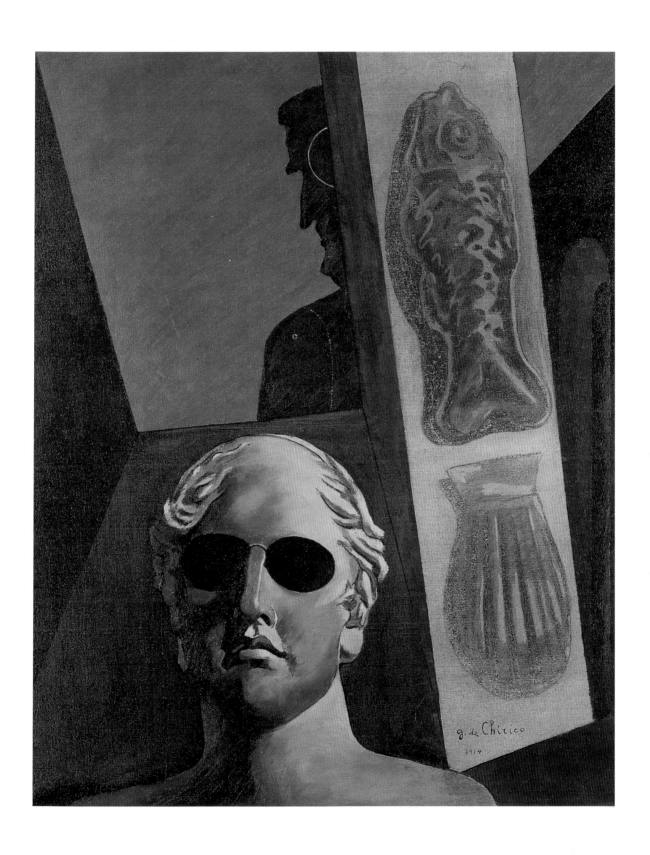

338 GIORGIO DE CHIRICO, *Portrait Prémonitoire de Guillaume Apollinaire /*
First Portrait of Guillaume Apollinaire, 1914
Oil on canvas, 81.5 x 65 cm
Musée National d' Art Moderne, Centre Georges Pompidou 1975

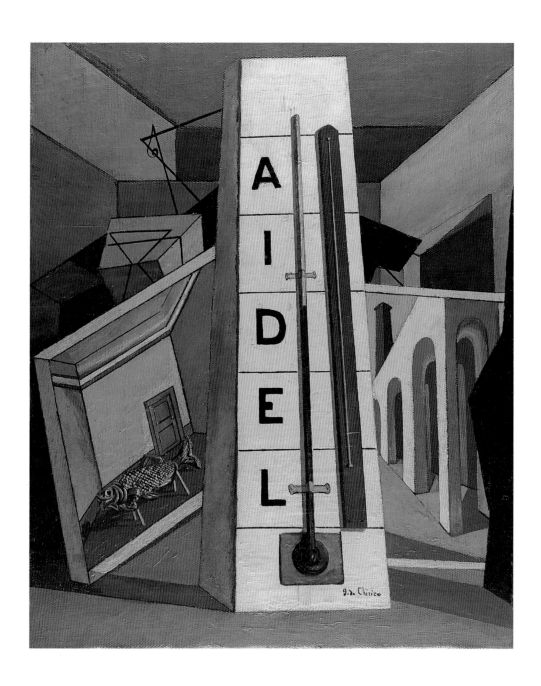

339 GIORGIO DE CHIRICO, *Il Sogno di Tobia* / The Dream of Tobias, 1917
Oil on canvas, 58.5 x 48 cm
Private collection, Courtesy Massimo Martino S.A., Mendrisio

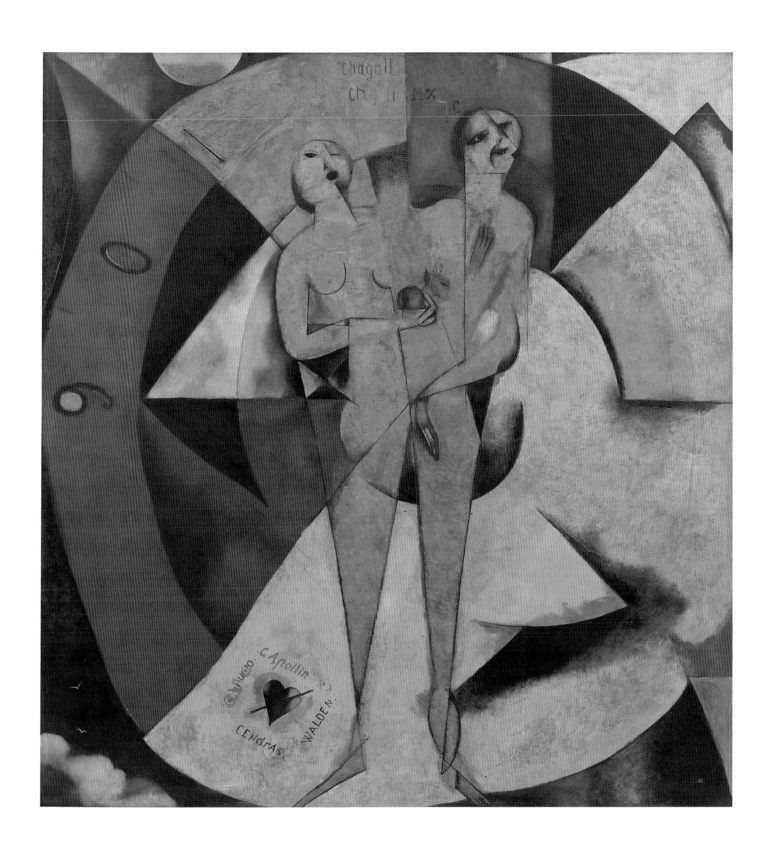

340 MARC CHAGALL, *Hommage à Apollinaire*, 1911–1912
Oil on canvas, 200 x 189.5 cm
Stedelijk Van Abbemuseum, Eindhoven, Netherlands

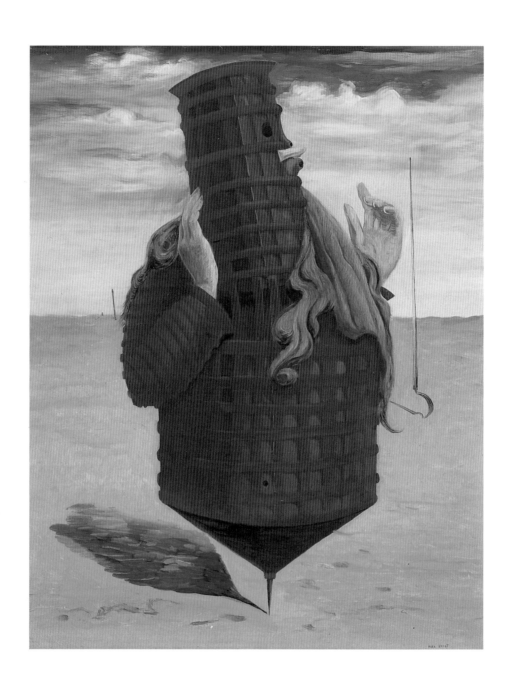

341 MAX ERNST, *Ubu Imperator*, 1923
 Oil on canvas, 81 x 65 cm
 Musée National d'Art Moderne, Centre Georges Pompidou, Paris;
 Gift of the Fondation pour la Recherche Médicale 1984

342 MAX ERNST, *Der Wald* / The Forest, 1927–1928
Oil on canvas, 96.5 x 129.5 cm
Peggy Guggenheim Collection, Venice

343 MAX ERNST, *aux 100.000 colombes* / To the 100 000 Doves, 1926
Oil on canvas, 81 x 100 cm
Private collection

344 MAX ERNST, *Vision provoquée par l'aspect nocturne de la porte Saint-Denis /*
Vision evoked by the Nightly View of Porte Saint-Denis, 1927
Oil on canvas, 65 x 81 cm
Private collection

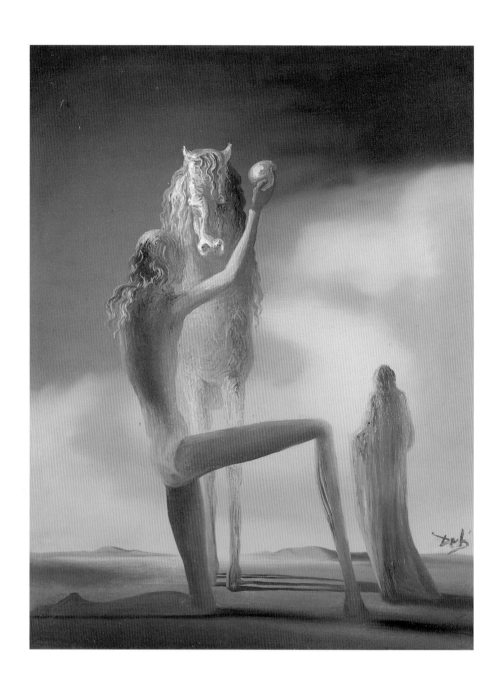

345 SALVADOR DALÍ, *Chevalier de la mort* / Death Knight, ca. 1937
Oil on canvas, 65.5 x 50 cm
Nahmad, Geneva

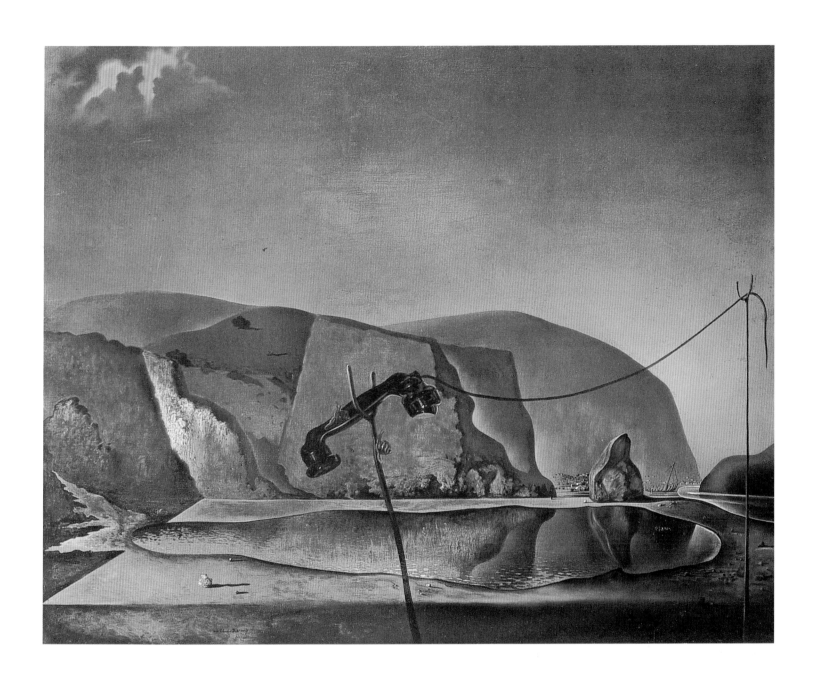

346 SALVADOR DALÍ, *Plage avec téléphone* / Mountain Lake, 1938
Oil on canvas, 73 x 92 cm
The Tate Gallery, London, Purchased 1975

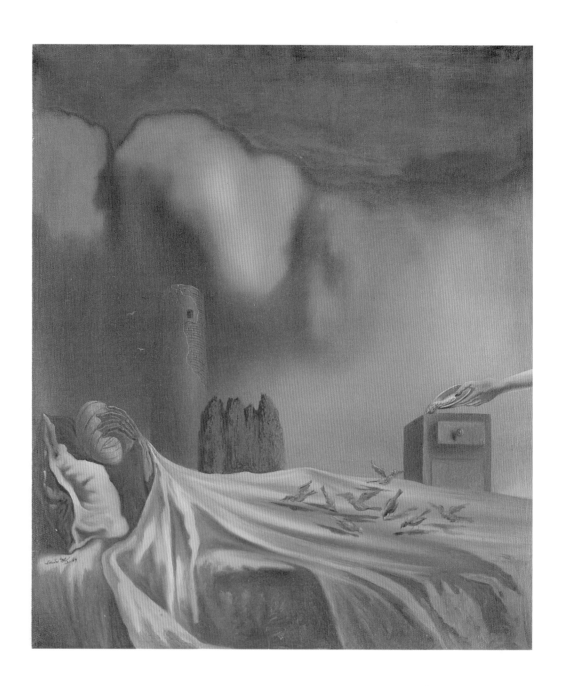

347 SALVADOR DALÍ, *L'Omelette baveuse* / Slimy Omelette, 1934
Oil on canvas, 69.5 x 60 cm
Nahmad, Geneva

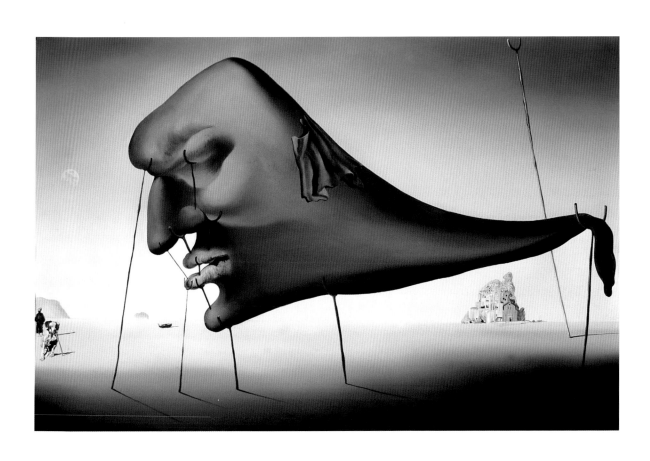

348 SALVADOR DALÍ, *Le Sommeil* / Sleep, 1937
 Oil on canvas, 51 x 78 cm
 Private collection

349 ALBERTO GIACOMETTI, *Homme et Femme* / Man and Woman, 1927
Bronze, 39.5 x 46 x 15 cm
Aaron I. Fleischman

350 ALBERTO GIACOMETTI, *Femme égorgée* / Woman with Her Throat Cut, 1932
Bronze, 22 x 75 x 58 cm
Scottish National Gallery of Modern Art, Edinburgh

351 RENÉ MAGRITTE, *L'esprit comique* / The Comic Spirit , 1928
Oil on canvas, 75 x 60 cm
Ulla and Heiner Pietzsch Collection, Berlin

352 RENÉ MAGRITTE, *Les complices du magicien /*
The Magician's Accomplices, 1926
Oil on canvas, 139 x 105 cm
Ulla and Heiner Pietzsch Collection, Berlin

353 RENÉ MAGRITTE, *L'Histoire centrale* / The Central History, 1928
 Oil on canvas, 116 x 81 cm
 Banque Paribas Belgique S.A., Brussels

354 RENÉ MAGRITTE, *Tentative de l'impossible* /
Attempt of the Impossible, 1928
Oil on canvas, 116 x 81 cm
Toyota Municipal Museum of Art

355 YVES TANGUY, *Terre d'ombre* / Shadow Country, 1927
 Oil on canvas, 99 x 80.5 cm
 The Detroit Institute of Arts, Detroit; Gift of Lydia Winston Malbin

356 YVES TANGUY, *Il faisait ce qu'il voulait* /
He did what he wanted to do, 1927
Oil on canvas, 81 x 65 cm
Richard S. Zeisler Collection, New York

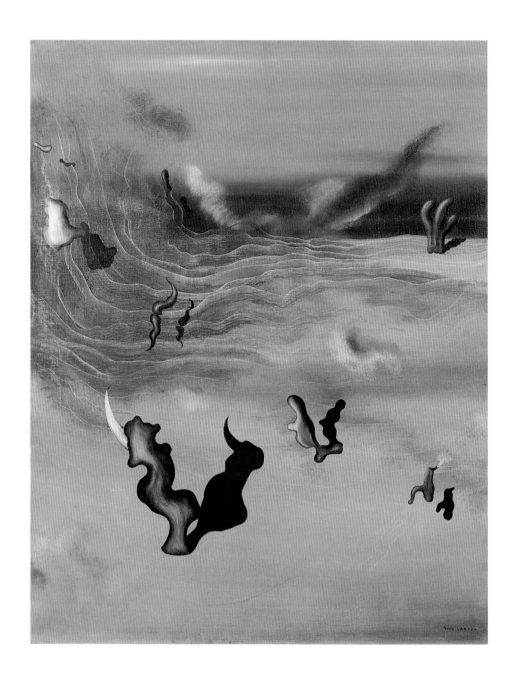

357 YVES TANGUY, *Sans titre (Il vient)* / Untitled (He is Coming), 1927
Oil on canvas, 92 x 73 cm
Private collection

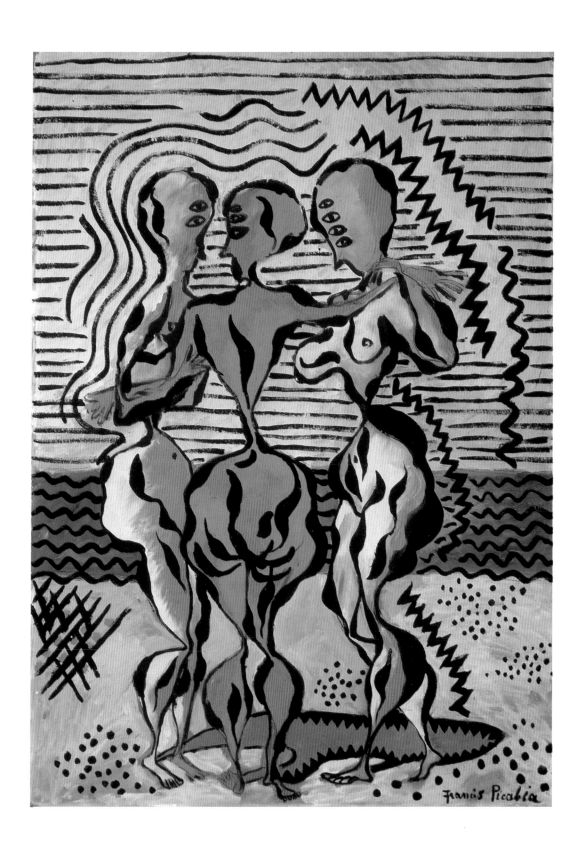

358 FRANCIS PICABIA, *Les trois grâces* / The Three Graces, 1924–1925
 Oil on board, 105 x 75 cm
 Collection Didier Imbert Art Production, Paris

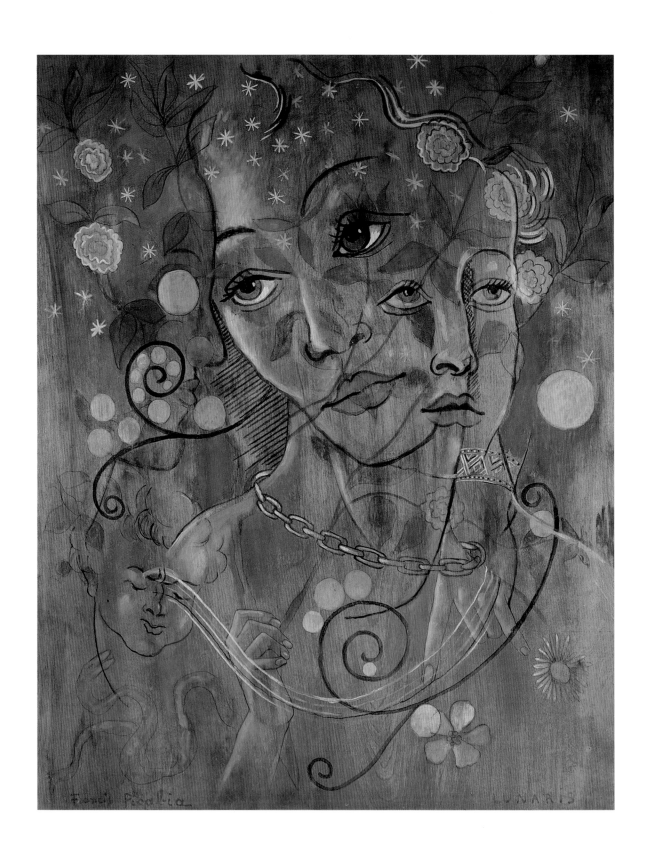

359 FRANCIS PICABIA, Lunaris, 1928
 Oil on plywood, 119 x 95 cm
 Henry and Cheryl Welt, New York

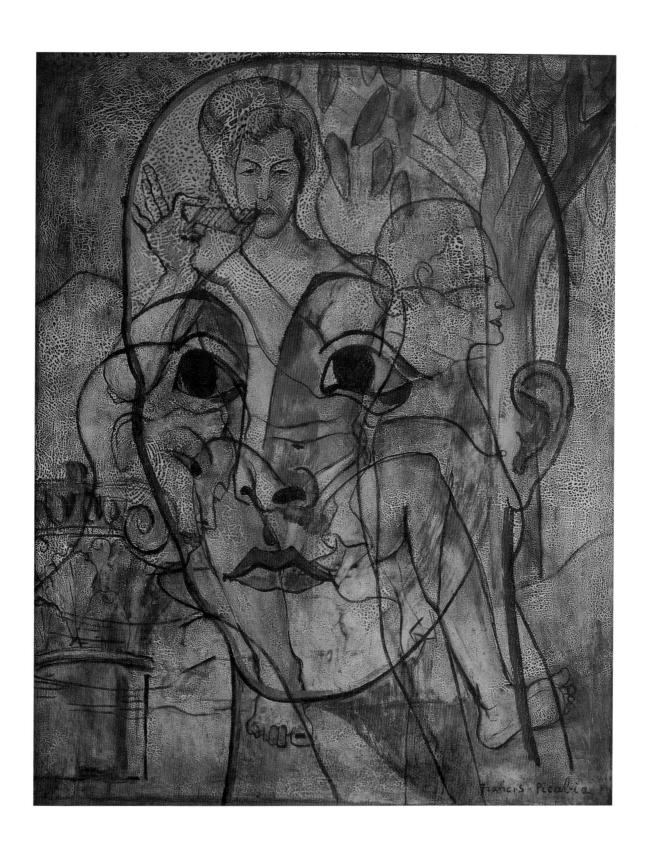

360 FRANCIS PICABIA, *Chloris*, ca. 1930
Oil on canvas, 160 x 130 cm
Private collection

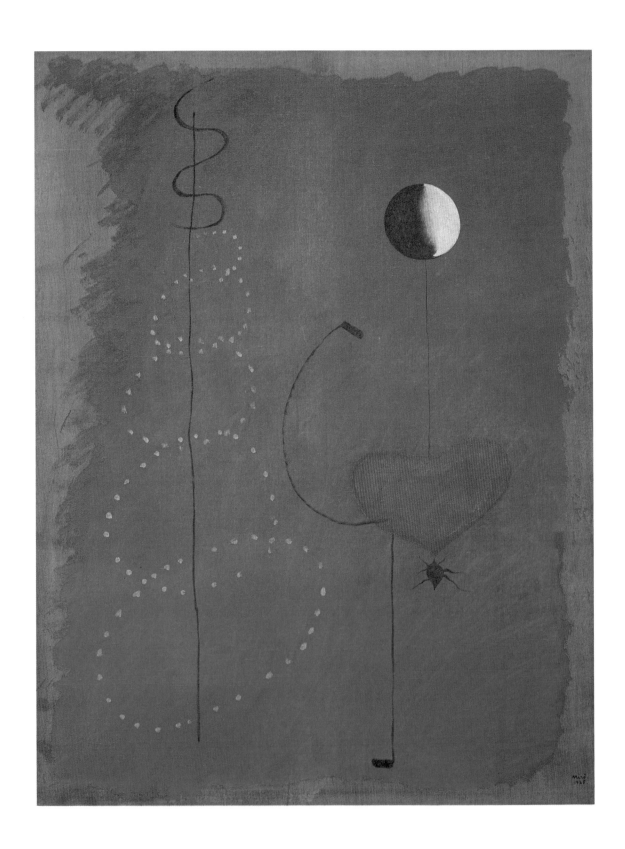

361 JOAN MIRÓ, *Danseuse II* / Dancer II, 1925
 Oil on canvas, 115.5 x 88.5 cm
 Collection A. Rosengart

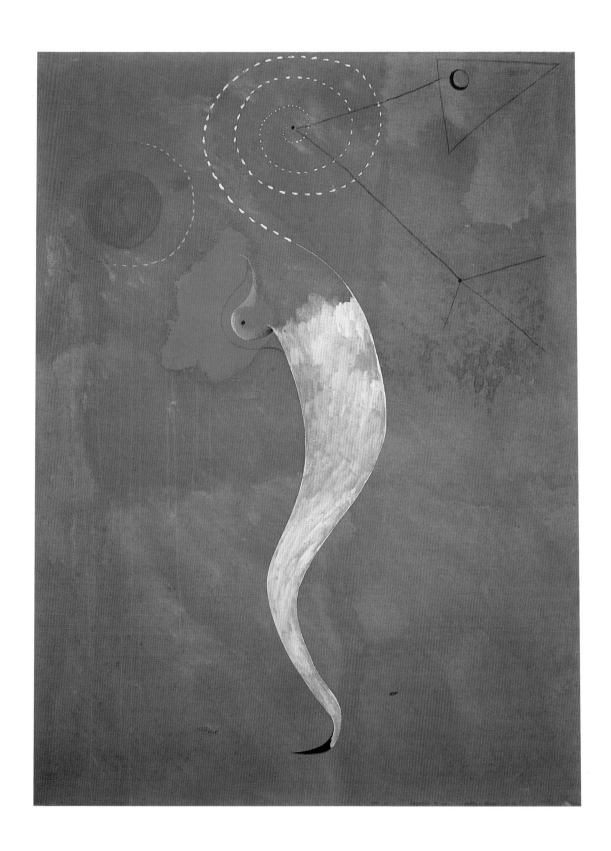

362 JOAN MIRÓ, *Dame se Promenant sur La Rambla de Barcelona* /
Lady Strolling on the Rambla in Barcelona, 1925
Oil on canvas, 130 x 97.5 cm
New Orleans Museum; Bequest of Victor K. Kiam

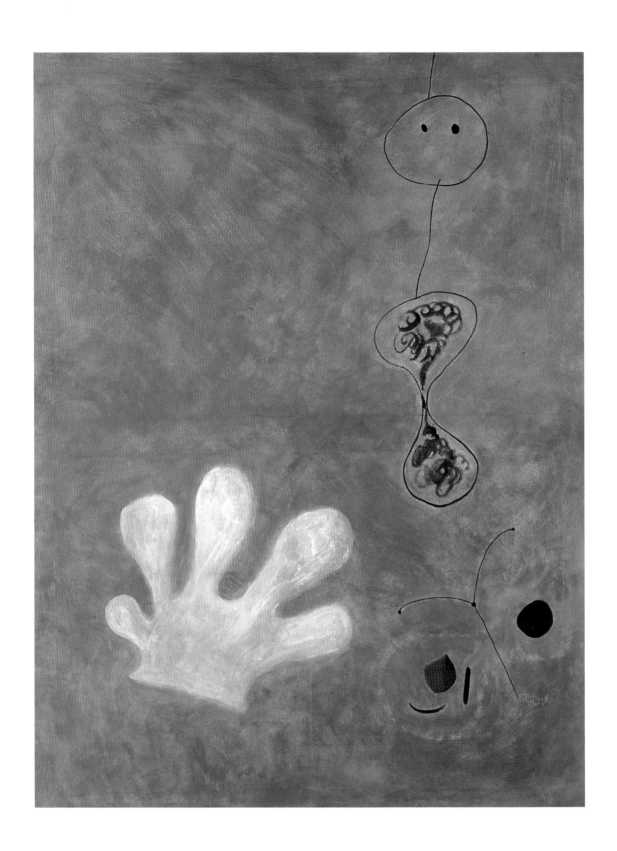

363 JOAN MIRÓ, *Pintura (El guant blanc)* /
Painting (The White Glove), 1925
Oil on canvas, 113 x 89.5 cm
Fundació Joan Miró, Barcelona

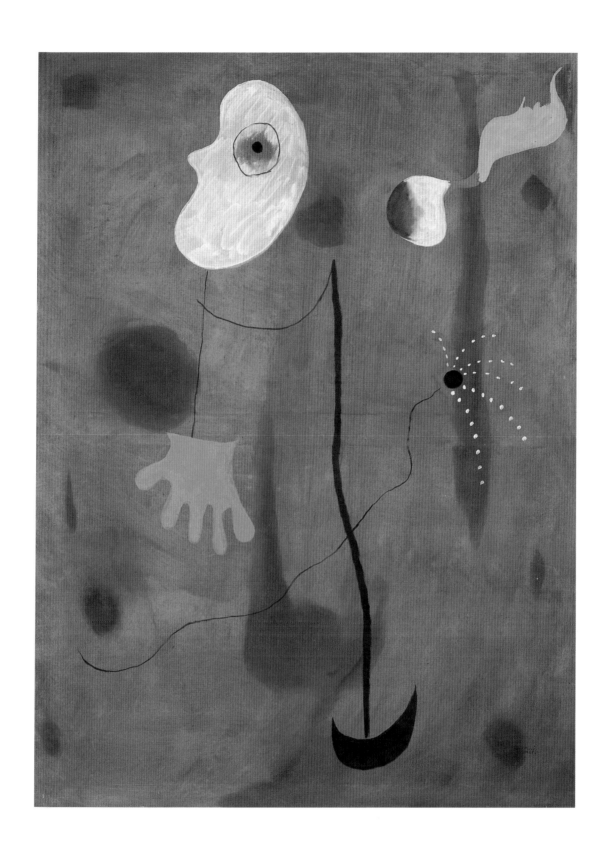

364 JOAN MIRÓ, Untitled, 1925
Oil on canvas, 130 x 97 cm
Ulla and Heiner Pietzsch Collection, Berlin

365 PAUL KLEE, *Bild mit dem Hahn und dem Grenadier* /
The Cock and the Grenadier , 1919 (235)
Oil on cardboard, 47 x 40.5 cm
Collection A. Rosengart

366 PAUL KLEE, *Fast getroffen* / Nearly Hit, 1928 (143 (E 3))
 Oil on cardboard, 51 x 39.5 cm
 San Francisco Museum of Modern Art; Albert M. Bender Collection,
 Albert M. Bender Bequest Fund Purchase

367 PAUL KLEE, *Bühnen-Gebirgs-Konstruktion* /
Theater-Mountain-Construction, 1920 (28)
Oil and mixed media on cardboard, 33 x 42 cm
The Metropolitan Museum of Art, New York;
The Berggruen Klee Collection, 1987

368 PAUL KLEE, *Der Mann unter dem Birnbaum* /
The Man under the Pear Tree, 1921 (19)
Mixed media on cardboard, 36.5 x 25 cm
The Metropolitan Museum of Art, New York;
The Berggruen Klee Collection, 1987

369 PAUL KLEE,
Verhext - versteinert / Bewitched - Petrified,
1934 (201) (U 1))
Water colour, wax on ply-wood, 50.5 x 50.5 cm
Nationalgalerie, Staatliche Museen zu Berlin,
Preußischer Kulturbesitz

370 PAUL KLEE, *Der Schlüssel "Zerbrochener Schlüssel"* /
The Key "Broken Key", 1938 (136 (J 16))
Oil on burlap over stretcher, 50 x 66 cm
Sprengel Museum, Hanover

371 PAUL KLEE, *Waldhexen* / Forest Witches, 1938 (145 (K 5))
Oil on paper on burlap, 99 x 74 cm
Private collection, Switzerland

372 PAUL KLEE, *Ohne Titel (Letztes Stilleben)* /
Untitled (Last Still-Life), ca. 1940 (N 1)
Oil on canvas, 100 x 80.5 cm
Private collection, Switzerland

374 HENRY MOORE, *Stringed Mother and Child*, 1938
(cast 1986)
Bronze and string, height 43 cm
Henry Moore Foundation

373 HENRY MOORE, *The Helmet*, 1939–1940
Bronze, height 29 cm
Henry Moore Foundation; Gift of Irina Moore 1977

375 HENRY MOORE, *Working Model for Upright Internal/External Form*, 1951
Plaster, height 63 cm
Henry Moore Foundation; Gift of the Artist 1977

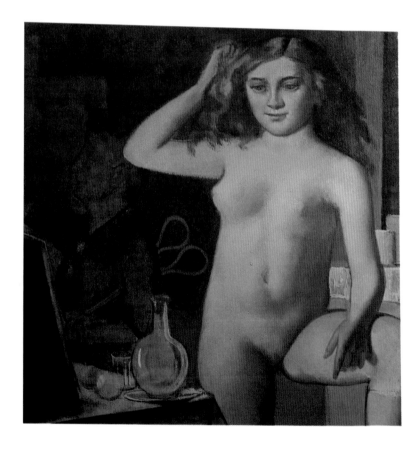

376 A BALTHUS, *Le Lever* / Rise, 1955
Oil on canvas, 161 x 130.5 cm
Scottish National Gallery of Modern Art, Edinburgh

376 B BALTHUS, *La Toilette de Georgette*, 1948–1949
Oil on canvas, 98 x 94 cm
Courtesy Elken Gallery, Inc., New York

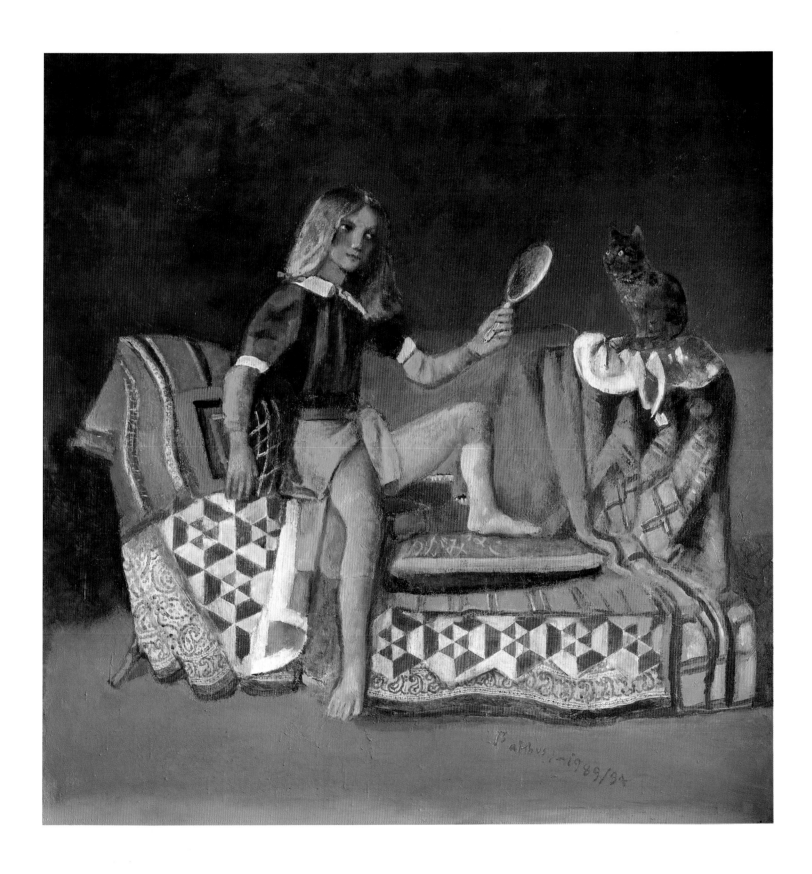

377 BALTHUS, *Le Chat au miroir III* / Cat with Mirror, 1989–1994
Oil on canvas, 200 x 195 cm
Courtesy Thomas Ammann Fine Art, Zurich and Lefevre Gallery, London

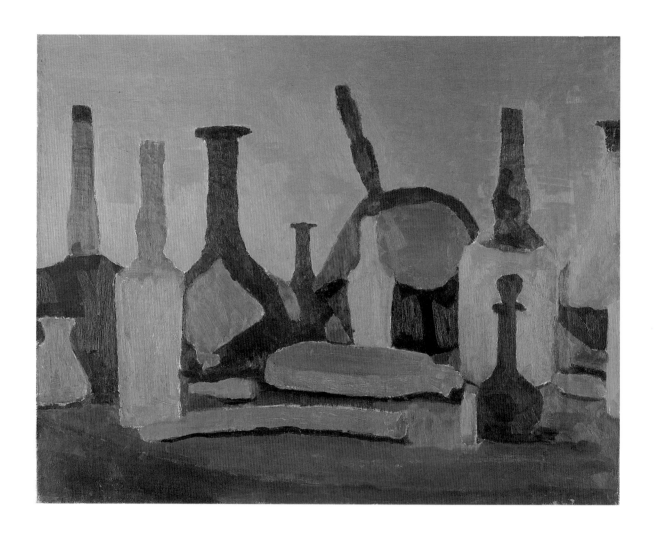

378 GIORGIO MORANDI, *Natura morta* / Still Life, 1937
 Oil on canvas, 45 x 59 cm
 Courtesy Claudia Gian Ferrari, Milan

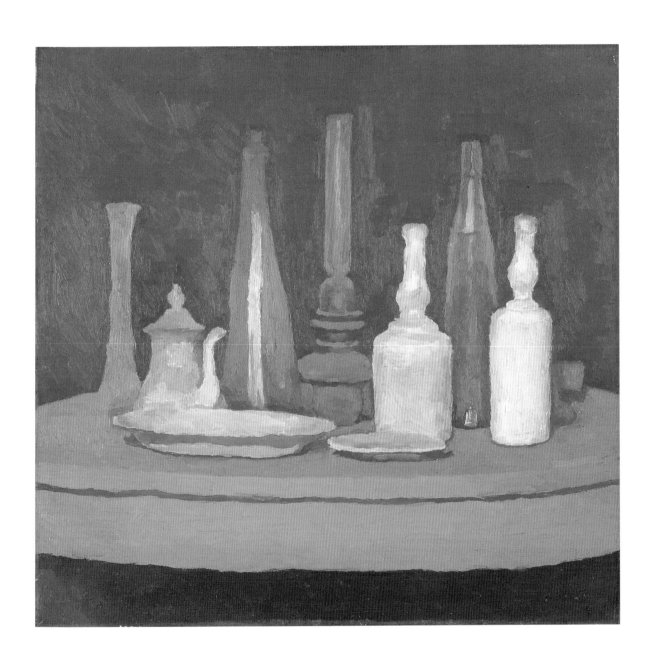

379 GIORGIO MORANDI, *Natura morta* / Still Life, 1929
Oil on canvas, 55 x 58 cm
Pinacoteca di Brera, Milan; Donation of Emilio and Maria Jesi

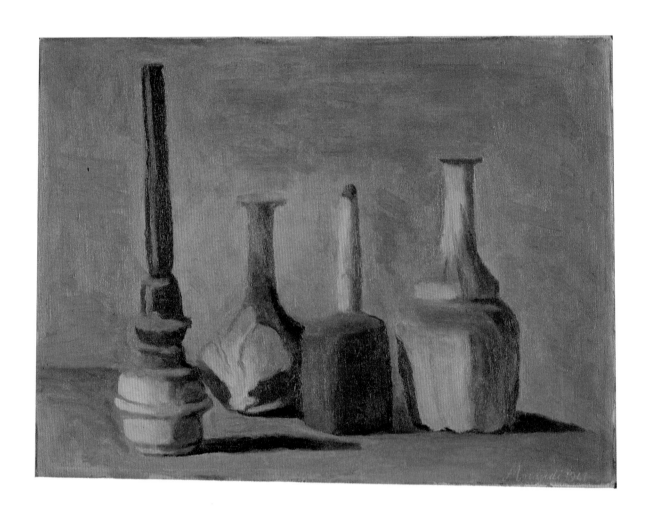

380 GIORGIO MORANDI, *Natura morta* / Still Life, 1941
 Oil on canvas, 37 x 50 cm
 Museo Morandi, Bologna

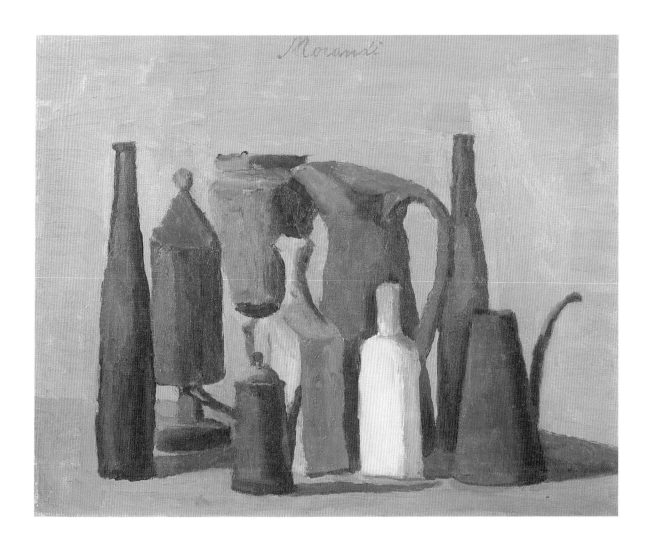

381 GIORGIO MORANDI, *Natura morta* / Still Life, 1940
 Oil on canvas, 42.5 x 53 cm
 Civico Museo d'Arte Contemporanea, Milan

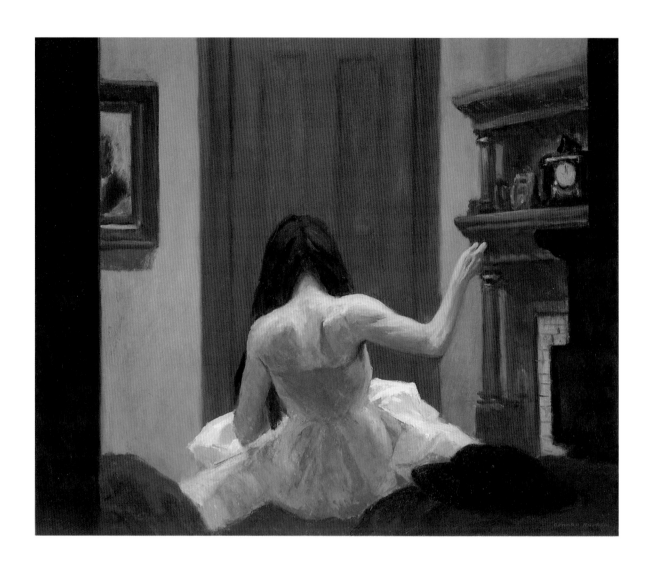

382 EDWARD HOPPER, *New York Interior*, ca. 1921
Oil on canvas, 61 x 74 cm
Whitney Museum of American Art, New York;
Bequest of Josephine N. Hopper

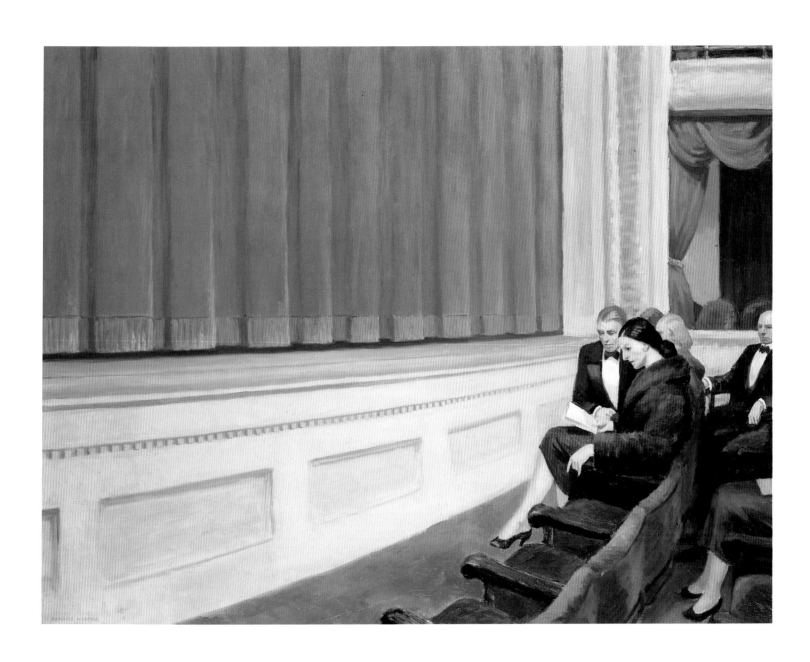

383 EDWARD HOPPER, *First Row Orchestra*, 1951
Oil on canvas, 79 x 102 cm
Hirshhorn Museum and Sculpture Garden, Smithsonian Institution;
Gift of Joseph H. Hirshhorn Foundation, 1966, Washington D.C.

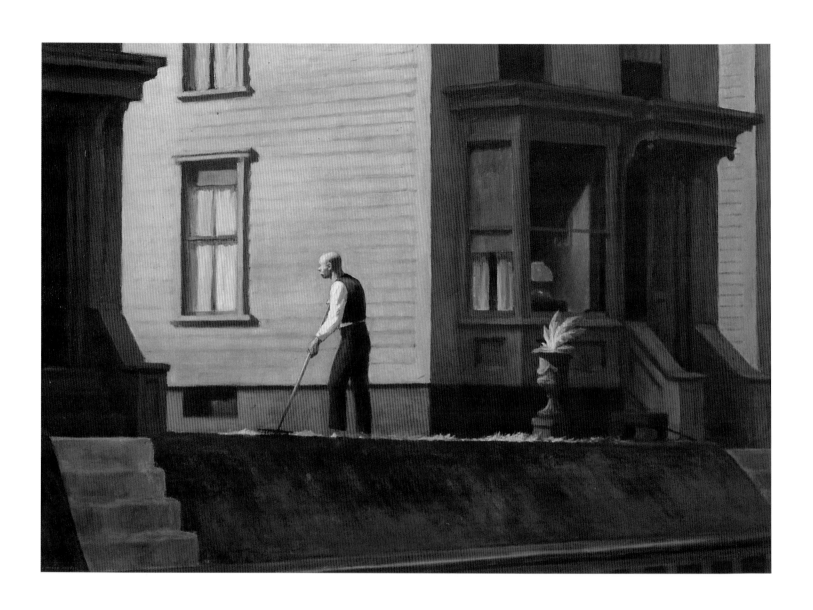

384 EDWARD HOPPER, *Pennsylvania Coal Town*, 1947
 Oil on canvas, 71 x 101.5 cm
 Butler Institute of American Art, Youngstown, Ohio

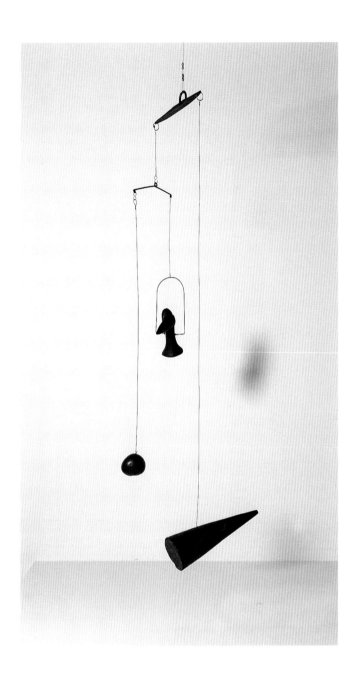

385 ALEXANDER CALDER, *Cône d'ébène* / Ebony Cone, 1933
Wood, steel sticks, iron threads, 250 x 110 cm
Estate of Alexander Calder

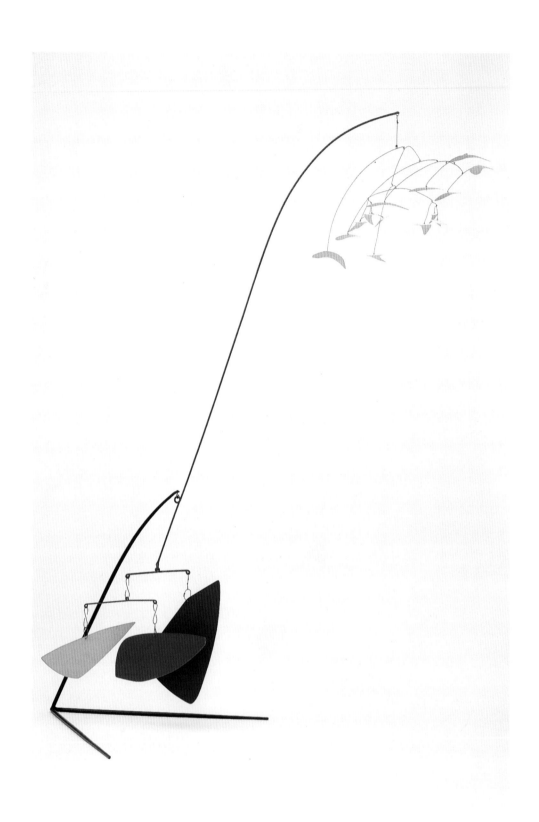

386 ALEXANDER CALDER, *Clanger*, 1941
 Sheet metal, aluminium and steel rod, 270 x 244 cm
 Onnasch Collection

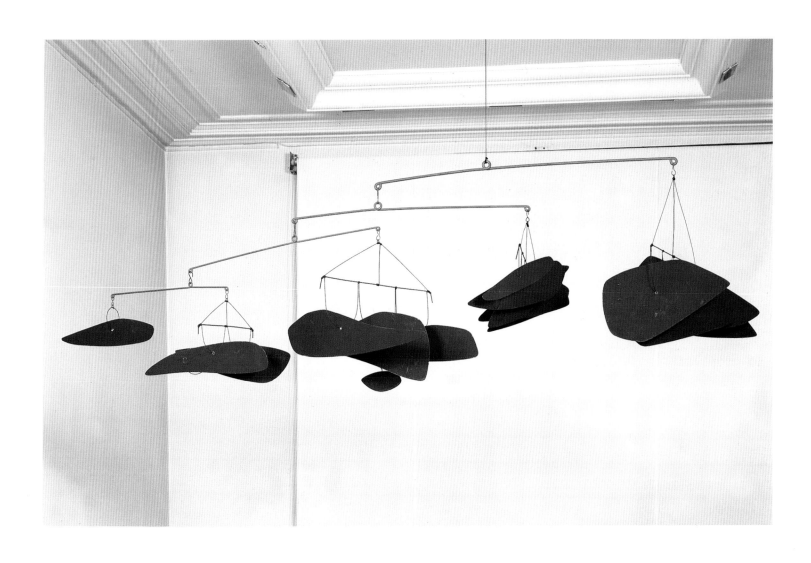

387 ALEXANDER CALDER, *Armada*, 1945
 Mobile: metal, 195 x 70 x 60 cm
 Claude Berri, Paris

388 MATTA, *Splitting the Ergo*, 1947
Oil on canvas, 197 x 244 cm
Onnasch Collection

389 ARSHILE GORKY, *Waterfall*, 1943
Oil on canvas, 153.5 x 113 cm
Tate Gallery, London; Purchased with assistance from
the Friends of the Tate Gallery 1971

390 WOLS, *Bäume* (ohne Titel) / Trees (untitled), ca. 1946
Oil paint, grattage, tube prints on canvas, 81 x 65 cm
Courtesy Galerie Karsten Greve, Cologne, Paris, Milan

391 WOLS, Untitled, ca. 1946/1947
 Oil on canvas, 145 x 113.5 cm
 Gräßlin Collection, St. Georgen

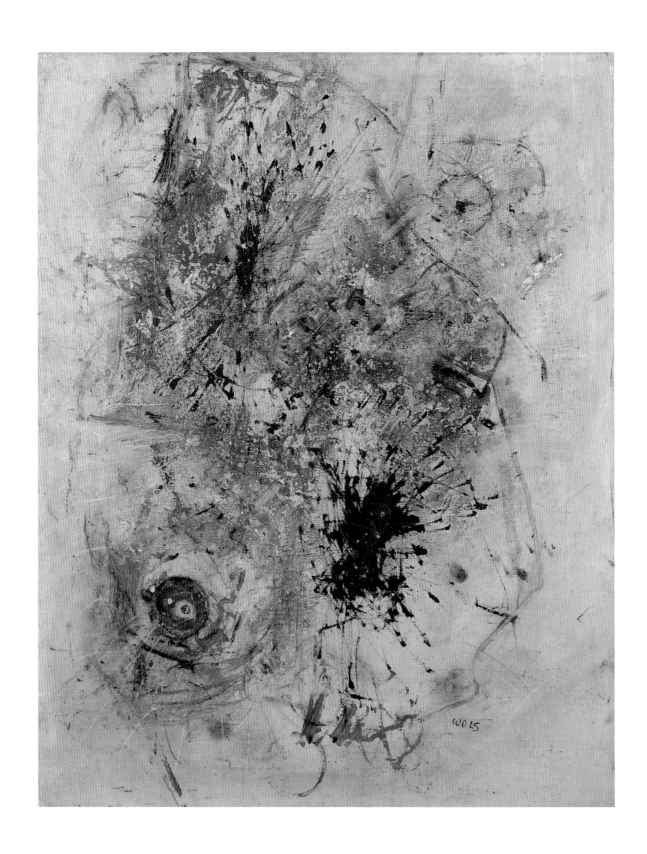

392 WOLS, *Fond ocre éclaboussé de noir* /
 Ochre Ground, splashed with Black, 1946/1947
 Oil paint, grattage, prints on canvas, 92 x 73 cm
 Private collection, Paris

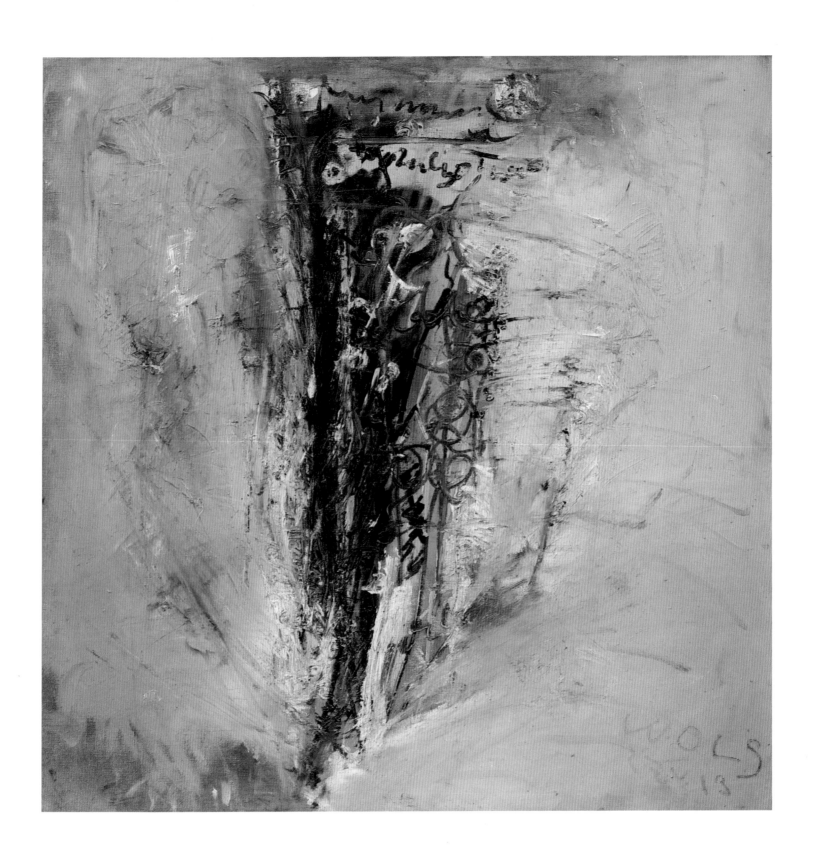

393 WOLS, *Peinture* / Painting, 1946/1947
 Oil on canvas, 80 x 80 cm
 Nationalgalerie, Staatliche Museen zu Berlin, Preußischer Kulturbesitz

394 CY TWOMBLY, *Salome*, 1961
 Wax crayon, oil paint, coloured pencil,
 lead pencil on canvas, 200 x 424 cm
 Franchetti Collection, Roma

395 JANNIS KOUNELLIS, *Senza titolo* / Untitled, 1986
 Iron, lead and plaster, 30 plates, each 200 x 90 cm, overall 600 x 900 cm
 Collection of the artist, Courtesy Galerie Konrad Fischer

396 CHRISTIAN BOLTANSKI, *Les Archives - Réserve Détective /*
The Archives - Détective Reserve, 1987
B/w photographs, lamps, tins, dimensions variabel
Collection Ydessa Hendeles, Courtesy Ydessa Hendeles
Art Foundation Toronto, Canada

397 ANSELM KIEFER, *Hermannsschlacht* /Hermann's Battle, 1976
Oil on canvas, 306 x 197 cm
Private collection

398 ANSELM KIEFER, *Unternehmen "Seelöwe"* / Operation "Sea Lion", 1975
 Oil on burlap, 175 x 180 cm
 Kunstsammlungen zu Weimar, permament loan of Paul Maenz

399 ANSELM KIEFER, *Innenraum* / Interior Space, 1981
Oil, paper and straw on perforated canvas, 287.5 x 311 cm
Stedelijk Museum, Amsterdam

400 BILL VIOLA, *Anthem*, 1983
 Videoinstallation, dimensions variable
 Courtesy of the artist

401 CINDY SHERMAN, *Untitled, # 67*, 1980
Colour photograph, 40 x 58 cm
Monika Sprüth Galerie, Cologne

402 CINDY SHERMAN, *Untitled, # 123*, 1982
Colour photograph, 86 x 61 cm
Monika Sprüth Galerie, Cologne

403 CINDY SHERMAN, *Untitled, # 122* , 1983
Colour photograph, 89 x 54 cm
⁻ Monika Sprüth Galerie, Cologne

404 CINDY SHERMAN, *Untitled # 93*, 1981
Colour photograph, 62 x 123 cm
Museum Boijmans Van Beuningen, Rotterdam

405 CINDY SHERMAN, *Untitled Film Still, # 22*, 1978
B/w photograph, 20.5 x 25.5 cm
Monika Sprüth Galerie, Cologne

406 CINDY SHERMAN, *Untitled Film Still, # 6*, 1977
B/w photograph, 24 x 18 cm
Monika Sprüth Galerie, Cologne

407 CINDY SHERMAN, *Untitled Film Still, # 14*, 1978
B/w photograph, 25.5 x 20.5 cm
Monika Sprüth Galerie, Cologne

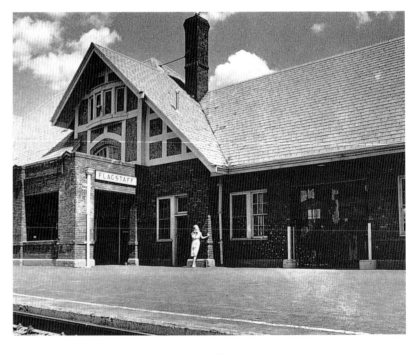

408 CINDY SHERMAN, *Untitled Film Still, # 44*, 1977
B/w photograph, 20.5 x 25.5 cm
Monika Sprüth Galerie, Cologne

409 KATHARINA FRITSCH, *Koje mit 4 Figuren* / Box with 4 Figures, 1985
Wood, plaster figures, 280 x 200 x 200 cm
Onnasch Collection

410 ROBERT GOBER, *Crib*, 1986
 Wood, cotton, email, 114 x 133 x 84 cm
 Collection Benedikt Taschen

411 ROBERT GOBER, *Leg with Candle*, 1991
Various materials, 34 x 18 x 96.5 cm
Collection Benedikt Taschen

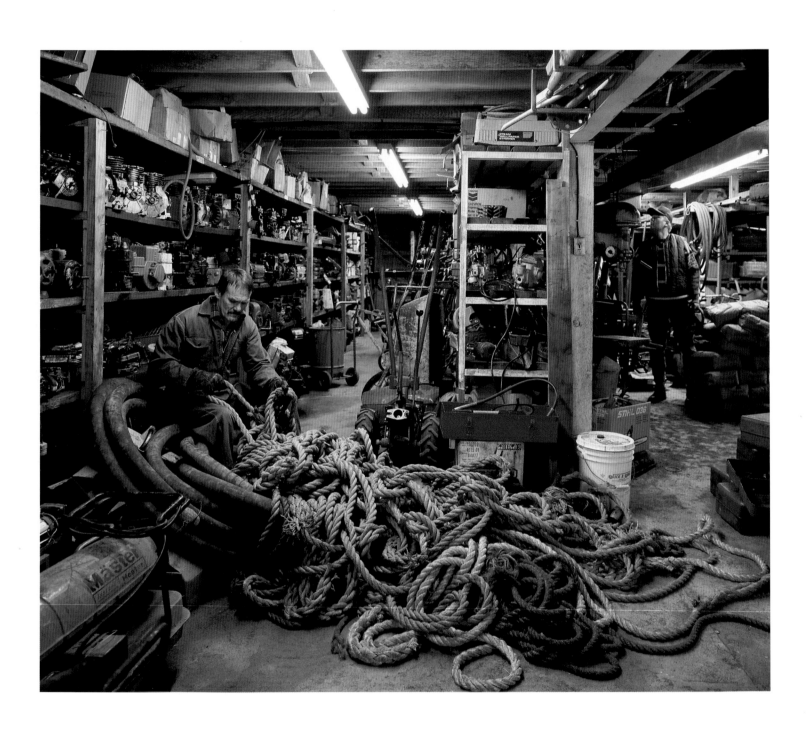

412 JEFF WALL, *Untangling*, 1994
Cibachrome transparency in aluminium display case,
fluorescent-light fixtures, 189 x 223.5 cm
Kunstmuseum Wolfsburg

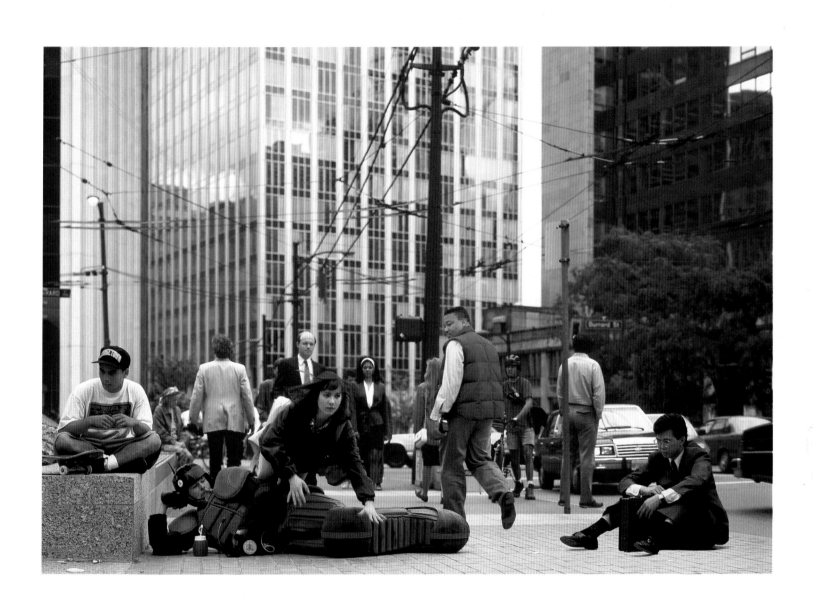

413 JEFF WALL, *The Stumbling Block*, 1991
Cibachrome transparency in aluminium display case,
fluorescent-light fixtures, 229 x 284 cm
Collection Ydessa Hendeles, Courtesy Ydessa Hendeles
Art Foundation Toronto, Canada

STEPHEN BANN

The Premisses of Modern Art

An end of century is an appropriate time to look back. It is also an appropriate time to analyse the forms of thought which have developed over a certain period, and to judge to what extent our retrospective view is conditioned by ways of interpreting human society and culture which are themselves inevitably historical in their origin.

To be more concrete, I will begin by asking two fundamental questions. At what stage did it become possible for the art of a 'century' to be presented to the public, in such a way that the chronological unity shared by the exhibits was a major, if not a dominant feature in their perception? The answer is, without any doubt, that the French antiquarian Alexandre Lenoir achieved this unprecedented effect in his 'Musée des monuments français', inaugurated at the time of the French Revolution and surviving up to the time of the Bourbon Restoration of 1814/15. Lenoir took over the former conventual buildings of the Petits-Augustins, on the Left Bank of the Seine, and filled them with largely sculptural and architectural work which had been salvaged from the iconoclasm of the revolutionary period. His distinctive achievement was to arrange his varied materials in a succession of 'century' rooms, following the lay-out of the former monastery.[1] It seems a commonplace nowadays to group works of art together, in a museum, according to chronology. Indeed we would find it disorientating if this were not the case. But the fact remains, however, that nowhere, before Lenoir's initiative, had works of art been placed together in a single space, to express the unity of a century in terms of its formal expressions. Lenoir's contemporaries could now configure the image of the past in a concrete way.

Obviously this example bears particularly on the question of public's ability to visualise historical periods in terms of the collections of objects which they engendered. But it is eccentric, with reference to the currently accepted notion of the 'exhibition', where an artist or group of artists contributes work to an overall display, whose unifying theme is celebrated by a specific title and discussed in an accompanying catalogue. This leads me to my second question. At what point did it become possible to see the work of an artist exhibited, in such a way as to display its overall development, when this was also the subject of an extensive catalogue publication? Once again, there can be little doubt about the answer. The French painter, Paul Delaroche, having been virtually the most popular painter in France when exhibited in the Paris Salons of the early 1830s (Fig. 1), ceased to exhibit in public from 1837 onwards. After his death in 1856, a retrospective exhibition was arranged at the Ecole des Beaux-Arts at the behest of his fellow artists. Not only was a significant proportion of his entire life's work placed on show, but also a magnificent

Fig. 1 Paul Delaroche, *The Execution of Lady Jane Grey*, 1833. National Gallery, London

1 Francis Haskell, *History and its Images*, London, 1993, pp. 236–52.

catalogue was published for the occasion in which, for the first time, extensive photo-graphic reproductions were included.[2]

My point in bringing up both these issues is, in part, to insist on the specific historical origins of the exhibiting practices which have come to seem 'natural' in the modern period. One might say that aspects of both the practices to which I have drawn attention are, in a sense, amalgamated within the concept of an exhibition such as this one. But there is a further point which deserves some discussion. Both the examples which I have introduced relate to the artistic history of France, and Paris in particular. This is by no means accidental. When Harold Rosenberg wrote his prophetic article on 'The Fall of Paris' in 1940, he generalised the significance of the historical events which had taken place, by claiming that 'the laboratory of the twentieth century' had been closed down.[3] For Rosenberg, the process finally consummated by the German occupation had already been under way in the earlier part of the inter-war period, when Paris ceased by stages to hold the monopoly of avant-garde activity. Yet there was no room for doubt that, in its origins, modern art had been a Parisian affair.

Fig. 2 Edouard Manet, *Le déjeuner sur l'herbe*, 1862–63. Musée du Louvre, Paris.

Of course, Rosenberg does not attempt to suggest when the 'laboratory of the twentieth century' was started up. This short essay is dedicated to offering a framework within which that question might eventually be answered. And the initial claim which will be made is that the institutional character of French artistic practice, more firmly marked than in any other European country, offered a base from which the modernist initiative could split itself off, by a process which could well be termed dialectical. Only the uniquely coercive structures of the French system could have produced a series of reactions so evident, on the public level, and so significant on the level of artistic practice, as to prepare the formation of the ideology of Modernism. Marcelin Pleynet well recognised the need to conduct analysis on two seperate levels, when he stated that the decisive factors in the emergence of modern art were the 'formal revolution' achieved in the practice of Cézanne, and the 'cultural rupture' signalled by the career of Manet.[4] But if the role of Cézanne, in this respect, can be assessed through the examination of his pictorial techniques, that of Manet depends on a much more comprehensive awareness of the cultural context within which he operated. The 'Salon des Refusés' of 1863, in which Manet and his colleagues established their right to exhibit together, in defiance of the jury of the official Salon, is rightly taken as being a landmark in the prehistory of modern art (Fig. 2). But it is itself hard to understand outside the context of a continuous struggle for emancipation from the norms of academic practice which had been taking place in French art, at least since the Salons of the 1820s.

In brief terms, the French academic tradition which derived from the foundation of the Academy in 1648, and had been consolidated rather than weakened by the prestige of the School of David under the Revolution and Empire, offered a comprehensive system for the regulation of artists and types of art. The Academy – a small, self-perpetuating, elective body, which included architects, sculptors, engravers, musicians and 'free members', as well as painters, among its membership – dominated the training of young

2 See my forthcoming *Paul Delaroche: History painted*.
3 Harold Rosenberg, *The Tradition of the New*, London, 1962, p. 209.
4 See Marcelin Pleynet, *Les Modernes et la Tradition*, Paris, 1990.

Fig. 3 Théodore Rousseau, *View of Barbizon*, end of the 1840s. Pushkin State Museum of Fine Arts, Moscow

artists through its supervision of the Ecole des Beaux-Arts and the competition for places at the French Academy at Rome; it also provided the jury for the periodic 'Salons', where artists had access to the visiting public and to critical review. In determining what should be admitted to these all-important occasions – which became annual from the early 1830s onwards – the jury had regard particulary to two necessary criteria. The work submitted should fall within a specific *genre*: it should be classifiable as a still life, for example, or a 'history painting' (in the terms established by Alberti in the Renaissance). Yet even before the submitted work could be assessed on these terms, it had to satisfy a logically prior question. Was it a painting at all? Or to use the terms employed specifically in critical debate, and impossible to translate into English, was it truly a *tableau*, or simply a *morceau*?[5] The same question applied a *fortiori* to works which might be considered as mere sketches (*esquisses* and *ébauches*) which did not qualify for exhibition at the Salon.

The creation of the 'Salon des Refusés' in 1863 was not in any sense, however, a stage at which the dike was breached and 'academic art' was flooded by the tide of modernism. In effect, there was constant conflict, in the world of artists and, indeed, in the Academy itself, around the issues which finally crystallised around the appearance of Manet and the Impressionists. In the early 1830s, for example, Paul Delaroche, who had been elected to the Academy in 1832 at the unprecedentedly early age of 35, put relentless pressure on his colleagues to reform the jury system, and was frustrated largely by the votes of architects devoted to the Neoclassical ideology of the School of David. His ultimate failure led to his withdrawal from the jury in 1836 (and contributed to his decision to cease exhibiting at the Salon after 1837). Also in 1836, the painter Ary Scheffer, who shared Delaroche's views, but was never a member the Academy because of his Dutch nationality, opened his studio for a special showing of the young painters refused by the Salon jury: these included, for example, the works of the landscape painter, Théodore Rousseau (Fig. 3), a pioneer of the Barbizon school, whose new style of *plein-air* painting proved a perpetual stumbling block to his acceptance by the jury, and had serious consequences both critically and financially.

To see the later and more celebrated gestures of Manet and the Impressionists against this context is helpful, precisely because it indicates how far the future development of modern art was shaped, to a great extent, by conflicts inherent in the French academic system, which continued to resonate long after Cézanne's 'formal revolution' had ostensibly transformed the vocabulary of the plastic arts. Scheffer's decision to give exhibiting space to Rousseau and his colleagues, itself without meaning except as a retort to the Salon, anticipates the more elaborate engagement of Courbet with the existing system. Claiming to be self-taught, Courbet secured a medal at the Salon with his *Un après-dîner à Ornans* (1849) (Fig. 4), and was allowed to bypass the jury as a result, until this privilege was abolished in 1857; however, he increasingly developed the practice of exhibiting in the provinces, and abroad, to forestall hostile criticism, and in 1855 took the occasion of the International Exhibition in Paris to hold a large private exhibition of his own work in the vicinity. It goes without saying that, in this period, the development of the com-

Fig. 4 Gustave Courbet, *Un après-dîner à Ornans* (An After Dinner at Ornans), 1848–49. Musée des Beaux-Arts, Lille

5 See Michael Fried, *Manet's Modernism*, Chicago, 1996, pp. 272–3.

mercial gallery system had no yet reached the point where artists could benefit from a genuine alternative forum for the sale and display of their works.[6]

How does this institutional history of the origins of modern art continue to affect its evolution in the twentieth century? One work which makes the implications exceptionally clear is Thierry de Duve's *Kant after Duchamp*, which takes its stance squarely on the artistic practice of Marcel Duchamp, but in the process succeeds in illuminating Duchamp's logical transformation of the existing system, as well as his legacy to the future. De Duve writes: 'Modernity starts with Salon painting … The avant-garde was born out of the controversies around Salon painting …'[7] What he implies is that the fundamental character of the jury system consisted in setting up a dynamic of exclusion/inclusion. The jury had no other function but to legislate on questions of the type: is this a sketch or a painting (*tableau*)? is this a landscape, according to the traditions of the genre? However the gestures of the independence which culminated in the creation of the 'Salon des Refusés' established a new precedent. From this point, it became increasingly open to the artist, or group of artists, to bypass the official system and proclaim, in effect: these works are 'art' because we, the artists, proclaim them to be so. De Duve's brilliant analysis of the significance of the 'readymade' in Duchamp's work pursues the logic of this position. In choosing to send a urinal, signed with the name 'R. Mutt' (Fig. 5) to the exhibition, or 'salon', arranged at the Grand Central Palace, New York, in the spring of 1917, Duchamp specifically challenged the institutional context – in so far as it had been decided to do away with the jury system and allow admittance to any artist who paid the admission fee.[8] He unequivocally established the principle that, since juries had traditionally included or excluded work as a result of conceptual distinctions, the absence of a jury left the artist free to develop his or her concept for an object that might or might not be the product of their own craftsmanship. To put it another way, Manet and his colleagues had established the principle that their work – which the Salon jury refused to accept as falling within the classification of 'painting' – was nonetheless worthy of exhibition as 'art'. It was, therefore, open to artists in the future to designate all kinds of objects which fell outside the canonical conception of 'painting' with the performative statement: This (I say) is art.

Objections to the consequences of Duchamp's position (if not of Manet's) generally take the form of saying that a work cannot (or should not) be classified as art, simply because the artist has chosen to place it in a gallery. But this way of putting the issue neglects the point that the 'gallery' is not an historical *given*, apart from the conditions of artistic production. More specifically, the 'gallery' or 'museum of modern art' is itself a product of the institutional history of the regulation of modes of exhibiting against which Manet, and Duchamp, made their interventions. Museums of Modern Art in Lodz, New York and elsewhere date their origins to the inter-war period. It seems reasonable to assert that, in their degree of specialisation and their effective break from the academic tradition of the Salon, they have been preconditioned to precisely the kind of dynamic exploitation of the reations of exclusion/inclusion which Duchamp perfected, in the previous decade.

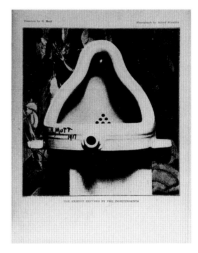

Fig. 5 Marcel Duchamp, *Fountain*, 1917. Photograph by Alfred Stieglitz, published in *The Blind Man*, New York, May 1917

6 It is however worth noting the advances made by Maison Goupil, centred in Paris, in the domains of printmaking and reproduction (including photography of art works) over the period 1830–1900.
7 Thierry de Duve, *Kant after Duchamp*, Cambridge, Mass., and London, 1996, p. 189.
8 Ibid., pp. 89–143.

According to the previous argument, the current of modern art deriving from Duchamp – and identified in the present exhibition grouping, under the category of 'Language' – depends essentially on the progressive development of new institutional structures. Before Duchamp, the crucial change in the wake of Manet was the foundation of the Société des Artistes Indépendants around Seurat: in De Duve's terms, 'the first time that an art institution claimed to found its own legitimacy on the mandate it had received from its members rather than on the continuity of a tradition guaranteed by a jury.'[9] After Duchamp, the logic implied by the proposition that even the artists' own exhibiting society can have no grounds for refusing an object that someone declares to be a work of art leads inevitably to the proposition, ardently defended by Joseph Beuys, that everyone can and should become an artist. The precondition of the last, Utopian position is, of course, that there should be museums and galleries of modern art whose thresholds determine the crucial borderline between art and the outside world; only in this context does Beuys's radical proposition acquire a precise meaning.

The current of modern art associated with Duchamp forms no doubt the clearest proof of Modernism's historical connection to the Academy. But no less convincing evidence can be found in the diverse ways in which modern artists have utilised the categories of *genre*, ostensibly jettisoning the traditional hierarchies, only to reinstate them, as often as not, under another guise.

By the end of the third quarter of the nineteenth century, the uneasy conflict of *genres*, which had developed since the 1830s both inside and outside the Salon, had apparently worked itself out, in the form of a simple polarity. Delaroche's pupil, Jean-Léon Gérôme, had carried the *genre historique* to a further peak of success within the Salon, and opened up a lucrative international market for his classical and oriental scenes. On the other hand, *plein-air* landscape had become the identifying hallmark of the most radical new group of young painters, baptised Impressionists. Landscape paintings continued to be exhibited at the Salon, throughout the nineteenth century, and in general they made little obeisance to the cult of brilliant colour and evident brush-work defended by Monet, Pissarro, Renoir and their companions. But there can be little doubt that, in the early propagation of a notion of 'modern art' which has proved remarkably long-lasting, the Impressionist landscape provided a central focus and rallying point. It was there that academic values were most spectacularly inverted, whilst generic safeguards were still, in a sense, preserved.

It would, however, be quite wrong, to assume that Impressionism wiped out the other *genres*, or made them irrelevant to modernist development. Indeed, the striking feature of Cézanne's career, viewed over its entire extent, was the catholicity with which he persisted in developing the full range of pictorial *genres*. Portraiture, including self-portraiture, was a thread which extended throughout his working life, from the early, crude, renderings of his father, painted for the family home, to the mysterious images of the Gardener, dating from the period just before his death. Still life and landscape occupied his most creative energies with an economy of labour which determined that the former

9 Ibid., p. 141.

would involve compositions of manipulable and repeatable elements, whilst the latter would record the elusive and changeable features of the same canonical scenes. Yet Cézanne was not unaware of the challenge of another type of *genre*, the traditionally superior history painting: his three great *Bathers* reflect in size and complexity of content the qualities of this, the highest of genres (Fig. 6).

Genre was also a highly relevant category, where the achievement of the Cubists was concerned. If we compare the works of Braque and Picasso in the period between 1906 and 1912, it is evident that, for both artists, the mode of still life, so audaciously exploited by Cézanne, became the vehicle for reworking the vocabulary of plastic form, to the point of abandoning the visual identity of objects and supplanting it with a semiotic code accessible to the eye only through the intellect. On the other hand, landscape, utilised by Braque to work through his relationship to the paintings and example of Cézanne, never played a major part in the pictorial practice of Picasso. Where Picasso seemed close to Cézanne once again, in the matter of *genre*, was in his periodic concern with the creation of large-scale pictures, compiled painstakingly from innumerable sketches and put before the contemporary audience in the spirit almost of a manifesto. If such works as the *Demoiselles d'Avignon* (1907) (see Fig. 1, p. 52) and *Guernica* (1937) (see Fig. 3, p. 54) are not history paintings, in the strict sense, they have nonetheless come to fulfil the demand for the complex masterpiece anchored within a historical tradition, which the academic history painting was intended to provide.

How far does *genre* continue to be useful, as a category for understanding the further development of modern art after Cubism? It could be argued that the differentiation which it implies ceases to have significance for the spectator when a development like the rise of abstraction challenges the very concept of subject matter or classifiable content, in the work of art. On the other hand, *genre* has proved surprisingly persistent in determining possible affiliations and differences within a body of work. Willem de Kooning may come across primarily, though not exclusively, as an Abstract Expressionist, preoccupied with the application of paint on large-format canvases. But the clues which his titles provide, of a differentiation between portraiture and landscape, help to prepare the viewer for a different kind of spatial organisation; in retrospective exhibitions of his work, this generic difference tends to be accentuated by the distribution of such works between different rooms.

The most recognisable and persistent of all genres, the portrait, has had a continued currency throughout the development of modern art. It is possible to find among the artists represented in the exhibition as a whole a number who are identifiable primarily as portraitists, though their choice of medium may show the widest of possible disparities. Alberto Giacometti and Cindy Sherman might be two such examples (Cat. 106–107 and 401–408) – or indeed Gilbert & George, though in their case, the predominant concern with large-scale compostions involving groups of figures and overt references to contemporary urban life might indicate a typology closer to history painting (Cat. 316). Traditionally regarded as of equivocal value in the academic system, because of its concern

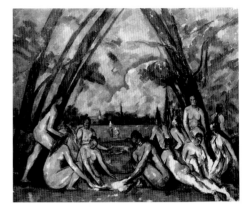

Fig. 6 Paul Cézanne, *Large Bathers*, 1899–1906.
Philadelphia Museum of Art

with the particular rather than the ideal, portraiture is now without doubt the *genre* of modern art whose categorial status is most evident, and most clearly linked with the non-modernist practice of academic painters and photographers which continues in parallel.

A further word needs to be said here about the significance for modern art of the academic distinction between *tableau* and *morceau*, and between the finished work and the sketch (*esquisse*, *ébauche*). It is obvious that Modernism involved a large-scale rearrangement, if not a complete inversion, of these categories which constrained the Salon juries in the nineteenth century. Clement Greenberg, indeed, proclaimed that the hallmark of good modern painting, since Manet, was its repudiation of 'received notions of unity and finish', and, in his judgment, the criterion could be applied without reservation to justify the quality of 'American-type painting'.[10] In the generation following the Abstract Expressionists, a painter like Cy Twombly has even more egregiously inverted the categories of the sketch and the finished painting by covering his immense and luminous canvases with small details, often in pencil, which connote the aesthetic of the sketch (see Cat. 172 and 394). But this does not necessarily mean that Twombly, for the sake of example, repudiates the traditional relationship between sketch and painting. He remains one of the many artists committed to producing large-scale, indeed explicitly mythological and historical, works, and who is also continuously engaged in the practice of drawing.

In fact, although modern art has repudiated the overt hierarchisation of artistic practices, it has not eliminated the need for artists to establish categories of work which in many respects correspond to the plurality of previous practices. Even Kandinsky, the painter most preoccupied with the need to establish a universal language of abstraction, felt the need to pursue parallel series of work throughout the period of his most revolutionary discoveries: there existed, side by side in his production, 'Studies', 'Improvisations' and 'Compositions', these different terms faithfully reflecting the degree of liberty which he had allowed himself, balanced against the need to devote special care and preparatory study to a select group of works.

I have perhaps said enough to suggest that the 'cultural rupture' which lies at the mythic origin of modern art was no overnight transformation, dateable, perhaps, to the 'Salon des Refusés' of 1863. On the contrary, it derived from the progressive and long-term establishment of a series of specific differences, which depended for their effect on the constraints from which they ostensibly diverged. It is no accident that Paris became the 'laboratory of the twentieth century' since, throughout the first half of the nineteenth century, Paris was the centre of a uniquely constraining system for the training of artists and the public exhibition of their works. Neither in Britain, nor in Germany, nor in Italy were the constraints so evident and so severe. Equally, it is no accident that French painting, specifically, became the driving force in the establishment of modern art, since only painting possessed the long and detailed academic pedigree, and the generic richness, capable of generating differences within – and, eventually, outside – the system.

10 Clement Greenberg, *Art and Culture*, London, 1973, pp. 125, 208–29.

The same is true of what might be called the ideology of modernism. But here we can trace with no less certainty the way in which concepts of art, nurtured in the Parisian ambience, were adopted and transformed, in the course of more than a century's development. It was as early as 1835, in the publication of the Preface to *Mademoiselle de Maupin*, that Théophile Gautier first sketched out the rationale of *l'art pour l'art* – art for art's sake – and enshrined the figure of the dandy at the heart of the modernist project. In order to intensify his message, that art should be divorced from utility, and thus conclusively separated from the constraints of bourgeois morality, Gautier invoked the non-utilitarian, transcendental imagery of theology. His legacy can be discerned, not only in the position of a *fin-de-siècle* aesthete like Oscar Wilde, but also in the critical writings of a twentieth-century critic like Adorno, when he defends the work of the poet German Stefan George for its 'asocial character' and relates it to late bourgeois society through the concept of 'determinate negation'.[11] An analogous process can be identified in the plastic arts, if we look at the way in which the negation of everyday subject matter, coming in the wake of Impressionism, initiates the drive to abstraction by invoking the tradition of religious painting. Maurice Denis asserts in 1890 that 'a painting – before being a warhorse, a female nude, or any kind of anecdote – is essentially a plane surface covered with colours assembled in a certain order.'[12] In explicitly returning to religious motifs (Fig. 7), and what he takes to be Byzantine tradition, Denis anticipates the 'formal revolution' of Malevich, whose own notion of a 'plane surface covered with colours' arrives at pure abstraction, by way of the icon.

In numerous, similarly complex ways, Parisian modernism facilitated the expansion of modern art to other centres, where specific differences of a local kind could be used to energise its message. When Rosenberg noted the 'Fall of Paris' in 1940, he was, of course, aware of the incipient rise of New York as a centre of the culture of modern art – a process which Duchamp's assumption of the identity of R. Mutt, in the spring of 1917, had helped to bring about. There is no inconsistency in saluting the international nature and vocation of modernism, whilst at the same time insisting on the specific cultural circumstances which gave it its unique power. If, in this exhibition, we can look at a vast range of works, sub-divided by category, as touchstones of modern art, we should also be aware that it is not just the works themselves, but the whole concept of exhibition and display which is historically determined. There is no reason to suppose any future century will be able to sum up the general view of its uniqueness in comparable terms.

Fig. 7 Maurice Denis, *Annunciation*, 1913. Musée National d'Art Moderne, Centre Georges Pompidou, Paris

11 Theodor Adorno, *Prisms*, London, 1967, pp. 225–6.
12 Maurice Denis, *Théories*, Paris, 1920, p. 1.

BEAT WYSS

The Two Utopias

In his investigation of the 'Principle of Hope',[1] Ernst Bloch distinguishes between two basic types of utopia: that of liberty and that of happiness. The utopia of liberty is founded on the idea of the autonomous individual, or subject, and the utopia of happiness on that of the calculable perfectibility of human destiny. These two promises to humankind are mutually exclusive – not least because of the time-lag between their first appearances in history. As a political dream, the idea of calculable perfectibility haunts the whole post-Renaissance age, from Thomas More by way of Francis Bacon to Charles Fourier and Karl Marx. The mysticism of rationality, as developed by Mondrian, harks back to the 'Ethica more geometrico' of Spinoza. The Baroque optimism of the idea of living in the best of all possible worlds lives on in classic modernism. The belief in the educative effect of 'good form' is anchored in the sensualism of the eighteenth century; and the belief in the technical feasibility of happiness is rooted in the theodicy. Like Leibniz, Le Corbusier took the view that humanity is able to understand and imitate the vast clock mechanism of Creation: 'The engineer, advised by the principle of economy and accompanied by calculations, puts us in tune with the laws of the universe. He attains harmony.'[2]

'Scientific Socialism' is the last link in the chain of post-Renaissance dreams, which also absorbed the 'Sun State' of Thomas Campanella – a utopia devised by a Dominican monk whose passionate hope for the future remained undimmed by torture and lifelong imprisonment, and who, from his Neapolitan prison cell, foretold the reality of absolutism as it was to develop in France. The 'Reality of Socialism', in our own time, also had its roots in dungeons; for utopias are nightshade growths that spring from starvation, blows and scurvy. Which is why their fruits always taste of the foul humus from which they grow. The 'Reality of Socialism' comes closer to the planetary model of kingship in the Baroque age than it does to the shores of the United States of America, to which the idea of individual freedom – the second of the promises of the modern age – was transplanted. This utopia is a more recent one: it unfolded in the eighteenth-century Enlightenment, acquired a political profile in the American Declaration of Independence of 1776 and found a cockpit in the French Revolution of 1789. It did not prevail. The history of individualism in the post-Renaissance age is a chronicle of suffering. Drawn towards freedom, the self-confident social individual perennially falls for the blandishments of the other utopia, that of human happiness, and is impelled to the barricades, only to be robbed of the fruits of his/her rebellion and forced back into the straitjacket of the so-called Collective Good. Artists and intellectuals are the embodiments of this conflict. The choice between aesthetic autonomy and service to society is among the central issues of modern culture.

1 Ernst Bloch, *Das Prinzip Hoffnung*, 3 vols., Frankfurt a. M., 1982; trans. as *The Principle of Hope*, London, 1986.
2 Le Corbusier, *Ausblick auf die Architektur*, Berlin, Frankfurt a. M., Vienna, 1963, p. 21.

Historically, the reality of their own powerlessness left artists with just two basic options: either identify with an ideal project for the world, or disavow usefulness altogether. And so the German Romantics dedicated themselves to restoring the Emperor Barbarossa to his throne, while in Paris and London the votaries of 'dandyism' assumed the right to transcend morality and the common good, and to do evil. The Bauhaus saw itself as the harbinger of a twentieth-century technological paradise, while simultaneously the various cells of the Dada movement staged revolts in the name of freedom from purpose.

The history of modernism is a tale of artists betrayed and punished. Their anarchic attempts at self-assertion were met with repression; their allegiance to political ideals clashed with the practical implementation of those ideals. Artistic utopias wilted in contact with practical politics. The Romantics' ideal of the 'unity of the German tongue' ended in a loudmouthed Kaiser; the poetry of the machine ended in the plain prose of environmental destruction. Utopia was finally achieved – only to defame the innocence of its artist prophets by its sheer banality.

The most favourable climate for the free development of modernist art was offered by Paris. By the turn of the century the wounds of the defeat by Germany, and of the crushing of the 1871 Commune, had healed. Paris had become the metropolis of culture – a claim that it effectively asserted through three successive World Fairs. Here, within a period of fifty years that spanned both Impressionism and Cubism, there evolved a hedonistic strain of art that politics could neither enlist nor define.

With Surrealism, the relationship between art and power once more became an issue. Against the background of the economic and political crises of the 1920s, controversy raged as to whether 'Revolution' was an artistic or purely a political matter. Should the Surrealists meekly accept the Communist Party's petit-bourgeois definition of art? Or should Trotsky's view prevail, according to which art was not a matter for dictation by the Party? Art presented a topsy-turvy image of the real world, so that the Trotskyist Breton was able to tilt the balance of power in his own favour. In 1932, in his capacity as General Secretary of Surrealism, he expelled the Stalinist Aragon from the group.

Cultural life in France was centralised in Paris, where the general mood – a legacy of the Commune – inclined to the left. In federalist Germany, the orientation was not so clear. The political ideas of German artists often included a dash of provincial idealism. The German avant-garde had an ambivalent attitude to Paris: even many intellectuals were not immune to the official ideology that branded France as the ancestral foe. The Expressionists felt themselves bound to Germany as a land of Faustian profundity and Nordic 'culture'. Such a self-image required France as a foil – a country ruled, with typically Latin superficiality, by a polished 'civilisation'.

Of course, there were left-wingers among the German artists. Some of these emigrated to the Soviet Union, where their enthusiasm did them no good at all. Although Hannes Meyer, the ex-director of the Bauhaus, got away almost unscathed, Heinrich Vogeler, formerly of the Worpswede school, died in the GULag. Like Orwell's Big Brother, Stalin mistrusted volunteers. Communists from the West were all too likely to be carriers of the

Fig. 1 Oskar Schlemmer, mural for the workshop building of the Bauhaus in Weimar. View of the relief to the left of the entrance, 1923 (destroyed in 1930). Photo-archive C. Raman Schlemmer, Oggebbio

Enlightenment virus; they must be eliminated. Oskar Schlemmer was an idealist, but a largely apolitical one; in this he shared the fate of the majority of German artists, whose high-flown idealism exposed them, despite the best of intentions, to the crossfire of entrenched left-wing and right-wing ideologies.

Artistic totality and totalitarian politics: the case of Oskar Schlemmer

Like many of his generation, Schlemmer went to war in 1914 in a spirit of patriotic euphoria. His war diaries largely omit the day-to-day routine of warfare. Schlemmer noted down his ideas on art and on his reading: he devoured Sören Kierkegaard's *The Sickness unto Death* and *Either/Or,* Jean Paul's *Siebenkäs,* Friedrich Nietzsche's *The Antichrist,* Thomas Mann's *Death in Venice* and Oscar Wilde's *The Picture of Dorian Gray,* while in the front line the catastrophe took its course.

In the autumn of 1916 Schlemmer was posted to a survey unit, where he was required to interpret aerial reconnaissance photographs. This was a task that inspired him greatly as an artist. The photographs were two-dimensional images, reminiscent of abstract compositions. He wrote in his journal: 'I am waging a battle against my Renaissance line. The weapon? Rigour, form, plane, forms of the new.'[3] While the artist, back at base, struggled to find new means of expression, aircraft dropped bombs on undefended cities and killed soldiers by the thousand in mustard-gas raids on the trenches. In retrospect, it is of course easy to marvel at the naïvety with which intellectuals stumbled into that horrific adventure. And on they stumbled – quite cheerfully, at first – into the 'Golden' 1920s, a decade that deserved its epithet for five years at most.

In 1921 Schlemmer was appointed to a teaching post at the Bauhaus in Weimar. There he stylised the Dadaist 'arts ball' into a *Triadic Ballet*. Increasingly radicalised after the Bauhaus moved to Dessau in 1925, the students found Schlemmer's productions too tame. Their leading spokespersons were members of the Communist Party, who aimed at a politicisation of the theatre. Schlemmer refused to change and left in 1929, together with the director, Walter Gropius. Gropius went to the US, Schlemmer to Breslau.

The political wrangles at the Bauhaus were soon terminated from on high. In 1929, the National Socialist German Workers' Party won the state elections in Thuringia. The new Nazi minister of internal affairs and education, Wilhelm Frick, appointed Paul Schultze-Naumburg as the director of the Hochschule für Handwerk und Baukunst (Institute of Craft and Architecture), in the building that had been occupied by the Bauhaus before its move to Dessau. Before the school opened for the winter semester of 1930, Schultze-Naumburg ordered Schlemmer's mural in the workshop building to be destroyed (Fig. 1). And so Schlemmer was one of the first artists to suffer from the Nazi iconoclasm. With characteristic confusion, the work of an artist who had been unceremoniously ejected from the Bauhaus by a Marxist student body was now removed from its walls under the slogan of 'The Fight Against Marxist Degradation'.[4] Times now became hard. In March 1933, a Schlemmer retrospective at the Württembergischer Kunstverein in Stuttgart had to be taken down from the walls before opening day, after anonymous telephone calls

3 Oskar Schlemmer, *Briefe und Tagebücher,* ed. Tut Schlemmer, Munich, 1958, p. 45.
4 Quoted from Karin v. Maur, *Oskar Schlemmer,* vol. 1: *Monographie,* Munich, 1979, p. 232.

threatened massive disruption if the showing of a 'cultural Bolshevist' went ahead. In the previous winter, Schlemmer's teaching work at the Berlin State Schools had been cut off. A poster had appeared at the Academy with the words: 'Avoid These Teachers!' The names listed were those of Schlemmer, Karl Hofer, Emil Rudolf Weiss, César Klein and Ludwig Gies, all of whom were branded as 'destructive Marxist-Jewish elements'.[5] At the end of the semester Schlemmer was dismissed. He complained to the local group leader of the National Socialist party and sent a letter of protest to the minister responsible, Joseph Goebbels, invoking the military honour of the members of the avant-garde who had willingly gone to fight in the First World War:

> We went to war for the ideals of art, in genuine enthusiasm for a great cause! In the name of my fallen comrades, I protest against the defamation of their ideals and of their works, now held in museums and due to be desecrated.

He concluded with a thought that was as honourable as it was naïve and foolhardy:

> Artists are apolitical to the depths of their being – necessarily so, because their kingdom is not of this world. What they have in mind is always humankind: the totality with which they must be united.[6]

At this point Schlemmer still believed that his dream of cultural totality could offer an alternative to the political fact of totalitarianism. His utopia was not a democratic one, in the liberal sense of the word; he envisioned a state that would largely be moulded by artists and would itself be a *Gesamtkunstwerk*, a holistic, total work of art. His 'Appeal on Matters Artistic', published in the *Deutsche Allgemeine Zeitung* on 22 August 1933, invokes the 'experiment of a State composed in the grand style, with all those hallmarks of thematic development and structure that we artists know so well from our more restricted sphere of activity'. His model for a future 'reunification of Art, State and People' was to be found in the theocratic cultures of Egypt and Babylonia.[7]

This article was Schlemmer's answer to Gottfried Benn's radio speech on 'The New State and the Intellectuals', which had polarised the avant-garde. A lyric poet had spoken in justification of book-burnings! Benn openly professed his allegiance to the National Socialist movement and condemned those in the arts who called for intellectual freedom: they were weaklings, pallid survivals of an overbred liberalism. These last remnants of a bourgeois age were, he said, being swept away by the power of the political movement. He called upon the intellectuals to bow to the 'yoke and the new law'.[8] Schlemmer answered Benn in a long, open letter in which he spelt out for the poet the true, philistine nature of the Nazis' cultural policy.[9] Not that he personally had anything against strength and rigour: those were the very criteria that governed his own work. If only the new regime had replaced the dismissed teachers at the academies with 'true revolutionaries'! But those who came in their place were mere 'kitschmongers', exponents of a *Neue Sachlichkeit* version of Biedermeier, whose 'vapid academicism' revealed not a trace of the 'State composed in the grand style' of which Schlemmer had dreamed. In his letter, he concentrated wholly on art; the Nazis' political programme hardly rated a mention. For a time, Schlemmer went on believing that the tide of cultural politics would turn in his favour. He followed with interest the activities of the NS-Studentenbund (Nazi Stu-

Fig. 2 Oskar Schlemmer, study for a design for the competition for the decoration of the Congress Hall in the Deutsches Museum, in Munich, 1934. Oskar Schlemmer Family Estate, Badenweiler

5 Quoted from v. Maur (as note 4), p. 234.
6 Schlemmer (as note 3), p. 309.
7 Quoted from v. Maur (as note 4), p. 242.
8 Printed in *Berliner Börsenzeitung*, 25 April 1933; quoted from Gottfried Benn, *Gesammelte Werke*, ed. Dieter Wellershoff, Wiesbaden, 1968, pp. 1004–13.
9 Dated 22 October 1933; see Schlemmer (as note 3), p. 315 ff.

Fig. 3 Oskar Schlemmer, *Vorübergehender* (Passer-By), 1924-25. Whereabouts unknown

dent League), led by Fritz Hippler, which disowned the 'chambers of horrors' to which the regime had consigned so-called degenerate art and spoke up in favour of Expressionism. Another glimmer of hope came when an exhibition of Italian *Aeropittura* was held in Berlin and Hamburg early in 1934 under the patronage of Mussolini. He wrote to his brother Willy: 'Succour comes from the Italian Fascist painters, the former Futurists. But everything just isn't the way it is in Italy – where there's no anti-Jew campaign either.'[10]

In 1934, Schlemmer entered a competition to provide murals for the conference hall at the Deutsches Museum, Munich; he submitted a design for a mosaic. The subject laid down was *The March of the Blond Nations*. A few sketches are all that remains of Schlemmer's entry. For the long sides of the hall he drew a close-packed procession of humanity, marching in serried ranks towards the radiant figure of a youth on the podium end wall (Fig. 2). Although he made concessions to prevailing taste by rendering the figures in a rather conventional, Neoclassical style, this did him no good. The competition was won by Hermann Kaspar. The former Bauhaus professor's designs were returned to him with the explanation that they were 'unequal to the demands of so important a commission'.[11] This was a painful humiliation for an avant-garde artist who had supposed himself to be adapting to the requirements of the new patrons.[12] He was now also compromised in his colleagues' eyes, because the design (now lost, perhaps deliberately destroyed) contained a swastika, possibly in a blaze of light above the youth's head. Schlemmer defended this in a letter to Willi Baumeister:

> I did use the present-day emblem of the nation as a solar symbol; and in the course of the work ... the greater part of which was not painful to me, I lived in a spirit of Schillerian idealism. I depicted The March of the Blond Nations (it would have amounted to about 3,000 figures in all), and there was in it something of the 'Community of the Nation', of which we hear so much. I take some pride in this, because I have not found it in any other design – as an idea – and the themes of it still preoccupy me (in a formal and artistic sense).

He concluded:

> I am now cured, at all events – not only because I realise that there is no point in playing fast and loose with symbols, but also because any effort we may make is hopeless: we are marked men.[13]

It is characteristic of the inscrutable style of National Socialist art policy that work by Schlemmer appeared in the official exhibition *Malerei und Plastik in Deutschland* (Painting and Sculpture in Germany), held in Hamburg in 1936 as part of the cultural programme of the Berlin Olympics. In July of the following year, five of his paintings hung in the Munich exhibition *Entartete Kunst* (Degenerate Art). The next of the Nazis' 'exhibitions of infamy' opened in Berlin a few weeks later: and this, *Bolschewismus ohne Maske* (Bolshevism Unmasked), in the foyer of the Kroll-Oper, included Schlemmer's painting *Passer-By* of 1924-25 (Fig. 3). He wrote to Gerhard Marcks: 'I fail to comprehend what this tautly idealistic painting has to do with the theme of the exhibition, which is "Bolshevism equals Jewry."' To Baumeister he complained of being 'lumped together with Stalin, Kerensky, murderers, robbers and Jews'.[14] Schlemmer could have emigrated to the United States, where his reputation was growing, but he had a wife and three children, and his inclinations were sedentary. He retreated to his new home at Sehringen, in the south of Baden. In 1938, when the New Burlington Galleries in London showed three of

10 Quoted from v. Maur (as note 4), p. 236.

11 Unpublished journal entry by Schlemmer; quoted from v. Maur (as note 4), p. 250.

12 Karin v. Maur urges in Schlemmer's defence that he acted out of a sense of responsibility, in the attempt 'to make this State, which had dismissed and excluded him, mindful of its humanistic traditions, and to convince it of the need for a free art, subject only to its own pictorial laws'. V. Maur (as note 4), p. 250–51.

13 Tut Schlemmer omitted this letter, dated 27 December 1935, from her edition of Schlemmer's letters and journals. It is quoted here from René Hirner-Schüssele, *Von der Anschauung zur Formfindung, Studien zu Willi Baumeisters Theorie der modernen Kunst*, Worms, 1990, p. 103.

14 Quoted from v. Maur (as note 4), p. 238.

his works in its exhibition of *Twentieth Century German Art*, which was meant as a riposte to *Entartete Kunst*, Schlemmer's reaction was apprehensive. He feared trouble, because Hitler was known to resent the exhibition as an interference in German cultural politics. Aside from a few artistic commissions, Schlemmer got by as a jobbing painter. For the Stuttgart painting contractor Albrecht Kammerer, he did camouflage work. From 1938 onwards, he occasionally decorated objects in enamel paint for the Herberts paint works in Wuppertal, where he became a full-time employee in August 1940. But this utilitarian work did not suit him. On 15 December 1940 he wrote:

> If anything, I ought to have disappeared in 1933 – gone abroad, where no one knows me – instead of display-
> ing before the forum of the artistic conscience the unworthy spectacle of selling one's soul for a few pieces of
> silver. Shall I ever master this gnawing feeling? Shall I ever set the example of one responsible action?[15]

Fig. 4 Oskar Schlemmer, *Am Fenster, Fensterbild IX* (At the Window, Window Painting IX), 1942. Von der Heydt-Museum, Wuppertal

He looked with some envy at the friend of his youth, the more robust and pragmatic Willi Baumeister, who had been responsible for getting him the job in Wuppertal. Schlemmer – who in the 1920s had been the more successful of the two, and who had a professorial career in Weimar, Dessau, Breslau and Berlin behind him – felt a sense of inferiority in his relations with the down-to-earth Swabian. Baumeister, who was work-ing on abstract experiments with colour, was better able to use the practical work in the paint factory for his own artistic ends. Schlemmer, by contrast, regarded himself as a 'nature painter', and saw in abstraction the peril of impersonality: 'I am anti-surreal, pro-Seurat and the like.'[16]

Schlemmer's own painting continued to be based on optical impressions. Early in 1941 he embarked on his *Window Paintings*. These show views from his attic window through the windows of neighbouring apartments, always seen in the early evening, just before blackout time. We see the spectral outlines of a supper table, a figure flitting past, the shadow of a piece of furniture behind drawn curtains (Fig. 4). These *Window Paintings* offer a form of abstraction created by the artist's impersonal view of a contingent reality. They are a poignant record of the modernist artist as he stares out, hollow-eyed, through the narrow cleft of his attic window, into an outside world that has dispensed with him.

A quotation from Rilke – 'not to treat art as a selection from the world, but as the total transformation of the world into splendour ...'[17] – is the last entry in Schlemmer's journal. He died on 13 April 1943.

The Marshall Plan of Modernism

Schlemmer typifies the artist who is profoundly apolitical but steeped in a lofty sense of his own artistic mission. A man who had worked at the Bauhaus on shaping a new soci-ety could never rest content with working for a wage in a paint factory – however ideal-istic the aspirations of its proprietor, who had been influenced by anthroposophy. Dr Herberts had transposed the Bauhaus notion of a reconciliation between art and techno-logy into the context of a family firm. What to Schlemmer was tedious hack work bore the marks of an art that was to become dominant in the postwar period. Working with the firm's paint technicians, he developed a drip device that dispensed paint through a

15 Schlemmer (as note 3), p. 382.
16 Schlemmer (as note 3), p. 394.
17 Schlemmer (as note 3), p. 406.

Fig. 5 Oskar Schlemmer, Enamel Panels for *Modulation und Patina*, 1940-41. Collection of Kurt Herberts, Wuppertal

Fig. 6 Oskar Schlemmer, Design for the *Lackkabinett* (Enamel Cabinet), 1941. Von der Heydt-Museum, Wuppertal

funnel-shaped glass tube. German art historians have seen this as an anticipation of Drip Painting. Schlemmer's experiments with paint and its material texture led beyond *tachisme* and *art informel.* The gloss enamel panels he painted in 1940-41 for the abortive book project, *Modulation und Patina* (Fig. 5), would not be out of place alongside Zero Group objects of 1960. The industrial process brought Schlemmer's experiments with colour close to Abstract Expressionism and Minimal Art. His enamel panels are 'nonrelational': the paint is applied direct, without a prior sketch, by a mechanical device. The French *tachistes*, by contrast, persisted in carefully composing their 'spontaneous' handling of paint, which was transferred to the canvas from a sketch. However, the format of the panels, a modest 29 x 20 cm, remains decidedly European. Schlemmer's death and the turning tide of war prevented the execution of his *Enamel Cabinet:* this was an experimental space in the factory, large enough to walk into (3.3 metres wide and 4.5 long by 2.8 high), and with its walls and ceiling clad with gloss-painted panels (Fig. 6). Had it been carried out, the installation would have made history as the first Minimal Art installation in Wuppertal.

Schlemmer himself was unaware of the prophetic nature of his late work, since he still defined art in terms of Kandinsky's idea of the 'Spiritual in Art'. He failed in of the lofty aim of the European avant-garde: that of removing the gulf between art and life by artistic means, whereby the artist's intervention would ennoble industrial products and rid them of their banality. But the paint factory where Schlemmer worked in Wuppertal supplied, among other things, camouflage paint for protection against Allied bombers. As a result of the war, which far outdid the Futurist manifestos in the hideous banality of its destructiveness, enthusiasm for industry and technology gave way to massive disillusionment. The utopian magic had been lost, and no pragmatic relationship had taken its place.

In postwar Europe, the critics of civilisation set the tone: conservative in the case of Martin Heidegger, progressive in that of Theodor W. Adorno. Art was there to compensate for a functionally organised world. Abstract artists named their paintings after gloomy heroes from the Old Testament and the Epic of Gilgamesh; the Fluxus movement played ironic games with industrial detritus; Joseph Beuys knocked together an esoteric counter-technology.

Europeans experienced industrialisation in the shadow of war production, and the outcome was defeat. Americans, by contrast, experienced it in the aura of victory. In the production of consumer goods, their industry and technology carried all before them. It was the triumph of the American Way of Life. Art in the US rejected the spiritual inheritance of classic modernism. Its relationship to technology was a pragmatic one. The process culminated in Pop art, the creative reaffirmation of 'everything that is the case' (in Wittgenstein's words) within the context of industrial society. Here, cultural aspiration and industrial reality were successfully united, and art's idealistic ambition to educate was jettisoned. Artists regarded themselves simply as the creative appliers and interpreters of industrial products. Jackson Pollock painted with automobile enamel; Richard Artschwager used vinyl; Andy Warhol reproduced the imagery of the world of commodities.

Beginning in the late 1950s, US culture conquered the Old Continent. Europe had proved that it could not apply the ideas of the Enlightenment for itself, and that it was oppressed by their fateful dialectic. Had the Enlightenment not been transplanted into the US ecosystem, it would perhaps have disappeared; the States of a Pre-Columbian Europe might by now be a cantankerous, encrusted collection of old-style Stalinist, techno-Fascist, clerico-gerontocratic travesties of Jean-Jacques Rousseau's 'Social Contract'. Nor must the rebuilding of Europe after the Second World War obscure the irreversible change that had taken place: Eurocentrism was finished. In two world wars, the political landscape that had launched the so-called discovery of the earth had turned the brute force of colonialism against itself.

The ideas of the Enlightenment flourished across the Atlantic, and after 1945 they were flown back in with the Marshall Plan and the Berlin Airlift. Enlightened conservatives such as Nelson A. Rockefeller financed exhibitions of US artists in Europe. And so, as a manifestation of the freedom of the individual under democracy, Abstract Expressionism acquired a political charge. One thing is certain: the historic avant-garde was not particularly democratically minded. Schlemmer's 'Appeal on Matters Artistic' is only one instance of the modernists' interpretation of their work as the foundation of a social *Gesamtkunstwerk*; it is an idea that plebiscites and parliamentary committees would simply have talked to death. Classic modernism treated art as a discipline for kings: artists, like the philosophers in Plato's ideal state, were there to give shape to an enlightened policy for the greater happiness of humankind. In the Americanised Western world, this older, absolutist utopia lost its relevance. Art gave up its claim to govern. 'Art is art', said Ad Reinhardt; 'everything else is everything else.' In the ideological battle for the rebirth of humankind, art had lost out to *Realpolitik*. The cultural politics of the *Pax americana* required the Old World to change course and adopt an Enlightenment that emphasised liberty rather than equality: not so much the General Will as the Pursuit of Happiness. This was the Enlightenment in its liberal variant, dependent not on central control by enlightened rulers but on competition between individual egos.

The Americanisation of culture also favoured a new aesthetic in the reception of art: the emphasis was now on subjectivity. In Europe, the dominant subjectivity was that of the artist, who in producing the work either expressed his own emotions like a seismograph or collected them as traces of an 'individual mythology'. In the USA, on the other hand, the viewer's subjectivity took centre stage. The big canvases of Barnett Newman and the unwieldy steel plates of Richard Serra are challenges to our perceptions. The artist is a surrogate viewer of the world who passes on his observations to the public. His techniques offer a grainy blowup of things that the technological world already offers us in non-artistic form. In this respect, too, Schlemmer's window paintings are prophetic.

And so the history of twentieth-century art is Janus-faced. One face looks backward to the zenith and decline of classic modernism, with its dream of the utopia of a State 'composed' by art. The other face looks forward to the worldwide spread of a Pop culture in which the Enlightenment deregulates itself.

BORIS GROYS

The Will to Totality

The art that was officially encouraged and praised in the Soviet Union, Germany and Italy during the 1930s and 1940s, when those countries were under totalitarian rule, remains highly suspect in the eyes of those whose aesthetic awareness has been educated under modernism, and fails to fit into any accepted historical classification of twentieth-century art. There is not much 'totalitarian' art in today's art museums. These artists and their works are not, as a rule, discussed in the language normally used for talking about art; on the contrary, the works are denied the status of art altogether. The official art of the totalitarian countries thus offers a rare instance of irreducible Otherness in a present-day art context in which generally, as is well known, 'anything goes'. Only in the last few years has this situation begun to change.

There is an undeniable moral force behind this public ostracism of totalitarian art. In all the totalitarian countries, art served primarily as a means of propaganda for the ruling ideologies concerned; therefore, those artists who were actively involved certainly bear some degree of responsibility for the consequences, many of which were horrendous. The fact is, however, that the strategies of exclusion practised by mainstream art historians are founded more on aesthetics than on ethics.

Many of the leading artists of the twentieth century have felt – and proclaimed – an affinity with one variant or other of Communism or Fascism. Nor has this done much damage to their reputations. Indeed, the artists of the Russian avant-garde, who were active champions of Soviet power, and the Italian Futurists, who demonstrated their loyalty to Italian Fascism, have been given their due place in the art-historical canon of the twentieth century. The real problem in dealing with totalitarian art lies in those works that seem to reflect premodern or antimodern artistic attitudes – Neoclassicism, Realism or Naturalism. As a rule, history deals leniently with a political dictatorship if it fosters the evolution of art. Italian Renaissance tyrants tend to be forgiven their misdeeds, because they were patrons of an aesthetically progressive art. Tyrants whose taste in art is passé are never forgiven for anything.

The significance of totalitarian art is therefore an aesthetic rather than a moral issue. In art-historical terms, how are we to assess the specific aesthetic promoted by the totalitarian regimes of the 1930s and 1940s? To put it another way: does totalitarian art, in spite of everything, have a place in the history of modern and modernist art in this century? It all depends on precisely what we mean by 'totalitarian'. For present purposes, it is enough to state that, over and above all the differences among individual totalitarian states, and all the numerous possible theories of totalitarianism, one crucial common

element remains: for the totalitarian state, the whole of society constitutes one undivided, homogeneous field of action. The modern political mind, as embodied in the totalitarian state, craves an entirely free hand in dealing with the context of its actions. The totalitarian mind believes that it can remodel that context, in its totality, at any moment and in any desired way. This is a quintessentially modern belief – and so art produced under its sway cannot really be either premodern or antimodern art.

Historically, the age of the totalitarian regimes followed the age of the avant-gardes. And what the artistic avant-gardes had done was to transgress and obliterate those boundaries that had traditionally divided and bounded the field within which art operates. In the first two decades of this century, all the norms of traditional art production were abolished, all its taboos broken, all its conventions abrogated. The artist acquired the freedom to deploy all possible forms and techniques. In this way, artistic production lost its boundaries. In common with modern technology as a whole, the techniques of art became equally applicable to everything in the world. And yet, in all this expansion, there remained one boundary that art could not cross: the boundary between art and reality, or in other words between art and its viewer.

Artistic revolutions or no artistic revolutions, the boundary of the context within which art was permitted to appear – that of the art market, the museum, the exhibition and so on – remained intact. And, on the other side of that boundary, the viewer's position remained protected and inviolate. Avant-garde art had emancipated itself from traditional taste and from traditional criteria of judgment; but, just as long as the public was still allowed to contemplate art from a secure, socially guaranteed, external viewpoint, the artist could never entirely emancipate himself from that public and its taste and judgment. After decades of artistic rebellion, the art system remained subject to the dictatorship of the consumer, the respondent, the viewer. 'Advanced' artists, in particular, inevitably found this dictatorship irksome, because the age of artistic revolutions had ushered in a new mass public whose aesthetic sensibility seemed worlds apart from avant-garde concerns.

The consequence, among the artists of the avant-garde, was the emergence of a specific 'hatred of the masses',[1] along with a desire to conquer and subjugate those masses, to bend them to the artist's will, to dictate the terms of their response to art. The avant-garde project was all about the integration of the viewer into the artwork. From the very start, it was thus a totalising or – one could say – a totalitarian project. The radical, historical avant-garde can best be defined as an attempt to replace the dictatorship of the art consumer with the dictatorship of the art producer. The avant-garde artist wanted to abolish the aesthetic detachment that placed the viewer in a position of superiority; he wanted to fashion the overall context in which his work would be situated. The aesthetic strategies adopted in order to make this dream come true were many and varied. They included, among others, the device of aesthetic provocation, the radical 'shock of the new', which was calculated to disconcert and disarm the viewer.

1 See John Carrey, *Haß auf die Massen. Intellektuelle 1880–1939*, Göttingen, 1996.

Clearly, however, there was no disarming the viewer by aesthetic means alone. Innovation throws people off-balance, but the effect does not last. Aesthetic dictatorship requires the support of a political dictatorship, one that can translate a specific aesthetic project into reality. Hence the tendency among avant-garde artists to favour activist political theories and movements, which promised – as did Marxism, for instance – to give a new form to life itself. The artist hoped that such movements would employ him to contribute to their artistic remodelling of reality as a whole.

The avant-garde sets out to abolish all the boundaries that impede the formative initiatives of art, in the same way as the modern political mind characteristically demands a free hand in determining economic, social and other conditions. Modern totalitarianism is simply the most radical fulfilment of this desire: the political (or artistic) mind attains absolute freedom by abolishing all the outworn moral, economic, institutional, legal and aesthetic boundaries that limit its political initiative. In itself, this inner kinship between aesthetic and political radicalism in the period in question totally undermines the assertion that the official art of the totalitarian countries is unmodern.

And yet the appearance of that art, in the 1930s and 1940s, does not exactly call the avant-garde to mind. In Germany under the Nazis, all modern art was officially denounced and proscribed from the very start, even in its more moderate forms. In the Soviet Union in the 1920s, modern art was merely tolerated, and from 1930 onward it was increasingly suppressed; after the promulgation of the dogma of 'Socialist Realism' in 1934, it was totally eliminated from the official art world. The situation in Italy was somewhat more relaxed, but under Fascist rule the work of Futurist or Futurist-influenced artists was tolerated rather than loved.

To the disappointment of many members of the avant-garde, both at home and abroad, the new holders of political power in all three countries favoured an art that – at least in its externals – appeared decidedly retrograde, because it seemed to revert to the traditional mimetic image which the international art of the day had long supposed to be obsolete. This created the impression that this was all an attempt to turn the clock back, on the part of political leaders who lacked an up-to-date aesthetic education.

The truth is, however, that the use of figuration and of the human image, the mimesis of outward reality, in totalitarian art cannot be interpreted as a mere reversion to the past. Of course, many artists who thought and worked in traditional ways, and who had previously felt marginalised by the avant-garde, exploited the new political and ideological climate to gain new recognition for their art. But those artists do not count as 'authentically totalitarian'. It is no easy matter to determine just who can be regarded as representative of totalitarian art, and why; it rests on a detailed scrutiny of the artistic, ideological and political context of the period. No sweeping answers are possible. And yet it is possible to list a number of artists who undoubtedly belonged to the official canon in their own countries: they include Albert Speer, Arno Breker and Adolf Ziegler in Germany, and Boris Iofan, Alexander Gerasimov and Alexander Deineka in the Soviet Union.[2]

2 For further information see, among others, Berthold Hinz, *Die Malerei im deutschen Faschismus. Kunst und Konterrevolution*, Munich, 1974; *Kunst auf Befehl?*, eds. Bazon Bock and Armin Preiss, Munich, 1990; exh. cat., *Agitation für das Glück*, ed. Hubertus Gaßner, Kassel, documenta-Halle, (Edition Temmen) Bremen, 1994.

If we restrict ourselves to these names, it becomes clear that totalitarian art by no means represents a simple return to Neoclassical architecture or to the traditional mimetic image. Instead, all these artists use images from new media – photography and film, in particular – which are of course mimetic in themselves, and which serve to preserve or enact the past.

In the 1930s, mimesis through new media was a growing interest everywhere, and by no means only in the totalitarian countries. In diverse ways, Surrealism, Magic Realism and all the other realisms of the day began to use the imagery and technology of the explosively expanding mass media. Post-avant-garde art, including totalitarian art, was drawn to these images and techniques – and not only because they reached the masses, thus holding out a prospect of increased sociopolitical influence. Between the avant-garde and the mass media there is an inner affinity that points to the possibility of a synthesis. In what follows, I shall try to show that totalitarian art aimed to create precisely this synthesis.

At the time, the prospect offered by such a synthesis was, above all, that of bridging the – characteristically modern – divide between avant-garde, elitist high culture on one side and mass culture on the other. Totalitarianism aims at a 'totality' that is ultimately none other than the closing of this gap.[3] The boundary that had cut the modern cultural elite off from mass taste, and thus from mass effectiveness, must be eliminated, so that the modern artistic and political mind could manipulate society with total freedom. It was believed that mass taste could be analysed, controlled and manipulated in order to remodel life itself in ways unknown and largely incomprehensible to the masses themselves. Only with the collapse of the totalitarian regimes did art finally abandon these objectives. Since then, it has responded to mass taste either by gratifying or by criticising it, but no longer by fighting to transcend it.

The inner affinity between avant-garde and media imagery lies in the fact that both are produced – in different senses of the word – unconsciously. In photography, external reality imprints itself directly on the film material, and this exerts a compulsion on the viewer. Criticism of photography is subject to specific limitations. With a photograph, the viewer cannot flatly deny – as he/she theoretically could in the case of a drawing or painting – that the given image bears any relation to reality. Because photography is partly unconscious, and thus partly beyond the artist's control, it forces the viewer to accept its truth, and thus partly to relinquish his/her aesthetic detachment. Avant-garde artists, likewise, always maintained that their images were unconsciously created, and that to some extent these represented the quasi-photographic imprint of a transcendental, hidden, true reality. This, again, placed the viewer under an obligation to accept the truth of the images. The reference to the unconscious served to eliminate – or rather to bridge over – the aesthetic detachment that had previously intervened between the viewer and the work of art. If a work is unconsciously created, it acquires the status of reality – and thus a power over the viewer that goes a long way towards offsetting the institutional, political or economic powerlessness of art. Aesthetic detachment becomes

3 In his celebrated essay, 'Avant-Garde and Kitsch' (1939), Clement Greenberg relegates totalitarian art to the realm of mass-market kitsch. Surely, however, with totalitarian art there is always the idea of an opposition to be overcome; Greenberg, *The Collected Essays and Criticism*, ed. John O'Brian, Chicago, 1986, 1, pp. 5–22.

an illusion, which serves only to conceal – and thus to reinforce – the unconscious effect of the image.

This programme for an artistic seizure of power via the unconscious was set down as early as 1912 in Kandinsky's celebrated book *Concerning the Spiritual in Art*.[4] In this, Kandinsky asserts that specific forms and colours exert a magical, unconscious effect on the viewer by imparting a specific mood. Such forms might be said to imprint themselves on the viewer's nervous system, as photography imprints itself on film. However, only a few souls, gifted with sensibility and the power of analysis, have the conscious ability to capture and to generate these unconscious effects. These few are the true artists. Their images spring from an unconscious but nevertheless intellectually coherent 'inner necessity'. Modern art, in Kandinsky's view, requires the artist to submit to this inner necessity, explore it, and master it technically. The artist who has experienced the unconscious influence of images has the ability to command the viewer's psyche, and to manipulate and educate her or him to become a new and better human being.[5] This ability to control and to manipulate marks the artist out as a member of an elite within society. For Kandinsky, society is hierarchically organised in such a way that the majority of humankind can and must be controlled, unconsciously, through the influence exerted by the artist.

Characteristically, Kandinsky stresses that neither a specific artistic style nor innovation nor originality counts for anything by comparison with the inner necessity of the image. Any image – figurative or abstract, old or new – conveys specific moods through the unconscious effect of its forms and colours on the viewer's psyche. The usual criteria of conscious, art-historical judgment, which are the means by which the viewer takes control of the art, are invalidated. Essentially, images differ from each other not in formal or aesthetic terms but in their unconscious effects, which only the artist can perceive and control. The viewer no longer has control of the image: the artist controls the viewer through the image, and thus becomes a magician, manipulator and educator who wields power over the viewer's unconscious.

The idea of an individual who secretly manipulates other people's unconscious minds had a hold on the contemporary imagination at the time when the artistic avant-garde came to the fore: from the sinister Dr Caligari and Dr Mabuse of the German Expressionist cinema to the benign Dr Freud with his psychoanalysis, or Dr Steiner with his anthroposophy. The avant-garde artist, too, wanted to be a 'doctor', investigating and employing the unconscious effects of colours and forms. Plainly, however, the unfamiliarity of form and instant identifiability of a reflective, analytical, avant-garde work tend to impair the unconscious immediacy of its impact. This led to the project that dominated much of the art of the 1930s and 1940s: to maximise the effect on the viewer by combining the unconscious imprint of external reality–in the form of photography – with the imprint of 'inner necessity'.

This combination dominates the artistic methodology of Surrealism, Magic Realism, *Neue Sachlichkeit* and the other realisms of the period. The inner, hidden reality of dream

4 Wassily Kandinsky, *Über das Geistige in der Kunst*, Munich, 1912; 4th ed., Bern, 1952. English trans. by M. T. Sadler as *The Art of Spiritual Harmony* (1914), revised as *Concerning the Spiritual in Art*, New York, 1947.

5 At the end of his book, Kandinsky speaks of the power of art, which makes the artist a king and imposes on him a corresponding moral duty to educate humankind for greater things; this duty consists entirely in the artist's moral responsibility to himself. Kandinsky (as note 4), pp. 133–36.

or desire is invested with presence and suggestive power by the use of quasi-photographic methods.[6] The result identifies dream with reality, present with future, exterior with interior. Totalitarian art forms one part of this generalised project of the 1930s. In it, the use of photographic, mimetic images combines with the manifestation of 'inner necessity'. But this is not the inner necessity of sexual desire, as with the Surrealists, or of the apocalyptic vision of death, as with many of the artists of Magic Realism and *Neue Sachlichkeit:* totalitarian art makes its appeal to the collective unconscious, as defined either by race or by class.

The manipulative action of the image thus becomes even less visible – and even more effective. The image in totalitarian art is more like a colour photograph than a traditional painting. The individuality of the picture, its expressiveness, its identifiable artistic style, are systematically eradicated. The artist aims for the anonymity, the neutrality, the sterility of a conventional photograph, in order to maximise the credibility of his work – and thus its influence on the viewer. He bypasses the customary aesthetic judgment, which is based on the autonomy of the viewer: this image has a 'normal' look to it. Its manipulative effect is all the more precisely calculated.

This calculation emerges with particular clarity from the treatises of Paul Schultze-Naumburg, which are perhaps the most representative documents of the aesthetic consciousness of National Socialism. In his book *Nordische Schönheit* (Nordic Beauty, 1937),[7] Schultze-Naumburg uses a wide variety of picture material in order to define and illustrate the Nordic, Aryan human ideal as precisely as possible. To this end he juxtaposes and implicitly equates quotations from classical art of different periods with photographs of real people, fashion drawings and other material. To Schultze-Naumburg, distinctions of style, period, artistic individuality or medium (painting, sculpture or drawing) are irrelevant. He is interested only in certain details – the shape of the foot, the line of the shoulder, the way the head is held–which he believes to reveal racial characteristics and racial differentiae (Fig. 1). Whether the image in question is an ancient Greek sculpture, a work by Raphael, Dürer or Rubens, or a contemporary photograph is more or less immaterial to Schultze-Naumburg's analysis: largely unconsciously, the makers of all these images have focussed on and reproduced certain racial characteristics.

In the – mostly very fragmentary – presentation of his picture material, Schultze-Naumburg effaces the boundaries between high culture and mass culture, and between classic art and modern photography, as well as those between different historical epochs and aesthetic styles. The pictorial world that offers itself to the viewer – principally through the neutral medium of photographic reproduction – becomes a totality into which the viewer is drawn as an image in his/her own right. No longer do we, the viewers, enjoy a secure, autonomous aesthetic viewpoint from which to inspect and judge the images: on the contrary, the images judge – and quite possibly condemn – us. Instead of calmly enjoying the art on show, we are reduced to comparing our own feet and shoulders, nervously, with those in the illustrations. The disinterested contemplation of which Kant spoke no longer takes place. The moment the artist begins to design his images according

Fig. 1 Illustration from Paul Schultze-Naumburg, *Nordische Schönheit*, 1937

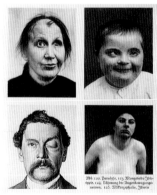

Fig. 2 and 3 Illustrations from Paul Schultze-Naumburg, *Kunst und Rasse*, 1928

6 On this see Rosalind Krauss, 'The Photographic Conditions of Surrealism', in Krauss, *The Originality of the Avant-Garde and Other Modernist Myths*, Cambridge, Mass., and London, 1985, pp. 87–118.
7 Paul Schultze-Naumburg, *Nordische Schönheit. Ihr Wunschbild im Leben und in der Kunst*, Berlin, 1937.

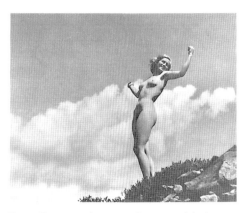

Fig. 4 Illustration from *Der schöne Mensch in der Natur*, ed. Wilm Burckhardt, 1940

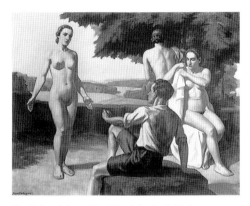

Fig. 5 Ivo Saliger, *Das Urteil des Paris* (Judgment of Paris), 1939. Property of The Federal Republic of Germany

to racist criteria, the viewer's aesthetic judgment – as a means of wielding power over the artist – is permanently disabled. And, sure enough, the representation of the human body in the art of the Nazi period is totally neutral, unsexed and anaesthetised. These are not so much 'real', live bodies as body blueprints, intended to optimise the Aryan look. As a result, there are virtually no stylistic differences between the photographs of the nude and the paintings of naked models. The photographic quality of the paintings is meant to show the timeless, Aryan physical ideal as an incontestable reality, and thus to identify its timelessness with the National Socialist present.

The images of classic art and of official National Socialist art are not the only ones that Schultze-Naumburg reads for their unconscious racial content. In his earlier book, *Kunst und Rasse* (Art and Race, 1928),[8] he seeks to draw visual analogies between photographs of mental patients, on one hand, and the human image as shown in German Expressionism, on the other (Figs. 2 and 3). Here, too, individual artistic attitudes and strategies are treated as irrelevant. Instead, the images are compared, irrespective of all formal and aesthetic categories, purely on the evidence of racial defining features. Far from being excluded from Schultze-Naumburg's world of imagery, the 'modern' features as a particularly dangerous area of 'degeneracy', which the viewer, having learned of its dangers, is instructed to avoid.

The naked human body played a central though not always explicit role in the German art of the Nazi period – if only because the ideology of the racial unconscious primarily relates to the unclothed human form (Figs. 4 and 5). Every part of it takes on a meaning and speaks a potentially dangerous language. The Marxist theory of the class-determined unconscious, by contrast, can be formulated only in the language of clothes. Class identity, of course, reveals itself mainly in the way one dresses. It is no coincidence that Mikhail Bakhtin placed the 'carnival' figure, constantly changing clothes, at the centre of his cultural philosophy, with its subversive relationship to the Soviet Marxism of the 1930s.[9] This also explains the vehemence with which both nudity and fashion were condemned in the Stalinist period. This aversion to nakedness had little to do with official prudery. The point was rather that the unclothed human being, like the fashionably dressed one, escapes from his or her recognisable social identity and thus becomes dangerous. Sexuality, as manifested in fashion, represents a menace both to racial and class segregation. The art of the Nazi period reacted by unsexing the body; the art of the Stalin period by strictly upholding a specific dress code.

This is one way in which the Soviet art of the Stalin period differs externally from the art of National Socialism. Other differences, both of ideology and of national artistic tradition, are evident between the two countries. And yet there is a clear, fundamental affinity between the two, which allows us to speak of totalitarian art as a single, unified phenomenon. In both, the usual conventions of historiography are subverted by the vision of a single – and partly unconscious – conflict, which runs through the whole of history, synchronising all periods and locating all places in a single, total space, while opening rifts within apparently homogeneous historic styles. In Marxism this single conflict takes

8 Paul Schultze-Naumburg, *Kunst und Rasse*, Munich, 1928; 2nd ed,. Berlin, 1935.
9 Mikhail Bakhtin, *Rabelais und seine Welt. Volkskultur als Gegenkultur*, Frankfurt a. M., 1988.

place between classes; in National Socialism it takes place between races. In both, images drawn from artistic tradition are used alongside the mass-produced images of the media, and in the same way: that is, as visual aids for the teaching of ideology.

This rhetoric of timelessness is well illustrated in Hitler's speeches on the position of German art in the Third Reich. He denounces, as a 'Jewish discovery', the idea that art is 'of its time'.[10] Hence, also, his dislike of the notion of modernity. The epithet 'modern', he says, is used with evil intent to subordinate art to periodic change and – ultimately – to fashion: 'for true art … is not to be judged like the seasonal output of a dressmaker's shop'.[11] True art is the expression of an Aryan 'racial core', which gives the art of the German people a timeless, inner, 'essential' affinity with ancient Greece and Rome, and with the other supreme achievements of European culture. It follows, for Hitler, that it would be wrong to seek a new artistic style for the Third Reich, one that could be produced in accordance with specific formal rules. True art will emerge spontaneously from the inner life of those who possess the Aryan 'inheritance' and therefore the correct world-view.[12] Hitler is here demanding the abandonment of all outer, stylistic criteria for the judgment of art. Works of art must cease to be distinguishable in formal, aesthetic terms, so that only one distinction will remain: that between Aryan and non-Aryan. This distinction does not rest on outward criteria, definable in neutral terms: on the contrary, it is itself the nub of a conflict that admits no such thing as an external, detached viewer.

In this respect, the official doctrine of Socialist Realism in the Stalin period differs little from Hitler's, except of course that racial conflict is replaced by class conflict. The classification of works of art by historical styles, along with the distinction between high culture and art for the masses, is rejected as typical of bourgeois, 'formalistic' criticism. The significance of individual artworks, and their quality, depend on whether the artist, in making them, has genuinely identified with the aspirations of the progressive classes – or, alternatively, with the historically superseded, reactionary classes.[13] The supreme achievements of art history – here, again, Graeco-Roman antiquity and the Renaissance – are construed as expressions of the optimism of the historically progressive classes in the periods in question. Since the progressive historic class in the twentieth century is the working class, Socialist art must take its cue from this earlier progressive art, rather than be cut off from it by boundaries of formal and aesthetic innovation. (That was the mistake made by the Russian avant-garde, which wrongly supposed that the new, proletarian art must look new in formal terms.) In every period of cultural history, according to Lenin's celebrated 'Theory of the Two Cultures Within One Culture', there is a conflict between two class cultures, one progressive and one reactionary. By homogenising the cultures of a given historical period, the ideology of modernism impedes the crucial choice between progressive and reactionary classes.

In both totalitarian regimes, an ideological and theoretical strategy thus exists to deconstruct, as it were, the various formally defined, aesthetically verifiable boundaries that subdivide and structure the field of image-production. This deconstruction is accomplished by reference to a hidden, unconscious conflict that cuts right across those same

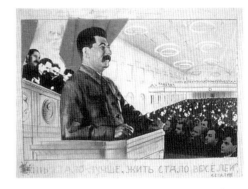

Fig. 6 Gustav Klutsis, '*Life Has Become Better, Life has Become More Joyous*' (J. Stalin), poster design, c. 1934. Museum Ludwig, Cologne

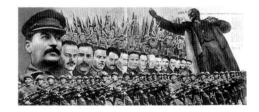

Fig. 7 El Lissitzky, *Red Army*, 1934

10 Adolf Hitler, speech at the opening of the *Große Deutsche Kunstausstellung*, Munich, 1937, in *Nationalsozialismus und 'Entartete Kunst': die 'Kunststadt' München 1937*, ed. Peter-Klaus Schuster, Munich, 1987, pp. 242–52.
11 Ibid., p. 244.
12 Adolf Hitler, 'Die deutsche Kunst als stolzeste Verteidigung des deutschen Volkes', speech at the cultural session of the National Socialist Party Congress, 1 September 1933, in *Reden des Führers. Politik und Propaganda Adolf Hitlers 1922–1945*, ed. Erhard Klöss, Munich, 1967, pp. 113-16.
13 See Boris Groys, *Gesamtkunstwerk Stalin*, Munich, 1988.

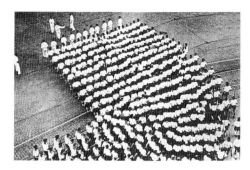

Fig. 8 Alexander Rodchenko, *Dynamo-Moscow*, 1930

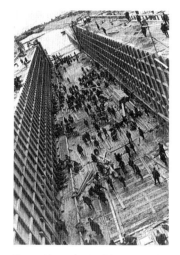

Fig. 9 Alexander Rodchenko, *Building the Lock. White Sea Canal*, 1933

14 Alexander M. Rodchenko, 'Gegen das "synthetische" Porträt – für die Momentaufnahme' (1928), in exh. cat., *Alexander M. Rodtschenko und Warwuru F. Stepanowa. Die Zukunft ist unser einziges Ziel …*, ed. Peter Noever, Vienna, Österreichisches Museum für angewandte Kunst, 1991; (Prestel) Munich, 1991, pp. 232–37.
15 Groys (as note 13), pp. 60–62.

boundaries. In the aftermath of the avant-garde discovery of the unconscious, attention is diverted from aesthetic form to unconscious effect. As a result, art and its imagery become a field of action for totalitarian power, because that power alone can determine what is Aryan, or proletarian, and what is not.

This figure of an unconscious, inner conflict is easily recognisable as a version of the old, avant-garde notion of 'inner necessity'. The avant-garde artist still, however, faces the traditional task of establishing a formal distinction between his/her work and earlier art, and thus creates new lines of demarcation. These last boundaries are effaced only by the use of the new, media-derived images, which are both unconsciously produced and – in the traditional sense – mimetic. Totalitarian art thus turns out to be entirely modern, even though it rejects words like 'modern', 'modernity' and 'modernism' as tainted with stylistic formalism.

The transition from the avant-garde to the new, mimetic image, via a new use of photography, is best exemplified by the evolution of Soviet art in the 1920s and 1930s, notably in the work of such leading representatives of the avant-garde as Alexander Rodchenko, El Lissitzky and Gustav Klutsis. Thus, in the 1920s, Rodchenko proclaims that photography has a truth that the painted image lacks: a truth that bypasses the will of the artist.[14] In their work, Rodchenko, Lissitzky and Klutsis all constantly use individual photographs as elements in photomontages that are highly conscious designs, geometrically organised in order to symbolise the rational nature of the new world (Figs. 6 and 7).

In Rodchenko's work, even when he is not making a montage but simply taking a photograph, the image subordinates the human figure to the logic of geometry (Fig. 8). Rodchenko's photography glorifies humanity in the shape of a geometric array of well-trained bodies, moulded by sporting techniques and reminiscent of the films of Leni Riefenstahl, *Olympia – Fest der Völker* (Olympia – Festival of Nations) or *Triumph des Willens* (Triumph of the Will). Even the non-sporting individual is tied into a geometrical construction. Thus, Rodchenko presents one of the first camps of what was to become the GULag, in an entirely positive vein, as a place where the human body is to be disciplined and inscribed in a geometrical order, thus conferring on it from outside the sublimity that in itself it clearly lacks (Fig. 9).

Although in the 1930s Soviet art was increasingly dominated by painting, the look of that painting betrays its dependence on the photomontage of the earlier period. The Socialist Realist paintings of Stalin's day look like colour photographs; and this photographic quality is not glossed over but publicly acknowledged and praised. Boris Ioganson, a leading official artist of the Stalin period, has argued that the locus of creativity in the art of Socialist Realism is not the technique of painting but the 'staging of the picture' – which is as much as to say that the painter's work does not essentially differ from the photographer's.[15] The paintings of Socialist Realism are, as it were, virtual photographs; they were painted only because photography then lacked the necessary technology of digital image manipulation. This photographic virtuality is well exemplified by those Soviet paintings that show huge throngs of people parading in front of the never-built

Palace of the Soviets. Incidentally, those people are clad in white garments that echo Malevich's dream of a 'white humanity' (Figs. 10 and 11).

Socialist Realist paintings display the same neutrality, impersonality, ordinariness and absence of artistic expression as Nazi paintings. In this, both differ radically from the productions of Surrealism or of Magic Realism, which also use a quasi-photographic technique to create the effect of a virtual reality, a photography of the dream. Surrealist art went on complying with the traditional demand for artistic originality; totalitarian art, on the other hand, consciously strove for impersonality of expression. In conformity with the totalitarian aesthetic, this art resists definition in formal or aesthetic terms. In the Soviet art criticism of the period, any identifiable stylistic feature – whatever the particular style might be – was regarded as a mark of failure, a sign that the artist was backsliding towards 'formalism'. Art under Stalin set out to be indefinable, 'informal' and inconspicuous, in order to escape the reproach of formalism, and to avoid ending up in the archives of the ideological inspectorate – in other words, in order to avoid attracting attention.

An art that tries not to attract attention, not to be identified – an art that tries to remain invisible – is clearly in a paradoxical position. This paradoxical desire to create art in order to remain invisible governed the strategies of totalitarian art. And the most interesting thing about the whole experiment is that to a great extent it worked. Our present-day museums, like the repressive mechanisms of the totalitarian regimes, concentrate on the art that seeks attention. The art that avoids the attention of a totalitarian censorship also by the same token avoids the attention of the present-day art world, and gets over-looked. And so the strategy and the fate of totalitarian art in this century have something to tell us not only about the ideologies of the totalitarian regimes but also about the nature of modern artistic institutions.

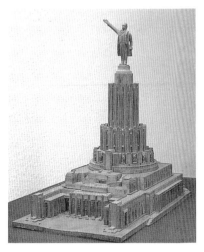

Fig. 10 Boris Iofan, *Model for the Palace of the Soviets*, late 1930s. Galerie Alex Lachmann, Cologne

Fig. 11 Alexander Deineka, *Stakhanovites*, 1936. Design for a mural in the Soviet Pavilion at the International Exhibition in Paris, 1937. State Gallery of Art, Perm

ROBERT C. MORGAN

Art Outside the Museum

> The museum spreads its surfaces everywhere, and
> becomes an untitled collection of generalizations
> that immobilize the eye.
>
> Robert Smithson[1]

At the moment of this exhibition one may think of Modernism as having an overwhelm-
ing scope that virtually encapsulates the gamut of visual styles available to the human
imagination. Whether veering toward concrete abstraction, figurative expressionism,
political art, performance, or dematerialised objects, the philosophy of Modernism –
from its inception – has been a reverberating sequence of visual statements that have
attempted to transmit and, in some cases, to reify some sense of reality in the twentieth
century. Modernism represents a reality determined to confront the illusions of the past.
Through a series of chain reactions and often simultaneous equivocations, beginning
with Cézanne and the Cubists, Modernism has set out to dispel the illusion of the picture
plane and its subject matter and, as Moholy-Nagy once proclaimed, to move into a new
'space-time'[2] (see Fig. 7, p. 560). By introducing various forms of art that insisted on
another criterion, a new critical language for Modernism had to evolve, in order for these
new forms to be accepted and understood.

One could say that there is a kind of schism – a conflict, in fact – that is fundamental to
the project of Modernism. What does it mean, for example, to have divergent artists and
movements at the beginning of the century espousing the ideals of a machine aesthetic,
and concomitantly to have another group equally impassioned in their rebellion against
the machine? Or what does it mean to have one group of artists who are interested in
prolonging the legacy of an aesthetic institution – guardians of the tradition of oil paint-
ing, for example – and others who think only in relation to the camera or the perfor-
mance and are out in the streets, distributing pamphlets against all conventional institu-
tions of culture.

The answers to these questions are not only aesthetic, they are also sociological, political
and economic; in fact, the answers require a clear recognition of many complex factors in
Western society's struggle to evolve from an agrarian to an industrial economy, from a
closed to an open democratic structure, and from a pre-modern toward a modernist sen-
sibility. One might argue that the basis of this struggle – at least, from the perspective of
the artist – began as a profound and deeply felt spiritual crisis, a yearning for a better
world and, in some cases, a neurosis about being unable to attain it. The burgeoning of
Modernism incited a crisis that most directly affected the changing role of the artist, as

1 Robert Smithson, 'Some Void Thoughts on
Museums' in *Robert Smithson: The Collected Writings*,
ed. Jack Flam, Berkeley, Los Angeles and London,
1996, p. 42; first publ. in *Arts Magazine*, February
1967.
2 Laszlo Moholy-Nagy, 'Space-Time Problems' in
Vision in Motion, ed. Sibyl Moholy-Nagy, Chicago,
1947; reprinted in *Esthetics Contemporary*, ed. Richard
Kostelanetz, Buffalo, New York, 1989, pp. 69–74.

the visionary (or tormented) subject of a rapidly evolving social drama. Whether recognised or not, artists have irrevocably changed the course of life in the twentieth century. This is less an aesthetic evaluation than a cultural observation. Given the remarkable formal and conceptual breakthroughs during the first quarter of this century, who can deny that this has not been the case?

In essence, the struggle of Modernism for the artist was the struggle to be modern, even if one existed outside those formidable institutions of the new industrial society – whether political, economic, social, or aesthetic. The drama of this struggle and this conflict among early twentieth century artists cannot be overplayed. This was a drama founded on conflict right from the beginning, a drama that has still not terminated, even as the industrial age has been presumably succeeded by the Age of Information. The rules of industry and its relationship to the institutions of art – museums, academies, publishers, galleries – still provide the momentum for our understanding of culture. One might speculate that the only real difference between the institutions at the outset of the century and in recent years is that now they function with a more 'professional' aura, a certain detachment that is more market-driven and more overtly cynical.

Fig. 1 Hugo Ball, reading his sound poem *Karawane* at the Cabaret Voltaire, Zürich, 1916

In writing on the activities of artists outside the museum in the twentieth century – or, shall we say, artists who have defied the conventional institutions of modernist art – several models or paradigms are available. Not all artists who rebelled against modernity had the same reason for doing so. Some did it for personal reasons or reasons that were forced upon them by historical, psychological or social circumstances. The Dada artists, living in Zürich in 1916, were a mixture of refugees and draft dodgers, who projected their guilt and frustration over the tragic circumstances of the war by rebelling against 'bourgeois intellectualism'. In their exhibitions and performances at the Cabaret Voltaire, they were hoping to re-invent the meaning of art by inciting absurd and outrageous actions in a deliberate and intentional way, thus diverting themselves from the chaos and destruction surrounding them (Fig. 1). Their emphasis on irrationality, nature and chance opened up a new discourse on art, far removed from the guardians of the institution. On the other hand, the Russian avant-garde (Futurists, Formalists, Suprematists, Constructivists, Productivists) were experiencing a different historical reality.

In contrast to the Zürich Dadaists, the Russian avant-garde had a different motivation in attempting to realise a different kind of work, more given to a utopian dream (Fig. 2). Yet in their pragmatic quest to discover a means for artistic survival, they wanted to express a spirit of optimism – even though optimism had little basis for justification. Kazimir Malevich and Liubov Popova (Cat. 126–132 and 136–138), for example, were working within a system that had failed to accommodate them, both socially and economically, after the fall of the provisional government and the return of Lenin (from Zürich).

Fig. 2 Vladimir Tatlin (third from left) and his assistants in front of the model of the *Monument of the IIIrd International*, November 1920

Yet beyond the personal and social reasons, one might investigate the phenomenon of modernist avant-garde art in another way – by using paradigms of a more theoretical nature; that is, by using paradigms that reflect the conflicting interests that are so endemic to the modernist discourse. In entering such a discourse, one might begin with the

assumption that Modernism became an institution, not only through the embrace of a machine aesthetic, but also by the desire to escape it. By escaping the desire for utopia through art, one might enter into another realm of desire, more directly associated with iconoclasm.

The escape from the institutions of culture – namely, the museum that sanctions art for historical and ideological purposes – through the avant-garde activities of *la belle époque* in late nineteenth century France, and the perpetuation of this conflict throughout this century, has been one of the major defining principles in Modernism. From a psychoanalytic view, one might say that the Freudian impulse to move beyond or outside the authority of the father – or, in this case, the institution – has possessed avant-garde artists of varying stature in the history of Modernism, ranging from Picasso to Duchamp. On numerous occasions over the past two decades, poststructuralist critics have pointed to the Oedipal drive, complete with its own subtextual legacy, including the various attempts at theoretical refutation, as a motivating force within the mainstream of Modernism.[3] Still, one cannot assume that this conflict is the sole factor motivating the evolution of art, in relation to the problems of Modernism.

Rather than laminating theories borrowed from the social sciences, in relation to the evolution of the modernist avant-garde, would it not be more to the point to examine actual events outside the museum and to infer from these events a set of paradigms that are indicative of this discourse? To begin with, empirical observation is certainly not a new strategy in the application of modernist theory, yet it is a strategy that has been derailed in recent years, particularly in the United States, given the extraordinary seduction of marginal issues related to semiotic theory and the claims of ideology that have been made for them.[4]

The remarks that follow in this essay are less oriented toward overt ideological claims than related to paradigms based on events that factually took place in the course of the evolution of the modernist avant-garde. Three paradigms have been chosen to characterise this divergent history. They serve as general categories and as indicators of related objects, events, and installations that have influenced Modernism from outside the institution of the art museum. Although separately conceived, these paradigms tend to overlap and reverberate against one another.

From History to Performance: Simulation and the Media

From a poststructuralist perspective it may be difficult to reconstruct the historical context which has given rise to the creation of non object-based works of art, over the past few decades. One reason for this difficulty is the current assumption that the electronic media are pervasive, that in the age of the internet anything can be obtained from anywhere, at any time. While our logic tells us this was not always the case, the ability to reconstruct a sense of temporality in relation to a specific event – as, for example, a performance that occurred in a foreign place, within another cultural context, at another point in history – may often elude us. Non object-oriented artworks are based on some

3 See, for example, Gilles Deleuze and Felix Guattari, *Anti-Oedipus: Capitalism and Schizophrenia*, trans. Robert Hurley, Mark Seem and Helen R. Lane, Minneapolis, 1983.

4 For a more in-depth investigation of these issues, see my essay 'Signs in Flotation', *The New Art Examiner*, vol. 22, no. 8, April 1995.

Fig. 3 *The Storming of the Winter Palace*, Petrograd, 1920

Fig. 4 Preliminary design for the Storming of the Winter Palace

form of temporality, even if the work is a conceptual document or a language piece, such as a definition by Joseph Kosuth or a statement by Lawrence Weiner (Cat. 317–319). In such cases, language is the medium by which the idea is signified and transmitted from one person to another, from sender to receiver.

The event in early Modernism which typified this paradigm was the performance in Petrograd on November 7, 1920 in honour of the third anniversary of the October Revolution, in which the storming of the Winter Palace was virtually reconstructed and re-enacted in every detail.[5] This extravaganza on a colossal scale, directed by Nikolai Yevreinov with the assistance of three theatre directors, included nearly 8000 participants (Fig. 3). Among them were soldiers, circus artists, ballet dancers and a five hundred piece orchestra and chorus. Inspired by agit-prop theatre and a demonstration organised two years earlier by the Russian Futurist Nathan Altman, this massive undertaking was the kind of spectacle that would only occur today, if major broadcast corporations were on the site, backed by major advertising. Instead of television footage, the only remaining documentation of this event is provided by a few grainy photographs and some sketches and diagrams, used to coordinate the production (Fig. 4).

The larger point related to 'The Storming of the Winter Palace' (as it was titled) was the desire to replicate the original political upheaval in exact detail, as a simulated event – in fact, as a performance. Even without the advanced technology of television and computers, the desire to make a spectacle that would accurately simulate the 'real' event suggests one of the critical attributes of the modernist avant-garde: that the reproduction of the original should, in fact, be a replacement of the historical actuality.[6] The performance of *The Storming of the Winter Palace* in 1920, three years after the original, constituted yet another historical staging, a theatrical doubling that would be labelled 'art'. Not only would the performance become 'art', it would also come to represent the historical event, as if the event were secondary to the experience of the performance itself.

During the Dada revival of the late fifties and sixties in New York, the avant-garde composer John Cage would revive the issue in another context, by ignoring history in favour of structural improvisation and chance operations.[7] Allan Kaprow, who had attended classes given by Cage at the New School of Social Research, further expressed ambivalent feelings about historical references to the theatre, as they might relate to a new con-

5 See Roselee Goldberg, *Performance Art: From Futurism to the Present*, rev. ed., New York, 1988, pp. 40–43.
6 I am clearly leaning on Jean Baudrillard's theory of the simulacra here, a pervasive theme in much of his recent work that is most ostensibly represented in *Simulations*, transl. P. Foss, P. Patton and P. Beitchman, New York, 1983.
7 See John Cage, *Silence*, Middlebury, Connecticut, 1961.

cept of performance – in his case, the Happening (Fig. 5): 'And the past? Those heroic men who also gave their lives to amuse themselves? What of them? I suppose to be a revolutionary, one must know and hate-love the past deeply.' Kaprow went on to say that 'the only general use of the past has for me to point out what no longer has to be done… The past cannot and does not want to be embalmed. I think that it can only be kept living in artists who appear to be spitting in its face.'[8]

Fig. 5 Allan Kaprow, *18 Happenings in 6 Parts*, Reuben Gallery, New York, 1959

At the crux of Neo-Dada in the early sixties was the Fluxus movement. Under the somewhat authoritarian leadership of an eccentric Lithuanian artist named George Maciunas, those associated with Fluxus generally preferred the ephemeral over the permanent, the concept over the form, and the event over the object.[9] They preferred absurdity and wit to the seriousness given to Abstract Expressionist painting or to the more fashionable, newly emergent Pop Art.

Fluxus was, in one sense, anti-historical. It tried to exist without a referent. Dick Higgins, Alison Knowles, Yoko Ono and Ben Patterson would perform mini-Happenings, often involving music and poetry. In contrast to the Happenings of Kaprow, the Fluxus performances tended to refute the large-scale spectacle, in favour of Artaud's more hermetic style of unmediated experience. Yet there was a certain elegance in all of this, a certain refusal to conform to what the museum wanted as official art or what the history of art seemed to dictate, as the next logical step in the progressive linearity of Modernism.

In retrospect, it is possible to consider Fluxus as the last art movement within the modernist period that could truly be defined as avant-garde. It was elegant, but not entirely cynical. It was spirited, but not spiritual. It was defiant of the system – whether in art or politics. In this way Fluxus captured the heightened, ecstatic flavor of the sixties, when revolution was in the air, and it did not matter whether the event was history or simulation, whether it was 'real' or 'art'. For artists associated with Fluxus, as designated by Maciunas, revolution and anarchy represented the ideal state of affairs (Fig. 6); and it is, perhaps, because of this cultural support structure during the sixties in America that Fluxus could not sustain itself as a significant force beyond that decade.[10] It was limited by its own contextualisation, namely the revolutionary spirit and openness of the sixties. It surfaced as a grand echo of a socio-aesthetic ideal, and it existed for the moment, within the context of a performance – a context that would soon be transformed into something else.

Fig. 6 George Maciunas, *Piano Piece*, New York, 1964. Photo: © Peter Moore

Art as a Free Agent: Conceptual Art and Duchamp's Readymades

When Henry Flynt wrote his important underground essay, 'Concept Art', in 1961 (published 1963),[11] it was not clear exactly where his speculations would lead (Fig. 7). At the time, Flynt was connected with avant-garde musicians such as La Monte Young and with intermedia artists such as Walter De Maria and Robert Morris, who were then working primarily in performance and choreography. The opening lines of Flynt's important (though underrated) essay read:

8 Allan Kaprow, *Untitled Essay and Other Works*, New York, 1967, pp. 2–5; originally written 1958.
9 See Simon Anderson, 'Fluxus Publicus', in *In the Spirit of Fluxus*, exh. cat., Minneapolis, Minnesota, Walker Art Center, 1993, pp. 38–61.
10 See Robert C. Morgan, 'The Fluxus Ensemble', in *Commentaries on the New Media Arts*, Pasadena, California, 1992, pp. 1–5; originally publ. as 'The Fluxus Phenomenon', *Lund Art Press*, vol. 2, no. 2, 1992, pp. 125–28.
11 Henry Flynt, 'Concept Art' (1961), in *An Anthology*, ed. La Monte Young and Jackson Mac Low, New York, 1963, unpaginated.

'Concept art' is first of all an art of which the material is 'concepts', as the material of for ex. music is sound. Since 'concepts' are closely bound up with language, concept art is a kind of art of which the material is language.[12]

While this version of Concept Art appears close to what LeWitt would eventually call Conceptual Art six years later, it was not exactly the same. In a 'Correspondence' with the curator Andrea Miller-Keller (1981–83), LeWitt stated that 'his (Flynt's) idea of it (Concept Art) was Duchampian-Fluxus. Mine tended to have more to do with the way artists do their work, and to redirect the emphasis to idea rather than effect.'[13] In retrospect, LeWitt's comment must be taken in the context of his association with Minimal Art – a term he never agreed with. Nevertheless, the passage from Fluxus to Conceptual Art is not so simple. While there were some similarities between the two, the spirit and method of Fluxus – as advocated by the movement's self-appointed leader, George Maciunas – was quite distinct from that of Conceptual Art.

Although Flynt has disavowed any connection with Fluxus in recent years, so as to retain rights to his linguistic breakthrough in art, it is also difficult to see him as divorced from the general scope of Neo-Dada activities in the late fifties and early sixties in New York.[14] This was the era of the Happenings and Environments, the era of the Assemblage and junk sculpture, the era of the Beat Generation, jazz and poetry readings, the underground rebellion against the status quo of the 'American way of life'. In contrast, LeWitt's concerns, as expressed in 'Paragraphs on Conceptual Art' (1967)[15] came from a totally different perspective (Fig. 8). This had more to do with reductivism, sequence and seriation. LeWitt was interested in approaching the formalist position from a radically different angle. Rather than seek diversity within unity LeWitt pursued the idea in art that allowed art to function as a machine.[16] This was a much more distant attitude about art – an attitude about reserve in the art-making process, as opposed to shifting the ground of art completely into the realm of mathematical speculation, as Flynt seemed intent upon doing. Nevertheless, Flynt's intuition about art as language was ultimately correct, in spite of the direction the market took at the end of the sixties. To change the predominance of aesthetic formalism in American art, as advocated by the critic Clement Greenberg, it was necessary to find another strategy which would allow the transformation of art through language.

This transformation would not have been possible without the advances made several decades earlier by Marcel Duchamp, particularly in relation to his readymades. After completing a group of cubist-inspired paintings in 1912, including his famous *Nude Descending a Staircase*, Duchamp began work on a new project. His research at the Bibliothèque Sainte-Geneviève in Paris, between 1913–15, would eventually lead to his work on the *Large Glass*, otherwise known as *The Bride stripped bare by her Bachelors, even* (1915–23; see Fig. 10, p. 310). It was also during these intervening years that he developed his theory of the Readymade.

The first example was a common bicycle wheel that he turned upside down and fastened to the top of a kitchen stool, in 1913 (Fig. 9). The following year he discovered a gal-

Fig. 7 Henry Flynt lectures at Walter De Maria's loft, New York City, 28 February 1963

Fig. 8 Sol LeWitt, *All combinations of arcs from corners and sides; straight, not-straight, and broken lines*, 1973, Installation at the Galleria L'Attico, Rome

12 Ibid.
13 Andrea Miller-Keller and Sol LeWitt, 'Excerpts from a Correspondence, 1981–83' in *Sol LeWitt: Wall Drawings, 1968-1984*, exh. cat., Amsterdam, Stedelijk Museum; Eindhoven, Stedelijk Van Abbemuseum, and Hartford, Connecticut, Wadsworth Atheneum, 1984, p. 21.
14 Flynt's disavowal of Fluxus began in a protest (with La Monte Young) during the *Ubi Fluxus ibi motus, 1990–1962* exhibition, at the time of the 1990 Venice Biennale (on the Giudecca). In Flynt's 1993 press release for his show at the Emily Harvey Gallery in New York, there is no mention of Fluxus, only 'Concept Art'.
15 Sol LeWitt, 'Paragraphs on Conceptual Art', *Artforum*, summer 1967, reprinted in *Sol LeWitt. Critical Texts*, ed. Adachiara Zevi, Rome, 1994, pp. 78–82.
16 Ibid., p. 78.

Fig. 9 Marcel Duchamp's studio in New York, c. 1917–18, with the readymade *Roue de bicyclette* (Bicycle Wheel), version of 1916

Fig. 10 Marcel Duchamp's studio in New York, c. 1920, with the readymade *In advance of the broken arm*, 1915. Photo: Man Ray

Fig. 11 Joseph Kosuth, *The 2nd Investigation* (detail), 1968. Billboard, Piazza Solferino, Turin 1969

17 Marcel Duchamp, 'Apropos of Readymades', in Richard Kostelanetz, *Esthetics Contemporary* (as note 2), pp. 83–84; reprinted from *Art and Artists*, vol. 1, no. 4, July 1966, p. 47.
18 Octavio Paz, 'The Ready-Made', in *Marcel Duchamp in Perspective*, ed. Joseph Masheck, Englewood Cliffs, New Jersey, 1975, p. 88.
19 Le Comte de Lautréamont, *Les Chants de Maldoror*, New York, 1966.
20 See Joseph Kosuth, 'Art after philosophy' (part I), in *Joseph Kosuth. Art after Philosophy and After*, ed. Gabriele Guercio, Cambridge, Mass., 1991, pp. 13–24; first publ. in *Studio International*, vol. 178, no. 915, October 1969, pp. 134–37.

vanised bottle-drying rack in Paris – near the Hôtel de Ville – which he purchased and took back to his studio, then signed and dated. His use of the term 'Readymade' was not determined, however, until he came to New York in 1915 and bought a snow shovel, in which he added the phrase 'In advance of the broken arm', along with his signature and the date (Fig. 10). Several decades later, in a talk given at the Museum of Modern Art in New York on October 19, 1961, Duchamp stated:

> A point which I want very much to establish is that the choice of these 'Readymades' was never dictated by esthetic delectation. This choice was based on a reaction of visual indifference with at the same time a total absence of good and bad taste ... in fact a complete anesthesia.[17]

One cannot ignore or deny the industrial context of the readymade. It functioned as a sign or series of signs related directly to mass-produced items taken from Ford's assembly line. Duchamp's point was that the Bride of industry had – at least, temporarily – taken over art. What was important was not the handcrafted object, but the simulated object that was selected on the basis of some unknown quantity, what the poet and critic Octavio Paz once saw as an erotic 'rendez-vous'[18] – a concept that owes a certain debt to the nineteenth century proto-Surrealist writer Lautréamont, who used the metaphor of 'a chance encounter between a sewing machine and an umbrella on a dissection table.'[19] Duchamp's readymades signified a shifting linguistic structure in art, but they were never intended by the artist to be art, in the strict sense. For Duchamp, the *concept* of the readymade was the work of art. This was a different proposition than saying the readymade was art itself. It was the signifying power of the readymade that was important, in shifting the emphasis of art from the object to the idea. In suggesting that art could exist as an idea, the Readymades gave art a secondary power: to further provoke ideas within a 'non-retinal' system, within a context that did not seem to be art, but one that could become art, through thought expressed as language.

Whether an early wall drawing by LeWitt, an installation by Rebecca Horn or an 'investigation' by Joseph Kosuth (Fig. 11), it was the signifying power of the readymades that influenced the development of Conceptual Art in the late sixties and early seventies.

Fuelled by Wittgenstein's *Tractatus* (1921), Duchamp's readymades and the 'Black Paintings' of Ad Reinhardt, art functioned as a sign by replacing formalist aesthetics with a new linguistic structure.[20] It was this new linguistic structure that moved art from its pre-eminent objecthood – paintings and sculptures predestined for the museum – to a more open and dematerialised existence, outside the museum. By the end of the sixties, art had become a free agent, removed from its past relic-container and thus destined to define itself outside the confines of the institution.

Beyond Utopia: Earth Art and the New Social Order

At the end of this century we are confronted with the ideals of the past. Just as we cannot ignore the past, we cannot ignore the ideals that were a part of it. As mentioned earlier, utopian thought was an important part of the conflict embedded within modernist ideology. In recent years, there have been numerous 'deconstructive' analyses that have tried to prove the instability of artists' utopias as being exclusionary models with impossible social agendas; but to what avail? What is the real purpose of trying to defeat the premises of modernist utopias?

Now that we are deadlocked in a cult of information, inculcated with metatheories and cynicism, overwrought with the pressures of the mundane, it may be advantageous to suggest that utopia, in spite of its apparent naïvety, still holds something of value. Perhaps the approach to utopia in the second half of this century has been less about solutions and ideological impositions than about the full spectrum of our structural fragmentation. The Earth Art of the late sixties (Robert Smithson, Michael Heizer, Dennis Oppenheim, Walter De Maria) was one sign of this phenomenon (Fig. 12). The site specific installations, both indoor and outdoor, that followed in the seventies (James Turrell,

Fig. 12 Walter De Maria, *The Lightning Field*, 1974–77. Near Quemado, New Mexico. © Dia Center for the Arts, New York

Fig. 13 Nancy Holt, *Views Through a Sand Dune*, 1972. Narragansett Beach, Rhode Island

Fig. 14 Robert Smithson, *The Spiral Jetty*, 1970.
Great Salt Lake, Utah. Photo: © Gianfranco Gorgoni

Fig. 15 Kurt Schwitters, *Merzbau* in Hanover,
photographed c. 1930

21 Robert Smithson, 'The Spiral Jetty', in *Robert Smithson: The Collected Writings* (as note 1), p. 149; first appeared in *Arts of the Environment*, ed. György Kepes, 1972.
22 See Robert C. Morgan, 'Who Was Joseph Beuys?', in Morgan, *Art into Ideas: Essays on Conceptual Art*, Cambridge, U.K., 1996, pp. 150–161.

Robert Irwin, Alice Aycock, Mary Miss, Richard Fleischner, Nancy Holt) were a continuance of this new subjective utopia – a vision that encompassed both the intimate and transcendental aspirations of individual artists (Fig. 13).

A clear example of this transcendental feeling was expressed by the artist Robert Smithson, in an essay written on his work, *The Spiral Jetty* (Fig. 14):

> The water functioned as a vast thermal mirror. From that position the flaming reflection suggested the ion source of a cyclotron that extended into a spiral of collapsed matter. All sense of energy acceleration expired into a rippling stillness of reflected heat ... I was slipping out of myself again, dissolving into a unicellular beginning, trying to locate the nucleus at the end of the spiral. All that blood stirring makes one aware of protoplasmic solutions.[21]

The search for the sublime within space-time has always been connected with utopia, as evidenced in the transcendental communities established in America in the nineteenth century or among the so-called 'hippies', a century later. The concept of a new social order is always related to the desire for individual subjective enlightenment. During the twenties in Europe, this was the case among artists of the Bauhaus and De Stijl. This was also true among the Futurists, the Constructivists and, in an ironic way, the Dadaists and Surrealists, too. In addition to being influenced by Abstract Expressionism and Minimalism the Earth artists were, arguably, strongly influenced by the Dadaists and Surrealists. At the same time, we might interpret such works as Kurt Schwitters' *Merzbau* (Fig. 15) and the underwater landscapes of Yves Tanguy (Cat. 355–357) as being sublimations of utopian concerns.

From another point of view, one cannot disregard the importance of Joseph Beuys, as a utopian thinker. His concept of 'Social Sculpture' is essential in understanding the extended possibilities of utopian thinking, as we move from the twentieth to the twenty-first century. Beuys' theories are very tactile in that they emanate directly from his func-

tion as an artist. He spans the width of both individual freedom and social necessity, the desire for a sublime relationship to nature, while at the same time embracing the need to change the work, to shift the ground of irrelevant institutions and recall the fundamental necessities of the social body.[22] Without Beuys as an artist/performer/theorist, the extended idea of a subjective utopia would not have been revived and interpreted as a bridge to the next century. His involvement with art actions outside the institution (Fig. 16) and his redefinition of the institution, based on his extraordinary metaphor of the *Honey Pump*, offers a signal of hope that artists still have a role in society that is both s ensory and conceptual, and that art is an epistemological and socially responsible endeavour, despite the enormous market-driven pressures to find fame and fortune in the halls of the museum. What Beuys' teaching suggests, in contrast to that of John Cage, is that the denial of the ego is less healthy and less beneficial than the re-channelling of the ego, as a source of energy. In a world where energy depletion has become a major issue, artists must confront and repair the separation of mind and body that has been precipitated through media, fashion and advertising. This seduction and concomitant dissolution of the ego has become the basis for conformity in the age of the virtual institution, an age where the insights of artists would seem not to belong.

It is conceivable that this situation will change again, in the near future; and when the change occurs, it will most probably come as a result of museums recognising the need to deal realistically with changing social and economic realities, including those realities that artists have to confront in the everyday world, outside the purview of the institution. To be truly effective, these changes may have to confront the entire legacy of modernist art through new forms of critical intervention, outside the current market-driven system, including the various metalanguages that have developed as a result of an accelerating, transcultural world.

Fig. 16 Joseph Beuys, *Ausfegen* (Sweep Out), Karl-Marx-Platz, Berlin, 1972

DIETER DANIELS

Art and Media

Beyond Objects

> It is intolerable that drawing and painting still stand
> exactly where writing stood before Gutenberg.
> André Breton, 1934[1]

The history of the avant-gardes, in the century that is now drawing to a close, has as a leitmotif the constant redefinition of the 'work' of visual art. The assumption that an artwork is a handmade object is as old as art history. In a world that consists entirely of handmade objects, such as a mediaeval living-room or an African clay hut, this confers no particular status. Only since the extension of industrial manufacture to almost all the objects of daily use – and, above all, since the proliferation of techniques for reproducing objects, images, sounds and texts – has the handmade object acquired the cachet of something original or unique. In European art history, the primary distinction between original and copy equates with that between idea and execution – as with an etching after an oil painting, or a plaster cast after a marble statue. In the course of the twentieth century, the meaning of the term 'original' has changed, so that in art it now primarily denotes objects made by human hands, as distinct from images generated by technology. In marketing, by contrast, the words 'The Original' can be extended to apply to a branded article.

The twentieth century will go down in history as the period in which manual, individual production was almost entirely supplanted by mechanical, industrial manufacture. This applies both to everyday objects, such as clothing, furniture and tools, and to the means whereby signs and images are transmitted, generically known as the 'media'. It also affects the status of the work of art – a point probably first and most clearly made in Marcel Duchamp's principle of the Readymade.

In an environment largely made up of industrial products, any object declared to be original acquires a privileged status that affects its aesthetic as well as commercial valuation. Writing in the 1930s, Walter Benjamin looked forward to the day when photography and film would emancipate the work of art from its 'parasitic relationship to ritual', as defined by its 'aura' of uniqueness, of being an original. He wanted to see the question 'whether photography is an art' replaced by the far more fundamental question 'whether or not the character of art as a whole has been changed by the invention of photography'.[2] Anyone who now walks through one of the great international art fairs will see photographs on every side, immaculately framed, in the same large formats and

1 André Breton, 'Phare de la Mariée', *Minotaure*, no. 6, winter 1934–35, p. 45.
2 Walter Benjamin, 'Das Kunstwerk im Zeitalter seiner technischen Reproduzierbarkeit' (1935), in Benjamin, *Gesammelte Schriften* Frankfurt a.M., 1978, p. 481, p. 486.

at the same price levels as paintings. The establishing of 'degrees of authenticity' for the means of technical reproduction – a task that Benjamin regarded as impossible – has long been part of 'business as usual' in the art trade. This process is even more conspicuous when the concept of the original is applied retrospectively – as evidenced in the meteoric rise in prices of vintage photographs over the past twenty years. It is just as irrational to congratulate photographic artists, 175 years after the invention of photography, on attaining parity of status with painting, as it is, conversely, to deplore their failure to break free of the notion of the 'original' as a criterion of value. The fact is that the mechanisms of value-creation based on the status of the 'original' fit in perfectly with the marketing of mass-produced reproductions. The eminence of the original generates a need for ever more reproductions, which in turn lead to even greater fame and still further enhance the value of the original. This same principle of the 'idolisation' of the original can be seen in operation in other areas besides fine art, including fashion, design and advertising.

Despite this transformation of the term 'original', it is clear as we look back over the twentieth century that the object status (and attendant commercial value) of the work of art has been a major obstacle to the evolution of the arts in a more comprehensive, more interdisciplinary direction. 'Media' art forms – those other than painting and sculpture – have been undervalued, and evolutionary lines have come to an untimely end for want of distribution and recognition, or simply for want of money. Within the distribution system of the fine arts, film and video, for instance, are not only harder to exploit commercially but more expensive to produce than painting. To this day painting remains the medium best suited to the current system of diffusion for the visual arts.

Perhaps no area of human culture has changed so radically over the last 150 years as the production of images. Pictorially, until the middle of the nineteenth century, the domains of 'art' and of 'the media' were identical. But then the great divide between manual methods and technology created the distinction between art, which remained in the singular, and 'the media', endlessly proliferating in the plural.

Between pictorial art and pictorial media there is one fundamental distinction: that between exclusivity on one side and mass dissemination on the other. In essence, this distinction is neither ideological nor technological, but economic. It separates two markets and two distribution systems governed by contrary laws. Is art therefore the last context in which the Marxist critique of the conditions of production (otherwise only of historical interest in the so-called postindustrial society) still holds good? It may well seem an anachronism that, in this age of mass media, visual art should still base itself on the sale of (in a wider or narrower sense) original objects. But then art does not always reflect the current state of theoretical knowledge. Even Benjamin's utopian vision of a new function for art never came to pass because – percipient though it was – it still referred to the reproduction of images and things: the word *media* does not appear in Benjamin. The art/media antithesis can be overcome only by treating the work of art as information, to be transposed into a variety of media. It was clearly Bill Gates, founder of Microsoft, who first took this to its logical conclusion: instead of artworks he collects the

reproduction rights of artworks, with the aim of distributing them as image data via the Internet.

Between the Genres

> No work of art of any consequence has ever fitted perfectly into its genre.
>
> Theodor W. Adorno, 1969[3]

Given the problems faced by those who work in the field of visual art but create no 'original' objects, what reasons can an artist have for using technological media?

By the nineteenth century it was already clear that art had ceased to stand at the cutting edge of human cultural achievement. The leitmotifs of social evolution are technology and science; their criterion is rapid progress. In his book on Cubism, published in 1913, Guillaume Apollinaire sums this up when he writes that people now parade through the streets in triumph carrying aloft the aeroplane in which Louis Blériot first flew the Channel, just as once they carried the paintings of Cimabue. Apollinaire looks forward to the day when a new generation of artists – artists who, 'free of aesthetic scruples, think only of energy' – will succeed in 'reconciling art and the people'.[4]

However, the marginalisation of art was not simply a matter of technological progress: it was also a response to the increasing radicalism of the avant-garde. It was at the beginning of the twentieth century that art first avowedly parted company with 'common sense'. In Europe, the years 1905–15 saw the emergence of an unprecedented profusion of new 'isms': Fauvism, Expressionism, Cubism, Futurism, Suprematism, Dadaism, to mention only the best-known. In itself this rapid pace of change, which intensified the social isolation of the avant-garde, was art's response to the principle of uninterrupted progress, as established by technology and science:[5]

> Comrades! We tell you now that the triumphant progress of science makes profound changes in humanity inevitable, changes which are hacking an abyss between those docile slaves of past tradition and us free moderns, who are confident in the radiant splendour of our future.
>
> We are sickened by the foul laziness of artists who ever since the sixteenth century have endlessly exploited the glories of the ancient Romans.[6]

This clarion call, from the 'Manifesto of Futurist Painters', issued in 1910, pinpoints the sense of inferiority that afflicts artists in their relations with technology and science – and still to this day sets the tone of the art/media debate. This lack of confidence in the efficacy of art went deep, as the Futurist manifesto shows; it was also widely shared – as transpired in the same year, 1910, when a new style, complete with manifesto, was launched at the *Salon des Indépendants* in Paris under the name of 'Excessivism'. It provoked violent reactions in the press – until it emerged that the one and only painting in the new style had been produced by a donkey, using its tail as a brush, in a scenario devised by a caricaturist, purely to create a scandal. As the exploitation of this scandal revealed, the

3 Theodor W. Adorno, *Ästhetische Theorie*, Frankfurt a.M., 1973, p. 297.

4 Guillaume Apollinaire, *Les Peintres cubistes* (1913), reprint Paris, 1965, p. 92. Apollinaire pinned this hope mainly on Duchamp; for this he was later criticised by Breton – whose verdict should perhaps be revised with the benefit of hindsight.

5 The association between 'art and progress' sets its mark on almost the whole of the age of modernism – as may be seen, for instance, from the diametrically opposed positions assumed by Gombrich and Adorno in the late 1960s – which from today's viewpoint perhaps means at the end of modernism. See Ernst H. Gombrich, *Kunst und Fortschritt*, Cologne, 1978; Adorno (as note 3), esp. p. 285 ff., p. 308 ff.

6 'Manifesto of the Futurist Painters' (11 February 1910), in *Futurist Manifestos* ed. Umbro Apollonio, London and New York, 1973, pp. 24–25.

volume of information has grown to such an extent that public attention can no longer be secured by the work of art on its own, but only by widespread diffusion through the media (above all, the daily press, in the case of the donkey's tail, cited above).

This brings us to a central problem of modernism. As forms of expression became increasingly radicalised, public acceptance diminished; in the end, the 'man in the street' came to associate the words 'modern art' with total balderdash. This directly frustrated the artists' growing need to step outside the bounds of visual art and of its institutions, which during the nineteenth century had become increasingly circumscribed, and to regain some degree of influence within society. Clearly, the desire that art should keep pace with the march of technology could not be fulfilled, simply by applying the principle of technical perfectability to artistic forms of expression. This dilemma of modernism ultimately springs from the fundamentally different ways in which historical evolution operates in art and in technology.

On one hand, the rapid technological progress of society as a whole primarily reflects a constant process of innovation in the *means* of production, information and distribution; any attempt by art to respond to this through innovation in its *forms* is doomed to fail unless accompanied by an equally radical change in its artistic techniques and channels of distribution: that is, its media. On the other hand, the problem cannot be solved merely by putting to artistic ends the new media that have evolved as industrial technologies. Artistic innovations such as Cubism and abstraction cannot simply be transposed onto the mass media in order to reach a wider public. They refer specifically to just one 'medium', that of painting, which – to counter the dominant role of photography in the depiction of reality – they reduce to its basic and original qualities.

The new image technologies have their genesis outside the arts; but, in seeking a cultural place for themselves, they initially gravitate to the artistic genres as traditionally understood. Only through the interaction with and between these genres can new media acquire something of a cultural history of their own – as can be seen in the emancipation of photography from painting, which was partial and diffident at first; or in the later, and markedly quicker, emancipation of film from theatre. By contrast, in the second half of the twentieth century such techniques as video and computer animation have evolved no cultural identity of their own at all. Both video art and computer art – marginal though they have remained, both to the industrial development of the techniques involved and to the arts as a whole – are indispensable as symbolic relics of the intellectual history of technology and as a mirror of changing cultural attitudes to these now dominant image media. From photography to virtual reality, all the so-called new media hold a cultural position in between or outside the existing artistic genres. Anyone who wants to work in them has to begin by reassessing and recombining elements of existing genres in order to make himself/herself understood. No artist – visual, musical or literary – can switch from one medium to another without simultaneously raising the question of the boundaries of the genre. The art/media relationship is thus conditioned by the principle of 'intermedia' – the overlapping, or (as Adorno called it) 'fraying',[7] of genres – but with-

7 Theodor W. Adorno, 'Die Kunst und die Künste', in Adorno, *Gesammelte Schriften*, Frankfurt a.M., 1996, vol. 10, pp. 432–53.

out the nineteenth-century ambition of creating a *Gesamtkunstwerk* or holistic synthesis of the arts.

In its relation to art, the intermedia principle operates in two ways. Internally, in the evolution of art as such and in relationships among the individual arts, genre crossover becomes the central principle of innovation and finds its application in new media techniques. Externally, in the relations between art and society, it overrides the contexts, conventions and institutions associated with individual genres and thus allows a constant redefinition of the role of art. When these two processes coincide, new genres may be created, as in the cases of photography and film, but only as transitional stages in a constant, progressive dissolution of genre boundaries. Video art is a case in point: its present status is somewhere between artistic genre and technological medium, and it is on the point of being overtaken by a wave of new, digital image techniques. When artists work with new media techniques, what is happening is not the creation of new genres but a fundamental reappraisal of all existing genres, and ultimately of the limitations of the notion of 'genre' as such.

All this may give the impression that technological progress is the sole motive force of artistic innovation. Not at all: the history of art reveals that, in almost every case, the autonomous dynamic of artistic evolution reaches and passes the limits of the given genre *before* a new technique appears and is thankfully adopted. Often, artists' projects far outstrip the current limits of technological or media feasibility; they bear early testimony to an awareness within society as a whole, which only then seeks out the technology required for its realisation. This profound parallelism between artistic and technological innovation has yet to be analysed. By contrast, nothing is more vacuous and feeble than those forms of 'media art' which spring from no inherent artistic dynamic but aim to innovate solely through technological progress; the results are no more than an illustrative apologia for technology.

The rivalry between the arts – the comparison or *paragone* that has been a vital impulse in artistic evolution ever since the Renaissance – is giving way to an interaction between the genres. The essential impulses, and problems, of the relationship between art and media are those of crossover, not of competition. As a stimulus to innovation in the arts, this crossover is a fundamental principle of modernism; as an often unavailing attempt to break through bounds conditioned by social forces, it points to the utopian function of art.

Case by Case

No theory can stand up without examples – least of all when it takes leave of the guiding thread of genre-related discourses. The innovative force of interaction between genres can be illustrated only by concrete, individual cases: for example, by the following specimen materials for a history of cross-media developments in twentieth-century art.

Artists on Stage

The simplest and most direct way to reach an audience is to perform on a stage, if possible in front of a full house. This elementary realisation is the starting-point of numerous attempts by the twentieth-century avant-garde to gain a hearing for its ideas outside conventional channels. The Futurists in their *serate*, and the Dadaists in their *soirées*, took the stage to declaim manifestos, recite poems, show paintings and present new forms of music and dance, sometimes with extraordinary costumes and masks (Figs. 1 and 2). Phonetic poetry and simultaneous readings of different texts, accompanied by actions, were new, performance-related forms of literature, which found reflection in experimental typography and montages of words and pictures. Benjamin was the first to see that this 'simultaneity' was the anticipation of cinematic effects by, as yet, inadequate means.[8]

Nothing but Optics

From the 1920s onwards, rumour had it that Marcel Duchamp had given up art in order to devote himself to other concerns. Among these were chess and the making of optical devices such as the *Rotative plaques verre (optique de précision)* of 1920 (Fig. 3 and Cat. 218). When viewed along the axis of the rotor, the rotating glass plates create an optical effect: according to speed, the spiral painted on the near side seems to contract or to curve outward. Other experiments of the same kind led to the film *Anémic Cinéma* (1925–26) and to the *Rotoreliefs* (1935), which went into large-scale production as optical toys. Duchamp repeatedly insisted that these pieces were just 'optics' and not 'art'.[9] They form part of the repertoire of the profoundly ironic para-science that had led Duchamp, back in 1913, to install a freely revolving bicycle wheel on a stool, like a test-bench in a pseudo-physics lab (see Fig. 9, p. 549 and Cat. 206).

Painted Music

A dramatic – and at times a tragic – chapter in the evolution of intermedia art is the (still inadequately studied) genesis of the abstract film. This came about as part of the great modernist utopia of 'synaesthetics': the amalgam of music and painting. There were numerous nineteenth-century attempts to make instruments that would render music visible; and in the early twentieth century the pioneers of abstract painting – including individuals as dissimilar as Wassily Kandinsky and Francis Picabia – seized upon music as the prototype for a visual art that would achieve a direct aesthetic and emotional effect without representing reality. All the pioneers of the abstract film started off as painters before trying to add the dimension of motion to their painting in the search for a marriage of visual art and music.[10]

Walther Ruttmann, the long-forgotten maker of the first abstract film (Fig. 4), wrote in 1919 that technological progress would accelerate the transfer of information, leading to a 'constant state of being swamped with material' – and thereby to an altered state of perception. As a result of this, a 'new, hitherto latent type of artist would emerge, approximately half-way between painting and music'. This 'new art ... can in any case expect to

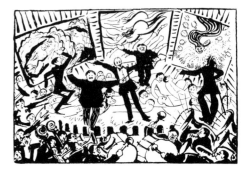

Fig.1 Umberto Boccioni, caricature of a Futurist Evening (*serata*) in Milan, 1911. Private collection. Left to right: Umberto Boccioni, Balilla Pratella, Filippo Tommaso Marinetti, Carlo Carrà and Luigi Russolo. In the background, Futurist paintings by Boccioni, Carrà and Russolo, together with the prostrate forms of unconscious 'Passéistes'

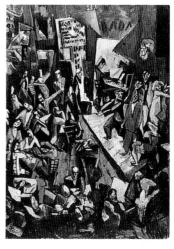

Fig. 2 Marcel Janco, *Dada Soirée at the Cabaret Voltaire*, Zürich, 1916. Lost. On stage, left to right: Hugo Ball (at the piano), Tristan Tzara (wringing hands), Hans Arp. Behind Arp: Richard Huelsenbeck, Marcel Janco. Dancers: Emmy Jannings with Fritz Glauser

8 See Benjamin (as note 2), p. 501.
9 The fact that Duchamp intended something other than an artistic effect from his optical experiments is shown by his attempt to market the *Rotoreliefs* as 'optical disks' to be played on the gramophone. Selling virtually nothing from his stand at the Paris Inventors' Fair in 1935, he summed up: 'One hundred per cent wrong. At least that is clear.' See Dieter Daniels, *Duchamp und die anderen*, Cologne, 1992, p. 125.
10 Léopold Survage created more than a hundred abstract images, beginning in 1912, for a film that remained uncompleted for lack of finance. He wrote: 'Painting has freed itself from the conventional language used for the representation of the objects of the external world and has conquered the realm of abstract forms. Now it must rid itself of its last and crucial fetter, immobility, in order to become as flexible and rich a means of expressing our emotions as music.' Survage, 'La couleur, le mouvement, le rythme' (1914), in *Film als Film*, eds. Birgit Hein and Wulf Herzogenrath, Stuttgart, 1977, p. 39.

Fig. 3 Marcel Duchamp, *Rotative plaques verre (optique de précision)* / Rotary Glass Plates (Precision Optics), 1920. Photo: Man Ray

11 Walther Ruttmann, 'Malerei mit der Zeit' (*c.* 1919), in *Film als Film* (as note 10), p. 64.
12 Viking Eggeling, 'Theoretische Präsentationen der Kunst der Bewegung' (1921), in *Film als Film* (as note 10), p. 45.
13 In Berlin in the 1920s, both Ruttmann and Eggeling (working alongside such other pioneers as Hans Richter and Werner Graeff) showed their work successfully, to considerable acclaim, but they never acquired an economic base for a systematic continuation of their work – such a base as, for instance, Oskar Fischinger was to find in the USA through advertising films and Disney commissions. Just as Bertolt Brecht called for radio to set up an experimental studio, Ruttmann too deplored 'the total lack of a laboratory' for film. See Brecht, *Werke*, Frankfurt a.M., 1967, vol. 2, p. 123; Ruttmann in *Film als Film* (as note 10), p. 65. This demand has been raised on behalf of every new medium since: in the 1960s and 1970s it was unsuccessfully raised for television. The same idea underlies all the artistic research facilities for media technology that have since been set up.

Fig. 4 Walther Ruttmann, two frames each from *Opus II*, 1919 and *Opus III* and *IV*, both from before 1923

Fig. 5 Viking Eggeling, frames from *Diagonal Symphony*, 1923–24

reach a considerably wider public than painting now has'.[11] Similarly, Viking Eggeling referred to his drawings of 1920–21, which he converted into films (Fig. 5), as 'formative evolutions and revolutions in the sphere of the purely artistic (abstract forms), roughly analogous to the events which take place in music, and with which our ears are familiar'.[12] This vision of painted music demanded more energy from the artists concerned than almost any other form of art. They worked with manic determination to convert their ideas into reality; and to this cause both Ruttmann and Eggeling sacrificed all their money and, to some extent, their health. The technical and financial difficulties involved in making the early abstract films are exceeded only by the historical calamities that subsequently befell them. Every one of those films is now either completely lost or preserved only in a fragmentary state.[13]

That the combination of music and moving pictures could indeed achieve the popularity dreamed of by the pioneers became apparent only with the success of popular music videos from the early 1980s onwards. This could happen only because in rock music, for the first time, the former 'subculture' became big business and gained access to the mass media.

The Picture Made of Light

The direct reproduction of objects placed on a light-sensitive surface was practised in the very early days of photography by Henry Fox Talbot, who in the 1840s sought to use his discovery, the 'pencil of nature', to compensate for his own lack of talent as a draughtsman. But the use of the camera relegated the technique to oblivion, until it was rediscovered in 1918 by Christian Schad and again in 1921 by Man Ray; in almost identical terms, both artists tell us that this happened entirely by chance, through a darkroom accident. Schad, who worked within the ambit of Zürich Dada, treated his little 'Schadographs' as abstract compositions of materials. He soon abandoned these experiments and – in a radical change of style – went on to become one of the most brilliant portrait painters of *Neue Sachlichkeit*.

Man Ray discovered the 'Rayograph' (Fig. 6) in the context of Parisian Surrealism, and employed it as the technique appropriate to 'automatic' creation as is evident from the title of his portfolio, *Les Champs délicieux* (Delicious Fields, 1922), with its reference to André Breton's and Philippe Soupault's first joint effort at 'automatic writing', *Les Champs magnétiques*. According to Tristan Tzara, Man Ray's portfolio set 'photography on an equal footing with painting for the first time. The photographic process serves to record a state of mind'.[14] The Surrealists regarded automatic writing not as a representation 'of something' but – like a cardiogram or an encephalogram – as a direct trace of psychic processes. Clearly, therefore, the 'automatic' image provided by photography is a suitable medium for the transference of this literary technique into the visual arts. But it is only by dispensing with the 'objective' camera – a step backward in technological terms – that photography can match poetry or painting in lending direct expression to a 'subject'. Only a media paradox could fulfil Man Ray's lifelong ambition to be recognised not only as a photographer but also as a painter.

Fig. 6 Man Ray, Rayograph from the album *Les Champs délicieux*, 1922. Musée National d'Art Moderne, Centre Georges Pompidou, Paris

At the Bauhaus, László Moholy-Nagy used the same technique under the name of the 'photogram'. His aim here, as in photomontage (which he called *Fotoplastik* or photosculpture), was to create on a plane a constructive representation of things in space. He had no interest in intuitive, 'automatic' depiction: on the contrary, the controlled, deliberate use of the new technique would enable the artist 'to handle light with sovereign assurance as a new means of formal creation, like colour in painting or sound in music'.[15] Moholy-Nagy was explicit about his interest in overcoming the boundaries between genres:

> The unavoidable phase of fumbling with traditional, optical forms of depiction is now behind us and need no longer stand in the way of the new work. We now know that working with captive light is a different thing from working with pigment. The traditional picture is a thing of the past. Opened eyes and ears are filled at every instant with a profusion of optical and phonetic wonders.[16]

This programme led Moholy-Nagy to project the chiaroscuro effects of the photogram into real space by means of his *Light-Space Modulator* (or rather *Light Property for an Electric Stage*) of 1922–30 (Fig. 7). He went on to make a film of the result. Man Ray's unpremeditated psychic automatism had given way to a precisely programmed electromechanical automaton.

Fig. 7 László Moholy-Nagy, *Light-Space Modulator (Light Property for an Electric Stage)*, 1922–30 (replica 1970). Stedelijk Van Abbemuseum, Eindhoven

The elementary principle of direct photographic exposure thus serves to link two entirely different, not to say antithetical, artistic intentions. Every time the technique appears, it does so at a crossover point between genres: in Schad's case, between collage and photography; in Man Ray's, between literature and painting; and in Moholy-Nagy's, between the photograph, the film, the light-generating object and the theatrical stage.

Directed Chance

In his musical compositions, from 1951 onwards, John Cage assigned a central role to indeterminacy governed by chance. This was also the time when he began to make use of audio tape. The resulting pieces can no longer be written down in musical notation but demand a graphic structure. The score for Cage's best-known tape composition, *Fontana*

14 *Surrealismus in Paris*, ed. Karlheinz Barck, Leipzig, 1990, p. 769.
15 Laszlo Moholy-Nagy, *Malerei, Fotografie, Film*, Munich, 1927, p. 30.
16 Moholy-Nagy (as note 15), p. 42f.

Fig. 8 John Cage, score: *Fontana Mix*, 1958

Fig. 9 Nam June Paik, *Exposition of Music – Electronic Television*, Galerie Parnass, Wuppertal, 1963. View of the space with eleven modified television sets

17 Just as Cage's own work covered a wide spectrum of media, he personally formed a link between artists of differing disciplines and generations. He studied with Arnold Schönberg and had close contacts with Duchamp and Max Ernst; at Moholy-Nagy's invitation, he taught at the New Bauhaus in Chicago in the 1940s. Cage linked these representatives of the avant-garde of the first half of the century with the intermedia of the 1950s and 1960s. From the early 1950s on, he was a close friend of Robert Rauschenberg and Jasper Johns, and his composition courses in New York at the time of *Fontana Mix* were attended by many of the artists who were later to be central to Happening and Fluxus: they included Allan Kaprow, George Brecht, Al Hansen, Dick Higgins, Toshi Ichiyanagi and Jackson Mac Low.

18 The term 'intermedia', which I here extend to the whole of the twentieth century, originated in the Fluxus movement, where it was coined by Dick Higgins. See Higgins, 'Intermedia', *The Something Else Newsletter*, vol. 1, no. 1, February 1966.

19 This is also shown by the parallel ideas of Wolf Vostell and other artists, c. 1963. Paik began to work with video as soon as Sony marketed its first video recorders in 1965. This new medium made it possible to take the step from merely modelling a change in reception on a modified TV set to producing original videos – and thus to the principle of the artist's participation in the potential of the mass medium of television. Ever since the 1960s, Paik has engaged in frequent collaborations with television companies. This culminated in 1984 and 1988 with major satellite TV projects, which took place on several continents at once and reached up to fifty million viewers. For Paik, video art is the point where the individual artistic intention meets the universal potential of the mass media.

Mix of 1958, consists of twenty-two drawings, twelve of them on transparent film (Fig. 8). By recombining the pages of the score with each other and with a variety of overlays, the work can be interpreted in many ways quite different from the one adopted by Cage on the tape recording; and many of these ways transcend the bounds of musical form. In 1958, in conjunction with the score of *Aria*, that of *Fontana Mix* served as the basis of a purely vocal piece based on sounds from five different languages. In 1959 it was used for *Sounds of Venice* and *Water Walk*, two pieces made for television; in 1960 Cage used it again for his *Theatre Piece*, to be performed by between one and eight musicians, dancers or actors, who must carry out between fifty and a hundred actions each. The same score can thus serve for a tape montage, an *a-cappella* vocal piece, a TV broadcast, or a theatrical performance.[17]

In the 1960s the notion of the 'open work', coined by Umberto Eco on the basis of the New Music, became the basis of a new, trans-genre aesthetic for which Cage was a central source of inspiration. The new role played by the audience in Eco's 'open work' foreshadowed the different principle of interactivity, which emerged along with the digital media in the 1990s.

Television as a Creative Medium

Fluxus might be described as the last movement in twentieth-century art. Without ever forming a style, Fluxus gave those involved a strong sense of collective identity, based above all on two fundamental aspects: internationalism and intermedia.[18] As distant aspirations, both have haunted many modern movements, from Futurism to Surrealism; but only Fluxus turned them into a way of life that made possible a genre-breaking form of art with a nonhierarchical, decentralised structure.

Nam June Paik is the typical – indeed the ideal – embodiment of this. As a Korean musician in Germany, he proceeded by way of the New Music to the electronic image; then, in the USA, he became the central figure of video art. Paik's first major project, *Exposition of Music – Electronic Television* (Wuppertal, 1963), is now considered to mark the inception of video art (Fig. 9). The exhibition's two-part title reflects Paik's transition from music to the TV screen. He here transferred his experience with electronic sound to the electronic image, which, by intervening inside the TV set, he turned into 'participation TV'. There was no video technology on the market in 1963, so Paik could work only by electronically manipulating twelve second-hand TV sets to modify the broadcast programme in constantly shifting, exemplary ways, some of which involved the active participation of the visitors to the exhibition. The idea of video art thus predated the availability of video technology by several years.[19] Paik went beyond video art to envisage a comprehensive cultural function for all the new technologies. As he put it in the theses he set out in 1974 for a 'Media Plan for the Postindustrial Age':

> The planning of the Broadband *Communication Revolution* must start right now. If the liberal establishment continues to ignore the media and communication and leaves them at the mercy of purely commercial capital ... the monopoly of all technology will revert to some mysterious power complex ... New economic dislocations, caused by the double shock of the increase in energy prices, the destruction of the environment

and the historical necessity of the transition to a postindustrial society, demand equally radical measures …
One of the stimuli so desperately needed will be a gigantic new industrial complex, attached to a network
of powerful transmission ranges … The building of new *Electronic Superhighways* will be an even greater
undertaking.[20]

The prophetic nature of Paik's project was evident well before the time of Bill Clinton's
presidential campaign of 1992, which centred on the building of a 'digital superhighway'
to revitalise the American economy. Drily, Paik commented: 'Bill Clinton stole my idea.'[21]
In the 1990s, the same two concepts on which Paik and Fluxus based themselves in the
1960s, internationalism and intermedia, have turned into a political and economic pro-
gramme that goes far beyond art and towards a media-defined 'way of life' that will turn
yesterday's artistic utopias into an everyday reality.

The Conditioned Viewer

Bruce Nauman's work is marked by a concurrent use of a wide spectrum of techniques,
media and materials. While continuing to work with objects, sculptures, installations and
performances, Nauman took up film in 1965 and video in 1968. Initially, he used them
mainly to make a record of his performances, which he now staged in the studio without
an audience. For the video *Walk with Contrapposto*, of 1968, Nauman built a narrow cor-
ridor, along which he was seen pacing to and fro, assuming poses reminiscent of those
in classical art. In 1969 he exhibited the same structure, initially built purely for use in
the video, as a sculpture through which visitors could walk; in 1970 it became the setting
for a closed circuit video installation. In this, Nauman installed a pair of video monitors
at the end of the narrow passageway and a video camera directly over the entrance
(Fig. 10). The viewer entered the empty *Live-Taped Video Corridor* only to see his/her own
image captured by the camera and displayed on one of the monitors; the second monitor,
however, showed a prerecorded videotape of the empty corridor. The viewer's attempts
to sort out the confusion created by the simultaneous video evidence of his/her presence
and absence were thwarted when he/she approached the monitors, only to recede from
the entrance camera and almost disappear from the screen altogether.

Video interests Nauman not as a mass medium but for its private, even intimate quality.
In contrast to the 'open work', as practised by Cage and Paik, in which the public ac-
quires a creative role, Nauman stresses and unsettles the viewer by actually limiting
her/his freedom of action: 'I mistrust audience participation.'[22]

Summary

As we look back over the twentieth century, it becomes clear how much intermedia art
has been lost, destroyed or simply forgotten. That is the disadvantage of an art which
falls between genres, which often accepts ephemeral status, and which tends to fall
through the conservatorial net of those highly genre-specific institutions, the museums
and archives of art. There remains the question why the field of intermedia is now being
considered specifically within the context of visual art. This is something that would
have made no sense to Clement Greenberg, whose central thesis it was that, for every art,

Fig. 10 Bruce Nauman, *Live-Taped
Video Corridor*, 1970. Solomon R.
Guggenheim Museum, New York;
Panza Collection

20 *Nam June Paik. Werke 1946–1976*, ed. Wulf Herzo-
genrath, exh. cat., Cologne, Kölnischer Kunstverein,
1976, p. 159ff., p. 165.
21 *Nam June Paik. Eine Database*, ed. Klaus Buss-
mann and Florian Matzner, Stuttgart, 1993, p. 110.
22 *Bruce Nauman*, exh. cat., Minneapolis, Walker
Art Center, 1994, p. 77.

'the guarantee of its standards of quality as well as of its independence' is to be found only in its 'purity';[23] he expressly ascribes a leading role to painting and singles it out as 'the Modernist, the avant-garde art *par excellence*'.[24] But surely, in visual art, the compulsion to innovate does not spring from a position of strength and self-assurance but from the deep-seated disruption and instability imposed on the whole field of human image-making by the advent of the technological media. It was precisely this radical undermining of its function and its tradition that left visual art so open, so ready to become the central locus of interaction between genres.

It is no coincidence that the examples cited here stem mainly from the periods 1910–25 and 1955–70. The relationship between art and media in the twentieth century has swung back and forth, rather like a sine wave, between highly open, intermedia phases and closed, genre-specific phases. These two particular fifteen-year spans were phases of intensive reorientation and rapid innovation in the arts. They are closely related historically. In the mid-1950s, Dada and Duchamp were rescued from a long period of oblivion; the 1960s saw the revival of abstract film, light art and kinetics.[25] A similar affinity is now emerging between the 1960s and the 1990s: the present-day situation – which my examples do not cover – is marked by the omnipresence of the media and by a debate on their cultural function. In the 1920s and in the 1960s, people debated whether artists should work with new technologies and why; today, the question that has to be asked is the converse. When all areas of daily life bear the marks of the digital media, can art be the only exception?

Intermedia Multimedia

> True, art has historically been a highly effective method of indicating the presence of an omnipotent power. But, just as in Hegel's day art ceased to be the highest form of the spirit, in a computerised world art is being superseded by a form of magic that invokes no longer omnipotence but reality . . . From this power over reality, artists unless they themselves become engineers or programmers are firmly excluded.
>
> Friedrich Kittler, 1993[26]

The interaction between genres and between media as a stimulus to artistic innovation in modernism, as sketched out here, ought really to be extended to the parallel history of media technology in the twentieth century. This would reveal that the relationship between art and media is not a one-track, causal one: art does not simply apply and convert what it receives from technology. Of course, artists and their impulses have little actual effect on today's media society; but the art of intermedia has nevertheless frequently anticipated, by modelling, the present-day multimedia 'way of life'.

The transition from the artist-generated concept of 'intermedia' to the technology-driven concept of 'multimedia' must not obscure the basic ideological contradictions between the two.[27] In the arts, since the 1970s, postmodernism has caused innovation to be regarded with some scepticism; by contrast, in the world of technology – and particularly in the

23 Clement Greenberg, 'Modernist Painting' (1960), in Greenberg, *The Collected Essays and Criticism*, ed. John O'Brian, vol. 4, Chicago, 1986, p. 86.

24 Clement Greenberg, 'Intermedia', *Arts Magazine*, vol. 56, no. 2 October 1981, p. 92. Any possible parallel between art and the evolution of the technological media remains, for Greenberg, absolutely taboo. The media are the 'blind spot' in his theory of the qualities specific to each art; this leads him to the following (for a convinced modernist) radically conservative view: 'Good art can come from anywhere, but it hasn't yet come from "intermedia" or anything like it.' Ibid., p. 93.

25 An important part was played in this by the anthology, edited by Robert Motherwell, *The Dada Painters and Poets*, New York, 1951.

26 Friedrich Kittler, 'Künstler – Technohelden und Chipschamanen der Zukunft?' in *Medienkunstpreis 1993*, eds. Heinrich Klotz and Michael Roßnagel, Karlsruhe and Stuttgart, 1993, p. 47, p. 51.

27 On this see Dieter Daniels, 'Über Interaktivität', in *Zeitgenössische Kunst und ihre Betrachter*, Jahresring 43, ed. Wolfgang Kemp, Cologne, 1996.

digital media – progress seems to be not only constant but accelerating. However, it has long been impossible to speak of technical evolution as purposive, and nowhere does the Darwinian 'survival of the fittest' hold firmer sway than in the realm of new digital media. The constantly growing complexity of both hardware and software, and their intricate networking structures, make it almost impossible to take in the whole picture. In the growth society, automatic innovation is an economic and technological imperative; but the growing efficiency of media production techniques has not been matched by any corresponding growth in the human capacity to respond to them. The result, as Jürgen Habermas remarks, is a 'new confusion', which prevents us from ever gaining an overview. Hence the often-deplored absence of the utopias and all-embracing models of earlier times. The boundaries between ideology and technology have become fluid, and it is not clear from which quarter any such new models may be expected to emerge. Here the shortcomings of efficiency-driven innovation becomes apparent.

As far as future evolution is concerned, it may be predicted that the 'universal machine', the computer, will amalgamate all the still-separate media, and that in future a single digital multimedia network will integrate the functions of text, picture, sound and dialogue.[28] The 'media' will no longer be a constantly expanding plural; any distinction between them – and with it the concept of 'media' itself – will become meaningless. With the digital image, a depiction of reality is indistinguishable from a simulation or an artificial construct; and so the divide between reproductive and creative image techniques – the divide that formerly separated photography from painting – becomes blurred. In a digital world, the idea of an 'original' becomes obsolete. All of this may herald a turning-point as momentous as was the emergence of the very first technological image, the photograph.

It may well be true that artists have no power over the real world – or indeed that they never had any. It may also be true that young people who, in an earlier age, would have become artists now go into the media.[29] But art, and visual creativity, in general, remain in possession of one vast swathe of territory – the source of all the definitive innovation, either in technology or in art, that is not powered solely by economic imperatives. This territory is commonly known as the imagination.

At the same time, the concept of 'art' as a single, coherent entity has been called in question so far as to make it almost impossible for us to speak about it in general terms. Instead of speaking of art as a whole, it is easier to speak of the individual arts, or genres, or media. Entities that formerly belonged to art now disengage from that context, join forces with a new technology, and become what Adorno called 'virtually a thing among things: the one thing of which we know not what it is'.[30] The relationship between art and media may be on the point of a momentous reversal, in which the singular of 'art' and the plural of 'media' will change places. If so, it might well become apparent that art always has been a medium.

28 On this see Kittler (as note 26), p. 52.
29 See Christoph Blase, 'Die Spitze im Internet', *Kritik*, no. 3, Munich, 1995, p. 42.
30 Adorno (as note 7), p. 450.

PETER SCHJELDAHL

For Waldo: An Essay on Art Criticism

Waldo Lydecker was a leading New York critic of an indeterminate type, who wrote about art among other things. He was rich and very elegant. His rhetorical style combined flowery sentiment and caustic wit. Waldo said things like 'I am not kind, I'm vicious. It is the secret of my charm.' He was a murderer. He was killed by a policeman, while trying to murder a beautiful woman with a shotgun. If you want to know more about Waldo, he is a fictional character played by Clifton Webb in Otto Preminger's 1944 thriller *Laura,* a Hollywood product remarkable for its equation of aestheticism with evil. A period type, he is a darker, kitschier cousin of the theatre critic Addison DeWitt, magnificently portrayed by George Sanders in *All About Eve* (1950). I propose Waldo Lydecker as the archetypal art critic of the twentieth century, who died for the sins of his fellow practitioners.

Ordinary people in America – middling citizens of the newspaper-reading classes – despise art criticism. They don't read it, of course. But they also don't read criticism of dance, say, or serious music, and they have nothing against those genres of writing. Art criticism, unread, affects popular imagination like a bad smell. Partly, this is because art symbolises creativity, which is a value sacred to bourgeois and entrepreneurial culture, and criticism symbolises the murder of creativity. There are other reasons as well. The reasons add up to make art criticism the most provocative and potentially the most revelatory medium of intellectual play in normal society, as well as the most difficult and shadiest, the most suspect. The reasons orbit the word 'art'.

Do not ask what art is. You know without asking that it is whatever you please. Select the answer you prefer, then rephrase the question to fit. Modern art built questions backwards from answers. Every really new (that is, successful) modern artwork raised again, by purporting to answer, the big questions of what art is and what art is for. The sure way to fail in modern art was to assume the continuous authority of any particular answer, laying the big questions to rest, from one generation to the next. Modern art compulsively stirred up uncertainties about the identity, nature and function of art. Everybody knew this. It delighted some and appalled others. It made everyone an art critic.

Modern art collapsed creativity into the critical function. The modern artist was an artist as critic, whose works launched and countered critical thrusts. Art critics played little part in these thrusts and counterthrusts, except as publicists and either advocates or opponents. Not all modern artworks declared that art could only be a certain way, but every modern artwork insinuated that art could never, or never again, be certain other ways. To forestall alternate histories was the modern art project. Modern art ended when

new artworks stopped denying each other the right to exist. Does the resulting pluralist situation vest power in art critics? Scarcely. Within the art world, power lost by artists has been usurped by patronage.

What legitimate power do art critics have? They can affect the climate of perception and opinion that it is their business to describe. They are more powerful than television weather forecasters, because when a critic declares that there is a storm in the art world, a veritable cloud may be seen to pass across the sun. But critics ultimately are judged like forecasters, rather strictly on their reputations for accuracy. Beyond that, the power of art criticism is negative: an overthrow of institutional coercion, a seam of playfulness in the fabric of terribly serious culture. Art criticism misses its main chance, if it does not represent liberty.

Modern art criticism was born and took form as an ad hoc, intermittent public performance, structured by the nervous systems of unusually sensitive and audacious souls: Charles Baudelaire, by all accounts, and others. Oscar Wilde and Gertrude Stein loom particularly large for me. Those souls understood and took personal comfort in modern art's incorrigible fluidity, its incessant production of questions sabotaging itself, its continual net gain of mystery. What was shiftily called the avant-garde – a term deferring toward the future an absolutely present motive – infused indecisive spirits with joy in their vacillation, even as it struck momentary postures of violent conviction. Modern art criticism made lack of identity an engine of intelligence.

The self-invented person of sensibility, the freelance trickster, the art critic – the Waldo Lydecker – floats like a flag over the twentieth century, inspiring bemused salutes. Art critics enjoy, if they have courage enough to admit what they are about, a freedom that attracts envy and resentment: the freedom of the mystery of art, a sensible sort of mystery that is easy to demonstrate, while impossible to solve. The freedom has to do with zones of constant slippage in the big meanings of culture. Big meanings slip whenever human activity is suddenly estranged – appearing new, weird, or frightening – and thus presents itself to consciousness, to be judged for efficacy, sanity or morality. Such slippage occurs in every field of modern life. But the art world, alone among culture's established franchises, is all but identical with it. The art world's view of what humans do constitutes a permanent state of emergency.

The art world confronts and addresses modern history, but scarcely belongs to it. Sphere of archaic forms of artisanly craft and mercantile commerce, the art world should, by rights, be obsolete. Consider just one anomaly: economically based on unique objects, visual art is the only modern creative field whose paying customers and public audience are not the same people. And yet the art world survives as an official site, like a game preserve, for persons licensed to dream of possible futures and of impossible, alternate realities. Deprived of the eliminative function of modern art's critical consciousness, the art world of today is a grossly congested arena, where things accumulate senselessly. But it remains a proper home for the renegade temperaments that may lead young intellectuals into becoming art critics.

I must speak for myself: I hate art criticism that is art criticism before it is something else of independent and inherent value, such as essayistic prose. I have read very little of it, considering that it has been my livelihood for thirty years. Writers who have inspired me as an art critic are mostly poets, philosophers, fictionists and journalists in fields other than art. Nor did I study art in school. I came to my vocation by accident, an amateur obliged to write for a living because, as a college dropout, I was unqualified for most employment. (New York's insatiable weekly and monthly demand for column inches of art criticism draws footloose writers into the job as a whirlpool collects driftwood.) I am not unusual in this. My countrymen Clement Greenberg and Harold Rosenberg were amateurs, too, as was Baudelaire, the father of us all. In fact, autodidactic grounding seems to me normal, and even ideal, for art criticism, whose proper focus is extra and often significantly hostile to what the experts in established fields of knowledge know.

Do art critics belong to the art world or to the public for whom they write? To both and neither, if they are good. The finest art criticism, without exception, functions inside and outside its subject, at the same time. To be too far outside is to be uselessly disengaged. Such is the condition of academic art writing, which at best explores ideas that intersect the course of art. To be too far inside is to be prevented, by all too human loyalties, if not venality, from telling the truth. At boundaries between private worlds of committed people and professionals, on the one hand, and the public world of spectators, on the other, the art critic works in a crossfire of conflicting interests. Perhaps no other writerly specialisation presents so many ways to fail.

Waldo Lydecker fails by every test, except that of glamour. A popular columnist, pandering to newspaper readers, he vulgarises the monkish values of his aesthetic cultivation. He uses his public power for personal ends, in the private worlds he covers. Waldo destroys, with a column, the reputation of a painter who is his rival in love. This is a familiar sort of novelistic motif, typical of Balzac and found also in Baudelaire – whose alter ego, in his novel *Fanfarlo,* uses a newspaper column to extort love from an actress. Waldo's sole justification is that he is readable. As a type that popular audiences love to hate, Waldo is, unsurprisingly, the villain of the movie *Laura.* But such is his entertaining appeal that, for his downfall to be dramatically acceptable, he must be proved a homicidal maniac.

Waldo Lydecker, *c'est moi?* No. But I admit him as a colleague, as I also admit all the thousands of writers – names unknown, by no one cherished! – who have received paycheques for appearing to mediate between realms that, finally, cannot be mediated: art world and art audience, art culture and culture at large. The story of twentieth-century art criticism is a baggy chronicle of picaresque doings in mostly obscure and shabby regions, very justly despised, with now and then a shining deed. I confess that I regard art criticism as the only form of journalistic writing worthy of serious ambition. Its impossible contradictions give it *gravitas.* Its contingency to the moment of its composition, with which it almost inevitably perishes, gives it a tragic charm.

Nearly all art criticism of the modern era is unreadable today, because the mediations that it attempted – and failed – to perform are of only antiquarian interest. Do you care how Roger Fry endeavoured to make crazy-looking French pictures acceptable to the tastes of Englishmen, now long defunct? I don't, though I would have respected him as a contemporary. (My one indelible point of fascination with Fry is a detail from Virginia Woolf's biography of him: he would not listen to music, because he was disturbed by the egotistical feelings that it stirred in him. He is, for me, a figure of bizarre scrupulosity.) Nor am I excited any longer, as I was in the early 1960s, by the rhetorical ingenuities with which Harold Rosenberg excited a fashion for New York painting among visually naïve New York intellectuals. That's cold pudding now.

In fact, only Baudelaire among modern art critics seems to me eternally readable – and only in part, comprising mainly his *Salon of 1846* (on which *The Salon of 1859* and *The Painter of Modern Life* expatiate). To read the 1846 *Salon* is, for me, to experience anew the 'alienated majesty' that Ralph Waldo Emerson found in writing, by others, that seems to express our own unspoken thoughts. In it, Baudelaire invented, described and practised modern art criticism with a single gesture of inflamed and humbled intelligence – inflamed and humbled by the emergent otherness of life in modern civilisation. He established in his own voice the figure of the critic as a node of isolated consciousness, openly registering the processes of other isolated nodes. His is the loneliest voice that ever declaimed, with reckless confidence, the mad poetry of journalistic prose.

To speak my thoughts as if they could be yours – and as if, come to that, they were even mine – is insane, unless couched in humour equal to its presumption. Baudelaire's dedicatory introduction to *The Salon of 1846*, 'To the Bourgeois', has the largest, most historically resonant, humour of any text I know. 'You are the majority, in number and intelligence; therefore you are power; and power is justice', the poet begins, committing himself and his posterity – including myself, 150 years later – to a posture that supplicates, while caricaturing the mass mind of democracy. The comedy of modernity in criticism here begins. It will be advanced by the self-treacherous paragraphs of every honest critic ever after.

Kneeling to the triumphal bourgeois with the mixed emotions – devotion, loathing – of a servant bound for life, Baudelaire spectacularly makes a burnt offering of his own intellectual class: 'the aristocrats of thought, the distributors of praise and blame, the monopolists of spiritual things … pharisees.' Now, you may read between the lines of 'To the Bourgeois' all the ambivalence you like, salvaging the pride of intellectuals as somehow superior to businessmen. But the arc of Baudelaire's rhetorical gesture defines the civic situation of art criticism, from that day to this. Many critics in our century have squirmed and stormed to deny the fatality of the bourgeosie's majoritarian power. In the end, history has confirmed Baudelaire's intuition, to the bittersweet satisfaction of his irritable ghost.

While he was at it, Baudelaire laid down the formal template of modern art criticism. All of us write 'Salons'. Ours may be a Salon without walls or a Salon fragmented in discrete

exhibitions, but structurally it is the same middle class palace in which the Frenchman conducted his fictive, strolling seminars. To stand beside the reader in the physical presence of art objects is the definitive imaginative act of the art critic. To do so with a style that stays in the mind, generating thoughts and feelings beyond those written down, is the mark of a good critic. A good critic is a companion for life, not always pleasant company, perhaps, but reliably alert to your constant interests and your most frequent moods. A good critic becomes an extra voice in your mind. That is what critical writing is good for.

A great critic becomes an extra voice in critics' minds. Such is Baudelaire for me. Such are Oscar Wilde and Gertrude Stein, D. H. Lawrence and W. H. Auden, William James and Ludwig Wittgenstein. Such are Allen Ginsberg and Frank O'Hara. O'Hara still whispers in my ear his ethic of performance, which scorns the support of such trifling bona fides as educational qualification. He spoke of poetry, but the principle applies generally: 'You just go on your nerve. If someone's chasing you down the street with a knife you just run, you don't turn around and shout, "Give it up! I was a track star for Mineola Prep."' Why should anyone, writing mere art criticism, feel that he is running for his life? I don't know, but I tend to respect only those critics who palpably feel that way.

The routine consternation – the workaday terror – of art criticism entails a fundamental sense of illegitimacy. The modern art critic is a bastard, born of aristocratic traditions and democratic institutions. There is only one honourable way to conduct oneself in this inescapable quandary: perversely. Because an art critic cannot be anything integral and changeless, he or she might as well be any partial thing that, in passing, pleases. The scriptural text of this insight is Wilde's essay 'The Critic as Artist' (1890). Written in dialogue form to emphasise its theatricality, it proposes criticism as a theatre of the mind, in which strange intellectual personae – hereditary and imagined formations of intelligence, called forth by aesthetic stimuli – take turns upon the stage. 'Man is least himself when he talks in his own person', Wilde advises. 'Give him a mask, and he will tell you the truth.'

The nature of what that truth might be is evoked in another great essay, 'What Are Master Pieces and Why Are There So Few of Them' (1936), where Gertrude Stein says the following:

> The thing one gradually comes to find out is that one has no identity that is when one is in the act of doing anything ... I am I because my little dog knows me but, creatively speaking the little dog knowing that you are you and your recognizing that he knows, that is what destroys creation ... [The masterpiece] has to do with the human mind and the entity that is with a thing in itself and not in relation ... [Masterpieces] are knowing that there is no identity and producing while identity is not.

Those thoughts, especially the distinction between identity and entity, seem to me pure common sense for any artist and for any critic as artist.

Any critic who is not a critic as artist is a critic as would-be scientist and/or a simple propagandist. Now, *would-be science* is a pretty fair portmanteau epithet for the modern in culture. As an idea, the modern was about bringing the world under the control of systematic knowledge. As an event, the modern was an adventure in howling chaos. The

various cocksure tones of canonical modern art critics strike my inner ear as ridiculous, sad, or horrible if not, as in the shady and sometimes glorious ilk of Waldo Lydecker, as guilefully, manipulatively false. That is, my ear divides critics between those whose presumptions are ludicrous and those who, between the lines, laugh at me and, in the finest instances, also at themselves.

The great types of modern art criticism are sacred monstrosities. Guillaume Apollinaire is a demonic, quite adorable charlatan, for instance, who figures forth the modern in seductive and bewildering tones of voice. His writing on Cubism is utterance that sounds like art criticism, and if you can make sense of it, you scare me. Apollinaire's critical writing stands in relation to normal criticism rather as Cubism stands to previously normal painting: a fractured reflection and labyrinthine analysis, an audacity conducted with hilarious matter-of-factness. Picasso and Braque called each other by the names of the Wright Brothers, evoking for art the spirit of American mechanical geniuses. Apollinaire could justly have been nicknamed 'Edison'. He made lightbulbs of bright ideas shine in the void.

In the court records of modern art, the writings of art critics are not primary or even secondary testimony, but tertiary. First come artworks, and second come writings by artists – from Wassily Kandinsky and Kazimir Malevich to Donald Judd and Robert Smithson – who took the propagation of their ideas into their own hands. Even the modern lumpen journalistic medium of the interview provides the future with more substantial evidence of twentieth-century art than most criticism. (Which would you save from a burning Library of Alexandria: Pierre Cabanne's little book of interviews with Marcel Duchamp or the collected works of Clive Bell?) A special talisman for me is Frank O'Hara's largely fictive interview with Franz Kline, containing this majestic *koan*: 'To be right is the most terrific personal state that nobody is interested in.'

I trust that my prejudice is obvious. I refuse art criticism the privileges and immunities due a professional specialisation, judging it strictly by its character and quality as writing. Accordingly, I read the soi-disant professionals, with their cunning jargons, as impersonators of an impossible myth, more or less amusing in their performances. I am unfair. Fairness depends on rules, and I do not accept rules for art criticism. What moves me to generosity is only the voice in prose of a living individual, who accepts his or her responsibility to persuade me. Usually this responsibility – an appeal to gods – occurs only in writers who are writers first and critics, incidentally. (I feel it in Julius Meier-Graefe.) But gods may parade in outlandish costumes.

Two modern critics who adopt the colours of Dionysos and Apollo, respectively, are Georges Bataille and Clement Greenberg. Those two names are much bandied at the twentieth century's end, for reasons that are understandable, if not good. Bataille proposed that 'the universe is something like a spider or a gob of spittle' (a formulation that fails with me, because I rather like spiders). He unflankably occupies a far left wing of modern sensibility, as a figure of intellectual ambition curdled into vengeful despair. For me, Bataille constellates mere pride, albeit of beguiling intensity. *L'informe* is only as dra-

matic as the strength of the forms that it attacks. What forms in this century have been strong, except locally and provisionally?

Clement Greenberg performed a conjuring trick, by which artistic form appeared to float majestically above the fray of history. Many art critics have tried something similar, but only Greenberg succeeded for long. Being something of a genius, able to convey subtle analysis in plain language, helped him succeed, but so did chance. He was virtually a fellow artist of the American Abstract Expressionists, who revolutionised painting and global cultural power relations after World War II. He provided Jackson Pollock's paintings with a retroactive ideology that made their conquest of the art world seem inevitable and just. He also advanced a compelling intellectual narrative of modern art, at a moment when a generation of intellectuals became suddenly avid for Picasso, Matisse and their posterities.

My perspective on Greenberg was formed in the 1960s, when I arrived on the scene. It is compounded of awe at his rhetorical force and contemptuous amazement at the futility of his thinking, in the face of art's actual unfolding. His theories of aesthetic judgment dazzle, even as his judgments of art after Pollock seem consistently bizarre. I well recall the schizoid impression made by Greenberg's simultaneous strength and weakness in the '60s. It was an impression prophetic for a disastrous change in art culture ever since. By the 1980s, art theory and art production came to inhabit not just different spheres but different universes, to the detriment of both. I blame Greenberg's example for a perennial glamour of ideas about art that overrule the testimony of the senses and of common sense.

Greenberg was a poet of purity in a dirty age. There is no honour in that, I think – especially in his case, given his shameless interventions in the studio practices and market promotion of his favoured Colour Field painters. But there is a certain vatic appeal. Among other common connotations of 'art' is a spiritual state of being entirely too good for this corrupt world. We still congratulate Vincent van Gogh on killing himself, before he could be sullied by financial security. For observers of art, purity entails being so far removed from the scrimmage of art-making and its immediate reception that they cannot possibly know what they are talking about. To be sufficiently engaged for wisdom is to be intimate with phenomena endlessly equivocal and foolish.

I give my own moral compass as an art critic a name: Waldo Lydecker, before his fall. Waldo fell when he made a Galatea of a woman, Laura, and felt entitled to destroy her when she betrayed him. He confused his talent as an intellectual performer with his prerogative as a man. An honest mistake! Before that, and even grotesquely during it, Waldo was a faithful steward of a public persona that owed exclusive fealty to his readers. The art critic, a loose cannon on the deck of modern culture, is never wrong, while acknowledging whose weapon he or she is. I belong to you, reader. You create and make or break me. I am as splendid as your uses for me, and as upstanding as your character. It is the secret of my charm.

The author warmly thanks Brooke Alderson, Dave Hickey, Christopher Knight, Jerry Saltz and Robert Storr for help and advice on this essay.

Appendix

Artists Biographics

Written by Hajo Düchting (H.D.), Karin Osbahr (K.O.) and Christine Traber (C.T.)

CARL ANDRE

was born on 16 September 1935 in Quincy, Massachusetts. After studying art for two years at the Phillips Academy in Andover he went on to work at the Boston Gear Works, in Quincy. In the course of a journey to Europe in 1954 he visited Stonehenge and other neolithic sites, which made a lasting impression on him. On completing his military service he went to New York in 1957, where he worked initially as an assistant in a number of different publishing houses.

In 1958 the poet and filmmaker Hollis Frampton introduced him to Frank Stella, at a time when the latter was engrossed in painting his first stripe paintings. In Stella's studio Andre began working on massive blocks of wood, into which he made deep incisions. In this, he was influenced not only by Stella's serial works but by Brancusi's sculpture, as was evident both from the working methods he employed and in the relation of the wooden blocks to the floor. The influence of the 'endless verticality' of Brancusi's *Endless Column*, in particular, led straight in to his towering, rough-hewn wooden stelae, such as *First Ladder* (1958). In 1959 he made several more works out of identical wooden beams, which he arranged into pyramid-shaped structures. As in the case of most of Andre's early work, these 'pyramids' were subsequently lost. In the following year he planned to make a number of wooden objects from a limited number of identical elements, arranged in a simple order ('Element Series') as towers or gateways, out of lengths of building timber stacked up and piled on top of each other. However, he only came round to making these ten years later. At the same time he made a number of text pieces, laid out serially as word groups in flat patterns ('Calligrammic Poetry'), which formed the counterpart to his sculptural work of the same period.

Unable to make a living from the sale of his art, Andre worked as a brakesman and shunter with the Pennsylvania Railroad in New Jersey from 1960 to 1964. His experience of the seeming endlessness of the railway tracks induced him to switch emphasis in his sculpture to arranging the elements in modular, horizontal groups. Much as his early 'cuts into space' (as he termed his sculptures) were vertically orientated, the new sculptures were laid out horizontally as lines delineating space, as in the case of *Redan* (1964), where twenty-seven lengths of timber were laid out to compose a zig-zag line, and *Lever* (1966), in which 137 bricks were laid end to end, in a dead straight line.

In 1964 Andre took part in the exhibition *8 Young Americans* at the Hudson River Museum in Yonkers, New York. Eugene C. Goossen, the organiser of the exhibition and early champion of the artistic tendency which later became known as 'Minimalism', had one of Andre's previously destroyed 'Pyramids' *(Cedar Piece)* remade for the exhibition. In 1965 Andre was given his first solo exhibition at the Tibor de Nagy Gallery in New York, where he showed a number of room-filling structures made of styropor beams (*Crib, Coin, Compound*, 1965).

Henceforth, Andre's work was to be characterised by the use of standard prefabricated elements, as components of a larger whole. In general, the individual modules were not firmly attached to each other, but assembled into simple, basic geometric forms. The so-called 'Scatter Pieces' were an exception to this – as in the case of *Spill* (1966), which comprised 800 small lumps of plastic, taken out of a bag and scattered at random over the floor. Here, too, Andre's concern was to define the surrounding space, but his concept of 'sculpture as place' was again given most stiking expression in his series of floor pieces composed of metal plates, beginning in 1967. In place of the building materials used in earlier works – bricks, timber and styropor blocks – Andre now began using identical square plates made of different metals (steel, lead, zinc, copper, etc.), laid out on the floor in large, mostly square, configurations, onto which the viewer was free to tread. *64 Steel Square* (1967), a floor piece made up of sixty-four steel plates, encloses the space and seems to give it tangible form. It is one of the earliest examples of those works for which Andre is now, perhaps, best known. The viewer is actively encouraged to enter the sculpture and makes a noise, walking across the metal plates, or experiences a novel sensation of space, when standing in the middle. Thus any perception of what sculpture is about is extended, as Andre put it, 'from form in sculpture to structure in sculpture, to place in sculpture'.

As a leading exponent of Minimal Art since the end of the sixties, Andre has taken part in many important exhibitions in Europe, such as the *Minimal Art* exhibition at the Gemeentemuseum in the Hague, *documenta 4* in 1968 and the epoch-making exhibition *When Attitudes become Form* in Bern, Krefeld and London, in 1969. In 1982 he took part in *documenta 7* and in 1984 he received an award from the German Academic Exchange Service (DAAD), under their artists-in-residence programme for Berlin.

Andre lives and works in New York. H.D.

Diane Waldman, *Carl Andre*, New York, 1970
Nicholas Serota, *Carl Andre: Sculpture 1959–1978*, exh. cat., London, Whitechapel Art Gallery, 1978
Carl Andre and Hollis Frampton. 12 Dialogues 1962–63, ed. Benjamin H. D. Buchloh, Halifax and New York, 1980
Carl Andre, exh. cat., The Hague, Haags Gemeentemuseum and Eindhoven, Stedelijk Van Abbemuseum, 1987
Rolf Lauter, Carl Andre. Extraneous Roots, exh. cat., Frankfurt a. M., Museum für Moderne Kunst, 1991
Carl Andre. Sculptor 1996, exh. cat., Krefeld, Haus Lange and Haus Esters and Kunstmuseum Wolfsburg, Stuttgart, 1996

FRANCIS BACON

was born to English parents in Dublin on 28 October 1909. At the outbreak of war he moved with his family to London. Bacon received individual tuition as a child, rather than going to a normal school, because he suffered from asthma – an affliction which was to trouble him for the rest of his life. In 1925 he left home and supported himself in London by taking casual work, mostly as a furniture designer and interior decorator. In 1927 and 1928 he made trips to Berlin and Paris, where he received commissions as an interior designer. A Picasso exhibition at the Galerie Rosenberg in Paris set him on the path of his first independent efforts as an artist. In 1930 the periodical *The Studio* published some photographs of Bacon's studio, with some of the furniture and rugs that he had designed. In 1931 he gave up work as an interior designer, in order to concentrate solely on painting. As an autodidact, he was initially influ-

enced by his friend Roy de Maistre. In 1933 Herbert Read reproduced a painting by Bacon (*Crucifixion*, 1933) in his book *Art Now*, but success and recognition did not come at once. During the war Bacon served as an air-raid warden. Dissatisfied with his artistic efforts thus far, he destroyed a large number of early pictures in 1943 and only took up painting again one year later.

The triptych *Three Studies for Figures at the Base of a Crucifixion* (1944) was exhibited at the Lefevre Gallery in London and created a sensation. Bacon's growing reputation was reinforced by the purchase of *Painting* (1946) by the Museum of Modern Art, in New York. In 1954, it was such that he was invited to represent Great Britain at the Venice Biennale, together with Ben Nicholson and Lucian Freud. By the mid-fifties his work had won international recognition.

Bacon's merciless exposure of human frailty, in scenes which are heightened by his use of highly expressive colour and distorted outline, attains a level of almost transcendental dignity thanks, in part, to his profane use of the triptych form, as a vehicle for pathos. Bacon sought inspiration and antecedents in the history of art, from Rembrandt, Grünewald and El Greco to Picasso and van Gogh. His series of paintings of *Popes* (1951–65) was based on Velázquez' portrait of Pope Innocent X. But Bacon drew inspiration from other media, too; thus, the motif of the cry in these paintings can be traced back, not only to Edvard Munch, but to the shrieking nursemaid in Eisenstein's film, *The Battleship Potemkin*, and to colour illustrations which he found in a book of diseases of the mouth. Bacon was especially attracted to Muybridge's chronophotographic studies – sequences of photographs of humans and animals in motion, which he used for his own studies of locomotion.

In 1957 Bacon painted his series of six *Studies for a Portrait of van Gogh*, in homage to an artist who was a kindred spirit, and this in turn triggered off a whole series of portraits and self-portraits. Bacon's portraits are not naturalistic imitations of a counterfeit reality, but attempts to come to grips with the spiritual condition of the subject, and the physical distortions, verging on unrecognisability, may be attributed to the disruptive effects of conflicting social pressures. Bacon does not aim to produce a recognisable likeness of any kind, but the characteristic features of his subjects are discernible through his predominantly expressive brushwork. Bacon's striving, in his portrait studies, for heightened expressiveness and contorted movements never leads him down the path to abstraction. In this respect he, like his colleague Lucian Freud, remained committed to a realist approach.

Whilst Bacon's early figures were frequently hemmed in by prison bars and cages reminiscent of those used in early psychiatric experiments, or surrounded by surreal furniture similar to that which he himself had once designed, from 1970 onwards his pictures became freer in their treatment of space and more extreme in their colouring.

Bacon found expressive pictorial equivalents for the hard struggle for survival and the hapless existence of so many people, and this is what made him one of the most impressive and outstanding artists of the modern period. Numerous retrospectives of his work were held during his lifetime; the most important among these included exhibitions at the Solomon R. Guggenheim Museum, New York, in 1963; the Hamburg Kunstverein and Moderna Museet, Stockholm, in 1965; the Grand Palais in Paris and Städtische Kunsthalle, Düsseldorf, in 1971–72; and the Tate Gallery, London, Staatsgalerie, Stuttgart and Nationalgalerie Berlin, in 1985–86.

Bacon died on 28 April 1992 in Madrid. H.D.

John Russell, *Francis Bacon*, London, 1971; rev. ed., London and New York, 1979

Gilles Deleuze, *Francis Bacon. Logique de la Sensation*, Paris, 1981

David Sylvester, *Interviews with Francis Bacon*, London and New York, 1975

Wieland Schmied, *Francis Bacon. Vier Studien zu einem Porträt*, Berlin, 1985; Engl., New York, 1996

Francis Bacon, exh. cat., London, Tate Gallery, Staatsgalerie Stuttgart and Berlin, Nationalgalerie, 1985

Hugh Davies and Stephen Yard, *Francis Bacon*, New York, 1986

Francis Bacon, exh. cat., Paris, Musée National d'Art Moderne, Centre Georges Pompidou, 1996

GIACOMO BALLA

was born on 18 July 1871 in Turin, where he attended the Accademia Albertina briefly in 1891, meeting Pilade Bertieri, Gaetano Previati and Pellizza da Volpedo, who introduced him to the techniques of Divisionism. In 1895 he moved to Rome, where he made friends with the educationalist Alessandro Marcucci, whose sister Elisa he was later to marry.

In 1900 Balla visited the *Exposition Universelle* in Paris and studied the Neo-Impressionist paintings of Georges Seurat, Henri-Edmond Cross and Paul Signac. He remained in Paris for several months to work with the illustrator Sergio Macchiati and on his return to Rome he taught the technique of divisionist painting to his pupils at the Porta Pinciana, Umberto Boccioni, Gino Severini and Mario Sironi.

Balla's pre-Futurist works combine humanitarian themes with positivist ideas of the day, and reveal an interest in natural and artificial light effects. His first Futurist work, *Lampada ad arco* (Arc Lamp) – dated 1909 but painted only in 1910–11 – was inspired by Marinetti's manifesto, 'Uccidiamo il chiaro di luna' (Let's Kill Moonlight). In 1910 Balla signed the 'Manifesto of the Futurist Painters' and the 'Technical Manifesto of Futurist Painting', but refrained from taking part in the Futurists' programmatic exhibitions. Only in 1912 did he fully embrace Futurism. Prompted by his scientific studies, he depicted movement in a series of overlapping sequences reminiscent of Marey's 'chronophotography' (*Dinamismo di un cane al guinzaglio*, Dynamism of a Dog on the

Lead, 1912), linked with a coarse form of Divisionism using variegated colours to produce a tesselated mosaic.

From 1913 on, Balla's paintings became more abstract and theoretical. The phased displacement of moving subjects gave way to new, sometimes spiral, patterns. The traces left by a moving subject were depicted in curving lines in, for example, *Linee andamentali – Successioni dinamiche – Volo di rondini* (Lines of movement – Dynamic Sequences – Swallows in Flight, 1913). The years 1912 to 1914 saw the emergence of fully abstract works, such as the *Compenetrazioni iridescenti* (Iridescent Interpenetrations), designed as decorations for the Löwenstein house in Düsseldorf. These compositions, composed of coloured triangles, were intended to illustrate the harmonious relationship between the natural colours of the spectrum. At the time, however, Balla's studies in colour and light fell on stony ground. Only with the advent of the Bauhaus were they taken up again, with Johannes Itten's studies in colour and László Moholy-Nagy's experiments with light.

Apart from painting, Balla also experimented with acting, stage design and writing ('parole in libertà') in his Futurist period before 1915. In 1915 he and Fortunato Depero published the manifesto, 'Ricostruzione futurista dell'universo' (Futurist Reconstruction of the Universe), which sought to extend Futurist aesthetic principles to every aspect of daily life. He was now no longer satisfied with canvas and began to experiment with three-dimensional forms, in a variety of materials.

During the war, Balla became increasingly interested in the decorative arts. In 1917 he produced the stage design for Diaghilev's *Feux d'artifice* (Fireworks), with music by Stravinsky, and in 1921–22 the decor for the *Bal Tic Tac*, a Futurist café-dance hall. In 1925, he exhibited with Fortunato Depero and Enrico Prampolini at the *Exposition des Arts Décoratifs* in Paris. By 1920, his own studio had become the show-place for a colourful environment.

Although Balla signed the 'Manifesto di Aeropittura' (Futurist Manifesto of Aeropainting) in 1929 and took part in the first exhibition of *Aeropittura dei Futuristi* in Rome in 1931, he had by then returned to

a naturalistic style. From 1934 on, in a fascist-inspired 'return to order', Balla renounced Futurism altogether and confined himself to figurative and realistic painting from then until his death on 1 March 1958. H. D.

Giacomo Balla, ed. Enrico Crispolti and M. L. Drudi Gambillo, exh. cat., Turin, Galleria Civica d'Arte Moderna, 1963
Giovanni Lista, *Giacomo Balla*, Modena, 1982
Futur-Balla. Un profeta dell'avanguardia. A Prophet of the Avant-Garde, ed. Maurizio Fagiolo dell'Arco, Basel, New York and Rome, 1982
Balla. The Futurist, ed. Maurizio Fagiolo dell'Arco, exh. cat., Oxford, Museum of Modern Art, Milan, 1987; 2nd ed., New York, 1988

BALTHUS

was born Balthasar Klossowski de Rola in Paris on 29 February 1908, the son of the art historian and painter Erich Klossowski and the painter Baladine Klossowska. Pierre Bonnard was a friend of the family, as were Wilhelm Uhde and Julius Meier-Graefe. On the outbreak of war the family had to leave France and move to Berlin, where Balthasar's father earned considerable acclaim as a stage designer. After his parents were separated Baladine Klossowska moved to Bern and then to Geneva with her two sons, Pierre and Balthasar in 1917. Balthasar attended the Lycée Calvin and spent the summer months in Beatenberg on Lake Thun. A visit by the poet Rainer Maria Rilke to Geneva marked the beginning of a close friendship between him and Baladine Klossowska, which lasted until his death in 1926. For a period Rilke then took on the role of guardian to the two boys and took charge of developing their artistic talents.

Balthasar confidently turned to Rilke for advice and encouragement, and in 1920 he sent him some illustrations to a Chinese short story. A year later, forty of these watercolour drawings appeared under the thirteen-year-old artist's first name, with a foreword by Rilke, as *Mitsou: Quarante Images par Baltusz*. Baladine was now compelled to return to Berlin for financial reasons, but shortly afterwards Balthus gained his independence and in 1924 went to Paris, at the invitation of André Gide. There he attended evening classes under Bonnard and Vlaminck at the art school 'La Grande Chaumière' and copied paintings by the Old Masters – especially Poussin – at the Louvre. Through Rilke, who dedicated his poem *Narcissus* to Balthus, Pierre and Balthus secured financial support from painting portraits commissioned by private patrons. Balthus, who was a passionate admirer of the Italian Renaissance, spent the summer of 1926 in Arezzo and made sketches of Piero della Francesca's fresco cycle *The Legend of the Holy Cross*. He made copies of Piero's *Resurrection* in Borgo Sansepolcro and of works by Masolino and Masaccio in Florence. On the occasion of his return to Paris he took to painting pictures of children playing in the Jardin du Luxembourg and street scenes.

On completion of his military service in Morocco, from 1930 to1931, Balthus discovered the work of the Swiss artist Joseph Reinhardt, in the Historical Museum in Bern, and made copies of his eighteenth-century genre scenes. In autumn 1932 he returned to Paris and developed his own individual style, which has scarcely changed since then, right up to his most recent work. Thus he abandoned his early, impressionist style of painting, which was closely related to Bonnard's, in favour of firm contours, tight compositions and a number of traits deriving from Surrealist painting of the period. Balthus first won recognition for his painting, *La Rue* (The Street, 1933), which translates motifs from his earlier townscapes into a new, sharply delineated style. Pierre Loeb was captivated by the picture and went on to organise Balthus' first solo exhibition at his own Galerie Pierre in Paris, in 1934 – an exhibition which created a scandal, on account of the ambiguous eroticism of the paintings on show.

One of Balthus' first new supporters was Antonin Artaud, who was impressed by his sets for Shakespeare's *As You Like It*, at the Théâtre des Champs-Elysées, and commissioned him to execute sets and costumes for his drama *Les Cenci*, which was first performed at the Théâtre aux Folies Wagram, in May 1935. In the same year the Surrealist periodical *Minotaure* published eight of Balthus' numerous illustrations to Emily Brontë's novel, *Wuthering Heights*, on which he had been working since 1932.

Balthus' first exhibition in the United States was held at the Pierre Matisse Gallery, New York, in March 1938 and established his international reputation. In 1939 Balthus was called up for war service and was wounded near Saarbruck, in Alsace. After the war he settled down in Paris to a successful career as a painter and stage designer (including work for Albert Camus' plays).

In the fifties Balthus moved to the country and bought the Château de Chassy in the Morvan. Here he devoted himself to painting landscapes, in which the occasional human figure serves merely a decorative function. In 1961 André Malraux nominated him to the post of Director of the Académie de France, at

the Villa Medici in Rome. He now returned to painting mysterious scenes of human figures against a rough background, structured in a manner reminiscent of early frescoes.

Balthus' individualistic work, which combines quirky, old masterly and surrealist qualities, has been honoured with countless retrospectives, including those at the Musée National d'Art Moderne in Paris, in 1983, and the Metropolitan Museum in New York, in 1984. Balthus lives and works in Rossinière, in Switzerland. H. D.

Jean Leymarie, *Balthus*, Geneva, 1978, 1982[2]
Balthus, exh. cat., Paris, Musée National d'Art Moderne, Centre Georges Pompidou, 1983
Stanislas Klossowski de Rola, *Balthus: Paintings*, New York, 1983; Munich, 1983
Balthus, New York, Metropolitan Museum of Art, 1984
Jean Clair, *Metamorphosen des Eros. Essay über Balthus*, Munich, 1984
Balthus. Dessins, aquarelles, huiles. Andros, Musée d'Art Moderne, Fondation Basil et Elise Goulandris, 1990
Balthus, Lausanne, Musée Cantonal des Beaux-Arts, Geneva, 1993
Claude Roy, *Balthus, Leben und Werk*, Munich, 1996

GEORG BASELITZ

was born Hans Georg Kern on 23 January 1938 in the town of Deutschbaselitz, in Saxony, where his father worked as a primary school teacher. On completing his secondary schooling in Kamenz in 1956 he went to study under Professor Walter Womacka and Herbert Behrens-Hangler at the Hochschule für bildende und angewandte Kunst in East Berlin, where he made friends with the painters Peter Graf and Ralf Winkler (A. R. Penck). However, after two terms there, he was expelled for his 'social and political immaturity'. In 1957 he resumed his studies under the abstract painter Hann Trier, at the Hochschule für bildende Künste in West Berlin. In 1957 he moved over to the western sector of the city and adopted the name Georg Baselitz, after his birthplace in the Oberlausitz.

Baselitz's first works as an independent artist were figurative, expressive paintings which already indicated the subsequent path that he would follow, but which stood no chance of success at a time when the *informel* and lyrical abstraction reigned supreme. In his efforts to steer a course which was independent both of doctrinaire realism in the East and of abstraction in the West, he took an interest in the themes of anamorphosis and of the art of the mentally ill, in the Prinzhorn Collection. Together with Eugen Schönebeck he composed two manifestos – (1st Pandemonium Manifesto, 1961, and Second Pandemonium Manifesto, 1962), which outlined a painterly approach based on a symbolist point of view. His first solo exhibition at the Galerie Werner & Katz in Berlin in 1963 issued such a strong challenge to sexual taboos that two of his paintings, *Die grosse Nacht im*

Eimer (The Great Piss-up) and *Der nackte Mann* (The Naked Man) were impounded by the authorities. Whilst on a scholarship at the Villa Romana in Florence he began a series of 'Hero' paintings – solitary, ill-proportioned, standing figures, looking helpless and gawky against the landscape in the background. The concluding painting in the series, *Die grossen Freunde* (The Great Friends, 1965), was a manneristic send-up of the Romantic genre of 'friendship paintings', to which he provided a crude ironic commentary in his third manifesto, 'Why the Painting "The Good Friends" is a Good Painting!'.

After moving to Osthofen, near Worms, in 1966, Baselitz continued to experiment with methods of fragmenting and dismantling the pictorial motif and dispersing the parts across the surface of the canvas. The 'Fracture Paintings' – figures split along horizontal fracture lines, whose aggressive treatment was matched in the choice of subject-matter ('Hunter', Woodcutter', etc.), eventually led to his turning the motif on its head. As early as 1970 Franz Dahlem presented for the first time, at his Galeriehaus in Cologne, a group of pictures whose subjects had been rotated 180 degrees. Thus, by inverting the subject – a gesture which swiftly came to be seen as a hallmark of his work – Baselitz discovered a means of imposing autonomy of form and colour, without having to disperse with the figurative motif. He aimed for a kind of 'pure painting' which took reality as the substance of his pictures, rather than (as in the earlier work) treating it as the content which had to be destroyed. The motif, deprived of its main narrative function by the process of inversion, still seemed necessary to him, if he was to avoid lapsing into the 'nebulous arbitrariness of abstract painting'; its purpose was to determine the overall structure of the image and open up the 'sensual process', as a means of 'coming to terms with the substance, density, fattiness and consistency of the colours and of the canvas' (Baselitz).

In addition to his extensive graphic output (especially, woodcuts in the sixties and large format linocuts at the end of the seventies), Baselitz began around 1979–80 to make large sculptures of figures and heads, crudely hacked out of rough wood and clumsily painted black and red, in a style almost resembling a caricature of the German Expressionist tradition. In recent years Baselitz has taken to working in a large format and he has increasingly resorted to embellishing his figurative motifs with abstract patterning and ornamentation.

Few other artists alive today have exhibited as frequently as Baselitz. In 1972 he took part in *documenta 5*, in 1977 in *documenta 6* and in 1982 in *documenta 7*. Most recently, a large retrospective of his work was held at the Guggenheim Museum, New York, and subsequently went on to Los Angeles, Washington and Berlin.

Baselitz was appointed Professor at the Akademie der Bildenden Künste in Karlsruhe in 1978 and at the Hochschule der Künste in Berlin, from 1983 to 1988. In 1986 he was awarded the Imperial Ring (Kaiser-ring) in Goslar, and in 1989 the French Minister of Culture, Jack Lang, appointed him 'Chevalier de l'Ordre des Arts et des Lettres'.

Baselitz lives and works in Derneburg, near Hildesheim and Imperia, in Italy. H.D.

Andreas Franzke, *Georg Baselitz*, Munich, 1988
Georg Baselitz: Der Weg der Erfindung – Zeichnungen, Bilder, Skulpturen, exh. cat., Frankfurt a.M., Städtische Galerie im Städelschen Kunstinstitut, 1988
Baselitz, ed. Angelika Muthesius, Cologne, 1990
Georg Baselitz, exh. cat., Zürich Kunsthaus and Düsseldorf, Städtische Kunsthalle, 1990
Georg Baselitz: Retrospektive 1964–1991, ed. Siegfried Gohr, Munich, Kunsthalle der Hypo-Kulturstiftung, Edinburgh, Scottish National Gallery of Modern Art and Vienna, Museum moderner Kunst, Stiftung Ludwig, 1992, Munich, 1992
Georg Baselitz, ed. Diane Waldman, exh. cat., New York, The Solomon R. Guggenheim Museum, 1995

MAX BECKMANN

was born in Leipzig on 12 February 1884. He determined to become a painter in the teeth of vehement opposition from his family. Rejected at first by the Kunstakademie in Dresden, in 1900 he was accepted at the Großherzoglichen Kunstschule in Weimar, which was considered to be among the most '-progressive' academies in Germany for its emphasis on plein-air painting. On completion of the compulsory first year course on classical sculpture Beckmann transferred to the nature class of the Norwegian painter Carl Frithjof Smith. In 1903 he left the Academy and rented a studio in Paris for a year. He studied at the private Académie Colarossi and was particularly impressed by Cézanne. However, he subsequently destroyed almost all the large-scale paintings he produced in Paris.

In 1904 Beckmann moved to Berlin, at that time the most important centre for contemporary art in Germany, under the triumvirate of Impressionists, Max Liebermann, Lovis Corinth and Max Slevogt. In 1906 he took part in the Berlin Secession's exhibition in Weimar and received the Prize of the German League of Artists, which was linked to a scholarship at the Villa Romana in Florence. Beckmann joined the Berlin Secession in 1907 and, as an aggressive champion of German Impressionism, became a joint founder of the Free Secession in 1914.

Beckmann volunteered for service as a medical orderly in the First World War, but the sheer horror

of his experience at the front caused him to have a mental breakdown in 1915. He was discharged from military service and moved into a studio in Frankfurt am Main. Around 1916 a change of style occurred in his painting: the figures now seemed locked in a collapsing pictorial space, deformed by unseen forces, exaggeratedly sharp-edged and pointed; the colouring turned pale, as if lit by a flickering candle. Beckmann found antecedents for this manner in Grünewald and, to a still greater extent, Picasso (*Les Demoiselles d'Avignon*, 1906–07) to whom he had previously been completely opposed. However, in contrast to Picasso, who ultimately favoured pictorial autonomy, he always placed his technique at the service of the message he wanted to convey. This message however became increasingly enigmatic and esoteric, especially in the large-scale triptychs he painted from 1932 onwards, which cannot be deciphered without a knowledge of the occult sources consulted by Beckmann (e.g. the cabbala and gnosis). At first Beckmann gained rapid fame as an artist in the 1920s, with the characteristic new expressive style which he used not only for his elegant portraits but also for his enigmatic, sombre self-portraits, landscapes and still lifes. He achieved international fame with his numerous solo shows and participation in group exhibitions in Berlin, Dresden, Bern, Paris and New York. Gallery owners such as Israel Ber Neumann, Günther Franke and Peter Zingler became agents for his work and Reinhard Piper published books with illustrations by him as well as a large monograph on his work, which appeared in 1924. In 1925 Beckmann took over a master class at the Städelschule in Frankfurt and he was appointed to a chair in 1929. In 1928 Gustav F. Hartlaub organised a large retrospective of his work at the Kunsthalle in Mannheim. Beckmann was awarded the Reich Prize for German Art and the Gold Medal of the city of Düsseldorf for his *Großes Stilleben mit Fernrohr* (Large Still Life with Telescope, 1927), a programmatic statement on man and nature.

Beckmann's meteoric rise was abruptly interrupted by the advent of Nazism: just two months after the Nazis' seizure of power in 1933 he was dismissed from the Städelschule, the Beckmann room in the

National Gallery's annex in the Kronprinzenpalais was closed and an exhibition in Erfurt cancelled; in 1937 many of his paintings, prints and watercolours were seized and twelve of his pictures shown in the propaganda exhibition of *Entartete Kunst* (Degenerate Art). One day after the opening of this exhibition in Munich Beckmann fled to Amsterdam. Under extremely difficult circumstances and suffering from a heart condition, he contrived to continue his work, thanks, in part, to financial support from his gallery owner Günther Franke and commissions for illustrations from Georg Hartmann.

After the end of the war, Beckmann turned down appointments to the Munich Academy, the Hochschule der Künste in Berlin and the Werkkunstschule in Darmstadt, but in 1947 he accepted a chair at Washington University Art School in St Louis. Despite his rehabilitation in Germany, with a large retrospective organised by Franke, he refused to return to his native country.

Beckmann died of heart failure on 27 December 1950 in New York, where he had been teaching since September 1949 at the Art School of the Brooklyn Museum. H. D.

Peter Beckmann, *Max Beckmann, Leben und Werk*, Stuttgart and Zürich, 1982

Hans Belting, *Max Beckmann. Die Tradition als Problem in der Kunst der Moderne*, Munich, 1984

Max Beckmann. Retrospective, ed. Carla Schulz-Hoffmann and Judith C. Weiss, exh. cat., Munich, Haus der Kunst, Munich and tour, Munich 1984

Max Beckmann, Gemälde 1905–1950, ed. Klaus Gallwitz, exh. cat., Leipzig, Museum der bildenden Künste, and Frankfurt a. M., Städelsches Kunstinstitut, Stuttgart, 1990

Carla Schulz-Hoffmann, *Max Beckmann. Der Maler*, Munich, 1991

Uwe M. Schneede, *Max Beckmann*, Hamburg, 1992

JOSEPH BEUYS

was born on 12 May 1921 in Krefeld, the son of a corn and animal feed merchant. The family moved to Kleve the same year. While still at school, he held his first exhibition of watercolours and drawings and manifested, early on, a talent not only for music and the humanities, but for science and technology.

In a period when people were increasingly preoccupied with the preparations for war, Beuys remained an outsider. He was deeply interested in the sculptures of the so-called 'degenerate' artist Wilhelm Lehmbruck, which give him 'the first real feeling for sculpture'. Instead of taking up medical studies as planned, in 1941 Beuys volunteered for the armed forces and, after training as a radio operator in Poznan and Erfurt, was stationed in Königgrätz (Hralec Králové). Beuys survived a crash in a dive-bomber and later went into action as a paratrooper on the western front. Beuys' war experiences, the constant exposure to danger at the front, his injuries and also his encounter with non-European cultures in the Crimea made a lasting impression on him.

In 1947 Beuys began studying wood carving at the Staatliche Kunstakademie in Düsseldorf. After three terms with Josef Enseling he switched to Ewald Mataré, and in 1951 was named master pupil. In 1952 he was awarded a prize for his relief of a pietà; this was followed by a commission from a stainless steel works in Krefeld, where he made a stainless steel Fountain (1952) for the courtyard of the Kaiser-Wilhelm-Museum which, in its combination of symbolist and technical and constructivist tendencies, represented a summation of his work of the early post-war years.

Beuys' artistic work came to a halt briefly in 1955–1956, as a result of a severe personal crisis. A period of several months working in the fields on the van der Grinten family's farm in Kranenburg in 1957 marked a break, which was reflected in numerous working sketches, drafts and drawings. Beuys now undertook a renewed, intensive study of scientific writings on a wide range of subjects, including texts by Novalis, Rudolf Steiner and James Joyce and a variety of art-historical treatises, in preparation for developing a new concept of art, in which art and life were to be not so much reconciled as brought into creative dialogue. His theories of an 'expanded role for art' and of 'social sculpture' interpreted art as the outcome of creative activity extending into all spheres of life.

With his appointment as Professor of Monumental Sculpture at the Staatliche Kunstakademie in Düsseldorf, from 1961 onwards Beuys began to communicate his ideas to his students. His lectures and his numerous appearances in Fluxus performances and happenings brought him widespread publicity, but he was also subjected to severe criticism, which he countered with patient argumentation and exhaustive explanations.

Through his use of a wide range of materials (e.g. fat, honey, felt) and techniques, Beuys sought in his sculptures and installations, watercolours and drawings, to leave the symbolic value of the material open to interpretation by the viewer. His performances between 1963 and 1974 made apparent the element of process involved in his artistic ideas. Relics of these performances, often assembled in blocks of work, were shown in a growing number of exhibitions of Beuys' work at home and abroad, which made him into one of the best-known and most controversial German artists.

Beuys' increasing politicisation in the seventies led him to found various organisations, including the 'Free International College of Creativity and Interdisciplinary Research'. He was dismissed from the Academy of Art in 1972 for offering a place in his class to any student rejected by the official committee for admissions. From 1970 onwards Beuys was also involved in the ecological movement, and in 1980 he stood for election to the parliament of North Rhine-Westphalia, as a representative of the 'Greens'.

In addition to his powerful public presence, up until the time of his death on 23 January 1986 in Düsseldorf he produced a powerful body of work, consisting of installations, sculptures, watercolours, drawings, multiples and writings, which broke with all

the conventional limitations of genre. For Beuys, everything revolved around the core questions of how art could exist in an advanced industrial society and what tasks it should perform. He maintained that social meaning could only exist in a dialogue between nature and the spirit, which thus guaranteed human beings the potential for self-realisation.

H. D.

Ingrid Burgbacher-Krupka, *Joseph Beuys, Prophete rechts, Prophete links*, Nuremberg, 1977

Volker Harlan, Rainer Rappmann and Peter Schata, *Soziale Plastik. Materialien zu Joseph Beuys*, 1980[2]

Similia similibus, Joseph Beuys zum 60. Geburtstag, ed. Johannes Stüttgen, Cologne, 1981

Götz Adriani, Winfried Konnertz and Karin Thomas, *Joseph Beuys. Leben und Werk*, Cologne, 1986[3]

Beuys zu Ehren, ed. Armin Zweite, exh. cat., Munich, Städtische Galerie im Lenbachhaus, 1986

Beuys, ed. Harald Szeeman, exh. cat., Zürich, Kunsthaus, 1993

UMBERTO BOCCIONI

Boccioni was born in Reggio di Calabria on 19 October 1882. In 1897 he followed his father to Catania, in Sicily, and took a diploma at the local Technical Institute. In 1898 he went to Rome, where he was apprenticed to a poster artist and attended life classes at the Academy. He subsequently enrolled at the Porta Pinciana, where he and Gino Severini studied under Giacomo Balla and absorbed his experience of Neo-Impressionism. Boccioni visited Paris, Russia, Warsaw and Padua in 1906 and attended the Academy of Art in Venice for a short time in 1907 before starting work as a commercial artist and illustrator in Milan.

In 1910 he met F. T. Marinetti, who had published his 'Futurist Manifesto' in the *Figaro* the year before, and he joined Carlo Carrà, Luigi Russolo, Giacomo Balla and Gino Severini in signing the 'Manifesto of the Futurist Painters' and the 'Futurist Painting, Technical Manifesto'. In the same year, some of Boccioni's work was shown for the first time, in the summer exhibition at the Villa Ca' Pesaro in Venice. His paint-

ing at this time combined new, Futurist elements with traces of Neo-Impressionist and Symbolist influence and strove for a synthesis of all three. A visit to Paris at the end of 1911, where he made the acquaintance of Apollinaire and the Cubists, acted as a catalyst releasing him from the last remnants of Impressionist theory.

The first Futurist exhibition opened at the Galerie Bernheim-Jeune in Paris in February 1912, and subsequently travelled to London, Berlin and Brussels. Boccioni contributed a selection of his Futurist pictures, including *La strada entra nella casa* (The Street Enters the House, 1911), *La risata* (The Laughter, 1911) and *Idolo moderno* (Modern Idol, 1911). Unlike the other Futurist painters, Boccioni represented time and movement, the major preoccupations of Futurist theory, in the Bergsonian sense – in dynamic, unbroken sequences, in which there was a characteristic overlap between the subject and the surrounding atmosphere. He adopted, from the Paris avant-garde, innovative methods of depicting simultaneity and the interpenetration of planes and, in his best pictures, combined these with a highly sensitive divisionist use of colour. However, the bold incursions and polemics of the Futurists in Paris did not long go unchallenged. Apollinaire, who was otherwise sympathetic to Futurism, accused Boccioni in a pamphleteering article of plagiarising French painting, in general, and Robert Delaunay, in particular.

In 1912, Boccioni tried his hand at sculpture. He published the 'Technical Manifesto of Futurist Sculpture' and had an exhibition of three-dimensional work at the Galerie La Boëtie in Paris. These works were intended to express the rhythmic interpenetration of figures and their surroundings. The few that have survived include his famous, dynamically striding figure, *Forme uniche della continuità nello spazio* (Unique Forms of Continuity in Space, 1913), which effectively conveys the flow of energy in sequences of movement. The Futurists were well represented at the *Erster Deutschen Herbstsalon* (First German Autumn Salon), organised that year by Herwarth Walden in Berlin. The year was marked by manifestos, actions and events, and Boccioni participated in most of them. His painting became increasingly

abstract and strong in colour, and he drew closer to the work of Balla and Kupka, but he still hesitated to take the final step of abandoning the subject altogether.

Following the publication in 1914 of *Pittura e scultura futuriste (Dinamismo plastico)*, a comprehensive survey of his artistic work, Boccioni suffered a crisis and subsequently returned to a figurative style of painting that owed much to Cézanne. He was arrested and held in custody briefly in connection with a demonstration in favour of Italy's entry into the war, and in 1915 he and other Futurists volunteered for service in a bicycle battalion. His works were shown in the *Panama-Pacific International Exposition* in San Francisco. In 1916 Boccioni was transferred to a field artillery unit near Verona. He died on 17 August, as a result of a riding accident. H.D.

Boccioni a Milano, ed. Guido Ballo and others, Milan, 1982

Maurizio Calvesi and Ester Coen, *Boccioni. L'opera completa*, Milan, 1983

Boccioni und Mailand, ed. Magdalena M. Möller, exh. cat., Hanover, Kunstmuseum and Sprengel Collection, 1983

John Golding, *Boccioni. Unique Forms of Continuity in Space*, London, 1985

Boccioni, ed. Ester Coen, exh. cat., New York, The Metropolitan Museum of Art, 1988

Uwe M. Schneede, *Umberto Boccioni*, Munich, 1994

CHRISTIAN BOLTANSKI

was born in Paris on 6 September 1944. He decided to teach himself to be an artist, first addressing the medium of painting.

Boltanski produced various large-format *Peintures d'histoire et d'événements dramatiques* (Paintings of History and Dramatic Events) from 1958 to 1967; most of the historical events were fictitious. In 1968 he made the short film *La Vie impossible de Christian Boltanski* (Christian Boltanski's Impossible Life). In the same year, he made the first of his reconstructions of scenes from his childhood, or rather of fictitious experiences, which he substituted for the real thing.

In the seventies Boltanski adopted an artistic method to which he gave the name 'collecting the evidence'. Here, he used the purported reliability of photography, as documentary evidence or proof, to derive subjective, autobiographical memory from cultural codes. He produced photographic collections featuring items such as favourite photographs of a school class, *Les Photos préférées* (1973). And from then on he used administrative methods to create fictitious collections in the form of inventories, archives or legacies.

In 1974 Boltanski created the *Saynètes Comiques* (comic, one-act plays), in which he represented scenes and events from everyday middle-class life in comic disguise. These grotesquely exaggerated stagings of family ritual – a child's birthday, sick grandfather, first communion etc. – took place in front of

gaudily painted backdrops. In 1975 Boltanski won a DAAD (German Academic Exchange Service) scholarship to Berlin, where he and Annette Messager jointly developed *Le Voyage de noces* (The Honeymoon) for the Venice Biennale – posed, transfigured scenes of stereotypically 'happy' honeymoons, staged as souvenir photographs.

The 'Compositions' date from 1978 to 1982. These were arrangements of large-format colour photographs divided into various categories (Japanese, Western, classical, modern, entertaining, mythological compositions, etc.), in which Boltanski featured items such as greatly enlarged copies of small toys or figures that he made from buttons, corks, nuts, etc. The panels of 'Compositions' are hung in rows, and this led subsequently to the creation of space-invading sequences of images and ultimately to entirely three-dimensional installations, in which Boltanski had recourse to a whole range of lighting effects.

Boltanski designed a new version of *Réserve*, an installation made up of second-hand clothing, for each venue of a retrospective that toured various museums in the USA, Canada and Europe in 1988–1989. For example, at the Ydessa Hendeles Art Foundation in Toronto in 1988 he set up a room enclosed on all sides, with over 6,000 garments hanging on the walls (*Réserve: Canada*), and at the Museum für Gegenwartskunst in Basel in 1989 viewers had to climb over masses of garments strewn around the floor (*Réserves: La Fête de Pourim*), as a particularly poignant reminder of absence and death. It was not only in this work, in which the garments evoked memories of their former wearers, that Boltanski admitted suggestions of the Holocaust, synonymous with the quintessence of death.

Our own mortality was central to *Les Suisses Morts* (The Dead Swiss, 1990), selected and arranged in rows from his collection of over 3,000 portrait photographs that had appeared in a Swiss regional newspaper. Boltanski's more recent installations are unusually solemn and arresting. The themes of violence, guilt and pain are elevated to a new plane of artistic consciousness.

Boltanski uses a wide range of resources to create parables and allegories from childhood and youth, in order to draw viewers' attention both to their own subjective history and to their collective, objective history.

Boltanski was represented at *documenta 5* (1972), *documenta 6* (1977) and *documenta 8* (1987) in Kassel;

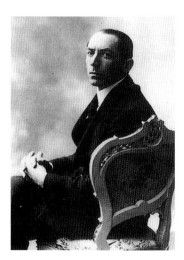

major exhibitions of his work have been held at venues including the Musée d'Art Moderne de la Ville de Paris in 1981, the Museums of Contemporary Art in Chicago and Los Angeles in 1988, the Whitechapel Art Gallery, London, in 1990 and the Hamburger Kunsthalle in 1991.

Boltanski lives and works in Malakoff near Paris.

H.D.

Christian Boltanski. Reconstitution, exh. cat., Karlsruhe, Badischer Kunstverein, Paris 1978
Boltanski, exh. cat., Paris, Musée National d'Art Moderne, Centre Georges Pompidou, 1984
Christian Boltanski. Réserves: La Fête de Pourim, exh. cat., Basel, Museum für Gegenwartskunst, 1989
Christian Boltanski. Reconstitution, exh. cat., London, Whitechapel Art Gallery, Eindhoven, Stedelijk van Abbemuseum and Musée de Grenoble, 1990
Christian Boltanski, Inventar, ed. Uwe M. Schneede, exh. cat., Hamburger Kunsthalle, 1991
Lynn Gumpert, *Christian Boltanski*, Paris, 1994
Christian Boltanski. Advent and Other Times, ed. Gloria Moure, exh. cat., Santiago de Compostela, 1996

PIERRE BONNARD

was born in Fontenay-aux-Roses on 3 October 1867. In 1885 he entered law school and, while still a student, enrolled at the Académie Julian in Paris, where he met Paul Sérusier, Maurice Denis, Gabriel Ibels and Paul Ranson. In October 1888 Bonnard joined these other artists in founding the group of 'Nabis', or 'prophets'. In 1889 Bonnard was admitted to the Ecole des Beaux-Arts – where he met Ker-Xavier Roussel and Edouard Vuillard – and rented his first studio in Paris. He was impressed with the Paul Gauguin show at the Café Volpini and equally struck by an exhibition of Japanese woodcuts at the Ecole des Beaux-Arts. Initially Bonnard earned his living as a lawyer, first in a registry office and then in the public prosecutor's office. He spent his military service in Bourgoin, in 1890.

Bonnard exhibited for the first time at the *Salon des Indépendants* in 1891, where five of his paintings were hung. He began to experiment with printmaking and designed a poster *France-Champagne*. His prints sold so well that he decided to give up his career in the law and devote himself entirely to art. Between 1889 and 1902, he produced some 250 lithographs for posters, mural decorations, theatre designs and illustrations. He also illustrated a number of books for the gallery-owner, Ambroise Vollard, including Paul Verlaine's *Petites scènes familières* and *Parallèlement*. Up to 1903 Bonnard was a regular contributor to the magazine *La Revue Blanche*; he later also completed a number of commissions for Alfred Jarry, including the sets for his play *Ubu Roi* (1896) and illustrations for the *Almanach du Père Ubu* (1899). Throughout this period Bonnard attached great importance to his graphic work, and his first one-man exhibition at the Galerie Durand-Ruel in Paris, in 1896, included posters, decorated screens and

lithographs, in addition to almost fifty paintings. His experience of commercial art was reflected in his painting, which is remarkable for its economical use of colour and dynamic line to express both movement and feeling. Initially Bonnard found his subjects in the life of the metropolis – in trivial everyday events, often depicted from an unusual angle.

Around the turn of the century, Bonnard began to break away from *Art Nouveau* and Symbolism. He began to observe his scenes and models more closely, and form became subordinated to content; he now used a brighter, more colourful palette, in preference to the restrained colour and the dark tones of his earlier work, and he increasingly took to depicting idyllic pastoral scenes, nudes and interiors, in preference to street scenes.

Bonnard first exhibited alongside the Nabis at the Galerie Bernheim-Jeune in Paris in 1900. His paintings in the *Salon d'Automne* attracted the attention of the writer, André Gide, who described them as 'unusual, searching, creative, never gloomy'. In the following year, Gide asked Bonnard to illustrate the German edition of his book *Prométhée mal enchaîné* (Prometheus Unbound). A visit to Matisse at Issy-les-Moulineaux in 1909 strengthened Bonnard in his growing conviction that line and colour were of equal importance. That summer was marked by his first long stay in the south of France. Apollinaire's unfavourable comments on Bonnard's *Salle à manger à la campagne* (Dining Room in the Country) at the 1913 *Salon d'Automne*, which he described as 'prettified Vuillard', contributed to a sense of crisis, which the painter was only able to overcome by applying himself intensively to drawing.

In the twenties, Bonnard developed his mature artistic style, in which the extraordinary complexity of his compositions, the unusual viewpoints, the reflections and the delicate and refined use of colour show that he had long outgrown the 'Post-Impressionist' label. His life now entered a peaceful phase. In 1925 he married his long-time mistress, Marthe Solange, and in 1926 he took possession of the Villa Le Bosquet at Le Cannet, which was to become his permanent residence in the south of France. There were major exhibitions of his work at the Kunsthaus Zürich in 1932

and the Wildenstein Gallery, New York, in 1934. Bonnard died at Le Cannet on 23 January 1947, rich in the satisfaction and the honours that had accompanied a long life devoted to the cause of art. H.D.

Bonnard: The Late Paintings, exh. cat., Washington D.C., The Phillips Collection and Dallas, Museum of Art, New York, 1984
Bonnard, exh. cat., Zürich, Kunsthaus and Frankfurt a.M., Städtische Galerie in the Städelsche Kunstinstitut, 1984
Bonnard: The Graphic Art, exh. cat., New York, The Metropolitan Museum of Art, 1989
Antoine Terrasse, *Pierre Bonnard, Illustrateur: A Catalogue Raisonné*, Paris, 1988; Engl., New York, 1989
Raymond Cogniat, *Bonnard*, Munich, 1991
Pierre Bonnard Das Glück zu malen, exh. cat., Düsseldorf, Kunstsammlung Nordrhein-Westfalen, 1993

CONSTANTIN BRANCUSI

was born on 19 February 1876 in Hobitza, a Romanian village in the district of Gorj at the foot of the Carpathians. The fifth of seven children, he had an unhappy childhood punctuated by frequent attempts to run away from home. He succeeded in getting away at last in March 1887, travelling to Tirgu Jiu, where he found employment in a dye works and as a waiter. With backing from friends, he was able to enrol at the College of Arts and Crafts in Craiova, which he attended from 1895 to 1898. He went on to study at the Academy in Budapest, graduating in 1902.

On completing his military service, Brancusi set off for Paris, which he reached in 1904 after an adventurous journey on foot to Langres on the Marne and onwards to his final destination by train. There, with the help of an allowance from the Romanian state, he continued his studies at the Académie des Beaux-Arts, working in the studio of the sculptor Antonin Mercié. In 1907 an exhibition of his early sculptures at the Société Nationale des Beaux-Arts attracted favourable comment from Rodin. Although Brancusi declined Rodin's invitation to work in his studio, on the ground that 'nothing thrives in the shadow of great trees', he was much influenced in his early years by the renowned older sculptor. In a move to distance himself from Rodin, he began to carve direct from the stone ('taille directe'). He quickly became known in artistic circles in Paris, frequenting the Café La Rotonde and Léonie Ricou's salon. He also attended Paul Fort's Tuesday soirées at the 'Closerie des Lilas' for the artistic avant-garde of Paris, where he made the acquaintance of Apollinaire and received support and encouragement from him, in turn.

Brancusi's massive stone sculpture *Le Baiser* (The Kiss, 1907–1908) marked his definitive break with naturalism. His growing preoccupation with developing a basic formal language led to increasing simplification in his sculpture. The core form was only

achieved at the end of a laborious working process, through which he achieved the utmost degree of simplicity and elemental expressive power consistent with the material employed. The enormous spiritual and formal concentration of this work precluded a broad range of subjects. There are fourteen variants on *Le Baiser* alone, the largest being that in the cemetery at Montparnasse (1909) and probably the best known that of the Tirgu Jiu ensemble (1938). Between 1906 and 1926, Brancusi also returned again and again to the subject of *Muse endormie* (The Sleeping Muse), finally reducing this to an isolated, highly polished egg, as a symbolic shorthand for deep meditation. Here, the physiological elements were reduced to a minimum and confined to a few necessary indications, to create an atmosphere of intense spiritual concentration, which is readily communicated to the viewer.

Brancusi made his own pedestals, in order to display his sculpture to the best advantage. By means of these original pedestals, he sought to achieve maximum independence from the environment and an enhanced sense of space, to allow free play to the spiritual dimension of his sculptures.

The high point of Brancusi's output was undoubtedly the Tirgu Jiu ensemble (1935–38), which brings together three great works, the *Table du Silence* (Table of Silence), *Porte du Baiser* (Gate of the Kiss), and the *Colonne sans fin* (Endless Column) – this last, a steel structure almost thirty metres high, composed of a series of individual elements, originally elaborated in wood, which were intended as the physical embodiment of a soaring, transcendental, upwards motion. The group drew on various sources and was dedicated to the men and women who defended the city against the German occupying forces. It is at once a monument to Brancusi's work and a memorial to a humanist and pacifist philosophy of life, the physical reincarnation of the path to enlightenment and redemption. Brancusi's other ambitious projects on this scale were doomed to failure. Thus, he was obliged to abandon a *Temple de la méditation* commissioned by the Maharajah of Indore.

Brancusi remained in Paris throughout the war. Life was very difficult, but he did receive food parcels

from friends. He became a French citizen only in 1952. A large retrospective exhibition of his work at the Guggenheim Museum in New York, in 1955, brought him international recognition and acclaim. His first one-man show had, indeed, been held in New York in 1914, at the '291' Gallery of Alfred Stieglitz, who had been impressed by his sculptures in the *Armory Show*, the previous year.

Brancusi died on 16 March 1957, having made over his studio to the French state the year before. The studio was reconstructed in 1977, to one side of the Centre Beaubourg in Paris. H.D.

Carola Giedion-Welcker, *Constantin Brancusi 1876–1957*, Basel and Stuttgart, 1958; Fr., Neuchâtel 1959; Engl., New York, 1959
Ionel Jianou, *Brancusi*, Paris, 1963, 1982[2]
Constantin Brancusi, 1876–1957, A Retrospective Exhibition, ed. Sidney Geist, exh. cat., New York, Solomon R. Guggenheim Museum, 1969
Sidney Geist, *Brancusi. The Sculpture and Drawings*, New York, 1975
Friedrich Teja Bach, *Constantin Brancusi. Metamorphosen plastischer Form*, Cologne, 1987
Anna C. Chave, *Constantin Brancusi: Shifting the Bases of Art*, New Haven and London, 1994
Constantin Brancusi, 1876–1957, exh. cat., Paris, Musée National d'Art Moderne, Centre Georges Pompidou and Philadelphia, Museum of Art, 1995

GEORGES BRAQUE

was born on 13 May 1882, the son of a self-employed house-painter, in Argenteuil-sur-Seine. His earliest artistic efforts were landscape paintings and copies of illustrations from the periodical, *Gil Blas*. In 1890 the family moved to Le Havre. As a fifteen-year-old secondary schoolboy he learned to make imitation wood and marble in his father's workshop and conceived an interest in learning how to paint. In 1899 Braque gave up his formal education and attended lectures and evening classes under Charles Lhuillier, at the municipal art school, at the same time as completing his training as a craftsman under the scene painter, Roney. In 1900 Braque went to Paris to continue his apprenticeship under the scene painter, Laberthe; at the same time he took part in drawing classes at the borough school in Batignolles. Acquiring his craftsman's diploma meant that he could reduce the length of his military service by one third (1901–02). After completing this he enrolled at the private Académie Humbert, where Francis Picabia and Marie Laurencin were also students.

Initially, Braque hesitated to take part in group exhibitions. It was only in 1906 that he showed some work for the first time, when he presented at the *Salon des Indépendants* a number of paintings in the tradition of Corot, Boudin and early Monet. Braque dated the beginning of his true creative activity to the summer of that year, which he spent painting with Othon Friesz in Antwerp, and the autumn spent in L'Estaque, hard on the heels of Cézanne. His palette became brighter, as he adopted the exuberant colours

of the Fauves, whose work he had admired at the 1905 *Salon d'Automne*. In 1907 he was already exhibiting with the Fauves at the *Salon des Indépendants* and he returned to paint in L'Estaque and La Ciotat, in the summer and autumn of that year. He then came to know Picasso, through the intermediary of Apollinaire and saw this painting of the same year, *Les Demoiselles d'Avignon*, which represented the first fruits of his quest for a new style. This work made a lasting impression on Braque and, together with two commemorative exhibitions of Cézanne's work at the *Salon d'Automne* and the Galerie Bernheim-Jeune, contributed to his abandonment of Fauvism. A nude study which Braque painted in December 1907 pointed in a new direction, in that sharp-edged forms and carefully gradated tonal values took the place of impressionist blobs and shimmering colours. These initial efforts were continued the following year in L'Estaque, where the colours became denser and more austere and the spatial elements more geometric. Braque's exhibition at the Galerie Kahnweiler in 1908, where he showed a selection of these pictures, marked the beginning of the 'hour in which Cubism was born'.

Picasso and Braque now worked closely together up to 1914, with Braque appearing the more inventive artist, proceeding by leaps and bounds, and Picasso exploiting the new discoveries, in a systematic way. Certain 'analytical Cubist' paintings by Braque and Picasso (1909–12) are almost indistinguishable from each other, in that they obey the same rules of composition and colour, and the motif is broken up into a labyrinth of signs. In order to avoid altogether losing touch with external reality Braque began to incorporate letters, painted labels, quotations of prices, newspaper headlines and *trompe-l'œil* effects (imitation wood and marbling) into his pictures, thereby making use of the techniques of interior decoration, of which he retained a perfect mastery. The paper collages ('papiers collés') which Braque developed in 1912, and which were taken up and elaborated on by Picasso, were to be of lasting significance. These heralded the beginning of 'synthetic Cubism', characterised by forms with large flat surfaces, a shorthand style of drawing and strong, high-pitched

colours, leading to the development of a completely independent autonomous pictorial reality, in the guise of the 'tableau-objet'. Throughout this legendary period, the only place where it was possible to see the fruits of these endeavours was at the Galerie Kahnweiler, since Braque, like Picasso, now stayed away from the various Salons.

During the war Braque, like his mentor, Apollinaire, sustained a severe head wound and had to have an operation on the cranium. After a long convalescence he next exhibited in public in 1920, by which time his style had changed yet again. His paintings now lost much of their Cubist severity, the outlines became softer and looser, the planes were built up in a less systematic manner and the highly accententuated colouring of 'synthetic Cubism' gave way to an earthy, tonal palette. Braque continued to employ almost exactly the same, modified and highly mannered variant of Cubism up to 1939, continuing the while to take part in important group exhibitions in Basel, New York, London, Paris and Brussels. Carl Einstein dedicated an important monograph to him, which appeared in 1934. In 1937 he received the First Prize of the Carnegie Foundation, Pittsburgh, for his painting, *La Nappe Jaune* (The Yellow Tablecloth) of 1935, sharing a distinction which had been bestowed on Picasso, six years previously and Matisse, in 1927. From 1939 onwards Braque took an increasingly strong interest in sculpture, ceramics and lithography, at the same time as continuing to paint. His 'Atelier' paintings (1949–56) represent yet another high point, when he was able to summarise and recapitulate some of the principal themes in his art.

Braque died in Paris on 31 August 1963 and was laid to rest in Varengeville-sur-Mer. H.D.

Georges Braque, *Le Jour et la nuit, cahiers de Georges Braque*, Paris, 1952
Georges Braque, exh. cat., Munich, Haus der Kunst, 1963
Edwin Mullins, *Braque*, London, 1968
Christian Brunet, *Braque et l'espace. Langage et peinture*, Paris, 1971
Francis Ponge, Pierre Descargues and André Malraux, *Georges Braque*, Stuttgart, 1971
The Essential Cubism. Braque, Picasso and their Friends 1907–1920, exh. cat., London, Tate Gallery, 1983
Braque. The Late Works, ed. John Golding, Sophie Bowness and Isabelle Monod-Fontaine, exh. cat., London, Royal Academy of Arts, 1997

MARCEL BROODTHAERS

was born on 28 January 1924 in Brussels. He studied chemistry briefly in 1942, but soon followed his artistic and literary inclinations and left the university to devote himself entirely to poetry and art. Broodthaers moved in the circle of the Belgian Surrealists Paul Nougé, Marcel Lecomte and above all René Magritte. He earned his living from 1947–1957 as a poet, bookseller and journalist, and as a guide to Brussels.

From 1945 Broodthaers published poems and articles in the tradition of French Symbolism and Surrealism. He signed the Surrealist manifesto 'Pas de quartiers dans la révolution!' in 1947. His first volume of poetry, *Mon Livre d'Ogre* (My Book of the Ogre), came out in 1957; his first film *La Clef de l'Horloge* (The Key of the Clock), a homage to Kurt Schwitters, was shown at the Knokke Film Festival in the same year. His confrontation with the communistic tendencies of French Surrealism led to him to join the Belgian Communist Party for a brief period.

Broodthaers' first appearance as a fine artist was in 1964, when he set remaindered copies of his poetry volume *Pense-Bête* in plaster. This object was shown in the Galerie Saint-Laurent in Brussels. He met artists in the Fluxus group around Joseph Beuys through exhibitions at the Wide White Space gallery in Antwerp, and analysed their work critically in the fictional exchange of letters *Jacques Offenbach/alias Broodthaers – Richard Wagner/alias Beuys* (1968).

Broodthaers' first museum exhibition was in the Palais des Beaux-Arts in Brussels, and called *Marcel Broodt(h)aers/Court Circuit*. Its exhibits included photographs of earlier objects, such as *Triomphe de Moule I* (Triumph of the Mussel I, 1965) and *Pot moule cœur* (Pot Mussel Heart, 1966), printed on canvas using the silk-screen process. Stimulated by Magritte, Broodthaers dealt with the discrepancy between word and image, concept and visual perception, but added a sociological dimension by analysing the role of the artist in modern society. He produced assemblages, accumulations and collages, but also films, photographic works, texts and books about artists, which he increasingly brought together to form a universal art work.

Increasing criticism of the museum as an institution and the strategies of the art market after 1968 led Broodthaers to found his own museum: *Musée d'Art Moderne, Département des Aigles, Section XIX^e* (Museum of Modern Art, Department of Eagles, 19th Century Section). Broodthaers used his home as the nucleus of this imaginary museum, sending out open letters and preparing his increasingly complex exhibitions. His analysis of the social and economic conditions of art, in contrast with Beuys' humanistic

emotionalism, did not proceed on a political plane, but a poetic one, with reference to literary models like Edgar Allan Poe, Lewis Carroll, Charles Baudelaire and above all Stéphane Mallarmé. Thus the legendary *Adler* (Eagles) exhibition of 1972 in Düsseldorf, where the artist had lived since 1970, broadened into an open discussion on the 'dismantling of the sublime notion of art' (Jürgen Harten), with the aim of 'suggesting a critical consideration of how art is presented in public' (Broodthaers). Broodthaers built the context of art production into his work, basing himself on Duchamp and Magritte and picking up ideas from the German Romantics, such as Novalis.

After presenting the final section of his museum, the *Musée d'Art Ancien, Galerie du XX^e siècle* at *documenta 5* in Kassel in 1972, Broodthaers started on a new work nine-part group of works using images involving writing, *Peinture Littéraire*. He moved to London in 1973. In the last two years of his life, 1974–1975, a retrospective of his work was presented in a series of six large museum exhibitions entitled *Décor* in Brussels, Basel, Berlin, Oxford, London and Paris. His last film, *The Battle of Waterloo* (1975), is a compilation cut of five hitherto unpublished sequences dating from 1968 to 1972.

Broodthaers died in Cologne on 28 January 1976.
 H.D.

Marcel Broodthaers, exh. cat., Cologne, Museum Ludwig, 1980
Marcel Broodthaers, exh. cat., Minneapolis, Walker Art Center, New York 1989
Marcel Broodthaers. Conférences, essays, ed. Benjamin H. D. Buchloh, Philipp Cuenat et. al., exh. cat., Centre National d'Art Contemporain, Paris 1995
Marcel Broodthaers – correspondances, Korrespondenzen, ed. Galerie Hauser & Wirth, Zürich and Galerie David Zwirner, New York, Stuttgart 1995
Marcel Broodthaers. Musée d'Art Moderne, Département des Aigles, Section Publicité, ed. Maria Gilissen and Benjamin H. D. Buchloh, exh. cat., New York, Marion Goodman Gallery, 1995
Marcel Broodthaers (cat. of editions, graphics and books), exh. cat., Göppingen, Städtische Galerie, 1996

ALBERTO BURRI

was born on 12 March 1915 in Città di Castello, in Umbria. After studying medicine in Perugia he served as a doctor in the Italian army until being taken prisoner in 1943. In 1944 he was transferred by the American forces to a camp for prisoners of war in Hereford, Texas, and it was here that he took up painting in a serious way. He continued his artistic training after his return to Italy in 1946 and held his first exhibition of expressionist landscapes and still lifes in Rome, in 1947. Burri soon abandoned figurative painting the following year and started to experiment with an abstract pictorial style influenced by the work of Klee and Miró. In 1951 Burri, Capogrossi, Ballocco and Colla founded the 'Origine' group, whose programme embodied a number of

leading concerns which were to play a decisive role in Burri's subsequent development – notably, the renunciation of three-dimensional illusionism and a return to basic pictorial elements.

Burri now passed rapidly through a series of different phases in developing a materials-based, painterly style of painting, achieving its effect through the use of raised surfaces, bulked out with coarse-grained pigment, sand and other substances, to give effects ranging from the cracked surface of an old, weathered wall to uniform black panels, which anticipated the monochrome paintings. Next Burri moved on to compositions of pure materials, such as sacking, sheets of industrially produced chipboard, plastic foil and sheet-iron, which took over the expressive function of colour. This crude material aesthetic, which flew in the face of the conventional rules of good taste, was given added force by the artist's artisanal methods of working: Burri solders, stitches, welds, cuts up and burns his different materials and uses these different processes to create a new pictorial unity, aiming at contrast and tension, rather than surface harmony.

The combustion pictures ('Combustoni'), created from 1955 onwards, owe their elemental expressive power to the agency of fire, whose fitful application creates a precarious sense of unity. Burri then went on to test the purifying – and destructive – effect of fire on a large variety of different materials: wood, paper, plastic foil, and sheet-iron. In each case, the materials determined the nature of the composition and the blowtorch was used to reveal their hidden essence.

This was most evident in the pictures made of plastic foil, where the aggressive flame liquefied the soft, flexible material on first contact. Both forces working together became physically perceptible, in the resultant picture.

This transformation of material was achieved by a different route, in the group called Cretti (Cracks, 1971–1981), where a mixture of zinc oxide, china clay, acrylic and wood glue was left to dry on sheets of cellotex chipboard, with the result that cracks, craters and gaps appeared, and form and material coalesced. The contemplative monochromes composed of

cracks and cellotex were succeeded (especially between 1973 and 1976) by a series of tempera paintings and coloured screenprints with fascinatingly colourful imagery, composed of minutely partitioned, cellular forms. Taking the Cretti as his point of departure, Burri now tried his hand at large-scale sculpture. He started consciously using the fissures in the Cretti to delineate cracks between the segments of iron. These deep fractures seemed thus to shatter the massive structure of the iron. The landscape sculpture Cretto Gibellina (1981), which traced the outline of the cracks which appeared in the streets in the aftermath of the earthquake which destroyed the Sicilian town of Gibellina in 1968, marked the climax of Burri's sculptural endeavour.

As a result of his many exhibitions in Europe and the USA Burri became the best known Italian artist of the post-war period. In 1953 Robert Rauschenberg visited Burri in Città di Castello and immediately afterwards began work on his 'Combine Paintings'. Above all, Burri's new material aesthetic and rough treatment of everyday materials had a direct influence on the development of Arte Povera, at the time of its emergence.

Burri lived and worked in Città di Castello and Los Angeles until his death on 13 February 1995. H.D.

Cesare Brandi, *Alberto Burri*, Rome, 1963
Maurizio Calvesi, *Alberto Burri*, Milan, 1971
Alberto Burri. A Retrospective View 1948–1977, exh. cat., Los Angeles, Frederick S. Wight Art Gallery, University of California, 1977
Alberto Burri. Il Viaggio, ed. Erich Steingräber, exh. cat., Munich, Staatsgalerie moderner Kunst, 1980
Burri, ed. Carlo Pirovano, exh. cat., Milan, Pinacoteca di Brera, 1984
Burri, Opere 1944–1995, ed. Carolyn Christov-Bakargiev and Maria Grazia Tolomeo, exh. cat., Rome, Palazzo delle Esposizioni, Munich, Städtische Galerie im Lenbachhaus and Brussels, Palais des Beaux-Arts, 1996

ALEXANDER CALDER

was born on 22 July 1898 in Lawnton, Pennsylvania. His father, Alexander Stirling Calder, was a sculptor and his mother, Nanette Lederer, a painter. After a great many moves, the family finally settled in San Francisco, where Alexander Calder senior was put in charge of all the sculpture work for the 1915 World Exhibition. Between 1915 and 1919, Calder junior completed a course of engineering studies in Hoboken, New Jersey. This was followed by a great variety of jobs, including that of fireman on a cargo vessel. From 1923 to 1926, he attended courses at the Art Students League in New York and for some years he painted landscapes in the impressionist style of John Sloan, who taught there.

During this time, Calder was also producing drawings of sporting events and circus life for the *National Police Gazette*, a satirical magazine. He developed his powers of observation and his flowing line in the fast-moving world of sport and the circus, and was

soon well known for his skill in depicting movement. In 1925 he constructed his first wire sculpture, a sun-dial in the form of a cockerel. This opened up a completely new area for him to explore, through the extension of his rapidly flowing line into three-dimensional bent wire. Then in 1926 he published his first sketchbook, *Animal Sketching*.

In 1926 Calder went to Paris to study at the Académie de la Grande Chaumière and soon joined the group of artists centred on Montparnasse. He started work on his famous *Circus*, comprising small mobile animals and figures made of wire, wood and scraps of cloth, with which he mounted a performance for the first time in 1927 before an invited audience, including Jean Cocteau. A visit to Piet Mondrian's studio in 1930 gave him the idea of defying gravity with a system of balanced elements of equal value. At his large one-man show at the Galerie Percier in Paris in 1931, Calder exhibited abstract mobile wire sculptures inspired by visits he had made to the Paris planetarium. This move to abstract form was given further impetus when he joined the 'Abstraction-Création' movement. Other important influences on him were Fernand Léger's abstract film *Ballet mécanique* (1924) and Marcel Duchamp's earlier attempt to express sequences of movement, in his *Nude Descending a Staircase* of 1912. Calder sought to exploit all these new ideas in his motor-driven constructions, in which brightly coloured and contrasting forms moving at different speeds were used to achieve a dynamic mobilisation of space.

Yet Calder's true vocation was to be his 'mobiles', as Marcel Duchamp called them – balanced structures composed of metal parts, held together by wires and threads and set in motion by currents of air. In contrast to Constructivists like Antoine Pevsner and Naum Gabo, Calder was concerned, not with the actual sequence of movement but with 'organic mobility' – the multi-dimensional, simultaneous movement of human and heavenly bodies – and this ultimately brought him closer to Hans Arp and Joan Miró.

The 'classic', non-motorised mobiles were exhibited to great acclaim at the Pierre Matisse Gallery in New York. In addition to his small, playful construc-

tions, Calder now started making large outdoor mobiles, such as *Steel Fish* (1934) and stationary, in some cases monumental, sheet steel structures, which Arp called 'stabiles'.

From 1939 on, Calder made technical advances in controlling the movement of his mobiles. The individual elements were now held together by wire rods instead of wire and thread, and suspending them from hangers enabled them to move freely. The mobiles thus acquired a strong organic unity, which was reinforced by the materials employed.

Calder's 'stabiles' and intermediate constructions, such as the 'mobile-stabiles', are to be found in many public places throughout the world. *Le Guichet* (1963), for example, is at the Lincoln Center in New York. In 1953 Calder took a studio at Saché, near Tours, where he began to produce monumental constructions such as *Teodelapio* (1962), which now stands at the entry to Spoleto, and the twenty-four-metre high *El Sol Rojo* (The Red Sun, 1966) at the Olympic stadium in Mexico City. His work also included stage designs (some of them produced for Martha Graham in the thirties), book illustrations, coloured graphics and gouaches.

Calder died in New York on 11 November 1976.

H.D.

H. Harvard Arnason and Ugo Mulas, *Calder*, New York, 1971

Jean Lipman, *Calder's Universe*, exh. cat., New York, Whitney Museum of American Art, 1976

Jean Lipman and Margaret Aspinwall, *Alexander Calder and his Magical Mobiles*, New York, 1981

Alexander Calder. Die großen Skulpturen. Der andere Calder, exh. cat., Bonn, Kunst- und Ausstellungshalle der Bundesrepublik Deutschland, 1993

Joan M. Marter, *Alexander Calder*, Cambridge, Mass. and New York, 1991

Alexander Calder 1898–1976, exh. cat., Paris, Musée d'Art Moderne de la Ville de Paris, 1996

MARC CHAGALL

was born on 7 July 1887, the eldest of nine children of a Jewish family in Vitebsk, Byelorussia. In 1906 he joined the studio of the painter Yehuda Pen. From 1907 to 1910 he studied in St Petersburg, among other places at the private Svanseva School run by Léon Bakst. In 1910 Chagall went to Paris, where he met numerous painters and writers, including Robert Delaunay and Fernand Léger, as well as Guillaume Apollinaire, who in 1913 introduced him to Herwarth Walden.

In his painting Chagall adopted the various stylistic innovations of the Paris avant-garde. His naïve delight in story-telling, fed by memories of his eastern Jewish homeland, led him to a synthesis of poetic, strongly coloured pictorial elements. In 1913 Chagall took part in the *First German Autumn Salon* in Berlin, and in 1914 he held his first solo exhibition in Walden's gallery, 'Der Sturm'. After that he travelled back to Vitebsk, where he found himself at the outbreak of the First World War. He moved to Petro-

grad in 1915, and in 1918 was appointed Commissar for Fine Art in the Vitebsk administration. There he founded a new academy, at which El Lissitzky and Kazimir Malevich were also among the teaching staff. Chagall left the academy after a dispute with Malevich and went on to design murals, costumes and stage curtains for the Jewish State Theatre in Moscow, as well as working as an art teacher in the war orphans' colony in Malakhovka, near Moscow.

In 1922 Chagall left Russia for good. He went first to Berlin before returning, in 1923, to Paris, where he had to make a fresh start. One of his first commissions came from Ambroise Vollard, the mentor of the Cubists, who in 1923 asked him to illustrate Nikolai Gogol's *Dead Souls* (which appeared in 1948) and, in 1925, to create a series of illustrations to the fables of La Fontaine. From 1931 to 1939 Chagall worked on a set of Bible illustrations, which appeared in 1956. In addition Chagall started to make replicas of many of his early pictures, which had been lost, in order to evoke the pictorial magic of those early years. The geometrical contrasts which Chagall had integrated into his forms under the influence of Cubism, Delaunay and, later, Malevich, now gave way to a softer method of painting. Long before the Surrealists, who dominated the art scene in the thirties, Chagall had discovered the pictorial significance of the dream, the vision and the unconscious. However, he remained detached from Surrealism, even when its leading theoretician, André Breton, tried to win him over to its cause. Chagall held on to his poetic pictorial language and continued to use the same stock of artistic metaphors to celebrate the bliss of pure love and the mythical enchantment of the world. That Chagall was also interested in social and political reality was demonstrated by his picture *La Révolution* (1937), the central theme of which was his passionate protest against the pogroms.

Chagall was only saved from deportation from France by the intervention of the USA, to which he emigrated in June 1941. From this distance, his pictures once again lost their sense of reproach and sadness. However, he continued to paint in his customary surreal, dreamlike style and to draw on the same fund of pictorial motifs – the crescent moon, the

lovers, the rooster and all the familiar figures of his 'shtetl', or little town. This breakthrough to a fabulously transfigured pictorial world determined the subsequent nature of Chagall's entire creative output, with its endless variations on the same themes. Chagall returned to Paris in 1947, and in 1950 he settled in Vence.

Chagall's work became internationally known through retrospectives in Zürich, Berlin, Amsterdam, Paris and London. Numerous honours were bestowed on him in the last period of his creative life, when he devoted himself above all to monumental work, including mural decorations for the foyer of the theatre in Frankfurt (1960), the Metropolitan Opera in New York (1965) and the new parliament in Jerusalem (1966); a ceiling painting for the Paris Opera (1964), stained glass windows for the United Nations building in New York (1964), the Fraumünster in Zürich (1970) and the cathedral in Reims (1974); and stained glass windows and mosaics for the Musée Chagall, in Nice (1971). In 1966, Chagall settled in Saint-Paul-de-Vence, where he created an extensive body of late work – primarily, paintings and prints – which was notable for its glowing colours and wealth of narrative detail.

Chagall died on 28 March 1985 in Saint-Paul-de-Vence, shortly after his great retrospective at the Royal Academy of Arts in London and the Philadelphia Museum of Art.

H.D.

Franz Meyer, *Marc Chagall. Leben und Werk*, Cologne, 1961; Engl., *Marc Chagall: Life and Work*, trans. Robert Allen, London and New York, 1964

Jean Cassou, *Marc Chagall*, London, 1965

Werner Haftmann, *Marc Chagall*, Cologne, 1972; Engl., (Abrams) New York, 1972

Sidney Alexander, *Marc Chagall. A Biography*, New York, 1978

Susan Compton, *Chagall*, exh. cat., London, Royal Academy of Arts, 1985

Marc Chagall. Die Russischen Jahre 1906–1922, ed. Christoph Vitali, Frankfurt a.M., Schirn Kunsthalle, 1991

EDUARDO CHILLIDA

Chillida was born on 10 January 1924 in San Sebastián, in the Basque region of northern Spain. In 1943 he enrolled at the Colegio Mayor Jiménez de Cisneros to study architecture, but abandoned the course after three years to devote himself entirely to art. In 1947 he attended the Círculo de Bellas Artes, a private art school in Madrid.

In 1948 he went to Paris where he lived in the Spanish students' quarters in the *Cité universitaire*. His first voluminous sculptures attracted attention at the *Salon de Mai* in 1949 and 1950, and in 1950 he also took part in a mixed exhibition of young artists' work, *Les Mains éblouies*, at the Galerie Maeght. However, Chillida was not happy with the direction his work was taking and in 1950 he decided to move to Hernani, not far from his home town San Sebastián, and make a new start.

There, with the assistance of a local blacksmith, he produced his first abstract iron sculpture, *Ilarik* (a funerary stele), in 1951. This work marked the start of Chillida's central preoccupation with the definition of space through form: 'Architects have always been concerned with space, but in architecture space is determined by surfaces, that is to say something that is three-dimensional is defined in terms of something that is two-dimensional. In my case, working as a sculptor, the three-dimensional is determined by something that is also three-dimensional and these two classes of space, which could be described as negative-empty and positive-full, are closely related to one another. I would even speak of a dialogue between them.' (Chillida, 1966.)

In 1954 Chillida had his first one-man show at the Galeria Clan in Madrid, exhibiting thirteen sculptures, in addition to collages and drawings. He produced four bas-reliefs in iron for the Franciscan basilica in Aránzazu, in the Basque country. In 1955 he took part in the *Eisenplastik* (Iron Sculpture) exhibition at the Kunsthalle in Bern and produced a stone memorial to Alexander Fleming which was erected in San Sebastián. His next sizeable exhibition was in 1956 at the celebrated Galerie Maeght, which gave him a contract and exhibited his work regularly from then on. He was awarded the Grand Prize for Sculpture at the Venice Biennale in 1958 and the Kandinsky Prize in 1960. That year also saw the beginning of his friendship with Alberto Giacometti, who approached the problem of space in a completely different way. In Giacometti's work, the volume of the figure appears to be formed by the surrounding space, whereas Chillida's sculptures reach out strongly into space, in order to enclose it within the complex angles and trajectories of the metal form. The material surrounds the space and gaps in between are left as traces of the sculptor's hand.

The greater part of Chillida's work comprises sculptures in iron, but he also occasionally used other materials such as wood, granite, concrete, ceramic and alabaster. A journey to Greece in 1963 opened his eyes to the particular quality of the Mediterranean light. The brightness of the white houses inspired him to work in alabaster from 1965 on. With this light, opaque material, it was possible to achieve a fusion of light and form. Since 1973, he has also been working with fireclay.

Alongside his activities as a sculptor, Chillida has always taken an interest in graphics and book illustration. Following a meeting with Martin Heidegger, he produced seven lithocollages for the philosopher's book, *Die Kunst und der Raum* (Art and Space), published in 1969. These were followed in 1971 by woodcuts to accompany poems by the Spanish poet, Jorge Guillén. A first retrospective of his graphic works was held at the museum at Ulm in 1972. That year saw Chillida also starting to explore the possibility of producing monumental concrete sculpture with the aid of a polystyrene mould, a method he employed for many of his public works over the next few years, including *La casa del Goethe* (Goethe's House, 1986), in Frankfurt am Main.

Chillida has taken part in mixed exhibitions throughout the world and held numerous one-man shows, including major retrospectives in New York, Madrid and Barcelona (1979–1980), Bonn (1989), Berlin and Madrid (1991), San Sebastián (1992), and Frankfurt a. M. (1993). He has been awarded many honours and prizes, including the German Order of Merit for Science and the Arts (1988). This was in recognition not only of his work as an artist but of his social commitment and lifelong devotion to the Basque cause. Chillida lives and works in San Sebastián. H.D.

Octavio Paz, *Chillida*, Paris, 1979
Chillida: A Retrospective, exh. cat., Pittsburg, Carnegie Institute and New York, Solomon R. Guggenheim Museum, 1979
Peter Selz and James Johns Sweeney, *Chillida*, New York, 1986
Eduardo Chillida – Zeichnung als Skulptur 1948–1989, exh. cat., Bonn, Städtisches Kunstmuseum and Münster, Westfälisches Landesmuseum, 1989
Chillida, exh. cat., Berlin, Neuer Berliner Kunstverein, 1991
Chillida, exh. cat., San Sebastián, Palacio de Miramar and Madrid La Luna S.A., 1992
Chillida, ed. Thomas Messer, exh. cat., Frankfurt a. M., Schirn Kunsthalle, Cologne, 1993

GIORGIO DE CHIRICO

was born on 10 July 1888 in Volos, Greece, the son of an Italian family. His brother Andrea was later well known as a musician, author and painter, under the pseudonym Alberto Savinio. From 1900 to 1905 de Chirico attended drawing and painting courses with George Jacobides, who was trained in Munich. After the death of de Chirico's father in 1905 the family moved first to Italy and then to Munich, where they lived from 1906 to 1909. There de Chirico attended the Academy of Fine Arts for about two years.

In Munich de Chirico experienced perhaps his most important artistic stimuli: art – especially Symbolism, including that of Arnold Böcklin and his teacher, Max Klinger – and the writings of Schopenhauer,

Weininger and Nietzsche. In 1909 de Chirico returned to Milan, painted pictures in the style of Böcklin and immersed himself in philosophical literature. From 1911 to 1915 he lived and worked in Paris. Thematically and atmospherically, the resulting pictures were linked to his reading of Nietzsche, which had a powerful emotional impact on him. The strong stylisation and cubist foreshortening created pictorial spaces which are full of mystery and psychological tension, further developed in the later pictures of 'Piazzas of Italy'. In 1912 and 1913 de Chirico exhibited at the *Salon d'Automne* and the *Salon des Indépendants*. Apollinaire noticed him and, in a review of the exhibition, spoke of his 'metaphysical landscapes', sparsely populated with lifeless doll-like figures, which exuded an eerie, oppressive mood.

In June 1915, de Chirico was ordered back to Italy and assigned to the 27th Infantry Regiment in Ferrara. Unequal to the strains of military service, he was able to devote himself to painting again during a spell in hospital. Under the influence of the architecture of Ferrara he painted a number of important works, such as *Il grande metafisico* (The Great Metaphysicist, 1917), *Le Muse Inquietanti* (The Disquieting Muses, 1917) and *Ettore e Andromaca* (Hector and Andromache, 1917). In the military hospital in Ferrara he met Carlo Carrà, who soon came under the influence of de Chirico's metaphysical interiors, in particular – rooms claustrophobically stuffed with symbolic objects.

After the war de Chirico began to formulate the theoretical principles of his 'Pittura Metafisica' and to publish them in articles, in the magazine *Valori Plastici*. His first solo exhibition at the Galleria Anton Giulio Bragaglia in Rome, in 1919, with works from the metaphysical period, provoked a devastating review by Roberto Longhi. For the next five years de Chirico turned increasingly to classical painting and made an intensive study of the painting techniques of the Renaissance. In 1925 he returned to Paris, where his early pictures were admired by the Surrealists, but his new paintings met with a deep lack of appreciation. Nevertheless, this second stay in Paris established de Chirico's reputation in the art world: Surrealist painters such as Max Ernst, Yves Tanguy, René Magritte and Salvador Dalí discovered him, as did the German artists of Neue Sachlichkeit and Magic Realism. A new series of pictures introduced his second 'metaphysical' phase. In 1929, he designed sets and costumes for Serge Diaghilev's ballet *Le Bal*, by Rietti, and published his autobiographical novel *Hebdomeros, le peintre et son génie chez l'écrivain*, a masterpiece of Surrealist literature. His lithographic illustrations to Apollinaire's *Calligrammes* appeared in 1930.

In the thirties de Chirico alternated between Italy and Paris. In 1933 he executed a large mural for the Milan Triennale, which was later destroyed. He designed sets and costumes for the opera *I Puritani*, by Bellini. In 1934 he completed a series of lithographs for Jean Cocteau's *Mythologie*, which inspired the series of *Bagni Misteriosi* (Mysterious Baths, 1937). After a successful stay in the USA (1935–

1937) and various interrupted periods in Italy de Chirico finally settled in Rome. From the late thirties onwards his pictures became more conventional, and he started to produce replicas of his successful metaphysical paintings. The situation was complicated by his own backdating of these copies and by a number of forgeries which appeared in various big exhibitions, such as the 1948 Venice Biennale. De Chirico's work has featured in numerous large retrospectives. The artist died in Rome on 20 November 1978. H.D.

James Thrall Soby, *Giorgio de Chirico*, New York, 1955, 1966[2]
Alain Jouffroy, Maurizio Fagiolo dell'Arco, Domenico Porzio and Wieland Schmied, *De Chirico: La vita e l'opera*, Milan, 1979; Ger., Munich, 1980
De Chirico, ed. William Rubin, New York, The Museum of Modern Art, 1982
Wieland Schmied, *De Chirico und sein Schatten*, Munich, 1989
Wieland Schmied, *Giorgio de Chirico. Die beunruhigenden Musen*, Frankfurt a. M., 1993

CHUCK CLOSE

was born on 5 July 1940 in Monroe, Washington. He studied from 1958 to 1962 at the University of Washington in Seattle, from 1962 to 1964 with Al Held at Yale University in New Haven, Connecticut, and from 1964 to 1965 at the Academy of Fine Arts in Vienna. During his time as a student, Close was confronted above all with Abstract Expressionist painting. In the early sixties he turned for a short time to Pop and Minimal Art and was given teaching appointments at the University of Massachusetts and the School of Visual Arts, in New York City.

In photography, Close sought a new medium for communicating objective experience. After initial experiments with collaged photographs, he arrived at his first photo-realist work, *Big Nude* (1967–68) – an oversize nude which is translated from a black-and-white photograph into a painting with grey tonal values. Close was not seeking to quote classical models with his nude of a reclining woman; nevertheless, the motif as a whole remained too 'loaded' to

serve as a neutral foil for a painting whose overall effect was one of objectivity.

In 1968, Close decided to use only photographs of faces as models – the faces of fellow artists, friends and members of his family, painted in precise detail with the aid of a grid system. The oversize portraits produce no effect of familiarity, or of intimacy. The view from slightly below, the blurring at the edges of the face, and the dominance of the eyes and mouth betray the degree of optical formalisation and present, as their central theme, not so much the portrait as the very process of seeing. Close uses several photographs, in order to find a new focus for each individual segment of the picture, which he then transfers as precisely as possible onto the canvas. In this way, by means of the subtlest shifts of focus, differences of a spatial and material nature are flawlessly transferred onto the information net of the picture surface. On this larger-than-lifesize scale, hyperrealism and fidelity to appearances are taken to an extreme, where they flip over into abstraction.

After four years of asceticism Close returned to colour, with his pictures *Keith* and *Kent*, produced with the aid of a mechanical process from printing technology. He had three colour separations made from a colour photograph in magenta, cyan-blue and yellow, which he transferred onto the painting ground in layers as glazes, one on top of the other. In addition to acrylic and airbrush, Close now took to working with watercolour and coloured pencils, in order to be able to test the colour effect in each segment of the grid. His renunciation of the characteristic brushstrokes and uniformly thin application of the paint served to emphasise the systematic nature of his new approach.

Close has continued to use photographic images as his starting-point. In the place of dots applied to a grid, he now makes symbolic use of his fingerprint, as a means of applying the paint through a circular piece of acetate masking material. These large-format finger paintings thus seem more personal and freer than the previous, rigorously structured works. In 1979, Close started working with a large-format Polaroid camera, the results of which not only serve as the basis for his paintings, but are regarded as works of art in their own right.

In his paper works from 1981 onwards, Close has harnessed another medium to his ends, by composing portraits which are composed of hand-made paper, in various shades of grey. The picture grid is replaced by a grill, each of whose segments is filled with a mass of liquid paper in twenty-two predetermined grey tones; this then divides up the picture into a hollow grid. Since 1986 Close has again devoted himself to oil painting. The colours are applied in a kind of magnified pointillist technique and blend optically, when viewed from some distance, to produce a unified image of the face, whereas, when viewed from close up, the tones separate out into a tapestry of abstract shorthand symbols.

Since the end of 1988, Close has been severely paralysed and confined to a wheelchair. With the help of colleagues and a sleeve for various different brushes fastened to his wrist, he continues to execute his complex pictorial ideas with absolute precision. Close lives and works in New York. H.D.

Close Portraits, exh. cat., Minneapolis, The Walker Art Center, 1980
Chuck Close: Works on Paper, exh. cat., Houston, Texas, Contemporary Arts Museum, 1985
Lisa Lyons and Robert Storr, *Chuck Close: Paintings and Drawings*, New York, 1987
Chuck Close Editions: A Catalogue raisonné, Youngstown, Ohio, The Butler Institute of American Art, 1989
Arthur C. Danto, *Chuck Close: Recent Paintings*, New York, The Pace Gallery, 1993
Chuck Close. Retrospektive, ed. Jochen Poetter and Helmut Friedel, exh. cat., Baden-Baden, Staatliche Kunsthalle and Munich, Städtische Galerie im Lenbachhaus, Stuttgart 1994

LOVIS CORINTH

was born on 21 July 1858 in Tapiau, East Prussia (now Gvardejsk, Russia), the son of a tanner. Numerous of his early drawings and watercolours, going as far back as 1875, have survived. Corinth's life-long interest in Greek and Roman mythology and his predilection for biblical subjects dates back to his schooldays in Königsberg. In 1876 Corinth enrolled at the Art Academy in Königsberg, where Otto Günther introduced him to the essays in realism of the Weimar school of *plein-air* painting. In 1880, he moved on to the Academy in Munich, starting off as a pupil of Franz von Defregger and switching soon afterwards to the studio of Ludwig Löfftz. He did his compulsory year of military service in 1882 to 1983.

In 1883, a visit from his father triggered his *Portrait of the Artist's Father, Franz Heinrich Corinth, with a Glass of Wine*, which clearly betrays the influence of the naturalist painters around Wilhelm Leibl. Corinth visited Italy that year and in 1884 he spent some time on a painting course in Antwerp. From 1884 to 1887 he studied at the Académie Julian in Paris, under the well-known salon painters, Adolphe William Bouguereau and Tony Robert-Fleury, but he was not influenced by the more innovative French

painting of the day (Courbet, Manet and the Impressionists). He then spent some months in Berlin, where he probably painted his *Self-Portrait* of 1887–88, which marked the beginning of an exercise in aesthetic self-examination that was to last all his life. Corinth remained in Munich from 1891 to 1899, working as a freelance artist, but although he was a founder member of the Munich Secession in 1892, he did not succeed in gaining entry to the artistic elite, which was completely dominated by Franz von Lenbach and Franz von Stuck. In the winter of 1898-99, he met Max Liebermann and Walter Leistikow, the founders of the Berlin Secession, who introduced him to the artistic life in Berlin.

Corinth's decision to move to Berlin was made easier by the Munich Secession's rejection of his *Salome with the Head of John the Baptist*, the second (1900) version of which created a sensation at the second exhibition of the Berlin Secession in the same year. Once settled in Berlin, he obtained lucrative portrait commissions through Leistikow, and in 1903 he married Charlotte Berend, his first pupil at the school of painting he established there. Charlotte and their son Thomas, born in 1904, were frequent subjects of Corinth's work at this time, which was increasingly free and impressionistic, although it continued to be punctuated by periodic reversions to his interest in history painting.

This lighter, 'impressionist' style of painting received further encouragement from study visits to Kassel, Holland and Belgium between 1907 and 1911. However, Corinth was not influenced so much by the French Impressionists – still largely rejected by the German artistic establishment on chauvinistic grounds – as by the paintings of the old masters, Frans Hals, Rembrandt and Velázquez, which he was still copying at the age of fifty.

In 1911 Corinth was elected to succeed Max Liebermann as President of the Berlin Secession, but in December of that year he suffered a severe stroke which left him paralysed on one side. Following visits to the Riviera, South Tyrol and Italy between 1912 and 1914, he was sufficiently recovered to be able to paint again. His style of painting became more expressive, finding an outlet in the vigorous self-por-

traits and fiery portrait studies on which his reputation as a portrait painter rests. A crisis in the Berlin Secession in 1913 led to the formation of a breakaway group, the 'Free Secession'. Unlike Liebermann and some others, Corinth remained loyal to the Secession and took over as its president in 1915. He visited Hamburg, the Baltic and Tapiau in 1916–17 and was appointed Professor at the Berlin Akademie der Künste, in 1918. In 1919 he purchased some land at Urfeld, on the Walchensee, and built a country house there. He spent a good deal of time there in the years 1919–25 and became increasingly interested in landscape painting. The *Walchensee* pictures are outstanding examples of German painting in the twentieth century and their influence can still be seen in some of today's neo-expressionist painting.

Corinth's final years were crowned with honour and success, including membership of the Berlin Akademie der Künste in 1919 and honorary membership of the Bavarian Academy in Munich in 1925. In June 1925 Corinth travelled to Amsterdam, to look again at the works by Rembrandt and Frans Hals. While there, he contracted pneumonia and died on 17 July.

H.D.

Lovis Corinth 1858–1925: Gemälde und Druckgrafik, Munich, Städtische Galerie im Lenbachhaus, 1975
Lovis Corinth 1858–1925, ed. Zdenek Felix, exh. cat., Essen, Museum Folkwang, Cologne, 1986
Horst Uhr, *Lovis Corinth*, Berkeley, Los Angeles and Oxford, 1990
Lovis Corinth. Selbstbiographie, ed. Renate Hartleb, Leipzig, 1993
Lovis Corinth. Gesammelte Schriften, ed. Kerstin Englert, Berlin, 1995
Lovis Corinth. Retrospektive, ed. Peter-Klaus Schuster, Christoph Vitali and Barbara Butts, exh. cat., Munich, Haus der Kunst and Berlin, Nationalgalerie im Alten Museum, Munich, 1996; Engl., Saint Louis Art Museum and London, Tate Gallery, New York, 1996

SALVADOR DALÍ

was born on 11 May 1904 in Figueras, in Catelonia, where he followed a course in painting at the Municipal School of Art from 1918 to 1921. In 1922 he passed the entrance examination to the Academy of Fine Arts in Madrid where he made important friendships with representatives of the literary and artistic avant-garde, including Luis Buñuel and Federico García Lorca.

In 1924 Dalí discovered the 'Pittura Metafisica' of Giorgio de Chirico and Carlo Carrà. In 1926 he was expelled from the Academy for persistent unruly behaviour and returned to Figueras, where he devoted himself totally to painting. In the years that followed Dalí worked as a tireless publicist in Spain for Italian Futurism and the Surrealist movement, with whose main principles he had become acquainted in Paris, in 1926. In 1929 Dalí went to stay in Paris for the second time. Miró introduced him to Tristan Tzara and the Surrealist group. Together with

Buñuel, he made the film *Un Chien andalou* and, one year later, *L'Age d'or*. His first true Surrealist picture, *Dismal Sport* (1929), combined two tendencies in Surrealism at that time – automatism and the representation of dreams, both of which were related to the work of Sigmund Freud, with which Dalí had already familiarised himself as a student. Psychologically vulnerable as he was, Dalí suffered from a persecution complex, from which, by his own account, he was rescued by Gala Eluard, who, together with Paul, came to visit him at his father's house in Cadaqués. Dalí was now officially accepted into the Surrealist group and his first solo exhibition in Paris at the Galerie Goemans, in 1929, which included pictures such as *The Enigma of Aetira* and *The Great Masturbator*, was a great success.

Dalí combines influences from de Chirico, Max Ernst, Miró and Tanguy with inspiration from Arcimboldo, Bracelli and Gaudí in a provocative pictorial language, which knits elements of dreams and the unconscious into pictorial metaphors, painted in a deceptively realistic, 'Old Masterly' manner. In 1930 Dalí set out the basis for his 'paranoiac-critical' method, in his essay *La Femme visible*. Dalí's eccentric behaviour, including his relationship with Gala, who was still Eluard's wife, led to a break with his family. Dalí and Gala bought a small fisherman's cottage in Port Lligat with the proceeds from the sale of a painting and progressively extended it over the years. Dalí held a solo exhibition at the Galerie Pierre Colle in Paris in June 1931, and it was here that his work first came to the attention of Julien Levy, who bought his first painting of 'soft watches', *La Persistance de la Mémoire* (Persistence of Memory, 1931), which laid the foundations of Dalí's reputation in the USA. In 1932 Dalí took part in the exhibition *Surrealist Paintings, Drawings and Photographs* at the Julien Levy Gallery in New York, and the Museum of Modern Art acquired three of his works. The following year Julien Levy gave Dalí his first solo exhibition at his gallery in New York.

During this period Dalí took an interest in Böcklin, Vermeer and Millet, among others, and Millet's *L'Angelus* provided the inspiration for numerous pictures of objects and poems between 1932 and 1933. One of

Dalí's *Guillaume Tell* paintings, which he exhibited at the *Salon des Indépendants* in 1934, sparked off a quarrel with the group of Surrealists around André Breton, who accused him of 'the glorification of Hitlerian fascism', and this led to a marked deterioration in his relations with the movement. In the same year he exhibited his illustrations to Lautréamont's *Les Chants de Maldoror* at the Paris bookshop, Les Quatre Chemins. The forty-two etchings and thirty drawings in this series, which Dalí had been working on since 1932, represented his most significant graphics cycle to date.

In 1940 Dalí fled to New York with Gala. His first retrospective was held there at the Museum of Modern Art at the end of 1941, and this established his fame in America. His autobiography, *The Secret Life of Salvador Dalí*, appeared in New York in 1942. In 1948 Gala and Dalí returned to Port Lligat, in Spain. There he created a series of pictures of religious subjects, in perfect trompe-l'oeil, playing refined optical tricks with the shifting boundaries between dream and reality. These made manifest his renunciation of the aggressive Surrealism of the thirties and commitment to the Catholic Church. At the same time Dalí began to take an interest in the latest discoveries in physics and to introduce into his paintings a combination of theories about atomic physics and the Catholic mysticism of his homeland. In his quest for new optical effects he took an active interest in Op Art, among other things, from 1958 onwards, with the result that he produced a number of still quite startling large format paintings around this time, though these were in much the same dazzling, pyrotechnical vein as the image of his personality that Dalí sought assiduously to project. Dalí died on 23 January 1989 in Figueras. H.D.

Salvador Dalí. Unabhängigkeitserklärung der Phantasie und Erklärung der Rechte des Menschen auf seine Verrücktheit. Gesammelte Schriften, ed. Axel Matthes and Tilbert Diego Stegmann, Munich, 1974
Robert Descharnes, *Salvador Dalí*, Cologne, 1974
Peter Gorsen, *Salvador Dalí, der 'Kritische Paranoiker'*, Frankfurt a. M., 1980
Robert Descharnes, *Die Eroberung des Irrationalen. Salvador Dalí, sein Werk – sein Leben*, Cologne, 1984
400 Obras de Salvador Dalí del 1914 al 1983, exh. cat., Palau Reial de Pedralbes, Barcelona and Madrid Museo Español de Arte Contemporanea, 1983
Salvador Dalí 1904–1989, exh. cat., Stuttgart, Staatsgalerie and Zürich, Kunsthaus, 1989
Salvador Dalí: The Early Years, exh. cat., London, The Hayward Gallery, 1994

HANNE DARBOVEN

was born on 29 April 1941 in Munich. She completed her course at the Hochschule für Bildende Künste in Hamburg in 1965, where her teachers included Alvin Mavignier. From 1966 to 1968 she was in New York, where she made close contact with some of the exponents of Minimal Art, especially Sol LeWitt and Carl Andre.

With the 'Zeichnungsblätter' (Drawing Sheets) that she started to produce in 1966, Darboven established a form of work and method of working that have remained constant down the present day. The sheets were based on convolutes of geometrical, construction-like drawings on graph paper with millimetre squares, containing quantative representations of periods of time in the form of tables, diagrams, figures and written-out series of numbers. Darboven worked out mathematical calculations in graphically compressed form – for example the sum of the digits of the running dates of a month, where the date $8.11.74$ gives the addition $8+11+7+4=30$ – or drew up an endless litany of numbers in typescript and handwriting, succeeding each other or repeating themselves in accordance with prescribed systems.

Darboven's serial works and her efforts to find all-embracing structures and apply as austere a way of representing them as possible reflect the ideas and methods of American Minimal Art and Concept Art of the 1960s. Writing, counting, calculating and listing form the basis of her operations; this is a closed system following precise rules and determining the form of individual sheets, and their sequence. In contrast with the fact that these processes are required to be applied practically outside the context of art as a matter of course, Darboven's notations remain self-reflective. They become independent, like written exercises or like exercises in writing that do not result in recognisable letters.

'Ich schreibe, aber ich beschreibe nichts' (I write, but I describe nothing) was one of Darbovens's guiding statements. For her the act of writing itself is in the foreground, as are the duration of the activity and the time needed for transcription and subsequent reading. The progressive sequence and chronological unfolding of the work are made visually explicit through the creation of a concrete graphic equivalent, which dispenses with the need for exegesis. Over the years, Darboven has drawn up different organisational models for her material and developed a variety of guidelines: she uses diaries containing engagements, addresses or personal reflections in note form and goes on to list and copy out literary or scientific texts, and combine images, picture post-

cards and portrait or other phototgraphs with columns of figures, check-lists or lines of writing. Darboven's work with literary models, such as Heinrich Heine's *Atta Troll* and Jean-Paul Sartre's *Les Mots* follows the strict order of a mathematical and aesthetic system to which the text is fully subordinated; the selection of words, sentences and passages that she copies out or transforms into mathematical form serves only to indicate Darboven's specific interest in text.

In the early eighties, Darboven increasingly introduced topical political themes, though she maintained the same element of formal discipline. Thus, the news of Franz Josef Strauss's candidacy for the chancellorship and the death of Rainer Werner Fassbinder found their way into blocks of work such as *Schreibzeit* (Writing Time) and *Weltansichten* (World Views), alongside pictorial material and textual quotations from news magazines. Darboven also started to include music in her repertoire. Her procedure for developing 'mathematical music' in this context corresponds essentially with her approach to 'mathematical literature': numerical constructions are transformed into musical notation, by giving each number a particular pitch, for example, and converting numbers that have been put together into an interval. This produces polyphonic compositions, which are noted down on specially devised manuscript paper, using her own system of writing.

Darboven has had numerous one-woman shows, for instance in the Kunstmuseum Basel in 1974, the Musée d'Art Moderne de la Ville de Paris (retrospective) in 1989, the Kyoto Shoin in 1990 and the Deichtorhallen in Hamburg in 1991. She was awarded the Erwin-Scharff-Prize of Hamburg in 1986, the city in which the artist lives and works. C.T.

Hanne Darboven, exh. cat., Münster, Westfälischer Kunstverein, 1971
Hanne Darboven. Bismarckzeit, exh. cat., Bonn, Rheinisches Landesmuseum ,1979
ArT RANDOM. Hanne Darboven, exh. cat., ed. Gerd De Vries, Kyoto, Shoin, 1990
Hanne Darboven. Die geflügelte Erde Requiem, exh. cat., Hamburg, Deichtorhallen, 1991
Ingrid Burgbacher-Krupka, *Konstruiert – Literarisch – Musikalisch / Constructed – Literary – Musical. Hanne Darboven. The Sculpting of Time*, Stuttgart, 1994
Hanne Darboven. Evolution Leibniz, 1986, exh. cat., Hanover, Sprengel Museum, Stuttgart, 1996

ALEXANDER ALEXANDROVICH DEINEKA

was born on 21 May 1899 in Kursk. He attended art school in Kursk from 1915 to 1917 and then moved on to the Art Academy, where he studied drawing under Mikhail Pestrikov and A. Liubinov. Deineka was greatly impressed by Symbolism, which was in the ascendant in Russia at that time, but above all by the Lithuanian painter M. K. Ciurlionis' abstract-musical compositions.

Deineka worked as a photographer for a short time after the Revolution in 1918, and chaired the fine art section of the Committee for Mass Culture in Kursk. He worked as a designer for the touring theatre while doing his military service in 1919–1920, and painted posters for the Kursk department of the ROSTA propaganda agency. Deineka made practical use of his monumental painting ideas for the first time during this period, creating 'garish Cubist' (Deineka) decorations for festivities in the city and agitprop processions.

From 1921 to 1925 Deineka studied in the graphic design faculty of VKhUTEMAS (Higher Artistic and Technical Studios) in Moscow under V. A. Favorsky, who taught constructive design on the principles of the Western European avant-garde (Cubism, Futurism). In the twenties he worked for the satirical magazines *Besboshnik u stanka* (The Atheist at the Work-Bench) and *U stanka* (At the Work-Bench). He made drawings of the civil war, experimented with designs for an eye-catching magazine type-face and produced illustrations and title pages. At this point Deineka's style was no different from that of other Soviet artists in the twenties, but he did show a particular interest in sequences of movement and complicated interplay between the expressive force of silhouettes and pictorial space. In 1925 the editors of *Besboshnik u stanka* sent Deineka to Kiev in the Donets basin and to Ekaterinoslav in the Ukraine in order to produce a suite of graphics recording workers' lives in the mines and factories there.

He founded the 'Society of Easel Artists' (OST) in 1925, with David Sterenberg, Nikolai Kupreianov, Alexander Tyshler, Yuri Pimenov, Piotr Williams and Andrei Goncharov. Deineka showed his first large paintings in OST exhibitions, including the famous *Defence of Petrograd* (1927); here the monumental style of composition he had tried out in his illustrations found an appropriate outlet. Deineka withdrew from the third OST exhibition because he had come to feel that panel painting was inadequate. He joined the 'October' group, which thought more highly of agitprop art, in 1928.

The exhibitions for the 10th anniversary of the October Revolution in 1927 and the 10th anniversary of the Red Army of Workers and Peasants in the same year brought Deineka general recognition as a representative of typically Soviet art. He produced landscapes and posters in the thirties, and also designs for monumental murals on the new People's Agriculture Commissariat building, as well as for the cinema in Gorky Park, in Moscow. In 1935 Deineka embarked upon a study visit to France, Italy and the United States. His travel sketches led to a large cycle of watercolours and paintings in 1935–1936. He also produced monumental works like the mosaics for the Miakovskaia metro station, ceiling paintings for the Red Army Theatre and a mural for the Soviet Pavilion at the 1937 Paris World Fair. He directed the studio for monumental painting at the Moscow College of Art from 1936 to 1946. Deineka was appointed director of the Moscow College of Applied and Decorative Art in 1945, even before the war was over, and became a 'Meritorious Artist of the USSR'; in 1947 he became a full member of the USSR Academy of Arts and started working on sculptures in wood, majolica, bronze, porcelain and cement, and also new mosaics and murals. Deineka's further development was determined by his increasing involvement with the party propaganda machine. The mural *The Soviet Union – Avant-Garde of the Struggle for World Peace* for the Soviet Pavilion at the Brussels World Fair in 1958 was evidence of this, as were his membership of the Soviet Communist Party (1960) and his subsequent honours: 'People's Artist of the USSR' (1963), the Order of the Red Banner (1962) and the Lenin Prize (1964).

Deineka died in Moscow on 12 June 1969. H.D.

Alexander Deineka, Malerei, Graphik, Bildhauerkunst. Monumentalwerke und literarischer Nachlaß, Leningrad, 1982
Alexander Deineka, ed. Jürgen Harten, exh. cat., Düsseldorf, Städtische Kunsthalle, 1982

ROBERT DELAUNAY

was born on 12 April 1885 in Paris. After leaving school early he started in 1902 an apprenticeship at Ronsin's studio for stage design in Belleville. Delaunay began by painting Impressionist landscapes and then moved on under the influence of Seurat to experiment with a synthesis of Neo-Impressionist and Fauvist elements, in paintings where the motif, portrait or landscape was broken up into a mosaic of colours distributed in decorative patterns over the picture surface, with scant regard for objective reality. In 1907 Delaunay met the art dealer Wilhelm Uhde's young wife Sonia Terk – also a painter – whom he married in 1910.

At the Cézanne retrospective at the *Salon d'Automne* in 1907, Delaunay was struck by the novel way in which this artist used colours as a means of articulating space and firmly tying the motif in with the background, and for a while he adopted a similar method in his own paintings. In 1909 he began a series of paintings of the interior of the church of Saint-Sévérin, translating views of the aisles into elo-

quently distorted compositions, flooded with light. He thus gave immediacy to communicating an active visual experience, without yet abandoning the traditional means of perspective. From 1909 to 1911 and again from 1924 to 1930 the principal theme of his compositions was the Eiffel Tower, illuminated with flashing coloured lights and soaring up into the pictorial space, only to explode into fragments as it burst against the edges of the canvas. The Eiffel Tower served as a symbol and rallying point for modernism, in the way that it seemed to give tangible form to contemporary dreams and longings for a technically achievable utopia, made possible by scientific and technological progress. Taking as his starting point a postcard with a panoramic view of Paris with the Eiffel Tower in the background, Delaunay went on to create a series of townscapes, *Les Villes* (1909–11), which moved increasingly into the field of abstraction. His monumental painting *La Ville de Paris* (1912) signalled the end of his so-called deconstructive period, in which he came to grips with Cubism.

The next series of 'Window Paintings', *Les Fenêtres* (1912–13), marked the transition to a 'constructive period' of painting with 'pure colour', devoid of any reference to external reality. Using a compositional method based on the simultaneous interaction of different colours and their vibrant effect on the sensations, Delaunay developed a way of using colour in his paintings as the vehicle for meditating on the properties of light, space and movement – a development in his work for which Apollinaire coined the poetic term 'Orphism'. Delaunay's next step was to employ circular forms, as the most vivid and precise vehicle for the radiant colours which he, like the Futurists, pressed into service for his series of abstract paintings and stylised paintings of modernist subjects. Paul Klee visited him in his studio in 1912 and he was given an exhibition at Herwarth Walden's 'Der Sturm' gallery in Berlin. His essay 'On Light' appeared in the periodical *Der Sturm* in 1912, in a translation by Paul Klee.

In the twenties Delaunay and his wife worked on stage designs for Diaghilev's *Ballets Russes*, Dadist plays by Tristan Tzara and films by Marcel Herbier

and René le Somptier, among others. He only took up painting again in 1930.

The works which Delaunay now painted are among the incunabula of abstract art. Created in a period which was not particularly favourable to abstract painting, on account of the fashion for various forms of Surrealism, they represent a high-point and a breakthrough in the history of art, for which his earlier series of 'Window Paintings' had been the preparation. On one level they may be interpreted as the precursors of Optical Art, with its emphasis on the physical properties of colour; on another, they may be seen to have played a central role in the evolution of a concrete, constructive style of painting. Yet Delaunay had no interest in creating a stiff, geometrical art – for him 'pure painting' meant a sensitive, universally comprehensible, pictorial language of colours which were suited to the needs of the time and applicable to a wide range of items, from straightforward easel paintings to complex interior designs and decorative features, as well as monumental wall paintings such as those which he created for the International Exhibition in Paris in 1937 and the *Salon des Tuileries* in 1938, where he provided visual proof of the scope for using colour to achieve a perfect synthesis.

In 1939, when he was already ill with cancer, Delaunay founded the *Salon des Réalités Nouvelles*, as a forum for abstract painting, and held a celebrated series of Thursday evening lectures on the course of his artistic development. On the outbreak of the Second World War the Delaunays fled to the Auvergne and from there to Mougins, in the South of France. Delaunay died on 25 October 1941 in Montpellier.

H.D.

Gustav Vriesen, *Robert Delaunay. Licht und Farbe des Orphismus*, Cologne, 1967; 1992
Hajo Düchting, *Robert Delaunays 'Fenêtres':
peinture pure et simultanée. Paradigma einer modernen Wahrnehmungsform*, Munich, 1982
Michel Hoog, *Robert Delaunay*, exh. cat., Paris, Réunion des musées nationaux, 1976
Robert Delaunay, Zur Malerei der reinen Farbe. Schriften von 1912 bis 1940, ed. Hajo Düchting, Munich, 1983
Delaunay und Deutschland, exh. cat., ed. Peter-Klaus Schuster, Munich, Staatsgalerie moderner Kunst, 1985
Robert et Sonia Delaunay, exh. cat., Paris, Musée d'Art Moderne de la Ville de Paris, 1985

JAN DIBBETS

was born on 9 May 1941 in Weert, Holland, and studied at the Academie voor Beeldende en Bouwende Kunsten in Tilburg. He continued his studies at St. Martin's School of Art in London in 1967, with the aid of a British Council scholarship. In the same year, he, Ger van Elk and Reinier Lucassen founded the 'International Institute for Re-education of Artists' in Amsterdam. Dibbets saw his early work as an artist in the late sixties, which was associated with the

ideas and aesthetic of Land Art, as a continuation of traditional Dutch landscape painting. His series called *Perspective Corrections* used photography, slide projections, film and video. In these works he investigated the relationship between different perspectives, from the point of view, respectively, of the camera and the naked eye. Working either indoors or out of doors, and starting out from a fixed viewpoint, he used wire and sticky tape to create outline geometric forms, which he integrated into the network of converging lines suggested by the traditional laws of perspective. In Dibbets' black-and-white photographs, taken afterwards from the same predetermined viewpoint, the areas enclosed by the geometric outlines appear to occupy their own autonomous space within the overall spatial context.

In the early seventies, Dibbets exploited still further the tensions between different, supposedly objective, perceptions of space (empirical experience and photographic suggestion) by introducing the phenomena of light and time, and demonstrating the influence which they exerted on visual perceptions. *The Shortest Day at the Van Abbemuseum* (1970), for example, showed the continuous transformation of a place captured on photographic film from a fixed perspective position several times within the course of a day. Dibbets mounted the individual photographs within a regular linear grid, so that zones of brightness or colour continuously increased or declined on the pictorial surface that was ultimately produced.

Since the early eighties, Dibbets has combined photographic work with elements of drawing and painting. Here, an important element has been the window, which he photographed for works such as *Minneapolis* (1987) and *Barcelona Window* (1989–90). Windows, which function as an architectural intermediary between exterior and interior, were photographed from an extremely sharp angle, so that their basically symmetrical form appeared to be distorted. Dibbets detached the pictorial motif from its architectural context by cutting closely around the window-frames, then fitted them on to a surface with a painted monochrome ground. In *Wayzata Triptych* he supplemented photography and painting with

geometrical drawings: a line led from each of the corners of the windows, which were reproduced in distorted perspective, to construct an imaginery three-dimensional space, but without suggesting a uniform, three-dimensional illusion. Viewers had to separate out laboriously, in their mind's eye, something that had been brought together artificially, without ultimately being able to obtain a clearer perspectival (perspective=looking through) idea of the image. The disturbance remained, but Dibbets also succeeded in his aim of forcing the viewer to look more intently at the image with which he or she was presented.

Since 1983 Dibbets has occupied a chair at the Düsseldorf Academy of Art. He has had major one-man shows of his work, for instance, in the Stedelijk Museum in Amsterdam in 1972, the Solomon R. Guggenheim Museum in New York, the Walker Art Center in Minneapolis in 1987, and the Centre National de la Photographie in Paris in 1991. Dibbets has also featured in international exhibitions such as *documenta 5*, *documenta 6* and *documenta 7*, and *Conceptual Art: A Perspective*, at the Musée d'Art Moderne de la Ville de Paris in 1989.

Dibbets lives and works in Amsterdam. C.T.

Jan Dibbets: Autumn Melody, exh. cat., Kunstmuseum Luzern, 1975
Jan Dibbets, exh. cat., Eindhoven, Stedelijk Van Abbe Museum, 1980
Jan Dibbets, exh. cat., Tokyo, Kamakura Gallery, 1982
Jan Dibbets, exh. cat., Minneapolis, Walker Art Center, 1987
Jan Dibbets, exh. cat., Galerie Lelong, Paris 1989
Rudi Fuchs and Gloria Moure, *Jan Dibbets. Interior Light, Works on Architecture 1969–1990*, New York 1991

OTTO DIX

Dix was born on 2 December 1891 at Untermhaus, near Gera. On the recommendation of his drawing master he obtained an award to study at the College of Arts and Crafts in Dresden. However, students were normally required to have a qualification in a trade and he therefore trained as a scene painter in Gera from 1905 to 1909. He attended the College of Arts and Crafts in Dresden from 1910 to 1914 and found a great source of inspiration in the works of German and Italian masters of the Renaissance, represented in the Dresden collections. However, he was also impressed by an exhibition of works by van Gogh, which he saw in Dresden in 1912, and he was able to acquaint himself with German Expressionism and Futurism in the course of his travels. In 1914, Dix volunteered for the field artillery and was trained as a machine-gunner. He was in charge of a unit which saw action in the front line, received several decorations and ended the war as a corporal.

Between 1919 and 1922, Dix continued his studies at the Dresden Academy, where he met Conrad Felixmüller among others and became a founder

member of the 'Dresdner Sezession – Gruppe 1919'. He was influenced by Expressionism at first but in 1920 he made the acquaintance of George Grosz, took part in the Dada Fair in Berlin and gradually moved towards a more realistic style. On the advice of Felixmüller, Dix moved to Düsseldorf in 1922, enrolled in the master class at the Art Academy and joined the circle surrounding Johanna Ey (known as 'Mother Ey') and the 'Das Junge Rheinland' group. He became a member of the Berlin Secession in 1924 and moved to Berlin in 1925, where he earned his living as a successful portrait painter. He showed work at the *Neue Sachlichkeit* exhibition in Mannheim in 1925 and was represented by the well-known Nierendorf gallery from 1926 onwards. In 1927 he took up an appointment at the Art Academy in Dresden.

1927–28 saw the production of the *Großstadt* (Metropolis) triptych, a dazzling genre painting of the twenties whose effect was enhanced by use of the triptych form, with its sacred connotations. The central panel contains a bitingly ironical depiction of the sybaritic bourgeoisie, whilst the side panels show the reverse side of this glittering society, the disabled ex-servicemen and prostitutes. Sobered by his experiences in the war, Dix developed in the twenties a style of deliberate ugliness, which seemed to him to be more true and more honest than 'la belle peinture' or the pathos of Expressionism.

Even well-known and much-loved personalities in the public eye were mercilessly exposed and reduced to their naked humanity, in portraits such as *Die Tänzerin Anita Berber* (The Dancer, Anita Berber, 1925) and *Die Journalistin Sylvia von Harden* (The Journalist Sylvia von Harden, 1926). In this context, the importance Dix attached to the technical aspect of painting seemed somewhat paradoxical. In 1924 he revived an Old Master technique, using varnish on wooden panels. The graphic and grotesque nature of the events depicted was enhanced by a perfectly smooth and highly detailed finish, while at the same time giving an impression of great coolness and detachment. However, the critical attitude of his contemporaries never led Dix to adopt a completely misanthropic, cynical view of humanity. The hardness and detachment with which he observed his fellow men was never fired by hatred or a desire to apportion guilt for the obvious ills of society, as may have been the case with George Grosz. Thus, Dix did not allow his energies to be harnessed to any political movement, for he was able to depict people as he saw them – a stance which attracted both sympathy and opprobrium, in the post-war years.

1933 brought a tragic turning-point in Dix's life and work. Dismissed from his post by the Nazis, who insolently attacked his major work, the triptych *Der Krieg* (War, 1932), for subversion and obscenity and misrepresented him in the propagandist exhibition of *Entartete Kunst* (Degenerate Art, 1937), he retired to Hemmenhofen on Lake Constance and took to painting landscapes and allegorical and religious motifs, in the style of the Altdorfer School. In 1945 he was again conscripted, this time into the German territorial army, captured by the French and held prisoner in Colmar.

After the war and a painful period of readjustment, his reputation was restored and his work recognised – albeit only the work produced in the twenties. The *Elternbildnis* (Portrait of the Artist's Parents) of 1924, for instance, was shown at *documenta I* in Kassel, in 1955. Dix declined offers of professorships in Dresden and Berlin, in order to devote himself entirely to painting. His work remained expressive, but his subjects lacked the impact of the inter-war years. His seventy-fifth birthday in 1966 brought many honours, including the Lichtwark Prize, awarded by the City of Hamburg, and the Martin-Andersen-Nexö Prize, from the City of Dresden.

Dix died on 25 July 1969 in Singen. H.D.

Dietrich Schubert, *Otto Dix in Selbstzeugnissen und Bilddokumenten*, Reinbek bei Hamburg, 1980
Fritz Löffler, *Otto Dix – Leben und Werk*, Dresden, 1972
Eva Karcher, *Otto Dix 1891–1969. Leben und Werk*, Cologne, 1988
Otto Dix. Zum 100. Geburtstag 1891–1991, exh. cat., Stuttgart, Galerie der Stadt and Berlin, Nationalgalerie, 1991
Otto Dix, exh. cat., London, Tate Gallery, 1992
Andreas Strobl, *Otto Dix. Eine Malerkarriere der zwanziger Jahre*, Berlin, 1996

JEAN DUBUFFET

was born on 31 July 1901 in Le Havre, where his parents were wine wholesalers and members of solid middle-class society. Dubuffet was passionately fond of drawing and began studying at the Ecole des Beaux-Arts in Le Havre, while still at secondary school. In 1918 he enrolled at the Académie Julian in Paris, but left again after six months, in order to continue his studies as an autodidact and to devote himself to the study of ancient languages, literature, philosophy and music.

Stimulated by encounters with Suzanne Valadon, Raoul Dufy, Max Jacob and others, Dubuffet became interested in the Dada movement, though without joining it. Following his military service (1923–24), he

decided to give up painting and work in his father's wine business. In 1930 he established a wine business of his own and lived a quiet, middle-class life with his wife Paulette Bret and their daughter Isalmine. In 1933–34 Dubuffet returned to painting for a short time, but not until after the war did he resolve to devote himself again entirely to this. At the urging of the writer Georges Limbour he exhibited for the first time at the Galerie René Drouin, in Paris. The public were irritated by Dubuffet's 'barbaric' pictures, and only a few, including Henri Michaux, Gaston Chaissac and André Breton, showed any enthusiasm. Dubuffet's second exhibition at Drouin's, in 1946, unleashed a storm of protest. This comprised pictures in *haute pâte*, made up of mixed materials such as asphalt, tar, cement, plaster, varnish, sand, coal dust, pieces of glass, pebbles and string, into which he had scratched archaic figures. Dubuffet found the inspiration for this unusual method of working in children's drawings, street graffiti and the art of the mentally ill, which he began collecting and evaluating in 1947. Through his 'Compagnie de l'Art Brut' he propagated an art without academic models, in opposition to the artificiality and untruthfulness of so-called 'high culture'. After a third trip to the Sahara in 1949 Dubuffet published 'L'Art brut préféré aux arts culturels' (Art Brut in Preference to the Art of the Cultured), a manifesto of Art Brut, and during a stay of several months in New York (1951–52) he delivered a manifesto-like speech, 'Anticultural Standpoints', at an exhibition at the Arts Club of Chicago in 1951.

At the beginning of 1954 Dubuffet made his first sculptures, which were mostly assembled from rubbish, roots and pieces of wood, or formed from cinders and papier mâché. In 1955–57 he produced the series *Tableaux d'assemblages*, comprising meticulously coloured structured canvases, cut up and assembled like mosaics to form abstract landscapes and gardens. Dubuffet used other procedures to set material structures into subtle, *informel* surfaces, as for example in the series of *Matériologies* (1959), relief-like pictures made of crumpled, painted silver paper, papier mâché, plastic resins and sand. He

used material as a means of working his way back to natural models; as a means, not of mimicking nature, but of extracting its elemental and essential substance from the most ordinary, commonplace materials. Dubuffet's largest graphics cycle, the four hundred lithographs of *Phénomènes*, created in 1958–62, provides a good illustration of his phenomenological vision.

In 1962 Dubuffet began work on the cycle *L'Hourloupe*, a series of pictures with cell-like structures which he interpreted as a kind of language which, with its network of references between figurative and abstract readings, he also translated into sculptural terms from 1966 onwards and, later, into free-standing sculptures and architecture. In his large sculptures and extensive environments the scriptural weave of the pictures changes into simpler lines, dividing planes and large sections of cross-hatching. Dubuffet followed this up by transposing his *Hourloupe* language into three-dimensional constructions, such as the *Villa Falbala* (1969–75) in Périgny, and then took the logical step into actual movement, when his surreal play *Coucou Bazar* was shown (after extensive preparations) at the Guggenheim Museum in New York, in 1973, and in a retrospective of his work at the Grand Palais, in Paris. For these performances Dubuffet composed special sound-music. The groups of pictures that followed increasingly opened out into an *informel* exploration of the processes of painting: the *Mires* (Test Pictures) of 1983 and, especially, the *Non-Lieu* (Non-Starters) of 1984 show only vehemently placed brush strokes and elemental gestures, yet these last series of pictures, too, were rooted in Dubuffet's concept of the visible, as a blueprint of the imagination.

Dubuffet died in Paris on 12 May 1985, a few weeks after the completion of his autobiography. H.D.

Max Loreau, *Jean Dubuffet, stratégie de le création*, Paris, 1973

Michel Thévoz, *Dubuffet*, Geneva, 1986

Mildred Glimcher, *Jean Dubuffet: Towards an Alternative Reality*, New York, 1987

Laurent Danchin, *Jean Dubuffet, peintre-philosophe*, Lyon, 1988

Michel Ragon, *Jean Dubuffet, paysage du mental*, Paris and Geneva, 1989

Andreas Franzke, *Dubuffet*, Cologne, 1990

MARCEL DUCHAMP

was born on 28 July 1887 in Blainville Crevon near Rouen, the fourth of seven children. Duchamp left school and moved to Paris in 1904, where he lived in Montmartre with his brother Gaston (later known as Jacques Villon). He registered at the Académie Julian, but showed little interest in developing as an artist, though some caricatures for magazines like *Le Rire* and *Le Courrier Français* revealed his sense of the ambiguous, even at this early stage.

Duchamp started exhibiting in the *Salon d'Automne* as early as 1908, and from 1909 in the *Salon des Indépendants*, where Guillaume Apollinaire noted some 'very ugly' Duchamp nudes in 1910. His early work shows a mixture of influences including Symbolism, Cézanne and the Fauves, before he turned to Cubism in 1911; thus for example *Les joueurs d'échecs* (The Chess Players) shows figures playing chess, his favourite occupation, broken down into cubist facets. In the same year Duchamp experimented with futuristic representation of movement in *Jeune homme triste dans un train* (Sad Young Man in A Train) and painted his first mechanical object, the *Moulin à café* (Coffee Mill), in which movement is indicated by dotted lines and an arrow, showing that he was familiar with Marey's chronophotography. Duchamp's famous nude *Nu descendant un escalier* (Nude Descending a Staircase, 1912) was produced at the height of the Cubist controversy, but he had to withdraw the picture from the *Salon d'Automne*, as the Cubists felt that it betrayed their ideas.

Subsequently Duchamp, stimulated above all by Raymond Roussel's linguistic experiments, turned increasingly away from traditional painting and pursued 'peinture conceptionelle', for which he prepared in 1912 with pictures like *Mariée* (Bride) and drawings like *La mariée mise a nu par les célibataires* (The Bride stripped Bare by the Bachelors) and notes that later formed a source for his major work *The Large Glass* or *La mariée mise à nu par ses célibataires, même* (1915–1923). The triumphal success of *Nude descending* at the *Armory Show* in New York in 1913 simultaneously ended Duchamp's career as a Parisian avant-garde painter. His last painting, *Tu m'* was produced in 1918 in response to a commission from Katherine Dreier, before he finally turned his back on the 'retinal' art of painting.

While still in Paris Duchamp undertook further preparatory work on *The Large Glass*, including the *Broyeuse de Chocolat* (1913; Chocolate Grinder) and the strange object *Trois stoppages-étalons* (1913–14; Three Standard Stoppages), measuring units of chance, which, Duchamp felt, played an important role in the creative process. It was at about this time that the first 'readymades' were created in his studio – the front wheel of a bicycle mounted upside-down on a stool and a bottlerack – although the term 'readymade' was not used as such until he arrived in the USA in 1915. In New York, where Duchamp settled for a few years after the outbreak of the First World War, further readymades followed. Others were mass-produced industrial items which, left as they were or slightly altered, were signed and usually given an inscription as well. Thus in about 1915 he wrote on a newly acquired snow-shovel 'In advance of the broken arm'. As co-founder of the 'Society of Independent Artists', in 1917 Duchamp submitted a urinal signed 'R. Mutt' and called *Fountain* for an exhibition; however, it was rejected and this led to the resignation of Duchamp and Walter Arensberg, his first collector and patron in America. Most of the readymades were lost, but Arturo Schwarz reproduced them and had them signed by Duchamp for an exhibition in Milan in 1964. It was only at this point that a genuine, frequently one-sided, response began to the readymades as a declaration and anti-institutional gesture.

Duchamp had started work on *The Large Glass* in 1913, and on his return to Paris ten years later he declared it to be 'finally incomplete'. In it Duchamp collected all the important avant-garde themes (movement, space-time, fourth dimension) and linked them with a personal symbolism full of erotic, but also hermetic and mystical, connotations.

In April 1920 Duchamp, Katherine Dreier and Man Ray founded the 'Société Anonyme, Inc.', a first exhibition platform for modern art in America. Highly revered in Dadaist and Surrealist circles in Paris, Duchamp nevertheless continued to refuse to take part in the official art business, instead entering chess championships or writing books about chess. Duchamp's artistic abstinence lasted until 1934, when he decided to collect all the notes and sketches that had led to *The Large Glass* in a single publication (*La Boîte verte*, 1934) and also to issue versions of his most important work (paintings, readymades, notes on *The Large Glass* and even *The Large Glass* itself) in a box containing miniatures and facsimiles (*La Boîte-en-valise*, 1936–1941). Some of Duchamp's work was shown in major international exhibitions and forms the basis of his fame as a motivating force behind the rapidly developing artistic scene in America. He finally settled in New York in 1942 and exhibited the *Boîte-en-valise* as a 'portable museum' at the opening of Peggy Guggenheim's 'Art of This Century' gallery in the same year. Although he produced scarcely any new work in subsequent decades, Duchamp was constantly present in the American public's consciousness because his earlier work was included in numerous exhibitions, such as *DADA 1916–1923*, in New York in 1953. In 1955 some of his *Rotoreliefs (Disques optiques)* dating from 1935 were shown in Paris. These were an early manifestation of kinetic art, which Duchamp had used even in 1920 in the *Rotative Plaques Verre (Optique de précision)* (Rotary Glass Plates (Precision Optics)), which he designed with Man Ray: rotating glass plates that create an optical illusion.

Two years after completing his last work of art (*Etants donnés*, 1946–1966) Duchamp died unexpectedly on 2 October 1968, in Neuilly. On his tombstone is the inscription he composed for himself

'D'ailleurs, c'est toujours les autres qui meurent' (Incidentally, it's always the others who die). H.D.

Marcel Duchamp, ed. Anne d'Harnoncourt and Kynaston McShine, exh. cat., New York, The Museum of Modern Art, and Philadelphia, Museum of Art, 1973; 2nd ed., 1989
Marcel Duchamp in Perspective, ed. Joseph Mashek, Englewood Cliffs, New Jersey, 1975
Marcel Duchamp, Musée National d'Art Moderne, Centre Georges Pompidou, 4 vols., Paris, 1977
Marcel Duchamp. Die Schriften, 2nd ed., trans. with a commentary by Serge Stauffer, Zürich, 1981
Robert Lebel, *Marcel Duchamp*, Paris, 1985
Dieter Daniels, *Duchamp und die anderen. Der Modellfall einer künstlerischen Wirkungsgeschichte in der Moderne*, Cologne, 1991
Marcel Duchamp Opera, exh. cat., Venice, Palazzo Grassi, 1993
Marcel Duchamp. Interviews und Statements, ed. Serge Stauffer, Stuttgart, 1992
Marcel Duchamp. The Complete Works, ed. Arturo Schwarz, New York, 1996

MAX ERNST

was born in Brühl, near Cologne, on 2 April 1891. His early artistic inspiration came from his father, a gifted and ambitious amateur painter. In 1910 Ernst enrolled on a philosophy, psychiatry and art history course at Bonn University, but he thought of himself mainly as a painter. He was particularly interested in the painting of van Gogh, Gauguin, Seurat, Matisse, Kandinsky and Macke. He and Macke became friends in 1910.
Even before Hans Prinzhorn's book *Bildnerei der Geisteskranken* (Art of the Mentally Ill) was published in 1922, Ernst was interested in the creative expression of people suffering from mental illness, an interest later reinforced by the Surrealists. Through his friendship with August Macke he became a member of the 'Rhine Expressionists' and contributed to their exhibition *Das Junge Rheinland* (Young Artists from the Rhineland) in Cologne and Bonn. Ernst's Expressionist early work is characterised by strong often complementarily placed colours, free, gesticulatory brushwork and expressively elongated, even distorted, representations of figures. Through Macke he met Guillaume Apollinaire and Robert Delaunay and in 1913 exhibited in the *First German Autumn Salon* at Herwarth Walden's 'Der Sturm' gallery in Berlin. The same year he made his first visit to Paris.
When war broke out Ernst volunteered for military service and after training with the field artillery was posted to France and later to Poland. Even during the war he had a small exhibition (with Georg Muche) at 'Der Sturm', where he met Georg Grosz and Wieland Herzfelde, founder figures of the Berlin Dada movement in 1918. In 1919 Ernst founded the Cologne Dada group 'Zentrale W/3' with Hans Arp and Johannes Theodor Baargeld, and as one of its leading members organised various Dadaist activities. Encouraged by his contacts with the Paris

Dadaists Ernst moved to Paris in 1922 and published his first collage books (*Répétitions*, with poems by Paul Eluard, *Les Malheurs des immortels*, with poems by Eluard and Ernst). Here, the perfectly assembled collages made from, among other things, fragments of old woodcut illustrations, create an indissoluble tension between reality and dreams, sometimes with an aggressive edge.
Ernst's first proto-Surrealist pictures, such as *The Elephant of the Celebes* (1921) and *Oedipus Rex* (1922), were acclaimed by the Cubists, Braque and Gris in particular, when they were shown at the *Salon des Indépendants*. In 1924, the year in which André Breton wrote his 'Manifeste du Surréalisme', Max Ernst went to South-East Asia and met his Paris friends Paul and Gala Eluard in Saigon. On returning to Paris he became an enthusiastic member of Breton's new Surrealist group and developed a series of new semi-automatic painting techniques – frottage in 1925, grattage in 1926, décalcomania in 1936, 'oscillation' (a drip technique) in 1942 – which he used both in paintings, such as *La Ville entière* (The Entire City), (1935–36), and graphic works, such as *Histoire naturelle* (1926). From these techniques, used in a quasi-playful manner, Ernst developed a rich repertoire of expressive media, creating entirely new forms linking the imaginary, the ecstatic and the apocalyptic and exposing the viewer to an associative range of oscillating meanings. Ernst was familiar with Freud's 'interpretation of dreams' and his psychoanalytical method and artistic innovations were undoubtedly influenced by his study of psychoanalytical works, but what remained paramount were his limitless capacity for achieving a poetic metamorphosis of the material and his ability, in defiance of all rational explanation, to create archetypal figurative Surrealistic images from the fusion in his work of totally disparate elements.
In 1941 Ernst emigrated to the USA and married Peggy Guggenheim, his third wife (the first two were Luise Straus and Marie-Berthe Aurenche). After travelling extensively in the USA he then settled in Sedona, Arizona, in 1946 with his fourth wife Dorothea Tanning. Some of the pictures he produced in the forties are among the masterpieces of Surreal-

ist painting, including *Vox Angelica* (1943), *Das Auge des Schweigens* (The Eye of Silence, 1943–44) and *Die Versuchung des Heiligen Antonius* (The Temptation of St Anthony, 1945). In 1944 he also seriously took up sculpture once more.
In 1951 the first major German retrospective of Ernst's work was mounted in his birthplace, Brühl. In 1953 Ernst returned from the United States to settle once more in Paris. In 1958 he took out French citizenship and in 1963 he moved to Seillans, in the south of France. He was awarded numerous prizes and honours, and retrospectives of his work were held at the Museum of Modern Art in New York in 1961, the Wallraf-Richartz-Museum in Cologne in 1962 and Stockholm and Amsterdam in 1969. During the artist's lifetime Werner Spies published the first three volumes of the catalogue raisonné of his works. Max Ernst died on 1 April 1976. H.D.

Uwe M. Schneede, *Max Ernst*, Stuttgart, 1971; Engl., *The Essential Max Ernst*, London, 1972
Werner Spies, *Die Rückkehr der schönen Gärtnerin. Max Ernst 1959–1970*, Cologne, 1971, 3rd ed., 1988; Engl., *The Return of La Belle Jardinière: Max Ernst 1950–1970*, New York, 1972
Werner Spies, *Max Ernst – Collagen. Inventar und Widerspruch*, Cologne, 1974, 3rd ed., 1988; Engl., *Collages – The Invention of the Surrealist Universe*, London, 1991
Max Ernst. Retrospektive zum 100. Geburtstag, ed. Werner Spies, exh. cat., London, Tate Gallery, Stuttgart, Staatsgalerie and Düsseldorf, Kunstsammlung Nordrhein-Westfalen, Munich, 1991
Max Ernst. The Sculpture, ed. Fiona McLeod and Judith Findlay, Newport Beach, Newport Harbor Art Museum, Edinburgh, Scottish National Gallery of Modern Art, 1992
Max Ernst. Dada and the Dawn of Surrealism, ed. William A. Camfield, exh. cat., New York, The Museum of Modern Art and Houston, The Menil Collection, 1993

JEAN FAUTRIER

was born in Paris on 16 May 1898. His father died while he was still young and his mother moved to London, where Fautrier entered the Royal Academy Schools at the early age of 14, later moving on to the Slade School of Art. He was obliged to return to France in 1917 to do military service and was posted to the front line, where he was gassed, sustaining serious lung and eye injuries that were to trouble him for the rest of his life. Following demobilisation, he settled in Paris in 1920.
The figure compositions, portraits and still lifes he painted in Paris were highly expressive, reminiscent of Chaim Soutine in their brilliant handling and approach bordering on caricature. During the same period, 1925–1926, he also created a number of unusual experimental compositions, in which the subject could scarcely be disentangled amid the rapid monochrome brush strokes. A series of female half nudes was still representational – certain

piquant details lent them a degree of erotic sensuality – but here too the handling was so full of life that the realistic elements merged with abstract passages of colour to form a pictorial unity. In the *Glaciers*, produced around the same time, the painting process was clearly in evidence, although fleeting lines dashed in at the last minute seemed to bear no relation to the original subject. The hazy effect of colour produced by broken whites clearly expressed the elemental character of the glacier as a natural phenomenon. This bold step into new territory, later to be recognised as a precursor of abstract art, was followed by a brief return to representational work – turbulent, imaginary landscapes, produced largely in the south of France in 1928–1929 and executed with the impetuous verve of a van Gogh.

Initially Fautrier enjoyed considerable commercial success – from 1925, he had a contract with the well-known Paris dealer, Paul Guillaume – but during the thirties he gradually withdrew from painting and developed a taste for skiing in the French alps. In 1934, he finally left Paris, to become first a ski instructor at Tignes and later the successful manager of an hotel in Val d'Isère and several nightclubs. On the outbreak of war in 1939, Fautrier was forced to abandon his mountain retreat under threat of an Italian invasion. After spending some time in Marseilles and Aix-en-Provence, he returned to Paris in 1940 and took a studio on the Boulevard Raspail, which became a rendezvous for friends involved in the resistance. Fautrier was himself arrested briefly in 1943. He took refuge in Dr Lesavoureux' sanatorium in Paris, where in the last years of the war he produced the series of paintings entitled *Otages* (Hostages), that was to make his name. Inspired by the dramatic confrontation of force and resistance, the *Otages*, with their brief indications of faces, bodies and heads, stood as a solemn warning against human cruelty. They also signalled a revival of his interest in painting and above all experimenting with new materials. Several thin layers of colour were painted on a smooth, thickly impasted white ground, and a special ground and powdered pastel rubbed into any areas not covered with paint. Thus the material aspect of the colour became the subject of the painting, and the representational basis was made clear. For this reason, it seems inappropriate to classify Fautrier as a precursor of 'art informel'. Even in his later works, the formal nucleus of a clearly discernible subject continued to provide at least the

challenge and the impetus for the painting process. Between 1949 and 1954, Fautrier's painting activities were again interrupted by pressing financial problems. He was appointed by the writer André Malraux, who was later to become Minister of Culture and was at the time a member of the editorial board of the publishers Gallimard, to supervise the graphics for art books on Venice and Leonardo da Vinci. With a view to gaining a wider public for his own work, Fautrier also developed the idea of 'multiple originals', which were a mixture of printmaking and painting.

From 1955 onwards, Fautrier's work was exhibited worldwide, including a show at *documenta 2* in Kassel, in 1959. He was awarded the Grand Prize at the Venice Biennale in 1960. His pictures, which had always sought to depict the simple and the elemental, now became increasingly simple in composition, with their veils of pink on a shadowy ground that seemed to encompass the beginning and the end of painting.

Fautrier died in Châtenay-Malabry near Paris on 21 July 1964. H.D.

Jean Fautrier. Gemälde, Skulpturen und Handzeichnungen, exh. cat., Cologne, Josef-Haubrich-Kunsthalle, 1980

Jean Fautrier. Gemälde, Skulptur, Radierungen, exh. cat., Neuss, Insel Hombroich, 1987

Pierre Cabanne, *Jean Fautrier*, Paris, 1988

Fautrier, 1898–1964, exh. cat., Paris, Musée d'Art Moderne de la Ville de Paris, 1989

Yves Peyré, *Fautrier ou les outrages de l'impossible*, Paris, 1990

Jean Fautrier, exh. cat., Biot, Musée National Fernand Léger and Budapest, Mücsarnok, Paris, 1996

DAN FLAVIN

was born on 1 April 1933 in Jamaica, New York. He trained as a meteorologist in the US Air Force from 1953 and served as a weather observer in the Korean War. He studied at the New School for Social Research in 1956 and attended art history lectures at Columbia University in New York from 1957 to 1959. Flavin was a self-taught artist, and his earliest work was subject to such contrasting influences as Abstract Expressionism and the incipient Pop Art movement. He exhibited for the first time at the Judson Gallery in New York, where he showed a group of water-colours and abstract constructions, in 1961. In the same year, he first introduced light into his work as a creative element by mounting bulbs on shallow wall boxes that he called *Icons*. Flavin made his actual breakthrough to 'electric light art' in *The Diagonal of May* 25, 1963. This was a 2.44 metre commercial fluorescent tube mounted on a wall at an angle of 45 degrees and declared to be the 'diagonal of personal ecstasy'. He dedicated the first version of this work – a fluorescent tube emitting yellow light – to Constantin Brancusi, whose *Endless Column* had provided the initial inspiration. Like Brancusi's endless column, which suggested that it could be continued to

infinity by repeating identical segments, the light shining out into the space neutralised the material quality of its source. In 1963 Flavin decided that in future he would use nothing but differently coloured standard fluorescent tubes as his artistic material.

Flavin's involvement in the pioneering *Primary Structures* exhibition in the Jewish Museum in New York, in 1966, was as an exponent of American Minimal Art, although he distanced himself from this movement's cool pragmatism. Despite reducing his formal resources as much as possible, through the use of an existing industrial item deployed in modular structures, Flavin did not exclude the transcendental and mythological interpretations traditionally associated with exuding light. The allusive quality of his titles for these anonymous manufactured light-objects contrasted with his rejection of subjective elements and his exclusion of everything that smacked of the personal or individual. Flavin dedicated some of his light objects to people to whom he felt bound in a variety of ways, such as art-historians and gallery-owners (Robert Rosenblum, Heiner Friedrich) and fellow artists (Barnett Newman, Roy Lichtenstein). He dedicated a series of works that he continued for more than twenty years to the Russian Constructivist Vladimir Tatlin. This started in 1964 with *Monument 7 for V. Tatlin*, an arrangement of fluorescent tubes of different lengths, which emit a cold, white light and appear to soar upwards in rocket formation.

From the mid-sixties onwards Flavin created his numerous light-spaces, using only a few fluorescent tubes in a spartan setting to create an immensely powerful effect. He picked out existing architectural features, like the edges of floors and ceilings, with bands of light, or flooded corners and surfaces with light. Thus the spatial effect was manipulated in such a way that new spaces (light-spaces) were created, and the viewer's shifting perceptions were affected, each time that he or she changed position.

In 1977 Flavin moved out of the gallery context and installed a number of fluorescent tubes on three platforms of Grand Central Station in New York. In 1992, he made installations of neon tubes all along the ramp on the inside and outside of Frank Lloyd

Wright's building for his exhibition at the Solomon R. Guggenheim Museum, and in 1996 he used green and blue glowing fluorescent tubes to accentuate the exterior façade of the new Museum of Contemporary Art in the Hamburger Bahnhof in Berlin.

As a leading innovator in the realm of three-dimensional work, and as a pioneer of light sculpture, Flavin featured in major exhibitions in Europe from the late sixties, such as the *Minimal Art* exhibition at the Gemeentemuseum in The Hague in 1968 and *documenta 4* in Kassel, in the same year. Large one-man shows were held at a variety of venues, including the Solomon R. Guggenheim Exhibition in New York in 1982 and 1992, the Stedelijk Museum in Amsterdam in 1986 and the Städtische Galerie im Städel in Frankfurt a. M. in 1993.

Flavin died on 29 November 1996 in Riverhead, New York. H.D.

Dan Flavin. Three Installations in Fluorescent Light. Drei Installationen in fluoreszierendem Licht, exh. cat., Cologne, Kunsthalle, 1973
Fünf Installationen in fluoreszierendem Licht von Dan Flavin, exh. cat., Basel, Kunsthalle, 1975
Dan Flavin: Drawings, Diagrams and Prints 1972–1975. Installation in Fluorescent Light 1972–1975, exh. cat., Fort Worth Art Museum, 1977
Neue Anwendungen fluoreszierenden Lichts mit Diagrammen, Zeichnungen und Drucken von Dan Flavin, exh. cat., Baden-Baden, Staatliche Kunsthalle, 1989
Dan Flavin, exh. cat., Mönchengladbach, Städtisches Museum Abteiberg, 1990
Dan Flavin, Installationen in fluoreszierendem Licht 1989–1993, exh. cat., Städtische Galerie im Städel, Frankfurt a. M., Stuttgart, 1993

GÜNTHER FÖRG

was born on 5 December 1952 in Füssen. From 1973 to 1979 he studied painting with Karl Fred Dahmen at the Akademie der Bildenden Künste in Munich.

Förg's art is characterised not only by his use of different media but by the combination and juxtaposition of different genres, such as painting, photography, sculpture and wall decoration. The separate genres are treated in such a way as to suggest structural and thematic analogies to the viewer and to reveal certain correspondences and transformations of meaning: 'In my watercolours I discovered the possibility of building on the achievements of my wall paintings. I subsequently translated the structure of certain of these watecolours into bronze reliefs. I then carried over the principles of these reliefs into my drawings and prints.'

While still at the Academy Förg began using unconventional supports for his paintings such as lead foil, whose material quality came to dominate the foreground to such an extent that these works took on an almost sculptural character, in spite of the flat application of the colour. At first sight, geometric colour planes and lines, ordered in a horizontal or vertical direction, constituted the strict, formally reserved structural principle of his paintings, whose surfaces

were enlivened by the varying thicknesses of colour, the visible traces of brushstrokes and a variety of scratch marks. In the course of time, Förg used ever more massive supports for his colour, such as copper, lead and wood, all the way to whole walls, incorporated in decorative schemes for interiors.

In his sculptures, by way of contrast, Förg takes the surface as his point of departure. He creates monochromatic bronze reliefs, fastened to the wall as rectangular forms on which, for example, he occasionally incises a number of vertical furrows. Once freed from the wall, Förg has gone on to create free-standing stelae and – from 1990 onwards – a series of small figurative masks, mounted on wooden plinths.

In his photographic work, Förg emphasises two thematic strands, above all: first, close-up portraits of young women, in large format, and secondly, architectural photographs – especially, photographs of buildings from the twenties and thirties, as well as of the façades of Roman palaces. His photographs are frequently slightly out of focus and he gives them a thin monochromatic tint, to emphasise the artificiality of the medium, in contrast to the reality of the subjects they depict. These photographs are presented in massive frames, with strongly reflective glass – a system Förg often employs for his paintings, too, as if to heighten their auratic and monumental presence (a feature which is common to all his work). In his panel paintings, which are mostly arranged around the room in serial sequence, and his wall decorations – whether they are self-contained (frequently, on staircases) or function as coloured spaces for installations – Förg strives to achieve, on the one hand, the full energy and transformative power of colour energies and, on the other, the ideal rhythms and proportions of space. Along the way, his installations or spatial concepts make play with a constant interchange between the reality of a physical space which can really be entered and fictitious elements, such as the illusionistic extension of that space by means of photography and a variety of means for drawing in the spectator, such as the use of mirrored surfaces, aluminium grounds and reflections in the glazing used to protect the image. It is easy to see

where Förg has found precedents and sources of inspiration for the transparent contextuality of his work, as a whole: his material and aluminium pictures are explicit in their references, not only to Blinky Palermo but to Barnett Newman, whose vertical colour stripes ('zips') crop up as quotations, in altered form. His environmental interiors also acknowledge the importance of the Dutch and Russian Constructivists.

Förg's work has been included in numerous group exhibitions, such as the Düsseldorf exhibition *von hier aus* in 1989, *Bilderstreit* in Cologne in 1989, *Metropolis* in Berlin in 1991, and *documenta IX* in Kassel, in 1992. Important solo exhibitions of his work have been held at institutions such as the Gemeentemuseum in the Hague, the Museum Fridericianum in Kassel (with further showings in Ghent, Tübingen and Munich) in 1990, and the Stedelijk Museum in Amsterdam in 1995.

Förg has been a professor at the Centre for Art and Media Technology in Karlsruhe since 1993. He lives and works in Karlsruhe and in Areuse, in Switzerland. C.T.

Günther Förg, exh. cat., Münster, Westfälischer Kunstverein, 1986
Günther Förg, Painting/Sculpture/Installation, exh. cat., Newport Beach, Newport Harbor Art Museum, 1989
Günther Förg, exh. cat., Kassel, Museum Fridericianum, Ghent, Museum van Hedendaagse Kunst, Leipzig, Museum der Bildenden Künste, Tübingen, Kunsthalle and Munich, Kunstraum, Stuttgart, 1990
Günther Förg, exh. cat., Paris, Musée d'Art Moderne de la Ville de Paris, Stuttgart, 1991

LUCIO FONTANA

was born on 19 February 1899 in Rosario de Santa Fé in Argentina, the son of Italian immigrants. In 1905 the family moved to Milan, where from 1914 Fontana attended the Carlo Cattaneo School for the Building Trade. In 1917 he started his military service, but in 1918 he was discharged, following an injury, and took his final examinations as an engineer. In 1920 he enrolled at the Accademia di Brera in Milan, but in 1922 went back to Argentina with his family and worked in his father's sculpture studio.

In 1924 Fontana successfully opened his own sculpture studio in Rosario de Santa Fé, but in 1928 returned to Milan (until 1930) to resume his studies at the Accademia di Brera, this time with the Symbolist sculptor Adolfo Wildt. In addition to making figurative sculptures, from 1931 onwards he produced terracotta reliefs and painted plaster panels, in which he came close to abstraction, and in 1934, together with Fausto Melotti, Atanasio Soldati and Mauro Reggiani, he established a Milanese section of the Paris art group 'Abstraction-Création'. The following year the group published a manifesto on abstract art and Fontana had his first solo exhibition of abstract sculpture, at the Galleria del Milione in Milan. Marinetti mentioned him in 1938, in his manifesto

'Ceramica and Aeroceramica'. The Futurist idea of a total work of art fell on fertile soil, in the case of Fontana.

From 1939 onwards Fontana was again in Argentina, where in 1946 he was a co-founder of a private academy in Altamira and drew up, in conjunction with his students, the 'Manifiesto Blanco' (White Manifesto), which called for the synthesis of genres and the renunciation of conventional materials. Back in Milan, in 1948 Fontana articulated his quest for a new spatial art in the 'First Manifesto of Spatialism' (the second, third and fourth manifestos of 'Spatialism' followed in 1949, 1950 and 1951) and founded the group 'Movimento Spaziale'. In 1949, at the Galleria del Naviglio in Milan, he created the first 'Ambiente spaziale' (*Ambiente nero*), a forerunner of the Environment, in which abstract forms painted in fluorescent colours were lit with ultraviolet light. For Fontana this was the start of a transformation of his concept of art, which aimed at a lively interaction with the surrounding space. The same year he produced his first perforated canvases which, like all similar subsequent works, bore the title *Concetto spaziale* (spatial concept). In these works the canvas was pierced by punches and other sharp tools, often soaked with paint. These 'informel' procedures recalled Surrealist pictorial experiments, such as frottage and grattage, but Fontana radicalised the dialogue with his materials by irreparably violating the 'sacred' surface of the canvas. Through the resulting series of holes the space is literally opened up, without recourse to illusionistic tricks, such as had been popular with the avant-garde from the Cubists onwards. In parallel with these perforations, in the fifties he produced the series of *Pietre* (Stones), in which coloured glass blocks occupied the picture surface and created an irregular, informal pattern of concrete ridges, which also extended the picture surface into real space.

In 1958 Fontana began making his famous cuts into the canvas – brutal incisions with a sharp knife into the generally monochromatic, painted surface. The series *Attese su paesaggio* (Assassination Attempts on the Landscape, from 1958), *Nature* (from 1959) and *Quanta* (from 1959) are all made up of perforated and cut canvases. Fontana's concern, in this instance, was to explore a metaphysical pictorial space behind the surface of the picture, which remained intact even after it had been violated.

At the start of the sixties Fontana combined new pictorial methods with thickly applied sections of paint, often mixed with sand, into which he drew and made scratch marks. This led to the creation of large, spherical, bronze objects (*Nature*) which, with their gaping gashes and cave-like hollows, represented an organic expansion of his attempts to turn space into a tangible moment of reality. Fontana's artistic development came to an end with the impressive series, *La fine di dio* (The End of God, 1963), which comprised oval canvases covered at irregular intervals with perforations of all sizes.

Fontana, who exercised a great influence on the younger generation of artists, died on 7 September 1968 in Comabbio, Varese. H.D.

Agnoldomenico Pica, *Fontana e lo spazialismo*, Venice, 1953
Wieland Schmied and Kurt Leonhard, *Lucio Fontana*, exh. cat., Hanover, Kestner Gesellschaft, 1967
Enrico Crispolti, *Lucio Fontana. Catalogo Generale*, Milan, 1986
R. Sanesi, *Lucio Fontana*, Milan, 1980
Carla Schulz-Hoffmann, *Lucio Fontana*, Munich, 1984
Giovanni Joppolo, *Une Vie d'Artiste. Lucio Fontana*, Marseille, 1992
Lucio Fontana, exh. cat., Frankfurt a.M., Schirn Kunsthalle, 1996

LUCIAN FREUD

was born in Berlin on 8 December 1922, son of the architect, Ernst Freud and grandson of Sigmund Freud. The family emigrated to England in 1933 and Freud took British nationality in 1939. He enrolled at the Central School of Arts and Crafts in London in 1938 and his drawings began to appear in the magazine *Horizon*, in the following year. In 1939, he transferred to the East Anglian School of Painting and Drawing in Dedham, where he stayed until he was called up in 1941. He served briefly in the Merchant Navy and was injured in a U-boat attack. In 1942–43, he was able to study part-time at Goldsmith's College, London.

Freud had his first show in 1944 at the Lefevre Gallery in London. His painting is realistic and his subject was and still is the human figure – for the most part, friends or members of his own family. In his 1952 portrait of his friend Francis Bacon, the celebrated painter is depicted in a magical realist style, where every feature and every strand of hair is faithfully reproduced, down to the last detail. Freud's meticulously accurate drawings and paintings prompted the art critic, Herbert Read, to dub him the 'Ingres of existentialism'.

Towards the end of the fifties, a new style began to emerge. The brushwork became coarser and thicker, the style more expressive. The heavy, grainy handling resulted partly from his use of Cremnitz white,

which contains twice as much lead as white lead and is consequently highly toxic. In using this medium, Freud was not concerned with 'la belle peinture' or the delicacy of colour expertly applied, but with the best possible means of portraying living human flesh. He wanted the colour to have the effect of flesh. He was, he said, aware that his idea of portrait painting arose from his dissatisfaction with portraits that were good likenesses. He wanted portraits *of* people, not portraits that were *like* them. He did not want the sitters' appearance, he wanted their essence. He did not want to produce a mere likeness like a mimic, he wanted to identify a character as an actor did. As far as his work was concerned, that meant the painting *was* the person. He wanted it to have the same effect as the sitter himself. Rarely, in recent times, has the idea of empathy and identification, of the painter actively taking possession of the model, been expressed so directly.

Unlike his English contemporaries, Francis Bacon and Frank Auerbach, whose work is also mainly concerned with the human form, Freud uses a tonal palette with few bright accents, attaching great importance to balanced composition, in which even small details are harmoniously integrated with the whole. Whereas with Auerbach the process of painting is quite separate and the subject is as it were drowned in a whirlpool of paint, with Freud the subject always dictates the handling.

Freud's concern is to represent his subjects with the greatest possible realism. The portraits, self-portraits and pictures of friends, often ruthlessly held up to the world in all their nakedness, are central to his work. The uninhibited attitudes of his nudes recall Degas' pictures of women bathing, but without the hint of voyeurism discernible in the latter. Freud works slowly, his pictures take quite a long time and he demands great patience and concentration from his sitters. Working from the model does not worry him. On the contrary, he feels more at ease that way, able to make selections that the tyranny of memory would not allow him to get away with. The portraits of his mother painted in the late seventies are among his best, psychologically most sensitive works.

Freud was awarded the Arts Council Prize for his contribution to the Festival of Britain in 1951 and he exhibited, with Ben Nicholson and Francis Bacon, in the British pavilion at the Venice Biennale in 1954. From 1958 to 1968, his work appeared regularly at the Marlborough Gallery in London, and in 1974 the Arts Council organised a retrospective at the Hayward Gallery. International travelling exhibitions of his work were organised by the British Council in 1987–1988, 1991–1992 and 1992–1993.

Lucian Freud lives and works in London. H.D.

Lawrence Gowing, *Lucian Freud*, London, 1982
Lucian Freud. Paintings, exh. cat., Washington D.C., Hirshhorn Museum and Sculpture Garden, Smithsonian Institution, British Council travelling exhibition, 1987
Lucian Freud. Paintings and Works on Paper 1940–1991, exh. cat., Rome, Palazzo Ruspoli, British Council travelling exhibition, 1991
Lucian Freud, exh. cat., Sydney, Art Gallery of New South Wales and Perth, Art Gallery of Western Australia, British Council travelling exhibition, 1992
Catherine Lampert, *Lucian Freud: Recent Works*, exh. cat., London, Whitechapel Art Gallery, New York, Metropolitan Museum of Art, Madrid, Museo Nacional Centro de Arte Reina Sofía, 1993

KATHARINA FRITSCH

was born in Essen on 14 February 1956. She gave up her history and history of art course and moved to the Düsseldorf Kunstakademie in 1977.

Fritsch attended Fritz Schwegler's master classes in painting and drawing in 1981; however, her work is at the interface of painting and object art in that she defamiliarises everyday objects, mainly through the addition of colour. Up until now the choice of paint for her objects has been crucial. For instance, she paints two massive plastic vases black and adds a white and a red bunch of plastic carnations (1979) or she coats a toy lorry with red paint, as in her *Roter Lastwagen* (Red Lorry) of 1980–86. Fritsch's installation *Acht Bilder in acht Farben* (Eight Pictures in Eight Colours) of 1990 is the most radical statement to date by an artist who does not see herself as a painter, but uses paint as a distancing element and to convey mood.

Fritsch's objects are not ready-mades, everyday objects turned into works of art; they are new creations, in which she makes minor but effective alterations to the original 'model' and brings out its evocative power. She transforms outsize or serial versions of commercial, museum-related or devotional articles, by simplifying their forms and coating them with paint; frequently, she then arranges them in glass display cases and other specially made exhibition furniture.

Fritsch aims to create pictures from memory and dreams. She piles white vases, with an ocean steamer printed on all four sides, into a pyramid (1987–89); she paints plastic brains white to make an hourglass; half-open money boxes, arranged in a rectangle, are

filled to the brim with artificial coins (1988); pieces of green silk printed with a picture of Saint Martin are heaped up on the *Wühltisch* (Bargain Counter, 1987–89). On the altars of consumption money becomes a fetish and salvation a commodity. But Fritsch's art is not confined to the commercial world: in 1984 she sprayed *Parfüm im Hausflur* (Perfume in the Hall); she recorded the croaking of toads (1982–88) and the monotonous sound of rain on rhododendron leaves (1988) on gramophone records, and in 1991 she enlivened the *Metropolis* exhibition in Berlin with a crimson room with wind howling in the chimney.

Fritsch gained a reputation with her installation *Acht Tische mit acht Gegenständen* (Eight Tables with Eight Objects), at the exhibition *von hier aus* (from here) in Düsseldorf, in 1984. The tables were arranged like slices of cake in an octagon, with the centre empty. The objects standing on them were very slightly altered, to deprive them of their original function, and combined in contrasting pairs (outsize and minute, open and shut, light and dark). In 1987 outraged members of the public smashed Fritsch's work for the *Skulptur Projekte Münster* (Münster Sculpture Projects) exhibition, a shining yellow-painted Madonna figure in the style of the devotional objects sold in Lourdes, erected in the pedestrian zone. In response, the artist had a hundred casts made of the statue and arranged them into a broken column, looking outwards.

In *Tischgesellschaft* (Table Company) of 1988 Fritsch combined recurring elements of her work: the number eight as a unit of measurement, this time with the human figure as a multiple, and a precise symmetrical arrangement, emphasised by the uniform painting in black, white and red. The magical effect of this work suggested a variety of different meanings, such that it could be interpreted, for instance, either as a reference to the 'collective unconscious' or to the infinity of space and time.

Fritsch's most shocking and unsettling work so far is *Der Rattenkönig* (the Rat King), made for the Dia Art Center in New York in 1993. Sixteen 2.80-metre-high rats form a circle facing outwards, ready to jump, but

their tails are knotted into an inextricable tangle, to symbolise the dark side of the urban jungle.

In 1995 Fritsch represented Germany at the Venice Biennale with *Museum/Modell*, an installation in which she reflected on the role of art in society and made an appeal for artists to be responsible for their own 'environment'.

Fritsch lives and works in Düsseldorf. H.D.

Katharina Fritsch. Elefant, exh. cat., Krefeld, Kaiser-Wilhelm-Museum, 1987
Katharina Fritsch, exh. cat., Basel, Kunsthalle and London, Institute for Contemporary Arts, 1988
Katharina Fritsch 1979–1989, exh. cat., Münster, Westfälischer Kunstverein and Frankfurt a. M., Portikus, Cologne, 1989
Katharina Fritsch, exh. cat., New York, Dia Center for the Arts, 1993
Katharina Fritsch. Museum, exh. cat., Venice Biennale, German Pavilion, Stuttgart, 1995
Katharina Fritsch, exh. cat., San Francisco, Museum of Modern Art and Basel, Museum für Gegenwartskunst, 1996

NAUM GABO

was born Naum Neemia Pevsner on 5 August 1890 in Bryansk, Russia. His father owned a metal factory. Naum's brother, Nathan (who was later known as Antoine) later became a sculptor of significance. In 1910 Gabo went to Munich, initially to study medicine and then the natural sciences. In 1912 he transferred to the Munich Technical College and studied civil engineering.

In Munich Gabo attended Heinrich Wölfflin's art history lectures and travelled to Italy and France, on his recommendation. During a visit to Paris he became acquainted with the art of the avant-garde in the *Salon des Indépendants*, including sculptures by Archipenko, Brancusi, Lehmbruck and Zadkine. Gabo's early artistic works – torsos and heads constructed of planes (1915–17) – were created under the influence of Cubism and Futurism and showed early signs of his interest in the penetration of space and dynamics.

He spent the war years in Norway, where he was joined by his brother Antoine. In order to distinguish himself, as an artist, from his brother, he adopted the surname Gabo. With the outbreak of the Russian Revolution in 1917, Gabo returned to Moscow. Amidst the post-revolutionary euphoria he created, amongst other things, his *Kinetic Construction* (1919–20), a metal rod which was set vibrating by an electric motor, and in 1920 he and his brother, Antoine Pevsner, published 'The Realistic Manifesto'. However, the initial euphoria soon gave way to resignation over the increasing dogmatism of artistic debate in Russia. When Gabo was permitted to leave Russia in 1922, to assist with the setting up of the *First Russian Art Exhibition* in the Van Diemen Gallery in Berlin, which exhibited works by Gabo, as well as sculptures by Tatlin, Medunetsky and Rodchenko, he decided to remain in Berlin.

In the twenties he created numerous 'space constructions', stereometric forms made from transparent synthetic materials such as celluloid and perspex. These were exhibited in 1924 by the 'Société Anonyme' in New York. In 1927, with Antoine Pevsner's help, he designed the stage set for the Diaghilev's ballet, *La Chatte*. Gabo held his first solo exhibition in 1930 at the Kestner Gesellschaft in Hanover. In 1932, as national socialism grew stronger, he left Germany and moved to Paris. There he joined the 'Abstraction-Création' group, through which he met Ben Nicholson and Barbara Hepworth, as well as the poet and critic, Herbert Read. In 1936 Gabo moved to England and stayed there until 1946. In lectures and exhibitions of constructivist art Gabo developed his artistic style, in parallel to the similar endeavours of De Stijl and the Bauhaus.

In 1946 Gabo settled in Woodbury, Connecticut, and in 1952 he took up American citizenship. He taught at Harvard University, in Cambridge, Massachusetts, from 1953 to 1954. In these years he achieved a distinctive style which dissolved sculptural volume in transparent materials that depended for their effect on the play of light and the angle from which they were observed. Nylon fibres of varying thickness were stretched over an irregularly shaped plastic frame, in such a way as to increase in density at their point of intersection in the middle and to appear increasingly transparent and virtually dissolve, as they radiated outwards towards the edges. The prototype of this sort of 'linear construction in space' was created in 1949, as a model for the entrance hall to the ESSO building in New York, although it was never realised. In 1956 he created a relief for the Rockefeller Center in New York and in 1957 a large sculpture for the Bijenkorf department store, in Rotterdam.

Even in his early sculptures, Gabo's efforts to overcome the ideas of mass and volume in favour of new concepts of space and time were evident. Whilst other artists (Moholy-Nagy, Rodchenko) continued to work in this area of constructivist sculpture, Gabo moved on to increasingly unusual devices, e.g. magnetic and electric apparatus. The influences of Gabo's work on the development of Kinetic Art, on George Rickey, Alexander Calder and Jean Tinguely, as well as Op Art are obvious.

Gabo died on 23 August 1977 in Waterbury, Connecticut, and was honoured internationally with a large number of retrospectives and awards. H.D.

Circle: International Survey of Constructivist Art, ed. J. Leslie Martin, Ben Nicholson and Naum Gabo, London, 1937, 1971[2]
Naum Gabo, *Constructions, Sculpture, Paintings, Drawings, Engravings* (with contributions by Herbert Read and J. Leslie Martin), London and Cambridge, Mass., 1957
Naum Gabo: The Constructive Process, exh. cat., London, Tate Gallery, 1976
Stephen A. Nash and Jörn Merkert, *Naum Gabo, Sixty Years of Constructivism*, exh. cat. Dallas, Museum of Art, New York, 1985

ALBERTO GIACOMETTI

was born on 10 October 1901 in the mining village of Borgonovo ob Stampa in the Canton of Graubünden, the son of the Post-Impressionist painter Giovanni Giacometti. In 1919 he began to study art at the Ecole des Beaux-Arts and the Ecole des Arts Industriels in Geneva. After further studies in Florence and Rome, Giacometti went to Paris in 1922, where he enrolled in the sculpture class of Antoine Bourdelle and at the Académie de la Grande-Chaumière.

In Paris, Giacometti slowly moved away from his initial impressionist orientation towards working spatially and sculpturally on a large scale, following the example, in particular, of post-Cubist sculpture (Laurens, Lipchitz, Brancusi). The first important phase in his work began with the *Torso* of 1925, leading to stereometrically stylised figure compositions which draw their main inspiration from the art of primitive people. In the winter of 1926–27 Giacometti made his first major independent work, *Femme-cuiller* (Spoon Woman), which was followed shortly afterwards by similar 'primitive' sculptures in slab form, whose archaic force of expression also appealed to the Surrealists. According to Michel Leiris, in his pioneering essay in *Documents 4*, Giacometti's first exhibition at the Galerie Jeanne Boucher in Paris in 1929 turned him into one of the most sought-after exponents of Surrealism. In the thirties Giacometti's sculptures became more aggressive and disturbing; his phallic objects without a pedestal, chessboard-like constructions, complicated wire constructions and a range of mysterious objects full of sadistic energy were to be seen in a number of Surrealist exhibitions. In 1934, however, Giacometti's interest in Surrealist art appears to have been finally extinguished. To the fury of the Surrealists, he took to making endless models of two portrait heads, and a row with André Breton abruptly broke the connection.

Giacometti spent the years up to the outbreak of war in lonely work on studies of heads from a few trusted models, for which he invariably started from stereometrical basic forms and arrived at ever more lifelike, but ever smaller, faces looking always to the front. Giacometti and his brother Diego earned their living from making decorative works, lamps and furniture for the Parisian interior decorator Jean-Michel Frank. In his painting Giacometti tried to compensate for temporary failures in his attempts at modelling portrait busts, which were often no larger than a nut.

Giacometti spent the war years in Geneva, where he lived and worked in a cheap hotel until September 1945. In the winter of 1945–46 he went back to Paris, where he produced sheets of drawings of isolated figures in a new, loose graphic shorthand and portraits taking up only the middle of the sheet, without precise contours or details. His sculptural style also changed at this time and the figures became elongated, almost without mass or weight. The typical 'Giacometti' style now began to emerge: thin, stick-like figures with indistinct anatomy (but exact proportions) and barely indicated heads. Giacometti was interested in the imaginary image of the figure in the field of tension created by the surrounding space, and in the resulting effect on the encrusted surface of the figure, covered in depressions and elevations. From modelling single figures he went on to creating group compositions on tall pedestals, which communicate both a tremendous concentration of energy and a palpable sense of suffering.

At the beginning of 1948 the Pierre Matisse Gallery in New York staged Giacometti's first solo exhibition since the war. This was the first time that Giacometti's life-size, wire-thin figures were placed on public display. The show was a great success with collectors and artists and Giacometti's fame first spread throughout the English-speaking world before fanning out to the rest of Europe as well. In the fifties and sixties Giacometti produced numerous portraits from the model, which enlivened the thin scaffolding of lines with a broad, painterly touch, but were nevertheless overlaid with a grey hue, to produce an almost monochromatic effect.

Giacometti's works in his last years were also characteristic of his view of humanity: his figures, standing alone or in groups, represented less a symbol of existential danger than the specific, uncommunicable reality of the isolated individual, alone in facing destiny and attempting to make some sense of human existence.

Giacometti died on 11 January 1966 from a heart condition, in the cantonal hospital at Chur. His series of etchings *Paris sans fins* (1958–1965) was published posthumously in 1969, and thus brought to a close his extensive output, the first examples of which had been exhibited in Maastricht in 1938.　　H.D.

Reinhold Hohl, *Alberto Giacometti*, Stuttgart, 1971, 1987[2]
Arturo Bovi, *Alberto Giacometti*, Florence, 1974
Herbert and Mercedes Matter, *Alberto Giacometti*, New York, 1987
Alberto Giacometti, exh. cat. Berlin, Nationalgalerie, und Stuttgart, Staatsgalerie, München, 1987
Alberto Giacometti, 1901–1966, exh. cat., Vienna, Kunsthalle, Edinburgh, Scottish National Gallery of Modern Art and London, Royal Academy of Arts, 1996

GILBERT & GEORGE

Gilbert, born in the Ladin Dolomites on 17 September 1943, studied at art schools in Wolkenstein in the South Tyrol and Hallein in Austria, and at the Academy of Fine Arts in Munich. George, born in Devon, England, on 8 January 1942, studied at Dartington Adult Education Centre in Devon, the Dartington Hall College of Art and Oxford School of Art.

Gilbert & George met in the sculpture class at St Martin's School of Art in London in 1967 and have worked together ever since. To eliminate the separation between the artists and their work, they themselves became the centre of their art. Wearing conservative suits, white shirts and ties, they were identifiable as Gilbert & George but at the same time interchangeable. In 1969 they began appearing in public as *Living Sculpture*: hands and faces sprayed with bronze paint, they moved about against a backdrop in a specially constructed, artificial setting. One of their most important performances as a *Singing Sculpture* – enacted over twenty times between 1969 and 1973 – was *Underneath the Arches*, named after a music hall song, in which robotic movements were endlessly repeated.

At the same time as their *Living Sculpture* performances, which ended with *The Red Sculpture* (their hands and faces dyed red) in 1977, Gilbert & George produced various works which clarified their broad concept of sculpture. The *Charcoal on Paper Sculptures* (1970–74) showed Gilbert & George in huge, sometimes foxed charcoal drawings, creating a complete image from several individual sheets of paper. From 1969 to 1975 they sent *Postal Sculptures* and produced *Postcard Sculptures*, collages made of postcards, photographs and statements. They published similar works as *Magazine Sculptures* in art magazines and other journals.

In 1971 Gilbert & George produced their *Photo-Pieces*, which they described as their first 'pictures', a series of photographic works with loose arrangements of individually framed black and white photographs. These, like the later series, dealt with such themes as drunkenness and alcoholism. In the next

few years the composition of the individual photos increasingly followed an overall, sometimes symmetrical pattern, for instance in the *Human Bondage* series (1974), made of separate photos arranged in the shape of a swastika. The works were on themes of urban life such as loneliness, social conflict and outsiders. Gilbert & George first started using colour in the red dyed photos of *Cherry Blossom* in 1974. In 1977 they began attaching the individual photos into large pictures without any spaces in between. They then developed these into large-format works, in which the subjects extended beyond the individual frames. The grid pattern of the frames gave them a resemblance to church windows.

Since 1980 Gilbert & George have no longer appeared in all their work and some of the pictures now feature other people and objects. In their extensive *Modern Fears* series (1980–81) they added yellow, green and blue to their range of colours and introduced ambitious titles such as *Living with Madness* and *Power and Glory*. Two years later the pictures became colourful, gaudy and enormous, sometimes with a multi-layered narrative structure. They now included cartoon-style drawings as well as photos.

Since the late seventies Gilbert & George have moved into taboo areas, using swearwords, homosexuality and religion, sperm, urine, excrement and the excretory organs as their subjects, on an outsize scale. They believe that true art comes from three basic energy sources: the brain, the soul and sexuality. Their pictures are intended to be real – as real as life. They explained the principles of their art in the 1981 film *The World of Gilbert & George*.

Since the early sixties Gilbert & George have taken part in many group exhibitions, such as *documenta 5* (1972), *documenta 6* (1977) and *documenta 7* (1982). Large retrospectives of their work toured Europe in 1980–81 (Eindhoven, Düsseldorf, Bern, Paris, London) and the USA in 1984–85 (Baltimore, Houston, Milwaukee, Palm Beach, New York).
Gilbert & George live and work in London.　　K.O.

Gilbert & George 1968 to 1980, exh. cat., Eindhoven, Stedelijk Van Abbemuseum, 1980
Gilbert & George, ed. Brenda Richardson, exh. cat., Baltimore, The Baltimore Museum of Art, 1984
Gilbert & George. The Complete Pictures 1971–1985, exh. cat., Bordeaux, Musée d'art contemporain de Bordeaux, and tour, 1986
Wolf Jahn, *The Art of Gilbert & George*, London and New York, 1989

ROBERT GOBER

was born into a working-class Catholic family in Wallingford, Connecticut on 12 September 1954. Gober studied at the Tyler School of Art in Rome from 1973–1974 and completed his training in 1976 at Middlebury College in Vermont, where he studied art and literature.

After college Gober moved to New York and continued to paint, but had to earn a living by doing odd jobs as a carpenter. He produced wedged stretchers and plinths for sculptures, renovated old factory buildings and built dolls' houses. He went on international tours with Johanna Boyce's multi-media dance theatre.

Gober now also started to take an interest in sculpture himself and became interested in the ideas of Minimal Art, under the influence of Donald Judd, Carl Andre and Joel Shapiro. His first one-man show, *Slides of a Changing Painting*, in the Paula Cooper Gallery in 1984, consisted of a slide series that Gober had taken with a fixed camera while painting and overpainting a picture. In the same year he produced his first objects, the *Sinks*, which were imitation objects cast in plaster and painted with several coats of white gloss paint. Here the anonymous everyday object became a mysterious symbol of human communication, but, through a latent anthropomorphism, also acquired erotic connotations. Depending on the way in which they are installed, the *Sinks* create complex environments with a particular aura, which are thus open to personal interpretation.

These objects were still like anonymous readymades, and a series of urinals was still committed to this notion. However, subsequent objects were apparently autobiographical: copied furniture, children's beds, playpens from Gober's childhood, all full of references to his family history. Their subject is awareness of one's own existence, social situation and sexual identity. The bed becomes a symbol of feelings that are contradictory and yet relate to each other, of birth and death, love, illness, sleep, dreams and isolation. A closed door can trigger fear and fantasies. The armchair stands for paternal authority. These items are charged with the energy of memory, but their history is collective rather than individual. Gober translates these psychological energies into objects made with precision and craftsmanship.

Some of Gober's other motifs are more disturbing. They appear for the first time in a version of the *Dog-Bed* (1986–87): pillowcases, each with a sleeping white man and a hanged black man. The same motifs appear as a wallpaper pattern in an exhibition at the

Paula Cooper Gallery in 1989. Here castration and death confronted symbols of male sexuality, which were hinted at in *Sinks*.

In another sequence of work in 1989 Gober copied individual parts of the body, which were imitated in a spirit of hyperrealism and look deceptively genuine. They have real hair and clothing, for example a single male leg dressed in a sock and shoe, which seems to be thrusting out of a wall.

Gober's work is often disturbing. It may be situated within the tradition of the readymade, but also draws surrealistic elements into a broader context, with personal, sexual and sociological implications. Gober's new installations create a dream-like atmosphere full of threatening undertones, permeated with cultural unease. In the 1991 exhibition in the Jeu de Paume in Paris, for example, a room was papered with a repetitive forest motif. In the middle of this was a cigar the size of a human being, the quintessential symbol of patriarchal masculinity. Wax casts of male organs cropped up again in this oppressive atmosphere, adorned with the musical notes or candles that parody social norms for establishing male identity throughout Gober's œuvre.

Robert Gober lives and works in New York. H.D.

Robert Gober, exh. cat., Rotterdam, Museum Boijmans-van-Beuningen and Kunsthalle Bern, 1990
Robert Gober, Paris, Galerie Nationale du Jeu de Paume, 1991
Robert Gober, Madrid, Museo Nacional Centro de Arte Reina Sofía, 1992
Robert Gober, London, Tate Gallery, Liverpool and Serpentine Gallery, 1993
Robert Gober, Basel, Museum für Gegenwartskunst, 1995

JULIO GONZÁLEZ

was born on 21 September 1876 in Barcelona. He started work in his father's wrought iron studio in 1891 and shortly afterwards took drawing lessons at the Escuela des Bellas Artes in Barcelona. He was on friendly terms with Picasso and other artists, but he did not himself train formally as an artist. Throughout his life González remained a loner and autodidact.

In 1900 the family moved to Paris where he came into closer contact with Picasso, Max Jacob, Maurice Raynal and André Salmon, in the artists' circle of the Latin Quarter. Here González came to know and appreciate, above all, the works of Brancusi. The death of his brother Joan, in 1908, plunged him into a deep, spiritual crisis and from then on he led an extremely solitary life in Paris. Until 1927 his artistic works appeared rather sporadically, compared to his work as a wrought-iron craftsman in his father's factory. In addition to a few paintings and pastel drawings which imitated Picasso's 'Blue Period' in style, González also practised sculpture. In 1910 he produced a few heads in punched bronze whose melancholic expressions reflected his state of mind at that time. In 1918 González served an apprenticeship as a

welder and learnt the art of oxy-acetylene welding, which he later applied to his iron sculptures. From 1927 onwards he increased his sculptural work and created the series of *Masques découpés et natures mortes*, which were his first cut and welded sculptures. From 1928 to 1931 González worked with Picasso on making iron sculptures.

Part of González' artistic interest lay in the human form, which became increasingly stylised and abstract, but he was also interested in an examination of basic artistic principles, especially the relationship of plane and line to volume and mass. The character and charm of his sculptures lie in this tension between narrative, illustrative works, on the one hand and concrete, constructive ones, on the other. He endeavoured to 'draw into space and draw with new means' (González). Even in his early works, such as *Woman's Head I* (1930), the human form is reduced to elemental, basic geometric forms and structures, following Cubist and Constructivist procedures, and rearranged in an architectonic and rhythmic structure. His iron constructions are made up of pieces of scrap metal and pre-existing metal parts, welded together into filigree forms resembling stelae, in which the energetic interplay of solids and voids is at a considerable remove from the figurative idea which served as the point of departure.

The sculpture *Monsieur Cactus* (1939) provides a very clear illustration of González' concept of sculpture. Here, he joined together pieces of forged iron and iron scrap to create a stele-like body, whose formal language refers both to a natural model and to the physical properties of the material employed. The sculpture's meaning is to be found in the tension between the natural experience of reality and the surreal play of artistic elements – a fact which is amply confirmed by his choice of an ironic title.

González' late drawings and pictures were influenced by Cubism and correspond in structure to his sculptural work. González' masterpiece, *La Monserrat*, was completed in 1937 for the Spanish pavilion at the International Exhibition in Paris. Inspired by the drama of the Spanish Civil War, it presents a more compact, closed composition, in line with the classic

tradition in sculpture, without losing the truthfulness to the material which was an important quality of all his iron sculpture.

Although González established links with international groups of artists such as 'Cercle et Carré' and 'Abstraction-Création' (1930–32) and was represented in the *Cubism and Abstract Art* exhibition at the Museum of Modern Art in New York in 1936, his early death on 27 March 1942 deprived him of the chance to exhibit widely or achieve the recognition that he deserved, during his own lifetime. The influence of his work on the post-war development of sculpture and the opening up of new opportunities of expression, using previously ignored materials such as iron or scrap metal, is so extensive that today he stands in the front rank with Brancusi, Henri Laurens, Jacques Lipchitz and even Picasso. It was not until the exhibition of his work at the Museum of Modern Art in New York, in 1956, that González received posthumous international recognition, as the chief exponent of constructive Surrealism. H.D.

Josette Gilbert, *Catalogue raisonné des dessins de Julio González*, Paris, 1975
Josephine Withers, *Julio González: Sculpture in Iron*, New York, 1978
Julio González. A Retrospective, exh. cat., ed. Margit Rowell, New York, Solomon R. Guggenheim Museum, 1983
Julio González 1876–1942. Plastik, Zeichnungen, Kunstgewerbe, exh. cat., Berlin, Akademie der Künste and Frankfurt a.M., Städtische Galerie im Städel, 1983
Jörn Merkert, *Julio González. Catalogue raisonné des sculptures*, Milan, 1987
Julio González. Sculpture & Drawing, exh. cat., London, Whitechapel Art Gallery, Glasgow, Art Gallery & Museum and Sheffield, Graves Gallery, London, 1990

ARSHILE GORKY

was born Vosdanik Adoian on 15 April 1904, the son of an aristocratic family, in Khorkom, Armenia. His childhood was influenced by the Turkish persecution of the Armenians which resulted in the family fleeing to the Caucasus where, in 1919, his mother died of malnutrition and exhaustion. The following year Gorky emigrated to America. Relatives in Providence, Rhode Island, took him in initially, and between 1920 and 1922 he attended Providence Technical High School in Rhode Island and studied at the Rhode Island School of Design. In 1922–24 he continued his studies at the New School of Design in Boston, where for a time he also taught drawing from the nude.

On moving to New York in 1925 Gorky came into contact with the young artists' scene and colleagues such as John Graham, Stuart Davis and Willem de Kooning. Between 1925 and 1931 he studied drawing from the nude and from plaster casts of classical sculpture at the Grand Central School of Art. At the time Gorky's own pictures were influenced by mod-

ern masters such as Cézanne and Picasso. It was only with difficulty that he found his own style – since he was still deeply affected by the 'culture shock' of his having to adapt to urban America and too caught up in memories of his Armenian homeland. In 1932, still in search of a new identity, he adopted the pseudonym Arshile Gorky. In addition to the problems of asssimilation, he faced constant financial difficulties – especially in the thirties, when he sold very little work. However, he found employment as a mural painter in the Federal Art Project of the Works Progress Administration (WPA/FAP), which provided support for many young artists in the New York avant-garde, and gradually began to acquire a name for himself in artistic circles. In 1934 Gorky held his first solo exhibition at the Mellon Galleries in Philadelphia, and in 1937 the Whitney Museum of American Art acquired one of his paintings. In the same year Gorky's mural *Conquest of the Air* (now destroyed) was unveiled in Newark Airport, in New Jersey. In 1939 he was commissioned to paint a mural for the World Fair in New York.

Gorky's encounter with Matta in 1941, who advised him to thin his paints with plenty of turpentine so that he would be freer to improvise, contributed to a radical change in his style. However, the way to this new beginning had been prepared over a long period by his knowledge of and admiration for the works of Wassily Kandinsky and Joan Miró. In the following years it was not only Gorky's hitherto eclectic, modernist style that changed, but also his rate of production. In summer 1946 alone he produced over 290 drawings. With the numerous oil paintings, drawings and pastel drawings he produced in the last years of his life, Gorky really broke new ground. Virtually no other painter in this period made such effective use of the Surrealists' discoveries as he, in translating them into a biomorphic, associative style of painting which was unmistakably his own. He would lay down coloured biomorphic shapes on a thinly coated luminous ground, in such a way that they interacted with a fine web of black lines to create the image of a heaving world of organic forms. André Breton discovered a kindred poetic spirit in

Gorky and included him as the last artist in the Surrealist group; in Gorky's work he found a 'natural spectacle and an undercurrent of childhood and other memories'. This was most in evidence in Gorky's numerous semi-automatic drawings, which transformed the landscape, and also a very personal symbolism, into an abstract language of signs.

Most of the time Gorky elaborated the detail of his large compositions from previously prepared drawings. From an abundance of freely invented forms he selected the most impressive, arranged them in a dense composition and complemented them with rich nuances of colour and graphic symbols. Gorky's last paintings are very autobiographical in their inner turmoil, gloomy colours and aggressive symbolism. A number of strokes of fate had numbed his creativity. In 1946 a large number of his paintings were destroyed in a studio fire. He underwent an operation for cancer in the same year and the breakdown of his marriage hit a vital nerve. In June 1948 Gorky was so badly injured following a car accident that he could no longer paint. A few weeks later, on 21 July, he took his own life in his studio in Sherman. The Whitney Museum of American Art in New York held a commemorative exhibition in 1951. H.D.

Harold Rosenberg, *Arshile Gorky: The Man, The Time, The Idea*, New York, 1962

Arshile Gorky 1904–1948. A Retrospective, ed. Diane Waldman, exh. cat., New York, Solomon R. Guggenheim Museum, 1981

Jim M. Jordan and Robert Goldwater, *The Paintings of Arshile Gorky. A Critical Catalogue*, New York, 1982

Melvin P. Lader, *Arshile Gorky*, New York, 1985

Arshile Gorky 1904–1948, London, Whitechapel Art Gallery, 1990

Arshile Gorky. The Breakthrough Years, ed. Karen Lee Spaulding, exh. cat., Fort Worth, Modern Art Museum and Buffalo, Albright-Knox Gallery, New York, 1995

GEORGE GROSZ

was born Georg Ehrenfried Gross on 26 July 1893 in Berlin, where his parents ran a public house. In 1898 the family moved to Stolp, in Pomerania. Gross' secondary schooling in Stolp was interrupted when he was expelled for retaliating in kind, when one of the masters boxed his ears. Between 1909 and 1912 he lived in Dresden, where he attended the Academy of Arts. In 1912 he studied under Emil Orlik at the School of Arts and Crafts in Berlin and in 1913 in Colarossi's studio in Paris. Gross volunteered for war service in 1914, but was discharged in May 1915, following an operation for sinusitis.

Back in Berlin, Gross became acquainted with the Herzfeld brothers; like Helmut Herzfeld, who had changed his name to John Heartfield, he anglicised his name to George Grosz in protest against the nationalistic, anti-English campaign. Grosz was called up again in January 1917. After assaulting a sergeant he was sent to a hospital for shell-shocked soldiers and in May 1917 discharged as 'permanently

unfit for military service'. In the same year his first portfolio of prints appeared in the Malik-Verlag, the publishing house belonging to Wieland Herzfelde. In these prints and in the oil painting *Widmung an Oskar Panizza* (Dedication to Oskar Panizza, 1917–1918) and *Deutschland, ein Wintermärchen* (Germany, A Winter's Tale, 1917–19, whereabouts unknown), he combined a dynamic painting structure, borrowed from Futurism, with a satirical, accusatory and revealing objectivity. From 1916 it was the tumultuous city which Grosz portrayed with expressionist intensity. The ordinary criminality of everyday life seemed to him both a reflection and a continuation of the murderous war.

The Berlin offshoot of the Dadaist movement, initiated by Richard Huelsenbeck, gave Grosz the outlet that he needed for venting his hatred of bourgeois society. In 1919 Grosz was a key contributor to a number of satirical journals, *Die Pleite, Jedermann sein eigner Fußball, Der blutige Ernst* (Bankruptcy, To Each his own Football, Bloody Serious), in which he, in collaboration with John Heartfield, employed collage and photomontage as means of ruthless political agitation. In 1921 the Malik-Verlag published a collection of drawings entitled *Das Gesicht der herrschender Klasse* (The Face of the Ruling Class), which were an open attack on bourgeois conformism and militarism in Weimar Germany. Grosz also worked regularly for the communist satirical journal *Der Knüppel* (The Cudgel) until 1927, and from 1924 to 1933 he worked for the literary paper *Der Querschnitt* (The Cross-section).

From 1920 onwards suggestions of 'Pittura Metafisica' began to appear in his works and these led to his developing in the mid-twenties a sober, representational technique. He made paintings of uniform streets along which strolled human automata, jointed dolls and men with artificial limbs. These figures were often given numbers, as if to emphasise the soulless egalitarianism of capitalist society. Some of the best and most well-known works by Grosz are in the *Ecce Homo* suite published by the Malik-Verlag in 1923. In these sixteen watercolours and eighty-four lithographs Grosz displayed a panopticon of tumultuous city life, from the petits-bourgeois and prosti-

tutes to the militaristic dunderheads and nationalistic fanatics, with the aim of presenting a didactic, accusatory panorama of the moral degeneracy of society. In these years art, for Grosz, was first and foremost a weapon which could be deployed politically, in the fight against the injustices and spiritual depravity of society.

In his portfolio *Der Spiesser-Spiegel* (The Mirror of the Bourgeoisie) of 1925, Grosz turned his attention to the new smart set of Weimar society, whom he also depicted in a number of penetrating socio-psychological portrait studies, such as the famous *Portrait of the Writer Max Herrmann-Neisse* of 1925. Other portraits from this period appear softer and more relaxed, and lack the pointed emphasis and politically revealing expression of earlier works. Towards the end of the twenties Grosz' work became still further removed from Neue Sachlichkeit in its striving for a new, lyrical ideal.

Grosz had become the focus of public hostility as a result of various trials for 'blasphemy' and was, therefore, glad to accept the offer of a visiting professorship from the Art Students League, in New York. He emigrated to the USA in 1933 and took out American citizenship in 1938. Grosz' later works lack the biting ferocity of his attacks on twenties society, which had made him one of the greatest satirists in German art. Towards the end of his life, he devoted himself increasingly to landscape painting and to reaching a critical understanding of his past.

Grosz died on 6 July 1959, soon after returning to Berlin. H.D.

Alexander Dückers, *George Grosz. Das druckgraphische Werk,* Frankfurt a. M., Berlin and Vienna, 1975; rev. ed., San Francisco, 1996

Hans Hess, *George Grosz,* London, 1974; New Haven, 1985

Uwe M. Schneede, *George Grosz. Der Künstler in seiner Gesellschaft,* Cologne, 1975

George Grosz. Seine Kunst and seine Zeit, Leben und Werk, ed. Uwe M. Schneede, exh. cat., Hamburg, Kunstverein, Stuttgart, 1975

George Grosz. Berlin–New York, ed. Peter-Klaus Schuster, exh. cat., Berlin, Neue Nationalgalerie and Stuttgart, Staatsgalerie, 1995

RAOUL HAUSMANN

was born on 12 July 1886 in Vienna. He received his first painting lessons from his father, who was a painter of portraits and historical scenes. In 1900 the family moved to Berlin.

In Erich Heckel's studio in Berlin he created his first expressionist lithographs and woodcuts. His acquaintance with artists from 'Die Brücke' (The Bridge), as well as with work shown in exhibitions of 'Der Blaue Reiter' (The Blue Rider) and the Futurists in Herwarth Walden's 'Der Sturm' gallery led Hausmann to reject academic conceptions of art. His first polemical art criticism appeared in Walden's periodical *Der Sturm,* in 1912. He started publishing in Franz Pfemfert's periodical *Die Aktion* in 1917. Haus-

mann was to become the co-founder and most enthusiastic protagonist of the Dada movement in Berlin, as a result of attending the 'First Dada Speech in Germany' by Richard Huelsenbeck, a member of the Dada group in Zürich. He caused an uproar during the first Dada soirée held in the Berlin Secession in April, with his talk on 'The new Materials in Painting'. In 1919 the first Berlin Dada exhibition was held in I. B. Neumann's Graphics Gallery. In the same year Hausmann and Johannes Baader founded the journal *Der Dada,* which mimicked the Zürich Dada publications in its unruly typography. In contrast to the rather anarchistic and fanciful Zürich Dadaists, the Berlin Dadaists, who included Johannes Baader, George Grosz and John Heartfield in addition to Hausmann, held strong left-wing views, which they disseminated in a host of pamphlets, appeals and posters.

In this period Hausmann principally employed the technique of photomontage. He adopted this around 1918, but it was also used in virtuoso manner by Hannah Höch – his companion from 1915 to 1922 – and by Baader, Grosz, Heartfield and Paul Citroën. In what is certainly his most famous work, the composition *Mechanical Head. The Spirit of our Time.* of 1920, Hausmann conveys the principle of montage in three dimensions: this strange apparition composed of a wooden head surmounted by a wig and furnished with a variety of workaday attributes, such as measuring tapes, a ruler, a number plate and a purse, represented, for Hausmann, the tedium and insipidity to which mankind had been reduced by mechanisation and the loss of individuality. Hausmann's photomontages were shown in Dr Otto Burchard's art gallery at the *First International Dada Fair* in 1920, together with works by other Berlin Dadaists, including the bitingly satirical, accusatory paintings of Grosz, as well as works by Picabia, Max Ernst and Hans Arp. This marked the climax to the Berlin Dada movement and its end.

At the beginning of the twenties Hausmann was in contact with the most varied factions of the contemporary avant-garde, from the Cologne artists' group 'The Progressives' to the international Constructivist movement; he also published his work in Franz Jung's periodical *Der Gegner* (The Adversary), in Kurz Schwitters' *Merz,* in Hans Richter's *G,* in Theo van Doesburg's *De Stijl* (including a 1921 'Appeal for Elemental Art' with Hans Arp, Ivan Puni and László Moholy-Nagy) and in the Hungarian *MA* periodical (including a joint contribution with the experimental film director Viking Eggeling, in 1923).

Through his acquaintance with Doesburg, Moholy-Nagy and Eggeling, Hausmann became interested in new areas which expanded the anarchist and political approach of the 'Dadasophs' into plans for a complete synthesis of tone and light, to be known as 'optophonetics'. His 'optophone', a device for 'combining a number of different elements', was rejected by the Berlin Patent Office in 1927, but officially accepted by the London Patent Office in 1936. In parallel to this, Hausmann experimented with photography and devoted himself especially to the composition of sound poems, in typographic transcription.

In 1933 Hausmann left National Socialist Germany and went to Ibiza. There he continued to work with photography and pursued ethnological and architectonic studies. However, in 1936 he had to flee the Spanish fascists, escaping to Paris via Zürich and Prague; from 1939 to 1944 he lives in Peyrat-le-Château. In 1944 Hausmann moved back to Limoges in southern France and took up painting again, alongside his work with photography and poetry. Between 1959 and 1964, he painted a number of impulsive paintings in a spontaneous style borrowed from automatism in addition to visionary and fantastic watercolours in the manner of Wols' hallucinatory pictures.

In 1969 Hausmann's novel *Hyle – Ein Traumsein in Spanien* (Hyle – A Dream Existence in Spain) appeared. He had started this on Sylt in 1926 and taken it up again in Limoges in 1947–1956. One year before his death on 1 February 1971 he completed the manuscript of his retrospective view of Berlin Dadaism: *Am Anfang war Dada.* H.D.

Raoul Hausmann, *Am Anfang war Dada,* ed. Karl Riha und Günter Kämpf, Gießen, 1972, 3nd ed., 1992

Raoul Hausmann, Texte bis 1933, 2nd vol., ed. Michael Erlhoff, Munich, 1982

Michael Erloff, *Raoul Hausmann, Dadasoph,* Hanover, 1982

Der deutsche Spießer ärgert sich. Raoul Hausmann 1886–1971, exh. cat., Berlin, Berlinische Gallerie, 1994

Adelheid Koch, *Ich bin immerhin der größte Experimentator Österreichs. Raoul Hausmann, Dada und Neodada,* Innsbruck, 1994

Fort mit allen Stühlen. Raoul Hausmann in Berlin 1900–1933, ed. Eva Zürchner, 1996

EVA HESSE

was born of Jewish parents in Hamburg on 11 January 1936. In summer 1939 her family fled from the Nazis to New York, via Amsterdam and London. In 1945 Hesse became an American citizen. She graduated from the High School of Industrial Arts in 1952 and then studied commercial art for a year at the Pratt Institute of Design. In 1953 she attended drawing classes at the Art Students League and continued her studies at the Cooper Union School in 1954–1957. From 1957 to 1959 she studied at the Yale School of Art and Architecture and attended classes given by Josef Albers. After obtaining her BFA there in 1959 she moved back to New York.

Hesse's early work, comprising paintings and drawings, inclined towards Abstract Expressionism. In 1960 she met Sol LeWitt, who was to become one of her closest friends and have a lasting influence on her work. She exhibited some gestural line drawings at the exhibition *Drawings: Three Young Americans* at the John Heller Gallery in New York, in 1961. Her first sculptural work dates from 1962, when she was staying in Woodstock. In 1963 she had her first one-woman show at the Allan Stone Gallery in New York, where she exhibited drawings and collages. Sponsored by the German collector and textile maker Arnhard Scheidt, Hesse and her husband, the sculptor Tom Doyle, received a grant to work in Kettwig an der Ruhr near Essen in 1964/65, where she began to create informel sculptures which were shown at the Düsseldorf Kunsthalle, in 1965. In mural relief works such as *Ringaround Arosie* (1965), for which electric cable provided one of the materials. Hesse first transposed the drawn line to the third dimension. She now began to concentrate on reliefs and fully three-dimensional works, which combined the painterly aspect with a wide variety of haptic qualities.

On her return to New York Hesse turned her back entirely on painting. She created hanging objects, formally related to the 'soft sculptures' of Claes Oldenburg, whom she had met in 1959, but with explicitly anthropomorphic and often sexual connotations. Her contacts with Richard Serra, Robert Morris and Rob-

ert Smithson familiarised Hesse with the ideas of Minimalist sculpture. She adopted some of the formal methods of Minimal Art, such as serialism and the rejection of illusionist representation, while herself pursuing a kind of 'expressive' style reminiscent of the apparently chaotic pictorial structures of Jackson Pollock. Hesse liked bringing out the sensual quality of materials and at the same time creating an indissoluble link between form, technique, material and content. In 1966 she took part in the *Eccentric Abstraction* exhibition organised by Lucy Lippard at the Fischbach Gallery in New York, which, in the wake of Pop Art and Minimal Art, first gave prominence to a new 'anti-formalist' concept of art, focussing on process and materials.

Hesse quickly acquired a reputation for works she created from the mid–1960s from synthetic resin, textiles and fibreglass, whose extension into space was based on the new concept of sculpture. From 1968 onwards she used translucent fibreglass and replaced colour with light. In 1968 she had a one-woman show of her fibreglass sculptures at the Fischbach Gallery in New York. That same year she began to teach at the School of Visual Arts and took part in the *Antiform* exhibition. In 1969 she exhibited alongside Bruce Nauman, Richard Serra, Keith Sonnier and others in *Anti-Illusion: Procedures/Materials* at the Whitney Museum, a programmatic exhibition reflecting the new approach to materials in sculpture.

Hesse's work is of fundamental importance to the development of the post-Minimalist, process-oriented aesthetic in the USA. Her art focusses on the measure and sensory quality of the human body and combines rational structure with irrational mutation. Using a variety of materials such as latex, textiles and fibreglass, she creates combinations of hard and soft, geometric and organic elements that convey a sense of pathos linked to a hint of irony and absurdity.

In 1969 Harald Szeemann showed Hesse's work in his exhibition *When Attitudes Become Form* at the Kunsthalle in Berne. Hesse did not live to experience the international acclaim she received, as when her work was shown at *documenta 5* in Kassel in 1972. She died of a brain tumour on 29 May 1970, at the age of 34. H.D.

Eva Hesse: A Memorial Exhibition, exh. cat., New York, Solomon R. Guggenheim Museum, 1972
Lucy Lippard, *Eva Hesse*, New York, 1976
Eva Hesse. Skulpturen und Zeichnungen, exh. cat., Hanover, Kestner Gesellschaft, 1979; Engl., London, 1979
Bill Barrette, *Eva Hesse. Sculpture. Catalogue raisonné*, New York, 1989
Eva Hesse: A Retrospective, ed. Helen A. Cooper, exh. cat., New Haven, Connecticut, Yale University Art Gallery, 1992

GARY HILL

was born on 4 April 1951 in Santa Monica, California. From 1969 he studied sculpture at the Art Students' League in Woodstock, New York. His first figurative works, made of wire-netting, reveal the influence of Picasso's and Giacometti's sculpture. These complicated meshed constructions, with their allusions to the human figure, were followed by abstract, biomorphic forms and, finally, some geometric works, which Hill showed in his first solo exhibition at the Polaris Gallery in Woodstock.

Hill began working with audiovisual media in the early seventies. In 1973 he started experimenting with a video camera, which he initially turned on himself, as a means of establishing a dialogue both with the technical means at his disposal and with himself, as the person who was at once 'seer' and 'seen'. There followed a series of sound sculptures, using both recorded sound and electronically generated noises. From 1974 to 1976 Hill worked as a coordinator in the Woodstock Community Video's TV laboratory, where he familiarised himself with the wider possibilities of this new medium. Hill's first video tapes, *The Fall* (1973) and *Air Raid* (1974), deal with ecological issues and employ a montage technique to combine sound and image.

Hill's first video installation, *Hole in the Wall* (1974), in which the video reveals the process involved in setting up the installation, marks the beginning of his conceptually orientated work. During his period as artist in residence at the Experimental Television Center in Binghampton, in New York (1975–77), Hill started a collaboration with the electronics designer, Dave Jones, and developed special equipment to cope with the increasing complexity and technical demands of his installations. Hill's encounter with the poet, George Quasha, in 1976, had a decisive influence on the way in which he now restructured his work and adopted a new approach to his subject-matter. Language, whose components Hill had separated out into speech, sound, writing and the (written) image, became both the material and the content of his films and installations. Texts by Ludwig Witt-

genstein, Gregory Bateson, Maurice Blanchot and Lewis Carroll were the sources for the montages of quotations which he used, in combination with visual information, to target the viewer's different levels of perception and reflexive response. In 1984–85 Hill went to Japan, within the framework of a Japanese–American cultural exchange programme. There he produced *URA ARU (the backside exists)*, a video which deals with the 'backside' of language and its transformation, through reversal, inversion and punning. The installation, *Red Technology* (1986–94), which makes use of Martin Heidegger's text, 'Enquiry into Technique', takes the physical quality of language as its main theme. The electronically controlled volume, the rapid and monotonous sound of the reader's voice and the flickering image of the text on the screen have a much more immediate impact on the viewer or listener than if they had been communicating something written or spoken, in a straightforward way.

The second, central theme in Hill's work is the human body, which may appear to be dismembered, when the focus concentrates on isolated segments, spread across a number of screens, as in *Inasmuch As It Is Always Already Taking Place* (1990), or transposed into visual structures, as in the rhythmic sequence of images in *Circular Breathing* (1994). Hill had already shown his video *Primarily Speaking* (1981–83) at *documenta 8* in 1987; and in 1992 he showed his video installation, *Tall Ships*, at *documenta IX*. The latter work involves the active participation of the viewer, who passes down a narrow, blacked-out corridor-like space and is confronted with a series of individuals of both sexes and of different ages, who seem to materialise out of the wall, on either side. In moving along this corridor the viewer triggers off an electronic signal, which causes these figures to approach out of the screen onto which they are projected and vanish again into the background.

Hill's first solo exhibition of video installations was held at the Galerie des Archives, in Paris, and was followed by important shows at institutions such as the Museum of Modern Art, in New York (1990), the Watari Museum of Contemporary Art, Tokyo (1992), and the Museum für Gegenwartskunst in Basel (1994). Hill is a guest lecturer at the Center for Media, State University of New York, Buffalo, and at Bard College, Annandale-on-Hudson, New York.

Since 1985 Gary Hill has lived mainly in Seattle. He teaches at the Cornish College of the Arts. C.T.

Gary Hill. And Sat Down Beside Her, exh. cat., Paris, Galerie des Archives, 1990

Stephen Sarrazin, Gary Hill, Belfort, Centre International de Création Vidéo Montbéliard, 1992

Gary Hill, Paris, Musée National d'Art Moderne, Centre Georges Pompidou, 1992

Gary Hill, exh. cat., Amsterdam, Stedelijk Museum, 1993

Gary Hill. Arbeit am Video, ed. Theodora Fischer, Basel, 1994

DAVID HOCKNEY

was born on 9 July 1937 in Bradford, Yorkshire. From 1953 to 1957 he attended Bradford College of Art. He did casual work in several hospitals before beginning his studies at the Royal College of Art in London in 1959. Among his fellow students was R. B. Kitaj, who has had a lasting influence on Hockney's work. In 1960 he visited the large Picasso exhibition at the Tate Gallery in London, since which time Picasso's work has continued to hold a strong fascination for him. In his early pictures Hockney drew quite openly on current artistic styles such as Abstract Expressionism, the painting of Dubuffet, Art Brut and anonymous graffiti. Hockney's paintings of the sixties resemble an open diary, in which the artist gave free expression to his desires, longings and dreams. During this time Hockney also depicted subjects from poems by Whitman, Auden, Blake and Cavafy or from works by the old masters, whose stylistic features or allusive motifs he incorporated into his own pictures.

Hockney soon acquired an outstanding reputation as an artist and received an award on completion of his studies at the Royal College of Art. He accepted the label 'pop artist' without demur and never troubled to enquire whether he belonged to a particular style or school. In 1963 he accepted a commission from the *Sunday Times* to travel to Egypt, to collect material for a series of illustrations. In the same year in Los Angeles he met Henry Geldzahler, the curator of twentieth-century art at the Metropolitan Museum of Art in New York, who later became a friend and promoter of his art. He soon moved to California, where he has lived ever since, with the exception of a number of years spent in London and Paris, between 1968 and 1975. Over the years Hockney has accepted teaching posts at a variety of American universities: Iowa City (1963–64), Boulder, Colorado (1965–66), Los Angeles and Berkeley (1966–67).

The Californian light, the size of the country and the specific lifestyle influenced Hockney and inspired him to develop new themes such as the *Shower Pictures* (1963), in which mostly autobiographical subjects are depicted in clear colours and forms, within a straightforward compositional framework. He takes snaps of his subjects with a Polaroid camera or makes rapid drawings, which he then works up into paintings with broad areas of bright colour, in the acrylic paints that he has used since 1964. Snapshots in the shower were followed by *Swimming Pool* pictures – calm, almost static shots with a hedonistic atmosphere, in which only the ornamental water shows movement and dancing light. Swimming or looking on from the edge are his friends, collectors and promoters, who are also portrayed in spacious apartments or sparsely furnished rooms, to which Hockney began to develop a curious kind of attachment.

From 1974 onwards, Hockney has done an increasing amount of stage designs, as a sequel to his earlier work for the theatre, when he designed the sets for Alfred Jarry's *Ubu Roi* at the Royal Court Theatre in London, in 1966. In 1975 he created the sets for *The Rake's Progress* by Stravinsky, and in 1978 the décor and costumes for *The Magic Flute* at Glyndebourne; in 1981 he worked at the Metropolitan Opera, New York, on *Parade, The Rite of Spring, The Nightingale* and *Oedipus Rex* by Stravinsky; and in 1983 for *Paid On Both Sides* by W. H. Auden at the Eye and Ear Theatre, New York. In more recent experiments, such as the production of *Tristan und Isolde* at the Los Angeles Music Center Opera, and the set he produced in 1992 for *Die Frau ohne Schatten* (The Woman Without a Shadow) by Richard Strauss at the Royal Opera House in London, Hockney gave clear evidence of his leanings towards a Wagnerian conception of the Gesamtkunstwerk.

At the end of the seventies Hockney started making photo-collages of countless Polaroid photographs taken from different angles, as a means of achieving an intensified visual awareness. Hockney's admiration for Cubism, especially Picasso and his late work, is evident from these often gigantic photographic compositions. In his more recent works, a heightened experience of space – Cubist simultaneity, combined with chronophotography – is rendered in glistening, garish Californian colours. Besides painting, since the end of the eighties Hockney has increasingly devoted himself to new media, producing four-colour copy prints and abstract computer graphics.

Hockney, who was appointed a member of the Royal Academy in 1991, has lived in Los Angeles since 1979. H.D.

David Hockney by David Hockney, ed. Nikos Stangos, London, 1976

Marco Livingstone, *David Hockney*, London and New York, 1981, 1988[2]

Lawrence Weschler, *Cameraworks: David Hockney*, London and New York, 1984

David Hockney. A Retrospective, ed. Maurice Tuchman and Stephanie Barron, exh. cat., Los Angeles, County Museum of Art, New York, Metropolitan Museum of Art and London, Tate Gallery, 1988

Peter Webb, *A Portrait of David Hockney*, New York, 1988

JENNY HOLZER

was born on 29 July 1950 in Gallipolis, Ohio. She grew up in Lancaster near Columbus and took an interest in art at an early stage. She studied at the Duke University in North Carolina from 1968 – 1970, and from 1970–1971 at the University of Chicago. In 1972 she was awarded her B.F.A. at the Ohio University in Athens and in 1977 her M.F.A. at the Rhode Island School of Design in Providence, where she did a great deal of work on Marcel Duchamp.

In 1977 Holzer moved to New York and took part in the Whitney Museum's Independent Study Program. She wanted to adopt concrete themes that were relevant to life, and so abandoned abstract painting and started to take an interest in public projects. She experimented with diagrammatic drawings and headlines and finally reduced her vocabulary to pure linguistic communication. From 1977 she distributed her *Truisms* on anonymously posted placards around the district in which she lived (SoHo). Holzer, who worked as a typesetter from 1979 to 1982, intended these sayings to demonstrate the diversity and contradictory quality of opinions: 'Humanism is obsolete' or 'Fathers often use too much force'. Holzer put them on posters, T-shirts, parking meters or in telephone boxes at first, but from 1982 she ran her *Truisms* on the large electronic advertisement panel in Times Square. She took part in *documenta 7* in Kassel in the same year.

Language is Holzer's artistic starting-point and also her principal medium, but she does not use it to convey concepts, or for analysis within the medium of art. Her sentences are usually simple and readily understood. They reach a broad public by means of various media - hoardings, television spots, bronze tablets on houses, granite benches in parks, results boards in stadia or, in most cases, using electronic displays (LEDs). She produces apparently affirmative or imperative statements or judgements, or explanations of basic everyday questions or of trivial or cruel social and political events. Her subjects include justice, love, war and sexuality, and constant repetition makes a sarcastic, mocking or simply disturbing effect.

The artist has spoken as follows about her work, which has been criticised as a "product of the television age and of the world of advertising and hoardings": "Individual statements may look simple, but the sequence of statements is not, just as little as the way in which the individual sentences play themselves off against each other."

Other series appeared after the *Truisms:* the *Essays* (1979–1982), posters each containing a hundred words; the *Living Series* (1980–1982), bronze tablets and enamel plates, with Peter Nadin; the *Survival Series* (1983–1985), announcements, some of which were conveyed on electronic screens over three metres high; *Under a Rock* (1986–1987), an installation made of stone benches, and *Laments* (1987–1989), cruel messages about death on sarcophaguses and column-like light diodes, which were shown at *documenta 8* in Kassel, among other venues.

The theme of death and violence reached a climax in 1993 in a contribution for the *Süddeutsche Zeitung,* in which Holzer pilloried violence against women in the Yugoslavian war, under the title *Lustmord* (Sex Murder): the title page contained a line printed in real blood 'Where women are dying I am wide awake'. Inside Holzer's accusation is illustrated with photographs of women's bodies on which the thoughts of both the victims and those responsible are tattooed – an action that attracted criticism for superficial sensation-seeking.

In 1986–1989 the Des Moines Art Center in Iowa organised a touring exhibition for Holzer, and in 1989 the Dia Art Foundation in New York showed her *Events*. At a one-woman show in the Guggenheim Museum in New York in 1989/1990 a large electronic band of writing 16 metres long ran through the centre of the museum. In 1990 Holzer was the first American woman to win the Golden Lion at the Venice Biennale.

Jenny Holzer has lived on a farm in Hoosick Falls, New York since 1985. H.D.

Jenny Holzer, exh. cat., Basel, Kunsthalle, 1984
Jenny Holzer: Signs, exh. cat., London, Institute of Contemporary Arts, 1988
Diane Waldman, *Jenny Holzer,* exh. cat., New York, Solomon R. Guggenheim Museum, 1989
Jenny Holzer: The Venice Installation, Buffalo, Albright-Knox Art Gallery, 1991
Michael Auping, *Jenny Holzer*, New York, 1992
Jenny Holzer. Writing – Schriften, ed. Noemi Smolik, Stuttgart 1996

EDWARD HOPPER

was born in Nyack, New York, on 22 July 1882. By the age of ten he began to sign and date his drawings. In 1899 he began a course in commercial art at the Correspondence School of Illustrating and in 1900 switched to the New York School of Art, where he continued to study graphic design and illustration and then painting under William Merritt Chase, Kenneth Hayes Miller and Robert Henri. Henri, the leader of the new Realist movement in art in the

USA, and the artists of the so-called 'Ash Can School', who found their often banal and 'ugly' motifs in the urban life of New York, inspired Hopper's early work although Hopper did not join them. After finishing his studies he worked in New York as an illustrator and commercial artist.

In 1906 Hopper went to Paris, where he painted brightly coloured townscapes which reflect the influence of Impressionism. In 1907 he left for London, Amsterdam, Berlin and Brussels. In both 1909 and 1910 he returned to Paris for fairly extended stays to study the old masters in the museums and to paint streets, bridges and houses in the open air. In 1910 he settled permanently in New York where he again worked as a commercial artist and illustrator. Paris and its life-style left a lasting impression on him; as late as 1914 Hopper painted a picture in the style of Degas and Manet entitled *Soir bleu* (Blue evening), in memory of summer evenings in a Paris street café. At the legendary *Armory Show* of 1913 Hopper managed to sell his first painting; but even his first one-man exhibition in the Whitney Studio Club in 1920 did not produce the breakthrough he had hoped for. Until 1924 he only painted in his free time and devoted most of his time to printmaking. Inspired by the work of Rembrandt, Goya, Méryon, Degas and his compatriot John Sloan, he mastered the technique of etching. His widely exhibited and much praised prints were preparations for the subjects and composition of his later oil paintings. In 1923 Hopper turned to watercolours. A successful exhibition of his watercolours in the Frank K. M. Rehn Gallery in New York in 1924 encouraged him to devote himself full-time to painting from then on.

Hopper painted only American subjects, boats in the wind, coastal landscapes, isolated houses, empty streets, lonely people in rooms, hallways and offices, passing through hotels and motels, yet he never became part of the complacent 'American scene' of the American regionalists. Even though Hopper's paintings are typically 'American' in their motifs, he is more concerned with the basic psychological make-up of people. He could only show the conditio humana in terms of his own time and environment:

his paintings are primarily statements about loneliness, alienation and disillusion. One of the first and most famous of Hopper's works, which was acquired by the newly founded Museum of Modern Art in New York, was *House by the Railroad* of 1925, a prime example of American architectural eclecticism of the 1920s, which Hopper recorded in his paintings. A typical feature of Hopper's paintings is his treatment of light, which he does not translate into impressionist dots but into large, contrasting areas of plastically modelled light and shade, accentuated by clear luminous colours. Besides the sun-drenched landscapes and rooms inspired by his summer house in Cape Cod, Massachusetts, artificial light also plays a key role in his compositions. A vivid example of this is possibly his most famous painting, *Nighthawks*, which dates from 1942.

His distanced approach to his motifs, his cool pragmatism, the film-like quality of his paintings, made Hopper a cult figure of contemporary American art and also influenced the photo-realists and American Pop artists in the 1960s. In his late works the composition becomes increasingly simple and details are omitted. His entire attention now focussed on the play of light and shade and its abstract structures. The first major retrospective of Hopper's work was held in the New York Museum of Modern Art in 1933, where his painting was described as unbiased, distanced and totally free of sentiment. In 1950 and 1964 the Whitney Museum of American Art in New York held further, major retrospectives. Hopper died in New York on 15 May 1967. H.D.

Lloyd Goodrich, *Edward Hopper*, New York, 1971, 1981[3]
Edward Hopper: The Art and the Artist, ed. Gail Levin, New York, Whitney Museum of American Art, 1980
Heinz Liesbrock, *Edward Hopper. Das Sichtbare und das Unsichtbare*, Stuttgart, 1992
Die Wahrheit des Sichtbaren. Edward Hopper und die Fotografie, ed. Georg-W. Költzsch, exh. cat., Essen, Museum Folkwang, 1992
Deborah Lyons and Adam D. Weinberg, *Edward Hopper and the American Imagination*, New York, 1995

JASPER JOHNS

was born in Augusta, Georgia, on 15 May 1930. After studying art at the University of South Carolina from 1947 to 1948, Johns moved to New York and trained as a commercial artist. Between 1951 and 1952 he did his national service in Japan. On returning to New York in 1952, he gave up his studies at Hunter College after only two days and began earning his living with casual jobs in the book trade and as a window-dresser in department stores.

In 1954 Johns met Robert Rauschenberg, with whom he designed window displays, for Tiffany's among other places. As a close friend Rauschenberg soon became a strong influence on his work. That year Johns made material constructions but these were

destroyed almost immediately. In the mid-fifties he produced the first *Flag, Target* and *Number* pictures, shown in his first one-man exhibition at the Castelli Gallery in New York, in 1958. In these influential pictures the subjects (the American flag, targets and numbers) were taken from the two-dimensional world of symbols. The subject was inseparable from the artistic medium. In *Flag*, for instance, the two-dimensional flag motif covered the whole surface of the picture, making it difficult to distinguish between figure and ground. Object and image were interrelated. This interweaving of ambiguous 'facts' provoked reflection on identity and the meaning of representation and reality. Johns' famous question 'Is it a flag or a painting?' must therefore remain unanswered.

The ancient technique of encaustic (wax painting) on newspaper collages gave the commonplace subjects a rich, sensual texture and a particular character. In his choice of subjects Johns also reflected the ambiguity of symbols in the consumer society, which were in danger of losing their symbolic function by being routinely reproduced in the mass media. Since the late fifties Johns has also worked on sculptures, such as *Painted Bronze* (1960), two beer cans cast in bronze and then painted. Here again he was using everyday objects which conveyed an artistic message by being transposed to another material and thus deprived of their inherent function.

In the sixties Johns experimented with assemblages, real objects or casts of body parts integrated into panel paintings, with the medium handled in an abstract expressive style, sometimes incorporating figures or letters. At the same time these works were artistic puzzles inspired by his interest in Ludwig Wittgenstein's philosophy and Marcel Duchamp's work and reflections on modern art.

From 1967 to 1968 Johns was artistic adviser to the Merce Cunningham Dance Company and worked for John Cage, a friend since 1955. He designed numerous stage sets and costumes for Cunningham's productions and performances, including the decor for *Walkaround Time* in Buffalo in 1968, inspired by Duchamp's *Large Glass*.

In the late sixties and early seventies schematic elements such as tile patterns and ormanental cross-hatching were introduced into his pictures. The surface patterns, which initially appeared abstract, were again based on anonymous everyday objects but were also references to personal and artistic experience. The cross-hatching, for instance, bore Johns' own imprint but was also an allusion to a detail in Edvard Munch's self-portrait. In the eighties Johns' art became more intellectually complex and his pictures were full of references to previous artists, from Grünewald to Picasso and Duchamp. In addition to the paintings, which were a major influence on the development of American art and not simply Pop Art, Johns' work also included sculptures and graphics which demonstrated great technical skill.

Since the mid-sixties Johns' work has been shown in major exhibitions such as *documenta 3, 4, 5* and *6* in Kassel. In 1988 he was awarded the Grand Prize for Painting at the Venice Biennale and in 1989 he became an honorary member of the Royal Academy in London. The Museum of Modern Art, New York, put on a major retrospective of his work in 1996.

Johns lives and works in New York and Saint Martin in the south of France. H.D.

Max Kozloff, *Jasper Johns*, New York, n.d. [1969]
Richard Francis, *Jasper Johns*, New York, 1984
The Drawings of Jasper Johns, exh. cat., Washington D. C., National Gallery of Art, 1990
Fred Orton, *Figuring Jasper Johns*, London, 1994
Jasper Johns: A Retrospective, exh. cat., New York, The Museum of Modern Art, 1996 and Cologne, Museum Ludwig, Munich, 1997
Jasper Johns. Writings, Sketchbook Notes, Interviews, ed. Kirk Varnedoe, New York, 1996

ASGER JORN

Asger Oluf Jorgensen was born in Vejrum, Denmark, on 3 April 1914. After training as a teacher, Jorn began painting in 1930. His early pictures, produced between 1930 and 1935, were small landscapes and portraits, which were influenced by contemporary Danish art. From 1935 he produced his first abstract pictures.

During his first stays in Paris, in 1936 and 1937, Jorn worked especially in Fernand Léger's 'Académie Contemporaine', although initially he was more attracted by Kandinsky's abstract late work. Together with Léger, he produced large-scale decorations for Le Corbusier's *Pavillon des Temps Nouveaux*, for the Paris International Exhibition, in 1937. At his first solo exhibition in Copenhagen, in 1938, Jorn showed works which were inspired by the fantastic allegories of Max Ernst and Paul Klee. During the German occupation of Denmark, Jorn's contacts with the Communist Party were reinforced, and in 1941 he became a co-founder of and one of the most active workers on the newspaper *Helhesten*, in which he also published translations from Kafka. In the last years of the war Jorn worked on a series of etchings, which were brought out under the title *Occupations*

1939–1945. In 1947 he took part in the conference of 'Surréalistes Révolutionnaires', in Brussels.

In 1948 Jorn, together with Karel Appel, Constant, Corneille, Christian Dotremont and Joseph Noiret, founded the CoBrA group (the acronym stood for the names of the cities of Copenhagen, Brussels and Amsterdam), which was given its first big exhibition as early as 1949, at the Stedelijk Museum in Amsterdam. Their basic aim was to increase the validity of spontaneity and expressivity in art and to challenge the artistic dominance of Paris, particularly the 'old-style Surrealism' which was dogmatically entrenched there. For the artists the so-called primitive (vernacular art, children's drawings, the art of the mentally ill, graffiti) had the true ring of authenticity. This movement, which created numerous scandals, was characterised by a return to figuration, an aggressive, spontaneous manner of painting, and its sociologically and politically-based commentary on contemporary and artistic issues, particularly in relation to established notions of value. The CoBrA period lasted only three years, during which time the artists held joint exhibitions, published manifestos and edited the magazine, called *COBRA*. At the same time, Jorn edited a series of small monographs on CoBrA artists. Commercial failure and ideological differences of opinion finally led to the break-up of the group.

During a stay in a sanatorium in Silkeborg in 1951 Jorn wrote his first theoretical book, *Helg og Hasard* (Well-being and Chance) published in 1966. Up until 1961 he also published important manifestos within the framework of the 'Situationist International', an anarchistic group of artists who vehemently criticised the functionalism of capitalist society and propagated a form of 'unitary urbanism'. In response to Max Bill's move in establishing the College of Design in Ulm in 1954, Jorn, together with Enrico Baj, founded the 'Mouvement International pour un Bauhaus Imaginiste (MIRI)'. In 1963 he founded the 'Institute for Comparative Vandalism' in which, for example, old graffiti in churches was collected and evaluated as an expression of 'genuine vandalism'. Jorn turned down the Guggenheim Prize awarded him in 1964 for his picture *Dead Drunk Danes*.

At the beginning of the sixties Jorn experimented among other things with painting over department store or salon pictures from the nineteenth century. These 'modifications' or 'defigurations' as he called them took place against the background of a more general re-evaluation of kitsch and so-called bad taste. In addition he created ceramic works and collages. In 1964 he worked on *décollages* – torn paper, which he manipulated for his own ends. After a long period spent on other things such as building up a photographic collection of Scandinavian art, he began painting intensively again in 1966. Between 1970 and 1972 he once again produced a large body of paintings. During the last phase of his life Jorn devoted a great deal of energy to making sculpture. In addition to ceramic works, he produced bronze and marble sculptures in Italy. In 1973 a large retrospective of his work was held at the Kestner Gesellschaft in Hanover, which then moved to the Nation-

algalerie in West Berlin and museums in Brussels, Aalborg and Humlebæk.

Jorn died from cancer on 1 May 1973, in Aarhusy.

H.D.

Asger Jorn, ed. Wieland Schmied, exh. cat., Berlin, Nationalgalerie, 1973

Asger Jorn, exh. cat., New York, Solomon R. Guggenheim Museum, 1982

Asger Jorn 1914–1973. Gemälde, Zeichnungen, Aquarelle, Gouachen, ed. Armin Zweite, exh. cat., Munich, Städtische Galerie im Lenbachhaus, 1987

Asger Jorn. Retrospektive, exh. cat., Frankfurt a. M., Schirn Kunsthalle, Stuttgart, 1994

Asger Jorn, exh. cat., Milan, Pinacoteca Casa Rusca, Locarno, 1996

DONALD JUDD

was born in Excelsior Springs, Missouri, on 3 June 1928. He did his military service in Korea in 1946 and 1947. He attended the College of William and Mary in Williamsburg, Virginia, in 1948 and 1949, and the Art Students League in New York from 1949 to 1953. He took evening courses at Columbia University at the same time, and studied art history and philosophy there under Rudolph Wittkower and Mayer Schapiro from 1957 to 1962.

In the fifties, Judd experimented with figurative and abstract painting, under the clear influence of Abstract Expressionism, and Jackson Pollock, in particular. In his first one-man exhibition at the Panoras Gallery in New York in 1957 he showed abstract pictures with irregular dark forms set against light backgrounds. Between 1959 and 1965 Judd earned his living mainly by working as an art critic for the magazines *Art News*, *Art International* and *Arts Magazine*; he was co-editor of the last. In that capacity, he was particularly concerned with artists such as Jasper Johns and Frank Stella, and with representatives of the emergent Pop Art movement. He taught at the Brooklyn Institute of Arts and Sciences in New York from 1962 to 1964.

Judd abandoned painting in the early sixties to devote himself to sculpture. He first produced objects that were still in an intermediate state between two and three dimensions. This development, in which he strove for rigorous clarity and purity of artistic form, started with monochrome reliefs and geometrical wooden and metal structures that seem like free-standing objects without plinths, like architecture or architectural models. Judd's position as a leading exponent of Minimal Art was confirmed at the time of his participation in a group exhibition at the Green Gallery in New York in 1963, alongside Dan Flavin, Robert Morris, Frank Stella, Ellsworth Kelly and Larry Poons.

From 1966 onwards, Judd restricted himself to metal (rolled sheets, brass, aluminium) and perspex. This was shaped into regular geometrical forms (usually boxes), unpainted or lacquered in glowing primary colours, presented individually or in serial arrangements. Judd placed these elements on the wall in vertical arrangements (*Stacks*), which were set up like sets of shelves, or in horizontal lines (*Progressions*), interrupted at intervals according to mathematical progressions. By using serial repetition and mathematical processes, Judd undermined the traditional hierarchical method of composition, and tried to create objective, 'democratic' art, which required the abandonment of a hierarchical ordering or subordination of individual parts, in order that the object might be grasped in its entirety. The object's independence had to be guaranteed, to the extent that it could not be alienated by its spatial context. In his famous text 'Specific Objects' (1965), Judd argued that 'specific objects' should be placed in real space, alongside traditional painting and sculpture. After 1963 these objects were machine-made, to avoid any sense of craft or suggestion of artistic handwriting.

From 1970 onwards, Judd increasingly addressed the issue of the surrounding space, and created works that took the specific context into account. In this way the objects installed in a given space reinforced the character of architectural forms and furniture, and thus undermined art's traditional claim to be absolute. Judd distanced himself from the art market and the exhibition business in 1973 by buying a set of buildings in Marfa in west Texas and adapting them into a spacious centre for culture and the arts. Two aircraft hangars were converted for his own use as a studio and as installation venues, and the remaining buildings became guest studios and exhibition spaces. In 1986 he set up the Chinati Foundation as a charity. Here Judd realised his notion of an ideal museum, as a place where art could be created in the context of both architectural and natural surroundings, and shown for long periods at a time.

Judd's work featured in all the major Minimal Art exhibitions and at *documenta 4* and *documenta 7* in Kassel, in 1968 and 1982 respectively; the Whitney Museum of American Art in New York organised a comprehensive retrospective in 1988. Judd won the Stankowski Prize in 1993 and a further retrospective was shown in venues including Wiesbaden, Oxford and Berlin.

Judd died on 12 February 1994 in New York. H.D.

Donald Judd, *Complete Writings 1959–1975*,
Halifax, 1974
Donald Judd, *Complete Writings 1975–1986*,
published by the Stedelijk Van Abbemuseum,
Eindhoven, 1987
Barbara Haskell, *Donald Judd*, exh. cat., New York,
Whitney Museum of American Art, 1988
Donald Judd, ed. Jochen Poetter, exh. cat., Baden-
Baden, Staatliche Kunsthalle, 1989
Donald Judd. Architecture, ed. Peter Noever,
Stuttgart, 1992
Donald Judd. Räume – Spaces. Kunst + Design,
exh. cat., Museum Wiesbaden, Stuttgart, 1993

ILYA KABAKOV

was born on 30 September 1933 in Dnjepropretovsk,
in the Ukraine. In 1941, during the war, his family
was evacuated to Samarkand, in Uzbekistan. Kaba-
kov studied art from 1943 to 1945, first in Samar-
kand, to which the Leningrad Academy of Art had
been evacuated, and then at the Secondary School for
the Arts in Moscow. From 1951 to 1957 he studied
graphic art at the Surikov Art Institute in Moscow,
ending up with a diploma in book illustration. From
1956 onwards Kabakov worked as an illustrator for a
variety of children's book publishers and for the
magazines *Murzilka* and *Wesselye kartinki*. In parallel
to this, he made studies from nature and painted and
drew in an abstract, expressive style.
The political climate of the sixties and seventies in
the Soviet Union and the repressive attitude of the
authorities towards any form of art which did not
support official policies by conforming to the tenets
of Socialist Realism contributed to the fact that
Kabakov's work went largely unnoticed. At the time,
the pictures and objects which he created in the six-
ties were characterised by his interest in the mun-
dane aspects of everyday reality and development of
formal procedures (which he still uses) for bringing
out the many layers of meaning in his work. In the
first half of the seventies he made more than fifty so-
called 'albums' of texts and serial drawings, carefully
stored in boxes bound with material and dedicated,
in each case, to an individual person.
In his work, Kabakov seeks to combine text and
image, at the same time as allocating a variety of dif-
ferent functions to the text. He questions or com-
ments on what he has painted, even if he does not
sharply contradict it. Kabakov uses the same com-

municative structure in his so-called SHEK-panels
(SHEK=shilishtshno-eksplutazionnaja kontora or ad-
ministrative office in a block of flats), a series of
mostly large panel paintings executed in 1978–82. In
these Kabakov simulated forms of bureaucratic plan-
ning and control, under the guise of imaginary com-
missions from the housing office, as in the case of the
SHEK-panel *Carrying out the Dustbin* (1980), which
outlined a six-year plan for the individually named
occupants of a specific communal apartment block;
or the display panel *Sunday Evening* (1980), in which
he presented the way in which a sober set of statistics
might serve to conceal the manner in which hidden
control could be exercised over the private lives of
ordinary people – in this case, illustrated by an invi-
tation to an evening out, listing the names of each of
the guests and itemising beside each of them the
clothing they wore, the food they consumed and the
exact duration of their visit. Several of the SHEK-
panels and albums were incorporated into the instal-
lations which Kabakov started making in the early
eighties. His first so-called 'total installation', *10
Characters Performing a Series of Actions* (1981–88),
was created at the Ronald Feldman Gallery in New
York. Kabakov's aim, in cases such as this, was to
confront the viewer with a self-contained, total work
of art. He creates environments as a kind of socio-cul-
tural description of everyday reality in the Soviet
Union (communal flats, shared kitchens and commu-
nity truck) and stages them as 'suspended activity'
(Kabakov), which is recorded with the eye of an
archivist categorising the officially propagated view
of a collective utopia, as well as the private fears,
social deprivation and corresponding adaptation to
circumstance in the lives of the ordinary Soviet citi-
zens. In availing himself of the language of ordinary
objects in everyday use in the Soviet Union, Kabakov
renounced the possibility of using traditional means
and mechanisms of representation; he consciously
relegated the artistic gesture to the background and
thereby created a penetrating, albeit clearly fictional,
insight into Soviet modes of behaviour.
Kabakov first became known in Europe through his
travelling exhibition, *Ilya Kabakov. Am Rande* (Ilya

Kabakov. On the Margins), which started in Bern in
1985 and went on to Marseille, Paris and Düsseldorf.
In 1986 he received a scholarship from the Kunstver-
ein in Graz and in 1989–1990 a scholarship from the
DAAD (German Academic Exchange Service), in
Berlin. In 1992 Kabakov designed the costumes
and sets for the Amsterdam production of Alfred
Schnittke's opera *Das Leben mit einem Idioten* (Life
with an Idiot) and he exhibited his installation *The
Toilet* at *documenta IX* in Kassel. In 1992 Kabakov
was appointed Visiting Professor at the Art Academy
in Frankfurt a. M.. In 1995 the Centre Georges Pom-
pidou in Paris exhibited nineteen of his installations
from the years 1983 to 1995.
Kabakov has lived in New York since 1992. C.T.

Ilya Kabakov. Vor dem Abendessen, exh. cat., Graz,
Kunstverein, 1988
Boris Groys and Ilya Kabakov, *Die Kunst des
Fliehens: Dialoge über Angst, das heilige Weiss und den
sowjetischen Müll* (The Art of Fleeing: Dialogues on
Fear, Holy White and Soviet Rubbish), Vienna and
Munich, 1991
Ilya Kabakov, *Das Leben der Fliegen*, exh., cat.,
Cologne, Kunstverein, Stuttgart, 1992
Ilya Kabakov. Ein Meer von Stimmen, ed. Theodora
Vischer, exh. cat., Basel, Museum für Gegenwarts-
kunst, Öffentliche Kunstsammlung, 1995
Ilya Kabakov, *Über die 'Totale' Installation*, Stuttgart,
1995
Ilya Kabakov. Installations 1983–1995, exh. cat., Paris,
Musée National d'Art Moderne – Centre de Création
Industrielle, Centre Georges Pompidou, 1995

FRIDA KAHLO

was born on 6 July 1907 in Coyoacán, a suburb of
Mexico City, the third daughter of Guillermo Kahlo,
a professional photographer of German extraction.
The growth of her right leg was stunted, as a result of
contracting infantile paralysis in 1918. She attended
elementary school at the German College in Mexico
City, at the same time as working at a timberyard and
helping her father to retouch photographs.
In 1923 she went to the National Preparatory School,
where she made the acquaintance of Diego Rivera,
who was engaged on painting his mural, *The Crea-
tion*, in the School's main lecture hall. In 1925, at the
age of eighteen, Kahlo had a bad accident, which left
her with severe pains and a nagging fear of death for
the rest of her life. During her stay in hospital, she
began intensively to paint. In 1927 she again met
Rivera and embarked on a long and difficult relation-
ship with him, which was constantly troubled by
affairs and separations. Kahlo's early pictures – por-
traits and self-portraits – initially displayed an affin-
ity to nineteenth-century Mexican painting, with its
naïve faithfulness to appearances, but the emphasis
on detail and morbid stiffness of the imagery pro-
duced an alienating effect, overall. Only from 1932
onwards, when she was already living in the USA
and conscious of the long-term implications of her
accident, did she develop an expressive intensity in

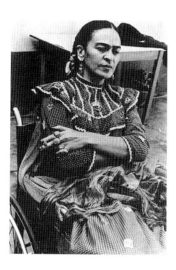

longing. Her interest in objects from Pre-Columbian and Mexican folk-art belonging to the collection in Diego Rivera's house was reflected in the style and subjects of her later pictures, which seem to be more influenced by these traditions than by the contemporary American and European avant-garde. After her return to Mexico Kahlo became a co-founder of the Seminario de Cultura Mexicana in 1942 and gave drawing classes at 'La Esmeralda' School of Painting and Sculpture. She formed the group 'Los Fridos', together with her favourite pupils, Fanny Rabel, Arturo Garcia Bustos, Guillermo Monroy and Arturo Estrada.

In 1946 Kahlo received the National Prize for Painting for her picture, *Moses*. In 1953 she was given her first solo exhibition in Mexico, at the Galeria Lola Alvarez Bravo. Kahlo died on 13 July 1954, from complications arising after the amputation of a leg.

<div align="right">H.D.</div>

her pictures, which from now on depicted her fears and suffering in a surrealist setting.

In her paintings Kahlo succeeded in attaining a degree of intensity which was virtually unsurpassed by any other woman artist in the twentieth century and in achieving a poetic transformation, both of her deep inner torment and of her burning passion. On the occasion of her exhibition in Paris in 1939, André Breton eulogised Kahlo as the personification of the 'surrealist woman', whose wounded body was the perfect expression of 'la Beauté convulsive', but this comparison with Parisian Surrealism, with all its intellectualism, scarcely did justice to the essential qualities of her work. Even a painting such as *What I saw in the Water* (1938), with its unreal, dreamlike details – despite bearing a distant resemblance to Dali's libidinously meticulous style of painting – is rooted in Kahlo's existentially conditioned female iconography, in which the minutiae of the objects depicted are all imbued with a particular significance. The same is true of the late still lifes, where the choice of typical local fruits and flowers transposes the theme of Eros and Thanatos (life and death) out of the Mexican tradition onto the spiritual plane of the artist's personal experience of life. Whilst Kahlo's portraits of friends seem curiously detached, like hand-coloured passport photographs, her self-portraits, such as *The Broken Column* (1944), are turned into poignant metaphors for her physical and spiritual existence. Her mainly mask-like, emotionless face finds a parallel in the faces in Mexican ex-votos, which bear the imprint of fateful events. In these pictures her body is frequently clothed in the full-length Tehuana costume of the Mexicans, as a symbol of feminine power, which seems to protect her tormented body like a magic suit of armour and to conceal her inner pain. This last is made all the more apparent by the inclusion of various attributes and surreal inventions, such as medical equipment, open hearts, bleeding brushes, chains and bandages. Her problematic relationship with Rivera, whom she first married in 1929 and, again, in 1940, also became the subject of a number of pictures, though these were mostly infused with a mood of tender forgiveness or

Raquel Tibol, *Frida Kahlo. Uber ihr Leben und Werk, nebst Aufzeichnungen und Briefen*, Frankfurt a. M., 1980
Frida Kahlo. Das Gesamtkunstwerk, ed. Helga Prignitz-Poda, Salomón Grimberg and Andrea Kettenmann, Frankfurt a. M., 1988
Hayden Herrera, *Frida Kahlo, Die Gemälde*, Munich, Paris and London, 1992
Das Blaue Haus. Die Welt der Frida Kahlo, ed. Erika Billeter, exh. cat., Frankfurt a. M., Schirn Kunsthalle, 1993

WASSILY KANDINSKY

was born into an upper middle-class family on 4 December 1866 in Moscow. He took drawing and music lessons from an early age, before going to Moscow University in 1886 to study law and economics. The Russian peasant culture Kandinsky encountered during a visit to the northern province of Vologda in 1899, particularly the brightly decorated wooden houses, which he viewed as pictures that could be entered on foot, made a lasting impression on him. He took his degree in 1893 and was then appointed attaché to the Law Faculty of Moscow University. However, a sighting of Monet's *Haystacks* in an exhibition and a visit to a production of Wagner's *Lohengrin* changed the course of his professional career. He turned down an appointment to a post at Dorpat University and in 1896 went to the 'art city of Munich', where he studied for two years at Anton Azbé's private art school and then with Franz von Stuck, at the Munich Academy of Art.

In 1901 Kandinsky was co-founder of the artists' and exhibiting association 'Phalanx' and of the association's painting school, at which Gabriele Münter was a student. Works by Corinth, Monet and Kubin as well as work by other Jugendstil, Symbolist and late Impressionist artists were exhibited by the association, but it failed to gain widespread acceptance. Worn down by the in-fighting of cultural politics, Kandinsky disbanded the 'Phalanx' in 1904 and journeyed through Europe and Tunisia with Münter,

staying in Paris from 1906 to 1907. 1908 was the start of a fruitful period for him in Munich. He went on painting excursions in the Murnau area, accompanied by Münter, Jawlensky and Werefkin. In 1909 he formed the 'Neue Künstlervereinigung München' (The Munich New Artists' Association) and worked on developing his new conception of art, which took its inspiration from a wide variety of different sources, ranging from Wilhelm Worringer's treatise *Abstraktion und Einfühlung*, (Abstraction and Empathy) to occult and theosophical theories, folk art and the contemporary music of Arnold Schönberg. Kandinsky's growing preoccupation with non-objective painting and use of free colours and forms came up against increasing criticism from amongst his own ranks. The rejection by the jury of *Composition V* in 1911 resulted in his leaving the 'Neue Künstlervereinigung München'. Kandinsky now worked with Franz Marc on the publication of an almanac, *Der Blaue Reiter* (The Blue Rider), which was intended to serve as a rallying point for all new tendencies in the arts. In parallel to this Kandinsky and his friends held an exhibition at the Thannhauser Gallery in Munich, in which works by the French Cubists, and Russian Cubo-Futurists were also included. In 1911 the Munich publisher Reinhard Piper brought out Kandinsky's treatise *Concerning the Spiritual in Art*, in which he set out a new programme for painting a 'sounding cosmos' of free-floating colours and forms, born of 'inner necessity'. Before the outbreak of the First World War Kandinsky established his line of advance with the completely abstract *Compositions VI* and *VII* (1913) and took part in a large number of exhibitions throughout Europe, through which he gained a reputation as the founder of abstract painting.

In 1914 Kandinsky returned to Moscow where, following the revolution, he did important cultural work as a member of the Commissariat for Popular Education. As professor at the SWOMAS (free state artists' workshops) and, later, the INChHUK (Institute of Artistic Culture) he developed a foundation course which was to appear under the title *From Point and Line to Plane*, in 1926. In 1922 Kandinsky

moved to Berlin, to escape the growing hostility from his artist colleagues and the party apparatus. He became one of the masters at the newly formed Bauhaus in Weimar. The publication of his graphic portfolio *Kleine Welten* (Small Worlds), a selection providing examples of techniques and painting methods, marked the start to his successful work as a teacher. His greatest influence as head of the workshop for mural painting was evidenced in his propaedeutic courses on colour and form, in which he undertook an analysis of the connections between the basic elements of painting. Following an initial period of geometric severity, Kandinsky's own painting at the Bauhaus became increasingly free, more fanciful and further removed from formalist dogma of any kind. Numerous exhibitions of Kandinsky's work were held in European cities to celebrate his sixtieth birthday. In 1928 he staged Mussorgsky's *Pictures at an Exhibition*, using a choreography dominated by abstract forms and colours. In 1932 the Bauhaus, which had already been compelled to move to Dessau in 1926, was closed down by the National Socialists. In December 1933 Kandinsky moved to the Paris suburb of Neuilly-sur-Seine, where he began a new phase of biomorphic abstraction. Notwithstanding many links with the Parisian art scene and involvement in a number of exhibitions, Kandinsky henceforth remained, to a large extent, an isolated figure. Kandinsky died on 13 December 1944 in Neuilly-sur-Seine. H.D.

Rose-Carol Washton-Long, *Kandinsky. The Development of an Abstract Style*, Oxford, 1980
Armin Zweite, *Kandinsky und München. Begegnungen und Wandlungen 1896–1914*, Munich, Städtische Galerie im Lenbachhaus, 1982
Wassily Kandinsky: Collected Writings on Art, ed. Kenneth C. Lindsay and Peter Vergo, London, 1982
Kandinsky: Russian and Bauhaus Years, ed. Clark V. Poling, exh. cat., New York, Solomon R. Guggenheim Museum, 1983
Wassily Kandinsky. Die erste sowjetische Retrospektive, Frankfurt a.M., Schirn Kunsthalle, 1989
Jelena Hahl-Koch, *Kandinsky*, Stuttgart, 1993
Das bunte Leben. Wassily Kandinsky im Lenbachhaus, ed. Vivian Endicott Barnett and Helmut Friedel, exh. cat., Munich, Städtische Galerie im Lenbachhaus, 1995

MIKE KELLEY

was born on 27 October 1954, the son of a Roman Catholic working-class family in Wayne, near Detroit, in Michigan. He studied at the College of Architecture and Design at Ann Arbor, University of Michigan, until 1976 and then went on to study under John Baldessari at California Institute of Arts in Valencia, until 1978.
Kelley began his career as a performance artist and saw his medium as a reaction against Conceptualism, which had become the dominant artistic language of the seventies. His actions, which may be interpreted in certain respects as a continuation of

the word-play of writers such as Gertrude Stein and Raymond Roussel, obeyed the principles of repetition and free association, in the way that they set out to investigate linguistic structures and play on the different levels of meaning of linguistic codes. At the same time the subject of these actions was related to psychological, political, ideological and social phenomena and structures. Thus, in the performance *The Poltergeist*, which he carried out with David Askevold in 1979, Kelley dealt with disconnected, illogical sequences of actions, interspersed with music and singing, which swelled up and faded away, and with invisible energies which he sought to shape in a variety of ways. In the action, *Plato's Cave, Rothko's Chapel, Lincoln's Profile*, which he carried out in 1986 with Molly Cleaton, he tackled the signs and mechanisms of possession and claims to possession. The sculptures, drawings, texts and photographs which he created in parallel to this activity were mostly constituent elements of parts of the performance.
In his work Kelley is concerned with the juxtaposition and jumbling together of partially antithetical or contradictory ideas, objects and sentiments. The products of mass culture and of trivial everyday existence are the most important source of his art; he not only takes them for his subject, but adopts certain of their formal aspects or picks out the most significant objects. Comics, cartoons and films – especially, splatter movies – kitschy toys and craft objects are the accepted forms of expression for a certain social milieu and reflect the tastes of a specific social class. He treats so-called 'high' and 'low' culture as communication models of equal value, thereby rejecting the notion of an art rooted in the hierarchical structures of society. In the nineteen eighties, Kelley went on to create sculptures and installations from toys found lying around or bought in junk shops: discarded, dirty, wracked-out dolls and stuffed animals, which he arranged in such a way as to create a strange atmosphere, combining affected kitschiness with morbidly sexual undertones. Thus, a work such as *Eviscerated Corpse* (1989) depicts a vaginal form, made up out of cuddly animals knotted together, out of which hangs a cord resembling excrement, worms or a larger-than-life-size penis. In *Dialogues* (1991),

stuffed animals are placed at opposite ends of some blankets and become the protagonists in a perverted dialogue, played on a tape recorder; whilst in *Craft Morphology Flow Chart* (1991) different kinds of - stuffed animals are arranged according to their species or the materials of which they are composed and turned into the subject of a grotesque, pseudo-scientific system of organisation.
In 1993 Kelley, in collaboration with Paul McCarthy, turned to the 'Heidi' legend and related clichés about an ideal vision of the world and of society, characterised by closeness to nature and individual self-sacrifice. The installation *Heidi*, which is composed of video, scenery, dolls and a variety of props, with the sub-title, *Midlife Crisis Trauma Center and Negative Media – Engram Abreaction Release Zone*, gives a blasphemous twist to the protagonists and their history, in that we are presented, not with a view of a wholesome world but with perversions and sado-masochistic scenes, which bespeak a nightmarish vision of society.
Kelley has been given numerous solo exhibitions since 1981, including one at the Hirshhorn Museum and Sculpture Garden in Washington, in 1990. His first one-man exhibition in Europe was at the Jablonka Gallery in Cologne, in 1989. This was followed by his inclusion in *documenta IX*, in Kassel and a survey show of his work at the Kunsthalle in Basel, which subsequently went on to London and Bordeaux. In 1993 the Whitney Museum in New York organised an exhibition *Catholic Tastes*, which subsequently went on tour to Los Angeles and Stockholm, ending up at the Haus der Kunst in Munich, in 1995. Mike Kelley lives and works in Los Angeles. C.T.

Mike Kelley: Three Projects, exh. cat., Chicago, Renaissance Society at the University of Chicago, 1988
Mike Kelley, exh. cat., Cologne, Jablonka Gallery, 1989
Mike Kelley. Art Resources Transfer, ed. William S. Bartman and Miyoshi Barosh, New York, 1992
Mike Kelley, ed. Thomas Kellein, exh. cat., Basel, Kunsthalle, 1992
Mike Kelley. Catholic Tastes, ed. Elisabeth Sussman, exh. cat., New York, Whitney Museum of American Art, 1993

ELLSWORTH KELLY

was born on 31 May 1923 in Newburgh, New York. He studied applied art at the Pratt Institute in Brooklyn under Maitland E. Graves and Eugen H. Petersen from 1941 to 1943. Kelly started his military service in 1943, took part in the Normandy landings in 1944 and was stationed in England in 1945. He produced mainly drawings and watercolours during his military service. After the war Kelly continued to study at the Art School of the Museum of Fine Arts in Boston, where he studied drawing under Karl Zerbe and painting under Ture Bengtz in 1947–48. In 1948 he attended the Ecole des Beaux-Arts in Paris. He taught at the American School in Paris in 1950–1951

and was given a first one-man show at the Galerie Arnaud in 1951.

Kelly met Hans Arp, Constantin Brancusi, Georges Vantongerloo and Michel Seuphor in Paris; his artistic ideas derived mainly from the Neo-Plasticism based on geometrical abstraction that Piet Mondrian had developed in the late 1910s. Thus, already in Paris, Kelly had begun to work in an abstract style involving two-dimensional geometrical elements distributed over several panel pictures and limited to simple primary colours, as in his painting *Colors for a Large Wall* (1951). Here the colours had autonomous value and were applied absolutely evenly, filling the whole surface of the picture so homogeneously that a uniform pictorial shape derived only from modular accumulation and the way in which it related to the surface of the wall.

Kelly returned to New York in 1954 and lived in the Coentis Slip Area in south Manhattan from 1956 to 1963. He was soon recognised on the American art scene as a result of various group exhibitions and one-man shows, in the Betty Parsons Gallery among other venues. He won freedom from European models of geometrical and Neo-Plastic abstraction by linking the colour figure to the surface of the picture very closely, thus producing a new unity of form and ground, a 'post-Cubist space' (Clement Greenberg).

Kelly's pictures usually consist of one or a few precisely contoured forms in intense colours. The term 'hard edge painting' was coined for this approach, including work by artists such as Leon Polk Smith or Kenneth Noland, as well as Kelly. Kelly often used angular forms during the sixties, and created installations combining individual monochrome panels on a whole wall. It was now, with his investigations into a new conception of pictorial space, that Kelly established himself as an artist of international status .

In addition to painting Kelly also produced graphics, collages, reliefs and sculptures in metal and wood, with alternating geometrical and organic forms, in combinations of warm and cool colours. But all the abstract geometrical objects share a succinct, mathematically calculated form on the space like a silhouette. Increasingly, for Kelly, image and sculpture/relief are equal partners in the realisation of variants of complex design interrelations. Thus he designed the *Houston Triptych* (1986) for the area outside the Museum of Fine Art. Its overall form could no longer be taken in at once, but grasped only as the

outcome of progressive observations from a variety of viewpoints.

A recent manifestation of this new pictorial approach was the temporary installation *Yellow Curve* at the Portikus Gallery in Frankfurt a.M. in 1990, which related to the concrete conditions of the space with a monochrome yellow form. *Yellow Curve's* clearly defined, eccentric form as a segment of a circle entered into a direct relationship with the architecture, and the work could be viewed in the space both as a painting and as a piece of sculpture.

Kelly has featured in major international exhibitions, including *documenta 3* (1964), *4* (1968) and *6* (1977) in Kassel, and *Geometric Abstraction and Minimalism in America* (New York, 1990). Major retrospectives have been held in a variety of venues including the Museum of Modern Art, New York (1973), the Stedelijk Museum in Amsterdam (1979), the Fort Worth Art Museum (1987) and the Galerie Nationale du Jeu de Paume in Paris (1992). A touring exhibition went to New York, Los Angeles, London and Munich between 1996 and 1998.

Kelly lives and works in Spencertown, New York.

H.D.

Barbara Rose, *Ellsworth Kelly: Paintings and Sculptures 1963–1979,* exh. cat., Amsterdam, Stedelijk Museum, 1979
Ellsworth Kelly, *Gemälde und Skulpturen 1966–1979,* exh. cat., Baden-Baden, Staatliche Kunsthalle, 1980
Diane Upright, *Ellsworth Kelly: Works on Paper,* exh. cat., Fort Worth, Fort Worth Art Museum, 1987
Ellsworth Kelly: Die Jahre in Frankreich 1948–1954, exh. cat., Münster, Westfälisches Landesmuseum für Kunst- und Kulturgeschichte, Munich, 1992
Spencertown. Recent Paintings by Ellsworth Kelly, ed. Anthony d'Offay and Matthew Marks, New York, 1994
Ellsworth Kelly: A Retrospective, ed. Diane Waldman, exh. cat., New York, Solomon R. Guggenheim Museum, Los Angeles, The Museum of Contemporary Art, London, Tate Gallery and Munich, Haus der Kunst, New York, 1996

ANSELM KIEFER

was born in Donaueschingen on 8 March 1945. He began to study law and Romance languages and literature in 1965 but turned to painting in 1966, studying first under Peter Dreher in Freiburg (1966–1968), then under Horst Antes in Karlsruhe (1969). After taking his state examination he studied with Joseph Beuys at the Staatliche Kunstakademie in Düsseldorf.

Kiefer's interest in the symbols and myths of German history, reflected in his photo series *Besetzungen* (Occupations, 1969), self-portraits with a fascist greeting, have made him one of the best-known, but most controversial, contemporary German painters. At a time when figurative, expressive painting was flourishing, Kiefer painted furrowed landscapes, silent forests or empty attics and vaults, seen in perspective. To these he added names and concepts

referring to German history and mythology, especially the Nazi past, in awkward, childish handwriting. There were immediate protests about his allegedly superficial misrepresentation of history, not just in his paintings of attics and woods but in his *Verbrannte Erde* (Scorched Earth) landscapes dating from the mid-seventies, in which he used a variety of materials, often worked on with a blowtorch. Kiefer uses pictures and words with deliberate ambiguity, to create a charged atmosphere that both repels and attracts the viewer. Word and image are not directly related: for Kiefer the image is never the vehicle for an unambiguous message; conversely his inscriptions never designate something that can be clearly recognised in the image. Kiefer's landscapes are 'areas of meaning without meaning' (Dieter Honisch). The deserted, bleak, burnt-out scenes are not meant as commentaries on contemporary history, but as transpositions of ideas inspired by the perception of trivial objects. First there is the large, blank pictorial concept, which only takes on concrete form through the act of painting, but still does not seem complete, even in the finished work. Kiefer offers very little by way of artistic statements, to help in the interpretation of his works. Instead, he leaves the images and objects open and uncertain, in order to create associations and moods.

In Kiefer's paintings, history appears as a series of interpenetrating layers, where the uppermost layer of meaning is not necessarily the all-embracing and valid one. This applies in particular to the material pictures of the nineties, which are saturated with cabbalistic or alchemistic meaning. These very large-scale works, incorporating a variety of materials, create associations at many levels, suggested also by the titles he often inscribes on their surface. The pieces of string, fragments and shreds of clothing seem to act as a bridge between the imaginative world of the artist and the world of the observer, who can grasp these ideas through his senses.

Another major theme of Kiefer's work stems from his interest in the myth of the artist, which he to some extent links to the heroic myths and myths of redemption, to which he gives an ironic twist. The

paintings with winged palettes, such as *Ikarus = Märkischer Sand* (Icarus = Sand from Mark Brandenburg, 1981–82), can be interpreted not simply in terms of the familiar parable about man's presumption, but as a symbol of the artist's trade. The falling or rising winged palettes symbolise the possibility that the artist may fail in his endeavour or even, on occasion, succeed beyond expectation.

Kiefer's paintings cannot be fully understood solely in terms of his working process or with reference to encyclopaedias of symbols. His materials, titles, inscriptions and applications combine to produce a complex story, which is based as much on personal predilection as on objective choice. Besides paintings and prints Kiefer's works include sculptures, installations and artist's books.

The first Kiefer retrospective was held at the Kunstverein in Bonn, in 1977; in 1987 his work was shown at *documenta 8*, in Kassel, and in 1991, the Nationalgalerie Berlin held a comprehensive retrospective. Kiefer lives and works in Barjac, in France. H.D.

Anselm Kiefer: Bilder und Bücher, exh. cat., Bern, Kunsthalle , 1978
Anselm Kiefer, exh. cat., Düsseldorf, Städtische Kunsthalle, 1984
Anselm Kiefer. Bilder 1986→1980, ed. Wim Beeren, exh. cat., Amsterdam, Stedelijk Museum, 1986
Anselm Kiefer, ed. Mark Rosenthal, exh. cat., Chicago, The Art Institute and Philadelphia, Museum of Art, 1987
Anselm Kiefer, ed. Dieter Honisch, exh. cat., Nationalgalerie Berlin, 1991

EDWARD KIENHOLZ

was born in Washington on 23 October 1927. From 1946 to 1951 he lived in various places, including Montana, Oakland in California and Las Vegas, and earned a living as a second-hand car dealer, medical orderly in a psychiatric clinic and window dresser.

In 1953 Kienholz moved to Los Angeles, where he worked on his first wooden relief pictures. He was self-taught. These irregularly shaped canvases were given a three-dimensional aspect through the addition of nailed – on pieces of wood. They were embellished with crude paintwork – often applied with a broom – abstract forms and found objects integrated into the surface.

In the fifties, Kienholz increasingly abandoned these relief-like pictorial surfaces and constructed freestanding assemblages from a wide variety of refuse. Their satirical titles, often in the form of word-play or metaphors, referred to political, social or cultural events and irregularities, especially in American society. He assembled these worn, usually dirty, paint-spattered objects to form images which constituted an assault on subversive standards and nationalistic hypocrisy. *Conversation Piece* (1959), for example, is made out of the torso of a doll dressed like an American Indian girl, mounted in the form of a hunting trophy, and was Kienholz's way of referring to the brutal treatment of America's original inhabitants.

Another work, *The God Tracking Station #1* (1958), evoked the Cold War rivalry between the USA and the Soviet Union in their race to conquer space.

In the early sixties Kienholz further developed the working form of the Environment, which was to become his trademark. This was an area in which the viewer could walk. It presented events and odes of life using a variety of properties, life-size dolls and, later, casts of human beings. The first complete accessible Environment was *Roxys* (1961–62), a cabinet-like, grubby brothel interior, which with its lower middle-class, unsophisticated furnishings demonstrated the ordinariness of the set-up whilst it mutilated female occupants, transfixed in grotesque poses, displayed the brutality and perversion implicit in the treatment of socially despised prostitutes.

Even more than *Roxys,* where the viewer involuntarily became a passive visitor to the brothel, Kienholz succeeded in dismantling the aesthetic barriers in his environment called *The Portable War Memorial* (1968). Here it was possible not only to walk into the setting, but to imagine taking up the invitation constituted by the presence of a snack bar, a soft drinks machine and camping furniture. Deprived of their detachments viewers were required to adopt a position, and subjected to a political and moral appeal for self-analysis: 'I would like my work to be understood for just exactly what it is: one man's attempt to understand himself better.' (Kienholz)

Unlike other artists of his generation, such as Duane Hanson or John de Andrea, who were concerned with authentic representation of human beings and their physical appearance, Kienholz sought to enhance the expressive power of his figures by a sense of alienation. They are deformed, mutilated or made up in Surrealist fashion of body-casts and everyday objects, like for example the depersonalised pubgoers in *The Beanery* (1965), whose faces have been replaced by clocks, turning them into symbols of unused time that has stood still or (from Kienholz's point of view) been frittered away.

Kienholz was given his first retrospective as early as 1966, in the County Museum of Modern Art in Los

Angeles. He featured in *documenta 4* (1968) and *documenta 5* (1972) in Kassel. In 1973 he won a DAAD (German Academic Exchange Service) scholarship to Berlin, since which time he has spent long periods, on and off, living and working in that city. In 1984 the San Francisco Museum of Modern Art mounted a major exhibition of the works of Edward and Nancy Kienholz, which was subsequently shown in Minneapolis, Chicago and Houston. After Edward Kienholz's death on 10 June 1996 in Hope, Idaho, the Whitney Museum of American Art organised an exhibition of the couple's work, which was also shown in Los Angeles and, in 1997, in Berlin.

C.T.

Edward Kienholz, 2 vols., ed. Lawrence Weschler, Los Angeles, 1977
Edward and Nancy Reddin Kienholz. Human Scale, exh. cat., San Francisco, Museum of Modern Art and Houston, Contemporary Arts Museum, 1984
Edward and Nancy Kienholz: 1980s, exh. cat., Düsseldorf, Kunsthalle and Vienna, Museum Moderner Kunst, 1989
Robert L. Pincus, *On a Scale that Competes with the World. The Art of Edward and Nancy Reddin Kienholz,* Berkeley, Los Angeles and London, 1990
Kienholz – A Retrospective. Edward and Nancy Reddin Kienholz. ed. Walter Hopps, exh. cat., New York, Whitney Museum of Modern Art, Los Angeles, The Museum of Contemporary Art, Berlin, Berlinische Galerie, Munich and New York, 1996

ERNST LUDWIG KIRCHNER

was born on 6 May 1880 in Aschaffenburg am Main. In 1890 his family moved to Chemnitz, where his father was to become professor for research into paper at the industrial academy. Kirchner's artistic talent was encouraged by his father from an early age. In 1903 he enrolled as an architecture student at the Saxon College of Technology in Dresden and in the winter semester 1903–04 he moved to the College of Technology in Munich.

Kirchner received an intensive education in composition and drawing from life in Wilhelm Debschitz's and Hermann Obrist's 'Technical and Experimental Studio for Pure and Applied Art'. In 1903 he visited the eighth exhibition of the 'Phalanx' Association, organised by Kandinsky, where he saw works by Seurat, Signac, Cross and Pissarro, whose methods he studied in detail but ultimately rejected. In the spring of 1904 he continued his architecture studies in Dresden, and it was here that he met Erich Heckel and Karl Schmidt-Rottluff. This led to the formation of the artists' group 'Die Brücke' (The Bridge), of which Kirchner's old school friend Fritz Bleyl was also a member. Kirchner himself composed the manifesto and carved it in wood as if were a 'tablet' of the Ten Commandments'. The predominant influence of van Gogh is evident in the richly contrasting colours and heavy brushwork of Kirchner's first oil paintings. In 1908 'Die Brücke' exhibited simultaneously with the Fauves at the Kunstsalon Emil Richter, in

Dresden. Kirchner had already discovered the expressive possibilities of pure colour, released from any descriptive function. In the period that followed, however, he renounced the use of impasto and began to dilute his paint with turpentine substitute, in order to be able to apply it as thinly and evenly as possible. The painting *Two Nudes with Bathtub and Oven* of 1911 shows this stylistic change in its smooth unmodelled areas, forming a sequence of planes bounded by cross-hatched contour lines. After moving to Berlin in October 1911 Kirchner turned from painting nudes to depicting scenes of city life. The paintings he produced in Berlin are the most famous in German Expressionism: hectic street scenes and the demi-monde of prostitutes and night clubs. Under the influence of his new subject matter, Kirchner's style changed: his colours became more muted and he gave his brushwork a nervous, feathery outline. However, in his later city paintings he reverted to the use of lively, shrill colours and stark contrasts, as in *Frauen auf der Straße* (Women on the Street, 1915).

In 1912 Kirchner exhibited with the 'Blaue Reiter' (Blue Rider) group in Munich and 'Der Sturm' gallery in Berlin. Inspired by the *Blaue Reiter Almanach*, to which the artists of Die Brücke also contributed, Kirchner wrote his *Chronik der Brücke* (Chronicle of the *Brücke* Group). However, this was rejected by the members of the group for being too subjective and led to the disbanding of Die Brücke in May. Soon after, Kirchner held his first solo exhibitions, including one at the Folkwang Museum in Hagen, in 1913. When war broke out Kirchner spent only a few months in uniform before being discharged in September 1916, after a physical and nervous breakdown. In that year he produced his most impressive self-portraits: *Der Trinker* (The Drinker) and *Selbstbildnis als Soldat* (Self-Portrait as a Soldier). Kirchner was treated unsuccessfully in hospital on a number of occasions for sudden fits of panic, until he was finally discharged from the sanatorium in Kreuzlingen, in July 1918. He subsequently settled in Frauenkirch near Davos, in Switzerland.

Kirchner's illness, his seclusion in the Swiss mountains and his lack of contact with artists, collectors and gallery owners, all conspired to make him ever more solitary, anxious and mistrustful. He began to paint over and pre-date his earlier pictures, in an effort to claim his artistic precedence. Under the pseudonym 'Louis de Marsalle' Kirchner wrote articles praising his own work. His diary is full of malicious slander against his former artistic associates. At the same time his art lapsed increasingly into decorative mannerism. Even the assimilation of Cubist influences after 1925, via a number of Picasso's paintings from the 1920s, changed nothing.

Unable ever to overcome his depression and dismayed at the political developments in Germany, where his work was considered 'degenerate', Kirchner took his own life on 15 June 1938. H.D.

Will Grohmann, *E. L. Kirchner*, Stuttgart, 1958.
Ernst Ludwig Kirchner, Zeichnungen und Pastelle, ed. Roman Norbert Ketterer, Stuttgart, 1979
Eberhard W. Kornfeld, *Ernst Ludwig Kirchner. Nachzeichnung seines Lebens*, Bern, 1979
Ernst Ludwig Kirchner 1880–1938, ed. Lucius Grisebach, exh. cat., Berlin, Nationalgalerie, 1980
Anton Henze, *E. L. Kirchner, Leben und Werk*, Stuttgart, 1980
Ernst Ludwig Kirchner, Aquarelle, Pastelle, Zeichnungen, exh. cat., Dortmund, Museum am Ostwall, 1986
Lucius Grisebach, *Ernst Ludwig Kirchner 1880–1938*, Cologne, 1995

R. B. KITAJ

was born Ronald Brooks in Cleveland, Ohio, on 29 October 1932. Later he adopted his stepfather's name. Even as a schoolboy Kitaj was constantly drawing, and he attended events for children at the Cleveland Museum of Art. In 1950 he signed on with a Norwegian freighter and travelled to South America. That same year he spent a term at the Cooper Union for the Advancement of Science and Art in New York studying under the painter Sydney Delevante, among others. In 1951 he obtained his seaman's licence and made further journeys on oil tankers, to Venezuela, the Caribbean and elsewhere.

During a stay in Europe in 1951 Kitaj visited Paris and Vienna, where he studied under Albert Paris von Gütersloh and Fritz Wotruba at the Academy of Fine Arts in Vienna. In 1953 he sailed to South America again. He spent his military service from 1954 to 1956 as a draughtsman in an information department in Fontainebleau near Paris. Kitaj continued his studies at the Ruskin School of Drawing and Fine Art in Oxford, where he also attended lectures by the art historian Edgar Wind who familiarised him with the methodology of Aby Warburg. Kitaj regarded the iconographical pictures in Warburg's pictorial atlas as a lesson in comparative seeing and they inspired his paintings of the early 1960s, with their collage-like and seemingly haphazard juxtaposition of motifs.

In 1960 Kitaj enrolled at the Royal College of Art in London, where he made friends with David Hockney and others and became a leading figure of the youthful London art scene. His links with Pop Art in London were reflected in his pictorial technique and fragmentary collages of images and texts. In 1962 he worked with the sculptor Eduardo Paolozzi and began his longstanding collaboration with the silkscreen printer Chris Prater, with whom he made collage prints.

At his first one-man show at the Marlborough Gallery in London in 1963, Kitaj met other painters who believed in figurative art: Francis Bacon, Frank Auerbach, Lucian Freud, Michael Andrews and Leon Kossoff. Kitaj began to furnish explanatory 'prefaces' to his pictures in which he explained his literary and intellectual sources of inspiration. In 1965 he held his first one-man show in New York, at which Alfred H. Barr acquired the painting *Ohio Gang* (1964) for the Museum of Modern Art. From 1961 to 1967 Kitaj taught at various London colleges and in 1967 he accepted a visiting professorship at the University of California in Berkeley. Here he made friends with the poet Robert Duncan and the painter Robert Creeley, with whom he produced the books *A Sight* (1967) and *A Day Book* (1970). In 1969 he became visiting professor at the University of California in Los Angeles. He lived in Hollywood until 1971, where he visited some of the great early film directors, including Jean Renoir, Billy Wilder, and John Ford, to paint their portraits. In 1971 he returned to London.

Under the impact of an exhibition of Degas pastels at the Petit Palais in Paris in 1975, Kitaj introduced pastel crayons into his repertoire. His move towards drawing gradually altered his pictorial style. Instead of creating montages he now sought increasingly to find a new unity of place, time and space. By examining his own Jewish identity in more depth he also found new pictorial solutions, although without abandoning the artistic strategy of quotation and montage.

In 1976 Kitaj organised the controversial exhibition of figurative painting, *The Human Clay*, for the Hayward Gallery in London and coined the title 'The School of London' for the participant artists taking

part, who included Francis Bacon, Frank Auerbach and Lucian Freud. In 1978–79 he stayed in the USA again, where his pastels were exhibited for the first time at the Marlborough Gallery in New York in 1979.

In 1980 Kitaj exhibited a personal selection of paintings from the collections of the National Gallery in London, in the series 'The Artist's Eye'. The following year a retrospective of his work was held at the Hirshhorn Museum in Washington, which then travelled to the Cleveland Museum and the Kunsthalle in Düsseldorf. In 1984 Kitaj was made an Associate Member of the Royal Academy in London, becoming a full Academician in 1991. In 1994 the Tate Gallery in London held a retrospective of his work, which then moved to Los Angeles. In recent years Kitaj has become increasingly interested in the subject-matter of the 'Jewish Passion', inspired by his friendship with the Jewish American writers Philip Roth and Aaron Applefield.

Kitaj lives and works in London and the US. H.D.

R. B. Kitaj, exh. cat., Washington D. C., Hirshhorn Museum and Sculpture Garden, Smithsonian Institution, 1981

John Ashbery, Joe Shannon, Jane Livingstone and Timothy Hyman, *R. B. Kitaj: Paintings, Drawings, Pastels*, London, 1983

Marco Livingstone, *R. B. Kitaj*, Oxford and New York, 1985

Jane Kinsman, *R. B. Kitaj's Prints*, Aldershot, 1994

R. B. Kitaj Retrospective, ed. Richard Morphet, exh. cat., London, Tate Gallery and Los Angeles, County Museum, 1994

PAUL KLEE

was born on 18 December 1879 in Münchenbuchsee, near Bern. Klee learnt the violin and became part-time member of an orchestra. In 1898 he moved to Munich in order to study at the Academy of Painting. His first application was rejected and he attended a private drawing school for preliminary training. Finally, in 1900, he was accepted into Franz von Stuck's class at the Munich Academy.

The academy seemed too conservative to Klee, who left it soon afterwards in 1901. In 1901–02 he travelled through Italy and recorded significant impressions and sketches of ideas in the diary he kept from 1897 to 1918. In May 1902 he returned to Bern, where he continued with his self-taught education. At first Klee devoted most of his time to graphic techniques, such as etching and engraving on plates of glass. During a trip to Paris in 1905 he became acquainted with French art. Back in Munich in 1906, he shared his time equally between artistic production and musical employment as a violinist and music critic. It was only when he encountered works by van Gogh and Cézanne in the art galleries in Munich that Klee started to become more interested in painting. However, his first exhibitions in 1910 at the Art Museum in Bern and the Kunsthaus in Zürich were almost entirely composed of graphic works. Through his

contact with the illustrator Alfred Kubin he received a commission to illustrate Voltaire's *Candide*.

In 1911 he developed important contacts with the contemporary art world in Munich, including Kandinsky, Franz Marc, August Macke, Gabriele Münter and Marianne von Werefkin. At the inaugural exhibition of *Der Blaue Reiter* (The Blue Rider) at the Thannhauser Gallery in 1911, he first encountered the works of Robert Delaunay, which subsequently exerted a strong influence on his own development. Some of Klee's graphics were included in the second exhibition of *Der Blaue Reiter*. Klee was now released from his artistic isolation and took part alongside other members of the avant-garde in the important 'Sonderbund' exhibition in Cologne, in 1912. On a momentous trip to Tunisia with August Macke and Louis Moilliet in 1914 he produced a large number of watercolours, in which he took the final step towards autonomous colour.

In 1916 Klee was called up to the territorial reserve and from 1917 worked in a paymaster's office, which gave him time for his artistic work. Klee's reputation grew to such an extent, as a result of sales and exhibitions of his work during the war, that his name was put forward for a teaching post at the Stuttgart Academy, once the war was over. However, this fell through, on account of internal opposition to his nomination.

In 1920, though, Klee was invited by a unanimous decision to join the teaching staff of the recently established State Bauhaus in Weimar. Klee's greatest influence on the Bauhaus was through his theoretical course on the 'Artistic Theory of Form'. His *Pedagogical Sketchbook* was published in 1926, in the series of Bauhaus books. In 1926 he followed the Bauhaus to Dessau and broadened the range of his teaching to include the themes of proportion, the articulation of planes and polyphony.

During his Bauhaus years (1920–31) he produced a large, complex oeuvre whose inventiveness of techniques and material, thematic diversity and intellectual depth set a standard which endures to this day. In contrast to his colleague Kandinsky, Klee did not unreservedly subscribe to abstract painting; the

extensive repertoire of symbols and forms, which formed the basis for the mysterious synthesis of natural and visionary imagery in his paintings, owed its origins to a deep scrutiny of the phenomena of nature.

In 1931 Klee moved to the Düsseldorf Academy, as a result both of internal difficulties with the Bauhaus organisation and of his increasing lack of enthusiasm for teaching. As a gesture of welcome, the Düsseldorf Kunstverein organised a large exhibition of his work. Around this time, Klee made journeys to Italy and Switzerland. In 1933, after being dismissed without notice by the National Socialist authorities, Klee left Germany to take up residence in Bern.

A large retrospective of Klee's works was shown in the Kunsthalle in Bern, in 1935. In the same year the first symptoms of a serious skin condition caused by measles appeared. He produced only a few works over the next few years. It was only in 1937 that Klee started to work again and he spent the remaining years until his death on 29 June 1940, in Locarno-Muralto, engaged on a large, independent body of late work which was characterised by calligraphic symbols and heavy, biomorphic forms. H.D.

Will Grohmann, *Paul Klee*, Stuttgart, 1954

Paul Klee, Schriften, Rezensionen und Aufsatze, ed. Christian Geelhaar, Cologne, 1976

Otto Karl Werckmeister, *Versuch über Paul Klee*, Frankfurt a. M., 1981

Wolfgang Kersten, *Paul Klee. 'Zerstörung, der Konstrukion zuliebe?'*, Marburg, 1987

Susanna Partsch, *Paul Klee. 1979–1940*, Cologne, 1990

Marcel Franciscono, *Paul Klee: His Work and Thought*, Chicago and London, 1991

Wolfgang Kersten and Osamu Okuda, *Paul Klee. Im Zeichen der Teilung. Die Geschichte zerschnittener Kunst Paul Klees 1883–1940*, exh. cat., Düsseldorf, Kunstsammlung Nordrhein-Westfalen und Stuttgart, Staatsgalerie, 1995

YVES KLEIN

was born in Nice on 28 April 1928. His father, Fred Klein, was a landscape painter, his mother, Marie Raymond, one of the first art informel painters in Paris.

Klein began to paint and evolve his first theories about monochrome painting in 1946. After travelling in Italy and Spain and doing his military service in Germany he went to Japan in 1952, where he obtained his black belt in judo from the Kôdôkan Institute and organised a private exhibition of monochrome paintings in Tokyo. In 1954 he became a teacher and head of technique at the National Judo Federation of Spain in Madrid. He published 150 copies of the book *Yves Peintures* with a 'wordless preface' by Claude Pascal, consisting of lines of text which had been blocked out. In 1955 Klein moved to Paris and submitted an orange monochrome painting for the *Salon des Réalités Nouvelles*, which rejected it. His exhibition at the Galerie Collette Allendy in

Paris in 1956 also met with public incomprehension. The critic Pierre Restany, however, became a fervent apologist of 'Yves – Le Monochrome', whose aim it was to awaken new spiritual energies through pure colour. In his search for pure pigments, in autumn 1956 Klein discovered a luminous deep blue that could only be affixed to the ground with an ether and petroleum solution. The powdery quality of this ultramarine blue was effective, both as a material substance and as a bridge to the spiritual discussion of infinity. Klein thus followed in the footsteps of the Romantics, in their search for absolute spiritual values, of which the colour blue had always been a symbol.

Klein's artistic breakthrough came in 1957, with his exhibition *L'Epoca Blu* at the Galleria Apollinaire in Milan, followed by other major exhibitions in Paris, Düsseldorf and London. Although Klein's next step was to coat various objects such as sponges, stones and roots with his patent IKB (International Klein Blue), he began to take an increasing interest in pure spiritual energy, the 'immaterial component' of painting. The most spectacular event in this respect, *Le Vide* (The Void), took place in 1958, when Klein painted the Galeric Iris Clert white all over and left it completely empty, as a backdrop to an artistic happening that was neither tangible nor visible, in an objective sense, but transformed what was 'immaterial', or indefinable, into an event. Klein's original plan was that the strictly ritualistic opening of the exhibition itself should be accompanied by flood-lighting the obelisks on the Place de la Concorde with the colour blue, but the police forbade this. At the opening itself, Klein made a speech announcing the 'Pneumatic Age' of the incarnation of the spirit, as opposed to the preceding 'Blue Period' devoted to the spiritualisation of the body.

With his *Leap into the Void*, staged in 1960, Klein produced a self-portrait of his artistic universe, a pictorial icon of the twentieth century. The photomontage bearing this title was printed in the sole issue of Klein's newspaper, *Dimanche – Le Journal d'un seul jour*, devoted exclusively to his themes and ideas.

Between the concept of 'the void' and the 'Blue Period', Klein created the 'Anthropometries', comprising physical imprints of women daubed in blue on a white-ground canvas. For Klein the female body, reduced by the imprint to the basic dimension of the torso, was the most concentrated expression of vital energy. Besides the positive imprints he also made negative imprints, by spraying paint around the contours of his models. Klein followed this with large-scale compositions combining the two processes – floating blue bodies, with memories of magic rituals and cave painting.

In his final creative years Klein used three primordial colours for his monochrome paintings, sculptures, sponges and sponge reliefs: blue, pink and gold, all three symbolising vital energies. Klein discovered the same colour sequence in the centre of the flame, which he now also used as a symbol of energy in his 'fire paintings'. With representations of a pillar of fire and a wall of fire, this trilogy of colours became the central theme of a large one-man exhibition in Krefeld in 1961. In 1962 Klein began to make casts of his fellow 'Nouveaux Réalistes', Arman, Martial Raysse and Claude Pascal which he dyed blue and mounted on gilt panels in an effort to revive the symbolic meaning of early Byzantine and Egyptian art.

Klein died of a heart attack in Paris on 6 June 1962.

H. D.

Catherine Krahmer, *Der Fall Yves Klein. Zur Krise der Kunst*, Munich, 1974
Yves Klein, 1928–1962: A Retrospective, exh. cat., Houston, Rice University, Institute for the Arts, 1982
Pierre Restany, *Yves Klein*, Munich, 1982
Yves Klein, exh. cat., Paris, Musée National d'Art Moderne, Centre Georges Pompidou, 1983
Sidra Stich, *Yves Klein*, exh. cat., Cologne, Museum Ludwig and Düsseldorf, Kunstsammlung Nordrhein-Westfalen, Stuttgart, 1994; Engl., London, Hayward Gallery, 1995

OSKAR KOKOSCHKA

was born on 1 March 1886 in Pöchlarn near Vienna. In 1887 the family moved to Vienna where, in 1904, Kokoschka began his studies at the School of Applied Arts with the help of a state scholarship. While still a student he joined the Wiener Werkstätten (Vienna Workshops) and designed postcards, fans and vignettes.

In 1908 Kokoschka published his first volume of poetry, *Die träumenden Knaben* (The Dreaming Youths), with his own illustrations. In the same year, at the *Kunstschau* (Art Show) jointly organised by the Vienna Secession and the Wiener Werkstätten, he exhibited some tapestry designs and a number of drawings and gouaches of female nudes which both delighted and scandalised Viennese society. He was given encouragement by Gustav Klimt and, above all, the Viennese architect Adolf Loos, who took him with him on trips over the next few years and provided him with financial support. Kokoschka left the Wiener Werkstätten to become a well-known, if con-

troversial, portrait painter. He brought a new, psychological approach to his subjects, whom he sought to analyse through their features and gestures and the application of the medium, rather than focussing on their good looks or an exact likeness. In his use of subdued tones, undefined areas and seemingly disintegrating physical outlines, often scratched out with the handle of his brush, Kokoschka tried in these early portraits to project nervous tension and a generally morbid atmosphere.

In 1910, during a stay in Berlin, Kokoschka met Herwarth Walden and the group associated with 'Der Sturm', with which he subsequently became closely involved. His play *Mörder, Hoffnung der Frauen*, (Murderer Hope of Women), which was published in the magazine *Der Sturm* (The Storm), showed off his talents as an Expressionist writer. In Vienna in 1912 Kokoschka met Alma Mahler, the widow of the composer Gustav Mahler, with whom he had a passionate affair which lasted until 1915. Her features can be seen in countless of his paintings, drawings and prints. As assistant to the head of the life class at the School of Applied Arts from 1912 to 1913, he taught drawing from the nude for a period, but he remained in financial difficulties as he had to support family. Starting in 1911 he produced a series of large-scale oil paintings on biblical themes which, inspired by Cubist examples, were subdued in tone and covered in networks of prismatic brushstrokes. He volunteered for the army on the outbreak of war and was badly wounded in 1915. He then applied for a professorship at the Dresden Academy of Art, but the appointment was not confirmed until after the end of the war, in 1919. He never fully recovered from the rupture with Alma, and the ensuing depression he suffered from, as a result, led to a change in his style. He started to apply paint more thickly, using brighter colours and drawing thick, terse tracks across the canvas with his brush. This left the motif in a state of nervous agitation, as it struggled to surface in a turbulent sea of colour.

In the 1920s Kokoschka's work gained in popularity throughout Europe, and in addition to his professorship a contract with the Berlin gallery-owner Bruno Cassirer provided him with a monthly income. In

1921 he began to produce views of cities, which became the focus of his work over the next few years. From 1924 he adopted Paris as his second home and travelled to Switzerland, France, England, Spain, Italy, the Middle East and North Africa. He did not return to Vienna until 1933, but faced with the threat of Nazi rule he fled via Prague to England, where he remained throughout the Second World War, taking British nationality in 1947. As a reaction to the *Entartete Kunst* (Degenerate Art) exhibition in 1937, where eight of his works were shown, he painted his *Selbstbildnis als entarteter Künstler* (Self-Portrait as a Degenerate Artist).

After the war Kokoschka settled in the town of Villeneuve on Lake Geneva and made a number of trips throughout Europe and America. Between 1953 and 1963 he directed the 'Schule des Sehens' (School of Seeing) at the Salzburg Summer Academy. His late work is characterised by great colourfulness and expressive brushwork, but without neglecting the subject, and his late portraits, in particular, represent a singular achievement. In major tryptychs such as the *Prometheus-Saga* (1950) and *Thermopylae* (1954) Kokoschka once again vehemently defended his fundamental humanist beliefs. As well as extensive series of paintings he also produced illustrations and stage designs for the Salzburg Festival, the Burgtheater in Vienna and the Opera Festival in Florence. Kokoschka died at a ripe old age on 22 February 1980 in Montreux. H. D.

Fritz Schmalenbach, *Oskar Kokoschka*, Königstein i.T., 1967
Gerhard J. Lischka, *Oskar Kokoschka: Maler und Dichter*, Bern and Frankfurt a. M., 1972
Frank Whitford, *Oskar Kokoschka. A Life*, London, 1986
Oskar Kokoschka 1886–1980. Gemälde, Aquarelle, Zeichnungen, exh. cat., Zürich, Kunsthaus, 1986
Oskar Kokoschka 1886–1980, ed. Richard Calvocoressi, exh. cat., London, Tate Gallery, 1986
Oskar Kokoschka, ed. Klaus A. Schröder and Johann Winkler, exh. cat., Vienna, Kunstforum, Munich, 1991.

WILLEM DE KOONING

was born on 24 April 1904 in Rotterdam. In 1916 he began to train as a commercial and display artist at the same time as attending evening classes at the Rotterdam Academy until 1924. He went on to study at the Académie Royale des Beaux-Arts in Brussels and the van Schelling Design School in Antwerp. In 1926 he decided to emigrate without valid papers to the USA, where he at first worked in New York as a commercial artist, window-dresser, sign painter and joiner.

In New York de Kooning met artists such as John Graham, Stuart Davis and Arshile Gorky and worked for the WPA Federal Art Project, for which he produced murals between 1935 and 1939, including a number for the World Exhibition in New York, in 1939. From 1935 he concentrated exclusively on

painting and was involved in the 1936 exhibition *New Horizons in American Art* at the Museum of Modern Art. De Kooning's paintings were first influenced by the Surrealist style of Gorky, with whom he shared a studio, and the paintings of Picasso. A second important source of inspiration came from the gestural branch of the New York School, represented by Jackson Pollock and Franz Kline. His black-and-white abstracts of 1946, which he had resumed in 1959, also had their roots there.

His first solo exhibition was held in 1948 at the Charles Egan Gallery in New York, from which the Museum of Modern Art bought a first painting. In the same year de Kooning lectured at Black Mountain College in North Carolina, and from 1950 to 1951 he taught at Yale University in New Haven, Connecticut.

In addition to biomorphic abstracts de Kooning worked during this period on figurative paintings, which in the 1940s he reduced to two-dimensional, fragmentary shapes. From 1950, under the influence of Pollock's and Kline's gestural painting, he produced a series of pictures of women whose wild vulgarity, vehement brushwork and glaring colours provoked a violent reaction among the public. These paintings, which have formed a leitmotif running through his work from the 1950s to the 1980s and 1990s, became a kind of trademark. Like Pollock's drip paintings or Kline's gestural abstracts, de Kooning's *Women* are key works for the twentieth century which have inspired and encouraged young artists from all kinds of backgrounds. But it would be unwise to suppose that de Kooning's treatment of this theme, which Sidney Geist described as something between 'cave-drawings and toilet graffiti', was all he could do. The female body was transformed into a landscape and painting into 'an adventure', where colours were thrown together in thick profusion and the sexual connotations of the subject, for which de Kooning was occasionally criticised, swamped by the greater immediacy of the central concern with the interaction between colour and space. In fact it was only a small step from the *Women* to purely abstract landscapes, such as *Woman*

as Landscape (1955). A series of tonally balanced paintings with landscape associations produced at the end of the 1950s and the beginning of the 1960s showed how much de Kooning relied on the European artistic tradition, which other American painters had long since declared outdated.

In 1951 de Kooning was awarded the Logan Medal and the Purchase Prize of the Art Institute of Chicago for his abstract painting with figurative allusions, *Excavation* (1950). This brought him fame as one of the leading exponents of Abstract Expressionism, although it would take several more years of alternating between figurative and abstract subjects before the full range of de Kooning's work received just recognition. He finally received acclaim at the 1954 Venice Bienniale, where twenty-six of his paintings were displayed. From 1969 onwards de Kooning also took to producing bronze sculptures with figurative subjects, caught mid-way between congealment and dissolution, suspended somewhere between solid and liquid form.

In 1961 de Kooning received American citizenship, moving a year later to The Springs near East Hampton, where he established one of America's most legendary artist's studios.

Willem de Kooning died at The Springs on 19 March 1997. H. D.

Harold Rosenberg, *Willem de Kooning*, New York, 1974
David Sylvester and Andrew Forge, *The Sculptures of de Kooning with related Paintings, Drawings and Lithographs*, exh. cat., Edinburgh, Fruitmarket Gallery and London, Serpentine Gallery, 1977.
Harry F. Gaugh, *Willem de Kooning*, Munich and Lucerne, 1984
Willem de Kooning, Retrospektive, Zeichnungen Gemälde, Skulpturen, ed. Paul Cummings, Jörn Merkert and Claire Stoullig, exh. cat., New York, Whitney Museum of American Art, Berlin, Akademie der Künste and Paris, Musée National d'Art Moderne, Munich, 1984
Diane Waldman, *Willem de Kooning*, London, 1988
Willem de Kooning, Paintings, ed. Marla Prather, exh. cat., Washington, National Gallery of Art, New York, Metropolitan Museum of Art and London, Tate Gallery, 1994

JEFF KOONS

was born in York, Pennsylvania on 21 January 1955. At the age of eight Koons copied prints of the Old Masters, which his father hung in the windows of his interior design shop. Koons attended the Maryland Institute of Art in Baltimore from 1972 to 1975 and painted surrealist dream pictures and landscapes. In 1975–1976 he went on to the School of the Art Institute of Chicago, where he studied theories of contemporary art with Ed Paschke.

In 1976 Koons moved to New York, where he established contact with the New York music and art scene and worked in the membership department of the Museum of Modern Art in New York, before

embarking on a successful career as a Wall Street broker.

Koons' first attempts to reinterpret Duchamp's notion of the readymade in the context of 1980s consumerism took the form of putting garish inflatable toys in plexiglass boxes and placing them on a plinth. For his subject-matter and aesthetic he turned to the strategies of Pop Art. He had his first one-man show in the New Museum of Contemporary Art in New York in 1980, where he exhibited his first series of sculptures, *The New*. Household appliances such as a range of brand-new Hoovers were shown in illuminated display cases, and their elevation to museum status gave them a subliminal erotic and fetishistic character (*New Hoover Convertible*, 1980). Another series of works, based on industrially manufactured objects, was shown at the International with Monument Gallery in New York under the title *Equilibrium*, in 1985; it included basket balls submerged in aquariums and bronze casts of a rubber dinghy.

Koons takes as his central themes the class structure, the world of luxury goods and the art market. In his series *Luxury and Degradation* of 1986, he focussed on creating an 'artificial luxury', i.e. an 'artistic value' capable of transforming objects. Once again he took objects from the everyday material world such as a bucket, a model railway or a kitsch toy, and had them cast in high-grade steel, as in the case of his huge cast of an inflatable rabbit (*Rabbit*, 1986). The *Banality* series consisted of monumentalised knick-knacks, reproduced three times over and shown concurrently in Chicago, New York and Cologne, in 1988. Here he exposed the strategies of the art market and the posturing of artists, in statements and a series of adverts, in which he styled himself the superstar of the art scene. His artistic self-promotion, calculated irony and professional knowledge of the strategies and machinations of the art market have made Koons a major artist of the late eighties: 'My art is among the best currently being made... This century had Picasso and Duchamp, I am leading us out of the twentieth century.'

Koons marketed his marriage in 1991 to the Italian porn star and politician Ilona Staller (La Cicciolina), for strategic ends. Back in 1989 he rented a billboard on Broadway, in New York, to advertise his film *Made in Heaven*, with La Cicciolina and himself in the main roles. After his effective stage-management of their romantic white wedding the *Made in Heaven* exhibition, shown in 1991 and 1992 in Cologne and New York, caused a sensation: huge colour photos reproduced in silk-screen on canvas and small, kitsch glass figures showing the Koons couple making love with what seemed like unaffected naïvety furnished a provocative combination of porn, kitsch and idyll. Retrospectives of Koons' work have been held in the Stedelijk Museum, Amsterdam, the Staatsgalerie Stuttgart, the San Francisco Museum of Modern Art and the Walker Art Center, Minneapolis, in 1992–93. Koons lives and works in New York. H.D.

Jeff Koons, exh. cat., Chicago, Museum of Contemporary Art, 1988
Jeff Koons, exh. cat., San Francisco Museum of Modern Art, 1992
Jeff Koons, ed. Angelika Muthesius, Cologne, 1992
Jeff Koons: Celebration, exh. cat., New York, Solomon R. Guggenheim Museum, 1996

JANNIS KOUNELLIS

was born on 23 March 1936 in Piraeus. He moved to Italy in 1956 and enrolled as an art student at the Academy of Fine Arts in Rome. Kounellis was particularly interested in Kazimir Malevich's work, and also in the Italian artists Alberto Burri, Lucio Fontana and Piero Manzoni.

From 1958 to 1965 Kounellis responded to the Informel movement in Europe by using stencils to print unprimed canvases and paper with letters, figures and symbols such as arrows or plus and minus signs. His main concern was to avoid references of any kind, so that the signs stood only for themselves. He exhibited these works at his first one-man show in the Galleria La Tartaruga in Rome, in 1960.

Kounellis stopped work as an artist for two years from 1965, and after that increasingly detached himself from the European art tradition. He was aiming for a new artistic language, and at staging the culture of life in such a way that it penetrated and united all levels of society, as in ancient Greece. Kounellis drew on Burri's material art, incorporating various mater-

ials and objects in his work and thus opening up the boundaries of painting. He preferred organic materials (coal, cotton wool, wool, hair, stones) and mass-produced objects (jute sacks, bedsteads, casts of ancient statues), which he used as metaphors or conceptual images.

Kounellis exhibited at the first *Arte Povera* exhibition in Genoa in 1967. This 'poor' art used simple materials, which for Kounellis were all the more viable as bearers of spiritual and psychological energy because they were not traditionally associated with artistic production and could therefore be used in highly expressive ways. In 1969 Kounellis' spectacular installation *Senza titolo (Dodici cavalli)* (Untitled (Twelve Horses)) was the opening show at the new L'Attico gallery in Rome. These impulsive creatures, moved into the context of the gallery, provided a metaphor for a vital and individual society, and for the way it communicated dynamically through the exchange of feelings, emotions and ideas.

During the social and political upheavals of the late sixties Kounellis introduced the medium of fire into his work, as a symbol of change, energy, purification or inspiration, but also of destruction. In 1969 he installed gas jets on the walls of the Galerie Iolas in Paris, and in Turin flames licked across one of Gian Enzo Sperone's studio floors like hand-laid fuses. Other works used sooty surfaces and extinguished flames as devices for alluding to vestiges of past cultures or, in the sixties, to a decline in political activity. Entrances closed off with a whole variety of materials, casts of ancient sculpture with blindfolded eyes and windows hung with sheets of lead all served to convey Kounellis' idea that a truly spiritual artistic vision was no longer recognised in modern society.

In contrast with the progressive ideas of the Futurists or of Fontana or Manzoni, who sought to give vital expression to the universalist spatial dynamics of modern physics, Kounellis used allegorical devices to create a mood of pessimism. His unrelated accumulation and isolation of things was reminiscent of 'Pittura Metafisca', to which Kounellis often referred with motifs drawn from Giorgio de Chirico, such as a tower, a train or a cast of an ancient sculpture. Both the material processes and the fragmented plaster casts took transience as their subject, which could be experienced in front of an iron sheet, an empty wall or a window, as a symbol of immaterial reality. In this context antiquity acquired the role of a lost Arcadia.

Kounellis started working for the theatre in the late sixties, and has designed sets for many productions, including *Uscite* and *Didone* in Genazzano in 1982, Arnold Schönberg's *Die glückliche Hand* in Amsterdam in 1990, and Heiner Müller's *Mauser* in Berlin in 1991.

Kounellis' work has featured in many major exhibitions, including *documenta 5, 6,* and *7* in Kassel; he has been given large one-man shows at venues including the Stedelijk Van Abbemuseum in Eindhoven in 1981, the Musei Comunali in Rimini in 1983, the Gemeentemuseum in The Hague in 1990, and the Padiglione d'Arte Contemporanea in Milan in 1992. Kounellis lives and works in Rome. H.D.

Kounellis, exh. cat., Paris, ARC, Musée d'Art
Moderne de la Ville de Paris, 1980
Jannis Kounellis, ed. Helmut Friedel, exh. cat.,
Munich, Städtische Galerie im Lenbachhaus, 1985
Jannis Kounellis: A Retrospective, exh. cat., Chicago,
Museum of Contemporary Art, 1986
Kounellis, ed. Gloria Moure, Barcelona, 1990
Jannis Kounellis, *Ein Magnet im Freien*, Bern and
Berlin, 1992

BERTRAND LAVIER

was born in Châtillon-sur-Seine on 14 June 1949. He
started to study horticulture at the Ecole Nationale
Supérieure d'Horticulture in Versailles, but aban-
doned the course in 1972 to concentrate exclusively
on his work as an artist.

Lavier's early work was influenced by the art of the
late sixties, especially Conceptual Art and Land Art,
which led him to experiment with ways of reproduc-
ing perceptions of reality in artistic terms. He was
interested in the instruments available for artistic
representation, and so photography, painting and
language all form part of his technical repertoire.

Lavier's first pictures used simple, vertical brush-
strokes, which overlapped in places, and were repro-
duced photographically and drawn in pastel on the
same pictorial surface. The picture series *Landscape
Painting and Beyond*, on which Lavier was working
in the late seventies, also juxtaposed photography
and painting as means of producing images: a
poster-size colour photograph of a landscape detail
was continued in paint, but did not correspond in
terms of illusion since the pictorial motif was shifted
closer in perspective without a transition, thus break-
ing the uniform spatial illusion.

In the early eighties, Lavier took up the idea of the
readymade, but made one crucial change: he used
mundane, mass-produced everyday objects, such as
a camp-stool, a ladder or a refrigerator, and gave
them a thick coat of paint. The paint applied fol-
lowed the original colouring precisely, and also any
markings or writing on the object. Thus the white
refrigerator was painted white, its silver door handle
silver, and the gold script of the brand name was
given a coat of gold. In this way Lavier stressed both
the painterly and the imitative aspect. At the same
time he altered the concept of the readymade in
such a way that art's ability to be recognised was

questioned, but its genres also lost their categoric
unambiguity. Lavier blurred the distinction between
sculpture and painting in such a way that he ran
counter to the relationship between real objects and
their artistic copies.

From 1984 Lavier produced more works using mun-
dane objects, but installed them in twos, one object
on top of another. No alienating paint was used, and
the emphasis shifted to the sculptural aspect of the
objects. He seemed to be interested in the fundamen-
tal question of the possibilities and values of modern
sculpture. By placing two objects, raised to the status
of sculpture, one on top of the other, Lavier was also
alluding to the traditional presentation of sculpture
on a plinth – but this association was again broken by
the properties of the two objects: a refrigerator on an
upholstered armchair, a plastic chair on a refrigera-
tor, a ship's propeller on a lavatory cubicle. The
works gained their titles from the brand names of
the objects concerned, e.g. *Ikea/Zanussi* or *Knapp-
Monarch/Solid Industries* (both 1986). In the early
nineties, Lavier finally came to use museum-style
presentation, with a plinth: *Motobecane* (1993), a
demolished motor bike, or *Giulietta*, a red Alfa
Romeo, ready for the scrap-heap, were placed on
neutral white plinths, thus expressly claiming the
status and attention due to a work of art.

Lavier's work has featured in numerous interna-
tional exhibitions of contemporary art, including
documenta 7 (1982) and *8* (1987) in Kassel, the Sidney
Biennale (1982, 1986, 1992) and the *International Sur-
vey of Painting and Sculpture* at the Museum of Mod-
ern Art in 1986. Major one-man exhibitions have
been held in venues including the Kunsthalle Bern in
1984, the Musée des Beaux-Arts in Dijon in 1986, the
Musée National d'Art Moderne in Paris in 1991 and
the Castello di Rivoli, near Turin, in 1996.

Lavier lives and works in Aignay-le-Duc, on the
Côte d'Or. C.T.

Bertrand Lavier, exh. cat., Villeurbanne-Lionne,
Le Nouveau Musée and Bern, Kunsthalle, 1983
Bertrand Lavier, 'Bertrand Lavier', exh. cat., Paris,
Musée d'Art Moderne de la Ville de Paris, 1985
Bertrand Lavier, exh. cat., Dijon, Atheneum, Le Con-
sortium, Musée des Beaux-Arts and Grenoble,
Musée de Peinture et de Sculpture, Dijon, 1986
Bertrand Lavier, exh. cat., Paris, Musée National
d'Art Moderne, Centre Georges Pompidou, 1991
Bertrand Lavier, exh. cat., Vienna, Museum moderner
Kunst, Stiftung Ludwig, 1992
Bertrand Lavier, ed. Ida Gianelli and Giorgio
Verzotti, exh. cat., Turin, Castello di Rivoli, Museo
d'Arte Contemporanea, Milan, 1996

FERNAND LÉGER

was born on 4 February 1881 in Argentan in Nor-
mandy. Between 1897 and 1899 he served as an
apprentice to an architect in Caen and subsequently
worked until 1902 as an architectural draughtsman
in Paris. After completing his military service in
1902–03 he applied to the Académie des Beaux-Arts

in Paris and was rejected, but he was accepted
instead at the Ecole des Arts Décoratifs. As an inde-
pendent student he worked in the studios of
Jean-Léon Gérôme and Gabriel Ferrier and at the
Académie Julian, at the same time as making draw-
ings in the Louvre.

Léger's first paintings were heavily influenced by
Impressionism. The Cézanne retrospective in 1907,
which made a great impression on the entire avant-
garde movement in Paris, also shaped Léger's artistic
style and ideas over the next few years. In 1911 at the
Salon des Indépendants he exhibited his first inde-
pendent work, *Nus dans la forêt* (Nudes in the Forest,
1909–10), a mesh of cubes, cylinders and spheres
which translated Cézanne's dictum into machine lan-
guage. Daniel-Henry Kahnweiler placed him under
contract, as he had already done with Picasso and
Braque. Under the influence of Delaunay, Léger
started to introduce colour into his paintings, and his
work came to be determined by the formal principle
of setting up a conflict between contrasting colours
and conflicting forms. He gave a number of lectures
calling for a new way of vividly depicting the mod-
ern world with all its rhythms and dynamics.
Inspired by the literature and paintings of the Italian
Futurists his compositions began to become harder
and more multifaceted, with an increasing emphasis
on the analogy between man and machine. His new
interest in people, and in particular workers,
mechanics and craftsmen, was followed by a change
in his understanding of art, in which he moved away
from abstraction towards a new kind of imagery that
was to convert the drama of the modern world into
generally comprehensible forms.

With his new 'machine age' phase between 1917 and
1923, which combined geometrical shapes represent-
ing mechanical elements (propellers, cylinders,
disks) with the use of symbolic colours, Léger trans-
lated the simultaneity of the modern city into a clear
shorthand. In 1920 he founded the gallery and maga-
zine *Esprit Nouveau*, which brought together contri-
butions from noted artists, writers and architects,
including Le Corbusier, on all aspects of modern life.
His various contacts with the art movements of his
time – De Stijl and Bauhaus, Purism and Constructi-
vism – also influenced his artistic activities. In 1924
he directed the film *Ballet mécanique*, a rhythmic
montage of real and abstract elements. In 1925 he col-
laborated with Delaunay, Laurens and Barillet to pro-
duce murals and decorative work for the *Salon des
Arts Décoratifs*.

Léger's *Composition aux trois figures* (Composition
with Three Figures, 1932) marked the beginning of a
renewed preoccupation with the human figure
which, as in Picasso's neoclassical paintings, gave the
human form a static, monumental appearance, in
contrast to the surrounding objects and areas of
colour. Léger received fresh inspiration from a num-
ber of sources in the USA, which he visited for the
third time in 1938, when he was commissioned to
paint some murals in the home of Nelson A. Rocke-
feller. In 1940, as the situation in Europe deteriorated,
he decided to emigrate to the USA and taught at var-
ious universities there between 1940 and 1945. There

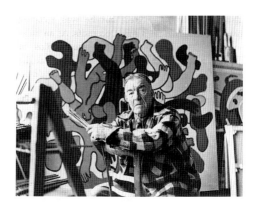

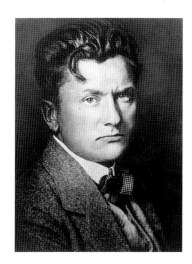

followed a wide range of new works, in which Léger, inspired by the neon signs on Broadway, reverted to 'pure colour', which he blocked in over whole sections of his crowded compositions. When the war ended Léger returned to France and joined the Communist Party, after which he went on to produce numerous paintings emphasising the social aspects of communication and understanding. He developed a greatly simplified, poster-like style, in which the rich complexities of the material world were swept aside, in favour of a much clearer definition of space. In addition to his painting Léger also continued to produce decorations and stage designs, such as those for *Bolivár* by Darius Milhaud at the Paris Opera in 1949. Between 1951 and 1954 he produced stained-glass windows in plate glass and concrete for the churches of Audincourt and Courfaivre (Switzerland) and the University of Caracas (Venezuela), and in 1952 he painted the mural for the main debating chamber of the UN in New York. He also produced a large quatility of ceramics at his studio in Biot. The sculptures, ceramics and mosaics making up his interior design for 'Gaz de France' in Alfortville were completed shortly before his death.

Léger died on 17 August 1955 in Gif-sur-Yvette.

H.D.

Christopher Green, *Léger and the Avant-Garde*, New Haven and London, 1976
Werner Schmalenbach, *Fernand Léger*, Cologne, 1977
Fernand Léger, exh. cat., Berlin, Staatliche Kunsthalle, 1980
Léger, exh. cat., Stuttgart, Staatsgalerie, 1988
Fernand Léger 1911–1924. Der Rhythmus des Modernen Lebens, ed. Dorothy Kosinski, exh. cat., Wolfsburg, Kunstmuseum and Basel, Kunstmuseum, Munich, 1994

WILHELM LEHMBRUCK

was born on 4 January 1881 in Duisburg-Meiderich, the son of a mining family. From 1895 to 1899 he attended the School of Arts and Crafts in Düsseldorf and from 1901 to 1907 the Academy of Art, where he studied under Karl Janssen.

In his early work Lehmbruck dealt with traditional subjects in a naturalistic and, occasionally, academic and idealised manner. Towards the end of his time at the Academy he produced a number of sociocritical works involving realistic subjects from the world of workers, miners and beggars. Typical of these were his workers' memorial of 1906 and his depiction of a mining accident in the *Schlagende Wetter* (Firedamp) group (destroyed). He gradually abandoned the academic rules of form, using increasingly simplified shapes and adopting a more severe style. His tectonically constructed, firmly contoured, nudes show a similarly expansive approach.

Lehmbruck went on study trips to Italy in 1905–06 (and again in 1912) and to Paris in 1907–08. He lived in Paris from 1910 to 1914, taking part in the *Salon d'Automne* in 1910 and the *Salon des Indépendants* in 1911 and 1912. He was friendly with other artists such as Alexander Archipenko, Constantin Brancusi, André Derain, Henri Matisse and Amedeo Modigliani. Instead of working with traditional materials such as plaster, clay, marble and bronze, Lehmbruck, like Brancusi, began to experiment with stone and cement casting, partly for financial reasons. Alongside his sculptures he also produced just under 50 paintings after 1910, most of which show sketchily drawn figures or groups of figures in transparent colours, in a style inspired by the likes of Edvard Munch and Georges Rouault.

The first sculptures produced in Paris clearly show the influence of Rodin and Maillol, although the spiritualised expression of his figures was already clearly one of his own stylistic trademarks. In 1911 he developed a new sculptural idiom, in his stone cast of the larger than life-size *Kniende* (Kneeling Woman), which was exhibited with great success in the *Armory Show* in New York. (This work was to form the centrepiece of the National Socialist propaganda exhibition of 'Degenerate Art'.) *Kniende* illustrates Lehmbruck's rejection of the rules of classical proportion in favour of greater expressiveness. His extremely elongated, narrow-limbed, almost fragile-looking figures (nudes and torsos) are – despite the emphasis on certain details – reduced to basic shapes and given extremely expressive surface treatment.

The figures which followed had an ascetically spiritual quality, with a lyrical, mournful expression reminiscent of Gothic sculptures which became a symbol of Expressionism in sculpture. The use of colour in Lehmbruck's sculptures, must also be regarded as an innovation. The colouring of the casts and the frequent use of surface colour after casting establish a certain homogeneity of form and colour that was unique in its time.

The female torso and the figure of a young man became the central features of Lehmbruck's work. In Paris he produced *Emporsteigender* (Rising Youth, 1913), *Große Sinnende* (Large Contemplative Female Figure, 1913–14), *Rückblickende* (Woman Looking Back, 1913–14) and *Badende* (Bathing Woman, 1913–14), all of which reflect the influence of French Cubism, in their treatment of volume and tectonics. However, the Cubist form here was always merely an interim stage on the way to expressive contours: 'the proportions define the impression … a good sculpture must therefore be handled like a good com-position, like a building where the dimensions are in tune with each other, and this is why we must also not reject detail, since it is by detail that the large-scale is measured… So you cannot have monumental, architectonic art without an outline or silhouette, and a silhouette is nothing more than a surface' (Lehmbruck).

At the beginning of the war Lehmbruck returned to Berlin, where he worked for a short time as a medical orderly. Devastated by his experiences, he moved to Zürich in 1917–18, where he set up a studio and exhibited at the Kunsthaus. There he produced his final works, in which he moved away from the influence of his Paris years. In 1919 he returned to Berlin, where his mental state and his financial situation deteriorated.

Lehmbruck committed suicide in Berlin on 25 March 1919.

H.D.

August Hoff, *Wilhelm Lehmbruck*, Berlin, 1933
Werner Hofmann, *Wilhelm Lehmbruck*, Ahrbeck and Munich, 1964
Henning Bock, Wilhelm Lehmbruck, exh. cat., Berlin, 1973
Dietrich Schubert, *Die Kunst Wilhelm Lehmbrucks*, Worms, 1981
Hommage à Lehmbruck. Lehmbruck in seiner Zeit, ed. Siegfried Salzmann, exh. cat., Duisburg, Wilhelm-Lehmbruck-Museum, 1981
Wilhelm Lehmbruck. Zeichmungern, ed. Erich Franz, exh. cat., Zürich, Kunsthaus, 1991

ROY LICHTENSTEIN

was born on 27 October 1923 in New York City. In 1940 he attended painting courses given by Reginald Marsh at the Art Students League. Between 1940 and 1942 he was an art student at Ohio State University in Columbus. During his military service from 1943 to 1946, when he was stationed in Europe, he produced landscape drawings and portraits of soldiers. After the end of the war he continued his studies until 1949 and painted subjects from American genre

and history painting in a style which incorporated elements of Cubism and Expressionism. He moved to Cleveland in 1951 and held his first, relatively unsuccessful, solo exhibition at the Ten-Thirty Gallery. In the meantime, he earned his living as an art teacher, technical draughtsman and window decorator. In his paintings he continued to concentrate on typically American subjects and built objects out of scraps of wood in a style somewhere between Cubism and Expressionism. From 1957 to 1960 he taught at New State University in Oswego, New York, then from 1960 to 1963 at Douglass College, Rutgers University in New Brunswick, New Jersey. Between 1957 and 1960 he produced non-figurative Abstract Expressionist paintings and his first drawings of figures from comic strips.

Through his acquaintance with Allan Kaprow Lichtenstein found out about the new Happening and Performance art and became interested in working on themes related to America's consumer society. At the beginning of the 1960s he abandoned his gestural-abstract style and took inspiration for his themes and designs from the images of mass culture. In 1961 he produced six large-scale oil paintings of comic-strips images, reproducing accurately everything, even down to the speech bubbles and dot-printing. Leo Castelli immediately brought him under contract and launched his career, as one of the leading exponents of Pop Art.

Lichtenstein's 'trademark' became the subjects from the world of consumer goods and everyday mass culture – always painted in black and white or primary colours – which he found in small ads in trade magazines or as illustrations in mail-order catalogues or romance or war comics, and which he developed in various series (household objects, food, war and violence, science-fiction, etc.). He took these as raw material, analysed their graphic qualities and translated them into his own particular style. The resulting pictures drew life from the ambivalence of the drily stereotypical technique and the heightened sense of drama generated by the choice and presentation of the subject.

In the 1960s and 1970s Lichtenstein produced his dot reproductions of modern classic masterpieces

(Cézanne, Matisse, Léger, Mondrian) or of particular styles (Futurism, Purism, Surrealism). In the *Brushstroke* series (1965–66) he examined the gestural brushstrokes of Abstract Expressionism with an ironic eye, typical of the artistic spontaneity and creativity which also inspired him to produce a mechanical dot picture. The *Mirror Paintings* (1969–72) dealt with optical illusions; another series dealt with the subject of the artist's studio, in which Lichtenstein alluded to various phases of his own work.

Since 1970 Lichtenstein designed a number of huge murals, such as those for the Medical Faculty of Düsseldorf University, the Leo Castelli Gallery in 1983, the Equitable Tower in New York in 1986 and the Tel Aviv Museum of Art in 1989.

In the 1980s Lichtenstein's pictures became increasingly complex; he combined an approach which owed much to Abstract Expressionism with areas painted using his mechanical dot technique, or else he painted contrasting pictures within pictures. His increasing preoccupation with the history of art and of his own work is evident from his 1988 series *Reflections*, in which he returned to the comic-strips which he had already used previously. In the 1990s he has also increasingly turned to making sculpture. Lichtenstein lives and works in New York City and Southampton, Long Island. H.D.

Roy Lichtenstein, ed. Jon Coplans, New York and Washington DC, 1972
Lawrence Alloway, *Roy Lichtenstein*, New York, 1983
Jack Cowart, *Roy Lichtenstein 1970–1980*, St. Louis Art Museum, 1982
Roy Lichtenstein, Die Zeichnungen 1961–1986, ed. Bernice Rose, exh. cat., New York, The Museum of Modern Art, 1987 and Frankfurt a. M., Schirn Kunsthalle, 1988
Janis Hendrickson, *Roy Lichtenstein*, Cologne, 1988
Roy Lichtenstein, ed Diane Waldman, exh. cat., New York, Solomon R. Guggenheim Museum, 1993
The Prints of Roy Lichtenstein. A Catalogue raisonné 1949–1993, ed. Mary Lee Corlett, Washington, Los Angeles and Dallas, 1994

RICHARD LONG

was born in Bristol on 2 June 1945. He studied at the West of England College of Art in Bristol from 1962 to 1965 and at St Martin's School of Art in London from 1966 to 1968.

Since the late 1960s Long's art has been inspired by his walks all over the world, mainly on Dartmoor near Bristol and in the Scottish Highlands, but also in Alaska, the Sahara, South America, Nepal and Australia. Long makes detailed preparations for some of these walks, using maps, and then exhibits the maps together with photographs of the works he has created and left behind. Other walks follow their own rules, or the rules imposed by nature. They are also documented by photographs and texts in which Long names the places, the distances travelled, the point of departure and the objective of the walk, sometimes also the colours, winds, and the system

according to which he has structured the walk or the time it took.

One of Long's earliest works, *A Line made by Walking* (1967), already indicates a basic principle of his artistic approach: by repeatedly walking back and forth he marked a straight line on an area of grass. He later discovered the circle as an expressive element, by the same spontaneous and simple method. He has taken up both these basic elements, the line and the circle, again and again, though with variations in material and dimensions.

For Long, the physical action of walking frees the spirit, allows him to experience nature and bring body and spirit in harmony with nature. Long's works reflect a pre-modern concept of time; on the one hand they demonstrate the transitory nature of things, while on the other they draw attention to the rhythms of nature. The act of walking in a landscape, which leaves traces, creates new forms inhabited by time and history. The sculptures made from stones or branches, which he documents photographically, primarily mark the place in which he is interested, but at the same time they signify 'time as an accumulation of steps' (Long); they define a limited period of time and become an image of time.

From the outset Long has worked both outside, in the open, and indoors. In 1967 he made a circle of sticks in a field in the north of England and then brought it to St Martin's School to be viewed. In his first one-man exhibition in 1968, at the Galerie Konrad Fischer in Düsseldorf, he laid out parallel rows of branches of varying lengths and thicknesses; the rows ended where they met the wall. The branches came from Bristol, where he was born – more specifically, from the gorge of the same river Avon, from which he was later to take the material for his paintings of *Mud-Circles* on gallery walls. Photographs of a bridge and a cyclist indicate the place of origin of his material. It was only in this interplay between nature and civilisation, accident and design, space and time, that these 'found objects' from nature became a work of art. Another work, *A Line of the Length of a Straight Walk from the Bottom to the Top of Silbury Hill*, which Long showed in the Dwan Gal-

lery in New York in 1970, radiated the same meditative peace typical of his work. In the gallery, he retraced in his muddy shoes the line which he had followed in a walk along a prehistoric earthwork in the country, thereby creating a pattern, as an ancient symbol of growth and development and expression of Long's feeling for the individual quality of the spaces in which he presents his work.

It is above all this careful, restrained treatment of nature that distinguishes Long's work from the Land Art of his American fellow-artists, such as Walter De Maria, Michael Heizer and Robert Smithson, who often made massive use of technology for their projects, resulting in irreparable incursions into nature. The sculptures Long leaves behind him on his walks are transitory or destroyed by the artist himself, after he has photographed them in position in the landscape.

In 1988 Long was awarded the Aachen Art Prize; in 1989 the Tate Gallery in London awarded him the Turner Prize. In 1990 the French government appointed him 'Chevalier dans l'Ordre des Arts et des Lettres'.

Long lives in Bristol. H.D.

Richard Long, exh. cat., Amsterdam, Stedelijk Museum, 1973

Selected Works. Oeuvres choisies 1979–1982. Richard Long, exh. cat., Ottawa, National Gallery of Canada, 1983

Richard Long, exh. cat., New York, Solomon R. Guggenheim Museum, 1986

Richard Long. Walking in Circles, exh. cat., London, Hayward Gallery, The South Bank Centre, 1991

Richard Long. Skulpturen, Fotos, Texte, Bücher, exh. cat., Bremen, Neues Museum Weserburg, 1993

RENÉ MAGRITTE

was born in Lessines in the Belgian province of Hainaut on 21 November 1898. In 1910 the family moved to Châtelet. Magritte enrolled at the Académie des Beaux-Arts in Brussels in 1916, where he studied with, among others, Paul Delvaux.

Magritte began to paint in a Cubo-Futurist style, but then became more drawn to a circle of literati working in the spirit of Dada. These included, initially, the poet and art dealer E. L. T. Mesens, who showed Magritte reproductions of works by De Chirico, and later Marcel Lecomte, Camille Goemans and Paul Nougé. This group, with Magritte as its central figure, formed the nucleus of Belgian Surrealism between 1925 and 1930. Magritte earned his living as a graphic artist for a carpet factory and with advertisement designs for fashion shops. Together with Victor Servranckx he drafted the text of *L'Art pur: défense de l'esthétique* (Pure Art: Defence of the Aesthetic), an unpublished book on painting and architecture.

Magritte's encounter with 'Pittura Metafisica' was the decisive moment in his artistic development and led to a change from his earlier style. Since his first Surrealist works met with incomprehension on the

Brussels art scene, he moved to Paris in 1927, where he was an active member of the Surrealist circle until 1930. His first one-man show was held in 1927 at the Galerie Le Centaure in Paris. Breton introduced Magritte to the works of Ernst, Picabia, Duchamp and Picasso. These were the years when Magritte's style, which was unconventional and austere, while at the same time creating a sense of the mysterious, began to acquire its final form.

Magritte tried to convey something of the mystery emanating from ordinary things by depicting them with great precision, in isolation from their surroundings and in juxtapositions that call to mind Lautréamont's famous dictum about the 'encounter between an umbrella and a sewing machine on a dissecting table'. The mystery and magic of his paintings derive primarily from the deliberate discrepancy between formal representation and expressive content. Deviations from the normal proportions of the represented objects or transformations of their material consistency produce a very curious effect, when depicted in an illusionist manner. He combined real objects with abstract figures, objects and words, which deny the identity between the concept and the object to which it refers, as in his famous painting *La Trahison des images* (The Treachery of Images, 1929), in which he depicted a pipe with the inscription 'Ceci n'est pas une pipe' (This is not a Pipe). Objects, animals and figures are transformed into stone shapes or convert the reality of their surroundings into a surrealist backdrop, through the simple effect of enlargement. Often the laws of nature are suspended, gravity disappears and objects lose their substance. Some series concern the relationship between art and imitation: the easel painting and the reproduction, the interaction between inner and outer space, the view into and out of the window, the reversal of the near and the far. The titles of the paintings are intended to undermine their realistic aspect and refer to poetic sources or heighten the contradiction between everyday perceptions and the philosophical questions often posed by the painter.

After his return to Brussels in 1930, Magritte was represented at all the major Surrealist exhibitions. In 1953 he completed eight wall paintings, entitled *Le*

Domaine enchanté (The Enchanted Domain), for the gaming room of the Municipal Casino at Knokke-le-Zoute; in 1957 he executed the mural *La Fée ignorante* (The Unsuspecting Fairy) for the Palais des Beaux-Arts in Charleroi, and in 1961 the mural *Les Barricades mystérieuses* (The Mysterious Barricades) for the Congress Hall in Brussels. Magritte's belated international fame in the sixties gave rise to numerous retrospectives. The pictures he made during those years are characterised by an intensified, almost photorealist precision of outline and, as ever, the contradictions between the visible and invisible and between reality and appearances, pose philosophical questions about the basic meaning of existence. Magritte illustrated works by a number of French writers, including Lautréamont's *Les Chants de Maldoror* (The Songs of Maldoror), and his reading extended to Hegel, Heidegger, Foucault, Husserl, Nietzsche and Plato.

Magritte died on 15 August 1967, in Brussels. H.D.

Suzi Gablik, *Magritte*, London, 1970

Michel Foucault, *Ceci n'est pas une pipe*, Montpellier, 1973

Uwe M. Schneede, *René Magritte. Leben und Werk*, Cologne, 1973

Ralf Schiebler, *Die Kunsttheorie René Magrittes*, Munich and Vienna, 1981

René Magritte. Sämtliche Schriften, ed. André Balvier, Darmstadt, 1981

Marcel Paquet, *René Magritte 1898–1967. Der sichtbare Gedanke*, Cologne, 1993

René Magritte. Die Kunst der Konversation, exh. cat., Düsseldorf, Kunstsammlung Nordrhein–Westfalen, Munich, 1996

ARISTIDE MAILLOL

was born in Banyuls-sur-Mer near the Spanish border on 8 December 1861. All his life he retained close links with the Mediterranean culture of his birthplace. Maillol displayed an early talent for painting and went to study this in Paris in 1882. After several unsuccessful applications to the Ecole des Beaux-Arts, he was finally taken on as a student of painting and sculpture with Jean-Paul Laurens, Jean-Léon Gérôme and Alexandre Cabanel as his teachers. Maillol soon grew disillusioned with the classically orientated academic teaching. He went to museums and galleries to copy works by Puvis de Chavannes and Gustave Courbet, both of whose styles briefly had a strong influence on his painting.

At first Maillol lived in great poverty and his early works were often painted on cheap, coarse sacking. In around 1890 he came under the influence of Paul Gauguin and the Nabis. Besides narrative motifs and portraits in strict profile, he concentrated on painting the female figure in landscapes, reduced to a few symbolic elements. Inspired by late mediaeval and Renaissance tapestries, he turned to weaving in 1892. Maillol founded his own workshop in Banyuls, where he had tapestries made of coarse wool and vegetable dyes from his own designs which, like his

painting and decorative ceramic work, owed much to Art Nouveau and Symbolism. Yet the nude remained a central theme in his painting.

In 1900, when he began to have acute difficulties with his eyesight, Maillol turned to sculpture. His first wood and terracotta sculptures date from as far back as around 1894–95 and include some flat reliefs and terracotta figures, which Ambroise Vollard then had cast in bronze. Yet these were not so much autonomous sculptural works as by-products of his activity as a painter and weaver. By the time he held his first one-man show of sculpture in 1902, however, Maillol had developed his own unmistakable style, which was scarcely to change thereafter. His main motifs were sensual, static, earth-bound female nudes, which reflected the ideals of humanism and whose closed, monumental forms, harmonious proportions and smooth surfaces dated back to his studies of the sculpture of classical antiquity.

In 1908 Maillol, together with the German art patron Harry Graf Kessler and the Austrian poet and playwright Hugo von Hoffmannsthal, undertook a journey to Greece, which reinforced him in his theory of the inner affinities between his Mediterranean home and classical antiquity. Maillol valued the notion of the 'taille directe', cutting directly out of the block of stone or wood. In his search for closed, monumental form in total contrast to the style of Auguste Rodin, he pointed early twentieth-century sculpture in a new direction. His figures appear to have no specific content; they are timeless and hark back to a classical, Arcadian ideal. Maillol saw sculpture as something enduring, stable and resistant to the constant changes created by light. The metaphorical titles of his sculptures, often invented by writer friends, are interchangeable. Most of his statues have two dates: the date of conception and the date of completion, which were often separated by a great many years.

Maillol preferred to work in Banyuls in the winter and near Paris (Marly-le-Roi) in the summer. He did not achieve recognition in France until around 1930. Between 1919 and 1933 he was commissioned to execute numerous war memorials, mainly in south-west France. But it was only around 1930 that he gained widespread recognition for these and for works such as the memorial to the revolutionary Louis Auguste Blanqui, *L'action enchaînée* (Action in Chains) and the Cézanne memorial in the Tuileries in Paris (1906) as well as the memorial to Claude Debussy (1930) and the planned monument to Henri Barbusse, *La rivière* (The River, 1937–43).

Much of Maillol's graphic work (etchings, lithographs, woodcuts), for which he invented his own paper-making technique (Montval paper), consisted of illustrations of classical literature, including Virgil and Ovid.

In harking back to the classical laws of sculpture Maillol exerted a strong influence on European sculpture, in general, and on German sculptors such as Georg Kolbe and Wilhelm Lehmbruck, in particular. With his generalised figures, which are 'synthetic' in the sense that they are the sum of a variety of impressions and experiences combined with a reduction and abstraction of forms, Maillol created time-

less allegories of life and of the yearning for Arcadian happiness.

Maillol died following a car accident in his birthplace, Banyuls, on 24 September 1944. H.D.

John Rewald, *Aristide Maillol*, Paris, 1939
Rolf Linnenkamp, *Aristide Maillol. Die Gross-plastiken*, Munich, 1960
Denys Chevalier, *Maillol*, Munich, 1971
Aristide Maillol 1861–1944, exh. cat., New York, Solomon R. Guggenheim Museum, 1975
Aristide Maillol, ed. Hans Albert Peters, exh. cat., Baden-Baden, Kunsthalle, 1978
Aristide Maillol, ed. Ursel Berger and Jörg Zutter, exh. cat., Berlin, Georg-Kolbe-Museum, Berlin and Lausanne, Musée cantonal des Beaux-Arts, Munich, 1996

KAZIMIR SEVERINOVICH MALEVICH

was born in Kiev on 23 February 1878. He attended the Kiev School of Drawing in 1894. From 1905 he lived in Moscow, enrolled at the School of Painting, Sculpture and Architecture there, and studied in Fiodor Rerberg's studio.

In subsequent years Malevich took part in exhibitions by artists' associations, including the *Knave of Diamonds* (1910–17), the *Union of Youth* (1911–13) and the *Donkey's Tail* (1912). During this period he painted mostly rural subjects, in which the human figures were reduced in Cubo-Futurist fashion to a few basic geometric, metallic-looking forms. In 1913 he worked with Matiushin (music) and Kruchenykh (libretto) on the St Petersburg production of the Futurist opera *Probeda nad solntsem* (Victory over the Sun). Malevich designed the set and costumes: a black square on a white background, along with free geometrical elements, the formal building blocks of Suprematist painting, appeared on the curtain for the first time. In 1915 he took part in the *First Futurist Exhibition: Tramway V* and the *Last Futurist Exhibition: 0.10* in Petrograd. At the latter he showed his first non-representational picture, including the *Black*

Square on a white background, the 'naked, unframed icon of my time' (Malevich), which became the model for Suprematism.

At the same time he published his brochure *From Cubism and Futurism to Suprematism. The New Realism in Painting*, in which he laid down the theory in Suprematism: pure, absolute painting, divorced from any representational function and becoming non-representational. For him Suprematism was the liberated nothingness of abstraction. The white background embodied the infinite void in which floated the square, pure sensibility and the forms that developed from it. In subsequent years Malevich's pictures became more dynamic and spatial. He avoided all systems of reference, so many of his pictures could be hung horizontally or vertically, without losing any of their expressive quality. Malevich worked on the scientific thesis that matter was energy. He said that behind the objective world was the energy that art made visible. He created a form for his new theory by founding the 'Supremus' group with Popova, Rozanova and Udaltsova in 1916. In the same year he took part in the *Futurist Exhibition 'Store'*, organised by Vladimir Tatlin, his future rival in his struggle for leadership in the Russian avant-garde. In contrast to the metaphysical and cosmic system of Suprematism, Constructivism, championed by Tatlin, addressed concrete design problems on behalf of society.

After the revolution Malevich served on various art committees; he became director of SVOMAS (Free State Art Workshops) in Petrograd and subsequently held the same position in Moscow, where he directed the painting section, and then the textile department, with Nadeshda Udaltsova. In 1919 he introduced a new art education scheme at the art school in Vitebsk, based on Suprematism and developed in a collective; from 1920 onwards it was called UNOVIS (Affirmers of the New Art).

In 1922 he became director of the Museum of Artistic Culture in Petrograd, which he reorganised as INKhUK (State Institute of Artistic Culture). He was head of the 'Section of Painting Culture / Formal-Theory' until 1926. Kazimir Malevich took part in the *1st Russian Art Exhibition* in Berlin in 1922 and the Venice Biennale in 1924. In the mid-twenties he turned to investigating the possibilities for a Suprematist architecture, in design sketches of so-called 'Planity' and models he described as 'Arkhitektons' – horizontal and vertical stacks of three-dimensional Suprematist cubes, to be seen as designs for a visionary architecture.

In 1927 Malevich travelled to Berlin, Germany, where he showed a substantial selection of work at the *Great Berlin Art Exhibition*. His essays 'Introduction to the Theory of the Additional Element in Painting' and 'Suprematism' appeared as a Bauhaus book under the title *The Non-Objective World*. On his return to Leningrad he first worked at the State Institute of Art History. The Russian artistic avant-garde had been increasingly subject to the reproach of 'Formalism' since the early twenties, and the work Malevich produced around 1929 should be viewed in this context. It was modelled on the pictures he

painted in the early 1910s abd dated 1909–10. From 1929 to 1932 he produced monumental, static images of figures, in a style which was poised mid-way between figuration and abstraction. After that he executed a series of paintings reminiscent of Renaissance portraiture.

Malevich died in Leningrad on 15 May 1935. K.O.

Kasimir Malevich: Essays on Art, 4 vols., ed. Troels Andersen, Copenhagen 1968–78
Larissa A. Shadowa, *Kasimir Malewitsch und sein Kreis*, Munich, 1982
Kazimir Malevich 1875–1935, exh. cat., Leningrad, Russian Museum, Moscow, Tretiakov Gallery and Amsterdam, Stedelijk Museum, 1988
Heiner Stachelhaus, *Kasimir Malewitsch: Ein tragischer Konflikt*, Düsseldorf, 1989
Andrei Boris Nakov, *Kasimir Malevich. Leben und Werk*, London, 1992
Kasimir Malewitsch. Werk und Wirkung, ed. Evelyn Weiss, exh. cat., Cologne, Museum Ludwig, 1995

PIERO MANZONI

was born on 13 July 1933 in Soncino near Milan. In 1951 he began studying law at the Brera Academy in Milan and in 1953 started to take private painting lessons. In 1954 he cut short his law studies and began studying art and philosophy, first in Rome and, from 1955 onwards, in Milan.

Having painted landscapes and portraits in a traditional style between 1950 and 1954, Manzoni began to experiment with new materials such as oil, plaster of Paris and enamel, drawing his inspiration from *informel* artists such as Alberto Burri, Lucio Fontana and Jean Fautrier. In 1956 he created pictures by dipping simple objects, such as keys, scissors and pliers, in paint and pressing them onto canvas. After this he moved on to pictures made from mixtures of oil and tar. At the end of 1956 he was the co-author of the manifesto 'Per la scoperta di una zona d'immagini' (For the Discovery of a Zone of Images), which was a plea for the forces of the subconscious in mankind. In

1957, along with Fontana, he joined the 'Gruppo Nucleare', which published the manifesto 'Per una pittura organica' (For an Organic Painting).

Working under the influence of Burri and Fontana, and of an exhibition of monochrome works by Yves Klein, Manzoni began a series of *Achromes*: colourless, plaster-based, structured canvases which thematised the infinite nature of colourless surfaces, on an analogy to Fontana's 'infinite spaces'. In the years that followed, he created series after series of *Achromes* from different materials, working with kaolin in 1958, felt, cotton and polystyrene in 1960, wool and rabbit fur in 1961, and loaves of bread and stones in 1962. In 1957 Manzoni was a signatory to the manifesto 'contro lo stile' (Against Style) by the 'Gruppo Nucleare Internazionale', a group of artists who had turned against academic rules of form and fixed generic concepts. In 1959 he left the 'Gruppo Nucleare' to work on a more independent basis. Manzoni now began to develop a conceptual approach to art and to work on his first *Linee di lunghezza variabile* (Lines of variable Length). These comprised rolls of paper of different lengths, printed with a black line, which were sealed in a container on which the length of the paper and the date of completion were recorded. Manzoni first exhibited the 'lines' in 1959, in the 'Azimut' gallery which he founded with Enrico Castellani, whilst the journal *Azimuth* became the theoretical mouthpiece for the artistic avant-garde of the sixties.

In the following year Manzoni organised an exhibition entitled *Consumazione dell'arte dinamica del pubblico, divorare d'arte* (The Consumption of Dynamic Art by the Art Devouring Public) at which he signed eggs with his thumbprint, distributed them to the audience and invited them to eat them. By using these 'edible sculptures'as he described them, Manzoni was intentionally alluding to Christian ritual, namely the transsubstantiation at the Last Supper, and presenting the artist as a creator figure.

In 1961 Manzoni worked on what became known as his 'living sculptures', nude models or even fellow artists whom he signed and thus declared to be works of art, i.e. individual bodily parts or particular

gestures, defined as art on the authority of the artist. In the same year he created *Il Piedistallo magico* (The Magic Pedestal), by means of which anyone standing on the pedestal was elevated to a work of art. Then, with *Socle du monde* (Pedestal of the World), an iron cube covered with the self-same inscription written in reverse, he ended up declaring the entire globe a work of art.

In 1961 Manzoni produced one of his most provocative works: ninety tins packed with *Merde d'artista* (Artist's Shit), which was labelled with a suitable inscription and offered for sale at the current equivalent price for gold. (This was in deference to the sale for gold of Yves Klein's 'Zones of Immaterial Pictorial Sensibility' in 1959.)

Manzoni was one of the most radical and innovative artistic personalities of the sixties. Through his works, projects and ideas, he took Futurism a stage further, distancing himself ever more radically from all conservative norms and bourgeois ideas of art. In this Manzoni stood in close relationship to Yves Klein and the 'Nouveaux Réalistes', Beuys and the Fluxus movement. In Germany his main influence was felt in the link that he formed between Fontana and the Zero Group; in Italy he provided some of the inspiration for Arte Povera.

Manzoni died in Milan on 6 February 1963. H. D.

Piero Manzoni, Paintings, Reliefs and Objects, exh. cat., London, The Tate Gallery, 1974
Germano Celant, *Piero Manzoni*, Milan, 1975
Piero Manzoni, Germano Celant, exh. cat., Paris, Musée d'Art Moderne de la Ville de Paris, 1991
Freddy Battino and Luca Palazzoli, *Piero Manzoni. Catalogue raisonné*, Milan, 1991
Piero Manzoni, Turin, exh. cat., Castello di Rivoli, Milan, Museo d'Arte Contemporanea, 1992
Piero Manzoni, exh. cat., Los Angeles, Museum of Contemporary Art, 1995

FRANZ MARC

was born in Munich on 8 February 1880. His father was a professor at the Munich Academy and a painter of landscapes in the manner of the Old Masters and interiors and genre pieces in the style of the Munich School. In 1899, Marc began studying theology and philology at the University of Munich. In 1900, however, he decided to change courses and study painting at the Munich Academy under Gabriel von Hackl and Wilhelm von Diez.

In 1903 Marc travelled to Paris, where he was particularly inspired by the French Impressionists and resolved not to return to the conservative Munich Academy. At the Durand-Ruel and Bernheim-Jeune galleries, he made copies of paintings by Monet, Renoir, Manet, Pissarro and Boudin, as well as of works by Toulouse-Lautrec, Bonnard and Vuillard. On his return to Munich Marc spent the next few years developing his art in isolation, mainly as a painter of animals.

Marc's paintings of animals became increasingly stylised and abstract, and following van Gogh's example he sought a route from the external appearance of the animal to its innermost intuited being. In 1910 he held his first exhibition at Brakl's Moderne Kunsthandlung (Brakl's Modern Art Shop). In consequence, he was visited by August and Helmuth Macke as well as by the patron, Bernhard Koehler jr., who entered into a sales agreement with him that gave him financial security. In 1910, enraged by hostile criticism of the second exhibition of the 'Neue Künstlervereinigung München' (New Artists' Association Munich), Marc wrote a spontaneous and enthusiastic review, on the strength of which he was accepted into the circle of progressive painters around Kandinsky.

Marc's encounter with Kandinsky stimulated his artistic development. He increasingly became immersed in the symbolic force of colour, whose rules and effects he discussed in correspondence, especially with August Macke. The tensions within the 'Neue Künstlervereinigung München' increased, and when an abstract painting of Kandinsky was rejected by the jury during preparations for the third exhibition in 1911, for supposedly being too large, Kandinsky and Marc walked out in protest. Together they formed the 'Der Blaue Reiter' (The Blue Rider), as a forum for exhibitions and publications. In 1911 the first, epoch-making exhibition of 'Der Blaue Reiter' opened in the Thannhauser Gallery in Munich, in parallel with the exhibition of the 'Neue Künstlervereinigung München', whose strength had been undermined by the defection of the more progressive artists. While this exhibition was touring cities such as Cologne, Berlin, Bremen, Hagen and Frankfurt, a second exhibition confined to graphic works was held at the Goltz Gallery in Munich. This also included works by the Expressionist painters of 'Die Brücke' (The Bridge), Paul Klee, and the Russian avant-garde artists Malevich, Goncharova and Larionov. 1911 also marked the appearance of the *Blaue Reiter Almanac*, which, with its programmatic artists' texts and numerous eclectic illustrations of modern and earlier art, was intended as a rallying-point for adherents to the new concept of the spiritual in art.

Marc's trip to Paris in 1912 with August Macke, in the course of which he visited Robert Delaunay, led to a change of style. Under the impact of Delaunay's *Fenêtres* and Umberto Boccioni's Futurist paintings, Marc now began to break up shapes prismatically and use colours in pure tones and stark contrasts. His stylised animal motifs were worked into the crystalline structure of the picture and imbued with symbolic significance. Subsequently Marc turned to abstraction, only to revert again and again to the figurative symbol of the animal, which for him represented spiritual purity and redemption.

In 1913 Franz Marc travelled to the South Tyrol, which inspired the subject of his apocalyptic *Tirol* (1914). An offer of a professorship in charge of the evening life class at the Academy in Stuttgart fell through. After this he embarked on a period of intense activity which led to the creation of several masterpieces, including *Der Turm der blauen Pferde* (The Tower of the Blue Horses), in which he arrived at an independent pictorial style through the fusion of his animal symbolism with a variety of French avant-garde influences (Cubism, Futurism, Orphism).

Marc was prevented by the outbreak of the First World War from taking any further this major new phase in his stylistic development. He volunteered for military service and was immediately deployed to the campaign in France. Despite urgent appeals from fellow artists and high-ranking politicians with responsibility for cultural affairs, Marc declined to be discharged, even after two years' action at the front. On 4 May 1916 he was fatally injured by a grenade blast, whilst on a reconnaissance mission outside Verdun. Marc's last artistic works were the preliminary studies for a new style of abstract painting, contained in his *Skizzenbuch aus dem Felde* (Sketchbook from the Front). H.D.

Franz Marc and Wassily Kandinsky, *Der Blaue Reiter*, Munich, 1912; new documentary ed. Klaus Lankheit, Munich, 1963; facs. ed., Munich, 1976; Engl., *The Blaue Reiter Almanac*, London, 1974

Klaus Lankheit, *Franz Marc. Sein Leben und seine Kunst*, Cologne, 1976

Frederick S. Levine, *The Apocalyptic Vision. The Art of Franz Marc as German Expressionism*, New York, 1979

Claus Pese, *Franz Marc*, Stuttgart, 1989

Susanne Partsch, *Franz Marc*, Cologne, 1991

Franz Marc, *Kräfte der Natur 1912–1915*, Erich Franz, Munich, Staatsgalerie moderner Kunst, 1993

HENRI MATISSE

was born in Le Cateau-Cambrésis, in northern France, on 31 December 1869. He went to Paris in 1887 to study law and worked in a solicitor's office in St-Quentin, from 1889. In his free time he visited the municipal 'Quentin de la Tour' School of Drawing.

In 1893 Matisse abandoned his law work and enrolled at the Académie Julian in Paris. Working in Gustave Moreau's studio, he met Georges Rouault, Charles Camoin and Henri-Charles Manguin. After the initial success of his rather conventional early work, his painting *La Desserte* (The Dessert, 1897), inspired by Impressionism and especially Monet, was sharply criticised by conservative members of the *Salon de la Société Nationale*.

In the following, economically difficult years, he painted free-style landscapes. At the suggestion of Camille Pissarro he studied the works of J. M. W. Turner in London and then began, under the influence of Paul Signac and Henri-Edmond Cross, to adopt a pointillist style. In 1905 Matisse successfully exhibited his outstanding work of that period, *Luxe, Calme et Volupté* at the *Salon des Indépendants*, whose deputy director he had become in 1904. This was followed by his first Fauvist paintings, which he exhibited with paintings by the other Fauves at the *Salon d'Automne*, in October that year. Matisse was introduced by Gertrude and Leo Stein into a circle of enlightened artists, critics, art dealers and connoisseurs, who made him more widely known and contributed to the considerable improvement in his financial situation. Matisse signed a long-term contract with the Paris art dealer Bernheim. He also found a well-known patron in the Russian merchant Sergei Shchukin, who bought two large murals for his house in Moscow: *La Danse* (1909–10) and *La Musique* (1909–10) – two incunabula of modern painting, with their accentuated flatness and balanced arrangement of forms.

The outbreak of war brought a temporary halt to this successful period and to his many journeys to Russia, Morocco and Spain. Matisse now strove to introduce an element of strict architectonic construction into his compositions, partly as a response to the paintings of Picasso, Braque and Gris. From 1916 on he spent the winter months in Nice. Increasingly interested in the effect of colours, he was fascinated by the brilliant light on the white houses and the clear blue surface of the sea. The relaxed mood of this Nice period, with its soft, bright colours, is reflected in a series of calm, contemplative interiors. A hotel room turns into a splendidly ornamental, oriental Garden of Eden, against which the figures stand out in sharp outline. In contrast to the works of his Fauvist period, these paintings met with growing public recognition. In 1921 the French state bought its first painting by Matisse, *Odalisque à la culotte rouge* (Odalisk in Red Trousers, 1921).

After 1928, Matisse devoted himself mainly to sculpture and graphic art. Matisse was influenced by African sculpture, in reducing the proportions of his figures, such als *Nus de dos* (The Back I–IV, c. 1909–29), as a means of heightening their expressive effect. In 1930 he visited his most important collector in the USA, Albert Barnes, and subsequently created a wall decoration, *La Danse* (1932), for the latter's private museum.

After 1930 Matisse became very interested in drawing as a medium, in his efforts to 'simplify the means'. Matisse executed hundreds of pencil and pen drawings, in search of the perfect line. The new unity of colour and line was also reflected in his paintings of the thirties and forties: figures depicted

in large-scale, stylised forms and subdued colours, surrounded by floral arabesques.

Following a major operation for cancer he began to produce small-format works and book illustrations in addition to coloured paper cut-outs, working at first in Cimiez and then, from 1943, in the Villa 'Le Rêve' in Vence. Matisse had experimented with this new expressive form as early as 1938, and reached a climax in 1947 with his album *Jazz*. Large-format works, somewhere between the abstract and the figurative, followed from 1950 on. For several years, Matisse devoted almost his entire time to his final great project, the decoration of the Chapelle du Rosaire in Vence (opened in 1951), with bold stained-glass windows based on his designs for 'papiers découpés'.

Matisse died on 3 November 1954, while working on a rose window for the Union Church in Pocantico Hills, near New York, to a commission from Nelson A. Rockefeller. H.D.

Albert E. Elsen, *The Sculpture of Henri Matisse*, New York, 1972

John Elderfield, *The Cut-Outs of Henri Matisse*, New York, 1978

Pierre Schneider, *Henri Matisse*, Munich, 1984

Henri Matisse. Zeichnungen und Skulpturen, ed. Ernst-Gerhard Güse, exh. cat., Saarbrücken, Saarland-Museum, 1991

Henri Matisse. A Retrospective, ed. John Elderfield, exh. cat., New York, The Museum of Modern Art, 1992

Henri Matisse. Zeichnungen und Gouaches découpées, ed. Ulrike Gauss, exh. cat., Stuttgart, Graphische Sammlung, Staatsgalerie Stuttgart and Stuttgarter Galerieverein, 1994

MIKHAIL VASILIEVICH MATIUSHIN

was born in Nijni Novgorod in 1861. He studied the violin at the Moscow Conservatoire from 1874 to 1880 and played in the St Petersburg court orchestra from 1881 to 1913. Matiushin was involved in music throughout his life; he is considered to have been the first composer to develop quarter-tone music. He also studied painting at the School of the Society for the Promotion of the Arts from 1894 to 1898. From 1903 to 1905 he worked in Jan Zionglinski's studio on 'open colour impressionism' (Zionglinski). He continued his education at the Svantseva School in Moscow in 1906–1907.

Matiushin founded the 'Shuravl' (Crane) publishing house with his wife, the painter Elena Guro, in 1909. This published about 20 works before 1917, mainly on art theory, including a Russian translation of *Du Cubisme* by Albert Gleizes and Jean Metzinger in 1913. He was a co-founder of the 'Union of Youth' artists' association in 1910, but took part in their exhibitions only occasionally.

Matiushin started to address the problem of space in painting in about 1911, taking a particular interest in the phenomenon of the 'fourth dimension' feeling it was possible to make a transition from one dimension to the next by movement. He published his thoughts on this in 1913 in the essay 'The Artist's Experience of the new Dimension'. In the same year he composed and staged the futuristic opera *Probeda nad solntsem* (Victory over the Sun), in partnership with Malevich and Kruchenykh.

Matiushin constantly returned to the subject of colour and movement. *Movement in Space* (1917–18) shows the colour taken on by a moving object. In 1919 he worked as an assistant in Malevich's Free State Art Workshops in Petrograd, and held a chair there from 1919 to 1926. He showed sculptures made of roots and branches at the *1st Free State Art Exhibition* in the Winter Palace in Petrograd in 1919. He called them 'Liberated Movement', because he felt that they embodied the organic principle of movement, material and form to the highest degree of perfection. Matiushin required artists to approach nature in a new way: they were not to observe it, but were themselves to become part of it. His organic view of the world was based on the idea that everything that existed was conceivable only within its surroundings. He used systematic colour studies to show the rules under which a colour changed in different colour contexts. He pursued this thought further in his theory of 'spatial realism', which stated that an object changed its form when its surroundings changed, thus revealing a new objective and non-objective truth. Matiushin announced his 'Knowing Seeing' programme (SORVED) at a meeting of the 'Association of Left-Wing Petrograd Painters' in 1923. This was an extension of his 'Expanded Seeing' theory, and required that the field of vision be enlarged in such a way that the viewer no longer saw from a fixed point, thus giving the eye a new and comprehensive view of the world. His aim was to extend the angle of vision to 360 degrees and thus achieve a new understanding of depth and movement.

Matiushin directed the 'Organic Culture' department at the Museum of Artistic Culture and its successor organisation the State Institute of Artistic Culture (INKhUK), from 1923 to 1924. One of his laws states that every form has a corresponding complementary form: for the straight line it is the curve, for the square, the circle and for the cube, the sphere.

Matiushin took part in the 1924 Venice Biennale and the 1925 Paris World Fair. In 1925 to 1926 he was director of the 'Organic Culture' department at the State Institute of Decoration and presented his research on the interaction of sound and colour at the INKhUK annual exhibition in 1926. An exhibition called *KORN* (Collective: Expanded Seeing), showing work by Matiushin and his circle, opened at the Central Leningrad House of Arts in 1930. The *Encyclopaedia of Colour* he devised with his pupils appeared in 1932. Only a few of Matiushin's works have survived. His importance derives above all from his theoretical work and his influence on the Russian avant-garde.

Matiushin died in Leningrad on 14 October 1934.

 K.O.

The Great Utopia, exh. cat., Solomon R. Guggenheim Museum, New York, 1992

Matjuschin und die Leningrader Avantgarde, ed. Heinrich Klotz, Karlsruhe, Zentrum für Kunst und Medientechnologie im Badischen Kunstverein, Stuttgart and Munich, 1991

MATTA

was born in Santiago de Chile on 11 November 1911, of Spanish–French parents, and named Roberto Sebastian Antonio Matta Echaurren. In 1932 he completed his studies of architecture at the Universita Católica with a dissertation on a utopian architectural project, 'League of Religions'. In 1933 Matta moved to Paris and spent some time working in Le Corbusier's architecture office, in 1934.

Thanks to Dalí, Matta came in contact with André Breton and the Surrealists, becoming an official

member of the movement in 1937. A year later Matta showed four drawings at the great *Exposition Internationale du Surréalisme*. In 1938 he published a manifesto in the Surrealist review *Minotaure*, entitled 'Mathématique sensible – Architecture du temps', which was a forceful rejection of rationalism in architecture and a complete break with Le Corbusier's ideas. Encouraged by Gordon Onslow Ford and inspired by Yves Tanguy's paintings, Matta began to paint his first 'psychological morphologies', amorphous forms in an undefined space that seem to undergo constant metamorphosis.

In 1939 Matta emigrated to New York and came to know the older generation of Surrealists, among whom Marcel Duchamp fascinated him most. Together with Robert Motherwell, who became interested in Surrealist art through him, Matta travelled to Mexico and witnessed the eruption of the Paricotín volcano. In the series of works that followed, including *Invasion of the Night* (1941) and *The Earth is a Man* (1941), he conjured up the forces of nature in flowing, biomorphous forms. The informal, improvisational procedure he used here – pouring on diluted colours, wiping with a cloth and then continuing to work the accidentally occurring shapes with a brush – became a basic feature of his own painting and also influenced the American painters of the New York School. In the following years, Matta continued to concentrate on metaphors for the Creation and his own cosmic vision of earth as the psychic projection of humankind. He created a continuous, twilit pictorial space, afloat with a universe of small forms, symbolising both the cosmos and the depths of the spirit and the psyche. Matta had always depicted anthropomorphic figures in his drawings; in his paintings, the first totem-like figure (inspired by the work of Wifredo Lam) appeared in *Le Vitreur* (destroyed), and then became a part of his basic artistic vocabulary.

After the experience of the Second World War, Matta incorporated the demons of a technical utopia into his work. The 'Great Invisibles', as Breton called them, are both doers and sufferers, at the same time exposed to and manipulating the ambivalence of the apparatus of civilisation. *Etre avec* (Being with), of 1945, concluded this fruitful New York period with a fantastic panopticum of multiform, monstrous figures and filmic effects derived from Duchamp. In early 1948 he left New York to spend a few weeks in Chile. In October that year Matta was officially suspended from the Surrealist group for 'intellectual disqualification and moral disgrace'. In 1949 he moved to Rome, where he remained until returning to Paris in 1954.

In the fifties Matta, who had now moved away both from the 'pure abstraction' of the New York painters and from the dogmatism of the Surrealists, turned to micro- and macrocosmic fantastic landscapes, which earned him the reputation of being a 'science-fiction painter'. At the same time, he painted narrative pictures with ever stronger references to political events, especially to the revolution and social situation in Cuba, such as *Che Guevara*, dating from 1967.

Matta achieved international success at numerous

exhibitions, such as the early *documenta*s of Arnold Bode in Kassel, and in retrospectives, such as those held at the Nationalgalerie in Berlin, in 1970 and the Centre Pompidou in Paris, in 1985. The first volume of Matta's notebooks appeared in 1986, documenting the development of his extremely varied work.

Matta lives and works in Paris and Tarquinia, Italy.

H.D.

Per il Chile con Matta, ed. Wieland Schmied, exh. cat., Hanover, Kestner Gesellschaft, 1974
Roland Sabatier, *Matta. Catalogue raisonné de l'oeuvre gravé (1943–1974)*, Stockholm, 1975
Matta, exh. cat., Paris, Musée National d'Art Moderne, Centre Georges Pompidou, 1985
Matta, Entretiens morphologiques. Notebook No. 1, 1936–1944, ed. Giorgio Ferrari, London and Paris
Matta, ed. Wieland Schmied, exh. cat., Munich, Kunsthalle der Hypo-Kulturstiftung and Vienna, Kunsthaus, Tübingen, 1991

MARIO MERZ

was born in Milan on 1 January 1925. His family soon moved to Turin, where Merz subsequently began to study medicine. During the Second World War he was involved in the anti-fascist resistance group 'Giustizia e Libertà' (Justice and Liberty) and was imprisoned until 1945. It was during his incarceration that he began to draw incessantly.

Merz familiarised himself with classical and modern art in the museums and galleries of Paris in 1946 and took a particular interest in the works of Jean Dubuffet, Jean Fautrier and Jackson Pollock. In the years 1946–49 Merz stayed in Turin and became friendly with contemporary poets and painters such as Mattia Moreni, Ennio Morlotti and Luigi Spazzapan. Merz held his first one-man exhibition at the Galleria La Bussola in Turin, where he showed works inspired by European *art informel*.

In the years 1960–65 there followed a period of intense experimentation with paint mixtures and sculptures. In one series of pictures he devoted himself to a spiral motif. Merz increasingly distanced himself from painting and informal expressive gestures and sought metaphors for the interrelation of nature and culture in objects themselves.

In 1966 he started using neon tubes and neon writing (pure light energy), alone or in close combination

with everyday objects such as bottles or umbrellas, as the vehicle for a new artistic approach that sought to articulate basic needs through simple materials and gestures. In 1967 this approach gained recognition as a new art form when, at an exhibition of works by, amongst others, Giovanni Anselmo, Giulio Paolini, Jannis Kounellis, Giuseppe Penone, Michelangelo Pistoletto and Mario Merz it was described by Germano Celant as 'Arte Povera' (Poor Art). The following year Merz took part in the exhibition and accompanying actions, *Arte povera + Azione povera*, in Amalfi.

Merz's concept of art was not actionistic in the sense of the term as it was applied to Beuys and the Fluxus movement but a 'silent demonstration' of natural things or simple materials (twigs, stones, slates, wax, wood, clay, rubber, glass and putty). Merz employed simple or archetypal ways of handling his materials such as bundling them up, folding them or stacking them in layers, as a means of releasing their inherent energies and personalising the perceptions of the viewer.

Since 1968 the igloo has been a leitmotif running through Mario Merz's work, a metaphorical form and formula for the relationship between interior and exterior, shelter and protection, and the transient processes of birth and death. Since 1969, to highlight these processes of reproduction, expansion and growth, Merz has used the so-called 'Fibonacci series' in his installations, the term being used to describe the numerical progression, 1, 1, 2, 3, 5, 8, 13, 21, 34, etc., whereby each new figure is the sum of the two previous ones. The proportional growth of a row of numbers, converted into neon light (an artificial medium of natural electricity), symbolises the interpenetration, and the literal and metaphysical energising, of the surrounding space. In 1973 Merz introduced another central motif, the table, which like the igloo represents a fundamental structure of human behaviour.

Around 1977 Merz returned increasingly to painting, combining three-dimensional objects, the Fibonacci numbers and iconographic motifs, above all animals from mythology, such as crocodiles, rhinoceroses,

bison and lions. His bright, expressive paintings were combined with bundles of brushwood, pierced with neon lighting tubes or stretched over igloos. They enriched his installations with new motifs and ideas that also alluded directly to the objects placed in the immediate proximity.

Since the end of the 1960s Merz has taken part in many important exhibitions as a leading representative of Arte Povera, including *When Attitudes Become Form* in Bern, in 1969, and *documenta 5* in Kassel, in 1972. In 1975 he had his first major museum exhibition at the Kunsthalle in Basel.

Merz lives and works in Turin. H. D.

Mario Merz, exh. cat., Essen, Museum Folkwang and Eindhoven, Stedelijk Van Abbemuseum, 1979

Mario Merz, Voglio fare subito un libro (I immediately want to make a Book), Frankfurt a. M. and Salzburg, 1985

Mario Merz, 28th International Art Debate at the Galerie nächst St Stephan, Vienna, 1985

Mario Merz, exh. cat., ed. Germano Celant, New York, Solomon R. Guggenheim Museum, 1989

Mario Merz, exh. cat.,Turin, Galleria Civica d'Arte Comtemporanea, 1995

JOAN MIRÓ

was born in Barcelona on 20 April 1893. He was given private drawing lessons at an early age and sketched village scenes and buildings. From 1907 to 1910 he attended the business school in Barcelona and, at the same time, the renowned 'La Lonja' School of Fine Arts. In 1910 he started work as an accountant with a construction and chemicals firm, but in 1912, after catching typhoid and suffering a nervous breakdown, he began an art course at the progressive, private Galí Academy in Barcelona.

Over the next few years Miró studied French art and literature in great detail, and his early pictures, which he showed in his first solo exhibition at the Dalmau Gallery, in 1918, clearly showed the influences of Cubism and Futurism. These were followed by a series of paintings which the 'Agrupació Courbet' (Courbet Circle), to which Miró belonged, called the 'détailliste phase' pictures, for their combination of a basic Cubist structure with minute detailing, in certain places.

In 1921 Miró rented a studio in Paris and became friendly with André Masson and the group of artists and intellectuals from the Rue Blomet (Michel Leiris, Georges Limbour, Antonin Artaud, Robert Desnos). *The Farm* (1921–22) was a key work for the new direction he took: impressions of country life were combined with fine details and abstract elements to suggest a form of 'magic realism'. Miró's *Terre labourée* (Ploughed Earth, 1923) and *Paysage catalan* (Catalan Countryside, 1923), which translated his real world into a system of symbols and colours, attracted the attention of André Breton's group of Surrealists, and the influence of Surrealist poetry became evident in Miró's picture poems. Another series with blue backgrounds and sparsely isolated symbols appears to

have been a reaction to Breton's 'Champs magnétiques'. In his *Paysages imaginaires* (Imaginary Landscapes) of 1926, Miró used colour alone to suggest broad, open spaces; in 1928 he produced a series of 'Dutch interiors', stimulated by his study of the Dutch Old Masters, on the occasion of a trip to Holland.

In the same year Miró scored a great success with his exhibition at the Galerie Georges Bernheim in Paris, in which he also included a selection of his first 'Papiers collés'. In the 1930s Miró went on to develop from his collages a series of large-scale paintings with abstract colour shapes, called simply *Painting*. The social unrest in Spain, which finally led to the outbreak of civil war in 1936, inspired him to produce posters in support of the Spanish Republic. The pictures from this 'wild period' show brutish figures twisted with pain, the finest example of which was the mural *The Harvester* (1937), now lost, which was produced for the Spanish pavilion at the International Exhibition in Paris.

At the outbreak of the war Miró moved to Varengeville-sur-Mer in Normandy, where he worked until 1941 on the gouache series *Constellations,* in which he developed a new system of painting where lines, shapes and symbolic forms were distributed across specially prepared backgrounds in tightly linked networks. These small gouaches were shown at his first major retrospective at the Museum of Modern Art in New York in 1941, where their innovative openness had a strong influence on contemporary American artists.

Over the new few years Miró gradually abandoned painting. He had already produced material pictures in his 'anti-painting' phase, and he now decided to use materials directly, as a new, 'unfettered' experience. As early as 1944 he produced his first ceramics, with the help of his old friend Josep Llorens Artigas, and his first bronze sculptures. In 1947 he produced a mural for the Cincinnati Terrace Hilton Hotel in New York, and from 1956 to 1958 two powerful murals for UNESCO's headquarters in Paris. From 1960 he received a number of international commissions, mainly for ceramic murals.

At the 'Son Abrines' studio house, designed in 1956 by the architect Josep Lluis Sert in Palma de Mallorca, Miró's style underwent a further change when he started to produce large-scale, abstract canvases under the influence of contemporary American painting. The surfaces of these canvases were interrupted at intervals by the occasional flourish of colour, which served to reveal a hidden dimension, full of poetry. As well as producing numerous ceramics and sculptures and experimenting with new painting techniques Miró also took up the old Catalan art of weaving. This led to the creation of his 'Sobreteixims', textile pictures incorporating real objects such as metal waste-bins and umbrellas, which constitute one of his most original contributions to modern art.

Miró died on 25 December 1983 in Palma de Mallorca. H.D.

Rosa-Maria Malet, *Miró,* Barcelona, 1983; Stuttgart, 1984

Joan Miró, exh. cat., Zürich, Kunsthaus and Düsseldorf, Städtische Kunsthalle, Bern, 1986

Walter Erben, *Joan Miró 1893–1983. Mensch und Werk,* Cologne, 1988

Pere Gimferrer, *Joan Miró. Auf den Spuren seiner Kunst,* Stuttgart, 1993

Joan Miró, ed. Carolyn Lanchner, exh. cat., New York, The Museum of Modern Art, 1993

Hubertus Gaßner, *Joan Miró. Der magische Gärtner,* Cologne, 1994

AMEDEO MODIGLIANI

was born on 12 July 1884 into an upper-class family in Livorno. Two serious attacks of tuberculosis in 1895 and 1900 left him in poor health for the rest of his life. Whilst still very young he became interested in art and literature and received his first drawing and painting lessons in the studio of Guglielmo Micheli, a latter-day plein-air painter. He was enthusiastic about the works of Tino di Camaino and the Italian early Renaissance.

In 1902 Modigliani founded a studio community in Florence with Oscar Ghilia and began to study from the nude. In 1903 he moved to the Academy in Venice. The Biennale introduced him to current trends in international contemporary art. Modigliani's drawings from this period indicate that he was already interested in portraits and in the dominant use of line as a formal element. Likewise the female nude became a central theme. Characteristically, he showed portraits and nudes in a closed compositional structure, with relatively slight variations of expression. Crudely simplified, gently undulating or gracefully distorted lines emphasised the elongation of the heads and figures (especially, the nudes).

In 1906 Modigliani arrived in Paris to study at the private Academy Colarossi. He discovered the works of Matisse and Gauguin, which inspired him to search for a different way of articulating form. In 1907 he exhibited a number of almost monochromatic watercolours of elongated heads to general

acclaim at the *Salon d'Automne*, and in 1908 he exhibited five oil paintings at the *Salon des Indépendants*. The few extant pictures from this period reflect the influence of the Fauves, Matisse, Toulouse-Lautrec, Picasso and Cézanne. In 1909 Brancusi encouraged Modigliani to try his hand at sculpture.

The extent and the dating of Modigliani's sculptural work between the years 1909 and 1915–16 are unknown. The number of works lost or destroyed is also uncertain. Twenty-five sculptures have been authenticated (twenty-three heads, a female figure and a caryatid). Modigliani intended the heads to be viewed together – seven were displayed at the *Salon d'Automne* in 1912, to create the 'effect of a primitive temple'. The spherical faces, block-like appearance, superficially carved mass and geometric facial features bear an obvious resemblance to Brancusi's own early works in stone, with their direct working of the material. Modigliani's analysis of African sculpture and his affinity to other non-European art, such as Egyptian, Etruscan and Greek sculpture, had great significance for his own work. A cycle of heads dating from around 1911–12, in which he achieved a new and highly individual formal language, testified to a variety of different cultural influences. His *Caryatid* (c.1914) and *Standing Nude* (c.1911) are presumed to have incorporated borrowings from Egyptian and Cycladic art, but Modigliani was always subtle in the way he appropriated and transformed influences of all kinds. Central to his efforts to achieve an expressive, emotional sculpture free from the ideals of classical beauty and anatomical verisimilitude, were the emotional energy of tribal art, as well as his rejection of modelling in favour of working directly in stone. Modigliani's influence on contemporary sculptors was, however, marginal, with the possible exceptions of Jacob Epstein and Jacques Lipchitz.

The visual issues raised by Modigliani's sculpture were explored further in his paintings from the period 1915–20. As a painter he has achieved lasting fame, above all for his portraits of artists. Despite their characteristic, mask-like stylisation (oval, elongated faces, tube-like necks, diverging eyes), his portraits retain a particular grace and spirituality in their

fusion of an elongated formal language with certain mannerist tendencies. In these later works the arabesques became ever more stylised, in comparison with the early portraits. Good examples of this were his female nudes, which radiate tranquillity and serenity. The subjects staring into the distance are lifted out of their environment and thrown back on themselves. Here, the artist's foremost concern was to penetrate the psychology of his subjects, who are mostly depicted frontally, in close-up.

Modigliani died in Paris on 25 January 1920. H.D.

Alfred Werner, *Modigliani, der Bildhauer*, Geneva, Hamburg, Paris and New York, 1962

Joseph Lanthemann, *Modigliani 1884–1920, Catalogue raisonné, sa vie, son oeuvre complet, son art*, Barcelona, 1970

Carol Mann, *Modigliani*, London, 1980

Amedeo Modigliani, exh. cat., Paris, Musée d'Art Moderne de la Ville de Paris, 1981

Werner Schmalenbach, *Amedeo Modigliani. Malerei – Skulpturen – Zeichnungen*, Munich, 1990

Anette Kruszynski, *Amedeo Modigliani. Akte und Porträts*, Munich, 1996

PIET MONDRIAN

was born Pieter Cornelis Mondriaan in Amersfoort on 7 March 1872. He received his first drawing lessons from his father and from his uncle, the painter Frits Mondriaan. After taking a diploma in drawing instruction, he studied painting at the Academy in Amsterdam in the years 1892 to 1997, during which time he produced landscape paintings in the tradition of the schools of Amsterdam and of The Hague. On leaving the Academy, Mondrian supported himself by painting flowers and portraits. The landscapes he painted in 1904–1905 already showed a gradual shift away from literal representation of the motif. His style, which began to reflect the influences of Divisionism and Fauvism, developed a stage further as a result of his encounter with Jan Toorop in Domburg in 1908. In the same year he joined the Theosophical Society and came into contact with the world of esoteric religious thought. In 1909, together with his fellow painters and friends Cornelis Spoor and Jan Sluyters, Mondrian held an exhibition at the Stedelijk Museum in Amsterdam; the pictures that went on display there underlined his final break with naturalism. In 1911 he took part in the first exhibition of the Amsterdam artists' association 'Moderne Kunstkring', in which works by Picasso and Braque were also exhibited, and these had a profound influence on Mondrian. One of Mondrian's works was also exhibited in the *Salon des Indépendants* in Paris, where he settled at the end of 1911.

Mondrian was in Holland at the outbreak of the First World War and unable to return to Paris. There, he made the acquaintance of the philosopher and mathematician M. H. J. Schoenmaekers, whose neo-platonic ideas upheld Mondrian in his quest for a spiritual concept of painting. In 1916 Mondrian became acquainted with Theo van Doesburg and began to

make a decisive contribution to the periodical *De Stijl*, in which he published writings on his theory of art in the years up until 1924. Central to his teaching, which went beyond aesthetic considerations, was the concept of 'Neo-Plasticism', according to which all forms of visual art, music and architecture should be based on abstract, universally valid principles independent from natural models.

In 1919 Mondrian returned to Paris and in 1921 he began to develop a system of painting in which he limited himself to the use of the primary colours red, yellow and blue, in addition to black, white and grey, and arranged them in a system of rigid, right-angled lines and planes of variable proportions and symmetries. He viewed this 'purification of painting' not as a formal spiritual exercise, but rather as the expression of a spiritual message and as a manifestation of the hidden order of the universe.

Mondrian's rigid artistic outlook met with protests in the inner circle of De Stijl. Unlike van Doesburg, who was working with the architects J. J. P. Oud and Cornelis van Eesteren, Mondrian produced only a few architectonic designs, such as a model for the stage set of Michel Seuphor's play *L'Ephémère est éternel* (1926) and a design for the layout of Ida Bienert's library. Mondrian's most impressive interior design was for his own studio, where painted sliding panels and strictly ordered right-angles offered a practical demonstration of his artistic principles.

In 1925 Mondrian split from the De Stijl group. In 1927 his articles on new architecture and city planning appeared in the journal *i 10*, edited by the anarchist Arthur Müller-Lehning. In Paris in 1929, together with Michel Seuphor, José Torres-Garcia and other abstract artists, he founded the group 'Cercle et Carré', a melting pot for all abstract schools of thought, in particular geometric abstraction. In 1931 Mondrian joined the 'Abstraction-Création' group, founded by Auguste Herbin. In 1938 he emigrated to London and in 1940 left for New York.

Under the new impact of Abstract Expressionism and, most likely, the stimulating atmosphere of the city of New York, Mondrian began a new series of paintings: a homage to the pulsating city, in which

puritanical rigidity was displaced by a rhythmic weave of coloured stripes. In Mondrian's last, uncompleted picture, *Victory Boogie-Woogie* (1943 to 1944), linear structures gave way to small paint spots, which created a staccato of colourful lights, a quasi-musical pattern and a new approach to painting that Mondrian was unable to pursue further.
Mondrian died in New York on 1 February 1944.

H. D.

Kermit Swiler Champa, *Mondrian Studies*, Chicago and London, 1985
The New Art – The New Life. The Collected Writings of Piet Mondrian, ed. Harry Holtzman and Martin S. James, London, 1987
Mondrian – From Figuration to Abstraction, Herbert Henkels, exh. cat., Tokyo, Seibu Museum of Art and The Hague, Haags Gemeentemuseum, 1987
Carel Blotkamp, *Mondrian: The Art of Destruction*, Zwolle, 1994
Piet Mondrian 1872–1944, exh. cat., The Hague, Haags Gemeentemuseum, 1994
Susanne Deicher, *Piet Mondrian. Protestantismus und Modernität*, Berlin, 1994

CLAUDE MONET

was born in Paris on 14 November 1840 and grew up in Le Havre from 1845. He revealed his artistic talent very early on, for instance in well-paid caricatures of the citizens of Le Havre. He was encouraged to paint by the landscape painter Eugène Boudin. In 1859 Monet went to Paris, visited the free Atelier Suisse and became friends with Camille Pissarro. After interrupting his studies to do his military service in 1861, he continued in 1862 as a pupil of the academic painter Charles Gleyre.
In Gleyre's liberally run studio, Monet was encouraged to paint from nature in the open air. Following the example of the Barbizon School, he and a number of fellow students and future Impressionists, Auguste Renoir, Alfred Sisley and Jean-Frédéric Bazille, went on painting expeditions to the Forest of Fontainebleau. Monet put his experience to the test in his highly successful, large and ambitious painting, *Le Déjeuner sur l'herbe* (1865–66). He felt supported in his quest for a fittingly contemporary pictorial language, which would mean abandoning some of the basic precepts of conventional salon painting, both by the theoretical stance of the new Realist movement headed by Gustave Courbet and by the unconventional painting of Edouard Manet. He and the other Impressionist painters also drew inspiration for new forms of composition, such as flat surfaces and images intersected by the edge of the canvas, both from photography and from Japanese coloured woodcuts. Monet's early depictions of scenes from contemporary life, often painted in situ (and not, as was the tradition, in the studio), led direct to Impressionism, via the painting he made of the pleasure spot on the island of *La Grenouillère*, in 1869. This small-format outdoor scene, showing the play of coloured light on moving water, was the first

systematic demonstration of the way in which changing atmospheric conditions, movement and a range of visual phenomena could be captured by the new technique of breaking down colours into their separate components and applying them to the canvas in quick, spontaneous brushstrokes. Monet also shocked the public by abandoning the elements of central perspective and the traditional methods of highlighting the contrasts of light and shade. The planned exhibition of Impressionist art at the influential *Salon* met with a series of objections which led to the independent *First Impressionist Exhibition* in 1874. One of the paintings which Monet exhibited on that occasion, *Impression, soleil levant* (Impression, Sunrise, of 1872), gave its name to the Impressionist movement.
After his exile in London and later in the Netherlands during the Franco-Prussian war (1870–71) Monet settled in Argenteuil, from 1872 to 1878. It was there and in the surrounding countryside that he painted the works that mark the golden age of Impressionism: bridges, boats, family scenes indoors and in the garden, townscapes and nature scenes, which have become classics for their richness of colour, luminosity and composition and proved an inspiration to the other Impressionists. From 1878 to 1881 Monet lived in Vétheuil, also on the Seine, where he painted deserted, melancholy, atmospheric landscapes after the death of his wife Camille, in 1879.
In his attempts to depict the constantly changing face of reality, Monet came to paint unusual subjects in the 1880s (inaccessible cliffs, rocks and bays, icy landscapes, storm and rain or brilliant sunshine, sometimes seen from unusual angles), which increasingly went beyond the bounds of Impressionism and topographic representation. With his series of late works (*Poplars, Haystacks, Rouen Cathedral*), painted after his move to Giverny in 1883, Monet moved beyond the compactly structured panel painting towards a new pictorial language, which reached its highpoint in his series of paintings of water-lilies. In Giverny Monet designed his famous garden and water-lily pond, which he recorded in over 200 paintings.

Going beyond objectively experienced reality, these paintings depict what happens 'between the motif and the artist'. Monet tried to use colours as a means of finding a counterpart to optical sensations. His water-lily paintings stand apart from contemporary avant-garde movements and were, therefore, forgotten for a long time and only rediscovered in the fifties, mainly by the Abstract Expressionists. With their open, virtually non-representational structure, expressive and abstract qualities and emphasis on colour and gesture, the water-lily paintings pointed the way to future developments.
Monet died in Giverny on 5 December 1926. H. D.

Monet's Years at Giverny: Beyond Impressionism, exh. cat., New York, Metropolitan Museum, 1978
Hommage à Claude Monet, exh. cat., Paris, Grand Palais, 1980
Robert Gordon and Andrew Forge, *Monet*, New York, 1983
Claude Monet: Nymphéas. Impression. Vision, exh. cat., Basel, Kunstmuseum, 1986
Daniel Wildenstein, *Claude Monet, Biographie et catalogue raisonné*, Vols 1–6, Paris, 1974–1991
Charles F. Stuckey, *Claude Monet 1840–1926*, Chicago, 1995

HENRY MOORE

was born in Castleford, Yorkshire, on 30 July 1898. After an apprenticeship and service at the front in 1917–1918 during the First World War, Moore decided to study sculpture and enrolled at Leeds College of Art. In 1921 he was awarded a grant to study at the Royal College of Art, in London.
The art and ethnology collections at the Victoria and Albert Museum and the Tate Gallery, and in particular the Egyptian and American sculptures in the British Museum, had a lasting influence on Moore's work. By the early twenties he had moved away from the traditional, academic canons of form, proportion and composition. Through his study of African and Oceanic art, he found his way first to crudely worked, block-like forms and then to column-like elongated figures that suggest the influence of Brancusi. In Moore's view, the modern sculptor must attempt to bring out the living content of the form, instead of regarding the form merely for its representational value. Moore sought to remain true to his material, not to distort its structural characteristics. Most of his sculptures were cast in bronze, although he also executed works in wood and stone.
From 1924 to 1931 Moore taught sculpture at the Royal College of Art. He then became head of sculpture at the Chelsea School of Art from 1932 to 1939. He was given his first public commission in 1928, a sculptural relief for a London Underground building. The same year, he held his first one-man exhibition at the Warren Gallery in London.
Moore's subject-matter centred from the outset on a few, recurring themes, including the 'Mother and Child' and 'Reclining Figure'. His first reclining figures date from the thirties and were again much

influenced by 'primitive' art, in particular Oceanic art and figures from Etruscan tombs. He was also influenced by Cubism, thanks to Jacob Epstein, and by aspects of Surrealism, especially the work of Joan Miró.

Shortly after the outbreak of the Second World War, Moore was appointed an official War Artist and created a series of drawings of people taking shelter in the London Underground, which made him widely known (the so-called *Shelter Drawings*). After the war, Moore was awarded numerous national and international prizes and became the best-known British sculptor. The first major retrospective of his work was held at the Museum of Modern Art in New York, in 1946, and in 1948 he was awarded the International Sculpture Prize at the Venice Biennale.

Moore now began to concentrate on bronze and added sculptures of groups of figures to his repertoire. The highpoint of his upright and seated figures is the two-metre-high bronze sculpture *King and Queen*, 1952–53, of which five casts exist, at least one of which is located out of doors. His concern with inner and outer form, the tension between the concave and the convex and the inclusion of hollow spaces – themes he had persued since the thirties – were reflected in abstract works such as *Upright Internal/External Form*, 1951. A further development of this composition can be seen in *Reclining Figure*, 1963, placed in front of the Lincoln Center in New York, which consists of two separate though harmoniousy interrelated monumental figures.

Moore's large-format sculptures, which reached monumental proportions in his late works, look most impressive when placed in relation to architecture or, as he himself preferred, in the open air. Like the human body, the hills and cliffs of his Yorkshire home provided him with much of his inspiration, reflected mainly in his later works and in sculptures that invite the viewer to walk through them. During this last period he executed major graphic cycles, such as the *Elephant Skull* album (1969–1970) and the *Sheep* album (1972 and 1974). In his large sculptures of the seventies and eighties, Moore remained true to his basic formal themes, as in his largest *Reclining*

Figure (1978), executed in wood for the Henry Moore Foundation, established in Much Hadham in 1977, or his *Large Arch: Torso* (1980) for Kensington Gardens, in London.

Moore died in his house in Much Hadham on 31 August 1986. H.D.

Henry Moore. Sculptures et dessins, Paris, Orangerie des Tuileries, Musée National d'Art Moderne, 1977
Herbert Read, *Henry Moore: Portrait of an Artist*, London and New York, 1979
David Mitchinson, *Henry Moore: Sculpture*, Barcelona, London and New York, 1981
Henry Moore, *My Ideas, Inspiration, and Life as an Artist*, ed. S. Webber, San Francisco and London, 1986
Henry Moore, ed. Susan Compton, London, Royal Academy of Arts, 1988
David Mitchinson and J. Stallabrass, *Henry Moore*, Barcelona, London, New York, Groningen and Paris, 1992
Henry Moore. From the Inside Out. Plasters, Carvings and Drawings, ed. Claude Allemand-Cosneau, Manfred Fath and David Mitchinson, exh. cat., Nantes, Musée des Beaux-Arts and Mannheim, Städtische Kunsthalle, München, 1996

GIORGIO MORANDI

was born in Bologna on 20 July 1890. After the death of his father Morandi moved to a flat in Bologna with his mother and three sisters, where he remained and worked until his death. He studied at the Academy of Fine Arts in Bologna from 1907 to 1913.

In 1909 Morandi came to know the work of Cézanne through reproductions and adopted him as his model for the rest of his life. In Florence he studied the early Renaissance masters, especially Giotto, Masaccio and Uccello. Like many other young artists, Morandi was initially attracted by Futurism. During a Futurist event in the Teatro del Corso in Bologna in 1914, he met Umberto Boccioni and Carlo Carrà. That same year the Galleria Sprovieri in Rome held the *First Free Futurist Exhibition*, in which Morandi also took part.

After studying the Cubist works of Picasso and Braque and, in particular, the paintings of Henri Rousseau, whose direct perception and representation of plastic forms had a lasting influence on him, Morandi turned to 'Pittura Metafisica' between 1918 and 1919. He executed a few works in which he took up elements of the pictorial repertoire of De Chirico, but on the whole created unspectacular, reductive compositions. The review *Valori Plastici*, founded by Mario Broglio, which was mainly a platform for De Chirico and Carrà, published several reproductions of works from this brief period of Morandi's art.

In 1920 Morandi visited the Venice Biennale and saw originals by Cézanne for the first time. The twenties were marked by considerable financial difficulties, and Morandi was forced to increase the amount of teaching he had been doing since 1914. His situation only improved in 1930, when he became professor of

etching at the Bologna Academy. Thanks to his new financial independence, Morandi was now able fully to develop his style of painting.

After his brief interest in Pittura Metafisica, Morandi turned almost exclusively to still lifes and a few landscapes, from 1920 on. Unlike the still lifes of Neue Sachlichkeit (New Objectivity) in Germany, for instance, Morandi – much like Cézanne – confined his formal repertoire to a few familiar objects, in ever changing arrangements (cups, bottles, bowls) and a restricted palette that avoided strong light–shade or colour contrasts. Within a given range of tonal values, he used subtle modulations and shadings to create delicate *sfumato* effects. He made these simple objects look three-dimensional by his free, painterly treatment of individual surfaces. Volume was suggested not by the effects of light and shade but by the positioning of light and dark areas to create a sense of space throughout the picture surface in an almost uniform, usually dull-coloured light. Morandi's growing interest in abstraction in the late thirties was reflected in his treatment of objects, which he reduced to increasingly simple, geometric forms. At the same time, the application of colour and the clearly visible brushwork became more important in his painting. From 1940, he created series of paintings in which he made subtle changes to objects, space and colours. Characteristic of these works is the contract between the solid positioning of the object and the free, painterly style in which it is depicted.

When he retired in 1956, Morandi travelled abroad for the first and only time, to the opening of an exhibition in Winterthur, arranged jointly with Giacomo Manzù. He went on to visit Oskar Reinhart's collection and the Kunsthaus in Zürich, followed by the Kunstmuseum in Basel. Morandi was awarded first prize for painting at the fourth São Paolo Bienal in 1957, two years after receiving the first prize for etching there, in 1955. Werner Haftmann arranged for eleven paintings by Morandi to be shown in a separate room at the first *documenta* in Kassel, in 1955. The town of Siegen awarded him the Rubens Prize in 1962. Despite his growing success, Morandi insisted

on living quietly in Bologna and the small mountain village of Grizzana, where he spent most of the summer months.

Morandi died in Bologna on 18 June 1964. H.D.

Guido Giuffré, *Giorgio Morandi*, Lucerne, 1970
Lamberto Vitali, *Morandi. Catalogo Generale*, Vol. 1: 1910–1947, Vol. 2: 1948–1964, Milan, 1977
Jean Jouvet and Wieland Schmied, *Giorgio Morandi. Ölbilder, Aquarelle, Zeichnungen, Radierungen*, Zürich, 1982
Angelika Burger, *Die Stilleben des Giorgio Morandi*, Hildesheim, 1984
Marilena Pasquali, *Morandi. Acquarelli, Catalogo Generale*, Milan, 1991
Efrem Tavoni, *Morandi. Disegni, Catalogo Generale*, Milan, 1994
Giorgio Morandi. Gemälde, Aquarelle, Zeichnungen, Radierungen, ed. Ernst-Gerhard Güse and Franz Armin Morat, exh. cat., Saarbrücken, Saarland Museum, Munich, 1993

REINHARD MUCHA

was born in Düsseldorf on 19 February 1950.

Mucha is very reluctant to make details of his biographical background public, and it is equally difficult to classify his artistic work within existing styles or systems of interpretation. Mucha works with elements of Concept Art, using some of the methods of the 'evidence collectors'. He constantly refers to the idea of the readymade by presenting *trouvailles*, whose self-referential character he emphasises (but often simultaneously betrays).

In the late seventies, Mucha started his 'Schriftbilder' (Writing Pictures), including for example the work *KREFELD–OPPUM* (1977), which was painted directly onto the wall, and consisted of gigantic letters in shiny black lacquer that spelled out the title of the work, or the first picture behind glass (Untitled, 1979), a pane of glass with a black ground and a brownish-red sequence of letters: 'S E X'. The written image is always direct, matter-of-fact and unambiguous in the literal sense.

However, written signs were only one of several elements that Mucha was concerned should be intelligible in his work. Precision of craft and technique was a feature of both his pictures and the objects and space-consuming (and space-forming) constructions that followed from the early eighties. He often produced an impression of poetic austerity that was almost melancholy – also a laconic quality, in early works such as *Lampe* (Lamp, 1981), a plain square wall-lamp, which originally lit the gateway to Mucha's studio, and more recent ones, such as the 'found' mattress in *Biblis* (1993), whose appearance was in startling contrast to its politically loaded title. Mucha uses both factory-new and old, worn objects, which he presents in isolation or in combination with each other. The individual components remain identifiable in either case; they are not transformed, but represent themselves, above all else.

In certain instances, Mucha suggests a possible continuity of meaning through his choice of an individual title, as in the case of his *Deutschlandgerät* (Deutschland Apparatus) of 1990, which he created as his contribution to the Venice Biennale. This title was the trade name of a 'compressed air hydraulic railway loader' manufactured by a firm called 'Deutschland', in the period of rapid industrial expansion in the early 1870s. Mucha, whose Düsseldorf studio was in one of this firm's former factories, built a bunker-like room in the manner of the German Fascist period inside the German Pavilion, and mounted wooden planks from his studio in glass showcases all over its interior walls. The supplementary information offered by Mucha in his parallel historical and documentary texts provided the only access for viewers wishing to understand something of the additional dimension created by linking objects from the artist's personal life and working context both with the historical facts and with the architectural context.

Mucha worked with objects from a more general and directly comprehensible context in works such as his installation *Wartesaal* (Waiting-room, 1982), in which he created a topology that was both historical and fictitious. He used 242 copies of station nameplates from the German rail network. Only one nameplate with a place-name was on show at each presentation of this work, and this was changed for each venue; the other plates remained in an archive, on eleven metal shelves. Two *trouvailles*, an old railway ticket and a 1943 list of fares, and the stipulation that each place-name had to consist of precisely six letters, were the formal starting-point for Mucha's fictitious topology, whose interpretation depended on the viewer's individual experience and readiness to make associations.

In 1981 Mucha was awarded an Annemarie and Will Grohmann Scholarship and the Prize for Advancement of the Cultural Circle of the Federation of German Industry. Solo exhibitions of his work have been held in many places, including the Württembergischer Kunstverein in Stuttgart in 1985, the Centre Georges Pompidou in Paris in 1986, the Kunsthalle Bern and the Kunsthalle Basel in 1987, the Palazzo delle Esposizioni in Rome in 1993 and the Ifa-Gallery in Berlin in 1996, as the first stage of a world tour. Mucha lives and works in Düsseldorf. C.T.

Das Figur-Grund Problem in der Architektur des Barock (für dich allein bleibt nur das Grab), exh. cat., Stuttgart, Württembergischer Kunstverein, 1985
Reinhard Mucha. Gladbeck, exh. cat., Paris, Musée National d'Art Moderne, Centre Georges Pompidou, 1986
Reinhard Mucha, Nordausgang; Kasse beim Fahrer, exh. cat., Kunsthalle Bern, and *Nordausgang*, Kunsthalle Basel and Kunsthalle Bern, 1987
Reinhard Mucha. Mutterseelenallein, exh. cat., Frankfurt a. M., Museum für Moderne Kunst, 1993
Reinhard Mucha, exh. cat., Berlin, Ifa-Galerie, Stuttgart, 1997

BRUCE NAUMAN

was born on 6 December 1941 in Fort Wayne, Indiana. From 1960 to 1964 he studied mathematics, physics and art at the University of Wisconsin in Madison. In 1964 he moved to the University of California in Davis, where he studied under William T. Wiley and Robert Arneson, among others. In 1966 to 1968 he taught at the San Francisco Art Institute. In 1966 he gave up his expressive paintings of landscapes and portraits and instead concentrated on the theory of art and the film, performance and video media.

There is a common artistic method and approach behind Nauman's works, which have extremely similar themes, materials and techniques. By examining structures and functions, internal logic and changes in sensory perceptions he tries to discover 'what art could be' (Nauman). He is not tied to one particular style, but works with a range of subjective forms of expression. In this sense his work may be regarded as 'going beyond' Minimal Art. For him, the crucial factor in determining form and the choice of medium is that these should trigger a physical or intellectual process, communicating new and often irritating experiences to the observer.

In the 1960s Nauman's works focussed mainly on the human body, such as his casts of body parts, which he alienated by combining them with other objects, and his photograph *Self-Portrait as a Fountain* (1966–67), a parody of Duchamp's readymade icon, *Fountain* (1917). He made films depicting very specific processes, such as *Thighing* in 1967 (a pun on thigh and sighing), in which the camera focusses on the artist's thigh as he kneads and twists it, sighing aloud all the while.

In 1967, inspired by Ludwig Wittgenstein's philosophy, Nauman produced one of his first neon works, in which the sentence 'The True Artist Helps the World by Revealing Mystic Truths' unwinds in a spiral. In other neon works he played with shock effects, as in *Raw War* (1970), where 'Raw' flashes red alternately with 'War' in orange. The neon pictures show a rapid succession of fragmented body parts whose encounters and penetrations end in disaster: a

satirical comment on sex and power. In a further important extension of Minimal Art Nauman produced sculptures made of fibreglass and cut-up rubber mats, which Mel Bochner described at the 1966 New York exhibition *Eccentric Abstraction* as 'not-forms'.

Since the end of the 1960s Nauman has consistently tested the limits of his work and of the impact it makes on the viewer, who is often confronted with paradoxical and even frightening situations. In 1984, at the Leo Castelli Gallery in New York, he set up his *Room With My Soul Left Out, Room That Does Not Care,* composed of three dimly-lit intersecting cellotex tunnels. Upon entering the tunnel the observer stood on a grid, looking down into an empty shaft, only to become quickly disorientated, partly as a result of being exposed to view from both sides. Although this 'experiential architecture' might be broadly self-referential and limited to the context of the individual concerned, there were also works of political commitment, such as those on themes of arbitrary justice in South America.

Nauman used Surrealist techniques in his animal sculptures of the late 1980s – as in the case of a work involving mass-produced stuffed animal dummies, which formed the basis for fragmented constructions of foam rubber or aluminium that were hung on wires from the ceiling or trailed along the floor.

In his more recent video work Nauman has increasingly tested the viewer's patience and tolerance to the limit. In *Clown Torture* (1987), for example, the observer is faced with two monitors, while two projectors on the ceiling project video images onto the side walls. The scenes shown are banal in themselves, and it is only the duplication and ceaseless repetition that give the work its intensity.

Nauman's work has been shown in countless international exhibitions, including *documentas 4, 6, 7* and *IX*, in Kassel. The Walker Art Center in Minneapolis produced a comprehensive programme on his work, which was shown on various TV channels in the USA and Europe.

Nauman lives and works in Galisteo, New Mexico.

H. D.

Bruce Nauman, exh. cat., London, Whitechapel Art Gallery, 1986
Bruce Nauman: Drawings / Zeichnungen 1965–1986, exh. cat., Basel, Kunstmuseum and Museum für Gegenwartskunst, 1986
Coosje van Bruggen, *Bruce Nauman,* New York, 1988
Bruce Nauman: Skulpturen und Installationen 1985–1990, ed. Jörg Zutter, exh. cat., Basel, Museum für Gegenwartskunst, 1990
Bruce Nauman, ed. Joan Simon, exh. cat., including catalogue raisonné, Minneapolis, 1994
Bruce Nauman. Interviews 1967–1988, ed. Christine Hoffmann, Dresden, 1996

BARNETT NEWMAN

was born as Baruch Newman in New York on 29 January 1905, to Jewish parents of Russian-Polish origin. He studied philosophy at the City College of New York from 1923 to 1927 and painting at the Art Students League from 1922 to 1929. From 1927 to 1937 Newman earned a living in his father's clothes factory and by teaching in New York schools. Newman was a life-long anarchist. He was particularly involved in politics in the thirties and stood as Mayor of New York City several times, notably in 1933.

Newman destroyed almost all his early work and stopped painting for four years in 1940. He published theoretical writings on art, which helped to make him a spokesman for young American avant-garde artists. Small drawings using biomorphic forms started to appear again in 1944, stimulated by his research in the Botanical Gardens and the Museum of Natural History. He studied the Surrealist technique of Automatism, often basing his abstract image world on myth, for instance in the *Death of Euclid,* 1947. In 1948 Newman founded the 'Subjects of the Artist' painting school, with William Baziotes, Robert Motherwell and Mark Rothko. In the same year he found his mature style in the picture *Onement 1,* in which a vertical, bright red line slices through a field of darker red.

Newman's first one-man painting shows with Betty Parsons in New York (1950 and 1951) already indicate a number of approaches. Monochrome areas painted without brushstrokes are divided by one or more stripes, which Newman calls 'zips'. The elements vary constantly, in the arrangement or composition of the coloured stripes, canvas size, format and colour. The compositions may remain purely symmetrical, sometimes the 'zips' shift to the edge. In *Vir Heroicus Sublimis* (1950–51) the immense, dark red horizontal format is articulated by five verticals.

Newman rejected the European tradition of abstract painting very firmly, considering it to be excessively based on reality. He developed an artistic and philosophical approach centred on the concept of the 'sublime', which he wanted to convey to his viewers. Experiencing the 'sublime' also means experiencing unlimited freedom; Newman's painting tries to liberate observers from the shackles of reason-directed experience, thus enhancing their consciousness. The glowing areas of colour range from deep indigo to

deep black, and are reminiscent in their intensity of mediaeval stained-glass windows. They are intended to be viewed from a very close range, and to trigger transcendental experiences; it is not possible to fit the picture into the architectural ambience as a piece of decoration. The colour space has no association with any reality outside the picture; it is concrete and spiritual at the same time, like the material and spiritual qualities of the colour itself. The borderlines are vertical – or sometimes horizontal, in one early phase – and cannot all be absorbed at close quarters; they seem to form fracture lines between different experiential spaces, as a reinforcement and source of contrast in the continuum of the colour areas.

Newman's pictures, purist in relation to the pictorial repertoire, are perfectly crafted. In the large formats the paint is applied layer by layer, and the colour effect is precisely calculated by differentiated underpainting. Line is handled and related to the picture as a whole with absolute precision, so that the act of seeing can be 'accelerated' correctly.

This austere style isolated Newman in the fifties New York, as Abstract Expressionism broke through and brought gestural painting to the fore. The situation was exacerbated by financial problems, which led to a heart attack in 1957. The paintings that form his great work, the fourteen *Stations of the Cross* (1958–1966), were created just after this severe illness. In them Newman distilled his artistic existence over many years, which had been sustained by faith that abstract painting would once more convey spiritual messages.

His last creative years produced large steel sculptures, like *Broken Obelisk* (1963–1967), which tried to transfer the experience of pictorial space into sculpture. A series of lithographs (*18 Cantons,* 1963–64), the impressive series of pictures *Who's Afraid of Red, Yellow and Blue* (1966–70) and the two innovative triangular pictures *Jericho* (1968/69) and *Chartres* (1969) concluded Newman's work in the sixties.

Barnett Newman died of heart failure on 4 July 1970 in New York.

H.D.

Barnett Newman, ed. Thomas Hess, New York, 1969
Harold Rosenberg, *Barnett Newman*, New York, 1978; 2nd ed. 1994
Barnett Newman: The Complete Drawings 1944–1969, ed. Brenda Richardson, exh. cat., Baltimore, Museum of Art 1979
Barnett Newman. Das zeichnerische Werk, ed. Claus Brockhaus and Bernd Vogelsang, Cologne, Museum Ludwig, 1981
Barnett Newman. Selected Writings and Interviews, ed. John P. O'Neill, New York 1990
Barnett Newman. Gemälde und Skulpturen, exh. cat., Düsseldorf, Kunstsammlung Nordrhein-Westfalen, Stuttgart, 1977

HERMANN NITSCH

was born in Vienna on 29 August 1938. He attended the Teaching and Research Institute for Graphic Design in Vienna from 1953 to 1958.

Nitsch developed the idea of his *Orgien Mysterien Theater* (Orgies-Mysteries Theatre) as early as 1957. This project was developed as a 'total' work of art – i.e. in line with a concept embracing the totality of art and life, which has determined the entire course of Nitsch's development, down to the present day. In 1959 Nitsch founded an order following the rules of the *Orgien Mysterien Theater* and embarked on his public 'theatrical painting actions', in which he interpreted and performed the act of painting as an act of religious devotion.

Under the influence of *tachisme* and the American tradition of 'Action Painting' – art movements that both, in different ways, emphasised the process by which works of art were created – Nitsch now gave still greater emphasis to the processual character of his painting. The paint, usually red, was splashed, dribbled or rubbed onto the support, forming some structures that were dense and intensely coloured, and some that were filigree and transparent, to reflect the changing dynamics of the painting action. The artist's smock, reminiscent of a chasuble, often became part of the structure of the picture, indicating the significance of the creative process, into which the viewer was also drawn, indirectly. Picture titles such as *Kreuzwegstation* (Station of the Cross, 1960), *brot und wein* (bread and wine, 1960) and *Geißelwand* (Scourging Wall, 1963) reflected the complex Christian and mystical ideas which served as the point of departure for this artistic activity.

In the early sixties Nitsch, along with Otto Mühl, Günter Brus and Rudolf Schwarzkogler, founded 'Wiener Aktionismus' (Viennese Actionism). This movement, unlike almost all other contemporaneous phenomena in the art world such as Happenings, which originated in the USA, and the Fluxus movement, which was emerging in Germany in particular, was not so much concerned with including the audience, or goading it into active participation. Nitsch favoured public exposure of the artist, in situations of extreme discomfort, with the accompanying risk of injury, and an almost abusive involvement of his own body, as an expressive medium. The actions which Nitsch and his associates performed in the period up to 1970 combined breaking social taboos with provoking the public and putting on a show of aggression – even though the aggression was directed primarily at the artists themselves. These actions frequently led to the imposition of fines on the artists, or even imprisonment.

Nitsch, who developed his idea of a universal work of art in the *Orgien Mysterien Theater* in the spirit of Viennese Actionism, in line with the principles of 'immoderation and excess', placed his actions in a liturgical framework. His actions took up old cultic rituals, and were characterised by animal sacrifice and rites of baptism and initiation, involving the blood and entrails of the sacrificial beast. Nitsch claimed a cathartic function, not only for the participants in such mystical processes, but also for all those who followed the rituals.

Nitsch's most important actions took place in 1975, as a twenty-four-hour event, and in 1984 as a three-day event in Schloss Prinzendorf, an estate in Lower Austria acquired specifically for this purpose. Nitsch – rather like a priest – was the central and determining figure in these actions, which included ecclesiastical rituals, such as processions and sacrifices, and religious objects such as the cross and altar. He carried out this 'staging of intensified life' (Nitsch) according to the rules and forms of a prescribed ceremony, but he also remained open to the excesses he intended to provoke with his archaic, ecstatic actions. The same apparently conflicting structural elements could also be seen in his pictorial panels and objects, which presented a combination of explosive, uncontrollable painterly self-expression with a carefully thought-out staging and installation.

Nitsch was a visiting lecturer at the Hochschule der bildenden Künste in Frankfurt from 1979 to 1981, and he occupied a chair there from 1989 to 1995. His work has been shown at exhibitions including *documenta 5* (1972) and *7* (1982) in Kassel and the Sidney Biennale in 1989. He has made important individual presentations at the Stedelijk Van Abbemuseum in Eindhoven in 1983, the Lenbachhaus in Munich in 1988 and the National Gallery in Prague in 1993. Retrospectives of his work have been held in the Pabellon de las Artes at the World Fair in Seville in 1992, at the Künstlerhaus in Vienna in 1995 and at the Konsthallen in Gothenburg in 1997.

Nitsch lives and works in Prinzendorf, Lower Austria. C.T.

Von der Aktionsmalerei zum Aktionismus Wien / From Action Painting to Actionism Vienna, Band / vol. 1, *1960–1965, Band 2 /* vol. 2, *1960–1971*, ed. Museum Fridericianum, Kassel, Kunstmuseum Winterthur and Scottish National Gallery of Modern Art, Edinburgh, exh. cat., Kassel, Winterthur and Edinburgh, Klagenfurth, 1988
Hermann Nitsch. Das bildnerische Werk, exh. cat., Munich, Städtische Galerie im Lenbachhaus, Salzburg and Vienna, 1988
Hermann Nitsch. Passionen 1960–1990, Aktionsmalerei und Relikte, ed. Galerie Heide Curtze, Vienna and Düsseldorf, exh. cat., Lübeck, Kunst pro St Petri, Vienna and Düsseldorf, 1991
Hermann Nitsch, *Zur Theorie des Orgien Mysterien Theaters, Zweiter Versuch*, Salzburg and Vienna, 1995
Hermann Nitsch. Das Orgien Mysterien Theater, ed. Museum moderner Kunst Stiftung Ludwig, Vienna, 1996

EMIL NOLDE

was born Emil Hansen in Nolde, near Tondern, on the German–Danish border on 7 August 1867. From 1884 to 1888 he took an apprenticeship as a cabinet maker and carver in Flensburg, and until 1890 he worked in various furniture factories in Munich. From 1892 to 1898 he taught ornamental drawing at the Museum of Industry and Crafts in St Gallen, in Switzerland.

In St Gallen, after initially executing watercolour landscapes and drawings of the hill farmers, Nolde became known for his small, coloured drawings in which he depicted the Swiss mountains as figures from legends and fairy-tales. He moved to Munich to become a freelance painter, but his application to the Academy, which was headed by Franz von Stuck, was turned down. Instead, he studied at Hoelzel's private art school in Dachau and, from 1899, at the Académie Julian in Paris. In 1900 Nolde rented a studio in Copenhagen, and in 1903 he moved to the island of Alsen. With their rich, bright palette and spontaneous brushwork, Nolde's paintings of that period show traces of late Impressionism. Exhibitions of his work in Leipzig, Berlin and Weimar met with little response, however, and Nolde's financial situation became desperate. Meanwhile, his art became more spontaneous and expressive. In 1905 he etched the *Phantasien* (Fantasies) series, which marked the beginning of his technically original and intensely expressive graphic work.

The 'Brücke' (Bridge) painters saw Nolde's paintings at an exhibition in Dresden, and he was invited to take part in several of their travelling exhibitions in 1906 and 1907. Nolde's stylistic development

received a strong impetus from his encounter with the paintings of van Gogh, Gauguin and Munch: the colours became brighter and more intense, he made increasing use of impasto, and he entirely abandoned perspectival depth in favour of a firmly closed pictorial surface. Flowers remained his most important motif. In the nineteen versions of *Herbstmeer* (Autumn Sea) created in 1910 and 1911, Nolde moved towards an almost entirely non-representational form of painting. Yet he did not take the final step to abstraction, and his brushwork, which had become increasingly free, now once more became linked more closely to the pictorial surface and representational motif.

After again having his pictures rejected by the jury of the Berlin Secession in 1910, Nolde launched a sharp attack on its president, Max Liebermann, which resulted in a public scandal and Nolde's expulsion. Nolde then went on to join other artists who had been rejected, in founding the New Secession, in whose exhibitions he participated until 1912. For a brief period Nolde was fascinated by big-city life and painted the nightlife, dance halls and street cafés of Berlin, in the winter of 1910–1911. He developed an interest in the expressive style of indigenous folk art and the exotic art of 'Primitive' peoples, which were also to influence the Brücke painters. In 1911 he began a book on the 'artistic expression of primitive peoples', but never completed it. He painted still lifes with exotic figures and masks from studies executed in the Berlin Ethnographic Museum. Nolde travelled to the South Sea Islands in 1913 to 1914 as a member of the German New Guinea Expedition, and recorded his impressions in a series of drawings, watercolours and paintings that continued up to 1915. From 1916 on he spent the summer months on the North Sea island of Föhr, before settling in Seebüll in 1928. His garden there became an inexhaustible source of inspiration for his painting. His other principal subjects included coastal landscapes and religious scenes.

A major retrospective of Nolde's work was held in Dresden, to commemorate his sixtieth birthday. A growing number of patrons and collectors were now interested in his work, but the Nazis' persecution of

modern art caught up with him, too, and in 1937 his paintings were included in the propaganda exhibition of *Entartete Kunst* (Degenerate Art); some works were sold abroad for foreign exchange, others burned. Although forbidden to paint, he executed hundreds of small watercolours in Seebüll from 1938 on, the so-called 'unpainted pictures', some of which he then executed in oils, after 1945. In his final years he concentrated on painting watercolours of flower and landscape motifs taken from the area round his house in Seebüll.

Nolde died on 13 April 1956 in Seebüll. H.D.

Werner Haftman, *Emil Nolde*, Cologne, 1958
Werner Haftman, *Emil Nolde, Ungemalte Bilder. Aquarelle und 'Worte am Rande'*, Cologne, 1963; London, New York and Washington, 1965; 2nd revised ed. Cologne, New York and Washington, 1971
Emil Nolde. Gemälde, Aquarelle, Zeichnungen und Druckgrafik, ed. Gert von der Osten, exh. cat., Cologne, Kunsthalle, 1973
Martin Urban, *Emil Nolde, Aquarelle und Handzeichnungen*, Seebüll, 1967 (5th revised ed., Seebüll, 1982)
Günter Busch, *Emil Nolde, Aquarelle*, Munich and Zürich, 1987
Emil Nolde, ed. Tilman Osterwold and Nolde Stiftung Seebüll, Stuttgart, Württembergischer Kunstverein, 1987

CLAES OLDENBURG

was born on 28 January 1929 in Stockholm. In 1936 the family moved to Chicago in the USA. After graduating from a literature and art course at Yale University in New Haven (1946–50) Oldenburg first started work as a journalist. From 1951 to 1954 he attended the Art Institute of Chicago, published a series of satirical drawings and began to exhibit his first Abstract Expressionist paintings. In 1956 he settled in New York.

In New York he met the new Environment Artists such as Jim Dine, Red Grooms, Lucas Samaras, George Segal, Robert Whitman and, in particular, Allan Kaprow, the creator of the multimedia Happenings. Over the next ten years Oldenburg played an active role in a number of Happenings, for which he designed costumes and props. In 1958–59 he produced his first neo-Dadaist assemblages of papiermâché and refuse painted in bright, primary colours, which made a direct statement about American consumer society. These led in the early 1960s to total environments such as *The Street* (1960) in the Judson Gallery, with figures, buildings and cars recreated from urban detritus. In 1961 came *The Store*, for which Oldenburg installed everyday objects and consumer goods encased in rough plaster papier mâché in a studio called 'The Store', in the Lower East Side in New York. He wanted to present his implicitly sociocritical works, which were inspired by displays in clothes and food shops, in their original surroundings in the midst of derelict materialism, rather than in a traditional museum.

For *The Home* (1962–63), Oldenburg once again chose everyday trivia to expose the fetishistic nature of consumer behaviour through exaggeration, enlargement and the use of bright luminous paints. Typical objects such as washbasins, toilets, kitchen equipment, fans and telephones were produced in three different versions: one 'hard' (garishly painted corrugated cardboard), one 'ghostly' and colourless (kapok-stuffed linen) and one 'soft' (vinyl). The finest examples of these manipulations of workaday objects were the 'Soft Sculptures', which were exhibited in 1962 at the Green Gallery and helped to launch the Pop Art Movement in New York. In 1966 Oldenburg was given his first major solo exhibition, at the Moderna Museet in Stockholm.

In 1965 Oldenburg began to produce designs for urban monuments, in a series of drawings and collages. The first project, *Lipstick (Ascending) on Caterpillar Tracks*, which was executed in 1969, is now sited on the campus of Yale University in New Haven. It is typical of the way in which Oldenburg incorporates so many allusions in his metamorphosis of everyday culture: an inconspicuous, ordinary object is enlarged and coarsened to the point where it becomes an aggressive, phallic 'object of desire', still owing something to the traditions of Surrealism, but reinterpreted in the Pop Art idiom. Plainly, it was Oldenburg's intention to create a surreal effect, but to 'extend the boundaries of art', in line with the views expounded by his colleagues in the Fluxus movement.

Since 1976 Oldenburg has been working with his second wife, Coosje van Bruggen, who also produces accompanying explanations and glosses on the work. In 1977, as a contribution to *documenta 6* in Kassel, Oldenburg showed an enormous, twelve-metre-high *Pickaxe* on the banks of the Fulda, symbolising both man's willingness to work and his potential for aggression. In 1979 he installed the *Mouse Museum/ Ray Gun Wing* in the Museum Ludwig in Cologne. In 1984 he started work with the architect Frank O. Gehry on the major project *Il Corso del Coltello* (The Course of the Knife) for Venice, which was staged in 1985 on the Campo dell'Arsenale, along with performances in which Oldenburg also took part.

Oldenburg's most recent monumental works include *Mistos* (Match Cover) from 1992, a matchbox measuring over 20 metres located in the Vall d'Hebron in Barcelona, *Bottles of Notes* (1994) in Central Gardens in Middlesbrough and *Shuttlecocks* (1994), now on the lawn in front of the Nelson-Atkins Museum of Art in Kansas City.

Oldenburg lives and works in New York City. H.D.

Claes Oldenburg: Mouse Museum/Ray Gun Wing, exh. cat., Otterlo, Rijksmuseum Kröller-Müller and Cologne, Museum Ludwig, 1979
Claes Oldenburg and Coosje van Bruggen, *Large Scale Projects 1977–1980*, New York, 1980
Claes Oldenburg: A Bottle of Notes and Some Voyages, exh. cat., Sunderland, Northern Centre for Contemporary Art, 1988
Claes Oldenburg. Multiples 1964–1990, exh. cat., Frankfurt a. M., Portikus, 1991
Claes Oldenburg. An Anthology, exh. cat., Washington DC, National Gallery of Art, 1995, and tour including London, Hayward Gallery and Bonn, Kunst- und Ausstellungshalle der Bundesrepublik Deutschland, Stuttgart, 1996

JOSÉ CLEMENTE OROZCO

was born on 23 November 1883 in Zapotlán el Grande (now Ciudad Guzmán), in the state of Jalisco, Mexico. In 1890 the family moved to Mexico City, where Orozco took part in events at the Academy of Art even before he left school. From 1897 to 1900 he trained to become a qualified agriculturist. He lost an eye and his left hand in a chemical experiment.

Following his studies at the Academy of Art in Mexico City from 1908 to 1914, Orozco drew caricatures for the liberal newspaper *El Hijo del Ahuizote* and the revolutionary magazine *La Vanguardia*. Between 1916 and 1920 he also produced watercolours with a strong sociocritical message. In 1922 he started work as a muralist at the Escuela Nacional Preparatoria, the experimental workshop of the Mexican muralist movement. While Diego Rivera and David Alfaro Siqueiros eulogised the glorious victory of the Revolution, Orozco's murals represented the suffering of the people, the futility of war, despair, and sympathy with the victims. In his early phase he developed an expressive realism, using dull, earthy colours and red tones. Much of the impact of his murals sprang from his carefully constructed compositions and moving imagery.

In 1927, when opposition from the Church and conservative circles began to make it difficult for him to work in Mexico Orozco moved to the USA, where the journalist Alma Reed introduced him to the 'Delphic Circle' of philosophers and artists. In 1930 an Orozco exhibition was held at the 'Delphic Studios' gallery in New York, founded by Alma Reed. In 1929 he painted the mural *Prometheus* at Pomona College in Claremont, California, and frescos on the nationalist revolutionary movements in India, Mexico and Russia at the New School for Social Research, in New York. Between 1932 and 1934 he painted a mural at Dartmouth College in Hanover, New Hampshire, on the history of American civilisation, in which Christ is shown smashing his cross, in a symbol of rebellion and refusal.

In 1936 Orozco produced his masterpieces on man and the creator and on the task of science in the Great Hall of the University of Guadalajara in Jalisco. In 1937 he created murals for the seat of government, showing the criminal court, with Hidalgo at the centre, as the symbolic figure of Mexican independence; and in 1938 to 1939 he painted a series on the Spanish Conquest, in Hospicio Cabañas. The naïve narrative style of his early period gave way to a powerful, monumental style, which used three-dimensional emphasis and strong colours to pick out the main elements in imitation of the primitive Mexican art of the Olmecs and traditional Mexican arts and crafts.

In 1940 Orozco was commissioned by the outgoing president, President Cardénas, to paint allegorical murals of Mexico in the library at his home town, Jiquilpan. In the same year he also produced the transportable fresco *Divebomber* for the Museum of Modern Art in New York, as well as writing a detailed commentary on the materials and techniques of fresco painting. While Siqueiros had started to use new industrial painting processes during a trip to the USA in 1932, Orozco preferred to keep to the 'genuine' fresco method, handed down from the Renaissance.

In 1941 Orozco produced a series of murals in the Supreme Court in Mexico City, unmasking the corruption among the judiciary in his country. Between 1942 and 1944, in a visionary fresco in the church of the Hospital de Jésus in Mexico City, he captured the horrors of war, using themes from the Apocalypse. In 1947 Orozco's first major retrospective exhibition was held at the Palacio de Bellas Artes, in Mexico City. His last major murals were produced at the National School for Teachers in 1947 to 1948, the National History Museum in Mexico City in 1948, and the main government building in Guadalajara in 1949. In addition to his great series of murals, which were all intended to promote humanist enlighten-

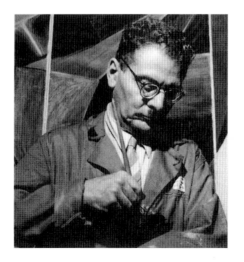

ment and demonstrated his rejection of the view that social developments had made art irrelevant, Orozco also painted a large number of oil paintings, portraits and historical-political allegories.

Orozco died on 7 September 1949 in Mexico City. In 1951 the Museo-Taller de José Clemente Orozco was opened in Guadalajara, Jalisco, Mexico. H.D.

Alma Reed, *Orozco*, New York, 1956
James Lynch, *José Clemente Orozco: The Easel Paintings and the Graphic Art*, diss., Cambridge, 1960
MacKinley Helm, *Man of fire: José Clemente Orozco. An Interpretative Memoir*, Boston and New York, 1971
Michael Nungesser et al., *José Clemente Orozco*, East Berlin, 1984
Laurence P. Hurlburt, *The Mexican Muralists in the United States*, Albuquerque, 1989

NAM JUNE PAIK

was born on 20 July 1932 in Seoul. At the age of fourteen he started taking piano and composition lessons and discovered the music of Arnold Schönberg. During the Korean War his family left the country and settled in Tokyo. From 1953 to 1956 he studied philosophy and the history of music and art at Tokyo University. His preoccupation with New Music brought him to Germany, where he studied composition with Thrasybulos Georgiades at Munich University and with Wolfgang Fortner at the College of Music in Freiburg.

From 1958 to 1963 Paik lived in Cologne and worked with Karlheinz Stockhausen in West German Radio's (WDR's) Studio for Electronic Music. At the International Summer Courses for New Music in Darmstadt he met his most important source of inspiration, John Cage, to whom he dedicated his first work, *Hommage à John Cage*, for tape recorders and piano. This was performed in 1959 in Galerie 22 in Düsseldorf and was the prelude to a series of spectacular music and Fluxus performances in the early 1960s. His exhibition *Exposition of Music – Electronic Television* with prepared pianos, sound effects and controlled television sets at the Galerie Parnass in Wuppertal in 1963 marked a watershed.

From the very beginning Paik was interested in finding ways of using television electronics creatively. Flickering colours and abstract screen images served as both aggressive attacks on wall-to-wall entertainment, and as an invitation to audiences to become involved in a contemplative way, as with *Zen for TV* (1963) and *TV Buddha* (1974). 'Just as collage techniques have replaced oil painting, so cathode ray tubes (TV) will replace the canvas', Paik proclaimed in 1965.

However, it was not until the arrival of the new technologies of the synthesiser, computer and digital media that Paik was able to put his ideas into practice, as with the electromagnetic manipulation of colour television sets that he developed in 1963–64 with the engineer Shuya Abe in Japan. After moving to New York in 1964 he showed his *Robot K 456*, at the '2nd Annual New York Avantgarde Festival'.

Wulf Herzogenrath, *Nam June Paik. Fluxus. Video,* Munich, 1983
Jean-Paul Fargier, *Nam June Paik,* Paris, 1989
Nam June Paik. La Fée électronique, exh. cat., Paris, Musée d'Art Moderne de la Ville de Paris, 1989
Nam June Paik. Video Time – Video Space, ed. Toni Stoss and Thomas Kellein, exh. cat., Basel, Kunsthalle and Zürich, Kunsthaus, Stuttgart, 1991
Nam June Paik, eine Database, ed. Klaus Bußmann and Florian Matzner, Stuttgart, 1993
Name June Paik. Baroque Laser, ed. Florian Matzner, Münster, 1995

This remote-control robot, which could walk and talk, was also built with Abe, in Japan. From this point on Paik worked closely with the organiser of the festival, the cellist Charlotte Moorman. Together they produced a number of musical works and video installations that were presented at unconventional concerts and performances in the USA and Germany. 1965 saw the start of Paik's video phase, using the latest video recorder to come on the market. At his solo exhibition *Electronic Art* at the Galeria Bonino in New York in 1965, he showed his first videos, *Robot K 456* and a black-and-white monitor showing individual images reminiscent of the phases of the moon. In 1966, at the Stockholm Museum of Technology, he presented for the first time an installation with a number of working televisions, piled up to form a sculpture. His electronically processed videos such as *Electronic Opera No. 1* (1969), continued the tradition of the abstract films of the 1920s. In *Global Groove* (1973) he combined dance scenes, adverts, his own performances and scenes with John Cage calling for free exchanges of culture across the world. In his 'Closed-circuit video installations' Paik confronted culture and technology, the most famous example being his *TV Buddha* (1974), where a buddha figure sits in front of a television showing video films of the same buddha taken by an unseen camera hidden behind the set. In his multi-series TV installations the arrangement of the monitors is just as important an experience as the continuous stream of impressions created by the asynchronous videos. Paik's more recent works have been on a larger scale and have involved the latest technology available, such as *Beuys-Voice* with a computerised centrepiece, shown at *documenta 8*, in Kassel, in 1987.

In 1979 Paik was appointed to a chair at the State Academy of Art in Düsseldorf. In his retrospectives he has combined various elements of his work, including drawings, oil paintings, laser photographs and laser installations, to form impressive displays, such as the new, thirteen-part video sculpture *My Faust*, shown at the Kunsthaus Zürich in 1991, which deals with controversial issues such as the environment, spiritualism and nationalism. In 1993 he represented Germany at the Venice Biennale.

Paik lives and works in New York and Düsseldorf

H.D.

PINO PASCALI

was born on 19 October 1935 in Bari. In 1956 he enrolled at the Academy of Fine Art in Rome and studied stage design under Toti Scialoja, amongst others. On completion of his studies in 1959 Pascali did a variety of jobs as a graphic and stage designer for film and television.

The majority of the Neo-Dadaist works that Pascali made between 1960 and 1964 was destroyed after his death, at his own express wish. He showed subsequent works, influenced by American Pop Art, in his first solo exhibition at the famous Galleria La Tartaruga, in Rome, in 1965. These included *Colosseo* (Colosseum) of 1964, a theatrical, fragmentary imitation of this building from Roman Antiquity; *Labbre Rosse. Omaggio A Billie Holiday* (Red Lips. Homage to Billie Holiday) from 1964, whose subject alludes to America.

The *Serie degli Armi* (Weapons Series), a series of faithful reproductions of weapons made out of cardboard and scrap-metal, was created in the succeeding years and first exhibited at the Galleria Sperone in Turin, in 1966. These sculptures, which derived more closely from Pascali's work as a stage designer than from an attempt to imitate objects by Pop artists such as Oldenburg and Andy Warhol, bear titles such as *Cannone 'Bella Ciao'*, *'Colomba della Pace' Missile* (Dove of Peace Missile) and *Lanciamissile Uncle Tom and Uncle Sam* (Uncle Sam and Uncle Tom Missile Launcher). The viewer was faced with the absurd and grotesque situation of 'weapons' which were perfect imitations of the real thing, from a mimetic and workmanlike point of view, but whose status as dummies and whose purpose completely gainsaid and vividly contradicted their gruesome purpose.

The so-called 'White Works' *(Opere Bianche)* were begun in 1966. These objects, which partially invade the surrounding space, are made of white canvases stretched on wooden armatures, reminiscent of fragments of huge mammals and reptiles or the limbs and skeletal remains of prehistoric creatures. They included *Due Balene* (Two Whales) and *Il Dinosauro Riposa* (The Reclining Dinosaur), both of 1966. The stylised, floor-hugging seascape, *Il Mare* (1966), an abstract-geometrical shorthand for a natural phenomenon, rounded off this series of white objects. The minimalist formal landscape which Pascali developed for these 'reconstructions' of natural phenomena led him on, in the following works, to real,

rather than metaphysical evocations of nature: *1 Metro Cubo di Terra* (1 Cubic Metre of Earth, 1967) consisted of real earth, shaped in a geometrical form, and *32 Metri Quadri di Mare Circa* (Approximately 32 Square Metres of Sea) was made of real sea water, contained in flat, rectangular metal containers.

Arte Povera – IM Spazio, the exhibition curated by Germano Celant which gave its name to the movement which eventually spread throughout the whole of Italy, showed works by, among others, Pascali, Jannis Kounellis, Giulio Paolini and Luciano Fabro. What united the Arte Povera artists from a conceptual point of view, for all the wide divergences between their artistic positions, was the particular attention they paid to the materials that they used in their works. The very material quality of the work itself became a part of the message and the traces left in the material by the working and processes employed became an essential, mostly visible, component of the finished work of art.

The *Bachi da Setola* (Hairy Caterpillars) and *Vedova Blu* (Blue Widow), both of 1968, were among Pascali's last works, in which he experimented with a variety of different industrial materials and highlighted their animal associations by blowing them up into artificially greater-than-life-size dimensions.

Pascali withdrew from the 34th Venice Biennale in 1968, as a gesture of sympathy with the student unrest which led to a temporary occupation of the exhibition grounds. In a written text, he joined a further twenty Italian artists in basing this decision on the uncalled-for situation of violence provoked 'on the one hand by the intimidations of the art students and, on the other, by the equally intimidating and repressive behaviour of the police'.

Pascali died on 11 September 1968 from the effects of a motor cycle accident in Rome. The following year, the National Gallery of Modern Art in Rome organised a comprehensive retrospective of his work.

C.T.

Pino Pascali, ed. Palma Bucarelli, exh. cat., Rome, Galleria Nazionale d'Arte Moderna, 1969
Pino Pascali, Pinacoteca di Bari, 1983

Pino Pascali, 1935–1968, ed. Fabrizio d'Amico, exh. cat., Milan, Padiglione d'Arte Contemporanea, 1987
Pino Pascali, exh. cat., Paris, Musée d'Art Moderne de la Ville de Paris, 1991
Pino Pascali, Otterlo, Rijksmuseum Kröller-Müller, 1991
Pino Pascali. La Reconstruccíon de la naturaleza 1967–1968, IVAM Centro Julio González, Valencia 1992

FRANCIS PICABIA

was born François Marie Martinez Picabia on 22 January 1879 in Paris to a Spanish father and a French mother. In 1895 he studied at the Ecole des Arts Décoratifs with Ferdinand Humbert and Charles Wallet, and later at the studio of Fernand Anne Cormon. In 1902 Picabia made his first trip to Spain, which gave him the inspiration for his constantly recurring motifs of bull fighting and Spanish women. In the years 1903–07 he contributed expressive paintings to several exhibitions.

In 1908 the musician Gabrielle Buffet, whom he later married, introduced Picabia to the theory of 'correspondences' which sought direct correspondences between certain colours, shapes, rhythms and sounds, and between spiritual and emotional experience. In his quest for a personal style, Picabia experimented with Fauvism, Cubism and even abstraction. At the beginning of the 1910s he joined a group of artists working in a Cubist style, with whom he discussed the problem of the 'fourth dimension' and non-Euclidian geometry. In 1912 this group, which included the Duchamp brothers, Léger and Delaunay, organised an exhibition which became known as the *Section d'or.* Apollinaire invented the term 'Orphism' for the works of these artists. In 1913 Picabia travelled to New York to take part in the *Armory Show* and became the spokesman for the European avant-garde. Several of his works were exhibited in the photographer Alfred Stieglitz's '291' Gallery, to which the avant-garde of the New World gravitated. At this time Picabia was creating his mechanomorphic pictures, representing man and machine in an identifiable relationship. In addition he produced pictures with puns and motifs borrowed from the world of advertising, which often had perceptible ironic undertones.

At the beginning of the First World War Picabia was conscripted for a short time, but he managed to escape to New York. In 1916, and again two years later, he suffered serious nervous disorders due to excessive alcohol and drug consumption. In the years 1917–1924 Picabia published the Dadaist journal *391.* Thereafter he concentrated on editing individual editions of other journals and producing several volumes of poetry. In 1919, after visits to Spain and Switzerland, he returned to Paris where, influenced by his encounter with the Dada group in Zürich, he founded the Paris Dada movement which included, amongst others, the Duchamp brothers (minus Marcel), André Breton and Tristan Tzara. Several of his Dada actions caused public indignation,

for example the exhibition of a toy ape which he called Cézanne, Rembrandt and Renoir. In 1921–22 he left the Dada movement, accusing it of being sectarian and dogmatic, and supported Breton in his demand for a 'normal' orientation to be applied once more to art. Picabia then turned once more to figurative painting, although he vehemently denounced Breton for transferring his allegiance to the nascent Surrealist movement. In spite of his distance from Surrealism, Picabia exhibited at the Galerie Surréaliste, which opened in Paris in 1926. Picabia opposed the Surrealists with his 'faith in the moment', representing the idea that life is in a continual state of flux – a notion reflected in his ballet *Relâche,* which was first produced in 1924 and accompanied by René Clair's interval film, *Entr'acte* (itself based on a screenplay by Picabia).

By 1925 Picabia had begun once more to concentrate on painting. He now created the so-called 'monster pictures' of contorted shapes, in garish Ripolin paints. He also completed a number of collages made from everyday materials (toothpicks, feathers, etc.). In 1927 his preoccupation with simultaneity led to his 'transparent pictures', in which several superimposed motifs suggest three dimensions, despite the absence of perspective. At the beginning of the 1930s Picabia began to produce allegories which poked fun at religious and classical themes, but which were for the most part later destroyed or painted over. In the period that followed, he worked on both figurative and abstract paintings at the same time. His 'popular realism' paintings of the late 1930s and 1940s, of toreros and nudes and the suchlike, bordering on kitsch, seem particularly bizarre and have long been ignored by art historians. After 1945 Picabia devoted himself once more to abstract painting containing symbolic and amorphous elements. In 1949 he developed his dot paintings, in which dots of one colour stand out against monochrome fields of colour. The titles of some of these were borrowed from Friedrich Nietzsche, whom Picabia had admired throughout his life.

Picabia died in Paris, on 30 November 1953 of the effects of arterio-sclerosis. K.O.

Francis Picabia, exh. cat., Paris, Galeries Nationales du Grand Palais, 1976
William A. Camfield, *Francis Picabia: His Art, Life and Times,* Princeton, New Jersey, 1979
Francis Picabia (1879–1953), exh. cat., Madrid, Salas Pablo Ruiz Picasso and Barcelona, Centre Cultural de la Caixa de Pensions, 1985
Maria Lluïsa Borràs, *Picabia,* London, 1985
Francis Picabia 1879–1953, exh. cat., Frankfurt a. M., Galerie Neuendorf, and Edinburgh, Scottish National Gallery of Modern Art, Stuttgart, 1988
Francis Picabia, Máquinas y Españolas, exh. cat., Valencia, IVAM Centro Julio Gonzáles, Barcelona, Fundació Antoni Tàpies and Paris, Musée National d'Art Moderne, Centre Georges Pompidou, 1996

PABLO PICASSO

was born on 25 October 1881 in Málaga. He received his first lessons from his father, the painter and drawing teacher José Ruiz Blasco, whom he followed in 1895 to the La Lonja Art Academy in Barcelona. Picasso exhibited his first pictures there in the artists' café 'Els Quatre Gats'.

In 1900 Picasso travelled to Paris, where he was inspired by works by Cézanne, Toulouse-Lautrec, Degas, Bonnard, Daumier and Steinlen. In 1901 Ambroise Vollard arranged the first exhibition of his pictures, which he was now signing 'Picasso', his mother's maiden name. He found his themes in Parisian everyday life, often characterised by poverty, old age and loneliness; this marked the beginning of his 'Blue Period'. In 1904 he set up his studio in the Bâteau-Lavoir in Paris. What is known as the 'Rose Period' began in 1905 with numerous circus pictures, which gave rise to Apollinaire's first, rapturous critical review.

Picasso's literary encounter with Leo and Gertrude Stein was of considerable importance to him, as was his discovery of African sculpture in the Trocadéro and of Iberian sculpture in the Louvre, which led to the creation of some archaic wooden figures and a series of portraits of women. In 1907 he created the key work for the Cubist movement, *Les Demoiselles d'Avignon,* which made an especially powerful impression on Georges Braque. In 1909 the term 'Cubism', which the critic Louis Vauxcelles had originally used in a derogatory sense to describe the new style, was adopted and converted into something positive and combative, above all by Apollinaire. Colours were limited to a few browns and greys, to emphasise the sculptural values of light and shade. In 1909, following in the footsteps of Cézanne, Picasso painted the landscapes and fragmented architectural forms which marked the transition to 'Analytical Cubism'. Starting in 1910, his progressive fragmentation and faceting of the motif led to a form of 'analysis' of the object as if it were being viewed from different angles, at the same time enabling him to achieve a constructive articulation of the picture surface, with the inclusion of 'papiers collés' as a direct allusion to concrete reality. In 1912 the paintings, which were becoming increasingly abstract,

moved into a 'Synthetic Cubist' phase comprising large, two-dimensional, emblematic forms and powerful colours. Picasso then went on to make three-dimensional constructions out of disparate materials such as paper, cardboard, sheet metal and wire. The new material aesthetic of these works had a profound effect on Vladimir Tatlin, when he visited Picasso in 1913.

For Picasso, this rapid development was cut short in 1915; he now began to alternate between naturalistic, expressive pictures and synthetic Cubist works. The Cubist repertoire became almost playfully elegant, in the way that it was now introduced into different contexts. That Picasso should have juxtaposed and interwoven different stylistic elements in this way was characteristic of his entire future development. Picasso's sets and costumes for the staging of Jean Cocteau's *Parade*, in 1917, prompted Cocteau to use the term 'sur-realist' for the first time. Through Cocteau, Picasso made the aquaintance of the Russian impresario, Sergei Diaghilev, and the composer, Eric Satie. He went on to design the stage sets, costumes and curtains for several productions of the *Ballet Russes*. In 1918 the Russian dancer Olga Koklova became Picasso's first wife.

In 1925 Picasso was represented at the first Surrealist exhibition in Paris, although his relationship to the movement was ambivalent. Surrealist theories never gained the upper hand over his own protean inspiration, which was triggered chiefly by external stimuli and only to a lesser extent by dreams and the unconscious. Whilst his work as a painter developed relatively slowly in the thirties, he created a series of important sculptural objects such as assemblages and wire constructions, which were to have a great influence on the development of sculpture in the twentieth century.

From 1930 onwards Picasso established a new style with his large, biomorphic women's heads and devoted himself with renewed vigour to graphics, such as the etchings on the theme of 'The Sculptor's Studio' for the later *Suite Vollard* (1930–1937) and to drawings on the theme of the 'Minotaur.' Graphics cycles formed an integral part of Picasso's creative output throughout his entire career.

The exhibition *Cubism and Abstract Art*, organised by Alfred H. Barr Jr. at the Museum of Modern Art in New York in 1936, included thirty-two works by Picasso which demonstrated the significance of Cubism for the development of different styles in modern painting. Following the aerial bombardment of Guernica in 1937 Picasso painted a monumental mural of the same name for the Spanish pavilion at the International Exhibition in Paris. The photographer Dora Maar, Picasso's new lover, documented the individual stages of the picture, which became the most important work of art for an understanding of the twentieth century. In a portrait of Dora Maar (1928) Picasso for the first time had recourse to the 'two-faced' motif, on which he was to make endless variations throughout his subsequent career.

During the war years, despite the ban on exhibiting his work, Picasso remained active in Paris and devoted himself primarily to sculpture. After the war

he began to experiment with different glazes and types of clay in the ceramics village of Vallauris and this led to the production both of items for everyday use and of fantastic and absurd objects. In the fifties he created variations on well-known pictorial themes and paraphrases of masterpieces by Courbet, Delacroix, Velázquez and Manet. He returned to the anti-war theme of *Guernica* in *Massacre of Korea* (1951), but otherwise his portraits of women provided the dominant theme.

Picasso now took refuge in the isolation of the Château de Vauvenargues, at the foot of the Montagne Sainte-Victoire near Aix-en-Provence, which he acquired in 1958, and his villa, 'La Californie', in Cannes. In the following years Picasso became deeply involved with graphics again, concentrating mainly on lithographs and, above all, with sculpture. He created works out of thin cut and folded sheets of metal which marked a return to Synthetic Cubism. A large sequence of 347 etchings, which he made in 1968, incorporated all the important themes of recent years – motifs taken from the circus and bull-fighting, in addition to some highly explicit amorous scenes.

In 1970 the Museo Picasso opened in Barcelona, with the help of work donated by the artist. At the beginning of March 1973 a four-metre enlargement of Picasso's (1928) design for the Apollinaire memorial was exhibited in the garden of the Museum of Modern Art in New York. A few weeks later Picasso died in Mougins, on 8 April 1973. He was buried in the garden of the Château de Vauvenargues. H.D.

Christian Zervos, *Pablo Picasso. Catalogue of paintings, sculptures and ceramics*, Vols. 1–33, Paris, 1932–78
Pierre Cabanne, *Le Siècle de Picasso*, 2 vols., Paris, 1975
Musée Picasso: *Catalogue Sommaire des Collections*, Paris, Réunion des musées nationaux, 1985, 1987
Pablo Picasso: A Retrospective, ed. William Rubin, exh. cat., New York, The Museum of Modern Art, 1980

Picasso and Braque: Pioneering Cubism, ed. William Rubin, exh. cat., New York, The Museum of Modern Art
John Richardson, *A Life of Picasso*, vol. 1: 1881–1906, London, 1991; vol. 2: 1907–1917, London, 1996

SIGMAR POLKE

was born in Oels, Lower Silesia, on 13 February 1941. In 1945 the family had to escape to Thuringia. In 1953 they moved to Berlin and hence to Düsseldorf, where Polke studied glass painting from 1959 to 1960. From 1961 to 1967 he studied with Gerhard Hoehme and Karl-Otto Götz at the Academy of Art in Düsseldorf. In 1963 Polke, together with Gerhard Richter and Konrad Lueg, invented 'Capitalist Realism', as a response to the dominant style of 'Socialist Realism' in the German Democratic Republic from which they had all come. In this, trivial objects were represented in a childishly naïve way with ironic undertones, as in *Der Wurstesser* (The Sausage Eater, 1963). At the same time Polke created pictures in which images of popular culture were overlaid with a screen which coarsened and flattened them. Patterned materials were used as the ground, in a curious parallel to the geometrical abstraction of the twenties. In works such as *Moderne Kunst* (Modern Art, 1968), décor and decoration, kidney-shaped table design and kitsch, appeared in deliberately arbitrary combinations, in a consciously dilettante exploration of the inflationary art of late Modernism, and with no attempt to create a specific style. In this way the artist dissociated himself from the search for style or meaning.

With the pictorial element, too, Polke distanced himself from existing artistic principles and challenged the reality communicated through the media, which was always ideologically conditioned. He used a variety of different media to create ironic mutations. The screen and fabric pictures of the sixties were followed by transparent superimpositions of informel techniques and graphic quotations, for which Polke drew inspiration from the whole fund of art history. Chance played an increasingly large part in Polke's artistic creations, which might be occult, spiritual or esoteric. 'Higher powers command' the artist-alchemist to use this or that painting technique or style. As an analogy to the fabric pictures, with their impenetrable patterns, or the screen pictures in which everything is intertwined, in 1984 Polke started creating his 'poured pictures'. In these, white emulsion is allowed to run in such a way as to form random linear patterns and is fixed with different varnish solutions, to create a kind of parody of artistic virtuosity. Since the eighties Polke has been using traditional painting materials (realgar, Paris green), chemical elements and metals (silver, zinc, aluminium, barium, iron, arsenic), as well as industrial materials (varnishes, corrosive fluids, sealing wax) and reagents (silver nitrate), to turn his paintings into chemical laboratories which can carry on changing their appearance even after they have reached a fixed position in a museum. Polke aims not at super-

ficial technical innovation in the 'informel' sense or capturing the artist's psychic energy in the material, but at reviving a concept of painting that the new media seem to have made redundant. The artist simply manipulates the free energies of materials in the same way that he employs various techniques and processes for his photographs, to show the process of evolution from reality to art.

Polke was awarded the Grand Prize for Painting for his work at the German pavilion at the 1986 Venice Biennale. His exhibit showed the combinatorial art of the artist who is always skilful enough to avoid the pitfalls of commercialism: chemical/physical ingredients reacted as the light fell on them and changed subtly in the room, as the 'visible effect of invisible forces' (Dierk Stemmler). In recent years ornament has become increasingly central to Polke's work as a symbol of psychic release, in the way that it can be used to combine inspiration from the history of art with a sense of the rich complexity of nature. The 'New Pictures' (from 1992) also show Polke's chameleon-like attitude to painting; he satisfies the generally felt 'hunger for images' with a wealth of different techniques and materials which merge into a complex whole, awaiting interpretation by the viewer.

Until 1991 Polke held a chair at the Hochschule für bildende Künste in Hamburg where he has been teaching, with only brief interruptions, since 1977. He lives and works in Cologne. H.D.

Sigmar Polke, Bilder, Tücher, Objekte, Werkauswahl 1962–1971, exh. cat., Tübingen, Kunsthalle and tour, Stuttgart, 1976
Sigmar Polke, exh. cat., Zürich, Kunsthaus, 1984
Sigmar Polke, exh. cat., San Francisco, Museum of Modern Art, 1991
Sigmar Polke, ed. Wim A. L. Beeren, exh. cat., Amsterdam, Stedelijk Museum, 1992
Sigmar Polke, Neue Bilder, ed. Dierk Stemmler, exh. cat., Mönchengladbach, Städtisches Museum am Abteiberg, 1992
Sigmar Polke, Photoworks: When Pictures Vanish, exh. cat., Los Angeles, The Museum of Contemporary Art, 1995
Sigmar Polke. The Three Lies of Painting, exh. cat., Bonn, Ausstellungshalle der Bundesrepublik Deutschland, Stuttgart, 1997

JACKSON POLLOCK

was born on 28 January 1912 in Cody, Wyoming. His parents were of Irish-Scottish farming stock. From 1928 he attended the Manual Arts High School in Los Angeles. His teacher, F. J. de St Vrain Shvankovsky, acquainted him with the 'colour light music' ('Lumia') of Thomas Wilfred, as well as the theosophy and teachings of Krishnamurti.

In 1930 Pollock went to New York and registered with the Art Students League. There he attended a class given by Thomas Hart Benton, a leading representative of American Regionalism, whom he assisted with a mural in the New School for Social Research. Pollock took lessons in the life class of the School's principal, John Sloan, who was one of the most significant representatives of the 'Ash Can School'. In the thirties Pollock continued to paint in the narrative style of Regionalism and in works such as *Going West* (1934–38) depicted themes from American history. This specifically American style was supported by the Works Progress Administration's Federal Art Project, for which Pollock worked on several occasions between 1935 and 1942, as part of the 'New Deal'. In 1936 he worked in an experimental workshop which had been set up by the Mexican painter David Alfaro Siqueiros in New York. Above all, Siqueiros developed new techniques for mural painting by applying the latest colours and enamel paints including Duco, which Pollock was to use frequently later on, with a spray-gun. Native Indian art also acted as an important creative, mythological and philosophical stimulus on Pollock, in his efforts to come to terms with the art of his time, including not only Picasso, but Paul Klee, Joan Miró and Max Ernst.

During this critically important period of apprenticeship, Pollock developed the prerequisites for his new concept of 'all-over' composition, as in the painting *Overall Composition* (1934–38) where all the elements of the gestural, expressive brushwork were given equal value in the abstract structure of the composition. In 1943 Pollock experimented with the surrealist technique of automatism. Pictures such as *Pasiphaë* (1943), which combined an abstract style of painting with figures and symbols from North American Indian art, attracted the attention of the critic Clement Greenberg and the collector and gallery owner, Peggy Guggenheim, who were to become two of his most important patrons.

The 1943 *Mural* for Peggy Guggenheim's house marked the first high point in Pollock's artistic development. Its ribbon-like configurations suggested musical as well as figurative associations. The colours were based on elementary contrasts between green-blue and red-yellow and black – a palette which Pollock used in many of his later paintings. In 1943 Pollock also held his first solo exhibition in Peggy Guggenheim's gallery 'Art of This Century', and the Museum of Modern Art in New York bought his painting, *She-Wolf* (1943).

In 1945 Pollock moved to Springs on Long Island where, between 1946 and 1947, he developed the new technique of 'dripping' which he constantly var-

ied and extended. This involved spreading the canvas out on the floor and dripping, pouring and flinging paint onto it with varying degrees of force, at the same time as experimenting with an increasingly wide variety of painting materials. The painting area became an 'arena' (Greenberg) and an experimental field for the free development of autonomous painting. Extremely tall vertical formats were interchanged with similarly extended landscape formats, to fit in with the movement of the brush. In 1950 Hans Namuth's famous film showing Pollock painting was released. This was a unique documentary of actionist painting, characterised by spontaneity and calculation, inspiration and technical economy, in equal parts. The painter moves around with a dancing rhythm 'within the picture', circling inside and outside the area of the painting surface, and using unorthodox painting tools to lay down trails of paint which are interwoven, knotted, superimposed and broken up again, finally to produce a structure in which forms and colours are fused into an indissoluble whole.

With these paintings Pollock became the most famous American artist of the century and his work was represented in numerous international exhibitions. However, at the same time his life became increasingly overshadowed by personal crises, excessive drinking, attempted cures and, from 1937 onwards, treatment for psychological disorders. In his late work, above all in his black and white 'Pourings', he attempted the reintroduction of figurative elements, but he rarely again achieved the intensity of his drip paintings, with the possible exception of *Easter* and *Autumn* (1953).

In 1955–56 Pollock fell into a lengthy, depressive phase, which made further artistic work impossible. On 11 August 1956 he was involved in a fatal car crash in East Hampton, Long Island. Shortly after his death the Museum of Modern Art in New York held a large retrospective of his work. H.D.

Jackson Pollock: A Catalogue Raisonné of Paintings, Drawings and Other Works, ed. V. O'Connor and Eugene V. Thaw, 4 vols., New Haven and London, 1978

Jackson Pollock, ed. Dominique Bozo, Paris, Musée National d'Art Moderne, Centre Georges Pompidou, 1982
Pollock and After: The Critical Debate, ed. Francis Frascina, New York, 1985
Steven Naifeh and Gregory White Smith, *Jackson Pollock: An American Saga,* New York, 1989
Siqueiros/Pollock – Pollock/Siqueiros, exh. cat., Düsseldorf, Städtische Kunsthalle, 1995

LIUBOV SERGEIEVNA POPOVA

was born on 24 April 1889 in Ivanovskoie near Moscow. Her father was a prosperous textile manufacturer. She studied under the Impressionist painter Stanislav Shukovski from 1907 and attended Konstantin Yuon and Ivan Dudin's art school from 1908 to 1909. Popova travelled to Kiev, Italy, France and Samarkand between 1909 and 1916. She was impressed by Giotto, Italian Renaissance painting, the religious painter Mikhail Vrubel and Old Russian painting and architecture. She encountered Picasso's and Braque's Cubist work on a visit to the Shchukin Collection. In 1912 she worked with the 'Tower', a collective studio of Moscow artists and literati, and studied under Jean Metzinger and Henri Le Fauconnier at the 'La Palette' studio in Paris. In 1913 she worked in Vladimir Tatlin's studio in Moscow.

Popova came into contact with the Futurist movement on a visit to Italy in 1914, and was lastingly influenced by Boccioni's 'Technical Manifesto of Futurist Sculpture' in particular. In her pictures, some of which show the influence of French Cubism very strongly, she turned to Cubo-Futurism, as for example in her still lifes, which are like collages and include some scraps of words. Some of her work combines painting and sculpture; thus in 1915 she produced pictorial reliefs with sculptural elements breaking up the pictorial surface and continuing it in three-dimensional space. In 1914–1915 a group of fellow artists collected around Popova to discuss new theories. Her work featured in: *First Futurist Exhibition Tramway V* and the *Last Futurist Exhibition: 0.10* in Petrograd in 1915 and in the *Knave of Diamonds* exhibition and Tatlin's *Futurist Exhibition 'Store'* in 1916. She was a member of the 'Supremus' group of artists founded by Malevich in 1916–1917. Her first abstract pictures showing the influenced of Suprematist design principles date from this period. She produced over thirty pictures under the general title *Painterly Architectonics*. In these, areas of colour determine the tectonic structure of the pictorial space and a two-dimensional quality and three-dimensional effect enter into an ambiguous relationship. Her *Space-Power Constructions* date from 1919; here, intersecting lines are set in a relationship of tension with the surrounding space. Popova experiments with materials like marble dust and sand in some of these works.

After the October Revolution Popova worked for official political events and took on commissions, including one to design decorations for the Mossoviet's May celebrations. In 1918 she joined the 'Left

Federation' of the Moscow Artists' trade union and featured in their first exhibition. In the following year she took part in the *10th State Exhibition: Non-Objective Art and Suprematism,* and in 1921 in the *5 x 5 = 25* exhibition, in which she showed her *Space-Power Compositions* for the first time, alongside works by Rodchenko, Stepanova, Exter and Vesnin. In 1920 she became a member of the State Institute of Artistic Culture (INKhUK) in Moscow, working in various sections, including the 'Objective Analysis Working Party', which discussed the theoretical basis of Constructivism. A year later she signed a proclamation of the end of easel painting and turned to 'production art', designing fabrics and fashions as well as books, magazines and posters. She also designed innovative stage sets and theatrical costumes for productions including Meyerhold's *The Generous Cuckold.*

From 1920 Popova lectured at VKhUTEMAS (State Higher Artistic and Technical Studios). She deserves credit for developing the basis of its practical art training. The key point in her curriculum was the section on 'Colour', which she approached as an independent design element in painting. She taught for a short time at the State Theatre Workshop, where her pupils included Sergei Eisenstein, and worked for the magazine of the literary group LEF (Left Front of the Arts), from 1922. She designed fabric patterns and clothing, working with Varvara Stepanova, for the 1st State Textile Factory in Moscow, from 1923. Outside Russia her work was seen at shows including the *1st Russian Art Exhibition* in Berlin in 1922 and the Venice Biennale two years later.

Popova died in Moscow on 25 May 1924.　　K.O.

Künstlerinnen der russischen Avantgarde 1910–1930, Galerie Gmurzynska, Cologne, 1979
Raumkonzepte. Konstruktivistische Tendenzen in Bühnen- und Bildkunst 1910–1930, exh. cat., Frankfurt a. M., Städtische Galerie im Städelschen Kunstinstitut, 1986.
Dmitri Sarabianow and Natalja Adaskina, *Liubov Popova,* New York, 1990
Ljubow Popowa 1889–1924, ed. Magdalena Dabrowski, exh. cat., Cologne, Museum Ludwig, Munich 1991

ROBERT RAUSCHENBERG

was born in Port Arthur, Texas, on 22 October 1925. He initially studied pharmacy at the University of Texas and was drafted into the US Navy in 1942, where he worked as a technician in various neuropsychiatric hospital departments. After briefly studying the history of art, sculpture and music at the Kansas City Art Institute (1946–1947), Rauschenberg spent a year at the Académie Julian in Paris. In 1949 he became a student of Josef Albers and Jack Tworkov at Black Mountain College in North Carolina, where he became friendly with John Cage and Merce Cunningham. That year he moved to New York. In 1952 he travelled in Italy, France and Spain with Cy Twombly.

In 1951 Rauschenberg began producing his first important works, such as the 'White Paintings', a series of pictures of the same format with monochrome painted surfaces incorporating alternate light and shade. He also worked on monochrome series in black ('Black Paintings') and red, in which newspapers and rags were worked into the surface of the picture by overpainting, producing curiously vibrant textures.

Rauschenberg's desire to make a 'monochrome nonpicture' was spectacularly expressed in 1953: he rubbed out a drawing by Willem de Kooning and put it in a gold frame, with a plaque with his own name on it. The *Erased de Kooning Drawing* was a sign of respect for the 'fathers' of Abstract Expressionism at the same time as a repudiation of their work.

From the mid-fifties Rauschenberg worked on the 'combine paintings', assemblages of pictures, photographs and found objects sprayed with paint, usually waste products of the consumer society which remained individually recognisable but were placed in unexpected conjunctions. *Monogram* (1955–1959), for instance, was a stuffed goat with a car tyre around its body, standing on a wood and metal collage structure. One of these 'combine paintings', *Black Market* (1961), consisted of a wooden suitcase which could be (and was intended to be) opened, underneath a panel picture hanging on the wall. It contained articles and instructions for a complicated barter process, symbolically also including Rauschenberg's art. With the 'combine paintings' Rauschenberg became one of the most important links between Abstract Expressionism and Pop Art and one of the leading exponents of Neo-Dada.

During that period Rauschenberg collaborated extensively with John Cage and Merce Cunningham. Between 1955 and 1965 he was manager, stage designer and technical director for the Merce Cunningham Dance Company. In 1966 he founded the 'Experiments in Art and Technology' group with the scientist Billy Klüver, to explore the potential for applying modern technology to art. Working with engineers and technicians he created works like *Mud Muse* (1968–1971): mud in a basin, which bubbled in reaction to sounds in the exhibition room.

Under Andy Warhol's influence Rauschenberg also began working with silk-screen, photofrottage and photo reproduction in the sixties. However, the sep-

arate elements such as newspaper cuttings, texts, comics, etc., were combined not in a narrative sequence but as diverse and sometimes overlapping events. In 1969 Rauschenberg was invited by NASA to attend the launch of the Apollo 11 rocket at the Kennedy Space Center in Florida and make an artistic record of the event. In the series *Stoned Moon* he combined photos of the space flight, technical drawings of rockets, and so on, with an exploration of the potential of modern technology.

With his wealth of innovative techniques, which also include projecting pictures onto thin transparent materials, his critical attitude to current trends and his inexhaustible creativity, Rauschenberg has opened up new forms of expression in art which have been a strong influence on the younger generation of artists.

In the Rauschenberg Overseas Cultural Interchange (ROCI) project, started in 1985 as an international cultural exchange programme, a selection of his works toured the world, covering Mexico, China, Tibet, Cuba and Malaysia, ending up at the National Gallery of Art in Washington DC in 1991. The project was dedicated to world peace.

Rauschenberg lives and works in Captiva, Florida, and New York. H.D.

Calvin Tomkins, *Off the Wall: Robert Rauschenberg and the Art World of Our Time*, New York, 1980
Robert Rauschenberg, exh. cat., Berlin, Staatliche Kunsthalle, 1980
Robert Rauschenberg im Gespräch mit Barbara Rose, Cologne, 1989
Mary Lynn Kotz, *Rauschenberg. Art and Life*, New York, 1990
ROCI – Rauschenberg Overseas Cultural Interchange, exh. cat., Washington DC, National Gallery of Art, Munich, 1991
Robert Rauschenberg, ed. Armin Zweite, exh. cat., Düsseldorf, Kunstsammlung Nordrhein-Westfalen, 1994

AD REINHARDT

was born on 24 December 1913 in Buffalo, New York, to parents of Russo-German extraction. The family moved to New York City in 1915, where Reinhardt studied art history under Meyer Schapiro at Columbia University from 1931 to 1935. In 1936 he moved to the American Artists School, where his teachers included Carl Holty, the abstract painter, then to the National Academy of Design, under Karl Anderson and John Marin. He was a member of the 'American Abstract Artists' group from 1937, and involved in the Works Process Administration's Federal Art Project until 1941.

Reinhardt painted and created his first collages in the late thirties, using the prevailing international mixture of Cubist and Constructivist elements: bright colours and precise biomorphic or geometrical shapes. In this period he divided his compositions strictly into horizontal and vertical elements, an approach borrowed from Mondrian. In the mid-forties this gave way to an expressive pictorial structure in which he covered the surface of the picture with a fine network of rhythmic, light-coloured calligraphy. Spontaneous brushwork, an 'all-over' approach to structure, and the meditative quality that informs these pictures indicate that Reinhardt was familiar with Mark Tobey's work. Reinhardt had touched on Far and Middle Eastern calligraphy while studying Asian art history at the New York University Institute of Fine Arts (1946–1950), and elements of this appear in his work. His first one-man show was held at Columbia University in 1943, and his first commercial exhibition in the Artists Gallery in New York in 1944.

During the war Reinhardt drew cartoons for the left-wing magazine *PM*. These caricatures anticipate his devastating later attacks on bigotry and superficiality in the contemporary art world. Reinhardt developed his idea of 'pure' painting in the fifties with equal rigour. This was intended to be abstract and 'non-representational', but also 'not magical' and 'non-subjective' (Ad Reinhardt, 1962). He first implemented his purist view of art by systematically refining and formalising his pictorial structure. The small, highly contrasting rectangles of the forties expanded, and their colour values harmonised more closely. He produced axially structured compositions with scarcely perceptible monochrome nuances, thus opening up a vibrant colour space with minimal movement in depth. The rectangular fields were red and blue at first; in the early sixties they shifted to an almost homogenous black, and the viewer has to look hard and long in order to experience their aesthetic impact.

Reinhardt intended that black, the non-colour that includes all colours, should not be seen symbolically. The 'Black Paintings' dominated his last thirteen creative years; they show the boundaries of the visible, and their consistency and radicality point towards the end of painting as a whole. Reinhardt did indeed say that he was simply painting 'the last picture', but he was not so much proclaiming pessimism about the role of painting as focussing

intensely on the medium's resources. He was not concerned with displaying virtuoso painting technique, but pursuing the idea of absolutely autonomous painting – 'art as art' – to which he committed himself in his countless theoretical writings. Themes and ideas from outside painting were not to 'contaminate' the autonomous image, and simple pictorial composition should not distract from the idea of pure art. Reinhardt's ascetic view defined art as an independent item of human self-knowledge, withdrawn from everyday life. This theoretical and artistic rigour made him a theoretical forerunner of Minimalist and Conceptual Art.

A teaching post at Brooklyn College earned Reinhardt a living from 1947 to 1967, supplemented by exhibitions at Yale University (1952–53), Syracuse University (1957), and Hunter College at the City University of New York (1959–67). Iris Clert showed Reinhardt's work in Paris (1960), but his main exhibitor was Betty Parsons (1946–65). The Museum of Modern Art bought a black painting in 1963, and a retrospective was held in the Jewish Museum in New York in 1966.

Reinhardt signed a protest note against the Vietnam War in 1965 and was actively involved in the peace movement.

Reinhardt died in New York on 30 August 1967.
 H.D.

Art-as-Art: The selected writings of Ad Reinhardt, ed. Barbara Rose, New York, 1975
Margit Rowell, *Ad Reinhardt and Color*, exh. cat., New York, Solomon R. Guggenheim Museum, 1980
Lucy R. Lippard, *Ad Reinhardt*, New York, 1981
Ad Reinhardt. Schriften und Gespräche, ed. Thomas Kellein, Munich, 1984
Ad Reinhardt, ed. Gudrun Inboden and Thomas Kellein, Stuttgart, Staatsgalerie, 1985
Ad Reinhardt, exh. cat., New York, The Museum of Modern Art and Los Angeles, Museum of Contemporary Art, 1991

GERHARD RICHTER

was born in Dresden on 9 February 1932 and grew up in Waltersdorf in the Oberlausitz. From 1949 to 1951 he worked as a scenery and poster painter in Zittau. Between 1952 and 1957 Richter studied first easel painting, then mural painting, at Dresden Academy of Art. In 1959 he came across abstract painting whilst visiting *documenta 2* in Kassel and was particularly impressed by the work of Jackson Pollock and Lucio Fontana. He refused to conform to the dictates of state-sponsored 'Socialist Realism' and in 1961 moved to the Federal Republic.

As a student of K. O. Götz at the Düsseldorf Academy from 1961 to 1963, Richter was introduced to the freedoms of 'art informel' and started to paint in a 'tachiste' style. He then came into contact with the Fluxus movement and American Pop Art and began painting in a style which came to be known as 'Capitalist Realism'. In his final year at the Academy, he and Konrad Lueg (later to become known as the gallery owner, Konrad Fischer), with whom he staged a happening, *Leben mit Pop – Eine Demonstration für den Kapitalistischen Realismus* (Living with Pop – Demonstration in support of Capitalist Realism) in the middle of a furnished living room, in a Düsseldorf furniture shop. By then Richter was already using photographs from magazines and books in his pictures.

In 1962 Richter began numbering his paintings consecutively. He saw his subsequent works as a fundamental reappraisal of painting as a medium. Richter took his images from a wide variety of sources – especially his own extensive collection, which he called the *Atlas*. He depicted trivial subjects either in a realistic manner, in which case the brushwork always revealed the genesis of the painting, or by obliterating most of the recognisable features, in a series of what he called 'mispaintings'. From 1968 to 1975 Richter created his series of 'grey pictures' – paintings, in all shades of grey, for which he employed a variety of different structures and techniques. Certain broad categories stand out among his varied subjects: seascapes (1969–76), cloud pictures (1970) and numerous landscapes (from 1969), which establish Richter as one of the greatest landscape painters since Caspar David Friedrich and J. M. W. Turner. The last time that Richter made use of found photographic material was for his *48 Portraits* – portraits of leading personalities, which he created for the 1972 Biennale.

In 1966 Richter painted the first of his 'Farbtafeln' (colour charts), based on colour samples from the paint industry. When he began working on this series again in 1973–74 he increased the range of colours to 1,024 different shades. He also produced the *Rot-Blau-Gelb* (red-blue-yellow) 'mispaintings', in which he spread shades of grey, arrived at by a process of subtraction, randomly over the surface of the picture. In 1976 Richter began to paint strongly coloured compositions on small canvases, making virtuoso use of a variety of 'informel' styles. These 'abstract pictures', as he called them, increased progressively in size and now represent his most comprehensive

and varied body of work on the theme of 'painting as painting'. Richter stresses that his painting is not just empty rhetoric or a demonstration of artistic technique. For him, abstraction is primarily a social model, an allegory of social conditions in which 'the most disparate and contradictory elements are brought together in a lively and spirited way, in the greatest possible freedom'. His abstract pictures are interspersed with realistic works, such as the sensational Red Army Faction (RAF) series in 1988 and the recent Mother and Child series (1996).

Richter's works have been shown in international exhibitions since the early seventies, including every *documenta* since 1972. He has had major retrospectives in, among other places, the Städtische Kunsthalle in Düsseldorf (1986), the Museum of Contemporary Art in Chicago and the Art Gallery of Ontario in Toronto (1988), the Tate Gallery in London (1991), the Musée d'Art Moderne de la Ville de Paris and the Kunst- und Ausstellungshalle in Bonn (1993). Richter was a Professor at the Düsseldorf Academy of Art from 1971 to 1995.

Richter lives and works in Cologne. H.D.

Ulrich Loock and Denys Zacharopoulos, *Gerhard Richter*, Munich, 1985
Gerhard Richter. Bilder / Paintings 1962–1985, ed. Jürgen Harten, exh. cat., Düsseldorf, Städtische Kunsthalle and tour, Cologne, 1986
Gerhard Richter, 18 October 1977, exh. cat., Krefeld, Museum Haus Esters, and Frankfurt a. M., Portikus, Cologne, 1989
Gerhard Richter. Text, Schriften und Interviews, ed. Hans-Ulrich Obrist, Frankfurt a. M. and Leipzig, 1993
Gerhard Richter, exh. cat., Bonn, Kunst- und Ausstellungshalle der Bundesrepublik Deutschland, Stuttgart, 1993; 2nd ed., 1996
Gerhard Richter. 100 Pictures, ed. Hans-Ulrich Obrist, Stuttgart, 1996

ALEXANDER MIKHAILOVICH RODCHENKO

was born in St Petersburg on 23 November 1891. After attending the Kazan art school from 1911 to 1914 he moved to Moscow to continue his training at the Stroganov School, where he read architecture and sculpture.

In 1916 Rodchenko showed abstract drawings produced with ruler and compasses at Tatlin's *Futurist Exhibition 'Store'* in Moscow. He was involved in designing the Café Pittoresque in Moscow in 1917, working with a group that included Tatlin. The series *Movement of Projected Areas and Constructions of Colours and Forms* dates from 1917 to 1918. Rodchenko's series *Black on Black*, a response to Malevich's white pictures, shows how Rodchenko treated colour as a fundamental pictorial resource. The black pictures featured at the *10th State Exhibition: Non-Objective Art and Suprematism* in Moscow in 1919, along with Rodchenko's first spatial structures, which he called 'white non-objective sculptures' were also shown. He experimented further along these lines in 1920–21, creating the first free hanging sculptures in the history of art. In 1920 he worked on a picture series dominated by lines. 'The line is the first and the last element, both in painting and also generally in every construction… The line has conquered everything and destroyed the last strongholds of painting – colour, shade, structure and surface', wrote Rodchenko in 1921.

From 1918 he worked in various sections of 'Narkompros' (Fine Arts Department of the People's Commissariat for Education), where his duties included directing the museums office and, with Olga Rozanova, the industrial design department. In 1919 Rodchenko taught painting theory at the Moscow 'Proletkult' (Proletarian Cultural Education Association). His work on synthesising painting, sculpture and architecture led to his being invited to join the 'Shivskulptarkh' commission in 1919–1920. His reflections on this topic were embodied in a series of architectural designs. In 1921 his hanging structures featured in the OBMOKhU (Society of Young Artists) exhibition in Moscow.

Rodchenko considered that he had brought 'painting to its logical conclusion' with the triptych *Red, Yellow, Blue* (1921), which consisted of three monochrome panels of equal size and he now turned entirely to 'production art'. As a founder member of INKhUK (Institute for Artistic Culture) he worked in the 'Objective Analysis Working Party', which discussed the theoretical basis of Constructivism, until 1924. In 1920 he joined the VKhUTEMAS (State Higher Artistic and Technical Studios), which became the VKhUTEIN (State Higher Artistic and Technical Institute) in 1927, playing a full part there as lecturer, from 1920 to 1930, and as Dean of the Faculty of Wood and Metal Design, which he himself founded in 1922.

Rodchenko worked as a graphic designer with Mayakovsky and as a magazine and book designer for titles including *Kinofot* and *LEF*, the magazine of the 'Left Front of the Arts'; his innovative typography

was particularly notewothy. He won the silver medal for designing a workers' club at the *Exposition Internationale des Arts Décoratifs et Industriels Modernes* in Paris in 1925. In the late twenties he worked on the design of a number of magazines, commemorative volumes and illustrated works, sometimes in collabotation with his wife, Varvara Stepanova.

From 1924 onwards Rodchenko took an intensive interest in photography. His bold compositions with foreshortened perspective and unusual focussing had a lasting effect on photography's development. Rodchenko worked as photographic correspondent for a number of magazines, including *Modern Architecture, New LEF* and *Building the USSR*. From 1927 to 1929 he worked as a film designer, creating costumes and sets for Meyerhold's theatre, including Maiakovski's play *The Bug* in 1929. In 1930 he was a founder member of the 'October' art association, which excluded him in 1932 after launching an attack on his 'formalist photography'. The official campaign against 'formalism' intensified in the mid thirties, and Rodchenko returned to painting, when he produced a series of melancholy clown pictures. In 1939 he was evacuated to the Moltovskaia area and went back to abstract painting after his return to Moscow in 1942.

Rodchenko died in Moscow on 3 December 1956.

K.O.

Rodtschenko, Photographien 1920–1938, exh. cat., Cologne, Museum Ludwig, 1978

Alexander Rodtschenko and Warwara Stepanowa, exh. cat., Duisburg, Wilhelm-Lehmbruck-Museum and Baden-Baden, Staatliche Kunsthalle 1982

Selim O. Khan-Magomedov, *Rodchenko. The Complete Work,* London, 1986

Alexander M. Rodtschenko, Warwara F. Stepanowa. Die Zukunft ist unser einziges Ziel..., ed. Peter Noever, exh. cat., Vienna, Österreichisches Museum für angewandte Kunst, Munich, 1991

Alexander Rodchenko. Aufsätze, Erinnerungen, autobiographische Notizen, Briefe, ed. Selim O. Chan Magomedow, Dresden, 1993

Alexander Laurentier, *Alexander Rodchenko. Photography 1924–1954,* Cologne, 1995

MARK ROTHKO

was born Marcus Rothkovitz on 25 September 1903 in Dvinsk, Russia. In 1913 the family moved to Portland, Oregon. In 1921 Rothko received a scholarship to Yale University in New Haven, Oregon, although he left early, in 1923. In 1924 he studied at the Art Students League in New York under, amongst others, Max Weber, whose Expressionist style influenced Rothko's early painting. In 1929 he began teaching at the Center Academy, a Jewish school in Brooklyn, where he was inspired by the children's drawings. He continued teaching these art classes, for which he developed his own programme, until 1952.

In the thirties Rothko's expressionistic painting was dominated by figurative subjects. He held his first solo exhibitions in the Museum of Portland and the New York Contemporary Arts Gallery. In 1935 he left the 'Gallery Secession', which he had co-founded in 1932, to form the artists' group 'The Ten' with Adolph Gottlieb, Ilya Bolotovsky and others, whose aim it was to organise exhibitions of their own work in New York. In 1936 'The Ten' held an exhibition at the Galerie Bonaparte in Paris. Rothko worked for one year with the Federal Art Project as part of the Works Progress Administration (WPA) artists' aid programme. In 1937 he visited two important exhibitions in New York – *Cubism and Abstract Art* and *Fantastic Art, Dada and Surrealism* – which had a decisive influence on his move into the orbit of Surrealism. In 1938 Rothko became a United States citizen and from 1940 signed his paintings 'Rothko'.

Biomorphic forms and mythical symbols now began to appear in his paintings. In defence of this style, Rothko and Gottlieb published a statement in the *New York Times* in 1943, which became a manifesto for 'mythical painting', in which they proclaimed an art with 'tragic and timeless themes'. Ancient mythology became Rothko's chief source of timeless symbols, which he then reduced to calligraphic signs. In the mid-forties, this calligraphy, which was related to surrealist automatism, disappeared further and further behind misty fields of colour.

The years 1949 to 1950 mark the beginning of Rothko's mature work, where large, rectangular fields of colour merge and hover in front of a monochrome ground. According to Rothko, the vagueness of the painting's internal structure 'erases the memory and liberates the power of recall'. The colours breathe in a wide, open space and borders and shapes cannot be defined with any precision. The steady tension and quiet grandeur are achieved through colour contrasts which combine with the form to create a transcendental experience. Rothko's Jewish origins mean we are as likely to find mythical connotations in his work as to discern a deliberate recourse to the tradition of the 'Sublime' in European painting.

Rothko joined the group around Peggy Guggenheim and held his first exhibition in her gallery 'Art of This Century' in 1945. He soon won recognition as one of the leading representatives of the emergent New York School of Abstract Expressionism. However, the art school 'Subjects of the Artists' which he founded

in 1948, together with David Hare, Robert Motherwell, William Baziotes and Barnett Newman, and which became wellknown for its evening lectures, was only short-lived. Rothko had more success with his pictures which, from 1950 onwards, were exhibited first at Betty Parsons' gallery and then at the Sidney Janis Gallery. At the invitation of Clyfford Still, whom he enormously admired as an artist, Rothko accepted teaching work at the California School of Fine Arts in 1947 and 1949. Later on he taught at Hunter College in New York (1951–54) and Tulane University in New Orleans (1957). In 1961 the Museum of Modern Art arranged the first retrospective of his work. Less and less was written about his work as time went by, but he exerted a lasting influence on American colour field painting.

Rothko received a number of commissions for murals: in 1958 for the Seagram Building in New York, in 1961 for Harvard University in Cambridge and in 1964 for a chapel in Houston, Texas, which, after his death in 1971, was consecrated *The Rothko Chapel*. Despite his success, Rothko had to fight harder and harder to ward off depression. In 1968 he suffered a stroke. His late work – dark acrylic pictures with stark white borders – was overshadowed by this tragedy.

On 25 February 1970 Rothko took his own life in his studio.

H.D.

Mark Rothko, 1903–1970: A Retrospective, ed. Diane Waldman, exh. cat., New York, Solomon R. Guggenheim Museum, 1978

Dore Ashton, *About Rothko*, New York, 1983

Mark Rothko 1903–1970, exh. cat., Cologne, Wallraf-Richartz-Museum, 1988

Anna C. Chave, *Mark Rothko. Subjects in Abstraction*, New Haven and London, 1989

The Art of Mark Rothko. Into an Unknown World, ed. March Glimcher, New York, 1991

James E. B. Breslin, *Mark Rothko*, New York, 1995

OLGA VLADIMIROVNA ROZANOVA

was born on 21 June 1886 in Melenkakh in the province of Vladimir. She started to study at the Bolshakov School of Art in 1904, continued with private classes in drawing under Konstantin Yuon and Ivan Dudin from 1907 to 1910 and finished at the Stroganov School of Art in Moscow. She moved to St. Petersburg in 1911, where she attended the Svantseva School of Art for a short time.

Rozanova was one of the most active members of the avant-garde movement in St. Petersburg and became a member of the 'Union of Youth', an association of progressive artists founded by Elena Guro and Mikhail Matiushin in 1910; she featured in its exhibitions for many years, and also worked on the Union's magazine. As well as her paintings she produced illustrations showing a pioneering freedom of design for volumes of Futurist poetry by Khlebnikov and Kruchenykh, her future husband; these included *TeLiLe* (1914), *High-Spirited Book* (1915) and *War* (1916). She sometimes worked with other artists, including Malevich and Puni. In *The Universal War*, an album of poetry published in 1916 – each copy was hand-made and unique – Rozanova applied Suprematist composition principles to collage technique, thus achieving a new synthesis of poetry and painting. But Rozanova found intuitive impulses more important than Suprematism's systematic approach, as she had pointed out in her essay 'The Fundamentals of new Creativity and why it has been misunderstood' in 1913. Her illustrations for Kruchenykh's volume of poetry *At the Top of My Voice* (1913) show that she was mistress of the entire Russian avant-garde repertoire. Rozanova also published her own poetry. In 1914 she showed pictures and books at the *Free International Futurist Exhibition* in Rome.

In 1916–1917 Rozanova attached herself to Malevich's 'Supremus' group and worked on its magazine, but this was never published. At this time she moved away from Cubo-Futurism and painted her own abstract pictures, developing from independently interpreted and occasionally very dynamic Suprematism to more static geometrical designs with a contemplative feel. The large colour fields now filled the whole picture, thus departing from the compositional principles of Suprematism. Her first textile and fashion designs date from the same period. In 1915 she exhibited in shows including the *Tramway V: First Futurist Exhibition* in Petrograd and the *Last Futurist Exhibition 0.10*, and in the *Knave of Diamonds* exhibition in Moscow in 1916.

After the October Revolution Rozanova worked on monumental propaganda and became a member of 'Proletkult' (Proletarian Cultural Education Association). She and Rodchenko directed the industrial design section at 'Narkompros' (Fine Arts Department of the People's Commissariat for Education), founded in 1918. She helped to establish SVOMAS (Free State Studios) in a numer of different cities.

Rozanova set new standards as an illustrator and typographer. She brought a new dynamic into design by unifying text and illustrations and introducing collage as a design element in book art.

Rozanova died of diphtheria in Moscow on 8 November 1918. Malevich accompanied her funeral procession carrying a black flag with a white square. Both Rodchenko and Ivan Kliun designed a tomb for her, which was shown at the *5 x 5 = 25* exhibition in Moscow in 1921. A memorial exhibition was devoted to her as part of the *10th State Exhibition: Non-Objective Art and Suprematism* in Moscow in 1919. Work by Rozanova was shown at the *1st Russian Art Exhibition* in Berlin in 1922. K.O.

Künstlerinnen der russischen Avantgarde 1910–1930, exh. cat., Cologne, Galerie Gmurzynska, 1979
Mjuda Jablonsky, *Russische Künstlerinnen 1900–1935*, Bergisch-Gladbach, 1990
The Great Utopia, exh. cat., New York, Solomon R. Guggenheim Museum, 1992

THOMAS RUFF

was born in 1958 in Zell am Harmersbach, in the Black Forest. From 1977 to 1985 he studied photography under Bernd Becher at the Staatliche Kunstakademie in Düsseldorf.

Ruff found his initial subject-matter in his home environment – in the flats and houses belonging to his parents, his relations and the parents of his friends. These were mostly interiors devoid of people, furnished in the style of the fifties and sixties and characterised by a kind of sober dreariness and oppressive impersonality. The series of large colour portrait heads which followed on from the interiors and won Ruff early international recognition as a photographer took up, in a sense, with the traditional style of seemingly factual documentary photography. Once again, Ruff chose his subjects from his immediate surroundings, since the subjects of these large-scale cibachrome prints were his friends and fellow students at the Academy, portrayed with the utmost precision, down to the minutest detail. Ruff employed the same setting throughout: his subjects looked straight ahead with a calm gaze and concentrated, sober expression. They were set against a neutral background and the overall colouring was restricted to a range of soft, relatively undisturbing pastel shades. The seductive aspect of these portraits was their size (205 x 160 centimetres), for which there was no equivalent outside the field of advertising. The gigantic scale of the heads almost inevitably endowed them with a degree of universality and an accompanying aura of generalised personal significance. What might seem initially to be naturalistic or documentary, on account of the photographic medium employed and the factual nature of the setting, was contradicted, in the last analysis, by the arbitrariness of the model: 'People must know my portraits if their behaviour is to be such as to allow my portraits to succeed.'

The portraits were followed, from 1987 onwards, by a series of photographs of houses, all of them examples of fifties architecture, put up at the time of the Economic Miracle, whose dumb façades continue to prescribe the social environment of their inhabi-

tants. For these photographs Ruff once more used a similar compositional technique. In contrast to Bernd and Hilla Becher's method of creating photographic documents of objects selected according to typological criteria, Ruff selected isolated buildings from his immediate environment and registered their façades in the most precise detail. Here, too, the effect is achieved by photographic enlargement, which plays a part in assigning special significance, uniqueness and general validity to a piece of banal architecture. Ruff took a further step towards depersonalising and distancing the pictorial subject and the method of its presentation in 1981, when he embarked on his series of photographs of the starry firmament. For this, he used second-hand images, photographs of the night sky from the European Southern Observatory (ESO). Here again the black and white prints (260 x 188 centimetres) achieved their effect, not through the choice of subject or the attractions of colour, but through the surface distortions caused to the image by the process of enlarging the photographs.

In 1991 Ruff started work on another project related to his collection of 'beautiful' newspaper photographs, built up over many years. He set about enlarging these photographs taken by strangers to double their width, at the same time retouching any of the captions which had survived. In this way, he presented the subject-matter and style of altogether disparate images in a disjointed and deliberately scattered hang, which would frustrate all efforts at finding a logical explanation or linking narrative. Ruff's most recent works seem in retrospect to be an almost inevitable consequece of his efforts to undermine the popular belief in photography as a medium for objective documentation, which is 'true to reality'. He is now making portraits once again – this time, manipulated with the aid of a computer – but these are 'depictions' of fictious or synthetically created people. In 1988 Thomas Ruff received North Rhine–Westphalia's Prize for the Advancement of a young Artist. In 1992 he was included in *documenta IX*, and in 1995 he represented Germany at the Venice Biennale.

He lives and works in Düsseldorf. C.T.

Thomas Ruff. Porträts, Museum Schloß Hardenberg, Velbert, Portikus, Frankfurt a. M., Cologne, 1988
Bilder – Elke Denda, Michael van Ofen, Thomas Ruff, Krefeld, Museum Haus Esters, 1988
Thomas Ruff: Portretten, Huizen, Sterren/Porträts, Häuser, Sterne/Des Portaits, des Maisons, des Etoiles, exh. cat., Amsterdam, Stedelijk Museum, Grenoble, Magasin, Centre National d'Art Contemporain and Zürich, Kunsthalle, 1989
Parkett, no. 28, 1991 (special issue on Franz Gertsch and Thomas Ruff)
Boris von Brauchitsch, *Thomas Ruff,* Schriften zur Sammlung des Museums für Moderne Kunst, Frankfurt a. M., 1992

ROBERT RYMAN

was born on 30 May 1930 in Nashville, Tennessee. He attended the Tennessee Polytechnic Institute in Cookville (1948–49) and studied music at the George Peabody College in Nashville (1949–50) with the aim of becoming a music teacher. In 1952, after completing his military service, Ryman moved to New York where, as a tenor saxophonist, he planned to become a jazz musician. However, he found himself increasingly drawn towards painting; as a museum attendant in the Museum of Modern Art (1953–60) he became acquainted with artists of the nascent Minimal Art movement who were also employed there (Dan Flavin, Sol LeWitt and Frank Stella).

Ryman produced his first pictures in 1953 and at the end of 1954 decided to give up music and devote himself entirely to painting. Even his early attempts, which were non-representational from the outset, showed a clear interest in the basic principles of painting, colour, materials and style. At the beginning of the sixties Ryman reduced his initially colourful palette to white, because white seemed to him to be the most neutral colour and at the same time to have the widest variety. This neutrality enabled him to make the painting process the central element of the picture: white has degrees of consistency, brightness and tonal values, and a susceptibility to the finest nuances of light which serve as an incentive to the act of painting and make it possible for the viewer to identify each separate application of paint and characteristic brush style.

Ryman's artistic approach was to expound the problems of how to handle colour – in his opinion, the essence of all painting. In 1965 he decided on a systematic method of working in order to examine this particular problem. Various series show the changes of the colour white in consistency, transparency and shade, when applied to completely different painting surfaces: cotton duck, linen, cardboard, copper, steel, wood, perspex, fibreglass and vinyl. To avoid the issues of composition, Ryman generally chose a square format for his series of paintings, for example *Winsor 5* of 1965. This 'perfect space' (Ryman) offered a surface without direction which excluded all associations and enabled the shape of the painting to be defined entirely by the act of painting and its structure by the material. Ryman had

already started approaching painting as a material process in his choice of the materials themselves: oil paints, casein, gouache, new polymer and vinyl paints, enamel and other varnishes. The paint surface varied from smooth and calm to agitated and thick; colour was applied in thick layers or so thin as to be almost transparent; the format of the painting became just as much a theme as the priming of the canvas or the preparation of the ground.

The relationship of the support to the painted surface, and of the painting to the wall became a central question in the sixties. Since 1961 Ryman had been using unstretched canvases as a support for his paintings and, from 1967, steel plates. He attached these materials directly to the wall. Consequently, the traces of glue left behind when a picture painted on a wall was pulled off also served to reveal and thematise the working process. These works were included in his first solo exhibition at the Paul Bianchini Gallery in New York.

In 1976 Ryman started integrating black, white or transparent 'fasteners' to his paintings as a compositional element: when applied behind the picture surface they pushed the painting in towards the room and produced a shadow on the wall; when attached to the surface of the picture these black pieces of metal contrasted with the white expanse of the surface. Ryman combined various sizes and types of hanging devices (*Receiver,* 1987), extended them to broad aluminium rails (*Transport,* 1985) or reduced them to screws or nails which, in the *Versions* of 1992, threw fine points of shadow on the white field. On pictures such as *Administrator* (1985) the fasteners were distributed at irregular intervals around the edges.

Despite his systematic, conceptual beginnings, Ryman has remained attached to the classical tradition of painting. He holds that the serial analysis of painting, rather than standing in the way of the viewer's immediate response to light and space, should serve to provoke 'joy and surprise at one's own reactions' (Ryman).

From the mid-sixties onwards Ryman has regularly held exhibitions in North America and Europe. He

took part in *documenta* in Kassel in 1972, 1977 and 1982. Comprehensive retrospectives of his work have been held in Amsterdam (1974), Zürich (1980), Paris (1981) and London (1993).

Ryman lives and works in New York. H.D.

Robert Ryman, exh. cat., Amsterdam, Stedelijk Museum, 1974
Robert Ryman: paintings and reliefs, exh. cat., Zürich, InK, Halle für Internationale neue Kunst, 1980
Robert Ryman, exh. cat., Paris, Musée National d'Art Moderne, Centre Georges Pompidou, 1981
Jean Frémont, *Robert Ryman: le paradoxe absolu,* Caen, 1991
Robert Ryman: Vestions, exh. cat., Schaffhausen, Hallen für neue Kunst, 1992
Robert Ryman, Robert Storr, exh. cat., London, The Tate Gallery, 1993

CHRISTIAN SCHAD

was born in Miesbach, Upper Bavaria, on 21 August 1894. In 1913 he began studying painting with Heinrich von Zügel at the Munich Academy of Art, but Zügel's idyllic Post-Impressionism did not satisfy him for long. In 1915 he exhibited in the Munich Secession, but left for Switzerland that year to avoid being called up.

In Zürich he produced pictures and graphics in a style influenced by Cubism and Futurism and came into contact with the Dada movement. In 1916 he moved to Geneva. In 1918, in his experiments with 'objets trouvés', Schad discovered the technique of 'photographing without a camera' – photographing objects on light-sensitive plates – which he called 'Schadographs'. With the writer Walter Serner, a friend since 1915, Schad founded Geneva Dada at the end of 1919. In 1919 Schad and Serner organised the first Dadaist 'World Congress' in Geneva, attended by, among others, Tristan Tzara, Hans Arp, Alexander Archipenko and Igor Stravinsky. One of many sensational events provoked physical violence, with the angry public tearing Schad's pictures from the wall and trampling on them. Between 1919 and 1920 he produced wood reliefs and relief assemblages in a Dadaist style.

From 1920 to 1925 Schad lived mainly in Rome and Naples, for a time with Serner. He painted café and theatre scenes, gypsy children and working-class girls with realistic intensity. The picture *Maria und Annunziata (vom Hafen)* (Maria and Annunziata from the Harbour, 1923), is an example of Schad's early work in the manner of the Neue Sachlichkeit (New Objectivity), but with the incorporation of classical elements. Georg Schrimpf, a friend from his student days whom he met again in Italy, was a decisive influence on this style. In 1925 Schad moved to Vienna, where he painted an impressive portrait of Pope Pius XI and in 1927 had his first one-man exhibition at the Würthle gallery. His move to Berlin in 1927 was the beginning of his most artistically prolific period.

Giovanni Testori, *Christian Schad. Werke von 1920 bis 1930*, Milan and Munich, 1970
Christian Schad, ed. Matthias Eberle, exh. cat., Berlin, Staatliche Kunsthalle, 1980
Christian Schad, Zeichnungen 1918–1977, ed. Günter H. Richter, Rottack-Egern, 1990.
Neue Sachlichkeit. Figurative Malerei der Zwanziger Jahre, ed. Hans-Jürgen Buderes and Manfred Fath, exh. ca.t, Mannheim, Städtische Kunsthalle and Ausstellungs-GmbH, München, 1994

EGON SCHIELE

was born in Tulln, Lower Austria, on 12 June 1890. He showed an early aptitude for drawing and received assistance from a number of different teachers.

After a brief period at the Vienna School of Arts and Crafts Schiele was accepted for the Vienna Academy of Art in 1906 and enthusiastically began to study painting with Christian Griepenkerls. However, the conservatism of the Academy and of his teacher, in particular, led to frequent conflicts. Schiele was more interested in the painting of Gustav Klimt, whom he sought out in 1907, and the Vienna Secession, which influenced him over the next few years. In 1909 he left the Academy and founded the *Neue Kunstgruppe* (New Art Group) with friends. Schiele showed four pictures in the *Internationale Kunstschau Wien* organised in 1909, with Klimt as president. Through the critic Arthur Roessler he met the collectors Carl Reininghaus and Oskar Reichel.

Until then Schiele's work had been largely influenced by the decorative forms of Jugendstil, but around 1910 he found his own independent style, which even Klimt freely acknowledged as masterly. With artistic virtuosity Schiele drew the outline of a figure in a flowing line. He added colour later from memory. Against all the academic rules, and with radical subjectivity, Schiele found in his erotic nude drawings visual angles and views which often made the figure look distorted or deformed. The public were shocked, not only by the undisguised nakedness and alleged obscenity of the portrayal, but also by the bizarre eccentricity of the pose, in which the model was exposed without protection to the voyeuristic gaze of artist and viewer.

In 1911 Schiele moved to Krumau. He produced countless views of the town and vineyards and also nudes, using younger and younger models and eventually provoking outright hostility from the petit-bourgeois locals. He moved to Neulengbach, where a similar situation led to the 'Neulengbach affair'. Schiele was sent to prison for three weeks in 1912 for circulating indecent drawings and charged with seducing a minor. During that period he did numerous drawings of prison life.

On his return to Vienna Schiele's artistic reputation, which had not suffered as a result of his prison sentence, began to grow, and as his work was bought by powerful collectors his financial circumstances improved. In 1913 he was accepted as a member of the *Bund Österreichischer Künstler* (Association of Austrian Artists) and showed his work in several major exhibitions, such as the Secessions in Munich and Vienna, the *Große Deutsche Kunstausstellung* in Düsseldorf and Berlin and the Hans Goltz Gallery in Munich. In Berlin Schiele came to the attention of Franz Pfemfert, founder and publisher of the magazine *Die Aktion*, who gave him several commissions for illustrations. At the beginning of 1914 Schiele learned etching and wood engraving, although apart from a series of seven etchings these media did not hold his interest for long. He was more interested in photography, producing a series of portrait photographs in which he himself features as self-confident, dandified even, and eccentric.

In June 1915 Schiele was sent to Prague for military service. After training he was put to work mainly in the orderly room. He did not succeed in returning to Vienna until 1917, after numerous attempts and official applications. Of the few paintings he did in that period the landscapes and city pictures were particularly noteworthy – generally, idyllic views which romantically transformed the subject, in contrast to the liberties which he took with the human figure.

Schiele had his last major success at the exhibition of the Vienna Secession in March 1918, at which practically all his fifty paintings and drawings were sold. He also took part in major exhibitions in Zürich, Prague and Dresden.

Schiele died of Spanish influenza in Vienna on 31 October 1918. H.D.

Erwin Mitsch, *Egon Schiele 1890–1918*, Salzburg, 1975; Engl., *The Art of Egon Schiele*, London, 1975
Christian M. Nebehay, *Egon Schiele 1890–1918. Leben – Briefe – Gedichte*, Salzburg and Vienna, 1979
Matthias Arnold, *Egon Schiele. Leben und Werk*, Stuttgart and Zürich, 1984
Reinhard Steiner, *Egon Schiele 1890–1918. Die Mitternachtsseele des Künstlers*, Cologne, 1991

In his famous *Selbstbildnis* (Self-Portrait), painted in 1927, Schad provocatively portrays himself as a cool and detached lover. A woman with the scar inflicted by a jealous lover on her cheek appears in the background as a depersonalised object – in a uniformly austere light, exposed and without any gloss, with an almost insistent realism. The theme of this portrait, with its over-emphatic realism, is narcissism and above all the alienation and isolation of the lovers. Many of Schad's pictures, such as *Graf St Genois d'Anneaucourt* (Count St Genois d'Anneaucourt, 1927), show urban figures with split personalities, outsiders who seem to conceal their alienation from society behind a cool, confident exterior. Schad's portraits are outstanding examples of Neue Sachlichkeit; they express the concept of self in fashionable society and the modern, liberal or libertarian attitude to life which is characteristic of city dwellers.

Such insight into the depths of a particular section of society obviously needed first-hand knowledge of Berlin's night life. Not surprisingly, therefore, Schad's artistic productivity declined rapidly with the political and social changes in the early thirties. In 1930 Schad had a special exhibition at the 'Juryfreie' (unjuried exhibition) in Berlin, with his illustrations to Curt Morek's *Führer durch das 'lasterhafte' Berlin* (Guide through depraved Berlin).

It was clear from his preoccupation with Eastern philosophy, however, that Schad was seeking a new direction. In 1935 he took a job in business. In 1936 he was included in *Fantastic Art, Dada and Surrealism* at the Museum of Modern Art, New York. He produced only a few more pictures in the National Socialist period – mainly landscapes and portrait drawings. In 1942 Schad went to live in Aschaffenburg, where he was commissioned to make a copy of Matthias Grünewald's *Stuppach Madonna* in the original dimensions. After the war he again worked on portraits and Schadographs. Schad's works have been shown in numerous exhibitions of Neue Sachlichkeit and in 1972 he had his first major retrospective, at the Palazzo Reale in Milan.

Schad died in Keilberg, near Aschaffenburg, on 25 February 1982. H.D.

OSKAR SCHLEMMER

was born in Stuttgart on 4 September 1888. He studied as an artist-craftsman at an intarsia workshop from 1903 to 1905, then attended the Stuttgart Academy of Art until 1909. In 1911 he went to Berlin as a freelance painter and became part of the circle around Herwarth Walden's 'Der Sturm'.

The first paintings he produced in Berlin were influenced by Cubism. In 1912 Schlemmer returned to the Stuttgart Academy, where he joined Adolf Hoelzel's master class. In 1913 he opened the 'Neuer Kunstsalon am Neckartor' with his brother Wilhelm, exhibiting works by the Cubists, the 'Blaue Reiter' (The Blue Rider) and Oskar Kokoschka, until 1914. With Willi Baumeister and Hermann Stenner, Schlemmer painted four of the twelve murals of old Cologne legends for the Werkbund exhibition in 1914, under Hoelzel's supervision. The same year he volunteered for the army, serving initially in the medical corps and later as an infantryman and cartographer. While on study leave in 1916 he met Johannes Itten in Stuttgart. He now produced his first abstract compositions. With Baumeister and four other artists Schlemmer founded the 'Üecht' group and in 1919 organised the *Herbstschau Neuer Kunst* (Autumn Exhibition of New Art) at the Württemberg Kunstverein in Stuttgart, which included work by members of the Berlin group, 'Der Sturm'.

Schlemmer was unsuccessful in his efforts to bring the Stuttgart Academy up to date. As a result he returned to Bad Cannstatt in 1920 and worked on the designs for his *Triadic Ballet* with his brother Carl. The three-dimensional costumes, which enveloped the dancers in basic geometrical forms (sphere, square and cube), were essential to the theatrical effect of this Cubist ballet. It was primarily the costume rather than the person's body that was expressive, since the body was artificially stylised in such a way as to permit the development of new forms of choreographic expression. The première of this work was held at the Württemberg State Theatre in Stuttgart in 1922, with Schlemmer himself as one of the dancers.

In 1921 Schlemmer took over artistic control of the workshops for stone-carving, metal and (in alternation with Johannes Itten) mural painting at the Bauhaus in Weimar, which he had visited the previous year at Gropius' invitation. For the 1923 Bauhaus exhibition he carried out extensive interior decorations in the workshop buildings (destroyed in 1930). But Schlemmer's main interest was theoretical and practical work for the stage. Until 1928 he ran the theatre workshop, on which the *Triadic Ballet* and *Bauhaus Dances* exerted a strong formative influence. In addition to his work at the Bauhaus Schlemmer designed numerous stage sets, including sets for the Volksbühne in Berlin and the German National Theatre in Weimar. His painting at the Bauhaus, which, like his teaching, focussed on the theme of 'Mankind', gained wide recognition. In 1929, as the Bauhaus in Dessau under Hannes Meyer came under increasing political pressure, Schlemmer accepted the offer of a post at the Breslau Academy, where he

was able to continue his successful work for the stage until 1932. He then taught at the United State Art Schools in Berlin, but was dismissed in 1933. Schlemmer's murals at the Folkwang Museum in Essen were taken down by the National Socialists in 1930.

Schlemmer lived in Switzerland from 1933 to 1937, acquiring a house in Sehringen in the Black Forest in 1937. The *Entartete Kunst* (Degenerate Art) exhibition put a bitter end to his attempts to carry on working as an artist. He struggled on painfully with painting jobs and camouflage, which increasingly sapped his mental and physical strength. He was then offered a post at the Dr Herberts paint factory in Wuppertal, in order to set up an experimental paint laboratory there. Schlemmer worked on various publications on painting techniques, including *Modulation und Patina* which investigated the artistic applications of enamel paints. The *Lackkabinett* project, a room fitted with painted panels, proved too costly and was never completed. The 'Window Pictures' which he produced in 1942 were Schlemmer's last artistic work.

Schlemmer died after a long illness on 13 April 1943, whilst on a cure in Baden-Baden. H.D.

Will Grohmann and Tut Schlemmer, *Oskar Schlemmer. Zeichnungen und Graphik*, Stuttgart, 1965
Wulf Herzogenrath, *Oskar Schlemmer. Die Wandgestaltung der neuen Architektur*, Munich, 1973
Karin v. Maur, *Oskar Schlemmer. Monographie und Œuvrekatalog der Gemälde, Aquarelle, Pastelle und Plastiken*, 2 vols., Munich, 1979
Karin v. Maur, *Oskar Schlemmer*, Munich, 1979
Oskar Schlemmer, exh. cat., Baltimore, The Baltimore Museum of Art, 1986
Dirk Scheper, *Oskar Schlemmer. Das triadische Ballett und die Bauhausbühne*, Berlin, 1989

KURT SCHWITTERS

was born in Hanover on 20 June 1887. He started a course at the School of Arts and Crafts in Hanover in 1908, then moved to the Dresden Art Academy from 1909 to 1914. He was called up for military service in 1917 and worked as a shop draughtsman in a Hanover ironworks.

In 1918 Schwitters exhibited some pictures in a Cubo-Futurist style painted the previous year in Herwarth Walden's 'Der Sturm' gallery, in Berlin. From 1918 to 1919 he studied architecture at the Technical College in Hanover. He produced his first collages or assemblages using scrap and all kinds of objects in 1919. The letters 'MERZ' happened to be visible in one of these works, as a fragment from the printed line 'Commerz- und Privatbank'. This was why Schwitters called this (missing) work *Das Merz-Bild* (The Merz Picture) and used the word Merz for the majority of his subsequent artistic output. He explained the idea as follows: 'Essentially the word MERZ means bringing all conceivable technical materials together for artistic purposes, and technically allowing each individual material to be equally valid in principle'.

Schwitters was in touch with the Zürich Dadaists, above all Tristan Tzara and Hans Arp, and also with the Berlin Dadaists, but the latter, with the exception of Raoul Hausmann, rejected him because of his "bourgeois" attitude. In 1922 Theo van Doesburg introduced him to the De Stijl movement, which transformed his collage style in the twenties. Excessively ornate Dada montages gave way to more austere vertical and horizontal structures.

Schwitters' interest in building the broadest possible range of materials and objects into his art reached a climax in the *Merzbau* (Merz Structure), which he started in his house in Hanover around 1920. This was a sculpture that extended through every room and storey, uniting sculpture and architecture. The *Merzbau* was destroyed in 1943, but surviving photographs and descriptions show how Schwitters tried to combine all the artistic genres and create a universal work of art.

Although Schwitters was not openly committed to politics, he reassessed artistic values, mingled genres and showed a marked preference for chance and nonsense in a way that indicated his awareness of the political and social upheavals of his day.

From 1919 he produced poetry, *Anna Blume* being the best-known example, as well as collages, prose, typographic fables, artistic manifestos and plays. From 1919 to 1924 he published numerous articles and poems in magazines like *Der Sturm*, *Der Ararat* and in his own magazine *Merz*, founded in 1923. Schwitters performed the *Ursonate* (Primal Sonata), a composition made up of asemantic 'Ur-Laute' (primal sounds), at the Bauhaus in 1924. He was interested in a new kind of typography, and this led to pictorial poems in which the text was designed in the tradition of Mallarmé and Apollinaire, as well as in visual form.

Financial difficulties in the twenties meant that Schwitters had to work as a commercial designer and

typographer for various firms, including some in Hanover. He founded the 'ring neuer werbegestalter' (new commercial designers' circle) with César Domela, László Moholy-Nagy and Friedrich Vordemberge-Gildewart in 1927; Willi Baumeister and Walter Dexel joined at a later stage. The founding meeting of 'abstrakte Hannover' took place in his house, now almost completely taken over by the *Merzbau*, in the same year. In 1929 Walter Gropius commissioned him to work as a commercial draughtsman on material relating to the Dammerstock estate in Karlsruhe.

A legacy from his father enabled Schwitters to return to working as a free-lance artist from 1931. He was now increasingly interested in abstraction. In 1930 he had taken part in demonstrations by the 'Cercle et Carré' group of abstract artists, and he joined the "Abstraction-Création" group in 1932. In 1937 Nazi pressure forced Schwitters to leave Germany, and he moved to Lysaker in Norway. In 1940 he fled from there to England, and settled in Ambleside in the Lake District in 1945. Schwitters began to build a *Merzbau* in both Norway and Ambleside.

Kurt Schwitters died in Ambleside on 8 January 1948. H.D.

Werner Schmalenbach, *Kurt Schwitters*, Cologne 1967, 2nd ed., Munich, 1984
Kurt Schwitters. Das literarische Werk, ed. Friedhelm Lach, 5 vols., Cologne, 1973–1981
John Elderfield, *Kurt Schwitters*, London, 1985
Kurt Schwitters, 1887–1948, exh. cat., Hanover, Sprengel Museum, 1986
Kurt Schwitters, exh. cat., Paris, Musée National d'Art Moderne, Centre Georges Pompidou, 1994
Dorothea Dietrich, *The Collages of Kurt Schwitters. Tradition and Innovation*, Cambridge, 1993

RICHARD SERRA

was born on 2 November 1939 in San Francisco. His father was an émigré Spanish factory worker and his mother a Russian – Jewish painter. Serra worked in various steelworks in order to finance his literary studies at the University of California in Berkeley and Santa Barbara from 1957 to 1961. He then moved to Yale University in New Haven from 1961 to 1964. There he met Josef Albers and worked with him on his key theoretical essay *The Interaction of Color* (1963). From 1964 to 1966 travel grants enabled Serra to spend substantial periods in Paris, where he shared a studio with his wife, the sculptor Nancy Graves, and also in Florence.

Serra was introduced to Arte Povera in Italy and experimented with materials such as rubber and neon, on his return to New York. His wall-hung rubber works identified gravity as an essential design element even at this early stage, when Serra was in close touch with the Minimalists, who were interested in fundamental structures of perception, and with sculptors like Eva Hesse and Bruce Nauman, who addressed materiality and questions relating to the body. Serra's 'Castings' and 'Splashings' (1968–1969), in which molten lead was thrown into the angle between the wall and the floor, were among the most famous examples of this process-oriented sculpture. At the same time Serra produced his 'Lead Rolls' and 'Props', sculptures using rolled-up sheet lead and lead bars that maintain their equilibrium through the weight of the material alone. Between 1968 and 1979 Serra made various films based on simple plots or mechanical and technical processes.

By 1970 steel was central to Serra's work. He handled it as if he were a building technician: first in circular works placed on the floor, and then using large Cor Ten steel sheets and blocks of forged steel – simple forms placed to relate to the space around them. Serra's principal theme from this point on was the balance between surface, mass and space. This could be seen as early as the 1969 work *One Ton Prop (House of Cards)* – four sheets of lead placed to form a cube, supporting each other in a threatening state of equilibrium.

Another central concern of Serra's work is the relationship between object and viewer, between the perception of space and bodily feelings, which can be experienced directly and physically in the large-scale sculptures in particular. In the early seventies Serra started to use large dimensions and industrial materials for sculpture in public places. His outdoor work focuses on relating to an architectural, landscape or urban context, as for instance in *Terminal* (1977) at the main station in Bochum, which became an election issue in 1979. In 1981, the year in which he married art historian Clara Weyergraf, the *Tilted Arc*, a slightly curved sheet of steel about 3.6 metres high and 36 metres long, was erected in the Federal Plaza in New York. This overwhelming sculpture also ran into violent protest. It had to be dismantled in 1989, after legal action. But clashes of this kind did not impinge upon Serra's international reputation: his sculpture *Clara-Clara* was erected in the Tuilerie gardens by the Place de la Concorde in 1983, on the occasion of his retrospective at the Centre Georges Pompidou; in 1984 he redesigned the Plaza de La Verneda in Barcelona and installed his bipartite concrete work *La Palmera* there; and in 1987 he took part in *documenta* in Kassel for the third time and set up his *Spiral Sections* in the Fridericianum. This was a 2.5-metre-high, semicircular steel slab placed on the upper floor of the former stairwell in such a way that visitors could experience the varying degrees of tension in the space between the sculpture and the walls.

Serra has taken part in major international exhibitions since the late sixties and has won numerous prizes, including the Goslaer Kaiserring für Skulptur (Goslar Imperial Ring for Sculpture, 1981). He was appointed a 'Chevalier de l'Ordre des Arts et des Lettres' in 1985 by the French Minister of Culture and became a Fellow of the American Academy of Arts and Sciences in 1993.

Serra lives and works in New York. H.D.

Richard Serra: Interviews etc. 1970–1980, ed. Clara Weyergraf, Hudson River Museum, Yonkers, 1980
Richard Serra, exh. cat., Paris Musée National d'Art Moderne, Centre Georges Pompidou, 1983
Rosalind Krauss, *Richard Serra: Sculpture*, ed. Laura Rosenstock, exh. cat., New York, The Museum of Modern Art, 1986
Richard Serra, ed. Ernst-Gerhard Güse, Münster, Westfälisches Landesmuseum, Munich, Städtische Galerie im Lenbachhaus and Basel, Kunsthalle, Stuttgart, 1987
Richard Serra. Drawings/Zeichnungen 1969–1990. Catalogue Raisonné/Werkverzeichnis, ed. Hans Hansen, Berlin, 1990
Richard Serra. Schriften Interviews 1970–1989, ed. Harald Szeemann, Bern, 1990

CINDY SHERMAN

was born on 19 July 1954 in Glen Ridge, New Jersey. She studied painting at State University College in Buffalo, New York, where she also attended courses in photography, taking a degree as a Bachelor of Arts in 1976. During her period as a student she formed the group 'Hallwalls', together with a number of other artists, including Robert Longo and Norman Dwyer, and she held her first solo exhibition in the group's artist-run gallery in 1976. In 1977 she moved to New York City.

Between 1977 and 1980 Sherman created around eighty *Untitled Film Stills*, which marked the beginning of her artistic career. These were coarse-grained black and white photographs, simulating film scenes from the fifties. Cindy Sherman herself featured in all of them as the sole protagonist, playing a variety of different roles, in characteristic make-up and clothes of the fifties. In these 'stills' she posed, for example, as a smart middle-class American girl, a housewife, a sex bomb and a careers woman. The pictures are not self-portraits of the artist, in any sense, but portraits of everyday, yet fictitious identities, functioning as familiar clichés, and thus giving the viewer the impression of seeing something familiar – something they have 'seen before'. In the process Sherman stages atmospheric pictures which are ambiguous and full of suspense, in the way that they happen, at any one moment, even though the protagonist's facial expression is blank and unmoved. It is left to the viewer to work out what has gone on immediately before the moment in which the action is staged, or what happens immediately afterwards. This method of sparking off fantasies and associations in the minds of the viewer is characteristic of Sherman's work as an 'image maker' or fabricator of images, as she herself describes her activity.

In the mid-eighties Sherman's imagery shifted to take in a whole new range of subject-matter drawn from myths and legends, including grotesque horror scenarios, focussing on disgust, perversions and destructive sexuality. Dolls, prosthetic appliances and bizarre masquerades played an increasingly important part in the imagery, whilst the artist herself progressively hid behind these various disguises or altogether disappeared from view.

In her pictorial approach, Sherman was now concerned not so much with the effect of illusion for its own sake as with tearing away the layers of disguise. Under the influence of Dada and Surrealism she now directed the spotlight onto the technique of dissimulation, as an end in itself. Artificial limbs and parts of the body, such as breasts and stomachs, remained visible as such; the transitional sections between real and artificial parts of the body were left exposed and not touched up; fully made-up masks revealed all their artifice and offered a glimpse of the 'true' face, behind. For her series of *History Portraits* (1988–90) Sherman had recourse, above all, to pictorial elements taken from Renaissance painting. Once again she herself stood in as the model, decked out in the costumes, wigs, make-up and other attributes and accessories of Old Master portraits, or staged tab-

leaux vivants of popular subjects, such as the Madonna suckling her Child and Judith holding Holofernes' severed head in her hands. Sherman made allusions to art history – abstract painting, in this case – in her series of *Molding Foods* and *Disgust Pictures* (1986–90), in which colourful compositions and alluring textures determine the aesthetic aspect of the image, whilst the subject-matter of mouldy and rotting food, vomit and rivulets of blood induces an ambivalent response of disgust, pleasure and attraction.

In her *Sex Pictures* of 1992 Sherman put together graphically detailed sex scenarios of such a bizarre nature with pieces of dolls, artificial limbs, dildos and imitation penises and vaginas that they took on a nightmarish life of their own, suggested solely by artificial means. Her red and yellow pictures of recent years were a further addition to the tableaux inspired by horror films. In these the faces, made up of scraps of skin sewn together, are shown in extreme close-up; the eyes, nose and mouth are added on at such a crooked angle and with such a degree of distortion that we are inclined to think that we are looking at grimacing monsters, rather than at images bearing human features. Since 1996 Sherman has been working on the screenplay for a horror film.

Sherman has taken part in numerous group exhibitions, such as *documenta 7* and the Venice Biennale in 1982. She has held important one-woman exhibitions at the Stedelijk Museum in Amsterdam in 1982, the Whitney Museum in New York in 1987, the Kunsthalle in Basel in 1991 and the Centre Georges Pompidou in Paris in 1993. In 1995 she herself arranged a retrospective of her work at the Deichtorhallen in Hamburg, which then went on to Malmö and Lucerne.

Cindy Sherman lives and works in New York. C.T.

Cindy Sherman, exh. cat., Amsterdam, Stedelijk Museum, 1982
Els Barents and Peter Schjeldahl, *Cindy Sherman*, Munich, 1987
Cindy Sherman, ed. Thomas Kellein, exh. cat., Basel, Kunsthalle, 1991
Rosalind E. Krauss, *Cindy Sherman 1975–1993*, New York, 1993
Cindy Sherman: Fotografien 1978–1995, exh. cat., Hamburg, Deichtorhallen, 1995
Cindy Sherman, exh. cat., Rotterdam, Museum Boymans-van Beuningen, 1996

MARIO SIRONI

was born on 12 May 1885 in Sassari, Sardinia. The family moved to Rome in 1886, where Sironi embarked on an engineering course in 1902, which he abandoned after a year, on grounds of ill health. He moved to the Scuola Libera del Nudo, a private life class school, where he became a pupil in Giacomo Balla's studio and made friends with Umberto Boccioni and Gino Severini. In the summer of 1908 Sironi shared a studio in Paris with Boccioni, who became his closest friend and spiritual mentor. They travelled extensively together in France and Germany.

Richard Wagner's music and Schopenhauer's and Nietzsche's philosophy were a crucial influence at this time. Fits of profound depression led Sironi to destroy most of his early, divisionist work.

In 1914 Sironi settled in Milan and joined the Futurist movement, for ideological rather than artistic reasons. He worked for various Italian magazines. In 1915 he volunteered to fight in the war and signed the manifesto 'L'Orgoglio Italiano' (Italian Pride) with Filippo Tommaso Marinetti, Luigi Russolo and Antonio Sant'Elia.

From 1913 to 1915, Sironi's Futurist paintings showed the strong influence of Boccioni. Sironi was not principally concerned with reproducing movement and dynamics, but with breaking motifs down into three-dimensional volumes and tying them into a Cubist surface structure. His palette was restricted to a very few strong colours and relied on powerful contrasts between light and darkness. At this time Sironis formal language showed a marked affnity to that of Fernand Léger.

The short 'metaphysical' period, lasting from 1921 to 1926 was dominated by urban landscapes showing the influence of Carlo Carrà. The 'Novocento Italiano' (Italian Twentieth Century) group, of which Sironi was a co-founder, came into being and flourished during these years. From 1922 Sironi worked on the Fascist magazine *Il Pòpolo d'Italia*, and was its art critic from 1927 onwards. Most of his paintings of figures dating from this period went back to Renaissance models. The dark colouring, sharp drawing and hard contrasts between light and shade made these figures look monumental and archaic. In subsequent years, Sironi applied the paint thickly and divided the pictures into individual scenes with different spatial depths, making them seem increasingly like reliefs.

In the early thirties Sironi distanced himself from 'bourgeois' easel painting and concentrated mainly on publicly commissioned murals. Sironi saw wall decorations, reliefs, mosaics and stained-glass windows – for the Turin Triennale, for instance, or Rome University – as new problems to be solved in terms of space and form. The manifesto 'La Pittura Murale' (Mural Painting), published in 1931, expressed his view of the social and educational duties of art in a Fascist state.

Sironi was inclined to use archaic forms for human figures in his wall and panel painting, and this led to ponderous compositions like *Il Pastore* (The Shepherd, 1932), which was shown at the Venice Biennale

in the same year. The shepherd motif goes back a long way, both thematically and formally. Here it again incorporates the principle of Italianità (Italian-ness), a sense of solidity and monumental size. Alongside this, he produced private, more relaxed paintings in the forties. After the war Sironi returned to easel painting and created a substantial late *oeuvre*. He continued to design for the stage, as he had before the war, including *Tristan und Isolde* for La Scala, Milan, in 1946 and *Don Carlo* for the '12th Maggio Musicale' in Florence in 1951. Sironi was elected to the Accademia di San Luca in 1956.

Mario Sironi died on 13 August 1961. A retrospective of his work was presented at the Venice Biennale in the following year. H.D.

Mario Sironi. Scritti editi e inediti, ed. Ettore Camesasca, Milan, 1980
Mario Sironi 1885–1961, ed. Claudia Gian Ferrari, exh. cat., Milan, Palazzo Reale, 1985
Mario Sironi, ed. Jürgen Harten and Jochen Poetter, exh. cat., Düsseldorf, Städtische Kunsthalle and Baden-Baden, Staatliche Kunsthalle, 1988
Mario Sironi 1885–1961, exh. cat., Galleria Nazionale d'Arte Moderna, Rome, 1993

DAVID SMITH

was born on 9 March 1906 in Decatur, Indiana. His family moved to Paulding, Ohio, in 1921. Smith took correspondence courses in drawing caricatures, while still at school, and attended a drawing class at the Cleveland Art School, Ohio, in 1923. He abandoned his art studies at Ohio University in Athens in 1925, after one year. He then spent a year in the Studebaker car factory in South Bend, Indiana, where he learned to rivet, solder, weld and work at a lathe. From 1927 to 1931 he studied painting at the New York Art Students League under Jan Matulka, a Czech abstract painter who influenced him considerably.

Matulka prompted Smith to examine Picasso's iron sculptures and work by the Russian Constructivists,

who made a lasting impression on him. From 1930 he experimented with wood, stone, various metals and paint. He produced unusual sculptures in which he tried to combine painting and three-dimensional construction. During an eight-month stay on the Virgin Island of St Thomas he produced small objects made of wood, wire and coral. Smith's artist friend John Graham introduced him to Julio González's welded sculptures and works of African tribal art; these, along with Picasso, Giacometti and Henri Laurens, inspired his first iron sculptures. From 1934 Smith worked in the Terminal Iron Works machine factory in New York and learned more metalworking techniques. In 1935–1936 he travelled in Europe, visiting Paris, London, Moscow and Greece.

In the forties Smith translated mythological themes into complex biomorphic steel sculptures, as in *Home of the Welder* (1945), a sculpture about 50 centimetres high, which blends abstract and representational forms into a mysterious, implicitly erotic structure, set against a theatrical-looking background.

Smith was increasingly recognised after the war; he taught at the Sarah Lawrence College in Bronxville from 1948 to 1950 and won a two-year scholarship from the Guggenheim Foundation from 1950 to 1951. He worked on a large scale, creating sculptures based on a new wealth of forms using machine parts and other *trouvailles* from his workshop. He produced substantial series like *Agricola* (from 1951) and *Tank-Totem* (from 1952), which radiated a surrealistic and magical aura as a result of the alienating way in which machine parts and agricultural equipment were combined. In these series Smith was concerned with the metaphorical changes the old equipment underwent, when amalgamated into new visual entities – often through an interplay of convex and concave forms, as in the case of the *Tank-Totem* series.

Smith represented the USA at the Venice Biennale in 1954 and 1958, and the Museum of Modern Art in New York organised his first one-man show in 1957. Smith featured in *documenta 2* in Kassel in 1959 and was awarded the main prize at the São Paulo Bienal. Smith handles forms and materials freely and effortlessly, combining a wide range of styles. His sculp-

tures reach out symbolically into the space they occupy; open-air exhibitions – in the Bolton Landing sculpture park, for example, where he had his workshop from 1940 onwards – reinforced Smith's idea that there was a fundamental relationship between art and nature. His work became increasingly geometrical in the sixties, in the groups of work called *Circle, Zig* and *Cubi*. Paint and polished stainless steel indicated a new interest in surface effects. As in the fifties, this development was accompanied by abstract drawings.

In 1962 the Italian government invited Smith to work in Italy for a month and create a sculpture for the 'Two Worlds Festival'. The twenty-six sculptures including two railway carriages which resulted from this invitation were shown in the Spoleto amphitheatre.

David Smith died after a car accident near Bennington, Vermont, on 23 May 1965. H.D.

Rosalind E. Krauss, *Terminal Iron Works. The Sculpture of David Smith*, Cambridge, Mass., 1971
David Smith, ed. Garnett McCoy, New York and Washington, 1973
Rosalind E. Krauss, *The Sculpture of David Smith. A Catalogue Raisonné*, New York, 1977
David Smith: Painter, Sculptor, Draftsman, exh. cat., Washington DC, Hirshhorn Museum and Sculpture Garden, 1982
David Smith. Skulpturen, Zeichnungen, ed. Jörn Merkert, exh. cat., Düsseldorf, Kunstsammlung Nordrhein-Westfalen, Munich, 1986
David Smith. Medals for Dishonor, exh. cat., Columbus, Ohio, Columbus Museum of Art, 1996

STANLEY SPENCER

was born on 30 July 1891 in Cookham-on-Thames, Berkshire. He attended the Slade School in London from 1908 to 1912. Spencer featured in Roger Fry's second Post-Impressionist exhibition at the Grafton Galleries in 1912. In the First World War he served as an orderly in the Royal Medical Corps, then as an infantryman in Macedonia.

In the post-war years the English avant-garde largely returned to figurative work. Spencer moved into the centre of a new group of artists who formed the 'New English Club'. His pictures combined naïve realism with religious sensibility, linking New Testament stories with events in his home town of Cookham. *Christ's Entry into Jerusalem* (1921) was a key work representing a grotesque amalgam of an interpretation of the biblical subject with a depiction of the Palm Sunday Procession along Cookham High Street, near the house where Spencer spent his childhood.

In the mid-twenties Spencer designed wall paintings for the Sandham Memorial Chapel in Burghclere, which considerably enhanced his reputation. These recalled his war experience, but emphasised feelings of brotherhood and solidarity among the soldiers rather than suffering and violence. Other projects for wall paintings, like the so-called 'Church House', a

building in the shape of a church with paintings on the 'theme of God in the world' and the 'Proclamation of His Gospel of Love', went no further than a few sketches and individual images, as insufficient funds were available for their realisation.

In 1932 Spencer showed ten pictures in the British Pavilion at the Venice Biennale and was elected to the Royal Academy. After this he produced the series, *The Beatitudes of Love,* with figure compositions that looked somewhat mannered; the Royal Academy selection committee rejected two pictures in this series for their 1935 exhibition on grounds of eccentricity. Spencer resigned in protest, and was not re-elected until 1950. He painted atmospheric landscapes of Cookham and the surrounding area during this period, as well as continuing with his narrative and figurative work.

When the Second World War broke out the War Artists Advisory Committee commissioned Spencer to paint the Glasgow shipyards. He worked on the cycle, *Shipbuilding on the Clyde,* for six years; this shows shipyard workers, often dramatically raised to heroic status, at their daily work. The shipyard pictures continued with the series *The Resurrection, Port Glasgow* of 1945 to 1950. As the title suggests, this series is permeated with religious allusions and an almost fanatical zeal. Subsequently religious motifs became a central theme in Spencer's work.

Spencer produced some impressive portraits, such as the double portrait, *The Sisters,* in 1949, a lively delineation of two women's characters and unique personalities –, but the female nude in *Self-Portrait with Patricia Preece* (1936) is oppressively close and intense, anticipating later developments in photorealism. Spencer's aim in his nude portraits was to present the human body in a way that was atmospherically private yet revealing in the way that he spared netting, in his detailed portrayal of age, illness or ugliness

In 1938 Spencer was again shown at the Venice Biennale. There were retrospectives of his work at Temple Newsam Gallery in Leeds in 1947, the Tate Gallery in 1955 and at the Royal Academy in 1980. Spencer was knighted in 1958.

Stanley Spencer died on 14 December 1959 in Cookham, while working on his monumental picture, *Christ Preaching at Cookham Regatta.* H.D.

Stanley Spencer 1891–1959, exh. cat., London, Arts Council, 1976
Stanley Spencer RA, exh. cat., London, Royal Academy of Arts, 1980
Stanley Spencer. The Apotheosis of Love, ed. Jane Alison, exh. cat., London, Barbican Art Gallery, 1991
Keith Bell, *Stanley Spencer. A Complete Catalogue of the Paintings,* London, 1992
Stanley Spencer. A Sort of Heaven, ed. Judith Nesbitt, exh. cat., Liverpool, Tate Gallery 1992

FRANK STELLA

was born in Malden, Massachusetts, on 12 May 1936. Stella studied with the abstract painter Patrick Morgan at the Phillips Academy in Andover, Massachusetts, from 1950 to 1954. He then studied history at Princeton University from 1954 to 1958 and also attended William C. Seitz's open painting classes. In 1958 he took a studio in New York and earned his living as a house painter.

Stella's first pictures in New York were influenced by Abstract Expressionism, but he was particularly inspired by the exhibition of Jasper Johns' *Flag* and *Target* pictures at the Leo Castelli Gallery in 1958. A few months later Stella produced his first 'Black Paintings', large canvases covered with a symmetrical pattern of black stripes of equal width, a minimalist conceptual style contrasting with expressive abstraction. Unlike traditional compositions based on the principle of harmoniously balanced artistic elements, Stella's painting is 'non-relational', with a systematic structure made up of serial elements.

Stella then began to shape the medium to the inner structure of the picture. The canvas, which until then had been right-angled, could be of any geometrical shape appropriate to the structure of the painting; later it was even asymmetrical. In his 'Aluminium' and 'Copper' series (1960–61), for instance, Stella developed the 'shaped canvas', turning his pictures into objects. To avoid spatial illusion, the material was emphasised by the gleam of silver, bronze and other metallic paint tones. After these systematic structures – similar to Minimal Art sculptures in their serial arrangement and resemblance to objects – Stella then progressed logically to clearly defined, strictly geometrical gradations of different colours, making each colour as separate as possible. From 1962 Stella produced intensely coloured pictures with irregular outlines, blank centres and zigzag patterns. The 'Protractor' series in the late sixties was based on the semi-circle of a protractor. The complex woven shapes linking traditional Islamic and Irish Celtic patterns to decorative abstraction were brightened by vibrant colours.

The 'Polish Villages' series, begun in 1971 – large collages made of felt, paper, canvas, plywood, resopal and aluminium, whose individual titles referred to destroyed Polish synagogues – marked a transition from painting to relief. Since the mid-sixties Stella had been making large reliefs from various materials, especially aluminium and fibreglass, in strong colours and geometrical shapes. These had initially been criticised as 'a break with style'. The titles reflected the artist's own experiences, including cities, places, exotic birds and his passion for motor racing. In addition to increasingly large paintings and reliefs, such as the *Moby Dick* series (begun 1986), from 1980 onwards Stella has created graphics cycles, such as the 'Circuits', 'Shards' and as well as the 'Cones' and 'Pillars' series, to go with his series of reliefs bearing the same title.

Since the early nineties Stella has also worked on architectural sculptures and decoration, such as the ornamental relief frieze for the Princess of Wales Theatre in Toronto (1992) and outdoor sculptures such as *Luneville* in Kawamura, Japan (also 1992), and *Sarreguemines,* for the Hypobank in Luxembourg. The increasingly extravagant spatial illusions in his recent pictures, such as *Hooloomooloo* (1994), are a reference to Baroque ceiling frescoes. In the lectures he gave as Charles Eliot Norton Guest Professor at Harvard University between 1983 and 1984 (published in 1986), Stella traced the continuity of certain of his artistic concerns from the Renaissance through to abstract painting.

As one of the most renowned American artists of the post-war period, Stella has had numerous of major retrospectives – the first of them in 1970, at the Museum of Modern Art in New York. He has received many awards and distinctions. Thus, in 1981 he became an honorary member of the Bezalel Academy in Jerusalem, in 1984 he received an honorary doctorate from Princeton University, and in 1996 he was awarded an honorary doctorate from the University of Jena, for which he created six outdoor sculptures.

Stella lives and works in New York City. H.D.

William S. Rubin, *Frank Stella,* exh. cat., New York, The Museum of Modern Art, 1970
Frank Stella. Werke 1958–1976, exh. cat., Bielefeld, Kunsthalle, 1977
Lawrence Rubin, *Frank Stella; Paintings 1958 to 1965. A Catalogue raisonné,* New York, 1986

Frank Stella, *Working Space. The Charles Eliot Norton Lectures 1983–1984*, Cambridge, Mass., and London, 1986
Frank Stella 1970–1987, ed. William S. Rubin, exh. cat., New York, The Museum of Modern Art, 1987
Frank Stella, exh. cat., Munich, Haus der Kunst and Madrid, Museo Nacional Centro de Arte Reina Sofía, Munich, 1996 (Ger. and Engl.)

CLYFFORD STILL

was born on 30 November 1904 in Grandin, North Dakota. His family moved to Spokane, Washington, in 1905, and a little later took over a farm near Bow Island in southern Alberta, Canada. The hard living conditions there made a lasting impression on Still. He was passionately interested in art, even as a schoolboy; he drew, painted and made an intensive study of works by old and modern masters. From 1927 to 1927 and 1931 to 1933 he studied art at Spokane University, Washington. After completing his graduate studies with an MA in 1933 he taught art at Washington State College in Pullman until 1941.

With the exception of two summers that he spent at the Trask (now 'Yaddo') Foundation in Saratoga Springs in 1934 and 1935, Still developed his particular artistic sensibility alone, away from outside influences. He combined austere living conditions with a remorseless sense of intellectual purpose. From 1941 to 1943 he worked in the Bay Area armaments industry as a steel checker for the navy, and later in San Francisco as a materials supervision engineer. Despite the heavy toll taken by this work, he produced a number of major pictures during this period, and some of these even featured in Still's first one-man retrospective at the San Francisco Museum of Art in 1943.

Still's first pictures concentrated on life in the prairie. *Row of Grain Elevators* (1928) is reminiscent of Regionalism and Thomas Hart Benton's powerful academic style. Still's early work was also influenced by Cézanne and van Gogh. The figurative studies of 1934–35 were followed by a more decisive phase in the late thirties, when he combined his knowledge of the work of leading European modernists such as Picasso, with primitive, mythological or symbolic subjects. His handling of paint with a palette-knife and effects of light and shade eventually took Still to a personal, semi-abstract style, which was made more intense by his adoption of larger formats from 1944 onwards.

After teaching at the Richmond Professional Institute in Virginia from 1943 to 1945 Still moved to New York in 1945 and embraced Abstract Expressionism. His first one-man exhibition there was mounted in Peggy Guggenheim's Gallery, 'Art of This Century', in 1946, through the good offices of Mark Rothko, whom he had met in California in 1943. There followed three further exhibitions at the Betty Parsons Gallery, from 1947 to 1951. He was involved in planning the 'Subjects of the Artist' art school, which was founded by William Baziotes, Robert Motherwell,

Barnett Newman and Mark Rothko in 1948. Although Still was a loner, some of his colleagues were important friends – especially Mark Rothko. At the same time his influence on the California School of Fine Arts in San Francisco, where he lived from 1946 to 1950, was clearly discernible.

Still reached his apogee in those California years: fissured monolithic forms force their way into the field of vision from the lower edges of the picture surface or thrust downwards from above. Often there is a single dominant colour, derived from a colour scale that plays nocturnal shadow values off against fiery tones. The textures are aggressively earthy, as if intending to express Still's sarcastic view of the world. In fact he felt increasingly alienated from the New York art world and left the city once for all in 1961, to settle in rural Maryland.

Despite his unconcealed disdain for critics, art dealers and gallery-owners, Still's artistic work was accorded appropriate recognition in numerous retrospectives. The first of these was held in 1959 at the Albright-Knox Art Gallery in Buffalo, and the last in his lifetime at the Metropolitan Museum in New York, in 1979–80. Still presented entire groups of his work to each of these institutions, and to the San Francisco Art Museum.

Still's large-format late pictures were characterised by a strong emphasis on the vertical, and what he himself termed the 'categoric imperative' of his canvases, in which he sometimes exploited the powerful impact of untreated areas. Still created numerous works in pastel in these last years. He received many awards and was admitted to the American Academy and Institute of Arts and Letters in 1978.

Still died on 23 June 1980 in New Windsor, Maryland. H. D.

Clyfford Still, exh. cat., New York, Marlborough-Gerson Gallery Inc., 1969
Clyfford Still, exh. cat., San Francisco, Museum of Modern Art, 1976
Clyfford Still, ed. John P. O'Neill, exh. cat., New York, The Metropolitan Museum of Art, 1979

Clyfford Still, exh. cat., New York, Mary Boone Gallery, 1990
Clyfford Still (1904–1980), ed. Thomas Kellein, exh. cat., Basel, Kunsthalle, Munich, 1992
Justus Jonas-Edel, *Clyfford Stills Bild vom Selbst und vom Absoluten. Studien zu Intention und Entwicklung seiner Malerei*, Cologne, 1995

YVES TANGUY

was born on 5 January 1900 in Paris. Tanguy spent his childhood summers in his family's holiday home on the Brittany coast, which made a profound impression on him. He entered the Merchant Navy as an officer cadet at the age of eighteen and travelled to South Africa and South America, among other places. He was called up for military service in Lunéville in 1920.

During his infantry training Tanguy became friendly with Jacques Prévert, later to become a Surrealist poet and film director. After being discharged from the army the two friends lived together in Paris from 1922, surviving on casual work. Lautréamont's *Les Chants de Maldoror* and later the magazine *La Révolution Surréaliste* drew their attention to Surrealism. Tanguy started drawing, but was not finally persuaded to become an artist until he saw Giorgio de Chirico's picture *Le Cerveau de l'enfant* (1914), in an exhibition organised by the art dealer Paul Guillaume in 1923.

Tanguy met André Breton in 1925, who soon introduced him to the inner circle of Paris Surrealists. His earliest surviving pictures date from 1926. In these, glazed paint were applied thinly, then fragmentary, irrational pictorial elements were placed in the delicate, transparent landscape backgrounds incorporating: architectural fragments, people and isolated parts of the body, amorphous and vegetal forms, and abstract signs like figures or letters. *L'Orage (Paysage Noir)* (The Storm (Black Landsscape)), painted in 1926, marked the transition to Tanguy's mature style. The black ground, illuminated by flashes of lightning, seems to be the sea-bed and a stretch of land at the same time. Here we already find the biomorphic structures that were to populate Tanguy's pictures for the next few years. The formal resources were inspired by Hans Arp's reliefs, but Tanguy developed Arp's forms in three dimensions, creating fantastic landscapes with them. He experimented with collage technique at the same time by incorporating real things like matches and cotton threads into his paintings, whose links with objective reality became increasingly weak.

The mature pictures, dating from 1927 onwards, always have a fixed or dissolving horizon. The biomorphic figures and micro-organisms placed in a vast and empty landscape cast clearly discernible shadows, but these fabulous Miró-esque creatures tell us nothing about their location are to be found. Tanguy's pictorial worlds are beyond time and place, inhabited by unidentifiable forms that seem to be part of a real and observed universe. These paintings are among the most important works of figurative

Surrealism. Tanguy was fêted as a pioneer of the new painting at an early stage, at the time of his exhibition *Yves Tanguy et Objets d'Amérique* at the Galerie Surréaliste, in 1927.

From 1930 tonwards, Tanguy's pictures often suggested the idea of beaches with cliffs, where ambiguous forms can be distributed throughout the illusionist depths, as in *Jours de Lenteur* (1937). The strange sterility and airlessness, the apparent silence and the magically fixed reality that Tanguy created, usually in 'automatic' drawings, became his most distinctive way of expressing himself. Tanguy's work featured in the exhibitions *Cubism and Abstract Art* and *Fantastic Art, Dada and Surrealism* at the Museum of Modern Art in New York.

Tanguy emigrated to New York in 1939, where he exhibited regularly in the Pierre Matisse Gallery. In 1942 he and his wife, the painter Kay Sage, moved to Waterbury in Connecticut; he took American citizenship in 1948. His large, late pictures, floating phantasms of the subconscious, show an almost photorealist precision. The illusory pictorial spaces are painted in cool metallic colours, and are often reminiscent of aquaria.

Tanguy died on 15 January 1955 in Waterbury, Connecticut. The Museum of Modern Art mounted a comprehensive retrospective of his work in the same year. H.D.

Yves Tanguy: A Summary of his Works, ed. Kay Sage, New York, 1963
Daniel Marchesseau, *Yves Tanguy*, Paris, 1973
Yves Tanguy. Das druckgraphische Werk, exh. cat., Stuttgart, Staatsgalerie and Kunsthandel Wittrock, Düsseldorf, 1976
Patrick Waldberg, *Yves Tanguy*, Brussels, 1977
Yves Tanguy. Retrospective 1925–1955, exh. cat., Paris, Musée National d'Art Moderne, Centre Georges Pompidou, 1982

ANTONI TÀPIES

was born in Barcelona on 23 December 1923 and grew up among the Catalan upper classes. His father, a respected barrister, was highly educated in both philosophy and literature, and held open house for Barcelona's cultural élite. Father and son clashed violently on one subject only: modern art. Tàpies had artistic ambitions even while still at school, but his father quashed them. He started to study law in Barcelona in 1943, but broke off three years later to devote himself entirely to painting. He studied at Nolasc Vall's academy for two months, but was otherwise a self-taught artist.

In 1948 Tàpies was a co-founder of the avant-garde magazine *Dau al Set* (Dice with a Seven), was strongly influenced by the circle of young poets, literati and artists involved with this publication. These included literati such as Joan Brossa and Arnau Puig, the art historian Juan Eduardo Cirlot and the Spanish painters, Modest Cuixart, Joan Ponç and Juan José Tharrats, and were apologists in Spain for abstract tendencies in modern art. They were also concerned to resist the threatened collapse of Catalan culture. Tàpies drew significantly on this tradition for his early Surrealist pictures, which were illustrative and anecdotal, an artificial world of mysterious spatial settings owing as much to his admired fellow-countryman Joan Miró as to Paul Klee, whom he has revered throughout his life.

Tàpies' first successful exhibitions in Barcelona led to a French government scholarship in Paris in 1950. There he was drawn into a seething intellectual climate involving Art Informel artists such as Jean Fautrier and Jean Dubuffet, who were creating a completely 'different' art rooted in Surrealism. The art critic Michel Tapié used the term 'art autre' to sum up these fifties experiments in exploiting the language of material, an expressive line in drawing, and chance and automatism for artistic purposes. Tàpies, too, increased the material density of his pictures, mixing sand and other substances into the oil paint in order to create rough, masonry-like structures into which he scratched a sparse repertoire of

signs using a technique akin to Surrealist *grattage*, and collaged in a variety of 'poor materials'. Religious signs of the cross recur continually in these expressively placed incisions, which can develop into fragments of words and scribbles, like graffiti. Colour is introduced into the black and brown incrustations only as an accent, so that the crude character of the materials is not compromised by excessive lustre.

Tàpies' current work, related to late Arte Povera, is full of signs and symbols that also conjure up esoteric and magical figures; they are still not easy to interpret. Tàpies is well travelled and broadly educated, incorporating elements from vanishing cultures such as Tantric art, for example, into his work (*Material in Nut Form*, 1967), but fundamentally he still draws inspiration from his Catalan home, childhood memories, graffiti on the walls of Barcelona and the Catalan tradition of organic ornament. This means that materials and *trouvailles* are not used decoratively, but integrated into the picture in such a way that any decorative charm is shifted into the background. The material image works like a spiritual map on which the viewer is intended to find fragments and signs of a spiritual reality that have been buried under technocratic everyday culture. In his writings and lectures Tàpies resists the notion of a one-sided, capitalist social rationale, as well as any kind of cultural *dirigisme*.

Tàpies has enjoyed international recognition since the sixties, and his work has featured in major exhibitions such as the Venice Biennale and *documenta*, in Kassel. The Museo Español de Arte Contemporáneo in Madrid mounted the first large-scale retrospective of his work in 1980. Tàpies has won numerous prizes and awards, including the Spanish State's Gold Medal for Fine Arts (1981).

Tàpies lives and works in Barcelona. H.D.

Michel Tapié, *Antoni Tàpies*, Barcelona, 1959
Werner Schmalenbach, *Antoni Tàpies. Zeichen und Strukturen*, Berlin, 1974
Tàpies. Das graphische Werk 1947–1972, ed. Mariuccia Galfetti, St Gallen, 1975
Roland Penrose, *Tàpies*, New York, 1978
Barbara Catoir, *Gespräche mit Antoni Tàpies*, Munich 1987
Tàpies, ed. Carmen Giménez and Dore Ashton, exh. cat., New York, Solomon R. Guggenheim Museum Paris, and Jeu de Paume, Paris, New York, 1995

VLADIMIR EVGRAFOVICH TATLIN

was born in Moscow on 28 December 1885. Tatlin started to train with the merchant navy in Odessa in 1904 and then studied from 1905 to 1910 at the Seliverstov Art School in Pensa. He showed pictures at the exhibitions by the 'Union of Youth', 'Donkey's Tail' and 'Jack of Diamonds' art associations in St. Petersburg and Moscow from 1911 to 1913. His work showed the influence of Primitivism, as well as Fauvism and Expressionism.

In 1913 Tatlin took collage as his starting point for

developing an 'analytical art', which he prefaced with the thesis, 'we should subject the eye to control by the sense of touch'. After travelling to Paris in 1914, where he visited Picasso's studio among others, he arranged an exhibition of 'synthesostatic compositions' (later known as the *1st Exhibition of Pictorial Reliefs*) in his Moscow studio in the same year. Tatlin moved away from easel painting in the so-called 'counter-reliefs' he showed there and used various materials (metal, wood, cardboard, glass etc.) as real spatial design resources. The subsequent 'corner counter-reliefs', placed across a corner of the space, lost their pictorial character entirely and embodied Tatlin's ideal of 'real materials in a real space'. Kinetic elements were also involved in these new material constructions, as in the *1915 Pictorial Relief*, which was shown at *First Futurist Exhibition: Tramway V* in Petrograd in 1915. Tatlin showed over 15 works at the *Last Futurist Exhibition: 0.10* in Petrograd at the end of the year. This exhibition increased his influence on the Russian avant-garde and triggered a long-lasting conflict with Malevich about the superiority of Constructivism over Suprematism. Tatlin organised the *Futurist Exhibition 'Store'* in a Moscow department store in 1916.

After the Revolution Tatlin worked actively on building up a new artistic life. He was involved in monumental propaganda and the reform of art education and the museum system, became chairman of 'Narkompros' (Fine Arts Department of the People's Commissariat for Education) in 1918–1919 and took over the 'Material Culture' department in the Museum of Artistic Culture in 1922. After the museum became INKhUK (State Institute for Artistic Culture) Tatlin came increasingly into conflict with Malevich, its director, in 1924. From 1925–1927 Tatlin lectured in 'formal-technological disciplines' in the Kiev Institute of Culture's faculty of theatre, film and photography, and subsequently taught 'material culture' and household design in the faculty of wood- and metalwork established by Rodchenko at VKhUTEIN (Higher Artistic and Technical Institute). He became professor at the Moscow Institute of Silicates and Building Materials in 1931.

Tatlin's work after 1918 was driven by the utopian and political ideal of a new art for a new society. The most striking project was his design for a memorial to the October Revolution, *Monument to the IIIrd International*. The model was completed in 1920 and taken to Moscow for the official exhibition at the VIIIth Soviet Congress. The tower triggered a vigorous debate about the role of art in the Soviet Union and also established Tatlin's name abroad, where his work was shown at exhibitions including the *1st Russian Art Exhibition* in Berlin in 1922 and the 1924 Venice Biennale. He paved the way for the notion of 'production art'; his work included theatre, book and furniture design and designs for working clothes and household goods; he also laid down theoretical foundations in lectures and essays such as 'The Artist as organiser of a Way of Life' (1929). The combination of concrete material research and social and utopian ideas culminated in the construction of a flying machine *Letatlin* (roughly translated 'Flying Tatlin') in 1932.

Dramatic upheavals in cultural policy caused Tatlin to return to panel painting in the thirties, when he painted still lifes, landscapes and portraits. He also continued to design for the stage, and was involved in Moscow's festivities to celebrate the twentieth anniversary of the October Revolution in 1937. However, his murals for the Agricultural Exhibition in 1938 were considered 'politically harmful' and the Party officially denounced him as a theatre artist who was an 'enemy of the people' in 1948.
Tatlin died in Moscow on 31 May 1953. K.O.

John Milner, *Vladimir Tatlin and the Russian Avant-Garde*, New Haven and London, 1983
Tatlin, ed. Larissa A. Shadowa, Dresden, 1984
Eva Körner, *Tatlin. Outlines of a Career in the Context of contemporary Russian avant-garde Art as related to Eastern and Western Tendencies*, Budapest, 1985
Vladimir Tatlin. Retrospektive, ed. Jürgen Harten and Anatolij Strigalev, exh. cat., Düsseldorf, Städtische Kunsthalle Düsseldorf and tour, Cologne, 1993
Vladimir Tatlin. Leben, Werk, Wirkung. Ein internationales Symposium, ed. Jürgen Harten, Cologne, 1993

JEAN TINGUELY

was born in Fribourg on 22 May 1925. Tinguely built his first constructions, driven by cog-wheels and emitting strange noises, in wood, wire and nails at the age of fourteen. He started to train as a shop window decorator in 1940, then gave this up and attended art classes at the General Craft School in Basel, where Julia Ris's courses introduced him to work by Kurt Schwitters and the Bauhaus artists. After the war he painted pictures in the Surrealist style. He produced shop-window decorations, and also décor for the Communist Women's Movement's pavilion in 1948 and the Swiss pavilion in 1949 at the Milan Fair.

Tinguely moved to Paris in 1953, where he designed his first abstract spatial constructions, operated by turning a handle. These works produced an impression of hesitation, courage, Sisyphus-like qualities and thus humour, all of which became fundamental elements of his work. His first one-man show at the Galerie Arnaud in Paris in 1954 was followed by participation in the *Le Mouvement* exhibition at the Galerie Denise René. Tinguely's so-called *Méta-matics*, his fantasy machines, made him one of the leading exponents of Kinetic Art. Viewers could produce movement and sound by pressing a button on his wall relief *Concert pour sept tableaux* (1958). Tinguely collaborated with Yves Klein during this period, for example on the exhibition *Vitesse Pure et Stabilité Monochrome* at Iris Clert's gallery, in 1958.

In 1959 Tinguely created a series of painting machines which could produce drawings by a semimechanical process, as a playful attack on informel painting. A bicycle-driven painting machine supplied the audience with a flood of paper strips painted in a tachiste style at one of the first happenings in London, in late 1959. At the beginning of 1959 Tinguely got an aeroplane to drop 150,000 copies of his manifesto 'Für Statik' at his first German exhibition at Alfred Schmela gallery in Düsseldorf. The manifesto called for a creative, life-affirming use of the human spirit. Tinguely showed his *Méta-matics* at the Galerie Staempfli in New York in 1960 and presented his auto-destructive machine *Homage to New York (machine-happening-autodestructice)* in the Museum of Modern Art.

In 1961 Pierre Restany founded the 'Nouveaux Réalistes' group, including Tinguely, Yves Klein, Raymond Hains and Daniel Spoerri. Tinguely lived with the artist Niki de Saint Phalle from this time onwards, and they produced many joint projects, including *Elle*, a gigantic female figure upon which it was possible to walk, for the Moderna Museet in Stockholm, and numerous fountain designs, e.g. for the City of Basel in 1977 and the Place Stravinsky in Paris in 1983. Starting with his *Baloubas*, which date from the sixties, Tinguely now constructed mainly monumental machines, using electric motors to drive various kinds of wheel, power belts and scrap items, which moved very slowly; examples included the series *Méta-Harmonies* (1984), which produced sounds.

In the eighties, death symbols occurred more and more in Tinguely's installations, for example sculptures using animals' skulls moving at different speeds, and scrap sculptures made of wrecked racing

cars or motor-bikes. The largest installation, called *Inferno,* appeared for the first time in the Galerie Kornfeld in Bern in 1984. This room-filling ensemble was made up of over twenty elements that were woven together, taking universal mythical events as its subject, as well as childhood memories. Aspects of *memento mori,* of terror and catastrophe, finally gained the upper hand in the Tinguely retrospective in the Palazzo Grassi in Venice in 1987; this was strikingly demonstrated in the *Mengele* high altar (1986), which included material from a house that had burned down. This theme was developed further in *Moto de la Mort* (1989), and *Safari in Moscow,* which were shown at the Tretiakov Gallery in Moscow, in 1990.

Tinguely was involved in numerous major exhibitions from the sixties as one of the Swiss artists who was best known internationally, able to use his abstruse machines to combine man's two driving forces in humanity, Eros and Thanatos, in a playful and ironic way.

Tinguely died in Bern on 31 August 1991. H.D.

Pontus Hultén, *Jean Tinguely – Méta,* London and Boston 1975

Christina Bischofberger, *Jean Tinguely. Werkkatalog Skulpturen und Reliefs, 1954–1968,* Küßnacht and Zurich, 1982; vol. 2: *Skulpturen und Reliefs 1969–1985,* 1990

Reinhardt Stumm and Kurt Wyss, *Jean Tinguely,* Basel, 1985

Jean Tinguely, ed. Stefanie Poley, exh. cat., Munich, Kunsthalle der Hypo-Kulturstiftung, 1985

Jean Tinguely Moskau Fribourg, exh. cat., Fribourg, Musée d'Art et d'Histoire, 1991

Heidi E. Violand-Hobi, *Jean Tinguely, Leben und Werk,* Munich, 1995

ROSEMARIE TROCKEL

was born in Schwerte, Westphalia, in 1952. From 1970 to 1978 she completed a teacher training course in anthropology, sociology, theology and mathematics at the University of Cologne. At the same time she studied painting at the School of Applied Arts in Cologne, from 1974 to 1978.

Trockel's work is limited neither to a particular genre nor to a predetermined style. The drawings, pictures, sculpture and objects which she has made in parallel, since the beginning of the eighties, are limited by their content, which always relate, to certain socially and culturally conditioned codes and symbols.

Throughout her period as a student Trockel devoted herself almost exclusively to drawing, and to this day she keeps this as a separate area of artistic activity, though many of her drawings of situations in which she finds herself are subsequently translated direct into three-dimensional works. Trockel herself talks of the 'plastic quality' of drawing and of 'plastic pictorial symbols', which are capable, at least, of communicating 'psychic qualities'. Her pictorial inventions are frequently absurd or even secretly surreal combinations and juxtapositions of motifs, such as one of

one muscleman standing on the exaggeratedly long nose of another; endless repetitions of monkeys' heads; and rows of noses and fingers, lined up on a grid.

Trockel began to make three-dimensional work in around 1981. It would seem that the heterogeneity of the sculptures and assemblages of objects that she made was intentional, since she is not interested in varying a form or technique once she has learnt it. Instead, she prefers to search for visual shapes and materials which have a strong expressive character and thus serve effectively to communicate the theme in question, through a culturally determined presentation of a material or manner of working. In the process she also makes use of 'objets trouvés' or incorporates readymade objects into her work. Trockel brings together disparate objects which seem at first sight to have little in common and appear arbitrary and contradictory – as in the act of hanging silk stockings fitted with branches from a tree, in *Komaland* (1988) or the invention of strikingly simple and telling images, such as the knitted object *Schizo-Pullover* (1988), which was an article of clothing finished off with a twin polo neck.

In 1983 Trockel was given her first solo exhibition at the Galerie Monika Sprüth, in Cologne – a gallery which at the time showed only women artists, including the Americans, Jenny Holzer, Cindy Sherman and Barbara Kruger. Trockel intensifies her discussion with the social position of woman, in particular of the woman artist. It was now, in the mid eighties, that she started making the knitted pictures and knitted objects for which she became internationally famous. Trockel deliberately chose a medium that was generally associated with the typical work of women. She then set up a tension between the negative connotations of this cliché and the mechanical means of production involved in the use of a knitting machine, on the one hand, and her choice of a computer-designed symbol, reduced to repetitive patterns, on the other. Politically provocative symbols, such as the swastika and the hammer and sickle, 'Playboy' Bunnies, corporate logos and endlessly repeated indications, such as *Made in Western Germany* (1987), cover these knitted fabrics,

which are stretched like canvases on a frame or made up into articles of clothing, such as woolly hats and pullovers. The idea for the pair of *Schwarzendlos Strümpfe* (Blackendless Stockings, 1987) came from meeting a mentally sick woman, who was unable to come to the end of a piece of work and went on knitting for ever. Trockel's over-long stockings give a symbolic interpretation to this working out of a mental defect and are transformed into an image of 'madness as perpetuum mobile' (Trockel), which is both touching and grotesque.

Trockel attaches great importance to the manner in which her work is presented, which owes a great deal to the museum context: her vitrines, plinths, packaging and other hanging and installation materials, such as wood, glass, cardboard and metal, are all distinguished by their sober functionalism and craftsmanlike precision. For all their thematic diversity and breadth of formal invention, Trockel's works share a common lack of pretentiousness, in their overall appearance.

Trockel has taken part in numerous group exhibitions and had retrospective exhibitions of her work in the Rheinisches Landesmuseum, Bonn, in 1985, the Museum of Modern Art, New York, in 1988 and the Kunsthalle Basel and the Institute of Contemporary Arts, London, in 1991–92, as well as an exhibition tour to Boston, Chicago, Toronto and Madrid, in 1991–92.

Rosemarie Trockel lives and works in Cologne. C.T.

Rosemarie Trockel. Bilder – Skulpturen – Zeichnungen, ed. Wilfried Dickhoff, exh. cat., Bonn, Rheinisches Landesmuseum, 1985

Rosemarie Trockel, exh. cat., Basel, Kunsthalle and London, Institute of Contemporary Arts, 1988

Rosemarie Trockel, Papierarbeiten, exh. cat., Basel, Kupferstich-Kabinett der Öffentlichen Kunstsammlung, 1991

Rosemarie Trockel, ed. Sidra Stich, exh. cat., Boston, The Institute of Contemporary Art and Berkeley, University Art Museum, Munich, 1991

Rosemarie Trockel, *Jedes Tier ist eine Künstlerin* (artist's book), Lund, 1993

JAMES TURRELL

was born on 6 May 1943 in Los Angeles. After taking a BA in experimental psychology and mathematics at Pomona College in Claremont, California, in 1965, he switched to studying art, first at the University of Claremont in Irvine and then, with some interruptions, at Claremont Graduate School in Claremont, until 1973. He has been an enthusiastic pilot, ever since acquiring his flying licence in 1969.

At the centre of Turrell's artistic concerns since the mid-sixties has been his interest in 'the properties of light within a space' (Turrell) – especially, specific perceptions of the phenomena of light and space and their mutual effect on each other. Thus, his early *Shallow-Space Constructions* (e.g. *Wedgework III,* 1969) comprise cones of light emanating from concealed projectors which seem to slice through the

surrounding space with immaterial-seeming planes of light. In *Mendota Stoppages* (1969–74) Turrell worked on a series of interconnecting rooms to create an interaction between inner and outer spaces, by first controlling the light entering through roll-blinds over the windows and through the apertures of the doors, and then leaving the changing light conditions to do the rest, as the day progressed and as day turned into night.

Turrell calls his light-filled experiential spaces in which the viewer is free to move about 'Ganzfeld rooms'. Viewers who spend some time in such spaces lose their sense of orientation and ability to judge distances. This goes to support the main tenet of Gestalt theory – that all perceptions are relative perceptions. Turrell has also developed models of free-standing architectural constructions, to illustrate this phenomenological perception. *City of Arhirit* (1976), for example, consists of a series of light-filled chambers. These are complemented by so-called 'Dark Pieces' – dark rooms in which faint emanations of light sensitise the viewer's powers of optical reception. *Blind Sight* (1991) takes this a stage further, in that vestigial images which the eye does not see are triggered off on the retina. In *Air Mass* (1993) a large blue cone of light is projected above the viewer. The intensity of the viewers' receptivity to colour is such that when they look away into the distance they become aware of changes in the colour of the sky.

Turrell has taken the next logical step of developing these light works in the wider context of the landscape. Since 1974 he has been working on the *Roden Crater Project*, to create a natural observatory inside an extinct volcano at Flagstaff, Arizona. This project, which is a combination of earthwork, sculpture and architecture, is currently the largest projected work of art in the world. The various rooms, tunnels, chambers and special zones which are planned inside and around the crater will facilitate a linking up of human perceptions with cosmic movements, via the changing patterns of light, through night and day.

Turrell's immaterial light spaces belong to a long artistic tradition of investigating the effects of light, from the Impressionists and Luminists via Robert

Delaunay's light metaphysics of 'pure painting', down to the Op and Concrete artists and the artists in the sixties who, through light kinetics and spatial environments, took as their subject the processes of seeing and perception. The technical precision of Turrell's work is a necessary precondition of his work on the fascinating effects of light at the limits of human perception and cognition.

Turrell has won numerous prizes and awards, including a Visual Arts Fellowship from the Arizona Commission for the Arts and Humanities in 1980 and the Lumen Award from the New York section of the Illuminating Engineering Society and the International Association of Lighting Designers in 1981. As the founder of the Skystone Foundation for supporting the *Roden Crater Project* (since 1977), his work has been rewarded with a Fellowship from the McArthur Foundation and awards from the Lannan Foundation in 1987 and the Andy Warhol Foundation for the Visual Arts in 1990.

Turrell lives in Flagstaff, Arizona, and Inishkeame West, Ireland. H. D.

A Topical Survey of the Works by James Turrell, ed. Peter Blum, exh. cat., Basel, Kunsthalle, New York, 1985
Craig Adcock, *James Turrell: The Art of Light and Space*, Berkeley, Los Angeles and Oxford, 1990
James Turrell. First Light, ed. Joseph Helfenstein and Christoph Schenker, exh. cat., Bern, Kunstmuseum, 1991
James Turrell. Perceptual Cells, ed. Jiri Svestka, exh. cat., Düsseldorf, Kunstverein für die Rheinlande und Westfalen, 1991
James Turrell, *Air Mass*, book cum exh. cat., London, Hayward Gallery, Stuttgart, 1993
James Turrell, Behind my Eyes: An Autobiography of Perception, ed. Julia Brown, Flagstaff, 1994

CY TWOMBLY

was born on 25 April 1928 in Lexington, Virginia. At the age of fourteen he attended painting courses and lectures by the Spanish artist Pierre Daura, who taught him about European art. Twombly studied at the School of the Museum of Fine Arts in Boston from 1947 and from 1949 to 1950 at the Washington and Lee University in Lexington.
Twombly moved to New York in 1950 and continued his studies at the Art Students League, where he met Robert Rauschenberg. In 1951–1952 he was at the Black Mountain College in North Carolina under Robert Motherwell and Franz Kline. Twombly and Rauschenberg travelled on a scholarship in South America, Spain, North Africa and Italy. Twombly returned to New York in 1953, and after doing military service started teaching at the Southern Seminary and Junior College in Buena Vista, Virginia in 1955. He moved to Rome in 1957.
In his early pictures, from 1951 onwards, Twombly explored the possibilities of gestural and expressionistic brushwork; Franz Kline made a considerable impact on him, but Paul Klee was his particular

model. Twombly saw pictures as a plane onto which he could project his own physical and psychological presence. Like Dubuffet he sought to enliven the surface of the picture by mixing other substances, such as earth, with the painting materials. His complex handling of line creates a sensitive relationship with the pictorial space and the ground of the picture; the latter's layered and refracted shades of white provide a foil for Twombly's signs, words, numbers and fragments. On moving to Italy in 1959, Twombly linked these psychograms with mythological and literary references, as in *Leda and the Swan* (1962). Painterly components now increasingly join the linear elements: powerfully placed patches of strong colour accentuate lines and the ground. Twombly makes the work more expressive by invoking the great names of antiquity in his titles and inscriptions. He enhances this effect by varying the pictorial texture between nervous reduction and opulent energy. Mediterranean landscape and culture, bright light and the world of ancient myth became essential sources of artistic inspiration for Twombly. These influences were reflected first of all in a lightening of the colour range and the increased liveliness with which colour was applied. Words, ciphers, signs and emblems seem to have been strewn hurriedly over the surface of the picture, often referring to local history. Place-names like Rome or Gaeta occurred, titles such as *The School of Athens,* after Raphael's Stanza fresco, and mythological figures like Venus, Apollo and Dionysus features frequently in his work.
Twombly's 'school blackboard' pictures were produced in the sixties. These were on a neutral, usually green or grey ground, on which he placed repetitive sequences of simple forms in chalk, using the gesture of handwriting. In the mid-seventies Twombly created multi-layered surface structures with paper in collage and a wide variety of colouring materials like oil, acrylic, water-colour and pastel, in which the written signs seem to be embedded , as for example in the ten-part cycle *Fifty Days in Illiam* (1978) or *Hero and Leander* (1981–1984). These paintings foreshadowed the eruptive flower pictures from Gaeta (where he has worked since 1986), produced in 1990. The graphic elements dissolved more and more in

violent swirls of yellow, red, purple and green. The writing became a coloured component within the pictorial structure.

Similar constellations of emotional directness and intellectual maturity could be seen in the sculptures that accompanied the paintings from 1955. The constructions, some of them converted into artificial resin or bronze, were made of existing objects and the simplest of materials, then painted with Cementito – a white matt paint for walls – and thus showed up the most refined nuances of white, as in the pictures. Twombly's unmistakable pictorial language combines history and a mythological world believed to have been lost with personal reflections on the psychological condition of the artist in the late 20th century.

Major one-man shows of Twombly's work have been held at the Whitney Museum in New York in 1979, the Baden-Baden Kunsthalle in 1984, the Kunsthaus in Zurich in 1987 and the Museum of Modern Art in New York in 1994. The Cy Twombly Gallery in Houston was opened in 1995, with architecture planned and executed by Twombly in association with architect Renzo Piano.

Twombly lives and works in Lexington, Rome and Gaeta. H.D.

Cy Twombly. Zeichnungen 1953–1973, ed. Heiner Bastian, Frankfurt a. M., Berlin and Vienna, 1973
Roland Barthes, *Cy Twombly*, Berlin, 1983
Heiner Bastian, *Cy Twombly. Das graphische Werk 1953–1984. A Catalogue Raisonné of the Printed Graphic Work*, Munich and New York, 1985
Cy Twombly, exh. cat., Zürich, Kunsthaus, 1987
Harald Szeemann, *Cy Twombly*, exh. cat., Kunsthalle Zürich, Munich 1987
Cy Twombly. Eine Retrospektive, ed. Kirk Varnedoe, exh. cat., Berlin, Nationalgalerie, 1995; Engl., New York, The Museum of Modern Art, 1994
Heiner Bastian (ed.), *Cy Twombly. Catalogue Raisonné der Gemälde*, boxed set, 4 vols., Munich, 1996

BILL VIOLA

was born on 25 January 1951. From 1969 to 1973 he studied at the College of Visual and Performing Arts at Syracuse University, New York.

His initial interests were especially in the areas of electronic music, performance and experimental film. In his first works on Super 8 film and video, made in 1970, Viola explored the technical and structural possibilities of the medium, under conditions of human perception. His first exhibitions with Nam June Paik, Peter Campus and Bruce Nauman placed him in the front rank of pioneers of video art. In 1973 Viola formed the 'Composers Inside Electronics Group', together with John Driscoll, Linda Fisher and Phil Edelstein. His meeting with David Tudor, at a workshop for new music in 1973, was decisive and led to his appearing in successive years in Tudor's multi-media piece, *Rainforest*. During this period, he started joining sound to image, as an essential component of his film and installation work.

From 1974 to 1976 Viola worked as technical director and production manager at the Art/Tapes/22 Video Studio in Florence. At the same time he started working with a portable colour video camera and took part in the *Biennale des Jeunes* in Paris, in 1975 and the Whitney Biennale in New York, in the same year. Following his time in Europe, he learned the techniques of shooting and montage for television, as artist in residence at the WNET/Thirteen Television Laboratory in New York.

Viola's growing preoccupation with the subject-matter of his video sound installations was matched by his interest in esoteric literature. His numerous journeys abroad, from 1976 onwards, have had a profound influence on his way of life and the subject-matter of his work. Thus, for example, he travelled to the South Pacific in 1976 to record indigenous music and traditional dance; to Solo City on Java in 1977, with the music ethnologist and composer Alex Dea, to film the traditional forms of music theatre; and to the Himalayas in 1982, to visit Tibetan Buddhist monasteries and, again, make recordings of traditional music.

In 1980–81 Viola spent six months in Japan, thanks to a scholarship and an invitation to join the Sony Corporation's Atsugi Laboratories as artist in residence. There, he studied traditional Japanese arts, such as calligraphy and Noh theatre, alongside the latest developments in video technology. The video film *Hatsu-Yume (First Dream)* (1981), which deals with time, light and space in the Japanese landscape, made clear the extent to which his work had been influenced by Zen Buddhist philosophy and a specifically Japanese attitude to nature. In 1983 Viola took up a post teaching video at the California Institute of the Arts in Valencia and had his first sizeable solo exhibition in Europe at ARC, in the Musée d'Art Moderne de la Ville de Paris.

The ninety-minute video tape, *I Do Not Know What It Is I Am Like*, for which Viola won the First Prize for Video Art at the 8th International Festival of Video Art and New Electronic Images in Locarno, in 1971, is a collage of recent and not so recent work, such as shots taken from the time around 1984, when he spent three weeks following a herd of bison in a

national park in South Dakota and some film sequences of the Hindus' fire-ritual on the Fiji Islands. This material explored themes such as the different levels of consciousness among peoples at different stages in their evolution and a variety of beliefs in the cycle of life, death and regeneration.

In his own immediate environment the decisive events were the death of his mother and the birth of his son, which provided the subject for his words, *The Passing* (1991) and *Heaven and Earth* (1992). The latter is a twin screen installation juxtaposing images of his son's first days of life and his mother's last hours on two screens mounted directly one on top of the other.

In 1992 Viola worked both on *The Arc of Ascent*, which combines changeable picture size with a technique of montaged projection, enabling the creation of a seven-metre-high image, and on the series of miniature video projections, *What Is Not and That Which Is*. Viola's countless exhibitions, fellowships and prizes confirm his status as one of the most important and innovative artists in the field of video art. In particular, he took part in *documenta 6* (1977) and *documenta IX* (1992), as well as representing the USA at the 1995 Venice Biennale.

Bill Viola lives and works in Long Beach, California. C.T.

Bill Viola, ed. Dany Bloch, exh. cat., Paris, ARC, Musée d'Art Moderne de la Ville de Paris, 1983
Bill Viola. Installations and Videotapes, ed. Barbara London, exh. cat., New York, The Museum of Modern Art, 1987
Bill Viola – Survey of a Decade, ed. Marilyn Zeitlin, exh. cat., Houston, Texas, Contemporary Arts Museum, 1988
Bill Viola: Unseen Images/Nie gesehene Bilder/Images jamais vues, ed. Marie Luise Syring, exh. cat., Düsseldorf, Städtische Kunsthalle, 1992
Bill Viola, ed. Alexander Pühringer, exh. cat., Salzburg, Kunstverein, 1994
Bill Viola. Reasons for Knocking at an Empty House. Writings 1973–1994, ed. Robert Violette and Bill Viola, London, 1995

JEFF WALL

was born on 29 September 1946 in Vancouver, Canada. From 1964 to 1970 he studied art history in the Department of Fine Arts at the University of British Columbia. During this period he came to grips with conceptual art, and in 1969–70 he took part in a number of group exhibitions. Wall went to the Courtauld Institute of Art in London from 1970 to 1973 to undertake research leading to a degree in the history of art, in 1973. Following this he found various kinds of teaching work in Halifax and Vancouver, before taking up the post of Professor at the Center for the Arts at Simon Fraser University, Vancouver, in 1976. Since 1987 he has been a Professor in the Department of Fine Arts at the University of British Columbia. The photographic works which Wall has been making since 1978 clearly reveal his familiarity, as an art

the photographic effect and expressive power. Wall works with large format cibachromes, which he presents in fluorescent light boxes. By this means the outsize pictures are endowed with a sharpness of definition and luminous intensity which lift them onto another plane of hyperreality, where they are deprived of their topographical or individual human characteristics and assume an all-encompassing allegorical function.

One example of a history picture which is, however, staged not as the scene of an heroic massacre but as a gruesome allegory of death, is the work *Dead Troops Talk* of 1991–92, which is set in the Afghan War. In this detailed, carefully composed tableau, set in a harsh light and put together with the aid of a computer, the living corpses appear in a setting reminiscent of a gruesome scene from a Hollywood production.

Wall has taken part in numerous group exhibitions such as *documenta 7* (1982) and *documenta 8* (1987) in Kassel. In 1984 the Institute of Contemporary Arts in London held a retrospective of his work, which then went on to Basel, and in 1988 he was given another retrospective at the Westfälischer Kunstverein, in Münster. A retrospective put together by the Museum of Contemporary Art in Chicago in 1995 subsequently went on to Paris, Helsinki and London, in 1995 to 1996.

Wall lives and works in Vancouver. C.T.

Jeff Wall. Transparencies, Munich, 1986; Engl., New York, 1987
Jeff Wall, exh. cat., Münster, Westfälischer Kunstverein, 1988
Jeff Wall – 1990, exh. cat., Vancouver, Vancouver Art Gallery, 1990
Jeff Wall, exh. cat., Chicago, The Museum of Contemporary Art, Paris, Galerie Nationale du Jeu de Paume, Helsinki, Museum of Contemporary Art and London, Whitechapel Art Gallery, 1995
Jeff Wall. Szenarien im Bildraum der Wirklichkeit. Essays und Interviews, ed. Gregor Stemmrich, Dresden, 1997

ANDY WARHOL

was born Andrew Warhola on 6 August 1928 in Pittsburgh, Pennsylvania, into a family of Czech immigrants. He trained first of all as a shop-window dresser and studied pictorial design with art history, sociology and psychology at the Carnegie Institute of Technology in Pittsburgh from 1945 to 1949. He subsequently moved to New York, where he changed his name. Warhol worked as a free-lance until 1960, as a commercial artist for fashion magazines, illustrator and shop-window dresser. As a talented draughtsman, he was awarded the Art Directors' Club Medal for designing newspaper advertisements. His first exhibition, *Fifteen Drawings based on the Writings of Truman Capote,* took place in the Hugo Gallery in New York in 1952.

Warhol's early pictures, such as *Saturday's Popeye* and *Superman* (both 1960), in which he used figures

historian, with the pictorial imagery of earlier periods in history and with the various genres and stylistic tendencies. The subjects of his photographs conveniently fall into the traditional genres of academic painting – landscapes, figures, portraits, history themes, interiors and still lifes – to which he has added snapshots of contemporary life, contemporary settings and everyday situations. He always mounts precisely and tellingly staged scenes and selected scenarios, in which each detail is prescribed an exact function.

Wall's interest in his subject-matter involves him in taking a critical view of social relationships and general cultural phenomena, as well as individual modes of behaviour. His architectural views, landscapes and objects, as well as the artificially staged gestural language and mimicry of his protagonists thus supply the narrative content of his work. In *Outburst* (1986) he captured the theatrical climax of an extremely tense situation, by concentrating on the convulsive gesture of defiance of an Asian employee in a textiles factory and turning this into a symbol of physical violence at the centre of the image. The surrounding scene and the shocked expression of the dumbstruck seamstress at whom this outburst is directed situate this symbol in a wider context, in which we are invited to reflect critically on working conditions in industrial societies.

The grouping of figures in *The Storyteller* (1986) reveals a clear indebtedness to well-known paintings in the history of art and may be traced back to Titian's and Giorgione's collaborative painting, *Concerto campestre* (1508) and Edouard Manet's *Le Déjeuner sur l'herbe* (1863). Wall interprets the figure of the storyteller as 'an archaic figure' and 'a nostalgic archetype', who has lost his function in modern European and North American culture. The construction of the picture shows isolated individuals and groups of individuals on the massive concrete support ramp of a federal highway; the fact that the gesticulating storyteller is set on the very edge of the scene serves to make clear the significance of his relegation to the margins of contemporary society.

The technical means and manner of presentation of Wall's colour photographs form an essential part of

from comic strips as models, had originally been used as items in window displays. In 1962 he produced the first series of *Campbell's Soup Cans* and *Coca Cola Bottles,* then screen prints of dollar bills, usually made by the 'Factory', a group of friends and assistants, with whom Warhol lived and worked in a commune. The use of familiar motifs and signs from mass culture and mechanical-serial manufacturing processes hitherto not seen as artistic was to be the hallmark of his work from then on.

In 1962 Warhol took part in *The New Realists,* an exhibition of American Pop Art mounted by Sidney Janis in New York. In subsequent years he produced series of images of death and disaster, involving plane crashes, road accidents, criminality, death by the electric chair, the atom bomb and earthquakes. Warhol made his mark on Pop Art with these pictures, which were produced by the impersonal screen print process and with deliberately poor reproduction, like print in a newspaper. Among his most sensational works were the *Brillo-Cartons* (1964) and other cardboard sculptures, precise imitations of commercial packaging in wood, whose logos were printed by the silk screen process.

In the sixties Warhol devoted himself increasingly to film as a medium, and developed his own film aesthetic: the technique was kept consciously simple, with long, static shots without dramatic intervention, and the lack of editing and montage created the monotony that became the actual subject of his films. Warhol received the magazine *Film Culture*'s Independent Film Award for his first silent films, such as *Sleep, Kiss* and *Eat* (all 1963) and *Empire* (1964). In subsequent years he made dubbed sound films, such as *Chelsea Girls* (1966), which were also shown at the Cannes Film Festival. His films were characterised by sexual frankness, verbal obscenity, trivial conversations and monotonous repetition. In 1966 Warhol started to organise multi-media events, including night-club shows with the rock group Velvet Underground. In 1982 he produced *Andy Warhol Television* for cable TV, and worked increasingly with video from then on.

In the seventies Warhol became a portraitist of New York society, using his own Polaroid photographs as

a starting-point. He left the actual execution to his production firm, the 'Factory'. His silk-screen versions of photographs of famous personalities, including *Elvis Presley* (1964), *Jackie Kennedy* (1965), *Marilyn Monroe* (1967) and *Mao Tse Tung* (1972) became twentieth-century icons. For the series 'Myths', dating from 1981, Warhol made fictitious figures like Superman, Mickey Mouse, and also himself, into American cult figures.

A fundamental feature of Warhol's artistic work was his self-dramatisation, which started even in the early fifties with the Americanisation of his name, and his trade-mark of hair dyed ash-blond. Conscious provocation through spectacular appearances, taboo-breaking subject matter and not least the use of industrial processes make him the most famous figure in Pop Art, but socially its most controversial one. In 1968 he was shot and critically injured by Valerie Solanas. In 1985 Warhol exhibited himself as a living work of art behind a pane of glass in a New York night-club. After years of working with his assistants he embarked on joint projects with artists such as Jean-Michel Basquiat and Francesco Clemente in 1984.

Warhol died in New York on 22 February 1987. In 1989 the Museum of Modern Art in New York mounted the most comprehensive retrospective of his work to date. H. D

David Bourdon, *Andy Warhol*, New York, 1989
Andy Warhol. A Retrospective, ed. Kynaston McShine, exh. cat., New York, The Museum of Modern Art, 1989
The Philosophy of Andy Warhol from A to B and back again, New York, 1975
Stefana Sabin, *Andy Warhol in Selbstzeugnissen und Bilddokumenten*, Reinbek bei Hamburg, 1992
The Andy Warhol Museum, The Andy Warhol Foundation for the Visual Arts, Inc., Pittsburgh, New York and Stuttgart, 1984
Andy Warhol, exh. cat., Ludwigshafen, Wilhelm-Hack-Museum, 1996

LAWRENCE WEINER

was born on 10 February 1942 in the Bronx in New York. After studying philosophy and literature at Hunter College in New York he started to experiment in the field of painting and sculpture. In 1959 he went to California, where his work included the *Cratering Piece* (1960), a series of explosions in the soil of Mill Valley. He returned to New York in 1964, and was given his first one-man exhibition at the Seth Siegelaub Gallery. This consisted of a series of paintings that were variations on the theme of a propeller-shaped television test card.

Weiner, who was one of the founders of Concept Art, concerned himself with the fundamental requirements of art production in the mid-sixties. He started with works in which he allowed others to determine the format and colouring of a painting, and how it should be executed. In order to detach himself even further from subjective decision processes when exe-

cuting a work of art he finally decided that language should be his artistic medium. He found a means of communication that allowed him to operate beyond the traditional artistic media. The idea and conception of a work of art that is articulated in language came into the foreground, and material appearances remained secondary. He formulated the fundamental propositions of his view of art as follows in 1969:

1. The artist may construct the piece
2. The piece may be fabricated
3. The piece need not be built

Each being equal and consistent with the intent of the artist the decision as to condition rests with the receiver upon the occasion of receivership.

This effectively cancelled the artist's role as the sole progenitor of a work of art, since there was no longer any need to realise the piece, once it had been adequately defined. Moreover, the observer acquired a crucial role as interpreter of Weiner's linguistically formulated works. Weiner said that the non-material identity of his work had the following implication for the recipient: 'In a sense, once you know about a work of mine, you own it. There's no way I can climb into somebody's head and remove it.'

Although Weiner has worked exclusively with language as a medium since 1968, he sees himself as a fine artist and not a writer. Turning art into language, which also featured in the work of artists like Joseph Kosuth, Robert Barry and On Kawara in the late sixties, reached an extreme point in Weiner's work. The work '*painted*' (1968) is an ideal example of a concentrated and reduced artistic statement.

Weiner's linguistic works related to material in terms of their significance, i.e. they did not relate to existential conditions or day-to-day political events, but to largely material realities, as in the case of '*A 36" x 36" REMOVAL TO THE LATHING OR SUPPORT WALL OF PLASTER OR WALLBOARD FROM A WALL*', dating from 1969, which was shown in Weiner's comprehensive retrospective in the Stedelijk Museum in Amsterdam in 1988, with the explanation that it consisted of 'language and the materials to which it relates'. In this sense Weiner also saw himself as a sculptor, making his sculptures out of language.

The aesthetic presentation of Weiner's work is marked by a great deal of diversity: it ranges from sheets of typescript stapled to the wall via letters stencilled directly on to the wall to professionally executed wall inscriptions, which often define the space. Alongside the large-format, interior and exterior wall inscriptions, which are the basis of Weiner's fame, he has also produced videos, films and gramophone and tape recordings, as well as numerous books. He also adapts 'trivial' objects such as badges, pieces of furniture and pocket knives for his own purposes.

Weiner's work has been shown in international exhibitions since the late sixties. These have included *When Attitudes Become Form* in Bern, Krefeld and London in 1969, and *documenta* in Kassel in 1972, 1977 and 1982.

Weiner lives and works in New York and Amsterdam. C. T.

Rudi H. Fuchs, *Lawrence Weiner*, exh. cat., Eindhoven, Stedelijk Van Abbemuseum, 1976
Lawrence Weiner. Posters. November 1965–April 1986, ed. Benjamin H. D. Buchloh, Halifax and Toronto, 1986
Lawrence Weiner. Works from the Beginning of the Sixties towards the End of the Eighties, exh. cat., Amsterdam, Stedelijk Museum, 1988
Lawrence Weiner. Books 1968–1989, ed. Dieter Schwarz, Cologne and Villeurbanne, 1989
Show (&) Tell. The Films and Videos of Lawrence Weiner, ed. Bartomeu Mari, Ghent, 1992
Lawrence Weiner. Specific and General Works, Villeurbanne, Le Nouveau Musée, Institut d'Art Contemporain, 1993

WOLS

was born Alfred Otto Wolfgang Schulze in Berlin on 27 May 1913. The family moved to Dresden in 1919. Wols was a talented violinist, and Fritz Busch, the musical director of the Dresden Opera House, offered him the job of principal in the orchestra in 1931, but Wols turned it down. On the recommendation of Lázló Moholy-Nagy, whom he had met while attending the Bauhaus in Berlin, he moved to Paris in 1932, where he made contact with Ozenfant, Léger, Arp and Domela.

Wols started to work as a professional photographer in Paris. In 1933 he returned briefly to Germany, to collect his legacy from his father. He did not respond when called up for labour service, however, which led to persistent difficulties with the authorities. He lived in Barcelona and on Ibiza from 1933 to 1935, then worked in Paris again from 1936 to 1939; one of his assignments was as official photographer to the International Exhibition in Paris in 1937. He adopted the pseudonym Wols in the same year.

Wols drew inspiration for his photographs from a wide variety of sources, including Ozenfant's book *Life and Design* (1931 and Moholy-Nagy's Bauhaus-Buch *Malerei Fotografie Film* (Painting Photography Film, 1925). Numerous photographic exhibitions and

publications in the early thirties showed the increasing importance of this medium and Wols used it in an unusual and diverse way for portraits, city scenes and still lifes, alongside his work as a reporter. He combined the objectivity of 'New Seeing' with a liking for morbidity and decay.

Wols was interned in various French camps when the war broke out. As he was unable to pursue his interest in photography there he turned to painting and drawing. He produced small watercolours and tiny drawings scribbled on scraps of paper, a 'journal' in pictures, as a counterpart to the collection of aphorisms he wrote down at this time. His motifs were figures and architecture; objects and landscapes overlapped and formed unusual combinations. His fantastic and droll inventions were reminiscent of Alfred Kubin and Paul Klee. Wols' knowledge of Surrealist work and his many personal contacts with members of the Paris Surrealist group, including Yves Tanguy, André Masson and Max Ernst had a catalytic effect on Wols's artistic creations. He used Surrealist pictorial concepts to the extent that his principal interest was in the visionary image, close to dreams and trances, occurring automatically and suggestively.

Wols was released from the internment camp in 1940, but conditions became even more oppressive after France was occupied by German troops. Wols fled to Dieulefit near Montélimar, to avoid the invaders' advance. He met the poet Henri-Pierre Roché, who in subsequent years acquired around fifty of his drawings and watercolours, which can be interpreted as a kind of 'psychic automatism'. But his art was not recognised more widely, and an exhibition of watercolours and ink drawings in the Galerie René Drouin in 1945 was a failure.

On returning to Paris Wols met Jean-Paul Sartre who supported him financially in subsequent years – also Alberto Giacometti, Jean Paulhan, Tristan Tzara and Georges Mathieu. He started painting in oils at Drouin's suggestion. He produced around forty paintings in the early part of 1947, which were exhibited by Drouin and triggered great enthusiasm among artists in Paris. The signs, lines and patches of colour placed spontaneously on a variety of grounds formed impenetrable thickets of form, with biomorphic and objective associations, but most of all y revealed the psychological condition of the artist (his 'wound'). Mathieu defined the 'Informel' on the basis of these psychograms, the new movement in painting that took over from Surrealism and Geometrism in Paris in the fifties, and affected style all over Europe. In these last years Wols illustrated works by Paulhan, Sartre, Kafka, de Solier and Artaud.

Wols died in Paris on 1 September 1951, his health ruined by alcoholic excess. H.D.

Wols. Aufzeichnungen, Aquarelle, Aphorismen, Zeichnungen, ed. Werner Haftmann, Cologne, 1963
Wols Photograph, ed. Laszlo Glozer, exh. cat., Hanover, Kestner Gesellschaft, Munich, 1978
Wols. Sa vie, ed. Gerhard Götze, exh. cat., Paris, Goethe-Institut, 1986
Wols. Bilder, Aquarelle, Zeichnungen, Photographien, Druckgraphik, exh. cat., Zürich, Kunsthaus and Düsseldorf, Kunstsammlung Nordrhein-Westfalen, Bern, 1989

The Authors

BROOKS ADAMS

(born 1954 in Lake Forest, Illinois) is an art critic and curator based in New York. He is a contributing editor of *Art in America* and a frequent contributor to other international art magazines. He is the author of many essays on 19th and 20th century art.

STEPHEN BANN

(born 1942 in Manchester) is Professor of Modern Cultural Studies and Chair of the Board of Studies in History and Theory of Art at the University of Kent at Canterbury. He has published numerous books and essays on contemporary art, museums and the representation of history. These include *The Clothing of Clio* (1984), *The True Vine* (1989), *The Inventions of History* (1990), *Under the Sign* (1994) and *Romanticism and the Rise of History* (1995).

DIETER DANIELS

(born 1957 in Bonn) is Professor of History of Art and Theory of Media at the Hochschule für Grafik und Buchkunst in Leipzig. Among exhibitions that he has organised have been *Übrigens sterben immer die anderen. Marcel Duchamp und die Avantgarde seit 1950* (Cologne, 1988) and *Minima Media - Medien-Biennale* (Leipzig, 1995). He is the author of numerous articles on media- and intermedia-art. Foremost among his recent publications is *Duchamp und die anderen* (1992).

ARTHUR C. DANTO

(born 1924 in Ann Arbor, Michigan) is Johnsonian Professor Emeritus of Philosophy at Columbia University, New York, as well as art critic for the magazine *The Nation*. He has written many books on art and philosophy, including *The Transfiguration of the Commonplace* (1981), *The Philosophical Disenfranchisement of Art* (1986), *Beyond the Brillo Box* (1992) and *Art after the End of Art* (1997).

BORIS GROYS

(born 1947 in Leningrad) is Professor of Philosophy and Aesthetics at the Staatliche Hochschule für Gestaltung in Karlsruhe. His publications include *Gesamtkunstwerk Stalin. Die gespaltene Kultur in der Sowjetunion* (1988) and *Die Erfindung Rußlands* (1995) as well as, with Ilya Kabakov, *Die Kunst des Fliehens. Dialoge über Angst, das heilige Weiß und den sowjetischen Müll* (1991) and *Die Kunst der Installation* (1996).

CHRISTOS M. JOACHIMIDES

(born 1932 in Athens) is an exhibitions organiser and art theoretician. For the last twelve years he has been Secretary General of the Zeitgeist-Gesellschaft in Berlin. He has organised numerous exhibitions, including, in co-operation with Norman Rosenthal, *Art into Society – Society into Art* (London, 1974), *A New Spirit in Painting* (London, 1981), *Zeitgeist* (Berlin, 1982), *German Art in the 20th Century* (London and Stuttgart, 1985–86), *Metropolis* (Berlin, 1991) and *American Art in the 20th Century* (Berlin and London, 1993).

WOLF LEPENIES

(born 1941 in Deuthen, East Prussia) is Professor of Sociology at the Freie Universität, Berlin, and Rector of the Institute for Advanced Study in Berlin. His most important publications include *Melancholie und Gesellschaft* (*Melancholy and Society*, 1969); *Die drei Kulturen. Soziologie zwischen Literatur und Wissenschaft* (1985) and, most recently, *Aufstieg und Fall der Intellektuellen in Europa* (1992) and *Folgen einer unerhörten Begebenheit. Die Deutschen nach der Vereinigung* (1992).

ODO MARQUARD

(born 1928 in Stolp, East Pomerania) is Professor Emeritus of Philosophy at the University of Gießen. He is the author of numerous essays and books on the philosophy of history, anthropology, aesthetics, hermeneutics, ethics and the history of ideas. His most important books include *Schwierigkeiten mit der Geschichtsphilosophie* (1973); *Abschied vom Prinzipiellen* (1981), Engl. *Farewell to Matters of Principle* (1989); *Apologie des Zufälligen* (1986), Engl. *In Defense of the Accidental* (1991); *Aesthetica und Anaesthetica* (1989) and *Glück im Unglück* (1995).

ROBERT C. MORGAN

(born 1943 in Boston, Mass.) is an art critic, artist and art historian based in New York. He is Professor of the History and Theory of Art at the Rochester Institute of Technology and Adjunct Professor of Art at Pratt Institute in Brooklyn, New York. His recent books include *After the Deluge: Essays on Art in the Nineties* (1993), *Conceptual Art: An American Perspective* (1994) and *Between Modernism and Conceptual Art: A Critical Response* (1997).

ANNA MOSZYNSKA

(born 1957 in London) is a Deputy Director at Sotheby's Institute, London, where she teaches the MA Course in Post-War and Contemporary Art, validated by the University of Manchester. She has acted as exhibition coordinator for the Arts Council of Great Britain and has published numerous articles on art since 1945, as well as a book on *Abstract Art*, in 1990.

NORMAN ROSENTHAL

(born 1944 in Cambridge) has been Exhibitions Secretary of the Royal Academy of Arts, London, for the last twenty years. Since 1974 he has organised a number of survey exhibitions on the art of the 20th century in co-operation with Christos M. Joachimides, including *Art into Society – Society into Art* (London, 1974), *A New Spirit in Painting* (London, 1981), *Zeitgeist* (Berlin, 1982), *German Art in the 20th Century* (London and Stuttgart, 1985–86), *Metropolis* (Berlin, 1991) and *American Art in the 20th Century* (Berlin und London, 1993).

PETER SCHJELDAHL

(born 1942 in Fargo, North Dakota) is an art critic based in New York. He is senior art critic of *Village Voice* and a contributing editor of *Art in America*. His publications include *Since 1964: New & Selected Poems* (1978), *The Hydrogen Jukebox: Selected Writings 1978–1990* (1991), *The 7 Days Art Columns* (1992) and *Columns & Catalogues* (1994).

WIELAND SCHMIED

(born 1929 in Frankfurt am Main) was Professor of the History of Art at the Akademie der Bildenden Künste in Munich until 1994. He has published numerous books on the art of the nineteenth and twentieth centuries, including monographs on Caspar David Friedrich, Giorgio de Chirico and, most recently, Edward Hopper and Francis Bacon. He is currently President of the Bayerische Akademie der Schönen Künste.

SHEARER WEST

(born 1960 in Rocky Mount, Virginia) is Senior Lecturer and Head of the Department of Fine Art at the Barber Institute of Fine Arts at the University of Birmingham. She is the author of a number of books, including *The Image of the Actor: Verbal and Visual Representation in the Age of Garrick and Kemble* (1991), *Fin de Siècle: Art and Society in an Age of Uncertainty* (1993), and co-editor of *Visions of the 'neue Frau': Women and the Visual Arts in Weimar Germany* (1995) and *The Victorians and Race* (1997).

BEAT WYSS

(born 1947 in Basel) is Professor of the History of Art at the Ruhr-Universität in Bochum. In 1996 he was Visiting Professor at Cornell University, New York. His publications on the history of art, architecture and aesthetics include *Trauer der Vollendung. Von der Ästhetik des deutschen Idealismus zur Kulturkritik der Moderne* (1985), Engl. *Hegel's Art Theory. The Sorrow of the Perfect* (1997), *Mytholgie der Aufklärung. Geheimlehren der Moderne* (1993) and *Der Wille zur Kunst. Zur ästhetischen Mentalität der Moderne* (1996).

Lenders to the Exhibition

Stedelijk Museum, Amsterdam

University of Michigan Museum of Art, Ann Arbor

Fundació Joan Miró, Barcelona

Fundació Antoni Tàpies, Barcelona

Berlinische Galerie, Landesmuseum für Moderne Kunst, Photographie und Architektur, Berlin

Staatliche Museen zu Berlin, National-galerie; Preußischer Kulturbesitz, Berlin

Museo Morandi, Bologna

Kunstmuseum Bonn

Museum of Fine Arts, Boston

Kunsthalle Bremen

Fitzwilliam Museum, Cambridge

Cincinatti Art Museum, Cincinatti

Museum Ludwig, Collection Ludwig, Cologne

Statensmuseum for Kunst, Copenhagen

Hessisches Landesmuseum, Darmstadt

Detroit Institute of Arts, Detroit

Museum am Ostwall, Dortmund

Scottish National Gallery of Modern Art, Edinburgh

Stedelijk Van Abbemuseum, Eindhoven

Museum van Hedendaagse Kunst, Ghent

Musée de Grenoble

Sprengel Museum, Hanover

Herning Kunstmuseum, Herning, Denmark

The Menil Collection, Houston

Louisiana Museum of Modern Art, Humlebæk, Denmark

A.F. Kowalenko Art Museum, Krasnodar

Sintra Museum of Modern Art, Lisbon

Arts Council, Hayward Gallery, London

Tate Gallery, London

Los Angeles County Museum of Art, Los Angeles

Museo Nacional Centro de Arte Reina Sofia, Madrid

Fundación Colección Thyssen-Bornemisza, Madrid

INBA /Museo de Arte Alvar Y Carmen T. de Carillo Gil, Mexico City

Civico Museo d'Arte Contemporanea, Milan

Pinacoteca di Brera, Milan

Städtisches Museum Abteiberg, Mönchengladbach

Central State Museum for Air and Space Craft, Monino (Moscow Area)

State Pushkin-Museum, Moscow

State Tretyakov Gallery, Moscow

Bayerische Staatsgemäldesammlungen; Staatsgalerie moderner Kunst, Munich

Städtische Galerie im Lenbachhaus, Munich

Stiftung Seebüll Ada und Emil Nolde, Neukirchen

New Orleans Museum, New Orleans

Solomon R. Guggenheim Museum, New York

The Metropolitan Museum of Art, New York

Whitney Museum of American Art, New York

Toyota Municipal Museum of Art, Nishimachi Toyota City

Musée d'Art Moderne de la Ville de Paris

Musée Maillol, Paris

Musée National d'Art Moderne, Centre Georges Pompidou, Paris

Musée de l'Orangerie, Paris

Musée Picasso, Paris

Carnegie Museum of Art, Pittsburgh

Andy Warhol Museum, Pittsburgh

Galleria Nazionale d'Arte Moderna, Rome

Open Air Museum for Architecture and Art, Rostov-Yaroslavski

Museum Boijmans Van Beuningen, Rotterdam

Museum of Fine Arts, St. Petersburg, Florida

San Francisco Museum of Modern Art, San Francisco

Kunstmuseum St. Gallen

State Hermitage, St. Petersburg

State Russian Museum, St. Petersburg

Schleswig-Holsteinisches Landes-museum, Schloß Gottorf

Staatliches Museum, Schwerin

Moderna Museet, Stockholm

Staatsgalerie Stuttgart

Toledo Museum of Art, Toledo

Galleria Civica d'Arte Moderna e Contemporanea, Turin

Galleria Internazionale d'Arte Moderna, Ca'Pesaro, Venice

Peggy Guggenheim Collection, Venice

Hirshhorn Museum and Sculpture Garden, Smithsonian Institution, Washington D.C.

National Gallery of Art, Washington D.C.

Kunstsammlungen zu Weimar

Historisches Museum der Stadt Wien, Vienna

Museum moderner Kunst Stiftung Ludwig, Vienna

Kunstmuseum Wolfsburg

Kunsthaus Zürich, Zurich

Fondazione Amelio, Istituto per l' arte contemporanea, Napels

Berardo Collection

Berggruen Collection
Galerie Berinson, Berlin
Claude Berri, Paris
F. and JPH. Billarant
Gilbert de Botton Family Trust
Eli and Edythe L. Broad, Los Angeles
Estate of Alexander Calder
Caldic Collection, Rotterdam
Eduardo Chillida
Attilio Codognato, Venice
Giovanni Deana, Venice
Dingwall Investments S.A.
Stefan T. Edlis
Essl Collection, Klosterneuburg
Betty and Monte Factor Family Collection
Aaron I. Fleischman
Fondazione Fontana, Milan
Franchetti Collection, Rome
Froehlich Collection, Stuttgart
"La Gaia", Cuneo
Centro Galego de Arte Contemporánea,
 Santiago de Compostela
Jacques and Natasha Gelman
Alberto Giacometti-Stiftung
Galerie Gmurzynska, Cologne
Estates of Julio González, Paris
Collection Gräßlin, St. Georgen
Galerie Karsten Greve, Cologne, Paris,
 Milan
Grothe Collection
Martine and Didier Guichard
Joseph Hackmey
Galerie Hauser & Wirth, Zurich
Ydessa Hendeles
Herbert Collection, Ghent
Stiftung Rolf Horn
Didier Imbert Art Production, Paris
Jedermann, N.A.
Jasper Johns

Ilya and Emilia Kabakov
James Kirkman Ltd., London
Frits de Kneght
Jannis Kounellis
Labeyrie Collection
Max Lang, New York
Linda and Harry Macklowe, New York
Paul Maenz
Loïc Malle, Paris
Susan and Lewis Manilow
Collection Mis, Brussels
Henry Moore Foundation
Nahmad, Geneva
Onnasch Collection
Banque Paribas Belgique S.A., Brussels
Ulla and Heiner Pietzsch, Berlin
Fondazione Prada, Milan
Archive A. Rodchenko and V. Stepanova,
 Moscow
A. Rosengart
Thomas Ruff
Sonnabend Collection, New York
Galerie Monika Sprüth, Cologne
Edition Staeck
Stober Collection
Benedikt Taschen
A. Alfred Taubman
Galerie Thomas, München
James Turrell
Ronny van de Velde, Antwerp
Bill Viola
Andy Warhol Foundation for the Visual
 Arts, Inc.
Henry and Cheryl Welt, New York
Donald Young Gallery, Seattle
Richard S. Zeisler, New York

and many lenders who wish to remain
anonymous

Courtesy
Thomas Ammann Fine Art, Zurich
Galerie Bruno Bischofberger, Zurich
Blondeau Fine Art Services SA, Geneva
Marc Blondeau S.A., Paris
Galerie Christine et Isy Brachot, Brussels
Busche Galerie
Leo Castelli Gallery
Galerie Chantal Crousel
Christie's, New York
Centro Cultural/Arte Contemporáneo,
 A.C., Mexico City
Elkon Gallery, Inc., New York
Claudia Gian Ferrari, Milan
Galerie Konrad Fischer, Düsseldorf
Fuji Television Gallery, Tokyo
Galerie de France, Paris
Barbara Gladstone Gallery, New York
Galerie Gmurzynska, Cologne
Galerie Karsten Greve, Cologne, Paris,
 Milan
Ydessa Hendeles Art Foundation
 Toronto, Canada
The Helman Collection, New York
Hirschl & Adler Modern, New York
Jenny Holzer
Michael Hue-Williams Fine Art, London
Galerie Jablonka, Cologne
Annely Juda Fine Art, London
Galerie Jule Kewenig
Lefevre Gallery, London
Massimo Martino S.A., Mendrisio
PaceWildenstein
Gallery dello Scudo, Verona
Sotheby's, New York
Galleria Christian Stein, Milan

Photographic Acknowledgements

Catalogue illustrations

Most photographs were provided by the owners or custodians of the works of art reproduced

Jörg P. Anders, Berlin 77, 369
Archiv Paul Maenz, Berlin 398
Archivo fotográfico Museo Nacional Centro de Arte
 Reina Sofia 171
Berlinische Galerie 148, 223
Ben Blackwell 87
Bridgeman Art Library, London 113
Michael Cavanagh/Kevin Montague 207, 209, 210
Giorgio Colombo, Milan 185
Jorge Contreras Chacel 102
Peter Cox 340
Fabien de Cugnac 242
W. Dräyer, Zurich 75
© State Hermitage, St. Petersburg, 1997 2, 3, 4, 6, 123
© Fitzwilliam Museum, University of Cambridge 104
© Bruno Giacometti, Zollikon, Switzerland 57
Musée Grenoble 35, 86
Karlheinz Grünke, Hamburg 239
© Solomon R. Guggenheim Foundation, New York
 7, 11, 14, 15, 25, 29, 45, 51, 59, 63, 122, 165, 185–187,
 191, 192, 241, 342
David Heald 7, 11, 14, 15, 25, 29, 45, 51, 59, 63, 122,
 165, 176, 191, 192, 241, 342
Courtesy The Helman Collection, New York 261, 261
Michael Herling 40
Javier Hinojosa 103
George Hixson, Houston 1995 226, 250
HLM, Werner Kump 206
Intercolor B.V., Eindhoven 30
Jochen Littkemann 54, 62, 351, 352, 364
© Estate Man Ray 216, 217
© The Metropolitan Museum of Art, New York 98,
 337, 367, 368
Henry Moore Foundation, © Henry Moore
 Foundation 373, 374, 375
© Museum of Fine Arts, St. Petersburg, Florida 227
© Nolde-Stiftung Seebüll 26, 27
Frank Oleski, Cologne 76
Paris-Musées – Musée d'art moderne de la ville de
 Paris & Jan Almeren, Stockholm 385
© Photothèque des Musées de la Ville de Paris 53
Douglas M. Parker Studio 335
Paolo Pellion, Turin 294
Kira Perov 327
Hans Petersen 33
Prudence Cumming Associates Ltd., London 72
Antonia Reeve 240
Rheinisches Bildarchiv, © Rheinisches Bildarchiv 74,
 195, 231
Ilona Ripke 148, 223, 225

Sally Ritts 186, 187
© RMN – Arnaudet 37
© RMN 71
J.M.Routhier 248
© Thomas Ruff 120
Foto Saporetti 1, 13, 16, 17, 18, 169, 170, 173, 174,
 175, 381
Edition Schellmann 119
© G. Schiavinotto 149, 298
Uwe H. Seyl 182
Sheffield City Art Galleries, 1991 68
Lee Stalsworth 65, 221, 264, 383
Richard Stoner 258
Nic Tenwiggenhorn, Düsseldorf 329
Courtesy Donald Young Gallery, Seattle 327
Patrick Young 50
Elke Walford 183
© Andy Warhol Foundation for the Visual Arts
 114,115, 256–260
John Webb 346
© Direktion der Museen der Stadt Wien 80
Jens Ziehe 393

Text illustrations

Claudio Abate p. 316 bottom
Lucien Braun p. 26 top
Peter Brötzmann p. 561
Kathan Brown p. 548 bottom
Courtesy Paula Cooper Gallery, New York
 p. 438 bottom
© Dia Center for the Arts, New York p. 550 left
© Gianfranco Gorgoni p. 551 top
François Goudier p. 27 bottom
Hickey-Robertson p. 208 top
Courtesy Nancy Holt p. 550 right
Courtesy Galerie Ghislaine Hussenot, Paris
 p. 439 centre
Courtesy Shigeko Kubota p. 317
© Peter Moore p. 309 bottom, 547 bottom
Caroline Nathusius p. 308 bottom
Österreichische Nationabibliothek, Vienna p. 21,
 p. 22 top
Dirk Pauwels p. 318 bottom
Photo archive Udo Pini, Hamburg p. 539 top
Archive A. Rodchenko and V. Stepanova, Moscow
 p. 216 top
Prudence Cumming Associates p. 219
© Oskar Schlemmer Family Estate, Badenweiler
 pp. 527–531
James Thrall Soby p. 320
Photo archive Süddeutscher Verlag, Munich
 p. 26 bottom
Diane Wakoski p. 548 top

Photographs of the artists

Francis Bacon: Paul Popper / Interfoto
Balthus: Privatarchiv
Georg Baselitz: Niklaus Stauss / AKG Photo
Max Beckmann: AKG Photo
Joseph Beuys: Niklaus Stauss / AKG Photo
Umberto Boccioni: Staatliche Museen zu Berlin –
 Preußischer Kulturbesitz
Christian Boltanski: Benjamin Katz
Pierre Bonnard: Henri Cartier-Bresson
Constantin Brancusi: Interfoto
Georges Braque: AKG Photo
Marcel Broodthaers: Philippe de Gobert
Alberto Burri: Giuseppe Loy
Alexander Calder: Paul Almasy / AKG Photo
Marc Chagall: AKG Photo
Eduardo Chillida: Schirn Kunsthalle, Frankfurt a.M.
Giorgio de Chirico: AKG Photo
Lovis Corinth: AKG Photo
Salvador Dalí: Paul Almsay / AKG Photo
Alexander Deineka: Karger-Decker/Interfoto
Robert Delaunay: Archives de la famille
Jan Dibbets: Ad Petersen
Otto Dix: Hugo Erfurth / AKG Photo
Marcel Duchamp: J. S. Lewinski / Interfoto
Max Ernst: AKG Photo
Jean Fautrier: Interfoto
Dan Flavin: Niklaus Stauss
Günther Förg: Dirk Bleicker
Lucio Fontana: Giancolombo
Katharina Fritsch: Benjamin Katz
Naum Gabo: Nina und Graham Williams
Alberto Giacometti: Paul Almasy / AKG Photo
Gilbert & George: Niklaus Stauss / AKG Photo
Julio González: Nachlaß González
Arshile Gorky: Courtesy Sarkis Avesidian
George Grosz: AKG Photo
Raoul Hausmann: August Sander / AKG Photo
Eva Hesse: Stephen Korbet
Gary Hill: Dirk Bleicker
David Hockney: Camera Press/Interfoto
Jenny Holzer: Abe Frajndlich
Edward Hopper: Sidney Waintrob,
 Budd Studio
Jasper Johns: Dennis Hopper
Asger Jorn: Gunni Busck
Donald Judd: Benjamin Katz
Ilya Kabakov: Dirk Bleicker
Frida Kahlo: AKG Photo
Wassily Kandinsky: AKG Photo
Mike Kelley: Dirk Bleicker
Ellsworth Kelly: Benjamin Katz
Anselm Kiefer: Binder/AKG Photo
Edward Kienholz: Nancy Reddin Kienholz

Ernst Ludwig Kirchner: Fotoarchiv Bolliger/Ketterer, © Dr. Wolfgang & Ingeborg Henze-Ketterer, Wichtrach/Bern
R. B. Kitaj: Lee Friedlander
Paul Klee: AKG Photo
Yves Klein: Harry Shunk, New York
Oskar Kokoschka: Erich Lessing/AKG Photo
Willem de Kooning: © Hans Namuth
Jeff Koons: © 1995 Andrew Southam/CPI
Jannis Kounellis: Frédéric Delpech
Bertrand Lavier: Galerie Martina Detterer
Fernand Léger: AKG Photo
Wilhelm Lehmbruck: AKG Photo
Roy Lichtenstein: Ksandr/Interfoto
Richard Long: Galerie Konrad Fischer, Düsseldorf
René Magritte: Richard de Grab
Aristide Maillol: A. Zucca/AKG Photo
Kasimir Malewitsch: Interfoto
Franz Marc: AKG Photo
Henri Matisse: AKG Photo
Matta: Stewart Mark/Camera Press/Picture Press Life
Mario Merz: Dirk Bleicker
Joan Miró: AKG Photo
Amedeo Modigliani: Interfoto
Piet Mondrian: Interfoto
Claude Monet: Paul Nadar/Interfoto
Henry Moore: Binder/AKG Photo
Giorgio Morandi: Herbert List/Interfoto
Reinhard Mucha: M. M. Kraft
Bruce Nauman: © Donald Woodman, Canyon Santa Fe; Courtesy Leo Castelli Gallery, New York
Barnett Newman: Ugo Mulas
Emil Nolde: Minna Dührkoop/Interfoto
Claes Oldenburg: Hans Hammarskjöld
Nam June Paik: AKG Photo

Francis Picabia: E. Wehner/Interfoto
Pablo Picasso: AKG Photo
Sigmar Polke: Niklaus Stauss/AKG Photo
Jackson Pollock: Hans Namuth
Robert Rauschenberg: © Christopher Felver, New York
Ad Reinhardt: Hans Namuth
Gerhard Richter: Dirk Bleicker
Alexander Rodtschenko: Erben von Alexander M. Rodtschenko und Warwara F. Stepanowa
Mark Rothko: Regina Bogat
Thomas Ruff: Dirk Bleicker
Robert Ryman: Timothy Greenfield-Sanders, 1987
Christian Schad: Nachlaß und Archiv Christian Schad, Keilberg
Egon Schiele: Interfoto
Oskar Schlemmer: Hugo Erfurth
Kurt Schwitters: AKG Photo
Richard Serra: Binder/AKG Photo
Cindy Sherman: Niklaus Stauss/AKG Photo
David Smith: Ugo Mulas
Stanley Spencer: Interfoto
Frank Stella: Marina Schinz
Yves Tanguy: Man Ray
Antoni Tàpies: Antoni Tàpies Barba
Wladimir Tatlin: Moisei Nappelbaum/Interfoto
Jean Tinguely: Niklaus Stauss/AKG Photo
Rosemarie Trockel: Benjamin Katz
James Turrell: Christian Vogt
Cy Twombly: © Plinio de Martiis, Galerie Karsten Greve, Köln
Bill Viola: Dirk Bleicker
Andy Warhol: AKG Photo
Lawrence Weiner: © Christopher Felver, New York
Wols: Nachlaß Wols

Index of Names

Figures in italics refer to illustrations